OUR
GOVERNMENT
AND THE
ARTS

A Perspective from the Inside

ACA Books
American Council for the Arts
New York, New York

Livingston Biddle

OUR
GOVERNMENT

A Perspective from the Inside

AND THE
ARTS

FOREWORD BY
Isaac Stern

No part of this publication may be reproduced by any means
without the written permission of the publisher. For infor-
mation, contact the American Council for the Arts, 1285
Avenue of the Americas, 3rd Floor, New York, NY 10019.

Edited by Ellen Cochran Hirzy
Book and jacket design by Celine Brandes, Photo Plus Art

Typesetting by Creative Graphics, Inc.
Printing by Port City Press

Director of Publishing: Robert Porter
Assistant Director of Publishing: Amy Jennings

Library of Congress Cataloging-in-Publication Data

Biddle, Livingston, 1918–
 Our government and the arts: a perspective from the
inside / by Livingston Biddle.
 p. cm.
 Includes index.
 ISBN 0-915400-67-7 : $24.95. ISBN 0-915400-68-5 (pbk.) :
 $16.95
 1. National Endowment for the Arts—History. I. Title.
NX735.B54 1988 88-6168
353.0085′4—dc19 CIP

TO
my wife Catharina

Contents

Part One
PREPARATION
1

Part Two
THE BIG PUSH BEGINS
57

Part Three
THE LEGISLATION EMBATTLED
119

Part Four
DEPUTY CHAIRMAN
183

Foreword

I T was a very special day for all of us. Many of my colleagues were world-renowned artists, others well-known leaders in the arts. Each one had known exciting and moving occasions in their disciplines. But this day was unique, for we were joined together in an extraordinary mission to advance the arts. Before us stood President Lyndon Johnson presenting us as participants in the first National Council on the Arts. He was announcing as well, for the first time in our history, our government's commitment to the arts in the context of a new program. We were launched on an uncharted path for the United States and we were very conscious of both the responsibility and the exciting possibilities.

Our task was to help develop excellence in the arts and to make that excellence more widely available and accessible to all our people. In the course of our very first deliberations, we also knew that we had responsibilities to the creative minds and spirits in this country to make possible more and more opportunities for them to experiment, to have as we said, "the right to fail" without which the arts do not flourish. It was a memorable time. It produced remarkable results. Roger Stevens was the chairman. Livingston Biddle became the first deputy chairman.

This book chronicles the development of the National Council on the Arts and the National Endowment for the Arts from their inception to the present day. It tells how legislation was created and grew to reality and of the extraordinary difficulties faced in Congress in the beginning and continuing periodically through the years. It describes the dedicated men and women who helped make it all happen and those others who tried hard to prevent its creation and growth by criticism or ridicule. It is a story we all should know in order to continue to bring those special values of the arts to our national consciousness. They are basic to our individual lives and absolutely vital to the future of our nation. They are integral to the legacy the United States will leave as its share and responsibility to world civilization.

When Liv Biddle was sworn in as the endowment's third chairman, he asked me to speak at the ceremony. The themes of the remarks were quality and excellence. They were true then, they will always be true. They must be nurtured and grow. Liv understands these essentials and, with many leaders of the council and others in government, he has sought with strength and heart to fulfill the goals we share.

As a successful novelist before he came to Washington, then assistant to Senator Claiborne Pell, as a legislative draftsman closely associated with the original language that created the legislation, and as an educator and administrator he brings to the story a unique perspective. It is history, and from its pages we all can learn.

1988

Introduction

EMOTION should be recollected in tranquility, counsels the poet seeking to guide the writer toward objective discourse. Pause in the journey, and reflect, and from a perspective given some distance by time, recount and shape the past. Mistrust the temporary passion. Take the long and calmer view.

The writer of these annals takes heed, but only in part. True, a respectable element of time has elapsed between past and present, and life, personally, may appear more tranquil as the writing instrument is placed against the piece of paper.

But what is presented here is not a distant citadel, finite, approachable, ready for ultimate definition. It's not the remains of Wordsworth's Tintern Abbey in a green and romantic English countryside reminding the visitor of the glories of yesteryear. It's not a Machu Picchu atop a peak in the Andes ready to be reclaimed by the scholar. It's not a Japanese temple in Kyoto with subtleties of line and symmetry that remain unaltered. What is presented here relates to these, and to their counterparts, and to an infinity of variations, but it is alive and growing and changing, year by year and day by day.

Here are the arts, which give us dignity and originality and en-

lightenment and a lighter heart. The tranquil is not their principal virtue. They are full of controversies. When I reflect on the contents of these pages I hear—at first softly, but rising in sound once more—the clash of battles fought and the individual voices, as individual as the arts them- selves—all manner of voices, artists, scholars, political leaders, citizens with contentiously strong opinions, defenders and critics, friends and foes. Emotions return, and tranquility disappears.

This is a personal history. It might be called intimate, in the sense that much of it is a private possession. It is not footnoted. The reader is not asked to search for references. It is anecdotal. The history of govern- ment support for the arts in the United States is full of anecdote, indelibly remembered here. People speak as I remember them speaking, as I have heard them, as I have listened attentively to them—short of a tape re- corder, which I never had reason to use.

Might the tranquil reflection have provided embellishments on history? Perhaps some will suggest occasional fictional overlay by a writer who has specialized in the novel. Not so, I would say. Some anec- dotes could be called stranger than fiction, and hence be accorded a quite opposite description.

The arts is not a limited term. It means their widest scope and variety. This is, in essence, their story. It is a story unique to our country. It is a story still evolving.

And so, like Marcel Proust remembering things past, I raise that small cake, the madeleine, and instantly its taste recalls to me a scene from my own childhood, on an immense covered veranda in the wood- lands near Bryn Mawr, Pennsylvania, where my great aunt presided, in the whitest of silk and crinoline, over family afternoon teas. I see that porch in such detail that it seems I have never left it.

With the same feeling of clarity and nostalgia, I see the events, large and small, that this book depicts. Tranquility is in the mind, I sup- pose. Someday it may be possible to grasp it, but not yet.

Livingston Biddle

Part One

PREPARATION

Chapter 1

IT WAS DURING 1962 THAT I BEGAN PLANS TO MOVE FROM MY PHILADELPHIA home to Washington to work for my old friend, Claiborne Pell. Recently elected to the United States Senate, he invited me to join his endeavors. He was in search of a writer. I had spent some sixteen years in that profession, producing a variety of articles and nonfiction work but concentrating chiefly on the novel. Four had been published. Two had been best-sellers. All had a Philadelphia background and content, though they had roamed, in part, to Italy and to the Caribbean.

Actually, I could not think of a fifth book to write about Philadelphia and its environs. (Some might suggest there was an overabundance already.) I had been considering a Washington experience, and our capital city had extended a beckoning hand. For me, this would have meant a departure from the examination of social mores, however bizarre or intriguing, to a discovery and developing knowledge of governmental dramas and political power.

Claiborne and I had gone to school (St. George's in Newport, Rhode Island) and college (Princeton University) in the same classes. We met again one evening at the spacious home of Philadelphia-born Joseph Clark, then also a U.S. senator, who was giving a party for his new-

found Senate friend, Claiborne Pell. Claiborne and I had not seen each other for a number of years. At the time I was considering how best to approach Washington.

I broached the matter to Claiborne and was surprised to find all at once that he was looking "not for a particular specialist, but for a writer." Perhaps there is something to be said for writing as a specialty, but he made the offer without such innuendo and with generous spirit. I accepted. The decision changed my entire life; I would make it again today with the same enthusiasm.

So the departure occurred. The old Philadelphia farmhouse where I was born, begun in pre-Revolutionary times, was left behind—the stream alive with watercress in spring, the rolling fields beyond, and the lush, tree-shaded countryside beyond those. The late-afternoons, after-writing hikes through the tall grass with a small shotgun and springer spaniel in quest of a pheasant or two, were left. Left also were the inter-woven, immensely intricate tapestries of Philadelphia society—a father who said to his son, upon learning that the young man, just home from the war, intended to write with altered and perhaps critical viewpoint about his own beloved city, "Wouldn't it be better, old fellow, to write about some other place? How about Chicago?" And left behind was the attic work space with desk and chair, and window tiny enough to satisfy even Somerset Maugham's admonitions against a writer's room with a view. Years later I was to tell President Carter about this abbreviated, ceiling-slanted work space, in the manner in which my young daughter had described it to her schoolmates. The story made the President laugh aloud, and I think it could have helped me win the job of chairman of the National Endowment for the Arts.

Of course, the farmhouse of Pennsylvania fieldstone with its post-Revolutionary series of additions remained ours for a time. The memories still evoke great nostalgia, and I can see the haunts of childhood and growing up with the clarity of yesterday. But it is another world, far less frequently visited than before.

Claiborne Pell and I reached agreement. I would work for two years and then be free to pursue my writing solo. By this time I believed I would be prepared for a fifth novel about the intrigues, the wonders, the struggles of the Washington scene. It is not yet written, that novel. Some strange and marvelous things happened to me on my way to it.

I had been working for about two months when late one after-noon Claiborne took me aside into his private office, the big room where he still works in the Russell Senate Office Building. (In those days, it was called the Old Senate Office Building. The name change occurred in def-erence to Senator Richard B. Russell of Georgia, but also because the

initials of the former name, old SOB, could be perceived to carry a questionable connotation.)

The room is high-ceilinged with large windows along one side. There is an elegant fireplace and mantel, and the walls are crowded—even more so today—with Pell memorabilia, lithographs of family members and ancestors including a Vice-President, photographs of the more currently notable, political cartoons, and, high on the wall, a painting or two of modest size from the Italian Renaissance. We stood beside Claiborne's large, leather-topped desk. I remember him repeating our understanding and describing my generalist's role. Then he said, "But if you should discover something that really fascinates you, Livy, tell me about it. Maybe I'd like it, too, and we can work on it together."

I thought about this. An unusual opportunity seemed to hover in that afternoon light. A number of days went by as my own thoughts continued. Then I said to Claiborne that my particular interests, experience, and special training, such as it was, all involved the arts. My parents had introduced me to their magic at an early age: to concerts at the Philadelphia Academy of Music, to opera, to theater. My great aunt Mary Drexel took me as a child each Friday afternoon to the academy, where her box was especially well located, within sight of all passersby. Aunt Mary, it must be admitted, enjoyed the passersby and their attention perhaps more than the music. Invariably she remarked to her guests or visitors that the soloist or the recitalist was a little off-key, indicating special critical acumen. But even as a child I found that sort of comment slightly unusual, as it was known in close family circles that Aunt Mary Drexel was, beyond any doubt, more than a little tone deaf. Nevertheless, music in all its glory was implanted in my experience.

In World War II I was a volunteer ambulance driver, a member of the American Field Service. My nearsightedness prevented me from joining our armed forces. I was classified 4-F. In that different war, in that different time, I felt humiliated. Then came word that the AFS was a possibility. A crusty British type in New York City, where the organization's headquarters were located, informed me, "Biddle, there are two criteria you must meet for this outfit: one, you must have a driver's license; and two, you must beyond any question be breathing." I was accepted. After eleven weeks at sea, through oceans frequently described as "submarine infested," on a leaky Egyptian ship undoubtedly spared torpedoes because no self-respecting U-boat wished to bother with it, I arrived in Cairo. Three years of work ensued, more often than not on the front lines, with all manner of Allied troops and groupings: from the United Kingdom, Canada, Australia, India, Trans-Jordan, the free Italians at one point, and later the free French. Clinging to my memories of those days

is the knowledge that in the very darkest days of World War II, when London itself was under bombardment from the skies, the British began their government-supported program for the arts. Priorities have special meanings at special times: what is worth defending, what is given precedence even in the bleakest, the direst of circumstances.

Claiborne was impressed by this disclosure. We began to talk in earnest about the arts. We recalled the art history courses we had taken at Princeton. I reviewed governmental help to the arts going back to the days of the Egyptian pharaohs. Leaders of all civilized countries had placed an abiding importance on the arts and cultural values. Wasn't it important that the United States join in? Claiborne Pell could become, in essence, the father of our own program, the senatorial parent.

We talked of President Kennedy and of Jacqueline Kennedy and her focus on leading artists at White House functions. We talked of August Heckscher, the President's advisor on the arts. We talked of efforts in which Claiborne was already involved to establish a new and precedent-setting arts program—efforts begun, but far from any fruition. We talked of the serious lack of substantive congressional support and of legislative ideas that had never been presented for action on the Senate floor. And somewhere during the conversation, I changed from generalist to specialist and was afforded a remarkable assignment and portfolio. I was given the latitude of spending as much time as seemed appropriate on a subject close to me. My Senate work often involved drafting speeches and magazine and newspaper articles for the senator's signature on a variety of other topics: the problems and challenges of youth, high-speed ground transportation in the Northeast corridor from Washington to Boston, "Pacem in Terris" and the eloquence of Pope John XXIII, even how to resolve the division between East and West Germany.

As the months passed, however, I was increasingly immersed in the arts. Perhaps at the time Claiborne did not view the project as ultimately viable. He said to me, "This will be the *pro bono publico* part of my job. I very much doubt it will help me politically, ever." The latter part of this remark others would corroborate.

There is, however, between Claiborne Pell and me a common bond, a fundamental feeling that privileges in one's lifetime dictate a deep responsibility to others. Sometimes the attitude was mistaken in Claiborne for naiveté, sometimes for eccentricity, sometimes as epitomizing the impractical. But once the basic quality is understood, it is endearing, and it is not pretended. It is the genuine article.

I was, however, the epitome of the naive as I first contemplated my new tasks. The truth is, I simply did not know enough about Washington, the U.S. Senate, or government procedures and practices to be aware of the possibility of failure. For me that evening, a new vista

stretched out, to the horizon and beyond. A new age of enlightenment would come. I would be part of its achievement. Claiborne had given me virtually carte blanche to proceed. I would investigate all avenues and report when needed. I would relay my findings by memo. Length was not a factor, Claiborne said. He would review the thoughts as his time permitted. I still have copies of many of these memoranda. In the beginning they reveal someone striving to learn, for the euphoria of that first evening was short-lived.

Chapter 2

CLAIBORNE'S FIRST MAJOR COMMITTEE ASSIGNMENT WAS THE COMMITTEE on Labor and Public Welfare. A great, indeed to me infallible, practitioner of the processes of Washington was the then chief clerk of the committee, Stewart McClure. As a Democratic newcomer, Claiborne ranked ninth on the majority side. But Stewart McClure had some twenty-five years of service. He was slender, tall, soft spoken; his mind, a vast storehouse of history, legislative attempts, legislative successes, procedures, significant protocols, even minute details—which senator liked a glass of Poland Water at his elbow; and which, a glass from the springs of Saratoga.

I was fortunate; Stewart's intellect welcomed the concept of support for the arts. From him I began learning about Washington: its structures, its protocols, its language (with a glossary that includes diplomacy, understatement, and seeming ambiguity, readily translatable, however, by an expert). Sometimes we would meet for a short breakfast, sometimes for a bite of lunch, sometimes for a brief discussion after work in his office, just beyond the tall portals of the committee's great paneled hearing room. Perhaps the eagerness of his pupil amused him—perhaps the prospect of tilting at another windmill, perhaps the unusual nature of

the assignment and the fact that a freshman senator would encourage dedication to the venture. I learned about who might be receptive—not senators, but staff members or the colleagues of staff members. Don't go to him, Stewart would say. He'll turn you down flat. Try his girlfriend. She's on Appropriations and plays Mozart.

I learned about introducing legislation, about statements for the Senate floor, always addressed, "Mr. President" to the Senate president pro tempore. I learned the 100 senators by name, and I studied their pictures and their records. I learned about hearings and how to invite testimony. And I learned of the essential nature of the legislative subcommittee.

"We need Claiborne Pell to be the chairman of a subcommittee," Stewart said. "That way, if a bill ever does reach the floor for final action, he'll be the floor manager." I learned where he would sit, or stand, on such an occasion—at the vacated desk of the majority leader. And I learned where I would sit—in a small, low, closely adjacent chair known as the "hot seat," where the staff assistant to the floor manager was permitted, and expected, to be, with his files and papers, both inaudible and for all intents and purposes invisible.

First came the subcommittee and approval from the chairman of the full committee, Lister Hill of Alabama. Lister Hill was a senior senator. While Claiborne Pell tied with three others for fortieth and was the eighty-fourth senator listed, Lister Hill ranked fifth. Senator Hill was elegant in attire, articulate in voice, and had a jutting jaw and a will of iron. He was noted especially for his legislation to improve health care; hospitals and health centers around the country bear his name. With eyes the color of well-tempered steel, he exuded authority. Stewart McClure visited his office at the end of each day to receive instructions.

One evening, as nearly as I can report, the chairman smiled, leaned back affably in his chair, hands crossed over his tweed waistcoat, and said, "Now, that's all I have, Stewart. But I've got a minute or two more. Anything on your mind tonight?" (Please feel free to imagine the mellifluous Alabama cadence.)

"Well, yes sir, Mr. Chairman. Actually there is." The chairman invited a rejoinder in his affable tone and in keeping with the many conversations these two had held over many years, as chairman vis à vis trusted and respected, and properly deferential, chief clerk.

"Well, Mr. Chairman," Stewart started, "you have on your committee a relatively new senator."

"Several," the chairman nodded pleasantly. "Which one did you have in mind?"

"It's Claiborne Pell, Mr. Chairman."

"Oh yes," Senator Hill nodded again in a friendly fashion. "Cer-

tainly, Claiborne Pell from Rhode Island. Claiborne," he repeated. "Now there's a good southern name. Probably," he suggested, "there could be a relationship to the Claibornes in Louisiana or Mississippi."

"Yes sir, Mr. Chairman," Stewart agreed. "One of his ancestors was a Vice-President from the South."

"Is that so? Well now—tell me, what does this boy want?"

"As a matter of fact, Mr. Chairman, he'd like to have a subcommittee." Stewart McClure began matter-of-factly. At this point, the chairman reportedly leaned abruptly forward, unclasping his hands.

"A subcommittee? Am I hearing you, Stewart? Am I hearing you correctly?"

"Yes sir, but—"

Lister Hill was leaning forward a bit further. "You mean, a subcommittee of his own? Am I hearing you right? Is that what you mean?"

"Yes, Mr. Chairman, but—"

The chairman moved his hand. No buts at all, he indicated. "I'm obliged to interrupt you, right here and now," he said. "A subcommittee. Well now, that's quite a surprise, isn't it?" His frown deepened. "I'm surprised—yes sir." He was very surprised, he was telling Stewart McClure, and he was surprised at his chief clerk. "Why, you ought to know better," he was saying. "You do know better."

"Mr. Chairman, I—"

"You know a lot better, Stewart."

He suggested the following advice for Claiborne Pell and a chief clerk suffering a temporary aberration. Mr. Pell was to be content with waiting for a while more, specifically for four years beyond the evening in question, until possible reelection, and then probably for another six years after that. In his third term, should fortune smile, a subcommittee chairmanship just might be considered.

Without further ceremony, while the steely eyes regarded him, Stewart was dismissed. He had started to back from the room, in some confusion, when the chairman rose and held up his hand.

"Just as a matter of interest to me, Stewart," the chairman said, his voice affable again, "which subcommittee did he want? Did he want Wayne Morse's Subcommittee on Education? Why, Wayne's been here almost as long as I. Did he want Pat McNamara to move over, or Jennings Randolph? Jennings came here with Franklin Delano Roosevelt. What subcommittee did he want?"

"It wasn't any of those," Stewart began once more.

"Which one was it?"

"A new subcommittee, Mr. Chairman."

"A new one? What new one?"

"A subcommittee on the arts, Mr. Chairman."

"On the what?" the chairman inquired.

"On the arts, Mr. Chairman."

"On the *arts,* did you say?"

"Yes sir, on the arts."

"You mean music, painting, things like that?"

"Yes sir, on the arts."

Suddenly the chairman was smiling. "On the arts!" he repeated. "On the arts!" After a southern exclamation or two denoting astonishment at the oddness of the request and its apparent lack of political relevance, the smile broadened.

"Well, if that's all he wants," he told Stewart McClure, "he can have it. In fact, he's welcome to it."

Possibly the chairman was thinking Claiborne Pell would not be making further requests for a while or that the promise of southern intelligence had been lost somewhere in the wilds of Yankee Rhode Island. In any event, the information was appropriately relayed. And so for the first time in United States Senate history, a Subcommittee on the Arts was created.

As an epilogue to this encounter and its consequences, I can report hearing Senator Hill deliver opening remarks to a large group of American clubwomen assembled in Washington a number of years later.

Still sprightly, still with bright-steel eyes, still elegant in attire, always courtly in manner, he stood on the podium surveying his audience, a number of whom were from Alabama. He noted nostalgically that in preparing his remarks his thoughts had returned to one special evening when, alone in his office, he had pondered, as was sometimes his custom, the nation's future. It had come to him, he said, that what we needed as a counterbalance to material growth was an emphasis on cultural values. He had determined then and there, he continued—and he hoped all his audience would remember it—to create a Subcommittee on the Arts. That was the real beginning.

And who should lead this subcommittee, he asked? Why it was a senator, no more than a few feet away, at this very head table. It was Claiborne Pell, who would soon follow with an address. He was pleased, the senior senator said, to see so many charming cultural leaders from his home state, and he felt sure they would recognize that, although Senator Pell so well represented the people of Rhode Island, he had a good southern name.

As another epilogue, history will record that the Subcommittee on the Arts became the Subcommittee on Arts and Humanities. And some years later, when Lister Hill had departed, and Harrison Williams was

chairman of the full committee (now called the Committee on Human Resources) and Wayne Morse no longer served as senator from Oregon, the subcommittee was retitled—this time as the Subcommittee on Education, Arts, and Humanities. Senator Claiborne Pell was its chairman.

Chapter 3

I N THE SUMMER OF 1963, I BEGAN TO PREPARE FOR HEARINGS BEFORE THE Senate subcommittee. Hearings are designed to foster legislation, to explore all sides of an issue or issues. They are fundamental to the legislative process. To one still in the neophyte class but increasingly learning, Senate hearings seemed of momentous consequence and the preparatory work of a similar size. Ignorance is perhaps the least tolerated of shortcomings on Capitol Hill. It ranks even above questionable behavior. I was determined to overcome it by whatever means possible. There were volumes to peruse on the arts and their practitioners, at home and abroad, a vast panoply of material beyond my own personal experience with which to grow familiar. But on some subjects there was scarcely a word, even from sources that were otherwise eminently dependable.

Claiborne decided we should research thoroughly what other nations of the civilized world (which in essence meant those financially able) were spending annually on the arts. If the United States, as I had written, was the only country in the civilized world yet to provide government support of the kind we had in mind, what were the precise dimensions of contrast with other countries? "We should have the very

best figures, and they should be fully documented," said Claiborne. "We don't want questions we can't answer on this or any other subject."

I turned, of course, to the Library of Congress, that repository for virtually all knowledge of the civilized, or uncivilized, worlds. Dutifully, I called the library, explained my needs and mission to a young woman whose responses connoted, it appeared, at least a Ph.D. in library science. I waited several days and called again, for I had received no documents. "Well, we're having a little trouble with this," I was told. "You see, no one's really ever asked for it before. Are you sure this is what you really want?"

I began to mistrust my assessment of expertise and waited a few more days. Then the librarian called. "We're trying the embassies," she informed me. "But there's a little problem. You see, they've never been asked for this, either, and the first few replies—well, they're really pretty sketchy, and it's kind of like trying to compare apples and oranges, if you know what I mean."

"Was there nothing in the stacks?" I asked.

"No, there really isn't. I think I can get you special permission to use them so you can come over and see for yourself."

Permission was granted, and she was right. I had never seen so many books in one place, or so many that skirted my request. With my special pass in hand, I prowled alone through the labyrinths, my guide having departed. All at once there caught my eye a small, almost inconspicuous monograph. As a child, trained by a nature-loving father, I had sometimes wandered Florida's west coast vacation beaches in search of rare shells. Once there was a junonia, prize of all prizes, peeking out from beneath a bit of seaweed cast up by the waves of a winter storm in the Gulf of Mexico. To me, catching a bolt of Jove's lightning on a kite string or first looking into Chapman's Homer or standing silent on a peak in Darien had nothing on this experience of excited discovery. And now the moment returned as I read alone in the dim light. The slender monograph told of a walking tour in West Germany. The author declared himself fascinated with one particular visit, which he said demonstrated so clearly West Germany's love of the arts. In one town he had documented government arts expenditures, from the local to the national, for the entire gamut of artistic activity—down to the last mark and pfennig.

This monograph became my Rosetta Stone. Previously somewhat averse to pure research and skeptical of its conclusions, I now gladly donned its mantle. I got atlases and censuses, and I studied all the towns of similar size in West Germany. I computed averages, made compensations for statistical variances, looked at economic summaries, and reviewed gross national products.

At the end of two days, I told Claiborne Pell of West Germany's

precise expenditure for the arts, per capita, per annum, with a factor for the higher U.S. standard of living computed in detail. As a former journalist, I naturally protected the particular source so it remained essentially my own.

"Where is this from?" Claiborne asked.

"From the Library of Congress," I answered without hesitation.

"Can it be questioned?"

"Not on your life," was the answer.

There followed similar pure research on other countries. It now became relatively easy to ascertain whether France, for instance, spent more or less than West Germany. "A little more, I think," was an embassy response which could be readily and mathematically translated. In some cases—for example, Austria—a certain amount of national pride was involved. The Austrian Embassy said, "Why, we spend that much on our opera house alone." In Senator Pell's statements, these computations were prefaced by "Even little Austria. . . ."

The figures I provided Claiborne Pell were published in the *Congressional Record.* Since it is often a general assumption that what appears in the *Record* is as reliable, say, as the *New York Times,* they were widely quoted, especially by other members of Congress. Indeed, they were quoted for years. In time those figures were superceded. Eventually the Ford Foundation did a comprehensive study, and later the National Endowment for the Arts did others, aided by computers and statisticians expert in determining differences between apples and oranges. Even by 1964 the data were beginning to take on elements of sophistication. And it is in passing strange: the old Biddle figures turned out to be a little more than 93 percent correct. If asked—which I have never yet been—I would just say the slight difference was probably caused by a variable, impossible to track exactly, of international inflation.

But lest the whole point be lost, it is simply this: European countries, the Soviet Union, and Canada were spending up to twenty-five times (and Austria about thirty-nine times) per capita the sum being discussed for the United States government: $5 million for the arts per year, with the possibility of $10 million as a later ceiling. That amounted to between two and a half cents and five cents per person per year. Analogies were drawn: aren't the arts worth at least the equivalent of one small glass of a popular soft drink, per person? (Ah, for the good old days when half a glass of Coke could be purchased for five cents.)

There were many who replied with a resounding no. There were a few who committed themselves and their sacred honor to yes. In those days, and in years before, the arts on Capitol Hill were considered frivolous, undependable, possibly embarrassing, tangential to life, not within its mainstream. These are not qualities that lend themselves to immediate

congressional action. Give me your huddled masses, the homeless, the tempest-tossed, and there is heartwarming response. But give me your huddled masses yearning to breathe free to enjoy the arts—that strikes a less responsive chord. Where in the Constitution is such nonsense as that?

So let us remember the senatorial pioneers. There was Joseph S. Clark, senator from Pennsylvania, former mayor of Philadelphia, a culturally-motivated Democrat, urbane, articulate, with a comfortable and rambling house of historic background on a tree-shaded street in Philadelphia's historic residential section of Chestnut Hill. Joe Clark could be called a populist with elitist tendencies; that is, a man with sufficient knowledge of the arts to make discriminating judgments on quality. He was sometimes acerbic, sometimes a loner. His book *The Sapless Branch*—a reference to the Senate and its need, as he saw it, for greater vitality—did not endear him to many colleagues. Trained as a lawyer, he enjoyed debate; he could be eloquently caustic and erudite at the same time. On one occasion he informed a fellow senator that his failure to express himself in any understandable manner was exceeded only by his lack of knowledge of the subject under discussion. But underneath impatience was a warmer humor. His contribution to the evolving arts legislation was important. Joe wanted the individual states to receive assistance. We were able to incorporate these concepts; and as time went on, despite contrary views, they remained.

It was important to Joe Clark that the arts, if governmentally assisted, should reach ever-widening audiences. This was a cause we all believed in, but none more than Senator Jacob K. Javits of New York. Like Joe Clark, Jack Javits was trained as a lawyer. I found him always exceptionally well-informed. There were occasions when his wisdom and experience helped win legislative and conceptual disputes, knotty disagreements among contesting individuals. It was clear to me from the very beginning of my work that Claiborne Pell, the junior Democratic senator from Rhode Island, must form a lasting alliance with Jacob Javits, the senior Republican senator from New York, elected four years before Claiborne and, unlike Claiborne, with a previous decade of service in the House of Representatives. Senator Javits was much admired by his colleagues, and he was the ranking Republican on our subcommittee.

I was told that the Javits staff people, with their similar degrees of seniority and experience, would eat me alive, or at least any day for breakfast, if such an inclination should move them. Al Lesser, on whom the senator much depended, almost always wore in his lapel a red flower, rose or carnation, with a flair and style that suggested Diamond Jim Brady's assured authority and accent of flamboyance. But we worked

in unison, and his bemused tolerance at the start eventually turned toward the respect I had expressed right away.

It was the arts, I believe, that brought Senators Pell and Javits into an abiding friendship. They were different in background (Javits was raised on the lower East Side of New York City; Pell, in Newport), religion (Javits was Jewish; Pell, a devout Episcopalian), and training (Claiborne Pell in the diplomatic service, Jack Javits in the turmoil and hurly-burly of New York's political process). But despite their differences these two found common purpose in the arts—though the senior senator liked to remind his junior colleague on occasion that, if pioneer wagons were to be involved, he was in a leading one.

On October 29, 1963, when the hearings began under the banner of National Arts Legislation, Senator Javits said, "Mr. Chairman, I take special pride in these hearings as it is now 15 years since I sponsored the first bill in the House of Representatives to establish a national cultural establishment. That was first offered in 1948 under the auspices of the American National Theater and Academy."

The legislation to which he referred was in the form of House Joint Resolution 104, 81st Congress, First Session. It declared that "the United States of America, almost alone among the great nations, does not now have a national theater and a national opera and ballet," and that these "are necessary for the enjoyment of these arts by the people throughout the United States, and especially outside the great centers of population." It spoke of "the development of playwrights, composers, performers, directors," of "enlarged opportunities for them." The President was authorized to convene an assembly of representatives of theater, opera, and ballet, arts critics, editors and publicists, educational leaders, the public as audience, and government officials to devise a plan for implementing the resolution, which, however, remained dormant.

The proposals before the Senate in 1963 called for establishing a National Council on the Arts and a National Arts Foundation. Senator Javits agreed that his early concepts focusing on the performing arts needed broadening to a wider inclusion of all the arts in their manifold variety.

In his opening statement Senator Hubert H. Humphrey spoke of the frustration that past efforts in behalf of the arts had come to naught. He joined with Senator Clark in commending Claiborne Pell. He praised his "diligence," his "real, genuine, dedicated leadership." He said, "We have not had the stick-to-it-iveness, the kind of perseverance" required to adopt legislation "which all too often takes a low priority on the agenda. I am sure that this year we are going to have better results, and

I am here primarily because I deeply respect what you have done," he told the chairman.

Senator Humphrey was then majority whip in the Senate, second only in the Democratic leadership hierarchy to the majority leader, Senator Mike Mansfield of Montana. Hubert Humphrey was a particular pioneer. He also had worked diligently in putting forth the concepts contained in the legislation.

On June 12, 1963, President Kennedy had issued what is known as an executive order, a fiat dealing with the executive branch of government and not subject to congressional action. Executive orders are not the norm; most presidents prefer to work out new proposals with congressional leaders so that initiatives can be shared. Executive Order 11112 called for the establishment of a President's Advisory Council on the Arts, to be composed of cabinet-level officials, heads of agencies with cultural activities (such as the Smithsonian Institution), and up to thirty private citizens noted for their achievements in the arts. The order followed publication in May of a report by the President's special consultant on the arts. August Heckscher had recommended a presidential council, and he stands in history—with his able assistant, Barbara Donald—as the first in a sequence of White House advisors given a special cultural portfolio. Thus "Augie" Heckscher, thin, seemingly frail, and of unusual intelligence, was also a pioneer. The historian Arthur Schlesinger followed in his footsteps. While the Heckscher report was not accorded the widest of courtesies by the press, and while Jacqueline Kennedy perhaps believed that one White House concert by a Pablo Casals was worth more than a thousand words, a tradition was being set: a White House cultural advisor close enough to the President to catch both his eye and ear and approval. (Lyndon Johnson followed in the tradition, as did Richard Nixon, Gerald Ford, Jimmy Carter, and Ronald Reagan, who appointed Daniel Terra as ambassador-at-large for cultural affairs, combining national and international interests.)

In his testimony, Senator Humphrey referred to the executive order. He hoped its concept would be congressionally mandated and so given permanence. "The legislation," he said, "is important because I do not believe that we ought to depend upon the promotion of the arts simply out of the White House. We ought to have this thing deep enough in the social fabric of our country that there is continuing support of the arts" in the Congress. The proposed National Council on the Arts would, Senator Humphrey went on, "recommend ways to maintain and increase the cultural resources of the United States, propose methods to encourage private initiative on the arts," advise and consult with private and public groups, conduct research and surveys, and file with the Congress an annual report, which "should prove extremely valuable in providing

the entire country with an annual inventory of major artistic and cultural activities."

President Kennedy's executive order was never implemented. Many illustrious names were suggested and were under scrutiny. I was working with all concerned—a list was nearing completion—when profound tragedy interceded. As we all do, I believe, when the always-to-be-remembered occurs, I can see the exact configuration of my desk in Claiborne's office when the first news arrived from an outer room, news that seemed to spread instantly everywhere. Disbelief changed to a numbing realization. In the days following, we were engulfed by ceremonies in prolonged succession, and by grief. Claiborne Pell and Jack Kennedy were close friends. They shared a special affection for New England waters and Newport harbor and mutual family bonds. I remember visiting Claiborne alone in his big and now shadowed office late on the afternoon of the assassination. There was little one could say. It was the loss of a friend and of a great political ally, though with Claiborne the personal memories came first.

And somewhere during those days, when we went to the Capitol and filed slowly past the coffin and catafalque under the lofty dome or watched the riderless horse approach on Pennsylvania Avenue, somewhere during all those crowded and contrasting moments of pomp and circumstance and sorrow with Jacqueline Kennedy walking graceful and aloof, with the Kennedy brothers moving in unison, with General DeGaulle marching detached, taller than anyone else in the funeral retinue, someone asked, "What does Lyndon Johnson know about the arts?"

Chapter 4

T HE HEARINGS HAD BEEN HELD THREE WEEKS EARLIER IN THE CAPACIOUS committee chamber on the fourth floor of what was then called the New Senate Office Building, now named to honor Everett Dirksen, the gravelly voiced, astute senator from Illinois. Congressional hearing rooms are designed to arouse feelings of respect, authority, and formality, to give a sense both of man's consequence and his inconsequence. The walls are richly paneled, and the large windows extend toward distant ceilings. There are chandeliers with long and graceful bronze arms and globes reminiscent of a time of gas lighting. The dimensions seem to diminish the individual, but the table from which witnesses speak, with its single microphone, suggests a more personal focus.

Before the doors open, senatorial aides make busy preparations, arranging copies of witness statements (required in lots of at least fifty), setting out cards containing in block type questions senators will ask, introductions they may proffer for home-state testifiers, comments they may deliver. A leather folder, suitably embossed, is provided for each senator on the committee. The documents inside are as carefully prepared as if they were for a bank examiner presiding at a foreclosure.

When they arrive, the senators affect a generally casual approach,

standing to one side at first, engaged in conversation, waving to an acquaintance here and there. A Capitol policeman in blue uniform supervises the entry portals. Spectators sit on heavy wooden chairs in well-ordered rows behind the witness table. The press has its own larger table below the windows. Dominant, however, is the wide, upraised area for the committee itself. A nicety for senators is the coping that extends along the curving, leather-topped surface behind which they eventually take their places. The coping is raised just enough so that cards slipped silently into place by staff members are invisible to the room at large. Thus the senator can say, with but the most abbreviated of downward glances toward the card perched just at the edge of the coping, "Let me compliment you, Mr. Witness, on a most insightful presentation. I realize, of course, you gave many of your views in summary form, but on page 17 of your original statement as submitted, I'm struck by your comments in paragraph 2. Would you care to expand on that section, just a bit?" For the senator, who is not totally certain who the witness is and who has not perused any portion of his statement, and for the witness, especially if appearing for the first time, the moment is an equal source of satisfaction. It is also a source of satisfaction to a staff person learning his trade.

My cousin George Biddle was a witness on October 30, 1963, the third of five days of hearings. Claiborne and I wanted the discussions to be as thorough and comprehensive as possible and to cover the past as well as the present. George was invited as a distinguished artist and as the brother of Francis Biddle, attorney general for Franklin Roosevelt and for a shorter time Harry Truman. During the Great Depression, with his brother's encouragement, George had helped in the formation of the Works Progress Administration (WPA), which gave assistance to needy and unemployed artists. Some of America's most renowned artists, then living in relative obscurity and poverty, were started on the road to achievement, and their commissioned works adorn our public buildings. It was a special endeavor for a special time. We wanted its results included in the record we were developing.

There was a small problem. It had become difficult for George, now in his latter years, to follow with precision the spoken word. I discovered this suddenly as we stood chatting before his testimony. "I've grown a little hard of hearing, Livy," he confided with understatement. "Better tell Senator Pell to speak up." Claiborne is famous for his politeness. It would not be seemly to shout at the white-haired artist at the witness table. George, for his part, seemed hesitant to admit overtly a lack of youthful verve. Claiborne did speak up, and George answered in a firm tone; but, as the saying goes, the two sometimes missed contact.

Claiborne would ask a question. George would lean forward attentively and nod. George would reply, but to quite a different question than the one asked. In this fashion they covered a variety of subjects—the old WPA days, government structures and the advisability of a uniform policy toward the arts, the current lack of it, the proposed President's Advisory Council, the August Heckscher report, and even (though here the Q-and-A became increasingly diffuse) elements of the pending legislation. It can be recorded that the "court stenographer"—that expert able with a small machine to extract from the air all words and syllables spoken and place them into verbatim transcript—lost the poker face of objectivity for one of bafflement. But he and I seemed the only two concerned.

The senator and the witness were now in a lively discussion of the ongoing Commission on Fine Arts, with which George Biddle had experience. Senator Pell expressed the thought that the commission might be given enlarged responsibilities.

"Mr. Biddle: Yes. If that is the case, I would say that they would be to a great extent carrying out what is under consideration in the President's Advisory Council.

"Senator Pell: The President's Advisory Council is not entirely concerned with government art. It is equally concerned with the area of private art.

"Mr. Biddle: I thought it was to advise the President on any question of art.

"Senator Pell: On all questions.

"Mr. Biddle: In the country; yes."

It is perhaps a tribute to both individuals that they seemed quite unaware of any missing links in communication.

George Biddle told me afterward that he had been delighted to find that Claiborne Pell was among the most intelligent senators he had ever encountered. Claiborne indicated that he had found George Biddle's responses a bit foggy at times, but that overall the impression was one of insight and clarity. It occurs to me that more congressional hearings could be conducted in this manner. No one in the audience at the moment appeared conscious of an unusual experience.

George was sufficiently moved to mail a written supplement to his views. It was thoughtful and helpful, if not precisely relevant to the questions asked.

On Thursday, October 31, 1963, Roger L. Stevens testified. Senator Javits asked for and received from Chairman Pell the courtesy of introduction.

"Senator Javits: The witness is . . . one of our most distinguished New Yorkers, very prominent in many worlds, including the very special

world of the arts and the theater. He is one of our most distinguished producers and very important here in Washington.

"*Senator Pell:* He is an old friend of mine as is his wife. I am privileged to know him in many aspects of his illustrious career."

In the hearing record, Roger is identified both as "theatrical producer" and "Chairman, Board of Trustees, National Cultural Center." The center, of course, had not been erected. Ground had not been broken. The tragedy of the November 22 assassination of President Kennedy was three weeks distant, and it would project an entirely new element into the center's concept and its name. Roger Stevens was chairman of the trustees appointed to begin plans for a national center and to help raise funding for an organization that had been conceived in legislation approved in 1958, but was still essentially on the drawing board.

As the producer or coproducer of more than a hundred Broadway plays, Roger talked eloquently about the needs of the American theater, the concentration of the performing arts in New York, and the necessity to bring the brilliance of fine theater to other parts of the country. He sounded a theme familiar to his thinking then and to his views today. "The most frightening part of this concentration," he said, "is that a handful of critics determine the fate of those engaged in the theater, and the number of critics is even more restricted in concerts, opera, and ballet."

He became more emphatic. "This is not the time to evaluate the critics in these fields. They are generally honest," he said magnanimously, "and voice their considered opinion. However," he continued, his blue eyes expressing indignation, "for the richest nation in the world, with a population of more than 180 million people, which prides itself on its industrial system based on private enterprise, to have its whole cultural growth dependent on a few seems to me to put us in a worse position than if we were a dictatorship."

Critics of Roger Stevens, and there have been some over the years, have suggested that his opinions about the small, prestigious number of New York theatrical adjudicators stem from their particular pronouncements on a number of his plays. Such carping should, in general, be discounted. The arts are by their very nature controversial. Only when the level of controversy is broad-based and expressed intelligently pro and con can the arts be healthy. For the few to be permitted a lofty perch of personal discrimination, on whatever side, is damaging.

It has been close to twenty-five years since Roger testified. He may have mellowed a bit in over two decades, but he remains an imposing figure. He still possesses the reflex to attack when challenged, and he has had ample opportunity to do so over time.

He spoke of unemployed actors, and in particular about the British

domination of the Broadway theater. "I notice with great interest," Senator Javits remarked, "that you say 45th Street is filled with English plays and actors—which I know from personal experience." He asked Roger how much of this could be attributed "to the development of theater in Great Britain through its government's Arts Council." Quoting Leland Hayward, another eminent American producer, Roger's answer quickly confirmed a substantial impact; the talent available in London auditions, for example, far exceeded that available in New York.

The resolution, he said, rested with a decentralized theater—not with bricks-and-mortar support from the government, but with federal encouragement of the less tangible, with a focus on improved management and on new opportunities for the individual artist. During this testimony, Senator Pell, Senator Javits, and Roger Stevens all speculated on the ultimate result if between $5 million and $10 million were authorized for growth of the arts ("seed money" it was called then, a phrase that remains). It was estimated that $10 million might stimulate five times that figure from other than federal sources. Optimism was the order of the day. Yet history will demonstrate how those optimistic numbers were surpassed, just as history demonstrates the foresight of early witnesses.

The next witness was John D. Rockefeller III, who rather modestly introduced himself as "a director of several organizations active in the field of the arts," but who was, among all those who appeared, perhaps the most significant. In securing John Rockefeller's acceptance of our invitation to testify, we had considerable help from a young woman named Nancy Hanks.

Nancy's reputation had been enhanced by her diligent work for Rockefeller causes in the arts. She had given particular attention to arts support at the community and state levels and was a founder of the Arts Council of America, an organization whose prestige and impact grew under Nancy's guidance. I knew Nancy then, and I had been in communication with her on the importance of the hearings and of John Rockefeller's testimony. I was delighted when he accepted our invitation, and I am sure that Nancy's fine hand was visible in the Rockefeller statement.

He began by saying that "democratic government and the arts are, in my opinion, in league with one another, for they both center on the individual and the fullest development of his capacities and talents." Then he uttered a memorable sequel. "To free men," he declared, "the arts are not incidental to life but central to it."

I had discussed this concept with Nancy, and variations had appeared in Claiborne Pell's early speeches, but one cannot overestimate the importance of having these words spoken at this particular moment in history by a leading citizen as influential in the arts as John Rockefeller. It was rhetoric, of course, and it contrasted sharply with then-current

congressional attitudes. But it came from an immensely respected and unassailable source. Although it may not have been avidly reported in the press, to me the Rockefeller testimony marked then, and marks now, a turning point.

In keeping with Nancy Hanks's work at the state and local levels, John Rockefeller stressed the need for state and community support. He was particularly complimentary of the legislative ideas I had prepared and woven into the proposals encouraging the development of state arts support, which Claiborne Pell had endorsed strongly. These views were important for Senator Javits to hear, for he had begun with mixed opinions on state arts programs. John Rockefeller's brother Nelson was then governor of New York and an advocate for increased state involvement. One of the most enlightened for the arts this country has seen and a leading collector of the contemporary and the controversial, his impact on the arts and on the nation was destined to grow.

John Rockefeller always seemed to me slightly embarrassed in public by his fame and fortune. As I came to know him well, he was a retiring man, scholarly, thoughtful, tall, sharp-featured, even a bit gangling as he sat in his chair and contemplated the long distance the arts needed to travel before a full governmental commitment to their value was made.

Senator Javits spoke of American affluence, of the growing failure of private philanthropy to support the arts adequately, and of the potential for growth and enrichment the arts possessed. "It is a fact our country has an almost $600 billion gross national product," he said, "that our corporations this year before taxes are expected to earn something in the area of $50 to $55 billion, that income from dividends and interest, let alone income from salaries and wages, runs in the multibillion-dollar figures, that, as I recall it, almost 18 percent of American families in 1962 had an income of more than $10,000 a year. Now, all of these are fantastic figures in terms of wealth. . . . Why do you feel our culture bill cannot be paid from private sources?

"Mr. Rockefeller: I think for so many in the private sector of American life the arts are a relatively new field in terms of having a responsibility to do something about them. I think many have thought of the arts as a luxury and for the few. And I think there is a long educational process which is needed to encourage these sources, which you referred to, to accept their responsibility for the arts as an important and significant community responsibility. So my hope would be, with the passage of time and (he paused, his wide-set eyes under heavy brows regarding the senators on their upraised platform) with this new emphasis on the arts in our national life, that these sources would become aware of the needs and their own responsibilities.

"As in other fields," he continued, "where something is so basic to the well-being of our people, the government, along with the others, has a very definite responsibility."

He was asked, in conclusion, if political influence or the personal desires of politicians might interfere with artistic progress. It was a concern, even a fear, often expressed in those days. Might there be a politician with "a favorite niece who expects to sing the leading role in an opera?" John Rockefeller pondered the question, seeming to search his mind for an example from his own experience. While the senators leaned to catch his response, he said he saw no danger.

It is interesting to review that testimony. So much of it proved true. So much of it went generally unrecorded—except in congressional circles, where the words meant a very great deal. Claiborne Pell, perhaps sensing an historic moment, had inserted into the hearings at this point two messages enthusiastically supporting the legislation. One came from Rudolf Serkin, "one of our nation's most eminent pianists, an artist of the very highest caliber and stature;" the other, from Richard Rodgers, "the renowned composer and Pulitzer Prize winner."

It is worth noting that both artists were to serve much later on the National Council on the Arts—on that morning, a concept far from reality, an idea whose time was still far from arrival.

It is also worth noting that both before and after his death, John Rockefeller's wife Blanchette gave her own dedicated efforts to the cause in which they both so believed.

Chapter 5

*E*ACH DAY THE NUMBER OF SPECTATORS IN THE HEARING ROOM GREW. There were those deeply interested in the future of the arts, those for whom curiosity seemed a principal motivator. Testimony ranged from favorable to unfavorable and into elements of surprise.

The hearing on October 31 was nearing completion. Claiborne was feeling pleased and in a generous mood. He turned to me, sitting in my accustomed chair, almost directly behind him. "Are there any individuals asking to testify today who haven't yet been scheduled?"

"There's a man named Wheeler Williams," I began, "but—" I was handing him a note.

"Our next witness is Mr. Wheeler Williams," Claiborne announced, "president of the American Artists Professional League, Inc."

It was too late for a remonstrance. Mr. Williams, grey-haired, rather average in height, was advancing, smiling at the chairman. He seated himself at the small table below the chandelier and took hold of the microphone.

"Senator Pell, members of the subcommittee," he commenced, "I appreciate very much the opportunity to be heard. Particularly, Senator

Pell, I am happy to meet you because I believe we are cousins. We are descended from the same Indian Princess."

If King Kong's head had appeared in the window at that moment, I do not believe Claiborne's expression would have demonstrated greater astonishment. He blinked and sat bolt upright.

"I do not think she was a princess," he started to say.

Mr. Williams interrupted. "Nevertheless, she was the daughter of a chief."

Senator Pell was too startled for immediate rejoinder. Apparently, the allusion was to a distant ancestor who actually was of American Indian lineage, but its remoteness in historic relevance and to the proceedings at hand simply compounded the unexpected.

"I feel my testimony will not be so welcome," Mr. Williams was saying, "because we feel the arts should not be supported by the government."

Claiborne turned toward me once more and said very quietly, "Who is this man?"

"He's a very conservative artist, I believe," I started to answer, but was cut short by the witness's voice. Mr. Williams represented, he told us, the American Artists Professional League and the Council of American Artists Societies. The combined memberships were estimated at several thousand.

The legislative proposals under consideration "are filled with good intentions," Wheeler Williams resumed, and seemed to pause. "But it is our well-substantiated professional opinion that they would have disastrous results."

The witness, as I recall, continued to smile. The chairman sat impassively with an occasional sidelong glance at me.

The "results" apparently related to contemporary American art, which a federal program might regard with favor. "Just when the bottom is dropping out of the market for the so-called modern art," said the witness in a matter-of-fact tone, "confirmed by numerous reports from here and abroad, to have this art rubbish given a shot in the arm (by the government) would be a blow to all our efforts to keep American art of coherent beauty, integrity, and craftsmanship alive."

"Many of you," he went on, "are doubtless still unaware of the communist use of art as a weapon pursuant to Stalin's directive to the Communist Party leaders everywhere outside the Iron Curtain for 'cultivation of the ugly, futuristic, and arrant in art, literature, the drama, music, the practice of crude orientalism, modernism, and degenerate perversion'."

It was obvious that Mr. Williams was marching to a different

drummer than those we had previously heard. He turned to the Washington Commission on Fine Arts. "I can assure you that my sculptor colleagues are aghast over the President's selection of Theodore Roszak to represent them on the commission," he said. "He taught what he calls sculpture at Sarah Lawrence, is best known for the sick vulture masquerading as an American eagle over the American Embassy in Grosvenor Square, London. The English papers were full of demands that the loathsome horror be removed." He was nearing his peroration. "I trust," he said, "that the Congress will kill these bills. A National Council on the Arts and a National Arts Foundation would be a menace to American art."

Claiborne favored the witness with careful scrutiny before speaking.

"Thank you very much, Mr. Williams," he said with the chair's politeness. "Your testimony has been interesting. It has covered a rather wide range . . . and I am glad we have not had uniform approval of our bill. Diversity is an important element of a democratic society."

Wheeler Williams, however, was not quite through. He pushed forward a document, a report of the Third Woodstock Art Conference, sponsored by the Artists Equity Association in September of 1950.

"They had at this meeting," he told the chairman, "prominent museum directors" and "openly Communist leaders. It is clear now that the plans published have been carried out in large measure. One of their express objectives was to get the museums and galleries and press together into one great movement." Mr. Williams paused. "Another objective," he announced, "was to get government into art."

Presumably, the testimony had come full circle. Hovering in the hearing room were implications of a conspiracy, devious and subversive, allegedly undermining the integrity of American art and casting darker shadows over American ideals. In all my experience with the legislation and its development and results over these many years, this was the most manifest reference to such a subject. Hence it has its place in history and indicates how close we were, even in 1963, to equating intellectual exploration, beyond a recognized or established norm, to a Communist-inspired undertaking.

Claiborne did not prolong the discussion. He said, "I would want the record to show that as chairman of the subcommittee I am in fundamental disagreement with the witness when it comes to relating alleged political belief with the virtues and values in art."

And so the drummer turned a corner, and Wheeler Williams departed. His group, however, would reappear in times to come with different arguments and assessments of American art, past and present.

Traditional art versus the arts on the frontiers of new expression would remain a continuing theme, an abiding controversy, sometimes acquiring the heat and glow of a flawed nuclear reactor.

Consulting his witness list for the final name prescribed for the day, Claiborne announced S. Melville Hussey, executive vice-president of the National Folk Festival Association, accompanied by Sara Gertrude Knott, its founder and national director. So often in the arts there is salutory contrast, and this moment was no exception.

Melville Hussey seemed a diminutive figure compared to the woman beside him. She reminded me then, and as I see her again in memory, of a great square-rigged ship making for home, all ropes taut, sails billowed, pennants flying in a stiff following breeze. Her white hair was fixed in an old-fashioned bun; her wide-set eyes were both shrewd and all-seeing. In her the folk arts had a passionate advocate. No doubt she had instructed the more reticent Melville Hussey to prepare the legislative language now presented to elevate the folk arts to a position of unquestionable and lasting importance. Claiborne accepted the words with polite gratitude, relieved, I think, to find strong support instead of detractions. And it is beyond dispute that Sara Gertrude Knott was responsible for the inclusion of the folk arts in the legislation. It seemed a sensible addition, for many of the arts indigenous to the American heritage—the arts of the American Indian, of the Louisiana Cajun, of the dwellers in the Appalachian wilderness—were then at risk of oblivion. The folk arts were later to have staunch defenders, none more so than Mark Hatfield of Oregon, a future chairman of the Senate Committee on Appropriations. It was Sara Knott, however, who first brought the matter into focus. Her annual National Folk Festival was the first of its kind.

So the day concluded with strong opinions voiced, and with mixed reviews. Only the Indian princess remains an enigma. Claiborne did not opt to pursue the purported relationship. It can be stated here, however, without fear of contradiction, that she was not Pocahontas.

Close to forty witnesses appeared before the subcommittee, including Sol Hurok, the renowned impresario; Martin Friedman, director of the Walker Art Center in Minneapolis (and much later a member of the National Council on the Arts), Albert Bush-Brown, president of the Rhode Island School of Design, whose testimony contributed to a further broadening of the definition for the arts; Francis Keppel, then U.S. commissioner of education; Stanley Young, director of the American National Theater and Academy and later a National Council on the Arts member; Stewart Klonis, director of the Art Students League of New York City; Howard Adams from Missouri, an early leader of the movement to sup-

port state arts councils, who worked closely with Nancy Hanks as this planning evolved.

The hearings were the most comprehensive yet to occur on the arts before the Congress. They covered a wide variety of artistic endeavor and resulted in more than 450 pages of closely annotated text. The viewpoints expressed ranged from lofty idealism to dark corners of suspicion, mistrust, and accusation. An optimistic spirit, however, outweighed pessimism. The positive was dominant over the negative.

The question was this: Should our government, after generations of indifference—even though possibly unrecognized and hence possibly inadvertent—finally commit itself, officially and through its duly elected Congress, to the support of our country's cultural values? The commitment proposed was both conceptual and financial. It was a commitment to the development of artistic progress and to the values such progress might bring.

As the hearings opened, Claiborne Pell had quoted President Kennedy, who had said just a month earlier during an address at Amherst College:

> *I see little of more importance to the future of our country and our civilization than full recognition of the place of the artist. . . .I look forward to an America which will reward achievement in the arts as we reward achievement in business or statecraft.*
>
> *I look forward to an America which will steadily raise its standards of artistic accomplishment and which will steadily enlarge cultural opportunities for all of our citizens.*

The eloquence of a President. A preponderance of testimony pointed in a favorable direction. But the question remained: Should these cultural values, so well described, be considered of sufficient priority to enact legislation in their behalf?

In the months ahead the question was only partly to be answered.

Chapter 6

"THE COMMITTEE ON LABOR AND PUBLIC WELFARE, TO WHOM WAS RE-
ferred the bill (S.2379) to provide for the establishment of a Na-
tional Council on the Arts and a National Arts Foundation to assist in
the growth and development of the arts in the United States, having con-
sidered the same, reports favorably thereon without amendment and rec-
ommends that the bill do pass."

So I was able to write for the report on the legislation submitted
to the Senate by Claiborne Pell on December 16, 1963.

A report is an essential, technical instrument written to accom-
pany legislation to the Senate floor after it has received favorable com-
mittee action. Printed hearings accompany the report, which must set
forth all pertinent information with succinct thoroughness. This was the
first such document for me. I had worked carefully on it under the
watchful eye of the committee's chief clerk. The material was essentially
mine: a full explanation of the bill and the reasons for it, summaries of
relevant statistics, quotations I had selected from the hearings, and a so-
called "section-by-section analysis," common to all reports, in which the
legislative language involved is meticulously detailed.

Subcommittee deliberations had been concluded in early December. The legislation moved inexorably forward.

The first part of the bill, its Title I, called for creation in law (as contrasted with executive order) of a National Council on the Arts consisting of twenty-five members to be appointed by the President. The council was "charged" with "duties and responsibilities," including recommending ways to maintain and increase the cultural resources of the United States, proposing "methods to encourage private initiative in the arts," and making "studies and recommendations" to encourage creative accomplishment and increased opportunities in the arts and greater appreciation by the American people. With the advice and consent of the Senate, the President would appoint a council chairman to serve at the pleasure of the President no more than eight years. (Later, this particular provision would cause a new crisis.) The council was to report to the President and to advise and consult with a National Arts Foundation, established in the second part of the legislation, its Title II.

Title II—reflecting the best thinking of all concerned, which I had now coordinated—provided the funding and established the mechanism for grant assistance. A twenty-one-member board of trustees would guide the foundation. Like the members of the advisory council, the trustees would be presidentially appointed from among private citizens noted for their experience in the arts. A foundation director would be appointed by the President, again with Senate advice and consent. The director would serve at the President's pleasure, no more than six years, as the "executive officer of the foundation." A deputy director was authorized, as were committees and panels as might be needed to provide detailed advice and recommendations. "The panels would judge the artistic worth and cultural significance of productions for which grants-in-aid are sought, to determine whether they merit the foundation's support."

Continues the report: "It is intended that the advisory panels which shall be composed of highly qualified professionals will give added assurance that government aid does not lead to governmental interference in the practice or performance of the arts." This so-called report language is quoted in full because it contains a basic concept that was later to be realized: the use of private citizen panels, which are a fundamental part of the federal arts program and in my view essential to its success. (Please note: the phrase "it is intended" in a report translates as "do it, or else!" Similarly, the word "shall" in legislation means "mandatory.")

Another key point enunciated in the legislation was the principle of partnership—between government and the private sector, between the federal government and state and local governments. This principle, like

the advisory panel system, would be a distinguishing characteristic of the
federal arts program. Grants were to be given to not-for-profit arts or-
ganizations on a matching basis, a departure from the European model
of total governmental support without need for matching funds. This tra-
dition of a governmental catalyst for private funding was established with
an eye on the tax laws, which encourage philanthropic giving to not-for-
profit institutions. From the beginning, the legislation was directed
wholly to the not-for-profit arts. Outside of a few successful commercial
enterprises—elements of the Broadway theater, the Hollywood film in-
dustry—arts organizations in the United States all operate on a not-for-
profit basis. Those that qualify under Section 501(c)(3) of the Internal
Revenue Code are thus the potential beneficiaries of a uniquely Ameri-
can tax system.

Groups could receive support for these activities:

1. productions of substantial artistic and cultural significance, with
an emphasis on American creativity;

2. productions, irrespective of origin, which are of significant
merit and which without such grant would be unavailable to
audiences in many parts of the country;

3. projects that will encourage and assist artists who are American
citizens or who have given evidence of their intention to adopt Amer-
ican citizenship;

4. projects that will encourage and develop appreciation and en-
joyment of the arts by the American people; and

5. other relevant projects, including surveys, research, and plan-
ning on the arts.

These words may seem relatively straightforward, but they were
the basis for heated arguments and recommendations and refinements as
time passed. Whatever else it may be, Congress is not a body where the
simple action is the norm—but this is proper and just, especially when
legislative ideas are taking shape for the first time in a nation's history.
My tasks in these five areas were far from completion.

States were also to receive matching grants, to enable those with
plans approved by the foundation and its trustees to provide "adequate
artistic services for all the people and communities in each state"—that
is, to increase artistic opportunities and to help develop a broad-based
excellence in all the arts, in all their many important areas of expression.
The amount available for support of state activities was prescribed at
one-half the foundation's annual appropriation. Should $5 million be ap-
propriated, half would support a national program and half a state pro-
gram, with each state receiving one-fiftieth of $2.5 million, or $50,000.

A section in the report enumerated "reasons for the Bill." It spoke of a "serious financial crisis facing the arts which stems primarily from the inadequacy of private sources to support artistic excellence and to foster and develop an environment which would stimulate fully the resources of American creativity"—a crisis "closely related to the projection of American culture throughout the United States and a projection of its basic values abroad."

It spoke of Americans' increasing desire to enjoy cultural activities and of the related increase in leisure time. It spoke of art as "central to our Nation's vitality" and forecast that the legislation would "provide an urgently needed means for promoting our national well-being and for enhancing the development of our best talents."

It spoke of the extraordinary lack of government assistance for the arts in the United States, compared with other countries. It spoke of the "modest" size of the sums authorized. (Modest, I had discovered, is a word legislators favored. It would be repeated later by the White House itself.)

"I believe that this cause and its implementation has a worldwide application; for as our cultural life is enhanced and strengthened, so does it project itself to the world beyond these shores." So said Senator Claiborne Pell, Chairman, Senate Subcommittee on the Arts, in the report.

The stage was set for bringing the legislation before the Senate as a whole, with the subcommittee chairman acting as its floor manager.

Chapter 7

SENATOR MIKE MANSFIELD, THE MAJORITY LEADER, MOVED TO MAKE S.2379 "the pending business" before the Senate on Friday, December 20, 1963. Equipped with copies of the legislation, the report, and the hearings, I accompanied Claiborne to the floor of the Senate. He was accorded the traditional front-row desk. Since only a few other senators were present, I was given a seat next to him, not the smaller "hot seat," which I was to use in times to come.

"Mr. President," Claiborne began in the customary salutation to the president pro tempore, who sat behind his large upraised desk across the well of the Senate chamber and above the seated figures of Senate staff and the Senate parliamentarian. "I rise to urge passage of S.2379, a bill which provides for the establishment of a National Council on the Arts and a National Arts Foundation."

Claiborne seemed outwardly composed, although this was his first significant task as a floor manager. For myself the phrase "baptism of fire" seemed appropriate. Over my shoulder I noticed Senator Strom Thurmond sitting a bit more to the rear of the chamber below the overhang of the gallery, which held only a normal complement of spectators.

Claiborne had been informed (and this perhaps contributed to his

composure) that the legislation had been readied with sufficient care to make passage likely by a simple voice vote. There was no suggestion of the absence of a quorum, no roll call demanded to identify each senator with a yes or no, aye or nay.

Senator Thurmond opposed the bill on constitutional grounds, I had been told. I had prepared a short rebuttal in case it was needed. He seemed now to be accompanied by a number of friends. Scattered in the chairs at desks behind Claiborne, they appeared indifferent to the proceedings, but I had observed such demeanor once or twice before, preparatory to sudden unexpected attack.

Strom Thurmond was then Democratic senator from South Carolina. In more recent years he has changed both his party affiliation and his attitudes in some measure toward the arts. (I came to know him some fifteen years after this day when visiting and bringing government arts assistance to the now-annual Spoleto Festival in Charleston, South Carolina.)

On this day, however, he came sauntering innocently down an aisle to the desk of the floor manager. "Claiborne, let's just do it with a voice vote. Why not right now?" he suggested in a genial conversational tone, interrupting for a moment Claiborne's presentation, smiling, taking Claiborne's elbow. Behind Senator Thurmond I shook my head as vigorously as I could without dislocating it completely. Claiborne gave me a glance and told the senator from South Carolina that he was grateful for the kind thought, but that he had a bit more to say.

"Let's just do it now—any time now," Senator Thurmond offered, and returned to his desk, where he remained standing.

"What's the matter?" Claiborne asked me in a low voice.

"He's opposed to it," I replied.

"Really? He is?"

"Definitely. And he seems to have brought enough support with him. I think he has the votes right now to win."

Claiborne glanced up briefly at the seemingly indifferent senators. He smiled toward Strom Thurmond and half waved.

"What will I do?" he asked me.

"Filibuster," I recommended.

"What?"

"Go over all of your statements. Read from the hearings." I handed him the constitutional rebuttal. Suddenly it seemed woefully inadequate.

Claiborne did not reply, but from our long friendship I could tell that my warnings had not been disregarded. I went swiftly through the well of the Senate, out a doorway with an opaque glass panel, and to the nearest telephone, one of several resting on mahogany surfaces in

the wide hallway used by senators approaching the floor. Senator Javits, arriving from New York, was expected momentarily. I was told Senator Humphrey would be on his way in a few minutes. Senator Keating, friend and colleague of Jack Javits from New York, was just leaving his office. Stewart McClure, alert to danger, was making other calls.

Senator Keating was the first to arrive. The others came in, like messengers from Garcia or eleventh-hour rescuing Cameron Highlanders at Khartoum. Minutes later, I looked toward the back rows of the Senate chamber. As Claiborne continued with his presentation, holding the green volume of the hearings, it was apparent that Senator Thurmond's colleagues were no longer where they had been. But where were they? Were they in the famous adjacent cloakroom with its copious leather-covered appurtenances for senatorial comfort, waiting for further summons? Strom Thurmond himself remained, to engage Claiborne in a memorable encounter.

"Under what provision of the Constitution," he inquired, now in a far less amiable tone, "does the senator from Rhode Island feel that the national government has jurisdiction to act in legislation of this kind?"

Claiborne replied, "The senator from South Carolina has raised a valid question." He paused, studying his notes carefully. "In the Constitution itself, in Article I, Section 8, there is a specific reference which, while it may not fully apply, brings into light the concern of the federal government for the arts.

"The provision reads: 'To promote the progress of science and useful arts, by securing for limited times to authors and inventors the exclusive rights to their respective writings and discoveries.'

"The only reason why I cite that clause is to show that the arts are recognized in the Constitution as part of our national life.

"But in direct answer to the senator's query, I can only read from the Preamble to the Constitution, a part of the intent of which is 'to promote the general welfare.' To my mind, the bill falls directly within the confines of general welfare."

The two now stood facing each other at their respective desks under the vaulted ceiling, Strom Thurmond in the semicircle of desks and chairs raised above Claiborne, and more toward the rear of the chamber.

"I recognize," Claiborne said, "that the distinguished senator from South Carolina has a narrower view or interpretation of the boundaries of the area covered by the general welfare clause than do I. This is a point on which friends can disagree, but I believe the phrase is open to this reading."

"I thank the distinguished senator from Rhode Island," Senator Thurmond responded. "I must say I am in hearty disagreement with him

as to his interpretation of the welfare clause, and also to the clause pertaining to science and the useful arts. I do not believe either of those two provisions of the Constitution is applicable in matters of this kind."

At this point, he launched into his major assault on the legislation. "It would require an imagination of truly artistic rather than legalistic talents to justify this measure under the general welfare clause, or under any other section of the Constitution," he said. He continued, "This is nothing but an outright subsidy to the arts, despite some attempts to label it as something else." (The word "subvention" had been used, a favorite word of Senator Javits.)

"Not knowing offhand the exact meaning of the word 'subvention,'" said Senator Thurmond, "I went to the trouble of looking it up in the dictionary. Here is what Webster says of the word.

"'A subvention: 1. A grant of money. 2. esp., a subsidy from a government or foundation.'

"So it can be seen in whatever words it is expressed, it all amounts to the same thing—a subsidy."

As do senatorial debaters, the senator from South Carolina was warming to his subject. "Although the amount of money involved is by some standards rather low," he said, "the principle of the subsidy is the same, and the dangers inherent in the program are many." It "will eventually lead to sterility of thought and production," he prophesied. "Centralizing the power of subsidizing . . . in . . . a few chosen trustees and officers of the foundation can result in nothing but the stifling of the truly creative mind."

This theme would recur. Its exposition by Strom Thurmond to the U.S. Senate in this form was another historic first, though hardly as welcome as other precedents being established.

He continued, "Mr. President, on page 9 of the report, under the heading 'reasons for the bill,' appears this statement: 'Almost alone among the governments of the world, the U.S. government has to date displayed little concern for the development and encouragement of the artistic resources of its people.'

"Far from being a justifiable reason for enacting this measure, I believe that the committee has enunciated one of the principal reasons why the bill should not be enacted. . . . I am certain that we do not wish now to emulate other forms of government after the one under which we have thrived for over a century and a half has enabled the people of America to have the best of everything. Our form of government does not contemplate, nor condone, dabbling in the arts."

While the phrasing may seem a bit hyperbolic today, these views were especially germane to the time, and their utterance, with variations, has not gone neglected with the passage of the years.

Claiborne Pell was quick in rebuttal. This was his bill to defend. We may not have fully assessed the source and weight of the attack, but we were well prepared to confront the basis of argument and opposition. Claiborne spoke of the private citizen experts in the arts who would serve on panels and on an advisory council expressly designed to prevent the kind of interference Strom Thurmond was propounding as inevitable. He spoke of the difference between partial assistance in keeping with democratic traditions, instead of outright subsidy.

"We must realize," he said, "that the rest of the world is progressing in the development of the arts and in the cultural and artistic development of its people at a faster rate than is the United States. . . . I wish to stress further," Claiborne continued, "that our national welfare is importantly involved. The United States is on the verge today of a cultural renaissance which could enhance in immense degree not only the well-being of our people, but also the prestige of our people throughout the world. And we are also on the verge of seeing that potential stifled and rendered ineffective, both at home and abroad. . . . We are at a point of crisis in our cultural life. . . . This warning may seem an exaggeration. But," Claiborne stated with conviction, "I believe it is not."

"The reason for the crisis I mention," he went on, "lies in the fact that, throughout the United State, there is a burgeoning desire on the part of our people to participate in and to enjoy the great diversity of American art. There is a wish to learn and to appreciate and understand. The desire is wholly new in the breadth of its appeal. Art," he declared, "is no longer the privileged domain of a relatively few practitioners and connoisseurs; it no longer exists in a remote and rarefied atmosphere. It can no longer be considered as incidental or peripheral to our way of life. It is central to the life we cherish and to the beliefs we hold; for as a nation we are reaching toward maturity, and the surest sign of maturity lies in the growing expression of an indigenous and creative national culture."

He added, "To me art can be defined as eloquence of expression—and it can be applied to words, to music, to a painting, to the design of a fine building, to the representation of an ideal in stone or marble or bronze, indeed, to any product of the truly creative mind which uplifts or inspires us or gives us a glimpse of the meaning in life we seek."

Claiborne then commended those who had helped the most. He spoke of President Kennedy and his First Lady in eulogistic terms and of the "extraordinary impetus" they had given to cultural progress; of Hubert Humphrey's belief that the arts express "the spirit, mind, intellect, the very souls of the people"; of Joe Clark's contributions; of Lister Hill, our "wonderfully wise, able, and fair Chairman of the Committee on Labor and Public Welfare"; of Jack Javits and his special pioneering work.

He summarized the hearings and their findings. "Artists repeatedly emphasized that they would welcome this form of government assistance which is so very different from direct subsidization or control. They stress that this principle is in accord with the best traditions of our democratic process because it would establish the needed working partnership between the government and the individual citizen."

Others spoke. Arriving, Senator Javits thanked Claiborne, his "beloved colleague," for "holding the fort," and presented his strong statement of support. Hubert Humphrey followed: "We only do harm to ourselves by accepting the thesis that art and democratic government are natural enemies. Other nations and freedom-loving peoples know that it is not so." He spoke of government help in other areas "necessary to the well-being and happiness of our citizens. I submit we must do as much in the arts, which have been the rock foundation of every great society since the dawn of civilization." (History aficionados may notice here a familiar phrase—to my knowledge, on a precedent-setting day, used for the first time. Lyndon Johnson's presidency had barely begun. The November tragedy in Dallas was scarcely a month past. A Great Society program was unborn.) Lee Metcalf, a somewhat maverick senator from Montana, home state of the majority leader, spoke and reminisced about his work on earlier cultural proposals with Senator Javits while both were members of the House of Representatives.

The technical procedures of the Senate moved forward. From my own vantage point on the floor, it was becoming quite clear that the day was advancing toward victory.

Only Leverett Saltonstall, the crusty, erudite, and cultured Republican senator from Massachusetts, added a further negative, but his opposition seemed halfhearted and half-apologetic. "From the brief study I have made of the bill—and I do not pretend to know a great deal about it," he began, "it seems to me that the subject is one which could best be left to the heads of local art museums or to the local directors of symphony orchestras, and so forth, rather than having an overall board that would try to stimulate action along any one line." Claiborne thanked the senator from Massachusetts, "for whom I have regard, affection, and respect," and talked again about the concept of a new partnership between government and the private citizen.

The presiding officer, Senator Birch Bayh from Indiana, a supporter, spoke: "The bill having been read for the third time, the question is, shall it pass?" I glanced toward the swinging doors leading to the cloakroom, They did not open. Strom Thurmond's earlier supporters did not reappear. The voice vote at last occurred, and the day was won.

Senator Thurmond's final remarks were tempered after Jack Javits had spoken with kindness about his concerns. "Of course," said Strom

Thurmond, "I believe that the federal government has no jurisdiction in this field. I predict that, as the years go by, the costs will greatly increase. I believe the bill to be a mistake." Then he added, "I hope I will be proved wrong, and that my colleagues will be proved right."

It seemed in keeping with the bipartisan spirit that had emerged. The prediction proved correct regarding the federal investment in the program, but not even the most sanguine among us could have predicted in 1963 how successful the catalyst would someday become.

Claiborne thanked all concerned—the principals, the members of the subcommittee, the cosponsors who, beyond those mentioned, included John Sherman Cooper, Republican from Kentucky; Edward Long, Democrat from Missouri; Hugh Scott, Republican from Pennsylvania; Jennings Randolph, Democrat from West Virginia; Abraham Ribicoff, Democrat from Connecticut; and Edward Kennedy, Democrat from Massachusetts.

The members of the subcommittee were thanked. In addition to Senators Pell and Javits, they were Ralph Yarborough from Texas and Harrison Williams from New Jersey, Democrats, and Winston Prouty from Vermont, Republican. Ralph Yarborough had a rollicking humor, and at a much earlier time, in a serious vein, had conducted a brief Senate hearing on the arts, the only witness for which had been poet Robert Frost. I cannot recall Winston Prouty as ever being overcome by enthusiasm for our legislation. He was not a speaker on that day of passage for S.2379 and was about as loquacious as his fellow statesman Calvin Coolidge.

On that December morning, as Senator Mansfield moved to congratulate Claiborne Pell, as he in turn was flanked by an exuberant Hubert Humphrey and a broadly smiling Jack Javits, I was aware of a singular moment in my life, and of relief. The ghosts of almost-Christmas, and of a long-ago Christmas past, return. I can see their faces and hear their voices. To me they are heroes. Separated from the mists of memory, they became clear, standing together like friendly sentinels, like comrades-in-arms when the battle is over. Claiborne praised his special assistant. Jack Javits praised Al Lesser, jauntily wearing his red boutonniere.

It seemed like a major victory. We had prevailed, we happy few as Mr. Shakespeare once wrote. I have no doubt that, if the vote had been taken earlier, we would have lost in the sudden parliamentary coup, well conceived but thwarted. All the hearings, all the efforts, all the documents, all the hours, days, and months of planning could have been forced into repetitive cycle, at some other time.

Actually, however, the whole—in terms of full congressional action and historic review—was but a skirmish. For the first time in history,

the U.S. Senate had given its approval to this legislation, comprehensive in scope and purpose. But the House had yet to act. The first session (the first year) of the 88th Congress was nearing conclusion. One more year and the 88th Congress would come to an end. Any unfinished business then would be terminated and returned all the way to the starting gate.

The House did complete a version of S.2379 in a year's time, but most of the substance of the Senate bill was blown away.

We would have to find another route to climb Mt. Everest.

Chapter 8

THE HOUSE OF REPRESENTATIVES CONDUCTS ITS BUSINESS IN A CHAMBER far larger than the Senate's, though there is a similar gallery for visitors and spectators and the same sense of polished wood and lofty ceiling. The members' desks are smaller, the aisles narrower, but the desk where the Speaker sits is enormous, somehow reducing by comparison the stature of a Carl Albert, but complementing a Thomas P. O'Neill. A resonant voice is an asset from any vantage point, for the House is accustomed to wider-ranging combats than the Senate, and often less circumspect language.

I had been introduced to the House through a curious circumstance, early in my work with Claiborne. He had instructed me one evening to visit John Fogarty, the undisputed dean of the Rhode Island congressional delegation. John Pastore had been a Rhode Island senator ten years longer than Claiborne Pell, but John Edward Fogarty had been in the Congress ten years longer than Senator Pastore. Mr. Fogarty had deep interests in education and, like Lister Hill, in public health. He was known as a man capable of fierce combat and fierce pride, occasionally tempered with an Irish wit.

He was also known as such a major power in the Congress that it

seemed exceedingly odd to me that I, a newcomer, would be selected
as Claiborne's emissary. Shouldn't the senator go? Wasn't it protocol?
Claiborne shook his head. He explained that he had long believed the
backgrounds of Messrs. Fogarty and Pastore more conducive to mutual
understanding and friendship than his own vis-à-vis either of the other
two. He was more than surprised, therefore, when on one of his first
trips from Providence to Washington, via all-night train after his election,
he was accosted in the station shadows by John Fogarty himself.

"I was flabbergasted," Claiborne said, "especially by his offer."
For John Fogarty had informed the newly elected Claiborne Pell that he
had decided to accompany him to the nation's capital and impart his vast
knowledge to the freshman senator if it took the whole night. "I was
amazed," Claiborne said. "I knew him more by reputation than person to
person."

They entered the club car. A waiter appeared and asked if the
congressman now wished "the usual." John nodded, and in his Irish
brogue asked what libation Claiborne might desire.

"A ginger ale," Claiborne said immediately.

The selection was questioned: "A ginger ale, is it?"

Claiborne assented. "Bring me the usual, then," John said to the
waiter, "and bring the senator—a ginger ale."

The drinks were served and finished with dispatch.

"Now we're getting down to business," John declared. He gestured
once more to the waiter, requested another of his usual beverage (which
Claiborne said was of an almost inky hue), and then genially invited his
guest to name his own *real* preference.

I have known Claiborne Pell for over half a century. I do not be-
lieve I have ever seen him take strong spirits—a glass of wine perhaps,
sometimes. He keeps impeccably fit. A cross-country track star at college,
he was known to run five miles from his Georgetown house to Capitol
Hill and, on occasion, back.

"I'll have another ginger ale," he said.

John seemed visibly to object. "If I'm going to be up all night re-
ceiving your wisdom," Claiborne explained, "I want to be fully alert."

The second round of drinks arrived and was finished. John ap-
peared in no way affected. Indeed, such was his reputation, no matter
how many of "the usual" disappeared. But then a strange thing occurred,
according to Claiborne.

John Fogarty did not request the waiter's attention. Instead, he
told his guest that perhaps an all-night session was not in the particular
best interests of either, that actually he was beginning to feel a bit like
turning in, and that perhaps they could best continue their discussions in
Washington or on another train in the future.

"What could have happened?" Claiborne wanted to know.

"I'm afraid maybe you offended him," I suggested.

"But how?"

"If an Irishman offers you a drink, and you don't—"

"But I didn't refuse at all," Claiborne said. "I asked for a ginger ale. It's what I always drink. I didn't want to lose my wits. I wanted to remember it all. I thought he'd be complimented."

Claiborne was silent for awhile. "As a matter of fact, he hasn't spoken to me very much since then. His help would be terribly important. So—" He had paused. "I thought you would be the best one to tell him about our arts bill."

John Fogarty's secretary and main aide-de-camp knew my name, as she knew almost everyone's name whether connected with a Rhode Island office or not, and took pity on me. "He'll see you at quarter to five," she said, setting the day.

At the appointed hour, I approached her desk. Here was a renowned guardian of gates, with vitriol for enemies, kindness toward friends, and decisionmaking authority between the two, a trusted confidante, a dedicated expert of unswerving loyalty.

"He's not had the best of days," she said. "I wouldn't stay too long."

I entered the office. John Fogarty stood up, frowning, from behind his large desk. He was ruddy-complected, muscular, stocky, with a barrel chest and a handshake like iron.

"Well—what can I do for you?" he inquired.

"I'm here to tell you about our bill," I began.

"Which bill is that?"

"About the arts, Congressman."

"About the arts, is it? And from Pell?"

"Yes."

"Sounds like Pell," he said. He looked down. "I have it here, some place. Grace left it." He looked up at me. "No matter," he said, "I'm more interested in the humanities, in education, than in the arts. You know that?"

"Yes, sir," I answered.

"What does Claiborne Pell want? My help, is that it?"

"Yes, sir. Your help and—"

But he interrupted. "Look—it's been a long day for me. You just tell Claiborne this: If he gets his bill through the Senate, I won't oppose it. Now how's that? Good enough?"

"Well, we were hoping—" I started to say, sensing I was about to be guided toward the door. "You see, Congressman, this legislation was somewhat my idea—I was in Ireland not too long ago, and—"

"In Ireland?"

"Yes."

"What part of Ireland?"

"Well, County Tipperary, mostly. A place called Clonmel, and the Rock of Cashel."

"The Rock of Cashel?" he asked.

"Yes, sir. That great old ruins. One of the most beautiful places I've ever seen. A great architectural masterpiece."

"Well, it was St. Patrick's church," he told me.

"Yes, I know. A great masterwork in its design."

The Rock of Cashel is supremely beautiful, rising from the Tipperary rolling hills and their greenness. I have seen it several times, the latest being under a moon nearly full, with the ancient gray stones and parts of walls and spires illuminated. But we had hit on a subject delaying my departure.

The congressman was surveying me. Perhaps he thought Ireland was a ploy, but it intrigued him, I noticed. He eyed me quizzically.

"You know," he said, "it's about that time of day. For me, at any rate. But I don't suppose you drink, do you?"

"Why not?" I asked.

"Well, you're working for Pell."

"That has nothing to do with drinking."

He continued to eye me.

"Then you'd join me in a libation if it happened to be available?" he asked after a moment.

"Of course," I said. "I'd be delighted."

He pressed a buzzer on his desk. The door opened. "Grace," he said, "Mr. Biddle is staying for a drink. Bring in the tray, and the usual."

That invitation took place at approximately five o'clock. At approximately nine-thirty, I was preparing to leave the office. It had been an extraordinary evening for me. Somewhere toward seven, as I recall, Congressman Fogarty pressed the buzzer again and suggested it was now suitable to call "the boys," which appeared to be a regular event in his working week. I knew some names; the importance of others I learned later. John Fogarty numbered among his close friends the powerful in the U.S. House of Representatives: Michael J. Kirwan of Ohio, James O'Hara of Michigan. There was Hugh Carey, later governor of New York, and Peter Rodino, not exactly of Irish lineage but close in political philosophy and, as I was to learn, a lover of Italian opera. Senior membership on the House Committee on Appropriations was well represented. This was John Fogarty's base and the base for his considerable influence.

He introduced me. Biddle here, he told the group, had just imparted to him knowledge of which he was not fully aware. Now who

would you think had one of the greatest art collections in the world, supported by special funding, dating back for a long period of time? If he were to tell his audience just how long, surely they would be able to guess. No one did.

"Why, it's the Holy Father, the Pope himself," John Fogarty said with a broad smile, correcting with pleasure an apparent ignorance. "The popes, over the centuries. The governance of the Vatican. Now, I want Mr. Biddle to explain to you his bill. He works for my old friend, Claiborne Pell." He paused, surveying his audience, who remained silently watching. "We'll just top off the drinks now, and he can begin."

It would be difficult to relate just what the reaction to my presence was. I had the feeling at first that some believed this all to be some wild joke of their colleague's. It was evident they had not discussed the subject matter previously, but they gave me a rare opportunity. Only in retrospect did I realize how rare it was.

I was allowed to present our legislation under this remarkable aegis. I recall searching very hard for all the right words. The hospitality continued. I remember opera being mentioned, and the terrain of Ireland. Biddle has been there, John Fogarty said; he and I were talking about the old Rock of Cashel. And I remember him saying, "When this comes over to us, boys, I want us all to help." That was a promise kept.

I can also remember that everyone seemed to me as sober as John Fogarty, as conviviality was extended and the time ticked past. It became evident that the discussions were going to continue. They were branching away from the arts. I did not wish to outstay. I was aware of a warm friendliness, if not of complete understanding. Just one more for the road, John recommended as I was taking my leave. He put his strong hand on my shoulder in friendship. I finished the glass, turned, and walked straight into the wall. But no one seemed to notice.

In the reception area, Grace instructed me that the corridor was straight ahead. Doors in strange places, she said, were sometimes not too easy to find.

I remember a warm night as I walked toward the dome of the Capitol. It was there, but the parking lot near the Senate seemed inexplicably to have moved. I decided to take the bus home.

The next day, Claiborne called me into his office and asked me how it went.

"I think he will help us," I said.

"It's funny," he responded. "He called me just a few minutes ago with the same news."

Chapter 9

THE HOUSE OF REPRESENTATIVES, HOWEVER, CONTAINS 435 MEMBERS, A large majority of whom were highly skeptical of our bill or were opposed to it. In 1964, S.2379 never came close to the House floor for debate and for the alignment of friends and foes. It suffered a great sea change in the Committee on Education and Labor, the House counterpart to the Senate committee headed by Lister Hill. S.2379 emerged from the House committee—on which John Fogarty did not serve—as H.R.9586. Remaining was a National Council on the Arts, as adopted by the Senate; but the National Arts Foundation, the funding and grantmaking substance of the legislation, disappeared.

We come now to the House leadership who were most closely concerned. Chairman of the Committee on Education and Labor, with almost twenty years of consecutive service, was Adam Clayton Powell of New York. The evangelical Baptist, now at the zenith of his prestige, was a complex individual, a champion for minorities, for the needy, for the oppressed, for civil rights. Some may consider it an unusual turn of circumstances that Adam Powell was in a determining position with respect to the arts at this time. Some supposed that he would at best be disinterested. They were wrong—and wrong in large measure because of the

energy and political persuasiveness of Frank Thompson, Jr., chairman of the Special Subcommittee on Labor, whose jurisdiction included the proposed arts legislation. Frank Thompson was Claiborne Pell's opposite number in the House. Ideologically, the two were closely allied, fellow Democrats, protagonists for liberal causes (which in those days were more sharply defined in terms of progressive values than was later the case when the word "liberal" lost some of its luster). Frank was a believer in the arts. He had convinced Adam Clayton Powell that the cause deserved attention, if not a sense of urgency.

But other members were less easily convinced. Among them was Robert P. Griffin, Republican of Michigan, as key to Frank's endeavors in the House as was Jack Javits to Claiborne's in the Senate. Bob Griffin, with over a year of service with the 71st Infantry Division overseas in World War II, a member of the American Bar Association and the American Legion, did not find the idea of the new legislation prepossessing. He would reluctantly support the concept of an advisory council, but no more. Other members of the committee were less restrained.

The National Arts Foundation came to a slow but unequivocal demise in the House committee, and minority views were filed when the proposed National Council on the Arts was at long last reported for full House debate. It was on June 11, 1964, almost seven months after the Senate had so grandly acted, that the abbreviated House version was presented in Report No. 1476. The procedures governing the presentation of legislation to the House floor for final debate and action are in many ways similar to those followed by the Senate: A bill is accompanied by a detailed report, filed sufficiently in advance so that all members may become as familiar with it as they desire. In this case, a majority of the committee had voted the bill's presentation to the floor, but a prestigious minority had vigorously voiced objection. Thus, unlike the earlier process in the Senate, the House report contained "minority views."

They said in part: "It is true that the pending legislation provides only for a National Arts Council, a broader bill . . . not having been approved by the committee. We should not be deluded, however. The bill, as reported, is a classic example of a resort to the camel's nose under the tent routine." (The tale of the camel slipping first his nose, then other anatomical features into a tent until the tent is filled with camel is a story much favored in congressional lore.)

The minority views continued with different imagery. "We can fully expect, if this bill is sanctioned, that the federal government, in the name of art and culture, will soon be called upon to subsidize everything from bellydancing to the ballet, from Handel to the hootenanny, from Brahms to the Beatles, from symphonies to the striptease." The language had a chilling effect on the legislation, relegating it from thoughtful argu-

mentation toward the absurd. It was clear that one of the principal weapons to be used was not the Constitution as in the Senate, but ridicule.

"Let us be prudent," said the concluding paragraph of the House report. "Let us forestall the deluge. Let us, in tuneful harmony and clarion chorus, reject this bill."

Floor manager Frank Thompson, with whom I worked on delegation by Claiborne, told me he was far from certain of the outcome as the House prepared for possible debate. Securing the necessary time presented almost as many problems as the legislation itself.

It came before the House on August 20, 1964. The 88th Congress was nearing its close. The Democrats were getting ready for their Atlantic City convention, which would see Lyndon Johnson and Hubert Humphrey nominated for highest office. There was not much time left for the arts. Defeat would mean a return to the drawing board for everyone. I took my place in the gallery overlooking the House floor and watched, by now fully understanding the intricacies of the House and the importance of this day. Victory would be partial at best, but defeat would mean the end of momentum after so many months of effort.

Among the minority was John M. Ashbrook, a Harvard-educated Republican lawyer from Ohio. For a while, Ashbrook held center stage. He brought to his colleagues an account of a performance given in December 1963 in Cologne, Germany by "our cultural exchange program." The work he selected for review was an "interpretation of the Greek tragedy *Phaedra,* conceived by Miss Martha Graham, a leading American exponent of modern dance." The story of *Phaedra,* he reminded the House, "involves a stepmother's overwhelming lust for her young stepson. The dancing," he went on, "involved a number of nearly nude young men who reclined with great frequency on various couches with young women. . . . It is my suggestion," said Congressman Ashbrook, "that this is the type of program which will be very much in vogue where the federal government is patronizing the arts."

Said Congressman Clarence J. Brown of Ohio, with twenty-six years of seniority in the House of Representatives, "Will the gentleman in the well of the House . . . put on a little demonstration of the type of dance referred to?"

Mr. Ashbrook demurred: "I would say to the gentleman from Ohio that the props could not be brought into the well. Otherwise," he suggested, he would ask the floor manager of the legislation for immediate help.

Perhaps to the uninitiated observer or listener, such excursions might seem infantile, or at least sophomoric, titillations for a locker room rather than for a chamber of august decision. Remember, however, that a tactic that will give the subject matter an aura of inconsequence, frivol-

ity, touched by the ribald or the profane, is a tactic practiced in other deliberative bodies than those in Washington. Ridicule more often than not succeeds; the House on this day was beginning to laugh at the arts, and laughter had been used in the past with telling effect.

Frank Thompson called on John Brademas to help stem the tide. Congressman Brademas, from the Indiana district that includes Notre Dame University, was to become one of the principal defenders of the arts in Congress. He was later to take the place of Frank Thompson as chairman of the special subcommittee. He and Claiborne Pell were to exert a strong leadership, linking the House and Senate in unified approach. This day he spoke eloquently—but as junior to Frank by four years—and reminded his colleagues of the relative backwardness of the United States "in the encouragement we give to cultural achievement." He recalled former Presidents who had espoused the arts and spoke of both Dwight Eisenhower and John Kennedy to demonstrate concepts of bipartisanship. President Eisenhower, John pointed out, had once considered a Federal Advisory Commission on the Arts, a concept endorsed by President Kennedy.

Peter Frelinghuysen of New Jersey and Ohio's Robert Taft, following in traditions of illustrious political families, were Republicans who favored the legislation Frank Thompson defended, along with New York's Ogden Reid and John Lindsay, later to become mayor of New York City. And here were Democratic Congressmen Hugh Carey and James O'Hara, the latter with his dozen years of seniority, giving support. And John Fogarty. Said John at the end of his remarks: "In closing, I would like to call the attention of the members of the House to the earnest efforts of my good friend and fellow Rhode Islander, the Honorable Senator Claiborne Pell, whose untiring labors in the other body have contributed in such a large measure to the enactment of this legislation." In view of my meeting with John Fogarty, it was a tribute I especially appreciated.

In the end it came down to a vote on a complicated parliamentary procedure proposed by Congressman H.R. Gross of Waterloo, Iowa. (Even in his congressional biography, the initials appear without further explanation.) H.R. Gross was first elected to the House following World War II, but he was then nearing fifty years of age and had served on the Mexican border in 1916 and with the American Expeditionary Forces in World War I. Of all the opponents of government help for the arts, this was the arch-foe, the leader unsurpassed.

He offered what was known as a "preferential motion," which in essence would delete the enacting clause from the bill, removing from it the possibility of a legislated approval.

"I have offered the motion," said Mr. Gross, "in the hope that the

members of the House will . . . kill off this monstrosity here and now without any more fuss and feathers." The motion was duly read by the clerk of the House. The deliberation ceased—and Mr. Gross lost by thirty-six votes. How narrow that margin seemed!

Then, following the established procedure of the House, came a full reading of the bill by the clerk, a process requiring some twelve minutes. Two amendments of note ensued, one offered by John Ashbrook aimed at preventing a National Council on the Arts from considering, studying, or recommending "activities . . . which involve, directly or indirectly, the use of federal funds" and one by Paul Findley, Republican of Illinois, to prevent any funding for the council until the national budget was balanced. (It is interesting to note that the nation's budget then was estimated to be some $5 billion out of balance. This seems almost a misprint today.) The Ashbrook amendment was defeated by twenty-three votes; the Findley amendment, by twenty-four.

So the bill passed.

Frank Thompson made one effort to have the House consider the much larger legislative framework the Senate had adopted that previous December. He asked immediately that the Senate bill, still before the House, be "taken from the Speaker's table" for action. Unanimous consent was needed. Mr. Gross objected, and that was it.

Was it then much ado about nothing or was it a major and history-making advance? I am convinced it was the latter. Legislative history sometimes runs at a pace that can make even the tortoise appear jet-propelled. It has been compared to the rapidity of grass growing during a drought. But this was in a different category.

Normally, when Senate and House adopt differing legislation, a conference is held to reach suitable compromise. But it was obvious to me that the House was in no mood to alter the bill or even to consider such a possibility. I could envision time consumed, no agreements reached, the House failing to approve an agreement even if one were achieved by a limited number of conferees. Nothing would please the opponents more than to see the legislation still in conference when the session ended. H.R. Gross would have seen a "monstrosity" expunged without lifting a further hand. Time was waning; a convention and an election were near. I had yet to witness the concluding hours of a congressional session, but I had read the records. They suggested all manner of possible parliamentary delay contrived to send a legislative proposal, at the very brink of passage, into permanent limbo.

So I recommended to Claiborne that we accept the House bill without change. That would send it forward to President Johnson, whose approval, we were informed, was assured. A National Council on the Arts

would be created, a legislative step never taken before. The old Kennedy executive order, not yet implemented, would be unnecessary. A congressional mandate would take its place. A National Arts Foundation, sadly, would have to wait. Claiborne accepted my recommendation, reluctantly, but realizing its practicality.

We moved with dispatch. On August 21, H.R.9586, legislation "to provide for the establishment of a National Council on the Arts" was brought before the Senate under the title of the National Arts and Cultural Development Act of 1964.

Said Claiborne, now putting the best face possible on the measure in a statement I had drafted, "If this Bill is passed, Mr. President, it will be another famous 'first' for the 88th Congress. For the first time on a federal level we will give recognition to the arts—recognition which has so long been postponed." This bill will enable us to make "comprehensive plans for future years," he said, "so that we may give added inspiration and renewing hope to our nation's artists in all their major fields of accomplishment and purpose.

"Mr. President, I endorse this Bill and urge its passage."

Senator Javits confessed he could not " 'crow' about what has happened," but he was also a realist. He praised Claiborne Pell for his work, without which "we would not have achieved anything," and called the legislation "only a beginning in what our country needs to do in the field of the arts in its own interest."

Hubert Humphrey termed the bill "a very good step forward," and Wayne Morse—the sometimes-cantankerous senator from Oregon who was to lead a long, personal, valiant, and sometimes lonely Senate attack against President Johnson's policies on Southeast Asia—came into the Senate well to commend Claiborne Pell for a "landmark bill."

Several years later, I asked Claiborne how he accounted for his political success. Skill as an orator is not his dominant attribute; a gregarious camaraderie is not his long suit. He is thoughtful, introspective by nature. He is more "elitist" than "populist," in a dictionary interpretation of such terms. He can enjoy a quiet accolade at Bailey's Beach in Newport more than a hoarsely cheering throng at a clambake on broader sands. He is a modest person, not given to sounding his own horn in claxon fashion. He is not averse to the eccentric, which in some political circles can suggest nonconformity—and be a political liability. Yet he has won consistently in a state where such a profile would suggest disadvantages, perhaps major ones.

Success? Claiborne did not need to ponder. "It's very simple," he told me. "You see, I always let the other fellow have my way."

And now on this August day in 1964, managing the final action on the arts legislation in the 88th Congress, he said to Wayne Morse, "I

know how long the senator from Oregon and other senators have worked for this measure. I am grateful for their success."

Thus the curtain fell. Thus had Mr. H.R. Gross met, as it were, a "Waterloo," however temporary it might have been. Thus had Claiborne Pell and Hubert Humphrey, Jack Javits, Joe Clark, and those few others set the pioneering wagons in motion. We had forestalled ambush from the magnolia-bordered lanes of Strom Thurmond's South Carolina and from the vast plains of H.R. Gross's Iowa.

Once, years later, when I was testifying on Capitol Hill and likening the progress made to a voyage of pioneers, I was asked how far we had come. If the imagery involved a journey across the United States, from East Coast to West, I said, perhaps we had just crossed into Kansas, with the tall mountains still to come, the foothills, then the highest peaks. "Well, you can stop right now," I was informed, "because you've just reached my district!"

There was one slipup. After H.R.9586 was engrossed (prepared in concordance with the actions of both bodies of Congress for the President's signature), it was discovered that the word "annually" had somehow disappeared from the appropriations section of the bill. When the appropriations were made, the National Council on the Arts received $50,000—not for a year's activity as intended, but for its lifetime.

But for those suspensefully inclined, that is a story for another chapter.

Part Two
THE BIG
PUSH BEGINS

Chapter 10

W HILE THESE EVENTS WERE TAKING PLACE, OTHERS RELATED IN NA-
ture were occurring. Other wagons were maneuvering to join
the procession west from a coastal shoreline. They bore a strange de-
vice—strange, that is, to the arts protagonists. The device did not say
"Excelsior," though a spirit of uplift was intended. The large block letters
festooned on the pristine canvas coverings of the Conestogas, as yet un-
traversed by hostile arrows, said simply, "The Humanities."

The words had a sonorous ring. I liked the sound. Claiborne Pell
liked the sound. So did Senator Ernest Gruening of Alaska. So did Repre-
sentative William Moorhead of Pittsburgh, friend of Frank Thompson.
Many, however, were uncertain, and skeptical of intruders or intrusion.
They included front and center the senior senator from New York, Jacob
Javits, who was not beguiled by these possible new resonances in the
air.

The words stemmed from a report, 222 pages in length, bound in
a plain blue paper cover and transmitted on April 30 to the American
Council of Learned Societies, the Council of Graduate Schools in the Unit-
ed States, and the United Chapters of Phi Beta Kappa. Those names I

can still recite in my sleep, and I retain a report copy, dogeared, worn, its important pages marked by paper clips a bit rusted now at the edges.

The report came from the Commission on the Humanities, with its roster of highly regarded leaders in the nation's academic areas. They included such luminaries as the Reverend Theodore M. Hesburgh, president of Notre Dame University; Kingman Brewster, president of Yale University; Robert Lumiansky, who later headed both the Council of Learned Societies and the United Chapters of Phi Beta Kappa; and Whitney Oates, the incumbent Phi Beta Kappa president. Business was represented by such commission members as Thomas J. Watson, Jr., chairman of IBM Corporation, and Devereux Josephs, former chairman of New York Life Insurance. The scientific community was represented by Glenn Seaborg, chairman of the U.S. Atomic Energy Commission; and the social sciences, by Pendleton Herring, president of the Social Science Research Council.

The report's foreword stressed its "two fundamental points: (1) that expansion and improvement of activities in the humanities are in the national interest and consequently deserve financial support by the federal government; and (2) that federal funds for this purpose should be administered by a new independent agency to be known as the National Humanities Foundation."

The word "independent" should be kept in mind; it will reappear.

In meeting the needs of the humanities in the United States, the foundation, this report emphasized, would help to "correct the view of those who see America as a nation interested only in the material aspects of life and Americans as a people skilled only in gadgeteering. . . . Mindful of the admirable record of the National Science Foundation," the report concluded, the organizations involved believed that "an independent agency," governed and staffed by those "who enjoy the confidence of the scholarly community, offers our best assurance against the dangers of government control."

The report addressed itself to "the humanities and the schools" in a section dealing with serious contemporary educational needs and shortcomings. The section is just as cogent today, and it is startling to find after more than twenty years that some of the recommendations still languish and have only recently been given fresh attention. Equally significant, and still lacking resolution, was the emphasis on goals for libraries and museums in need of improved research and greater reliance on the wisdom and vision the humanities provide.

The report contained detailed statements from twenty-four learned societies in different parts of the United States, representing national leadership and scholarship in such fields as esthetics, anthropology, ar-

cheology, folklore, geography, history, modern languages, law, linguistics, musicology, philosophy, and political science. Included were the Association for Asian Studies, the American Oriental Society, the Renaissance Society of America, and, on perhaps a more esoteric note, the American Numismatic Society and the Metaphysical Society of America—in other words, all those seeking "to explore, across all sectional lines, the similarities and differences among all groups of philosophies in American life," and the cultural aspects of such explorations. Suffice it to say that all the bases of the humanities were covered. Proposed was a greatly broadened application of values that had been germane to human heritage since the brain began to function.

Most importantly, the report contained some seventeen pages devoted to a legislative draft recommending how a National Humanities Foundation would be established and how congressionally appropriated funds would be utilized. There would be individual fellowships for teachers in the expansion of their educational training and broader horizons and for school administrators "to increase their appreciation of the values and responsibilities inherent in humanities teaching." And there would be a wide range of group and organizational activities, including aid for schools, colleges, universities, libraries, and museums.

The scope of the foundation was delineated. Said the report, "The humanities are generally agreed to include the study of languages, literature, history, philosophy; the history, criticism and theory of art and music; and the history and comparison of religion and law."

That sentence was followed by these memorable, not to say fate-laden, words: "The Commission would also place the creative and performing arts within the scope of the Foundation. . . . These are the very substance of the Humanities and embrace a major part of the imaginative and creative activities of mankind."

The report from the Commission on the Humanities made its impact on the academic and scholarly world during the summer of 1964. As is common for closely annotated documents of this nature, which are meant to be examined and reexamined, reverberations did not spread all at once. Similarly, the humanities pebble dropped into congressional waters caused no immediate tidal wave of enthusiasm.

The report, however, entered a vacuum caused by the demise of the National Arts Foundation legislation. Its impact began to grow in Congress, while outside the foliage changed in color and dead leaves fell.

Nowhere was the impact more perceived than at the desk of Claiborne Pell's special assistant. Though it would have been obvious at this point, even had I remained a neophyte first class, I noticed the following: (a) that the arts were relegated to a citizenship within the pluralistic

realm of the humanities; and (b) that the chairman of the commission issuing the report was none other than Dr. Barnaby C. Keeney, president of Brown University.

While Claiborne Pell at one time may not have stood fully within the congressional embrace of John Fogarty, at another side of life's spectrum, he stood not, at this present moment, within the total intellectual clasp of Barnaby Keeney. Few did. Barnaby was a medieval scholar of immense prestige. To him the humanities were Holy Grail, and intellectual pursuits, especially into the myths and intricately rewarding, little-known byways of the Middle Ages, were not easily shared without doctoral and postdoctoral reputation. Barnaby was a renowned fisherman, which might have been an entering wedge on another level, but Claiborne was not. So the two had coexisted in Rhode Island. Claiborne's staff in Providence, rebuffed once or twice as they let me know, did not seem over-eager for closer rapport.

On the other hand, Claiborne himself looked forward to building strength among all Rhode Island elements, the intellectual and the non; and Barnaby Keeney, in this respect, was far from insignificant. Rhode Island has its goodly share of educational institutions, and Brown University stands high—many would say highest—among them. And so it came to pass that the word "humanities" took on for Claiborne an added sense of attraction. Perhaps, he suggested, as winter approached, I might journey to Rhode Island and talk to Barnaby, "sort of sound him out and get his views."

We talked in his book-lined office, with its polished antique desk, with old prints and a wonderful pre-Revolutionary clock on the wall, about bass fishing off the rocky coast close to his home, with great waves running and an outboard motor sputtering. We talked of the angler alone in a small skiff, maneuvered almost into the foam and spray where the lure was cast. We spoke of trout fishing in Pennsylvania and of the wily tarpon on Florida's west coast, where I had spent vacations as a child. I found Barnaby Keeney an engaging conversationalist. Like John Fogarty, he offered me a libation; and he had some of the Fogarty gruffness of voice and picturesqueness of expression, though the scholarly allusions and the choice of phrasing were obviously not identical.

But on the Humanities Commission report he was adamant. The arts were part of the humanities; that was the way it was at Brown or Harvard—or even at Princeton, he added to this *Old Nassau type* with sly but fully intended deprecation. That was the way it always had been with the humanities and always should be.

In his brown tweeds, he put his head sideways a trifle and gave me a shrewd smile. You go back and tell Claiborne, he advised, that he'd

better get aboard the humanities, pronto. Or would I want to see him—the smile broadened ingenuously—miss the boat?

But I was thinking of Jacob Javits, and of alliances already formed and fashioned with the bonds of legislative tradition. A National Humanities Foundation that would tangentially, or even as a part of its radius, include the arts? The performing arts under the aegis of academicians, no matter how well intended? Despite all the advantages of a vast and respected new constituency and protective shield, such a proposal, it seemed to me, would be torpedoed at the dock.

Two bills of identical concept were introduced as the 89th Congress began its labors in January 1965—one in the Senate, the other in the House. Both attracted numbers of cosponsors. Both called for the new National Humanities Foundation Barnaby Keeney proposed.

The Senate bill came from the office of Ernest Gruening of Alaska; the House bill, from William Moorhead of Pennsylvania, both Democrats. Ernest Gruening had been in the Senate since 1956, as Alaskan statehood began. He was a graduate of Harvard College and the Harvard Medical School. He was nearing his eightieth birthday, venerable, benign, of high intelligence, greatly respected. He was devoted to the humanities cause.

So was Bill Moorhead, forty years Ernest Gruening's junior, a Navy lieutenant (like John Kennedy) in the Pacific Theater during World War II, a graduate cum laude of the Harvard Law School, a congressman since 1959. As much as he approved of support for the arts, Bill found the humanities of particular appeal; they could bring their sisters in cultural values, so to speak, to safety.

The word "umbrella" gained currency. A National Humanities Foundation was the umbrella under which good things for the mind would be fostered, and the arts—so frivolous in the eyes of opponents—would be protected. Give the arts the proper camouflage, and they would slip by undetected, one of many subjects, not made singular.

In marked contrast, Senator Javits, and the colleagues and friends he had mustered over the years, found such an approach objectionable. His staff told me, We'll create a National Arts Foundation, which will accommodate the humanities *tangentially.* But the senator introduced his own bill, for the arts alone. Thus ships were heading for the high seas, and heading in different directions, not quite on a collision course, but like large ocean liners gaining momentum. And there were now increasing numbers of relative newcomers, volunteering divergent expertise, finding fault, and beginning quarrels which among the major factions now involved could become intense, perhaps irretrievably so.

As I pondered these matters nightly, it seemed to me that politically we could not succeed without Senator Javits. At the same time we

could not afford to lose the support, however adamant, of Barnaby Keeney, with the massive unanimity of viewpoint his growing numbers of the influential were capable of demonstrating.

I went to see the Bureau of the Budget. Its name may have changed today to the Office of Management and Budget, but its function is still, as it was then, as the fiscal arm of the President. I went personally and informally for I did not want an official inflexible negative. I asked if there might be a possibility that President Johnson would approve two new small agencies, one discretely concerned with the arts; the other, with the humanities. I explained the situation carefully and, I believe, comprehensively. The listeners were patient, as friends should be. I was told to wait for an informal answer. It was, as I expected, no; but it was also a definite no, and it went slightly beyond the negative. The President, I was told, *certainly* would not approve two new agencies, and, unofficially now, it was considered doubtful that he would approve one— other than what already existed, a purely advisory National Council on the Arts.

Armed with this information, not exactly a cause for rejoicing, but having foreclosed alternatives, I drafted for Claiborne two bills, both of which he introduced. One coincided to a degree with the Javits approach so we would affirm that alliance; the other, for the first time, cast the arts and humanities into the role of partners. Neither would supercede the other; both sides would be equally represented by individuals of distinction and experience. Each partner would be equally funded. The arts would not be tangential to the humanities, or vice versa. Such a compromise might, in retrospect, seem obvious given all the circumstances. But given these same circumstances in 1965, the Pell solution was not considered ultimate by any means. Senator Gruening agreed to cosponsor Claiborne's bill if Claiborne in turn would cosponsor his. Senator Javits picked up some added support for the arts. In the House, Frank Thompson introduced legislation similar to Claiborne's, but Bill Moorhead's bill had more cosponsors than any other.

Barnaby Keeney became more enigmatic, neither fully approving the Pell plan for separation and equality, nor yet disapproving. In a well-known Washington phrase, we could call his reaction at this point, "no comment."

And so in February, we began to prepare for six more demanding days of hearings, with a witness list larger and more prestigiously varied than in the past. It included the country's leading scholars and academicians, those who sought to protect the many towers of research and study from philistine invasion and those who sought to bring those spires into a more central and lasting harmony with American life. Old friends

were assembled and some old antagonists, and there were new acquaintances. An overall atmosphere of growing opportunity began developing. The past year was considered now more success than failure. Despite arguments over precisely where the sun would rise, a new day beckoned.

On the morning of the first Senate hearing, as I was once again arranging all the necessary paraphernalia in an almost empty room, going from desk to desk and location to location, depositing the myriad documents, the cards, and other *aides-memoire* in their appropriate order, I noticed my old friend Stewart McClure leaving the chamber. I was astonished.

"Good Lord, Stewart," I called as he moved into the doorway. "You're not deserting me, are you?"

He turned slowly. "Laddie," he said using a Scottish diminutive he sometimes favored, "I'm leaving." Then he grinned at me and waved. "Today," he said, "I think you're ready to solo."

Chapter 11

*B*UT FIRST LET US SET THE STAGE MORE FULLY. A FEELING OF PROGRESS toward cultural goals was certainly in the air. Reality was beginning, just beginning, to replace rhetoric. On December 2, 1964, hefting the same gold-plated spade President Taft had used to break ground for the Lincoln Memorial in 1914, the same one President Roosevelt had used at groundbreaking for the Jefferson Memorial in 1938, Lyndon Johnson similarly turned the earth on the east bank of the Potomac River to inaugurate the construction of the John F. Kennedy Center for the Performing Arts. The long-cherished but languishing concept of a national cultural center became a reality in embryo, if only through the movement of a few fragments of soil. The memory of the late President gave the center its focus and pushed forth a source for new energies.

Robert Kennedy, then a senator-elect from New York, stood close to the President as the ground was broken. The day was chill and blustery; television crews on a temporary platform muttered complaints about their assignment and the cold, loud enough for at least one spectator to overhear. Kennedy and Johnson both said the right and generous words. Lyndon Johnson attributed the center to the inspiration, encouragement, leadership, and imagination of the President he had succeeded.

Senator-elect Kennedy said, in his address, that the center "would not have been possible without the energy and determination of President Johnson."

Both were right, of course, there in the cold with dignitaries flanking them, and both no doubt had other thoughts. Lingering animosities were rumored, and were more than rumors, perhaps not as much at the personal level as at the level of the key advisors, whose influence and authority on the one side had been lost, and on the other side gained. One might speculate on how the great French marshals of destiny surrounding a Napoleon or the Greek generals surrounding an Alexander might have reacted had there been abruptly thrust on them a wholly new loyalty with which to cope. Perhaps a Jean-Louis Meissonier, with his love of detail, its surface, and what may lie beneath, was needed to capture expressions.

Power in Washington near the top of the pyramid indeed holds a special fascination for the possessor and the observer. Power was beginning, just beginning on this day to look toward the arts. Among its representatives at that moment was Roger Stevens, chairman of trustees for the incipient Kennedy Center and the President's special assistant on the arts. Roger introduced Lyndon Johnson in his usual brief and to-the-point style: "Ladies and gentlemen, the President of the United States."

Then, the very day the hearings began, February 23, 1965, President Johnson named the members of the National Council on the Arts. They were in three categories, or classes. Since this was the first such council in American history, and since we will hear more from them, they are listed here:

Class of 1970
Albert Bush-Brown, president, Rhode Island School of Design
René d'Harnoncourt, director, Museum of Modern Art, New York City
Paul H. Engle, director, Program in Creative Writing, University of Iowa; poet and writer
R. Philip Hanes, Jr., president, Community Arts Council of Winston-Salem, North Carolina; industrialist
Oliver Smith, theatrical producer, designer, painter
Isaac Stern, concert violinist
George Stevens, Sr., motion picture director and producer
Minoru Yamasaki, architect
Class of 1968
Leonard Bernstein, composer and conductor; music director, New York Philharmonic
Anthony A. Bliss, president, Metropolitan Opera Association

David Brinkley, NBC News commentator
Warner Lawson, dean, College of Fine Arts, Howard University
William Pereira, architect, teacher, former movie producer
Richard Rodgers, composer, producer, writer
David Smith, sculptor
James Johnson Sweeney, director, Houston Museum of Fine Arts
Class of 1966
Elizabeth Ashley, actress
Agnes de Mille, choreographer, author, lecturer
Ralph Waldo Ellison, author, lecturer, teacher
Father Gilbert Hartke, head, Speech and Drama Department,
 Catholic University
Eleanor Lambert, fashion designer, honorary member, Council of
 Fashion Designers of America
Gregory Peck, actor and producer
Otto Wittmann, director, Toledo Museum of Art
Stanley Young, author and publisher

S. Dillon Ripley, the Smithsonian's secretary, was named an ex officio member and Roger Stevens was nominated as chairman, pending advice and consent of the Senate. Isaac Stern, Gregory Peck, Agnes de Mille, Richard Rodgers, and Leonard Bernstein were perhaps the best known at the time, but George Stevens was earning awards and lasting recognition for his films; David Brinkley, for his contributions to the media; David Smith, for his sculpture; Ralph Ellison, for his remarkable book, *The Invisible Man*; Paul Engle, for his poetry and his teaching of creative minds. "Bush" Brown, Minoru Yamasaki, and Bill Pereira had achieved high accolades in architecture, design, and education. René d'Harnoncourt was a tower of strength among museum professionals, an area also distinguished by Jim Sweeney and Otto Wittmann. Father Hartke presided with genial grace over Catholic University's unique theater program, which he founded; Stanley Young, equipped both with wisdom and ebullient humor, directed the American National Theater and Academy. Warner Lawson was the thoughtful musician-educator renowned for his work at Howard University. Phil Hanes, articulate and outspoken, well represented the community arts movement where Nancy Hanks was pioneering. Oliver Smith, urbane and imaginative, was considered the country's most distinguished scenic designer. Tony Bliss presided over the famous "Met," a position he was to keep for nearly two more decades. Eleanor Lambert was recommended by Jack Javits to represent the field of fashion design, a task she was to perform admirably—though this arts area was accorded then, and later, a priority short of full enthusiasm. Elizabeth Ashley was youthful (said Roger Stevens, "we need

youth"), vivacious, and a passionate speaker for the arts, with a keenly intellectual turn of phrase.

The members of this council proudly shared a feeling that they were the first, and they soon developed strong bonds of friendship and mutual regard. This council set a pattern, not always in every respect emulated, as the years unfolded. Its members were of notable achievement in the arts, experts in their fields. The variety of the arts was represented, as were diverse viewpoints and diverse methods of approach. Lyndon Johnson swore them into office at the White House, but he continued silent toward the legislation seeking to spread its wings in the Senate.

By tradition and practice it is most desirable to have one's administration present what are termed "favorable views" or "views in full support" when one's legislation is testing the forum of the hearing room. For a Democratic chairman to be without such expressed approval from a Democratic President was a lapse in tradition and practice. I was told the matters were too complex for quick response, and indeed they were complex. It was becoming evident, albeit not fully clear, that this legislation, with its new additions and accoutrements, was better favored for success than the bills of earlier times—if it could all be sorted out. The very complexity of the situation attracted more opinion-givers, and both would-be and established opinion-makers.

The essential conceptual arguments—for and against government aid for the arts—took on refinements. Government help was still equated in some quarters with Communist conspiracies and murky unconstitutional activities. Attacks of that kind, however, seemed to be drifting out to sea. There was a different argument, more difficult to refute. Its promoters maintained, and often with a compelling level of intelligent voice, that government support would inevitably lead not to excellence in the arts, but to mediocrity. Wavelets of this criticism washed up on the still-pristine shores of the humanities.

Russell Lynes, from an admired vantage point, had written in phrases now finding new currency, "I am not worried about creeping socialism but about creeping mediocrity. *The less the arts have to do with our political processes, I believe, the healthier they will be.*" Given government support, he predicted, we would have a tried-and-true art popular with Congress, but shunning the experimental and in essence sterile. The critique was simplistic because there was far more subtlety involved, but it also appeared to have an element of truth. The possibility of mediocrity indeed existed because no programs had been attempted. This made the argument against government support theoretical, speculative. But then so was the counterargument for the same reason. Nothing

had been tried, so one could only theorize about what the result would be.

Mediocrity or excellence? Excellence or mediocrity? More than twenty years later, much evidence has been amassed. I know precisely where I have always stood on this issue. I have not moved. The evidence I find conclusive; the theory we espoused is proved by abundant, repeated demonstration. Yet I know that others, on an opposite side, have not moved, or are not moving, and that they speak with a sense of conviction that is only faulted by inadequate information and study.

We might ascribe all such debate to the benefits of a free democracy. But let us consider another argument. For if you believe that the arts and our political process are somehow inimical, and if you believe that our political process is the basis of our exceptional freedom, then you must believe that art and democracy itself are somehow at odds. That is by no means an illogical progression, and it is an exceedingly difficult and unattractive position to maintain. And if you believe that the arts are important to life, and that politicians, the officials we duly elect to represent us at all levels of our government, are a generally unattractive lot unable to deal with matters of such importance, then implications of a failed democracy and a failed fundamental principle grow apparent. That is an exceedingly sticky wicket, indeed.

There were other issues—conceptual, structural, and, as will be seen, on occasion personal. How should the already established National Council on the Arts best be positioned within the broad framework of a foundation concerned with the arts *and* humanities, their interrelationships and the possibly quite separate avenues they could pursue? Would there be "directors" of the proposed foundation? If so, what role, if any, would the Isaac Sterns and Lenny Bernsteins and Agnes de Milles, already presidentially appointed, play? What would be the proper terminology and authority? One with definite views on these and other subjects was Abe Fortas, then cast in the role of an advisor of particular standing with Lyndon Johnson.

Claiborne sent me on a mission to consult with Abe Fortas. I fancied myself at this point growing relatively better able to confer with personages of high estate. But the height of this "estate" and its reputation were more lofty than those previously encountered, as was the detailed knowledge of law and of the mind of a highly complex and by no means predictable President. Seeking to make an impression that would demonstrate knowledge and competence, I came equipped with a raft of documents written in purplish typewriter ink on long sheets of paper and designated "draft" and "confidential." Legislative alternatives were provided, in the technical language in which I was by now quite fluent.

I was ushered into Abe's office. It was on a quiet street with only the most barely audible indication of traffic outside and no sound whatsoever from adjacent chambers. I had not met Abe Fortas before, and I was impressed by a youthful appearance, despite his years, and by the air of confident authority he personified, in a quite casual and hence disarming manner. My memory recalls a man of medium height, in a handsome grey suit, striped shirt with white collar, a tie chosen for muted harmonious accent. I remember the low yet strong voice and firm handshake, an atmosphere of polite welcome.

Would I like a cup of coffee? I was asked.

It was brought in delicate china cups. The silver tray was discreetly placed on the large desktop, to one side of the papers I was arranging and now beginning to explain. Abe lifted one of the cups to me, and picked up one of the drafts for closer examination.

At this moment, I sneezed. Once in a great while this happens, the sneeze of uncontrollable volume seeming to come from nowhere (it was not even the hay fever season, when such occurrences were for me less rare). Abe Fortas seemed somewhat startled to find coffee on his grey suit, necktie, shirt, and across the papers in his hand on the desk. I was dumbfounded.

Abe pressed the intercom on his desk. The secretary was suddenly in the doorway. She looked at the scene in consternation.

"I think we need a towel," Abe said, in a very calm, modulated tone. "And—oh yes, I think Mr. Biddle needs another cup of coffee."

It could be said that I was not able to settle all of Abe Fortas's concerns about the pending legislation that afternoon.

With respect to the personal and personalities, Claiborne called me into his inner sanctum one evening to introduce me to Thomas Corcoran, known ubiquitously in Washington as "Tommy the Cork." He was a small, genial man with a round, friendly face, which on closer inspection betokened a combination of wisdom, humor, and great shrewdness. The lines were etched from many battles won, and undoubtedly some lost. It was the Washington face of experience, with an Irish overlay. In his younger days, Tommy Corcoran had been among the few advisors carefully chosen by Franklin Roosevelt to be members of his Brain Trust. Until his passing years later, Tommy the Cork remained a respected voice in Washington. Age did not diminish either his wit or his keenness of intellect. It only added new elements to his experience, new chapters, new volumes.

In Claiborne's office, he stood surveying me as if seeking to assess whether the special assistant to a junior senator had the requisite knowl-

edge to cope with intricate matters. He seemed neither satisfied nor dis-
satisfied.

"What are the real prospects for this legislation?" he inquired.

"In the Senate," I answered, "quite good, if we can continue to
find agreement."

"This year?"

"Yes," I replied.

"The President is considering legislation. Does that help?"

"It would—but there are still a number of problems."

"But they can be resolved? Is that right? In the Senate."

"I think that's true."

Claiborne said something like, it may be true.

"Yes," I said. "There's no certainty."

"And in the House?" Tommy Corcoran inquired.

"That's less certain—but it could be better than last year."

"What's your feeling about Frank Thompson?"

"The best," I said.

"No reservations?"

"None," I replied.

"Good," Tommy responded. Of course he knew Frank Thompson,
I thought, but perhaps not in relation to the arts.

He turned to Claiborne. I had the feeling I had been scrutinized
up and down, backwards and forwards. He and Claiborne were chatting
briefly about other matters. Tommy took his leave.

At the doorway, he said to me, "Keep me posted on this, please. I
want to follow these developments closely."

When he had gone, I raised an eyebrow toward Claiborne.

"He's interested in Barnaby Keeney," Claiborne said. "And so, it
turns out, is Lyndon Johnson."

Another personality I encountered in these early times of prepar-
ing in 1965 for the marshaling of forces, for assaults yet to come, was
Richard Goodwin. I had met Dick Goodwin at a private lunch to which
Claiborne had invited him in the Senate Dining Room. Its white-clothed
tables, under the watchful eye of a George Washington displayed in a
large stained-glass panel, are arranged to suggest both formality and the
social graces. Waitresses hover at attention; a major domo, in this case
generally of female gender, presides. The menu is somewhat spartan, but
there are always numbers of senators present, and invitations are rarely,
if ever, refused.

Richard Goodwin was a fast-rising star, articulate with word and
pen, somewhat saturnine in appearance, experienced in the arts and with
their most current practitioners in New York. I found this knowledge ex-

haustive, except that its recitation seemed a shade calculated to impress. Claiborne, however, was not so moved, the avant-garde never being exactly his cup of tea. Claiborne nodded politely, but some of the names and references Dick was dropping could have been spoken in a foreign tongue. Dick was reputedly close to the Kennedy White House, rising in favor on a return from service in South and Central America where his cultural portfolio had been enhanced. At one time, just before the assassination of the President, he was rumored as August Heckscher's replacement in the role of arts advisor. Now with President Johnson in office, Dick Goodwin had managed a key White House role. He had moved from the Kennedy to the Johnson camps with great skill. His star, after brief eclipse, continued to rise. Indeed, Dick Goodwin, the selector of significant words, is given credit for coining that phrase, such a bright emblem for the Johnson years, the "Great Society." (I do not believe he would ever have attributed it to Hubert Humphrey, speaking at an arts hearing.)

After the initial lunch we spent more than two hours together in his White House office. I went alone after having requested and been granted an appointment. Dick had asked for a thorough briefing, so I rehearsed at length the full history of the developing legislation. He listened, puffing on a long cigar, lighting another one. His eyes suggested sympathy, yet they stayed aloof in expression, noncommittal in a classic Washington manner.

Eventually he told me that while of course he favored the arts and humanities, the creative world, scholarship, and so on, the prospects of a full presidential endorsement or espousal were somewhat remote. They were not impossible, but a great deal of convincing would be needed.

This President, said Dick, was not ideologically attuned to the arts. They were apart from his Texas background, and the fact that the Kennedys had given personal luster to the arts and to a glittery world focused on the East more than on other places did not improve chances for a change of view. Maybe the humanities had something to offer, though Dick himself did not see their particular merit as partners with the arts. Still, Lyndon Johnson had a great desire to improve educational opportunities for young people. Maybe he could support the humanities, but not the rarefied levels of research scholarship, not the ivory tower.

I tried a different approach. I suggested that the constituency the Kennedy White House had stimulated encompassed the leading creative life of the country. This constituency did not represent large numbers of votes, but it had considerable prestige. It shaped opinions and was responsible for editorials. It had found a new harmony with the previous Democratic President and his administration, and the ideology was there

to bolster, uniquely, the presidency of his Democratic successor. It would be a shame to allow it to drift away to seek another home. The humanities, like the best in the arts, could be called synonymous with intellectual leadership. A minuscule financial investment would ensure the loyalty of a constituency with nationwide prominence, an asset of political value on one level, but an asset also for the making of history. Surely there were merits here.

Dick Goodwin lit another cigar and puffed on it awhile in silence. "I'll think it over," he said to me. "I'll stay in touch."

So did the cast of characters expand. So did our beginning efforts grow in complexity. And so was a wider stage in preparation.

Chapter 12

AGAINST SUCH A DEVELOPING BACKGROUND, CLAIBORNE PELL MADE A number of speeches emphasizing the merits of the legislation, the reasons for it, the possible impact it might produce.

"Throughout our history, America has been known as the land of the free," he told the National Society of Arts and Letters assembled at the Mayflower Hotel in 1965. "Traditionally, these words have described our national heritage of independence. Today, however, we are a free people in yet another way; we have more free or leisure time than any people have ever had at any time or any place on earth—and we are rapidly entering a new period when the whole concept of leisure will become increasingly important. . . . Particularly will it become important to young people," he continued, who "will reap the benefits as well as face the challenge of this new leisure time." He called for the creative and constructive use of leisure and spoke of how these goals could be enhanced by a focus on cultural pursuits and activities.

"One recently published estimate," he said, "forecasts that, before another 25 years have passed, *2 percent* of our population will be able to produce all the goods and food which the remaining 98 can possibly con-

sume. If that should happen, leisure time would grow to truly astronomic proportions."

He contrasted material values with those of the mind and spirit, a small American town with a counterpart abroad. "Walk through a small European town and you will hear, if you listen . . . the musical instrument, or the voice, the sounds of a rich cultural past—sounds which stem from the vigor of the culture which was thriving long before Columbus crossed the seas."

He concluded: "Our most needed scientific explorations, our scientific research, for which we spend *billions* of dollars annually; our billions spent to maintain the position of strength we require in the world; our billions spent to provide the physical amenities of a better life for our citizens—all these will mean very little, if the culture of our people stands still, or worse yet, is allowed to erode.

"We are in conflict today with the materialism of totalitarian forms of government which by definition stifle creative thought. We must contribute to the world something better than this, something more lofty, something in tune with free men, something to improve them.

"Let us make certain, therefore, that we make the best possible use of our advantages. Let us make sure that we use our new leisure, our new free time well—and that the working artist, who can so immeasurably invigorate this newly gained time for us all, is given the maximum climate for developing his or her creative and imaginative spirit. If we do these things, we will give to the world a truly meaningful heritage."

Barnaby Keeney, in his opening statement at the hearings now beginning before Claiborne Pell's Senate subcommittee, also stressed leisure. "It is argued," he said, "that the development of technology and automation and a greatly increased national product will reduce the labor force, and the working day of those who remain in it, to the point where the use of leisure will become an increasingly serious problem. Therefore, we must educate ourselves and our children to use leisure properly and profitably, particularly through the improvement of our minds. . . . We must provide great opportunities for humane study and artistic appreciation."

In his own scholarly way, Barnaby added to the argument. "The real problem is not the utilization of leisure, important as it may be, but rather the development of an ethic and an outlook appropriate to new circumstances. We have now an ethic in which work is equated with virtue. Before long we shall have to develop one where not to work very long for a living and to be content is as virtuous as labor itself. This will

require hard work by some well-trained philosophers who have compe-
tence outside the area of symbolic logic. We are going to need those phi-
losophers very badly."

Parallel expressions from Claiborne Pell and Barnaby Keeney,
though individually distinct, illustrate the beginnings of an intellectual
rapport. The subject matter, given serious attention as the great hearings
of 1965 commenced, seems in retrospect a bit shy of the core. I recall
no crowds cheering, no banners waving, no bandwagon thumping to
justify that the arts and humanities would enhance, even illumine,
Americans' increasing leisure time. Like new-found relics, the thoughts
Claiborne Pell and Barnaby Keeney expressed then might have interest
and value to the scholar sifting through a tangle of ancient fragments,
but they are not King Tut's tomb or the ruins of Pompeii.

It would appear that while free time for free Americans has
grown, so has a welter of new activities to compete in the Elysian fields
of leisure. Automation (a solid mid-1960s word), yes—but industry to
manufacture new tools for automation, also yes. The labor force can con-
tinue to grow, we are told; it has just become more specialized, with
ever-greater skills required. Those philosophers Barnaby mentioned are
still in the wings, and a different dimension of argument and solution
seems needed—not so much based on how to alter the ethic of hard
work, but how to keep mankind human in the face of dehumanizing
technology. You philosophers: Isn't that a subject for today?

And now to the hearings and stage center. As these deliberations
began during the final week of February 1965, they were again without
precedent in congressional history. Artists and scholars joined together—
hitherto suspicious of one another, hitherto convinced that only their
own causes were just. Now they seemed amiably united, at least on the
surface, for a day or so.

But the artists said under their breath: All those humanities people
do is talk, and there isn't one of them who can say in plain English what
he's talking about. And the humanists said quietly in their corridors: The
folk arts? Did you see that woman in the folk arts? I mean—*really!* And
the senators tried to be as profound as possible.

"*Senator Pell:* The question has come up, a rather basic one, and
this is where we are so fortunate to have you as the prime spokesman,
what would be your definition of a humanist?"

"*Dr. Keeney:* A humanist is a person who studies the activities of
human beings . . . "

There, said an artist, didn't I tell you? But Barnaby was only
beginning.

". . . whether they be social, political, artistic, imaginative, religious, who tries to interpret them, and who tries to do so through methods other than quantitative."

Better, said the artist, but still typical.

"I make that point to distinguish him from the mathematical economist," Barnaby continued.

Uh oh, there he goes again, said the artist.

Incidentally, the court stenographer, whose profession I greatly admire and who, with that small electrified machine, with few keys, is able to transcribe through sequences of phonetic symbols every word and syllable uttered, had a problem with Barnaby's name. Dr. Barnaby C. Keeney was transcribed Dr. Barney Bikini. I remember my pleasure at seeing that in the initial transcript. I showed it to Claiborne. He instructed me to correct it forthwith.

Aside from all extraneous matter, however, outside all the crosscurrents involved, if you browse through the two volumes of these hearings in search of gold from the past, you will discover a remarkably clear statement from Dr. Keeney on the relevance and significance of both the humanities and the arts. It is the most clarion in its essence, for that time and, indeed, for time to come. I have not found quite its peer in all the literature and materials compiled year after year. Here it is:

> The humanities and arts are of central importance to our society and to ourselves as individuals. They at once express and shape our thoughts. They give us the beautiful to see and teach us what to look for. The development of thought undoubtedly reflects institutions and circumstances, but these are shaped by ideas. The two are, in fact, inseparable. Our relations to one another as individuals and to our society are determined by what we know and think. Our use of knowledge is inseparable from our ability to express it in words and shapes. Only through the best ideas and the best teaching can we cope with the problems that surround us and the opportunities that lie beyond these problems. Our fulfillment as a nation depends upon the development of our minds, and our relations to one another and to our society depend upon our understanding of one another and our society. The humanities and the arts, therefore, are at the center of our lives and are of prime importance to the nation and to ourselves. Very simply stated, it is in the national interest that the humanities and arts develop exceedingly well.

These words, taken from Barnaby's carefully prepared remarks submitted in writing for the record, demonstrate his literary flair and the

orderly process of his scholar's mind. But only in part were these special comments verbalized. Claiborne wanted a free exchange of ideas, without lengthy recitations. Thus this passage does lie like buried gold in the sands of the past.

Chapter 13

BARNABY TESTIFIED IN THREE CAPACITIES: AS CHAIRMAN OF THE COMmission on the Humanities, as representative of the Association of American Universities (numbering forty-two prestigious bodies), and as president of Brown University.

He was asked about religion, for the proposed legislation listed the study of religion as a subject germane to the humanities and its defined purpose. The inclusion had already become an issue, impinging, some said, on the separation of church and state. Should federal funds be used to "study religion?"

Barnaby parried Claiborne's question. "I like that definition," he said. "You will find one very much like it in our report. That may be why I like it." Barnaby smiled engagingly at Claiborne Pell.

I recall his brown tweed suit again, as a kind of badge of estate, the owlishly wise large eyes, the pointed strong chin, the look of knowledge and authority, the head and shoulders bent slightly forward above the witness table. Barnaby suffered a good deal from the often persistent pain of an old World War II leg wound, and he carried a cane, the hollow, glass-encased interior containing a modicum, we could say, of medicinal liquid. But his mind never bowed to any such ministrations when

taken. He was always alert, and one of the very few people I have en-
countered in life who can speak in precise paragraphs.

"Religion," said Barnaby, "is the expression of man's intangible
and emotional and spiritual aspirations, speculations and thought. I don't
see how you can interpret a society without studying its religion. I have
taught the history of religion myself, and I regard it as one of the most
meaningful aspects of history. . . . I do not wish this confused with the
advocacy of a religion," he added, "but the study of a variety of
religions." Listening to this, I believed I had found a means of satisfying
Barnaby's wish to include the word religion within the humanities lexi-
con without subjecting it to schisms and controversy.

Claiborne turned to another developing issue: the foundation-to-be
as an independent agency, either free of other connection and reporting
directly to the President or under the protection of an already well-estab-
lished and larger entity. "Originally I thought of it in terms of an inde-
pendent agency," Claiborne said. "Indeed, it was so identified in our bill.
I see merit, however, in a Smithsonian affiliation, provided certain funda-
mental independent aspects for the Foundation could be arranged. I be-
lieve we have a most imaginative Secretary of the Smithsonian Institution
at present. He is a truly brilliant and able man. A less able person, how-
ever, might inhibit the Foundation in this respect. I wonder if you could
enlarge on your own views."

This assessment of the Smithsonian and its leadership seemed to
catch Barnaby a bit by surprise. It reflected Claiborne's serving now as
chairman of the Subcommittee on the Smithsonian Institution, a position
(not highly contested) afforded to him by Senator B. Everett Jordan,
North Carolina Democrat, chairman of the Senate Committee on Rules
and Administration, where the subcommittee was lodged. Previously, the
Smithsonian subcommittee had drowsed in limbo, but both Claiborne and
I found its potential intriguing—from cultural, educational, and instructive
perspectives. We had forged new relations with a relatively new and dy-
namic secretary—S. Dillon Ripley—and had worked on several projects
not far afield from the central focus on the arts and the humanities.

Dillon Ripley and Claiborne Pell were both urbane gentlemen with
shared backgrounds and experiences. They were social friends. Dillon
had also established a close rapport with Lyndon Johnson. I had already
surmised that, if the President finally moved on the arts and humanities,
Dillon could be in part responsible—and that Dillon, who possessed ambi-
tion as well as imagination, might well be thinking of a controlling inter-
est in a new, precedent-setting program as significant, even integral, to
his own then-growing museum "empire." (One would hear this designa-
tion, common to Washington's stars on the rise, more frequently.)

After a moment's pause, Barnaby Keeney showed a political as-

tuteness I found refreshingly welcome. "Since Mr. Ripley's predecessor is a member of my board," Barnaby responded somewhat drily, "I feel obliged to say that he, too, is an imaginative and brilliant man."

Leonard Carmichael was thus given a rare accolade in absentia.

"I agree with you," said Claiborne, "and he is also a Rhode Islander."

So Barnaby avoided addressing a potential Ripley intrusion, or a Pell predilection, and he continued in a firm, measured tone:

"The principal reason in our minds for having an independent rather than a subsidiary agency was to permit freedom of activity in a positive way and to avoid interfering with the existing activities of another institution in a negative way. For example," he added, moving away from direct reference to the Smithsonian, "the National Science Foundation has a very strong and well-established program. It would seem to me with the staff they have built and the board they have built they would be unnecessarily distracted by the addition of another quite different form of activity, however closely science and the humanities and arts may be joined in universities.

"The Smithsonian is an institution for which I have the greatest admiration," Barnaby declared. "I think, however, it would be rather an irrelevant joining. I don't honestly see what useful purpose would be served by placing a humanistic foundation under the Smithsonian."

He went on to say that the leadership of the foundation might be affected "very seriously," that much stronger leadership could be found and secured for an independent foundation, rather than for a "subsidiary" one.

A note of tension was developing between Barnaby Keeney and Dillon Ripley. Two strong personalities of differing power structures, with differing eyes on the future, their relationship would not be easily resolved. Claiborne, listening attentively to these comments, paused. Then politely he said, "Thank you," and changed the subject.

It should also be on the record and emphasized that on this late February day, Barnaby spoke consistently in his long testimony about the humanities *and* the arts, linked in that order, but linked. It could be construed from his remarks that one perhaps outweighed the other in value, but essentially the testimony was evenhanded. The two are inseparable, he said, and left it there. Perhaps a message had been imparted. The Senator Gruening-Representative Moorhead axis, focusing foremost on the humanities, was being replaced by the Pell parallel concept. So it appeared, though ringing endorsements were lacking, and many witnesses seemed anxious to please all sides, thereby enhancing their own flexibility without giving offense.

Beguiled, unable to take the whole forever seriously—a mood that many seemed bent on perpetuating—I tried my hand at a melody:

Arts and Humanities
Humanities and Arts
Go together like strawberries and tarts
This I learned from mother
You can't have one without the other!

Try, try, try to separate them—
It's an illusion
Try, try, try, and you will only
Come to this conclusion.

Even one Art
And one Humanity
Go together like
A Brown and Keeney
Have you got it, brother?
You can't have one without the other!

I gave Claiborne a copy. He was not quite certain of the intent. "Like it," he wrote in pen in the margin. "But not sure suitable for *Record*," he added seriously. "How about sending to Barnaby?"
Reflecting on this, I decided not to.

In the developing cast of principal characters now moving toward stage center was also Roger L. Stevens, presidential advisor, good friend of Abe Fortas, Kennedy Center chairman, chairman-designate of the National Council on the Arts. There were some who found Roger inarticulate and others who offered with some derogation that he was only an occasionally lucky theatrical producer, with knowledge of the arts—if such it was—limited to that area, and that Abe had bestowed a politically partisan friendship for Roger's service to the Adlai Stevenson campaigns, during which Roger had been finance chairman. There were some who scoffed at the claim that Roger Stevens had once purchased the Empire State Building singlehandedly, and that he was several times a millionaire as the result of shrewd real estate transactions.
Roger did little to satisfy his critics. That is not his nature. When attacked, he attacks. He was later to demonstrate this quality for me, on purpose, with respect to a newspaper foe. It worked. Roger seemed to enjoy the mystique his reputation engendered. Of imposing stature and with the eyes of a hawk, he was not one who took gently to compromise.

I cannot vouch for all the stories of success. Obviously, there were several who bought the Empire State Building, but I am sure Roger was the organizer, the engineer. He was a lonely man sometimes, a man apart, with a kind and gentle wife who loved all animals. Sometimes Roger would say of a new nondescript mongrel appearing on the premises, "Christine found him—with an injured leg." And the dog would come forward toward Roger with the confidence dogs show only to those they know like them.

He is a riddle, people would say, an enigma. He made enemies on Capitol Hill, and friends. He enjoyed the successful ones and had little time for others. But of all the minds of those involved in the arts and humanities in these days of beginning and hope, Roger's seemed among the most agile. Concepts, large ideas, bright ideas, he understood instinctively. They engaged him and he knew how to expand on them, instinctively; but he lacked the ability to shape them into words that could have an abiding and hence compelling eloquence. He spoke in a kind of shorthand some equated with the musings of Dwight David Eisenhower. Roger simply shrugged. It did not really matter that much. With the ideas in his head, the formal syntax was of no major consequence. A good speechwriter would iron it out, when necessary, and there were enough of them to go around.

On some important occasions, the Roger Stevens verbiage was of distinct advantage. Congressional appropriations chairmen would be subjected to it when Roger was not reading from a prepared text. "Would you kindly explain to the committee now, Mr. Stevens, what is intended by project (so and so) in your submission?" "Certainly," Roger would reply. "As a matter of fact, it's very simple. The idea (or i-dee, as Roger was wont to say as a result of his Michigan background) is. . . ."

A certain expression of puzzlement would adorn the congressional face midway through the ad-lib explanation. "Mr. Stevens, I'm having a little trouble following you. Would you be good enough to—"

"Of course," Roger would say. "Let me put it this way, then."

Under such circumstances it sometimes transpired that the salient points of a potential critique or a building criticism rolled completely off the table. At first, I thought this was a particularly clever gambit, a means of disarming and defusing possible antagonism. But I came to believe this was not so at all. Roger professed a strong antipathy to "government gobbledygook," or any kind of gobbledygook, for that matter. I am sure he believed his responses clear and concise because that is the way they appeared on the radar screen of his own mind.

Claiborne Pell was not a notable ad-lib orator, though he could do much justice to a written text. Conversations between Claiborne and Roger were a lesson in the art of communication, for each perfectly un-

derstood the other. They also had a mutual affection and regard. Once Claiborne bestowed such attributes on another individual, it would take heaven and earth to alter them. Roger and Frank Thompson, so key to cultural prospects in the House of Representatives, also enjoyed each other's company—and tales of old political wars and reminiscences based on the special lore of leading personalties in triumph or under duress, the intimate insights gained from shared experiences. Roger was one of the few Frank permitted to use his special nickname, Topper. (Frank was to suffer a demise later on, but I remember his jests and his spirit. He was a tower of strength in those early days.)

Roger shared an element of flamboyance with Dillon Ripley. Dillon respected Roger, and it was true the other way. When the subject first arose of a possible home for a fledgling arts and humanities foundation under the protective arms of the Smithsonian, Roger professed no particular objection. He may not have thought the matter through at this point, a possibility that will later emerge more sharply. But unlike Barnaby, he seemed unaware of shadows; he and Dillon got along just fine.

Barnaby Keeney's attitudes, however, remained clear in my mind in that opening of the all-important Senate hearings. I had known of his scholarship and the comprehensive nature of his experience in higher education. An old curmudgeon, people in Rhode Island had told me, like a rattlesnake—never step on it. Now there seemed a willingness to bend, a certain but undefined distance. And there was for me a new dimension on this day of give-and-take, this day of personalities. Barnaby Keeney, unlike so many of his compatriots in the fields of education, had shown himself skilled in the art of politics. If crossed, he would be a formidable foe, I thought. It remained to be seen, if events moved in ways now becoming less obscure, how he would get along with Roger Stevens.

Chapter 14

*T*HERE WERE OTHER CURRENTS COURSING BELOW A GENERAL FLOW OF favorable and optimistic comment. One that surfaced and ran with considerable power—only to submerge and resurface again—involved the issue of the professional versus the nonprofessional: the wage-earner in the arts and the one struggling, with talent, to reach a professional, compensated status, the student versus the pro. In the arts this issue took on a particular importance. Wage-earning professionals in the arts, especially in the performing arts, were represented by union organizations—Actors' Equity, the American Federation of Musicians, the American Guild of Musical Artists, the Screen Actors Guild. Their leadership was articulate, idealistic in many ways, willing to look at broad rather than purely parochial concepts. Its support was vital to the success of the legislation.

The parent committee in the Senate was the Committee on Labor and Public Welfare; in the House, the Committee on Education and Labor. The labor movement, feisty and synonymous with strength in those days, was identified as a force for good, if not for total enlightenment, by a great majority of the Congress and by the administrations, first of Kennedy and then of Johnson. Labor came to defend the arts and humanities

and was the best organized of all the supportive groups at this time of beginning. Its witnesses spoke eloquently, and Congress listened.

Following Barnaby Keeney came David Winstein, executive board member of the American Federation of Musicians, AFL-CIO. He represented his union president, Herman Kenin, and the sentiment of some 250,000 members. He quoted from the report of a Commission on National Goals established by President Kennedy. "An industrial civilization," it said, "brought to the highest point of development, has still to prove that it can nourish and sustain a rich cultural life."

"Yes," David Winstein continued, "four years have come and gone and still we find ourselves considering starting legislation that proposes only minuscule assistance to a human resource that literally is dying of malnutrition."

Endorsement for Claiborne Pell's proposals followed, with a forecast of overall support from the AFL-CIO. We could not have asked for more than this. But there was an important stipulation that was to take on a weight of its own: Any final legislation should emphasize "the traditional prevailing wage formula which has long been recognized by government as a fair and just employment premise." Added to this would be proper working conditions, traditional to labor law, for those the new legislation would assist. I had drafted Claiborne's bill with assurances of this nature, which we both agreed were eminently fair. Other bills lacked these and they came under criticism.

The issue of fairness now became linked to a more difficult question: Just precisely how would this evolving, untried, and untested legislation deal with the professional musician, or actor, or practitioner in the arts? Was not a professional career the goal sought by serious-minded artists? Certainly the taxpayer's money should not be used to encourage the dilettante, the weekend guitar player, the Sunday painter. Excellence in the arts, these voices said, is equated with professional standards, with discipline, with achievement, and this legislation was to encourage excellence, not mediocrity. A thousand times no, said these voices. Support the professional; forget the amateur.

But there was another voice. It came primarily from the educators, newly emboldened by their linkages to the august connotations of the word humanities. It was a voice that grew in volume. It said, in one formulation, the professional needs no real help. The professional is earning monetary compensation based on the immutable laws of the marketplace. Those really in need are those struggling upward against the odds to reach a "prevailing wage." The professional has made it. Don't inflate wages; put the modest funds where they can become most effective with artists most in need. Concentrate on them, and the whole program will thrive. Otherwise, it will simply perpetuate the status quo.

It so happened that on February 17, 1965—just a week before these hearings began—two advertisements appeared in the *Washington Post.* One advertised George Bernard Shaw's *Heartbreak House,* presented by the Catholic University Theatre, all seats reserved, weekdays, $2, weekends, $2.50. The other advertisement was for *Heartbreak House,* by George Bernard Shaw, at Arena Stage. "Gorgeously literate. . . . Fine production," the Post's Richard Coe was quoted as pronouncing, while the *Washington Star* said, "Vastly witty, hilarious, a delight."

Zelda and Tom Fichandler were responsible for Arena Stage, developing a degree of professional excellence few then or since could equal. Father Gilbert Hartke was the pioneer of theater at Catholic University, with an especially high reputation. In fact, the President had just appointed him to the National Council on the Arts. It goes without saying, however, that tickets to the professional production were over four times more costly.

The two ads were printed side by side in the hearing record. They symbolized the struggle, now joined and beginning to accumulate heat. Didn't the lower price, permitted because the actors were unpaid, threaten Arena's audience and thus mitigate against the professional? On the other hand, suppose the amateurs, skillfully led, brought new vitality to Shaw, and excited or even monopolized the audience. Wouldn't the audience, growing in theatrical education, turn to Arena for other works later on? Wasn't it vital that the nation's audience for the arts grow in all possible ways?

Frederick O'Neal, the well-known black president of Actors' Equity, speaking solemnly and deliberately, warned against the federal government "being placed in the position of helping groups that would compete with artistic institutions by undercutting professional salaries and ignoring standards of professional working conditions." Said Theodore Bikel, vice-president of Actors' Equity, in reference to the possibility of a Catholic University receiving government aid under the legislation, "We have no objection where they are all students and playing to students and university staff. We do have an objection where there is a public box office. There," he said with considerable emphasis, "is where we have an objection."

And a day later, Albert Bush-Brown—engaging, imaginative, and high-spirited president of the Rhode Island School of Design—said, "I have serious reservations" about requiring "colleges and universities to pay not less than full minimal professional wages in any production attended by a non-college audience; that provision would cripple the activities of some important college theaters and museums." Bush's usually benign

countenance was altered. He look sternly at Claiborne, as if hoping to gain a favorable comment from his Rhode Island senator. None was forthcoming. "We intend to explore this matter further," Claiborne said. It was obviously in need of exploration.

Theo Bikel, actor, folksinger, balladeer, performer, upwardly mobile in his own career and in the positions of responsibility he would hold, spoke out with a developing sense of presence. "While I welcome the upsurge of amateur activity throughout the country due to the increased prestige of the professional artists whom they emulate," he said, "I earnestly beg you neither to mistake one for the other nor to throw them both into one and the same pot or give them equal priority. We must take care of the needs of the hen before we consider the egg."

Divergent views remained unsatisfied. The hearings concerned a multitude of both conceptual and technical details. But there were moments when witnesses spoke from their hearts, attuned both to the broad framework of proposed action and to their own background and persuasions.

U.S. Commissioner of Education Francis Keppel: "Let us be bounded only by our hopes." Indeed, Francis Keppel deserves special attention. Influential leaders in the executive branch and in Congress had suggested that a proper home for the proposed foundation would be safely within the Department of Health, Education, and Welfare. Frank Keppel could have encouraged such an approach and aggrandized his own areas of authority. He was already planning more stress on the arts and humanities, more educational funding, when I went to see him, half-expecting he would urge that the foundation come under his wing. This would not have been easy to counter, given his position within the hierarchy and the protection he could give a small new agency. But Frank was more farsighted. We discussed the new concepts, the need for new approaches beyond the reach, however well intended, of the large bureaucracy of a department. Frank offered support without reservation. It was steadfast.

Theo Bikel: "Historians and librarians, with all respect for their academic achievements, might not be ideally equipped to cope with the task unless flanked by persons of the live arts who are capable of a different grasp and endowed with a different and new perspective. For what you are setting out to do is a new concept. Yesterday's formula will not apply. It is said that old men have dreams, but young men have vision. This particular vision is within promise of fulfillment if we are bold enough to give it reality."

Albert Bush-Brown: "Art is essential to shaping cities and will sup-

port a higher form of civic and cultural life. Today, the American city fails to sustain our economic and social well-being. We have not enabled art to create the physical environment needed to nurture civic health."

Ernest Cuneo, white-haired pundit, writer, long-time friend of Claiborne Pell: "It was not hyperbole when the Librarian of Congress told this Subcommittee that the enactment of this bill would be an epic event in our history."

Glenn Seaborg, chairman of the U.S. Atomic Energy Commission: "As a scientist, I recognize that we are brought face to face with many alternatives for controlling our environment in all its aspects—physical, social and spiritual. But the use we make of these alternatives, the means we use to direct them toward the most exalted human objectives will depend on the values we create for ourselves. If we are to achieve humanity in terms of its greatest fulfillment, we need to share deeply in the varied experience that can be reached only through the arts and humane letters." His statement as a national and world leader of the scientific community was particularly welcome. I knew his feelings and sought his testimony, especially for this reason. And Dr. Seaborg used a word not heard too frequently in congressional hearings: The foundation, he said, "would give us a sense of *humility*—a realization of our place in history and in the universal scheme of things, even though at the moment we seem to possess great power, for good or for evil."

Lillian Gish: "A prizefighter gets more publicity than an artist. In some cases a truckdriver is better paid. It would seem that our system of values has reached an Alice in Wonderland absurdity, worthy only of satire. A nation has no claim to greatness solely through material wealth. It is great only when the essence of its mind and spirit is great. We judge every ancient culture by its works of art. Why should we not judge ours by the same standard?" Diminutive and contentious, large eyes flashing, Lillian Gish was among the pioneers of notable performers who through the years broke away from tight schedules and came to Washington to speak out—and, incidentally, to attract an often blasé press to cover these proceedings. (Conscious of that role, the luminaries have come. In crowded hearing rooms, as time unfolded, cellos and violins have been played. Leontyne Price has sung.)

Frederick Dorian came to testify, professor of music at Carnegie Institute of Technology and author of a then most timely, just published book, *Commitment to Culture*. An absolute must on the Biddle reading list in those days, it set forth in cogent detail many elements of my somewhat less documented research of two years earlier—and, fortunately, corroborated them with a scholar's and musicologist's authority. "The United States," said Fred Dorian, "is the only large progressive nation in Western civilization" without systematic support for the arts.

"The prestige of the United States has suffered all over the world because of the constantly repeated charge that we in America do not really sustain a rich cultural life. . . . Today, American art," he continued, "is concentrated in our large cities. This is a major disadvantage. The enjoyment of art must become part of the American way of life in all communities, small or large, and in all of our 50 states."

Otto Wittmann, director of the Toledo Museum of Art in Ohio, vice-president of the American Association of Museums, and now member of the National Council on the Arts, pointed to the significance of museums in an evolving U.S. commitment to cultural progress: "Museums are the cultural centers in many communities across our land." Claiborne Pell listened carefully, for these words reflected his own assessments of museum values.

John Hunt Fisher, executive secretary of the Modern Language Association of America: "No library in this country or abroad can buy the complete works of Mark Twain, Ralph Waldo Emerson, Nathaniel Hawthorne, Washington Irving, Henry David Thoreau, Walt Whitman, Herman Melville or Edgar Allan Poe. How can a nation that claims to be devoted to the creative arts or to humanistic scholarship allow this situation to persist?"

Dan Lacy, managing director of the American Book Publishers Council: "A library could buy all the responsibly published poetry first appearing in book form in the United States for well under $500 a year. If a stimulant grant from an Arts and Humanities Foundation enabled as few as ten libraries in each state to do this on a regular basis, the publishing of poetry would be transformed, and poets would (begin to) find . . . a market, and more usefully, an audience."

George Stevens, Jr., director of the Motion Picture Service of the U.S. Information Agency: "Plato said, 'What is honored in a country will be cultivated there.' " and "The great French Marshal Lyautey has been quoted as once saying to his gardener: 'Plant a tree tomorrow.' And the gardener said, 'It won't bear fruit for a hundred years.' 'In that case,' Lyautey said to the gardener, 'Plant it this afternoon.' That is how I feel about these challenges."

"As a boy, I played the violin in the Mark Twain High School orchestra in Statesbury, West Virginia, and as an adult, I have indulged my fondness for poetry. . . . To write, to paint, to draw, to etch, to play the violin, to delve into history and preserve its artifacts, to trace biographies, to contribute to the prose of philosophical studies—these are all elements of knowledge and the means of living life to the fullest. In every American home a respect for, and a sense of, beauty in art should be nourished, and the development of knowledge encouraged. A national

program to support and advance the arts and the humanities is long overdue. To give to gifted Americans encouragement to work to develop their talents and to provide recognition of their achievements is to strengthen and enrich our Nation. 'Ill fares the land, to hastening ills a prey/Where wealth accumulates, and men decay'—Oliver Goldsmith."

These eloquent words were spoken by Senator Robert C. Byrd of West Virginia. They have an historic content. Byrd was then tied with several other senators for a rank of thirty-fourth. Twelve years later, in 1977, his Democratic colleagues would elect him Senate majority leader. His concerns for the particular welfare of the arts and humanities may not always have been as pronounced later on, being at times overtaken by other priorities, but these words stand out, uniquely, in 1965. Anyone who has heard the senator—sharp-featured with hair now greying to white—play his lively fiddle, his eyes half-closed and his voice rising nostalgically to embrace West Virginia's country hills, can recognize the origins of his affections.

Chapter 15

OTHER HISTORIC FIGURES WERE INVOKED IN THE COURSE OF THESE PROceedings: Thomas Jefferson on the importance of education and of the individual in a democratic society; John Adams on the progression of learning, from the practical in a young, expanding country to the cultural and artistic as a country matures. St. Matthew: "Man does not live by bread alone." Victor Hugo: "Nothing is as inevitable as an idea whose time has come." For aficionados of congressional arts and humanities discussions over time, some of these will seem old saws indeed. But in 1965 the quotations had a certain freshness, and they were spoken with a relish to adorn originality.

In addition to Claiborne Pell, chairman, six senators were members of the subcommittee in 1965: Democrats Ralph Yarborough of Texas, Harrison Williams of New Jersey, Joseph Clark of Pennsylvania, and Edward Kennedy of Massachusetts, and Republicans Jacob Javits of New York and George Murphy of California.

Senator Murphy, who served one Senate term and was named to the subcommittee by Lister Hill in an apparent effort to include representatives from fields of the arts, did not overly participate. I remember a genial quality in his heavily lidded eyes, quick-moving like those of a

juggler. He had a slender frame, a somewhat rasping voice. He professed to being generally favorable, but his conservative nature, which could be qualified further by the adjective "ultra," prevented him then and later from any special enthusiasm. History, of course, will record his song-and-dance proficiency and his genuine skill with Frank Sinatra—and his proximity to the then-actor Ronald Reagan, already moving from films to politics. George Murphy should be noted as among the very first to make such a move, but ultimately top stardom in either area was withheld.

Joe Clark moved in and out of the hearings with sophistication and aplomb, serving as temporary chair when requested, welcoming witnesses he had invited from Pennsylvania's considerable resources in both arts and humanities. He had been joined by another Pennsylvania pioneer, Senator Hugh Scott, a connoisseur of oriental art. Hugh was a Republican. This was the first state to show such bipartisanship for the arts.

Edward Kennedy made his presence known with a strong opening statement, in keeping with his family's high regard first for the arts, but also for the scholarly world of the humanities. His voice had that quality which captures attention, even in this early period of service. And his brother Robert, newly elected senator from New York, took an active interest as a cosponsor of the legislation and as a full committee member, even though he was its lowest-ranking Democrat.

Harrison Williams, a senator whose regard for the arts and humanities was growing, also presided on occasion. History can note an ascendancy in the senator's career. In due course, he was to become chairman of the committee and oversee all its wide-ranging areas of interest and concern, until other events intervened.

But that is not the subject of this book. Like Frank Thompson in the House and from the same state, "Pete" Williams was a valiant leader in the cause, and he is remembered here as such.

Ralph Yarborough, the jovial yet shrewd senator from Texas, ranked next to Claiborne Pell in the subcommittee's structure. He was in frequent attendance, sometimes presiding, as the hearings progressed. He spoke of the values of classical scholarship and of the teaching of Latin and Greek. At one time, when operatic star Risë Stevens was testifying that American artists receive far more recognition abroad than at home, Senator Yarborough acted as jester. He told of a House colleague from deep in Mississippi who was running for reelection during the Depression. Senator Yarborough's friend chaired a committee with jurisdiction over the Library of Congress, which had requested more than a million dollars to acquire a collection of rare books assembled in Switzerland. After careful study, the Mississippi chairman committed himself to the request.

"I agree with him," said Risë Stevens enthusiastically. But it nearly cost him his election, Senator Yarborough continued. "He voted the money, and sure enough, an opponent announced he would run against him, and all reports from Mississippi were that he would be defeated. His friends wrote to him and told him, "Come down here and say it isn't so."

"He waited," Ralph Yarborough said, "until ten days before the election and had a mammoth barbecue in the middle of his district. He talked for an hour or two about everything he had done. They waited to hear about the books. He said, 'Yes, we bought those books . . . and I put it over, and it is the biggest bargain in history because do you know what I got? I got the only copy of the Bible in the world in Jesus Christ's own handwriting!' " He was reelected, Senator Yarborough concluded with a broad and knowing smile, while the hearing room responded with a great burst of laughter.

Senator Javits played his own important role, as always, in these hearings, complaining at one point that he was shuttling among the demands of six subcommittees, but with his lawyer's skill asking the provocative questions that allowed favorable witnesses to clarify and in some cases to embellish their prepared statements.

Jack Javits particularly focused on New York and the accomplishments of the New York State Council on the Arts, whose annual budget— then by far the greatest among that handful of states where arts activities were being governmentally supported—had just topped $500,000. As an indication of success and a harbinger of things to come, at Senator Javits's bidding, the latest annual report of the New York State Council, sixty-three pages in length, was included in the record. Its illustrations, the first to appear in such a congressional document, depicted moments in the arts that only a short time ago could have been the subjects for concern, rebuke, or ridicule—dancers in flight, controversial choreographers attentive to rehearsals, even an abstract painting with an admonition "curve" and "go slow." No one objected, although a few purists thought a picture of Nelson Rockefeller (accompanied by wife Happy) was a shade too political. To this we Democrats said with Senator Javits, the arts are nonpartisan.

John Hightower, the dark-haired, handsome, young, and debonair director—pictured with senior-statesman-type advisors—presented the council report to the Senate. Said Senator Yarborough: "I congratulate you. I think this is . . . astonishing . . . that in a short period of four years the number of communities in your state participating in this touring performing arts program has doubled, the number of performances has tripled, the number of touring companies increased twelvefold. . . . This is something I want all the states to see."

New York—as an example for the rest of the country, as a center for arts activity—was not always treated with such praise. Later the question was, why so much emphasis on New York? But in these beginning days an example of progress was admirable, and it suited the Javits' purpose to stress the homegrown preeminence.

Claiborne Pell, in keeping with his station and responsibilities, was the most conspicuous at these hearings, which lasted more than two weeks. He was always polite and patient with the sixty witnesses, the high and the mighty, those less renowned, the dignitaries and the hitherto obscured from a national limelight. We were building a record, gradually and painstakingly, for the immediate future and the longer haul—a record for the Congress, a record for the new program if it came to pass. We sifted all the recommendations, and there were scores, and preserved the shiny objects. We wanted as few objections as possible to the bill, knowing that if objections remained, they would be found and given sudden prominence.

So it was that we listened with immense patience to Harold Weston, chairman of the National Council on the Arts and Government—a gentleman whose senior years were approaching, a student of legislation and legislative phrasing in minutest detail, a painter, a friend to a wide variety of leaders in the arts, performing, visual, literary. Mustachioed and prickly, Harold possessed a stubbornness of conviction that could be equated at times with inflexibility. He had been to see me a number of times. I knew from whence he came, as the saying goes, and it was not exactly the direction we were seeking to pursue. It was vastly complex, and impeccably motivated.

Harold's testimony, including addenda and documentation, consumes more than fifty pages in the record, most of them in fine print. Harold's Washington "correspondent," who assisted in much of the preparation, was Barbara Donald, who had served as principal aide to August Heckscher, President Kennedy's advisor on the arts. August was now director of the prestigious Twentieth Century Fund in New York. "Augie" Heckscher was a member of Harold's executive committee, as were a great number of the illustrious, from Alvin Ailey, the choreographer, to René d'Harnoncourt, so eminent in the museum field. Altogether there were sixty-five whose names were synonymous with excellence in the support and practice of the visual and the performing arts. Lillian Gish spoke in introduction of Harold and as an important member of his committee.

Harold felt strongly that the National Council on the Arts, just named by President Johnson, should remain solely as presidential advisors. To direct the arts program and its funding, he recommended a

presidentially appointed National Arts Board of twenty members, also
presidentially appointed, and a staff answerable to the board. The board
would appoint an executive committee and other committees as appro-
priate, one for each area of the arts.

For the humanities, a like structure would be created, an advisory
council to the President, a board, a director, an executive committee,
and so forth. There would be a cross-pollination between the arts and
humanities councils and boards, and ex officio memberships for govern-
ment officials from agencies and departments with work related to the
new programs. A meticulously drafted bill was submitted, with some fif-
teen proposed amendments to existing law and other refinements. All in
all seven appendices were included.

It was a massive job. One had to admire the sheer volume and
the professionalese of the submission, but it was like suggesting to racers
about to receive the start-up flag at Indianapolis after months of prepara-
tion that they return en masse to their garages for a set of new engines.
Valves, yes, carburetors, perhaps—but not new engines. It just was not
workable, politically or otherwise.

"We will consider your views very carefully," said Claiborne. "We
may end up agreeing or end up disagreeing, but these questions are . . .
of structure. . . . I do hope your support for the general concept will
remain."

Harold Weston indicated possible agreement. I was to have a
number of additional visits and long conversations with him. I was never
quite sure how much of his organization was on paper, how many of his
expressed views were deeply shared, and how far he might be willing
to go to push ahead a conviction. Suffice it to say, he was a force with
whom we needed to reckon. I thought hard about Claiborne's admonition
regarding success in the political process: "Always let the other fellow
have *your* way."

Among the structural proposals offered was one of such appeal-
ingly recondite complexity that it is printed here as it was in the hearing
record. It emanated from a group calling itself the National Council on
the Arts in Education, with a membership spanning seventeen organi-
zations in such fields as theater, art education, music education, archi-
tecture, dance, and film. Joseph Sloane was its spokesman and also
chairman of the Department of Art and the Division of Fine Arts at the
University of North Carolina. Representing "the thousands of members of
our constituent societies," he spoke articulately and knowingly about the
values of the arts and humanities, their role in the nation generally and
in education particularly. Then he submitted the following structural
plan:

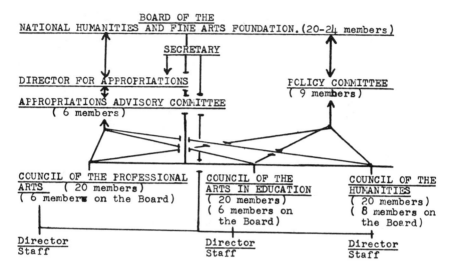

Members of the board ex officio:
 The Secretary of the Foundation.
 The U.S. Commissioner of Education.
 The Librarian of Congress.
 The Secretary of the Smithsonian Institution.

Claiborne said, "I see your suggestion is here. I am not sure I agree with it." The comment is demonstrative of his willingness to listen to any and all proposals with an attentiveness on which all witnesses remarked. There were days when a genuine working consensus seemed about as near as Pago Pago.

Chapter 16

*T*HEN FROM THE WINGS TO MIDDLE PROSCENIUM CAME THE GREAT SCHO-
lars. They were the voice of the humanities, impressive in their cre-
dentials and scope of activity, ready to speak with a unified, well-orches-
trated purpose. They represented the constituencies that had developed
the now well-noted report of the Commission on the Humanities. They
included Gustave O. Arlt, president of the Council of Graduate Schools in
the United States; Whitney J. Oates, Avalon Professor of the Humanities
at Princeton University, speaking for the United Chapters of Phi Beta
Kappa; and Frederick H. Burkhardt, president of the American Council
of Learned Societies (accompanied by Charles Blitzer, who was later to
be assistant secretary for history and art at the Smithsonian Institution).

Of the three, Gustave Arlt was the principal organizer and orches-
trator. The Council of Graduate Schools comprised "235 universities and
colleges, public and private, in 49 of the 50 states," enrolling 319,980
graduate students in 1965 and "producing almost 90 percent of the Na-
tion's college teachers."

"The real issue," said Gus Arlt, "is the recognition of the arts and
humanities as an intellectual enterprise coequal to the natural sciences
and of equal importance to the national interest. . . . What are the arts,"

99

he asked, figuratively extending a large branch of olives in their direction, "if they are not the activity of the humane mind and spirit?" He emphasized to Claiborne that he had once been a "performing musician and later for many years a concert manager."

Public attitudes were stressed. "Even more important than the education and training of artists and performers is the education of a receptive public. There is little virtue and no profit in the performance of new music and unknown composers before empty houses. . . . The theater, the concert hall, the opera, the museum can flourish only with an educated audience. They can get that audience only if the educational system, from the university down to the grade school, develops it." So would the humanities contribute to the bolstering of the arts.

Reacting to the notion of a possible location for the new foundation within the Smithsonian's shelter, Gus Arlt followed Barnaby's party line. "Now without wishing to be facetious, I would say that I would have no objection to placing the new Arts and Humanities in the Smithsonian Institution, provided the National Science Foundation were moved in there at the same time." Followers of details were acquainted with the impossibility of such a move, so while the statement might have seemed oblique, it was direct enough to score.

As a Princetonian with a fellow Princetonian at his side, Claiborne welcomed Whitney Oates, speaking for approximately 175,000 living members of Phi Beta Kappa and 176 separate chapters of the national organization. Professor Oates was somewhat less forthcoming toward equality between humanities and arts than his graduate school colleague. "A single National Humanities Foundation which includes the arts, as in Senator Gruening's and Congressman Moorhead's bills," he declared, "is clearly indicated." But when Claiborne asked if Professor Oates would support his legislative approach, the answer was, "Oh yes, sir." This might be termed playing the field, a practice not entirely unknown in academic circles, particularly its higher echelons.

Fred Burkhardt's testimony was measured and thorough. The ACLS, he explained, was a broad federation of the Nation's professional scholarly societies in the humanities and most of the social sciences. With Whitney Oates he stressed the need for support for research libraries, too often neglected in the trend toward generalization, and with his confreres he advocated an independent agency. "There is no doubt in my mind of the tremendous impact such an institution would have on the intellectual and artistic life of our country," Fred Burkhardt said. "In a few years this new Foundation would invigorate the humanities and the arts at every level of our educational system and in our society generally. . . . We live in a scientific culture; we could not escape it or retreat from it if we wanted to. . . . But we must learn how to live in such a

culture—and it is time that we gave attention to the quality of life in a world of science."

The emphasis on education, the scholars explained, had shifted since the nineteenth century, from a focus on the humanities and so-called liberal education as the proper preparation for life to increasing focus on science and technology. As these elements began to grow in American esteem, and in new discoveries applicable to new careers, science became dominant in education. Material values were in ascendancy. The intellectual pursuits that had once engaged higher education—and, indeed, the Nation's Founding Fathers—were dwindling. The ideal of a Renaissance man, broadly versed in philosophy, history, languages, and the arts, was replaced by a limited, but believed-to-be-practical specialization. They were not seeking to deny or denigrate the values of science, these humanists; but they were seeking diligently to correct a lack of balance.

They bolstered their case with compelling statistics. "Of the millions of federal dollars granted for research every year, over 70 percent is expended on projects in the physical sciences (including mathematics and engineering), about 25 percent in the life sciences (biological, medical, and agricultural), and perhaps one percent in the social sciences. The humanities are, with few exceptions, forgotten. To call the relationship an imbalance would indeed be an understatement." This statement came from Alvin Eurich, president of the Aspen Institute for Humanistic Studies (which was to become a leading center for an invigorated humanities community).

Office of Education figures, which I had tabulated for the hearings, showed that one out of fifteen recipients of a bachelor's degree in the sciences progressed to receipt of a doctorate, tantamount to a full teaching commitment. In the humanities, the comparable numbers were one in forty-five, or three times less. Full professors in the humanities were teaching more hours than instructors—at the lower end of the educational totem pole—in the sciences. That meant research for new texts and new teaching tools in the humanities was at serious disadvantage. "One must conclude," said Barnaby Keeney at one point, "that the undergraduates studying the humanities a decade from now will be less well taught than students in other fields."

And Claiborne Pell, wishing to seem at home with the scholars, scored a point or two of his own. "I was struck with your statement," he told Fred Burkhardt, "as to Uralic and Altaic languages." Fred blinked, for this mention was buried deep within the long prepared text he had presented but not read. "They are a family of languages that includes Finnish and Hungarian," he said delightedly, "and the Mongolian-Turkish languages," he added. "They encircle the Soviet Union," he continued.

"They are becoming more and more important for us to know about."
He was about to expand further for an appreciative senator, but Clai-
borne was now aware of the clock. "Thank you very much for your
statement," he said.

It is worth mentioning in this context that on a number of occa-
sions Claiborne's mind focused on paths, as Mr. Frost might say, "less
traveled by." One day I was doing a rather basic speech for him, con-
trasting cultural achievements in history with more short-lived successes
in other areas. It began: What do we think of when we remember an-
cient Egypt? A long political progression of Pharoahs or the great archi-
tectural triumph of the Pyramids? It went on to ancient Greece. Do we
remember best the conflicts between Athens and Sparta or the Acropolis
and the Parthenon?

Claiborne was fond of alliteration, as I knew. He liked the speech
and gave it full flavor. On the draft copy, however, he wrote vigorously
in the margin: "Re: Renaissance and beginning, pls. include wars be-
tween Guelphs and Ghibbilines." The alliterative parallel, I decided, could
nicely be that pioneering painter in Assisi and Padua, Giotto.

In reviewing the hearings—in my case volumes bound in fading
green paper, with bits of old markers still in place here and there—one
encounters the name Howard Mumford Jones. He was seventy-three
years old then and president of the Modern Language Association of
America. With volumes in hand, retracing memories, I am reminded that
one night with a moon obscured by clouds, in a canoe off the New En-
gland coast, I saw suddenly emerge from the gray mists, quite close by,
the great moving shape of a battleship. The mists parted to allow a mo-
mentary visibility, and then surrounded the shape once more, and it dis-
appeared. So it is to me with some of these names from the past. At this
instant, and as it is recalled, they appeared supremely vital, and, in a
sense, unconquerable.

Ralph Yarborough provided an introduction, for early in his career
Howard Jones had taught for six years in Texas. The senator reviewed
the background: a teacher with a panoply of earned and honorary de-
grees, a publisher, a writer, a poet, a dramatist, with books entitled *Ideas
in America* (1944), *American Humanism: Its Meaning for the World*
(1957), *Reflections on Learning* (1958), and a number of others of equal
reputation. Howard Jones personified a special dedication to this new
endeavor the Congress was considering. Perhaps he was the dean of
scholarly participation, perhaps he was *primus inter pares,* although such
accolades could have been contested with validity. Beyond question,
however, he was imposing.

He struck a familiar theme: "The training of teachers becomes dry

103

A Perspective from the Inside

and dull unless the subjects they teach are continually refreshed with new knowledge, new interpretations, new ideas, all resulting from competent investigation by professionally skilled research workers. This we take for granted in the sciences, but somehow we do not take it for granted in non-scientific subjects. Yet, just as in science, where there is an endless frontier that must be constantly patrolled, explored and pushed back if science is to retain its vitality, so humane learning must be constantly revitalized along the endless frontier of knowledge."

He gave the subcommittee an illustration from European history. "When I was an undergraduate," he said, "I was taught as a matter of course that the Europe of the Holy Alliance—that is, the European balance of power established by statesmen after the fall of Napoleon—was an evil thing maintained through the cunning of cynical diplomats like Metternich.

"Looking back on European history today," he went on, "looking at this period across the slaughter of two World Wars and other tragic happenings of the 20th Century, the historian discovers that the period in Europe between 1815 and 1870 was rather a stable time. He inquires why. He reads and analyzes primary documents not available to the historians who taught my generation and discovers that the earlier view was too simple-minded: that the statesmen who created and long maintained the balance of power were not necessarily wicked men, that, indeed, they may have been wiser than the books of 1910 described them as being.

"If the example is in any way persuasive," he said, "it is clear that we must do all we can to keep fresh winds of thought blowing across all the fields of humanistic activity."

I decided, silently, that I wished I had had in my own education the opportunity of a history course from Professor Jones.

Speaking of the foundation and of its goals, he put it in this special perspective: "For the first time it is proposed that investigations into the arts, philosophy, the languages and literatures of the world . . . and other branches of humanistic learning are to receive federal support at least comparable to the support given to the so-called practical subjects. For the first time in American history, inquiries into all past time and all cultures and nations, including our own, are thought to be financially relevant to the enrichment of American life."

The word "financially" seems interesting. No one else put it quite this way—but, after all, tax dollars were to be used. The nation's pocketbook was involved, and a new priority. The good historian can shed special light.

So the fragments were being gathered to form a new design. Indi-

viduals with their own agendas, individuals with a strong wish to contribute to an enterprise that might grow and last; individuals of a practical cast, individuals touched by idealism; artists and scholars, lawmakers and educators: They deserve our memories. We particularly need to remember the contexts in which they spoke.

To some, parts of these annals may seem merely fragments, almost set down at random. Yet they form a mosaic, a complex pattern whose greatly varied hues reflect not just a time gone by, but a present day—individuals and the words they spoke or presented for the record, individuals in some cases now long deceased. Yet see how many of the words have a current ring: aspiration, and admonition.

Chapter 17

HELEN M. THOMPSON WAS EXECUTIVE VICE-PRESIDENT TO THE AMERI-can Symphony Orchestra League, representing, as it does to-day, the majority of symphony orchestras throughout the country, with their boards of directors and widespread memberships extending far be-yond the major metropolitan centers. ASOL could speak with authority for an important and increasingly vocal sector of the arts. Its influence was prestigious and was especially to be felt later on.

I had spoken with Helen a number of times. She seemed almost furtive at the outset, with Gothic features and a smile slow in coming. I am sure her heart, and her own political sensitivity to the possibility of a gradual change toward the arts on Capitol Hill, gave her reason to welcome governmental assistance. But when I first met her in Wash-ington, she was reluctant to testify and, in fact, to comment in any quot-able manner. The leadership of her organization was opposed to govern-mental support. It was 91 percent opposed, according to a survey Helen had quietly conducted among the numbers of governing boards involved.

But this was not 1963. It was 1965. A National Arts Foundation had received serious attention. A National Council on the Arts was in

place. Isaac Stern was a member. So was Leonard Bernstein (whose "Mass" was later to open the Kennedy Center). Music was well represented. A National Arts and Humanities Foundation was proposed. It appeared to gather momentum. "In our most recent survey (1965) undertaken in preparation for this testimony," Helen Thompson told the subcommittee, "we find the vast majority of orchestras are responding either with statements of positive support for the legislation or statements that their boards no longer actually oppose the proposed federal programs in the arts. There are exceptions, of course," said Helen, "in which the prevailing sentiment remains strongly opposed," but attitudes had altered dramatically. Realism, together with expectations, was belatedly entering the orchestral field. There were caveats concerning specific legislative language, but all in all, it was a great improvement over the past. I doubted that conservative board members, often a culturally dominant group in cities large and small, would rush to embrace the liberally minded Democrats in Congress, but I also doubted that they would work with congressional opponents. Self-interest was emerging.

(A footnote: When the Reagan administration proposed in 1981 that the budget for the National Endowment for the Arts be cut in half, and shortly thereafter by 60 percent, conservative orchestra board members, still in the majority, were torn between interests in the arts and interests in a President they had helped elect. It was reported to me that at a Buffalo, New York, board meeting a businessman announced his full endorsement for the President's plan: "He's right, the private community will gladly take up the slack." "In that case," said a colleague, "we'll be expecting double your usual contribution." The businessman abruptly remembered a pressing engagement elsewhere.)

We had a Rhode Island day at the hearings, with state leaders coming to testify. Arlan Coolidge, descendant of Calvin and quite resembling his forebear, spoke as president of the Rhode Island Fine Arts Council. He advocated embarking on a comprehensive cultural history of the United States as part of the humanities mission, a recommendation that would later take the form of similar histories for each state. Educators spoke of needed emphasis on humanities programs and pointed to the availability of outside funding in the sciences, but not in humanistic fields. To the University of Rhode Island had come $45,000 from the National Science Foundation for an electron microscope, but there was no aid in sight for a needed sculpture studio. Claiborne took the Rhode Island delegation to lunch with Risë Stevens in the Senate Dining Room. Privately he asked me to seek approval of an arrangement in the legislation for state funding on the basis of equal amounts for each state. It was partly in keeping with previous proposals, which had never materialized.

Others had suggested that state funds be divided on a per capita basis or in accord with congressional representation. If you were not a Rhode Islander, that might have seemed fair. If you were from New York with ten times the population of Rhode Island and virtually ten times its congressional representation, such fairness might seem a subject for applause. A Texas would receive six times the Rhode Island allotment. Only an Alaska, a Delaware, and a Vermont would receive a modicum less.

It appeared a sticky proposition—the chairman of the subcommittee asking for favored treatment for a process that ran counter to the usual per capita state distributions.

I was fortunate in having as a good friend Roy Millenson, my counterpart on Senator Javits's staff. Roy was never one to give away a senatorial privilege, or a Republican senatorial belonging, but he appreciated Claiborne's predicament and had a profound knowledge of senatorial courtesies. I suggested to Roy that the largest state owed the smallest of its brethren a certain magnanimity, and that New York with all the relative affluence of its established state budget was in a position to be generously magnanimous to the poor and downtrodden. It was part of New York's reputation. Eventually we decided that a federal dollar for the arts in Rhode Island would mean more than a federal dollar for the arts in New York. The small were, by and large, the impoverished. Dissemination of quality in the arts was our aim. Under a fair distribution policy, the arts would be permitted an equal opportunity to grow.

Senator Javits decided to be magnanimous. Senators from larger states followed in approval. The matching funds provided for the states were divided by fifty, not by a more complex formula. The total involved for all states grew, gradually. Rhode Island cheered Senator Pell.

A nagging concern threading its way through the hearings, their preparations and aftermath was the issue of a loyalty oath required of individuals or organizations receiving federal support. It was an issue that had plagued the education field and still lingered at the doorstep. It emanated from the days of Senator Joseph McCarthy, which some remembered with loathing, others with fear that they might be revived. This writer can remember being in Rome in 1953 when the emissaries of Joe McCarthy, Messrs. Cohn and Shine, arrived to investigate possible subversion in the U.S. overseas library there. So intimidated were the diplomatic authorities that I can recall a pitcher of martinis being consumed to deaden pain, and possibly to bolster courage. My friend Stewart McClure remembered Joe McCarthy's rise, power, and final fall with a personal depth of misgiving and was the first in Washington to regale me with detailed accounts of this phenomenon in our country's political life—his shrewdness, his calculated grasp and manufacture and use of an

issue that vaulted him to fame. He left a heritage, and leaves one today. In 1965 it was still quite fresh in the minds of Congress and of others.

How could one really argue against loyalty to the United States? many voices asked. Shouldn't anyone, given the opportunity, be pleased to express such an attribute? Weren't some of these artist types still pretty pinko? Weren't there pretty subversive attitudes among some of those so-called far-left scholars? Weren't some of those universities encouraging the teaching of philosophies that were hardly reflective of true Americanism? "I heard from my own son about a professor of his who thinks Karl Marx wasn't all wrong by any means." Let's flush them out; what's wrong with loyalty? Surely Senator Pell believes in it. Don't we all swear allegiance to the flag? What's wrong with signing a piece of paper, saying you'll defend this country against all enemies, foreign and domestic? If you're on Uncle Sam's gravy train, you should be proud to get that paper notarized.

I was approached by voices connected to the past, and those more reasonable. After all, this is a small thing, they said. Education survived it. With an untried bill like this, vulnerable on all sides to attack, why take unneeded risks? It's by far the better part of valor just to accept. Get the legislation passed. Other matters are more important; don't go way out on a limb for this one. You'll win conservative points, and you'll need them—and they'll need them in the House. The Senate can be a big help. Amend the bill a couple of years from now, if you want to.

Witness after witness, however, mentioned the subject. "I would very much hope that the legislation will contain no special loyalty provisions," said Fred Burkhardt. His sentiments were echoed by the leaders of both the arts and humanities. It became a recurring plea, quietly spoken, by those who recognized that politically their requests might be damaging, but whose integrity and convictions were of both high caliber and great significance.

Claiborne asked for a recommendation. I gave him the pros and cons and said we ought to stick with principle, not set back the clock. I remember the flicker of a smile he used when deep in thought. "Yes," he said, "I feel the same way." So the risk was left unchanged.

If there was to be one foundation with two equal parts, one for arts, the other for humanities, what would they be called? There was thought of expanding the arts and humanities branch in the Office of Education, but "branch" did not sound overly appealing. We knew that the Bureau of the Budget would object to two "foundations" (and possibly even one as an "independent" entity), so it did not appear advisable to invent a new title for the overarching enterprise and call the two equal parts "foundations." I considered the word "endowment." It had a nice

sound, better than "branch." But in the context of law, what precisely would it mean? Would it convey what we sought?

Claiborne tried it out. Addressing Harold Weston, he referred to "each one of the endowments, or whatever we want to call them." But Harold was too intent on his own subject to react. He was describing his favorite structural complexities. "Seven or eight different lines for liaison are established. These are by means of ex officio members, . . . some of whom vote and some of whom don't vote. . . . I would like to make a few more statements."

"Certainly," said Claiborne.

(Parenthetically, it could be noted here that, as the legislation developed, the proposed structure was a special target for criticism. It might be called fortunate that our efforts were toward simplification.)

But to the subject of semantics again: Which would come first, humanities or arts? Top billing on the stage means the final individual to perform, but the star is listed first on the program. As the scholars testified, invariably the humanities took sequential precedence. Humanities. Humanities, including the arts. One could detect a preference for a capital "H" and a lowercase "a," though scrupulously no one sought such direct distinction.

Claiborne put the point somewhat bluntly to Gus Arlt, who had just finished saying, "It matters little whether the structure to be established is called the National Humanities Foundation or the National Humanities and Arts Foundation. I naturally favor the former because in my vocabulary the arts are humanities, but I shall certainly not object to the latter title."

"Actually," Claiborne intervened, "the name might easily be the National Arts and Humanities Foundation, might it not?" I think Gus realized he was wading out into the ocean a bit beyond where he had intended. "I would not object to that," he answered briefly.

Students may note some prophetic overtones here. They stand out, however, chiefly in retrospect.

Of the important voices raised in objection to the legislation, one belonged to Philip Hanes from Winston-Salem, North Carolina.

To Phil Hanes the answer to governmental support was "obvious." It should be in the form of advocacy, not direct federal financial assistance. "I understand last year the arts received only 1.5 percent of the donations given to [charitable] organizations." The total, he explained, was "far in excess" of sums proposed in the pending legislation. "Nevertheless," he said, "the percentage is disgraceful and is certainly insignificant in the overall picture of American generosity." He continued: "It

would be far more effective if our fine President and the Congress and Senate would urge individuals, businesses and foundations to increase the percentage of support given to the arts with the hope that there would be an improvement in 1965 to 3 percent. With adequate publicity and a strong effort on the part of our leaders, the arts would benefit to an extent beyond belief since they would have both increased funds and an improved attendance at shows and concerts."

He used the argument that tax incentives for charitable organizations were unique to the United States and the source of great potential for cultural progress. "Direct federal aid, even when matched," he concluded, "would merely create another large bureau in a government overloaded with such."

Phil Hanes's voice was important because of his reputation and experience. He was from the family that had established the Hanes hosiery business. His house in a rolling, wooded area, where other Hanes family members lived in similar opulence, was impeccably furnished with early American antiques, the tables decorated with colonial silver, the walls with paintings of elegance and charm. A cousin, Gordon, has one of the great Henry Moore sculptures, recumbent on a nearby extensive front lawn.

Phil Hanes possessed acute business acumen, but he had devoted a large portion of his life to the arts. At first encounter he seemed surprisingly young, but his background demonstrated vigor, experience, and persistence. More than others he had energized the Winston-Salem community toward an appreciation of the arts. His success had come through personal contacts, through his own ingenious methods of promoting competition among businesses whose arts interests he had piqued. "No federal aid" was his motto; the private world, properly motivated, could do it all. Phil was well known to the local arts council movement, to Nancy Hanks, to Roger Stevens. He had just been appointed by Lyndon Johnson to the National Council on the Arts. With his round face deceptively guileless, but with a mischievous smile lurking, he was soon to identify himself as the council's stormy petrel, speaking his mind at a first meeting to what might be termed the astonishment of a number present.

The views he expressed to the subcommittee were accompanied by encomium from North Carolina Senator Everett Jordan, chairman of the influential Committee on Rules and Administration: "Mr. Hanes, whom I have known for a long time, is not only President of the Arts Council of America but also was President of the North Carolina State Arts Council [an incipient body at this point] and a Trustee of the North Carolina School for the Arts [financially benefited by the Hanes family], and is highly respected throughout the Nation."

Senator Jordan was joined by the other Senate North Carolinian, Sam Ervin (later of Watergate fame), in helping to present Phil's opinions. It is interesting to note that these two senators, senior to Claiborne but affable friends who often agreed with him, abstained from cosponsoring the arts and humanities legislation all through the process of its rise in esteem. With Strom Thurmond's views evidencing no alteration, it seemed to me we might well anticipate growing opposition in the generally conservative South as the bill moved forward in deliberations.

My concern only escalated when Phil Hanes amended his views, or rather added to them, in a letter to Claiborne, also published in the record. He emphasized a need for further study and discussion: The newly appointed National Council on the Arts, now advisory to the President and only advisory, should have at least a year to review the possibility of arts support and make recommendations. He reiterated his belief that "business, industry and foundations" could be encouraged toward arts support. "I think you may be right," he said at the end, "but I think you are a couple of years too early." I felt at the time that such an argument, if properly mounted, could cause a fatal delay. Other critics were to follow suit.

It is worth recording here a glimpse of the future. The programs of the National Endowment for the Arts succeeded in large part because they provided seed money, the essential catalyst that stimulated support from individuals, corporations, foundations, and other governmental entities, large and small, at the state and local levels. As the federal catalyst grew, so did the financial support from these other sources. It is a comment on today, on yesterday, and for tomorrow that advocacy alone, words alone, urgings alone, are insufficient. The first commitment—tangible as well as philosophical—has to be there. Phil Hanes ultimately reached that conclusion, after witnessing the catalyst in action, both on a national level and for an organization as familiar to him as the North Carolina School for the Arts. One day he held out his hand to me. His smile broadened. "I won't quite say I was all wrong," he told me. "But you were right."

For Philip Hanes, however, in March of 1965, a federal foundation for the arts and humanities, or vice versa, was not an idea whose time had come.

Chapter 18

O N THE FINAL DAY OF THE HEARINGS, MARCH 5, SENATOR ERNEST
Gruening came before the subcommittee. His testimony extends
through forty-two pages of the record, for he came with many
documents to make his case. At his request these were included,
germane to the issues and to the presentation of a venerable senator,
who was approaching his eightieth year and whose respect among the
scholarly and humanistic community was unchallenged.

He addressed Claiborne. "Mr. Chairman, we stand at a crossroads.
Ahead lies an uncharted sea, an unmarked road, an unexplored universe.
Tomorrow, if we wish, we can be the age when mankind prospers, an
age when we are a part of, rather than apart from, our culture. Do we
want knowledge or know-nothingism? The choice is ours."

It was an eloquent performance. He was asserting a leadership he
had nourished for many months. Thirty-six senators, he announced, had
cosponsored his bill (thirty-two were listed now with Senator Pell).

I remembered going to visit with the Gruening staff. Their experi-
ence in Washington was superior, and they let me know how deeply the
senator cared about the humanities and how, from his own learned back-

ground, it was a special and most logical association. It was not that I was an upstart intruding into a province already claimed, but their attitude suggested that when it came to the humanities no one possessed such a comprehensive understanding as the senator from Alaska. Senator Pell might be wise to permit Senator Gruening to take the lead. By now, of course, I understood such loyalties and their expression. Eventually we had signed each other's legislative proposals. But Senator Gruening was not about to come down from the hill. He preferred inviting Senator Pell to come up and join him near the summit.

"I think we are joined in an extremely important enterprise, you and Representative Moorhead and others."

One, or at least I, had the feeling that, were he to issue a trumpet call to all deeply involved in the humanities to join him in full and sole espousal of the Humanities Foundation he proposed (with the arts included among the subject areas to be assisted), there might be something approaching a scholarly stampede—with the arts bugles starting to sound when the dust settled.

Senator Gruening, however, was too much the statesman for dissension at this juncture. "By working together, we can perfect a bill," he said to Claiborne, conceding nothing to his own sense of priority or to the high ground he felt was his.

It is my observation that a distinctive etiquette or sense of ritual prevails among senators. Seeming ideological enemies in heated debate on the Senate floor can put their arms around each other's shoulders when leaving, screened suddenly from public view by the overhang of the gallery's balcony, and go off together for a friendly lunch. Republicans, on occasion, can so embrace Democrats—or vice versa—and seniors can embrace juniors, under certain circumstances, though it is more likely to see contemporaries in experience thus joined. Lunch is in a clublike atmosphere, no matter what diatribes are being delivered on the floor above. So sanity is maintained, and decorum, and all the protocols of seniority, all the refinements that permit an ordered operation, all the rankings from chairman to last in line of succession, all the prescribed hierarchy for floor debate. But let one of these be breached, or threatened, or misunderstood, or treated with inappropriate levity, and wrath descends, and sometimes recrimination. Let a junior chairman take unwarranted advantage of a senior senator and the delicate balance of relationships can disintegrate.

"Jefferson," Senator Gruening said, "had a genius for timeless writing. He said of history in 1782: 'History, by apprising the people of the past, will enable them to judge of the future; it will avail them of

other times and other nations; it will qualify them as judges of the actions and designs of men; it will enable them to know ambition under every disguise it may assume; and knowing it, to defeat its view.' "

Senator Gruening urged affirmation of the values of archeology and Greek and Latin. "How else can we learn more about the once highly developed civilizations which have perished? . . . The late T.S. Eliot was proficient in both classical and modern languages. Eliot revolutionized the English-language poetry world." He emphasized the urgency of greater research in the humanities by experts freed, to a greater degree than present university budgets permitted, from daily concentration on teaching. He summarized the salient arguments made in other statements, and he reviewed the similarities between Claiborne Pell's proposals and his own, and the differences. "The 1964 Report of the Commission on the Humanities should be required reading," he said, "and its passages deserve to be quoted as often as possible. . . . How far-reaching are the humanities? As wide as we wish them to be."

He was giving instruction to the subcommittee, and he was establishing a record of his own position. He was reaffirming that position in a manner familiar to the Senate.

To his verbal testimony he added a goodly number of letters from distinguished leaders of the academic world—professors, directors of programs, university administrators, college presidents—some lengthy, some brief. Other letters were simply from constituents in Alaska, eager for a deeper experience in learning. From the old Gold Rush village of Ketchikan: "This happens to be somewhat of a personal thing with me, but I'm sure many others feel as I do."

As he neared conclusion, Senator Gruening said, "Perhaps a quotation from a letter I received January 28, 1965 from President Barnaby C. Keeney of Brown University . . . best expresses the purposes for this hearing and for the work of the Senate in this area. President Keeney wrote, in part: 'My greatest hope is that out of the two bills we will get one that will move things forward.'

"I can only add 'amen,' " said Senator Gruening.

As a proper chairman should, Claiborne Pell made acknowledgment, referring to the Rhode Island educator with whom we had been working so assiduously, but praising Ernest Gruening's great contributions to the humanities. Then he added that Barnaby Keeney "is working in cooperation with this Subcommittee," indicating a subtle emphasis on his own chairmanly prerogatives. And in the marvelously complex ritual of senatorial parlance, no one could tell who had won or lost, or indeed whether a contest had been intended. But from this day on, Claiborne's position on the development of the legislation became dominant.

My own memory of Ernest Gruening especially involves this mo-

ment. I felt both admiration and affection for him. He understood his cause. He loved it. He died a few years later while running for reelection. It was said he went swimming in icy waters to demonstrate his youth, and illness overtook him afterward. I think on that morning in early March, at the hearing, he sensed that Claiborne Pell as chairman would eventually become a hero, if there was to be a hero. The senator from Alaska just did not want to let it go by without a final and eloquent "hurrah." Stewart McClure was right: The chairman's position is key.

Representatives of schools of music came, and of education in speech and theater. Dorothea Ward and Daniel Millsaps, copublishers of the *Washington International Arts Letter,* submitted lengthy testimony in support of the arts from a broad spectrum of educators, librarians, and early state arts organizers. Included was a draft bill to establish on a more permanent basis an exemplary state program in Missouri. Howard Adams, who had started as a dairy farmer, was the responsible party in Missouri and was to become a guiding light of the early state arts movement.

The lawyers came to urge that the study of law, its history, its worldwide ramifications, be specifically included in the definition of the humanities and be applied both to law schools and liberal arts colleges. I recall a memorable learned discussion on Roman law between Clarence Morris, stocky, bespectacled, with high forehead, noted professor at the University of Pennsylvania, and Ralph Yarborough, who revealed his own broad knowledge by pointing out that many of the land laws of the American Southwest had Roman origins. The episode illustrates the detailed nature of the hearings and the efforts being made to perfect all aspects of a legislative vehicle for action.

And finally, in these hearings, history should record two more events. One, initiated by Claiborne Pell, set a precedent for future congressional deliberations on the arts and humanities. He and I decided that a joint hearing with the House of Representatives could produce added cooperation and an atmosphere of partnership at a time when the new and unexplored were being tested. I approached Frank Thompson's chief of staff, Robert McCord, and found him amenable. There were joint committees between Senate and House, but a joint hearing of this nature definitely entered the arena of the unexplored. On whose turf would a hearing occur? Bob inquired. Claiborne would not insist on the Senate side, I answered. Then would it be on the House side, Bob asked, with Congressman Thompson accorded the chair? I suggested a joint chairmanship. Bob agreed.

We decided on neutral ground in the U.S. Capitol, and on a one-

day test period. The minority members did not disappoint us. They presented no objection, and thus were set in motion a protocol and a process that were strengthened in years to come. Claiborne and Frank sat side by side; Claiborne opened the proceedings and gave Frank Thompson the privilege of presiding. It was all quite formal. Those present included Senators Ralph Yarborough, Edward Kennedy, and Jacob Javits, and Representatives James O'Hara, Hugh Carey, James Scheuer, Robert Griffin, Paul Findley, and Glenn Andrews. Bill Moorhead, though not a member of the subcommittee, attended as a special guest because of his leadership in sponsoring the legislation now under public scrutiny and review.

We had invited the poet Paul Engle to testify. The opening statement I had prepared for Claiborne contained a quote from his book *American Song.* He spoke so appropriately of "new and untried sails," and of America, he said: "We build it out ourselves, . . . blazing the trees for those who are the generations after us."

Roger Stevens was the first witness. Senator Javits issued a complaint. The abbreviated arts legislation had been made law at the end of the previous September. Here it was almost the end of February. Wasn't it high time that President Johnson named the membership of the National Council on the Arts? With an experienced showman's flair, Roger announced that he had the names in his pocket. Frank Thompson was smiling. "Would the Senator from New York like to have anything else done today?" he asked.

It could be said that the joint hearings of February 23 produced winning combinations—including Paul Engle's appointment by the President to the first National Council on the Arts.

John Brademas was before long to replace Frank Thompson as chairman of the House special subcommittee. John welcomed the joint hearings procedure, and it became traditional as he established his own tradition of leadership for cultural progress—arts, humanities, museums— in House authorizing legislation. Here it is also appropriate to introduce Sidney Yates, soon to become a cultural force in the House of Representatives and to emerge as its preeminent leader in appropriations for all the causes that in 1965 were stirring into life.

The other episode relates to the testimony of Smithsonian Institution secretary S. Dillon Ripley at the first joint hearings.

The questioning of a number of witnesses sought resolution for one of the most basic of issues. If created, where would the proposed foundation best be lodged: within its own tent or under another's? within the Smithsonian or independent, a new agency standing on its own and reporting directly to the President?

Artists and scholars alike favored the independent course, and they were given free rein to express themselves without hints of negative comment from members of Congress, who knew full well that troubled seas were already sighted on a not-distant horizon and that a respected haven was preferable to vulnerability. Claiborne knew the opinion of Barnaby Keeney and the great desirability of his agreement for reasons that included the political as well as the intellectual. But Claiborne and Dillon Ripley had worked closely together on projects referred to Claiborne's chairmanship of the Senate Subcommittee on the Smithsonian. Strong ties, becoming stronger, thus existed between a secretary and a senator, and they included the possibility that at some future time an enterprise with the Smithsonian could be effected in a Rhode Island setting.

Claiborne was most concerned, however, with protection for the brand-new endeavor we had initiated. We had studied the departmental possibility with the Office of Education and steered away from it, but the Smithsonian continued to have undeniable appeal. In addition, confidential reports reaching me now indicated that the Johnson administration, recognizing the full extent of support for the foundation revealed in the hearings and in the list of witnesses, was nearing completion of a bill of its own, prepared through the Bureau of the Budget (with an undoubted acquiescence from Richard Goodwin). Rumors were that BOB was leaning toward a Smithsonian umbrella.

On the day he questioned Dillon Ripley at the joint hearing, Claiborne told me he was balanced between the two alternatives and leaning slightly in a Smithsonian direction. I saw the merits clearly, and the demerits. They revolved around Barnaby Keeney, not around Roger Stevens, who as chairman of the National Council on the Arts and a respected Johnson advisor still seemed to feel secure no matter what the arrangement. They also revolved around profound questions of ideology. Independence, yes, seemed Claiborne's view—but in time, after the fledgling had grown in the safety of a protecting nest.

We had prepared careful questions for Dillon Ripley, and in a measured tone he answered them, quite emphatically. Supposing the proposed foundation were sheltered by a Smithsonian umbrella, would it perhaps be like a National Aeronautics and Space Administration, which began life under Smithsonian auspices and later emerged to independence?

Dillon Ripley saw a possibility, but they were two very different enterprises.

Might the new foundation, then, be within the Smithsonian, like a National Gallery of Art given considerable autonomy or like a Kennedy Center given even greater freedom of action—two quasi-independent bureaus, in other words?

Dillon thought a closer organizational structure best.

How close?

It would be under the secretary and the regents of the Smithsonian, Dillon indicated.

Claiborne persisted. It was clear Dillon Ripley did not wish to modify his views. A new foundation would be sheltered and would be in accord with the Smithsonian's abiding concerns with cultural values and the diffusion of knowledge among men, as its founder had emphasized. The generalization seemed to defer the specific.

"Basically," Claiborne said, "if it was decided by the Congress that the foundation should come under your umbrella, you would permit it the freedom of the exercise of its judgment?"

"I would have to await, Mr. Chairman, the results of conversations that might ensue between the Bureau of the Budget and ourselves and the President's office about any such proposal. In general, I can say that the regents feel that some sort of budgetary review is implicit . . . and I think they are entitled to this sort of thing. There is no question in our minds that the institution, which is so fraught with history and in current activities with matters of the highest national interest, should be used in any other way than with the proper responsibility and relationship to the other agencies of the government."

"But the parallel might not be true as to how this could develop?" Claiborne asked, giving emphasis to the word "could."

"I think this is a matter for some discussion and perhaps for testimony if that seems appropriate, at a later time," Dillon answered.

The responses may not have been quite conclusive, but it was evident to both Claiborne and me that the Smithsonian, while relatively safe from congressional attack and early appropriations vulnerability, could become a home forever, with chairmen reporting to the secretary and becoming in effect the secretary's assistants. (Students might like to examine the phrasings as a marvelous and sophisticated example of politely enigmatic governmentese.)

I am not quite sure why these answers were given. It was reported that Dillon Ripley was so close to Lyndon Johnson that he honestly felt he had to make no special effort toward compromise. The National Gallery of Art, NASA, and the Kennedy Center were enterprises started before his term of office began. Why would he want such a loose, unresolved chain of command? Why would he seek it? Why make premature concessions when they were unneeded?

And so the hearings ended—and there was still no place called home.

Part Three

THE LEGISLATION
EMBATTLED

Chapter 19

*I*HAD A CALL FROM WILLIAM B. CANNON AT THE BUREAU OF THE BUDGET. Bill's legislative masterminding and oversight included the cultural fields; Emerson Elliott specifically concentrated on arts and humanities. Both were of highest professional caliber. "I think we have something you'll want to see," Bill told me.

I found myself the only one of the congressional staff members invited to the Executive Office Building. That old, gray, architecturally ornate hulk of a building has always suggested to me a great beached battleship, with turrets mounting upward, as if by steps of different sizes, all having an intricate interlocking purpose, and with the flag flying proudly on top. The EOB housed the BOB, and both were so closely related to the White House that invitations were to be so construed.

My solitary estate seemed surprising—not a Stewart McClure, not a Robert McCord, not a minority representative. It was certainly a nice and welcome acknowledgment, but it left me somewhat exposed should special advice, even of a confidential kind, be sought.

It was more than this. I was shown, confidentially, two bills prepared for Lyndon Johnson, not yet seen by him. The first established a National Foundation on the Arts and the Humanities within the Smith-

sonian Institution, with the secretary of the Smithsonian reporting to the President on the foundation's progress and with the annual budget under the secretary's attention. It was a bill Claiborne Pell could approve, if the Smithsonian was the best route to pursue. It was ingeniously designed with some flexibility for the leaderships of the arts and humanities, and some restraints.

The second draft described an independent agency, with two parallel chairmen, each advised by a national council and one national foundation. Each chairman would preside over an "endowment," a term I could recognize; and there was a Federal Council on the Arts and the Humanities, consisting of agency or departmental heads, to provide liaison with related federal programs such as the Smithsonian.

We asked you here because this one is very similar to the Pell approach, I was told—although it was quickly added that the first alternative had received a number of approvals and seemed in line with a good many of the Pell questions and interests. When I am in this special kind of environment with officials of this ability, it is always interesting to me how closely all facets of a situation have been followed.

I was permitted some minutes to study the two alternatives, sitting in a brown leather-upholstered chair with an early March light coming through a large window, with Bill Cannon and Emerson Elliott present. Bill was almost always breezy in his manner and conversation until matters became serious. Then his eyes took on a hard and probing quality. Emerson was the skilled technician, slender, with the studious face you might equate with the highest honors of a Ph.D. They watched me silently, and the room seemed quite still as I turned the pages, trying to decide how—in these circumstances, which seemed to me so unexpected—I would answer the question if it were put to me.

It was, and more directly than I had anticipated. What are your comments? seemed the likely question.

"All right," Bill said as I put the pages down. "Which shall it be?"

"Independence," I answered, looking at him.

His expression did not change. It seemed quite matter-of-fact, neither pleased nor displeased, suggestive neither of a momentous moment nor of simply a passing personal opinion.

Bill scrutinized me for a second or so. "Okay," he said, and stood up. "I have a few calls to make," he told me, and stepped into an adjoining room. The door remained slightly ajar.

I do not recall Emerson and I speaking to each other. I could hear Bill's voice, distant, seemingly modulated. He was gone for perhaps five minutes, possibly ten. I do not believe he called President Johnson, as some have suggested, but there were authorities higher than his own— Kermit Gordon, for one, the BOB director, or Elmer Staats, his deputy,

well known to me later but not then. Did he call Richard Goodwin? I somehow doubt it, in retrospect, but I wondered at the time. Dillon Ripley? If so, perhaps my reply would carry little weight. I guessed he would seek other reactions on the Hill and elsewhere; perhaps mine was the first to be reported. Time went on. Emerson gave no inkling of what was in progress, and I made no inquiries.

Then Bill returned.

"Thanks, Liv. We'll be in close touch on this. I've relayed your views. Give my regards to the senator."

That is what seemed to me likely.

Instead, he said, "All right, we've signed off on it, the administration. It's independent." His face was still quite matter-of-fact.

I remember saying "Uhruhu!" It was a word I had learned from reading Robert Ruark's then-popular book about the struggles in Africa. It meant independence, and there had been joyous dancing at its mention, for its potentials, for the hopes the word contained.

Bill and Emerson seemed unmindful of the allusion, but they were now standing, smiling, and we were all shaking hands.

It seemed unreal then, and somewhat so in retrospect. An administration bill, carrying the full weight of a popular President's authority, was soon to be sent to the Congress reflecting, in essence, the legislative fundamentals on which Claiborne and I had been working for months—indeed, it could be said, for years. He would note, Bill emphasized, that the bill also included the liaison with other programs we thought would be helpful. There would be one foundation, two parallel "endowments" equally funded, a proper place for the National Council on the Arts, and a provision for the establishment of a National Council on the Humanities. There was a refinement in funding I had observed, a provision for matching unrestricted private gifts to either endowment with federal funds. With a variation, that provision was to prove beneficial for the future.

The elements of the bill were not in themselves too surprising, given the working relationship we had established. What surprised me was how well this draft coincided with our own ideas—and how quickly that fateful decision had been made, and how it was made.

I kept thinking there would be modification, or change, or reversal.

On March 10, however, President Johnson sent a bill for the independent foundation to the Congress. It was transmitted for introduction by Claiborne Pell in the Senate, with Senators Gruening and Javits as cosponsors. Simultaneously it was transmitted to Frank Thompson for introduction in the House.

Thus it became Claiborne's bill in the Senate and was the vehicle for advancing the final legislation, for amending it and refining it as might be needed. There could be no further question about whose Senate bill might take precedence, whose name would forever be listed in the Senate's records as chief sponsor. The bill, entered on the ledgers and automatically referred to the Senate Committee on Labor and Public Welfare and thence to Claiborne's subcommittee, received its number S. (for Senate) 1483 (a number, someone suggested, predating Columbus's discovery of America by nine years). Cosponsors of Senator Gruening's bill began joining on S.1483, as did the cosponsors of the original Pell proposals.

The bill was accompanied in its transmittal by a special presidential message. In part, in as memorable a way as anyone could wish, it said: "This Congress will consider many programs which will leave an enduring mark on American life. But it may well be that passage of this legislation, modest as it is, will help secure for this Congress a sure and honored place in the story of the advance of our civilization."

President Johnson placed the most important elements of his administration's efforts within the context of the phrase "the Great Society." On March 10, 1965, the arts and humanities legislation took its place among these priorities.

Dancing in the streets, however, was abbreviated. S.1483 was "circulated," in congressional parlance, to the witnesses who had already testified on the Pell, Javits, and Gruening legislative concepts. The great majority responded affirmatively and with sentiments that suggested decks cleared for action, as congressional initiatives were now fully endorsed by a President of great persuasive powers.

John Rockefeller wrote, "No longer can we question the importance of the arts to our society, nor doubt that our government has a responsibility toward them." In the final framing of the legislation, he added to Claiborne, "your committee has a historic opportunity."

The scholars joined hands in general agreement. Barnaby Keeney was pleased to join with the arts on equal footing, for the humanities had achieved their goal of a special autonomous program, answering needs they had expressed.

Harold Weston, writing at length, expressed the view others were also advancing: "We congratulate the administration and the subcommittee on the progress that has been made." He was willing to withdraw the complexities of his structural objections, and agreed on the far more simplified procedure. He hoped the Federal Council on the Arts and the Humanities would meet more regularly than indicated in S.1483. As we embarked on amendments, I was happy to include this appropriate recommendation on Harold's behalf.

It seemed for a few days that inevitability was taking charge. A tenuous and often tortuous effort was emerging from congressional byways and turning into a far broader avenue—maybe not the ultimate highway to the sea, but a marvelous improvement. Even when Clarence Morris wrote in disappointment that his discipline and his deep interest in the study of law had not gained, but "lost ground" in S.1483, the matter seemed easily rectifiable. Senator Yarborough's staff and I could work together in this regard.

Senator Javits remained reserved about the humanities. Roy Millenson showed me a roster of projects funded by the National Science Foundation in the broad and loosely defined area of the social sciences. They seemed very close to projects that could be supported by a humanities endowment. I think Senator Javits was beginning to wonder if the arts, even given their separate program, could suffer sudden loss in the face of developing competition. Don't spoil the arts, don't muddy the waters, he seemed to be indicating. I was able to tell Roy of the proposed Federal Council on the Arts and the Humanities, which would include the director of the National Science Foundation as a member. Possible project duplications could be prevented by this liaison group, which had been especially created, I told Roy and it was true, in answer to Senator Javits's concerns. Roy gave me a look, and I could not tell if the problem was resolved or not. At least it was deferred.

But the expressed concerns of labor, Actors' Equity, and the AFL-CIO were entirely otherwise. After reviewing S.1483, proposed by an administration allegedly in favor of working men and women, they were ready to protest in a manner that all at once threatened to short-circuit all advancement and bring me from a state of euphoria solidly back to earth.

Chapter 20

BEFORE MARCH ENDED, FREDERICK O'NEAL, THE HIGHLY REGARDED AND
usually supportive president of Actors' Equity, wrote to
Claiborne Pell: "I am deeply concerned that in all of the current enthusi-
asm for action, the worthy interest of 'promoting progress . . . in the arts'
is being overshadowed. The cause for my disquiet lies in the fact that,
although previous bills before your subcommittee clearly stated that
grants-in-aid were intended to benefit 'professional groups or groups
meeting professional standards,' there is no such direction or statement
of intent in the sections relating to the arts in S.1483.

"I am not alone in my concern," he concluded. On March 17, *Va-
riety* (an authoritative source of responsible arts opinion in those early
days) reported similar misgivings by professional leaders in the perform-
ing arts. *Variety* quoted the general belief that the legislation "might be
trying to help too many with too little money. . . . There are at least
5,000 amateur little theaters over the Nation, and it is easy to envision
them asking for federal aid. . . . The effectiveness of the arts will hinge
on . . . the guidelines to be originally written into the bill.

"You are setting the guidelines now. Whether this legislation is to

encourage higher standards in the arts or merely a wider proliferation of mediocrity rests with you and your committee."

There are a number of expressions to which the skilled Washington ear becomes attuned. Washingtonese is so often the language of understatement. The words "concern" or "trouble," for example, are precisely and intimately understood by official users and listeners alike. They mean a funnel-shaped cloud has been sighted, bearing in a dangerous direction.

A perusal of Fred O'Neal's letter made this quite clear. "Deeply concerned" is about as serious as Washington vocabulary permits.

I called Jack Golodner, a much-admired friend with whom I had worked. He looked then rather like a young business executive—short hair, high forehead, conservative attire—but his eyes had that look of wise experience, particular to qualities of patience and diligence. The eyes of the ultra-ambitious, and there were a number of these, had a certain glitter, an unusual shine. Unless you looked closely, it could be mistaken at first for brilliance, or even genius, until the superficial nature was discovered. Jack's were far more reflective, but they were also direct and they suggested no nonsense. Jack had worked for Robert Giaimo, Democratic congressman from Connecticut, one of the early leaders for the arts in the House of Representatives, and was on his way to becoming one of Washington's most skilled lawyers, preeminent in the area of labor's involvement with the performing arts and its continuing and traditional support for the arts as a whole.

We met privately and negotiated during most of one day. We discussed all the early testimony—O'Neal's, Theo Bikel's. We discussed the testimony of the leading educators and the positions that seemed often diametrically opposed—the professional, the amateur, the student, the box office. And we talked about all their ramifications—especially excellence and mediocrity, and from whence these two might spring.

We went over S.1483 line by line, including the opening section, the so-called declaration of purpose. Jack framed a new paragraph for the declaration. It reflected, expanded on, and clarified earlier Pell concepts, repeated in comments made by Lyndon Johnson.

Beginning with the general phrase, "The Congress hereby finds and declares . . . ," the new paragraph reads:

that the practice of art and the study of the humanities require constant dedication and devotion and that, while no government can call a great artist or scholar into existence, it is necessary and appropriate for the federal government to help create and sustain not only a climate encouraging freedom of

*thought, imagination, and inquiry but also the material condi-
tions facilitating the release of this creative talent.*

Perhaps we felt a little like drafters of another declaration, but the paragraph seemed to bring us closer to each other in goals and their expression. Now, how should such a climate best be fostered? "Constant dedication and devotion" did not imply a sometime artist. It implied a far deeper commitment.

In section 5, which dealt with the authority and function of the National Endowment for the Arts, we amplified the general phrases listing the kinds of activity that would be assisted, by adding the italicized words:

> productions which have substantial artistic and cultural significance, *giving emphasis to American creativity and the maintenance and encouragement of professional excellence;*
> productions, *meeting professional standards or standards of authenticity,* irrespective of origin, which are of significant merit and which without such assistance would otherwise be unavailable to our citizens in many areas of the country;
> projects that will encourage and assist artists *and enable them to achieve standards of professional excellence.*

We did not alter the following two paragraphs, which read:

> *projects that will encourage and develop the appreciation and enjoyment of the arts by our citizens; and*
> *other relevant projects, including surveys, research and planning in the arts.*

For the very legally minded, the definitions of the terms "production" and "project" are included, but we did not alter them. They read:

> *The term "production" means plays (with or without music), ballet, dance and choral performances, concerts, recitals, operas, exhibitions, readings, motion pictures, television, radio, and tape and sound recordings, and any other activities involving the execution or rendition of the arts and meeting such standards as may be approved by the National Endowment for the Arts established by section 5 of this Act.*
> *The term "project" means programs organized to carry out the purposes of this Act, including programs to foster American artistic creativity, to commission works of art, to create opportunities for individuals to develop artistic talents when carried on as a part of a program otherwise included in this definition, and to develop and enhance public knowledge and understanding of the arts, and includes, where appropri-*

ate, rental, purchase, renovation or construction of facilities, purchase or rental of land, and acquisition of equipment.

We considered the subject of compensation for professional performers and related or professional supporting personnel and agreed that endowment grantees should pay them no less than the prevailing wage, recognizing that such wages might vary according to the particular locale. Thus the door was open for the paid professional to work with the student, unpaid performer. The box office, we decided, would not be an issue once these changes had been approved.

These alterations in wording might seem of no urgent consequence. Would not the act, once passed, have functioned beneficially without them? Was it not desirable to have the basic language free from limitations of any kind?

To lawmakers, however, the new language can provide an essential sense of balance. As all artists know, commitment is the essential ingredient. Commitment brings discipline. The true artist, or just "the artist" if you use the word correctly, is never fully satisfied. There is forever the quest for improvement, for a keener eye, or ear, or mind. If you watch such a painter at work, today's canvas may bring satisfaction, but no feeling of an ultimate achievement. The phrasing in the legislation got it right, I think; there is a qualification, and it applies to music, or dance, or theater, or any other art form. The quest for excellence is the universal one, the lifelong quest to which artists devote themselves.

And so, from time to time, excellence emerges from the commitment. We strove to put this in the law. It seemed a long day's work just to add these few words. I remember how carefully they were weighed and the strength of argument, for agreement was distant in the beginning. Claiborne approved our work. So did Bill Cannon and Fred O'Neal. It was approved by the subcommittee and the full committee.

It was my responsibility to write the report for S.1483, in language with a legal tone, clear and concise, to accompany the legislation to the Senate floor for debate and action.

On the matters Jack Golodner and I worked out that day, the report says:

> *The intent of these amendments is to give full recognition to the values which the professional practitioner brings to the arts; but the amendments are not intended to imply that worthwhile nonprofessional activities in the arts are not to be encouraged to their most beneficial potentials or that worthwhile activities in the arts which combine the talents of professionals and nonprofessionals do not merit similar support. The committee endorses the concept that amateur interest in the arts is necessary to their well-being, that it can help create au-*

diences for performances of high professional quality, and that this interest should be stimulated and encouraged in all possible ways.

Jack and I later joined in another special project. Together we prepared successful legislation for the preservation and continuance of Ford's Theater, where Abraham Lincoln was assassinated. The goal was to make it not just a museum-shrine, as it had become, but a center for live performances in an authentic setting dating to an earlier century. Under the guidance and leadership of Frankie Hewitt, it adds a special dimension to the Washington arts scene, blending an historic past with contemporary themes.

Chapter 21

SOMETIMES THE ENDEAVORS OF 1965 SEEMED AKIN TO THE START OF A great horse race, with the famous thoroughbred, schooled long years, balking at the starting gate. Now John Fogarty was inside, carrying Rhode Island's colors, ready to move—or was he? Now Abe Fortas was agreeable at last, carrying the Johnson banner—or was he? Now Frank Thompson and Bill Moorhead were moving in harmony to adjacent gates—or were they? Claiborne seemed ready and waiting—was he fully prepared?

John Fogarty had introduced legislation similar to Claiborne's, without remonstrance, with a show of goodwill. Basically he still favored an Institute for the Humanities (arts included a bit *sotto voce*, it appeared), located within the Office of Education and the Department of Health, Education, and Welfare, where resided his chief jurisdictions and influences in the House of Representatives. It was clear he wished to underscore his turf.

Abe Fortas seemed pleased with S.1483, as he should have been for he had worked so closely with us in the days of preparation and could say truthfully that the Pell plans (minus all coffee stains) were improved because we had listened to his counsel.

I was in touch almost daily with Frank Thompson's office, and Frank as recounted had introduced legislation in the House identical to Claiborne's S.1483. Frank's colleagues, however, were far from unified. Bill Moorhead did not wish to relinquish the humanities cause he had so championed unless an alternative was conclusively proved preferable. He had nourished an intellectual premise, relatively obscure in the beginning. He had gained a national constituency and the reputation it implied. He did not want to lose it.

Born in Pittsburgh in 1923, member of a well-known family, Bill was a graduate in 1944 of Yale University and of the Harvard Law School in 1949. A city official before election to Congress in 1958, Bill's background included both civic and cultural philanthropic causes. An open countenance and quick smile were assets. He admired the intellectual giants for whose goals he was a legislative pioneer, and he could talk on an equal basis with whoever his visitor might be. Members of the humanities community held him a very close second in esteem to Ernest Gruening, whose venerable senatorial age seemed to tilt the balance slightly.

Frank Thompson was not from the Ivy League, but from Trenton, New Jersey's parochial and public schools, from North Carolina's Wake Forest College and its law school. Both he and Bill had joined the Navy in World War II and had served in the Pacific, Bill as a lieutenant, Frank, five years his senior, as a squadron commander of landing craft for the infantry with combat decorations at Iwo Jima and Okinawa. He was elected to the House four years before Bill's arrival. His penchant toward the arts stemmed in part from the interests of his wife, Evelina; the same was true of Bill Moorhead and his wife, Lucy. Frank had been in Congress six years before Claiborne's first term began. His political background included five years in New Jersey's General Assembly.

Claiborne Pell was sometimes labeled a patrician. The word could also be applied to Bill Moorhead, but not as much to John Fogarty or Frank Thompson. It seems to me that the patrician goes forth to battle because of the opportunity for derring-do; the other understands it as part of an upbringing. In a sense each envies the other, the fortune of birth contrasting with experiences the patrician can never duplicate. But both are enticed by prospects of victory, and this is the cement that bonds Washington together and makes the coat of many colors seem, on occasion, harmonious. So were Claiborne and John, Frank and Bill joined in a battle unlike any fought in Congress before.

But the four had not yet devised a master plan. Each was bringing different armies to the field. The House seemed willing to wait for the Senate, as Senate action had preceded House action before. The same procedure was unfolding and would become in itself part of tradition.

The difference between past and present was that this was no longer skirmish or reconnaissance. Race horses were being replaced by sturdier mounts, and tents were being pitched as far as the eye could see. In his own, Claiborne was surveying his armor.

It was not the best trained of armies, however, for Claiborne's needs. It was clad more in enthusiasm than in accoutrements for sophisticated political warfare.

I had been called by a woman who identified herself as Elvira T. Marquis. She pronounced it "Mark-ee."

The voice was pleasant. It seemed to have a slight accent, perhaps a distant suggestion of Germanic lineage. There was a pause.

"I don't know quite how to begin," she said. "I've never made a call quite like this. I don't want to make a mistake and say the wrong thing."

"I think Gus Arlt said you might telephone," I responded after there was another pause.

"Oh, then you know," she said with relief. "But I'm still not quite sure what I should say to you about—arrangements."

"I don't want to know about arrangements," I told her. "Perhaps we should meet and discuss things informally—and off the record."

"Oh yes," she said. "That would be a good idea."

Elvira Marquis was to engender support for the humanities. I gathered she had been informed about rules relating to tax-exempt organizations lobbying the Congress, a forbidden fruit of some magnitude. I gathered she was not a registered lobbyist and very possibly had been instructed that any traipsing through the halls of Congress on related missions could be taken amiss—with consequences too hideous to contemplate, her expression seemed to suggest at first. She was in her middle years, attractive, bright-eyed, and tentative in her opening remarks. But she looked extremely competent, and she was fully conversant with the legislation in all respects. I asked no questions about arrangements. How she was compensated, by whom, or if, I had no interest in knowing then or now. Some things are best left mysterious. Elvira Marquis was a private citizen, profoundly interested in a cause. It was logical that she would act upon her interests and seek advice, and she seemed to know educators of every humanities variety.

"Now I thought," she said, after we had begun to find common ground, "that I'd call a number of college presidents, I already have a long list compiled, and get them to communicate with the senators or representatives they know best."

"You can get through to them like that?"

"Oh yes," she said, and was about to expand on that theme, per-

haps on the why of it, but halted abruptly. "For instance," she said, "someone at, let's say, the University of Pittsburgh or Carnegie Mellon University could get in touch with Congressman Moorhead, or President Stratton at the Massachusetts Institute of Technology could write to Senator Kennedy."

"Wouldn't it be like preaching to the choir?" I asked.

"Would it?" she inquired, and paused once more. "Oh yes," she said, "I see what you mean." She smiled. "Then you must tell me possible opponents to the bill and I'll get the presidents to communicate with them."

"Not quite it either," I offered.

"No? Then—"

"Members of Congress," I suggested, "may respond to college presidents, but the reactions sought are more likely if there is a good working association between the member and the communicator, as you say."

"What sort of association?" she asked.

"Financial," I said.

"You mean constituents who—"

"I mean constituents who contribute."

"Oh yes," she said, leaning forward a bit. "I do see."

"For instance, if there is a college board of trustees, or board of regents, or overseers, and there's a member who contributes to Congressman X, regardless of party, and this board member is a community leader, as he is bound to be, and knows the college president, as surely he does, then—"

"Then the college president communicates with *him,* and he writes the congressman."

"Telephones him."

"Telephones him, I see."

"Or better still, goes to see him, after a phone call, either in his home state or district office, or even in Washington, if that just might be possible."

"I think it just might be," said Elvira Marquis, and embarked on a time of invaluable service.

Undeniably the troops were eager. Elvira Marquis's command began producing interesting results. New visitors with a new message were coming to Capitol Hill. Dan Millsaps and Dorothea Ward continued publishing calls to the colors in their *Washington International Arts Letter.* They were reaching a new audience, seeking converts, attempting to turn observation into activism. And there was Joseph Patterson, director of the American Association of Museums, trying with almost no financial

resources to muster through information a concerted effort from a wide but unorganized constituency.

A National Rifle Association would have found the battalions for the arts figuratively barefoot and those for the humanities insufficient in numbers. But the spirit was there—and if the winter at Valley Forge was not recalled, it could have been.

Whenever Claiborne spoke in public, and he was on the hustings more than before, he urged his listeners to make their views known to their own senators or representatives. "It does no good to write to me," he would say, "my mind is made up," They would look at him sadly, as if somehow he had affronted them. After all, such a friend should welcome messages of support, carefully composed.

"I just have to answer you," he would say in candor. "It takes staff time. Write your own member—that's most important."

"Suppose you don't know just who it is?" someone would inquire. "I know who my senator is, but I'm not sure which district—" From the way others leaned toward the questioner, it was obvious this was not a unilateral concern.

Claiborne would survey the room.

"Livy Biddle will help you," he would say.

Time has improved the situation. There is the American Symphony Orchestra League grown from Helen Thompson's day into an organization with greatly enlarged staff skillfully representing a constituency tripled in numbers. There is Opera America, a relatively new entry, representing a field that has also increased threefold in size. There are the Theatre Communications Group (TCG) and Dance/USA, representing areas of the arts that have grown respectively ten and fifteen-fold. The American Association of Museums, from those resourceless days, has vastly strengthened its service to a constituency numbering now close to 5,000 separate institutions. The American Council for the Arts has made giant strides both in assessing the development of the arts and in providing the basics of advocacy. The American Arts Alliance, which coordinates and expresses the needs of all to Congress, has grown in strength. Times have changed. The climate has changed. The sun more frequently shines. Winters on Capitol Hill are less severe.

But a really tough lobby for the arts and humanities, speaking out with the full potential of eloquence and influence? The National Rifle Association or any self-respecting oil company could still say, in a Washington phrase of understatement, there is room for improvement.

* * *

Spring was returning to Washington. The Tidal Basin, the banks of the Potomac, the parks, the edges of the avenues, the narrow streets of Georgetown, all were taking on those pastel shades that mark momentarily the start of the season. Would this be a spring of special promise?

On April 10 a letter came to me from Barnaby Keeney, to whom we had written requesting some specifics on the type of humanities program he might envision, should the endowment we hoped for come to pass and should the annual budget be about $10 million. Claiborne and I shared a copy with Frank Thompson. I was looking ahead to such congressional questions as, "Yes, we know what the humanities are, but what will they do?"

Barnaby was thoughtful and as always scholarly and political to the extent that his reply was couched as a suggestion to avoid the possibility of seeming to second-guess a future course of action. He spoke of the need for recruiting first-rate individuals into the humanities by better funding for university programs that would create new opportunities for teaching. There was continuing emphasis on improved research methods and on new ways of using the Library of Congress in coordination with smaller libraries. He talked about fellowship funds to aid overburdened graduate departments, where the addition of just two new teaching assistants could serve to double enrollments. He mentioned the need for international studies, with Western Europe—surprisingly to me—singled out as a neglected area "obviously important . . . to us." He explained how postdoctoral fellowships could greatly enhance teaching in the humanities. He spoke of working with the Aspen Institute in Colorado or with the Great Books Program at the University of Chicago, of joint endeavors among universities modeled on the one the University of North Carolina and Duke had just begun (this undertaking would lead to the creation of a special humanities center). He talked of library-sharing devices and uses of new technologies. He talked of assembling the country's best minds to work on recommendations and serve on panels of experts.

All this was grist for our mill, and it answered our purpose.

In like manner, Roger Stevens had prepared a draft on how the arts might use an annual $10 million budget. Agreeing with Senate proposals, Roger assigned one-half to matching grants for state arts organizations and the remainder to be spent as follows:

- tours by notable performing arts organizations—$750,000;
- artmobile tours of the visual arts to small communities, schools, museums off the beaten path—$500,000;
- special concerts, plays, ballets in some national parks—$375,000;
- grants to outstanding foreign performing groups unable to finance tours

of the United States, with an initial grant contemplated for a Pan-American Arts Festival—$550,000;
- educational programs for museums—$300,000;
- projects in the field of the folk arts for tours and exhibitions—$200,000;
- grants for studies "of ways and means" to preserve historic and nationally important sites—$225,000;
- grants for special poetry readings—$50,000;
- media support for new films and noncommercial, educational television—$600,000;
- grants for research in design, especially as applicable to government departments and agencies ("This," said Roger, "could result in the saving of millions of dollars for the government.")—$300,000;
- grants in the fields of modern dance and ballet ("Dance," Roger said, "is the least well endowed from private sources of any field of the performing arts.")—$450,000;
- grants to financially pressed museums for purchase of works of art—$500,000;
- grants in the field of photography—$200,000.

Rudimentary and cryptic as it is, this document is the first to designate specific sums to the wide spectrum of the arts. Obviously, the support for foreign performers was challenged and deleted, but the historian will find, in these beginnings, patterns for future expansion and development. I doubt if the National Council on the Arts gave it too much heed then. Their tasks in apportioning support lay ahead. But there are prophecies in this brief document for the student with lantern to discover.

Above all, the details Roger and Barnaby provided imply a spirit of optimism. Ten million dollars, however—even divided by two—was not just around the corner.

Spring brought another harbinger, which at first glance I did not fully recognize as a major obstacle to the legislation. In some respects it was more serious than any yet encountered. It came in the form of a memorandum to Representative John V. Lindsay, the same John Lindsay who was later to become mayor of New York City and afterward a candidate for what non-New Yorkers might term even higher public office. John was a participant at the hearings, an important Republican voice in the House, a staunch supporter of the arts and the humanities as well. He and Republicans Ogden Reid, also from New York, and Joseph McDade from Pennsylvania all were cohorts valuable to Frank Thompson's preparations.

The memorandum came from W. McNeil Lowry, who headed the arts and humanities program at the Ford Foundation, which provided help

for these areas far in excess of the governmental proposals. Under Mac
Lowry's guidance, Ford was beginning major support for the Nation's
orchestras. The foundation was considered a model of excellence compa-
rable to Mac Lowry's reputation.

He wrote to John Lindsay regarding S.1483: "The organization pro-
posed for the foundation has serious defects, some of them intrinsic but
further complicated by the fields in which the proposed Foundation is
designed to act, namely the arts and the humanities." That was the
opening paragraph.

What followed was a critique of the proposed structure. It was reminis-
cent of Harold Weston, though less detailed and complex. It went to the
roots of matters that I believed had already been resolved. The principal
concern was with the two advisory councils, arts and humanities. The
membership was called too numerous for effective action; but the basic
problem for Mac Lowry, as it had been for Harold Weston, was that the
two councils *were* advisory to the chairmen and at the same time had
the authority to review applications for support and make recommenda-
tions on them. Although a chairman could legally override a recommen-
dation (a prospect that will enter this story at a later time), he or she
could not proceed with a grant before receiving the advice and the spe-
cific recommendation of the council.

The reason for this procedure was very simple. A group of private citi-
zens could not dictate the expenditure of federal funds—legally, that is.
So spoke the Bureau of the Budget to me initially, and again when Mac
Lowry's memorandum was discussed. He wanted a stronger private citi-
zen authority than existed. He favored directors, not advisors.

It did not seem to me then and it has never seemed to me an insoluble
or soul-wrenching problem. The provisions for councils of eminent back-
ground, bolstered by panels of private citizen experts in each of the
many areas involved, would have to mean guidance of the highest cali-
ber. Would a chairman, in solitary decision, go against the majority
viewpoint of such advisors? Only the foolish would take such action, I
believed then and now—especially since all actions and recommendations
were to be fully visible and documented, and councils were given the
opportunity to make their own annual reports, if desired, to the
Congress. (In passing, it might be worth noting that such a council report
has never been transmitted, which would seem to affirm a strong coop-
eration between council and chairman.)

A cultural czar? That specter, once of the deepest concern, seemed to
have been laid to rest. Now it rose up again, not perhaps with the impor-
tunity of the ghost of Hamlet's father summoning him to the battlements

of Elsinore, but with a powerful voice, normally associated with reason and wisdom.

I read the memorandum carefully several times. There were flaws in it. From a legal standpoint, it misinterpreted parts of the legislation. But it was clearly, in its premise, opposed to the basics of the bill.

It forecast a diffusion of responsibilities, which could lead to irresponsible behavior. The National Council on the Arts as constituted would "automatically [engender] logrolling, special pleading, favoritism or the tendency to generalize" and thus presumably obscure individually beneficial motivations.

"A contrasting situation may be found in the eight-year history of the Ford Foundation," Mac Lowry stated, where there was a *bona fide* board of directors in full authority to give wise support not only to organizations, but also to individuals, which a government agency, as proposed, would be ill equipped to do. "The Ford Foundation," said the memorandum, "has had a great deal of experience in making grants-in-aid to individual artists, an experience which has been overwhelmingly constructive and helpful, but the Ford Foundation has no constituency and is obligated to get only that consensus on its selection of individuals which appeals to the judgment, thoroughness and demonstrable standards of taste and experience."

Was there perhaps a note of favoritism here toward father Ford? Was there a kind of prejudgment of abilities as yet untried and untested? (The matter was to come up again, in quite a different context—in part deadly earnest, in part hilariously—at a later National Council on the Arts meeting.)

Finally, the memo prophesied, emphasis on professionalism would so skew the finances of struggling performing arts groups seeking endowment assistance that within three years the budget of "performing groups throughout the United States" would be increased "by an amount far in excess of the total budget proposed for the entire Endowment's operation."

At this point I had not met Mac Lowry. We were to know each other much better in the months, and the years, thereafter. I knew of his shock of white hair and his soft voice, and that he had the bearing of an individual about whom it could be said "by his works ye shall know him."

I was also well aware that Claiborne and I had discussed in great depth the concept of grants to individuals questioned in the memorandum. Scholars worked often in solitude, though frequently with institutions in educational settings. But many writers, painters, sculptors, choreographers, and composers worked alone, outside an organizational structure. They worked in loneliness with their thoughts and ideas. To exclude

them would fundamentally detract from the purposes we wished to pursue.

I also knew full well that disagreement involving a proposed board of directors and the council of advisors as described in the legislation was so clear as to prevent compromise. Frank Thompson had immense regard for Mac Lowry, for they were close friends. He wanted time to think.

I remembered once listening to Stewart McClure's advice to a young senator under duress. "I haven't been able to sleep all night," he said. "Tossing and turning. If I decide one way, I'll be close to my own deep beliefs. If I do the opposite, I'll be favoring a majority of my constituents although I think they're wrong. What should I do?"

After listening for several minutes more, Stewart said calmly, "You're forgetting another alternative."

"I am?" the distraught senator inquired. "What is it?"

"It's a famous Washington alternative," answered Stewart. "For a time, just do nothing."

Problems can sometimes vanish when such a procedure is given opportunity. But not in this case. Mac Lowry would not go away.

Chapter 22

THE BILL PROCEEDED NEXT INTO DELIBERATIONS AT THE SUBCOMMITTEE level and then into a series of amendments reflecting views expressed in the two weeks of hearings—a record in length for the arts and humanities that still remains. We tried to cover as many suggestions as possible, culled from more than 800 pages of testimony.

A comprehensive plan for assistance to the states, and to their official state arts agencies, as they were called in the legislation, was refined and worked out carefully with Senator Javits. I worked for many hours with Roy Millenson. In the course of my own efforts, I had encountered that special breed, schooled on Capitol Hill, who are the chief staff representatives of their principals. In my book they are the great pros of the democratic process. The best of them know precisely in what manner they can speak for the boss, how far they can go without consultation, and when it is necessary. In my time they dressed in somber attire, in dark suits suggestive of a similar anonymity. A few, such as Al Lesser with Jack Javits, were permitted liberties because of their long service.

They are generally unsung. It would be unthinkable to mention oneself in a press release. It would be unthinkable to speak out in sub-

committee or committee unless asked. The staff is the staff. It greets members of Congress politely in corridors. It has intimate knowledge of congressional likes and dislikes, fortes and sometimes limitations, and where and when exactly the best foot forward is to be placed. Satisfaction, and it can be intense, comes from the job well done, attested to in particular by one's peers. There is vaulting ambition in such an environment, but it is by no means an admired characteristic. It is recognized as the Achilles heel for ultimate failure.

In my view Roy was among the very best of the pros. We did not always begin in harmony, but we worked with patience and care. Always let the other fellow have *your* way, Claiborne said. I let Roy have mine, and he let me have his.

Another stalwart was Terry Emerson, member of the Senate legal counsel staff. Whenever a concept needed legal attention or a cross-reference to or legal distinction from the vast body of existing laws, Terry had an answer. Sometimes he seemed as immersed in this undertaking as I was. He kept the language free of error, and he gave me the great compliment of never arguing about a concept or new idea and giving me a final say on words, which, after all, were written to last.

"It's lucky that this legislation," I was to be told, "was written by a novelist, and not by a lawyer." This I took as high praise, indeed. When it was added that the good fortune stemmed from the law's allowing all things possible in the arts ("you could drive a truck through it and not hit the side walls"), I took this as an even higher compliment. Over the years amendments have been added—one to foster increased private giving—but the basic structure is intact, along with those three fundamentals: the development of quality, access to it, and guidance by private citizens.

For the states, $2.75 million was authorized, to be divided equally, on a matching basis, among the fifty states and the Commonwealth of Puerto Rico, the District of Columbia, Guam, American Samoa, and the Virgin Islands. There was a proviso that a one-time, nonmatching grant of up to $25,000 could be awarded to a state for a survey of needs in the arts and for the development of plans for a state arts agency. All fifty-five entities applied for help, even though the maximum each could receive was only $50,000. Fifteen years later, the states were supporting their arts programs with $120 million, approximately four times the federal support of $30 million. This shows a remarkable growth and the impact of the federal catalyst. State funding for arts agencies continues to climb. It is reported at $244 million today.

There were other interests and opinions to be considered. Senator Yarborough wanted to see greater attention given to the arts during important national and historic events, so language was added to the duties

of the Federal Council on the Arts and the Humanities for this purpose. It seemed a concession to the senator from Texas, not entirely needed, but it came to have a special importance eleven years later during the Nation's bicentennial.

In line with scholarly desires, the definition of the humanities was expanded to include study of the classical languages, linguistics, and jurisprudence. Said the Senate report, "With regard to 'jurisprudence,' the intent is to include appropriate areas of humanistic study related to the more than 100 law schools in the Nation. Such aspects of the law as those dealing with comparative law, Roman law, legal history, and legal philosophy would be legitimate humanistic studies." Senator Yarborough was pleased, and the cup of Clarence Morris ran over with satisfaction, at last. As was once said about Harry Truman, we also remembered friends—when their cause was just.

To guard against limitations on any future artistic endeavors, an often-standard but interesting phrase—"not limited to"—was applied to the definitions of the arts and the humanities. In seeking broad yet legally concise definitions, and in considering the possibility that the foundation's life would be longer than any of our own, we left open the opportunity to explore whatever horizons might later come into view. Before enumerating the subjects suitable to a then-current program, the words, "but is not limited to" were appended. I wrote in the report: "The Committee intends that, if any additional subjects should be added," these should be fully explained and justified in the *Federal Register,* where matters of governmental concern are recorded week by week. A new art form, some fine day? Who knows? The law can accommodate it.

To answer at least a portion of McNeil Lowry's critique—regarding a threat of spiraling costs for performing groups encouraged toward professional standards and salaries—this clarification appears: "It is not the Committee's intent that non-professional groups, assisted by this act, should be required to hire professional personnel; they could continue their present practices with regard to the use of volunteers and amateurs." That is, no mandatory deadline was to be imposed on organizations striving toward professional standards and the excellence implicit in those standards. In a related explanation, regular faculty and technical staff at educational institutions, if supported by the Arts Endowment, could be paid at their prevailing wage scales, rather than at the higher rates that might apply to professional artists and personnel such as stagehands. Only if such professionals were chosen would the situation change.

It is a good time to mention here that this issue, which Jack Golodner and I had resolved in the law—and which had created at the time such controversies, fears, animosities, diatribes, and exaggerations—was

only a problem once or twice afterward. One case was brought against a ballet company endowment grantee in Utah for failing to pay a prevailing minimum wage, but the complaint involved a tour over areas where the prevailing wage differed, and the complexities were finally resolved peacefully without punitive actions.

In my judgment, the emphasis on the value of the professional to the development of quality in the arts is beyond argument. The principle was correct. Those who represented that principle on the National Council spoke early and often in its behalf—on occasion perhaps a shade too vehemently, according to their colleagues. In time, of course, dancers were paid more, and musicians, and actors. But could that not be said also of athletes, executives, blue-collar workers, doctors or the good old-fashioned plumber?

Artists found a better share of American sunlight. Some would say they contribute most to it. The arts were not stifled or suffocated by disproportionate costs as McNeil Lowry feared. They grew. They continue to grow, nourished by a partnership unique to our history and uniquely American in its philosophy. Many more now than before would maintain that this growing, this blooming is directly related to the better quality of their lives.

The American Symphony Orchestra League was concerned about working conditions for traveling orchestras, because safety and sanitary regulations in different locales could cause confusion. Accordingly, the bill was amended so that the laws in the state where a performing group was temporarily at work would be the determinant. "Prima facie evidence of compliance" was the legal phrase Terry Emerson gave me. The league was satisfied, and the so-called Davis-Bacon Act, earlier landmark legislation to ensure proper working conditions for all, was reviewed carefully and appropriately updated.

Membership on the two councils was increased from twenty-four to twenty-six, with the unpublished purpose of appointing key union leaders. They not only supported the legislation, but understood its applications to the professionals involved—performers on the arts side, educators for the humanities. The White House joined with Senators Pell and Javits on this amendment. Its concept had been adopted, but history will show it was never carried out. At the eleventh hour Roger Stevens found his council short a leading visual artist. He asked urgently for the sculptor David Smith, and the request was approved. Herman Kenin, the scholarly, bespectacled, quiet-voiced president of the American Federation of Musicians, was appointed to fill the other vacancy. (The humanities already had educators from professional organizations and associations who qualified under the rubric.) As the years went by, this

amendment became less well remembered, perhaps because the rationale for its adoption seemed less pressing. Never officially recorded, it lost steam—some would say beneficially, while some would say (though perhaps not in the present administration) a promise is a promise is a promise. I needed to remind the Carter administration of this relatively ancient history, for by then the promised two seats had dwindled to zero. As a result, Theo Bikel was appointed, then president of Actors' Equity and champion of the arts par excellence.

Other amendments to the bill clarified the distinctions between the work proposed for the two endowments. Most references to the arts under the humanities sections, holdovers from earlier drafts, were eliminated; but one part remained firmly in the legislation. The bill stated that the humanities would include "the study of" the "history, criticism, theory and practice of the arts." The report explained: "Leading representatives of the humanities pointed out that the arts are often practiced in conjunction with their study, as in music, painting or drama, for example." In essence, the word "practice" was a Keeney recommendation. He did not wish to give up an arts involvement. The carefully worded language seemed appropriate, and it opened doors for cooperation between the two endowments while making their separate jurisdictions clear.

(Barnaby was later asked by a less than fully appreciative appropriations chairman: "In a sentence, Dr. Keeney, what is the difference between the arts and humanities?" Barnaby eyed his inquisitor: "If you think about it or study about it, it's a humanity; if you do it, it's an art," he said gruffly. "Did you hear that?" the chairman asked his clerk, with obvious pleasure. "Write that down.")

"The arts and the humanities are closely allied partners," said the committee report. "The programs of the two endowments would be mutually beneficial; each would serve to strengthen the other. Knowledge in the humanities is fundamental both to the practice and appreciation of art. The arts flourish best in a climate in which they are fully understood and appreciated; and the arts translate into creative and abiding form the scope of human knowledge."

The intention was clear: to place the two broad cultural areas into an equality of performance and companionship. In days to come the endowments did work cooperatively. In museum exhibits, for example, the humanities acted as interpreter, through text and documentation, of the artistic works on display. Stemming from "Bush" Brown's comments on the practical and tangible nature of cultural values, the report stressed "interdisciplinary cooperation" among artists and scholars, architects and sociologists in designing and in the growth of "fine cities." Many projects have evolved with these concepts in mind.

Considerable attention was given to the funding of the endowments. Each was authorized a total of $10 million for the following three fiscal years. The Arts Endowment received a basic $5 million for its nationally oriented programs, $2.75 million for the state agencies, and up to $2.25 million to match private contributions to the endowment. The Humanities Endowment received $5 million for basic programs and up to $5 million to match donations received. Because of the three-year authorization period, the press called the program a $60 million program of support for the arts and humanities, but it was hardly that.

No state plan was legislated for the humanities. Barnaby was against it, and Jack Javits was primarily interested in the arts. Claiborne alone felt a state involvement would be beneficial, but there was not sufficient impetus. Unlike the arts, the humanities had no history of previous congressional efforts, nor was there such vigorous state activity. I did not feel it was worth contesting; Claiborne agreed. We decided to wait for a year or so and see how situations and opinions might develop. (The issue was far from forgotten, however. It was to arise in later years—and it was to unseat an incumbent humanities chairman.)

The federal funding provided to match private donations to each of the endowments was an experiment to test the willingness of American philanthropy to work in new ways with government. There was a catch, of sorts. Federal dollars would match private dollars only if the gift was unrestricted. Thus, the philanthropist enticed by a particular endowment project could only have his gift matched if his support was undesignated. As one cynic put it, "Who would ever give an unrestricted gift to Uncle Sam unless it's his income tax." Behind the privacy of closed doors, Bill Cannon and Emerson Elliot, inventors of this special funding provision, were said to call it "funny money."

Private philanthropy, however, had demonstrated the beginnings of support. From the hearings two interesting examples and food for thought:

"A thorough grounding in the humanities is, I believe, vital training for many kinds of leadership, including the preparation of leaders who can manage people with wisdom and understanding. The need for such leaders exists today, and I believe will intensify in the future in universities, in public service, and in business" (Thomas J. Watson, Jr., chairman of the board, International Business Machines Corp.).

And: "Many smaller American communities are observing the truth of the survey made by the U.S. Department of Commerce itself, that an average of only 28 tourists a day visiting a town with historic attractions (i.e., a history museum) will bring in as much money during the year as the new industry or business with a $100,000 annual payroll" (Otto Wittmann, vice-president of the American Association of Museums,

director of the Toledo Museum of Art, member of the National Council on the Arts).

A fundraiser's spirits could be enlivened by such arguments, couched in general, not-too-specific terms.

To me the special funding proposals provided the kind of challenge that can be termed opportunity. I did not doubt that the Bureau of the Budget found the sums involved politically appealing: They appeared to increase the Johnson administration's generosity, without too much risk. I foresaw a possible blunting of congressional objections with this emphasis on private philanthropy. Although cynics might be given ammunition and these special sums might be distant, the package as a whole had appeal.

The matching sum for private gifts to an endowment was not funny money after all. Roger Stevens and I were to devise an ingenious method for retrieving the federal funds that some thought to be elusive. The Bureau of the Budget did not laugh all the way to the U.S. Treasury, for a door was unlocked. Its opening suggested further explorations, and these generated still further ideas to improve the catalyst and its workings with the private community.

Some ten years later, in my third incarnation with Claiborne Pell, I hit on the idea of a new endowment procedure that we called challenge grants. In some instances these grants changed the ratio of government support to private support from the legislated one-to-one to one-to-four, and in many cases one to ten—that is, one federal dollar generated ten nonfederal dollars. Higher ratios were not uncommon.

Why is this possible? It has to do with recognition. If you are Corporation X, do you respond with unbounded enthusiasm to the challenge of Corporation Y and therefore allow Y, a competitor, to claim the initiative? Are you not more likely to find agreeable partnership with an entity that gives your philanthropy top billing? Look at any endowment-sponsored project with an important private funding source involved. You find the National Endowment for the Arts usually in small print, maybe on the back page. That is how I wished it to be, in my time in the sunlight of the arts. That is how it should be, always.

Chapter 23

*H*ERE IS HOW THE PRINCIPLES GOVERNING A NEW PARTNERSHIP BE-
tween our government and the allied arts and humanities are
phrased in the Senate report:

> *1. The committee wishes to emphasize section 4(c) of
> the Act: "In the administration of this Act no department,
> agency, officer or employee of the United States shall exercise
> any direction, supervision or control over the policy determi-
> nation, personnel or curriculum, or the administration or op-
> eration of any school or other non-Federal agency, institution,
> organization or association."*
>
> *The concept of this subsection is given further emphasis
> by section 2(1) which recognizes the primary importance of
> private and local initiative in regard to the encouragement and
> support of national progress and scholarship in the humanities
> and the arts. The principle is further developed by providing
> that the advisory bodies of the two Endowments shall consist
> of distinguished private citizens. It is the responsibility of the
> seven governmental members of the Federal Council on the
> Arts and the Humanities to promote cooperation between the*

two Endowments; but the Federal Council thus constituted has no authority to direct or control the policies and programs of the two Endowments.

2. The committee believes it is important that acknowledged community leaders in the arts and humanities will be significantly included in implementing contributions to the purposes of the Act. Respected leaders of arts organizations and in the field of scholarship, as well as civic leaders experienced in cultural areas, should be given opportunity to help implement the activities of the two Endowments. In this respect, the committee believes that all appropriate use should be made of the panels of experts and consultants prescribed for in section 10(5), so that the Act can best serve community needs throughout the United States.

It is the intent of the committee that in this Act there be given the fullest attention to freedom of artistic and humanistic expression. One of the artist's and the humanist's great values to society is the mirror of self-examination which they raise so that society can become aware of its shortcomings as well as its strengths.

Moreover, modes of expression are not static, but are constantly evolving. Countless times in history artists and humanists who were vilified by their contemporaries because of their innovations in style or mode of expression have become prophets to a later age.

Therefore, the committee affirms that the intent of this Act should be the encouragement of free inquiry and expression. The committee wishes to make clear that conformity for its own sake is not to be encouraged, and that no preference should be given to any particular style or school of thought or expression. Nor is innovation for its own sake to be favored. The standard should be artistic and humanistic excellence. While evaluation in terms of such an abstract and subjective standard will necessarily vary, the committee believes such a standard to be sufficiently identifiable to serve the broad purpose of the Act and the committee's concern with the cultural values involved.

So the legislation was given interpretation in a way I felt we all desired. The basic tenets are there: the full disclaimer against government interference, government domination of cultural activities; the emphasis on private and local initiatives; stress on the private citizen memberships of the guiding national councils and the private citizen panels authorized to help them; recognition of the independence of the two endowments from other agencies; the intent of cooperation at all levels; and the stress on freedom of expression.

I remember writing much of the report on weekend days and nights at the Philadelphia farm I still owned. The weather had turned hot. The leather on the desk top was moist in daylight, but the nights were cool. I thought of it as a job more than anything else, an arduous, demanding task summarizing more than two years of labor. That I was speaking for a chairman, for a large and important committee of the Congress, no longer seemed disturbing. After all, I was supposed to know my work. I do not believe I thought too much about imperishable words, though this particular document has often been used and quoted and its interpretations repeated. I was concerned chiefly about total accuracy. Who were those who were vilified and prophets to a later age? Should the words be milder in tone? No, I thought, they were vilified; they were on the frontiers of new thoughts, new expressions. Vilified was not hyperbole. I could name you a dozen and more—if not from A to Z, from Aristotle to Van Gogh.

So the drafting continued, sometimes with a moon outside over the garden, and always with the Scotch tape, the portable typewriter as a friend, the mountains of transcript from the hearings, and the history of earlier times.

On occasion I was moved to think that there could be a permanence taking shape, though the news from the House of Representatives, where action had been postponed, seemed to suggest repetitions of past attempts rather than a bright, conclusive victory. Then suddenly another obstacle loomed from the shadows. Two individuals of vital consequence to the legislation were involved. They were neither McNeil Lowry nor Dillon Ripley (to this sentence could be added the word "yet").

We had given long thought to how the legislation should best deal with the National Council on the Arts, established in law the previous September and appointed by President Johnson just before the 1965 hearings started. Claiborne and I felt the members named should serve as the principal advisors to a National Endowment for the Arts. So did the Bureau of the Budget. (The humanities side was not at issue in this respect, for they had no council as yet and thus no chairman.) But how about Roger Stevens, already named chairman of the National Council on the Arts? Would he become chairman of the Arts Endowment if it were created in law? The Johnson administration's bill was moot on this point. Under the bill, the endowment chairman would chair the National Council, and the endowment chairman was to be presidentially appointed. I quietly requested a legal interpretation. It said, as I had suspected, that Roger Stevens would have to be presidentially nominated for appointment as chairman of the National Endowment for the Arts, for approval by the Senate, or that the President could make another selection.

I prepared a memorandum for Claiborne setting forth some alternatives—and, it seemed to me, some ambiguities—and recommended that we find a way of preserving Roger's authority and continuing his service without interruption. "It would seem a shame," I wrote, "if we couldn't assure Roger's continuity." Claiborne agreed. He had high regard for Roger Stevens, and so did the members of the council.

In transferring the established National Council on the Arts from the Executive Office of the President (where it was then located) to the endowment, I included the following phrasing:

"In addition to performing any of the functions, duties, and responsibilities prescribed by the National Arts and Cultural Development Act of 1964, Public Law 88-579, approved September 3, 1964, the individual appointed under such Act as Chairman of the National Council on the Arts shall serve as the Chairman of the National Endowment for the Arts."

The "individual" was, of course, Roger.

It will be remembered that some witnesses, including Harold Weston, wished to keep the council advisory only to the President, within the Executive Office of the President. But Harold and I had resolved our differences. Now came an extremely unexpected call from Richard Goodwin. It had a different tenor.

"Your bill seems to me unconstitutional," Dick began.

I thought I was not hearing right. "Unconstitutional, Dick?" I had a sudden wild image of unanticipated linkages between Dick Goodwin and Strom Thurmond.

"You've taken away a President's authority to make appointments," Dick said.

"You mean—"

"I mean S.1483, as first drafted, gave the President authority to appoint a chairman. You've taken it away."

"Are you objecting to Roger Stevens?" I asked.

"I'm not objecting to Roger," Dick said. "I'm fond of Roger. I'm objecting as a matter of principle. The President has the right to make these kinds of appointments—all Presidents have had that right, through history. This is an exception. It's unconstitutional."

"And so?" I still couldn't quite believe my ears.

And so, he would be recommending a veto if the bill passed.

"A veto?"

"A veto by the President," Dick said.

I sat by the phone for several minutes. Wasn't it true that Dick Goodwin had been rumored first in line for appointment as special arts advisor to the President, just before the assassination of John Kennedy? Wasn't it true that Lyndon Johnson held him in high esteem? But how

much regard was for the skilled writer's flair? How much reflected deep confidence?

I called Bill Cannon. Had he heard of any problems with the way the Senate was making the council transferral? I inquired. He had endorsed other amendments, but his response now was enigmatic. You made that change; it's your baby, his voice seemed to say. I did not press further. If there were a White House division, it was best to let it stay where it was. I told Claiborne of the episode. He did not appear unduly alarmed. "Roger has a lot of friends," he said. I wondered how many Dick Goodwin had, and what his next move might be.

I reread an earlier long memorandum to Claiborne I had composed relating to another call from Dick. In effect, the message was that the President favored a strong chairmanship authority for both endowments, not one that could be vitiated by others involved. Bill Moyers, another White House figure of weight and substance, had repeated the same message to me. I recall thinking that both Dick Goodwin and Bill Moyers would be good choices for an argument with Mac Lowry—but now these calls had a different dimension. Was Bill Moyers supporting Dick? Didn't a strong chairmanship make the job more appealing?

We had not heard recently from Roger's friend Abe Fortas. Would a call to him be in order? I decided not. Isn't the prober into the hive likely to be stung himself? Roger seemed the soul of composure, perhaps resulting from his own conviction that no one could do the job as well as he.

As the clock ticked on, I went one day to consult privately the chief lawyer on the Senate Committee on Labor and Public Welfare. Was the provision I had included unconstitutional? I wanted to know, in the quiet of confidential conversation. In the end, after a time of careful attention followed by silent reflection, he said, giving me a legal-type expressionless stare, "Livy, you never asked me the question." I had my answer. I did not like it; but I decided, since I had never asked the question, to leave it all precisely where it was, unspoken.

I knew I would have to tell Claiborne. We could be facing an unrebuttable point of order—if the circumstances developed. Yes, I thought, if they developed.

On April 26, May 26, and June 2, Claiborne Pell addressed the Senate to name additional cosponsors for S.1483.

It should be noted that cosponsors are inclined toward endorsement of a given piece of legislation. They express accord for its basic principles, but by Senate procedures they are not obligated to vote for it, and they have been known to speak in opposition, either in whole or in part. Nevertheless, the phalanx of support grew impressively, surpassing

earlier Pell and Gruening numbers. I still retain the logs I used, one on yellow paper, one on white; and because the names are so etched in memory, I can identify the hieroglyphics used to make sure that all were duly entered in the *Congressional Record.* The staff names are there; many, many phone calls were made as tentative yeses were confirmed and the nos or not-at-this-times separated.

The subcommittee deliberated, and the full committee; and the bill with its twenty-eight amendments—the substantive ones, together with technical changes in language—moved toward the Senate floor.

The Senate report was ordered to be printed, in the official parlance used. The final phrasings were put into place. I believe I had memorized most of this. Like a poem learned in high school, the words, given a bit of refreshment, come back.

We have spoken of Roy Millenson, Terry Emerson, Stu McClure, and others, but there should be a particular cheer now for old Steve Coffey, master of the printed text, master of uppercase and lowercase, of the value of the semicolon, of the strict and intricate governmental regulations regarding all punctuation marks. I have a copy of my report on S.1483, now over twenty years old, neatly tied in string, full of the hieroglyphs and little red marginal instructions that were part and parcel of Steve's special province. They transformed my labor on my favorite portable typewriter, my hunt-and-peck system learned in newspaper days, into a vast assortment of type sizes, each conforming to exact and traditional usage. Here is just part of the opening page.

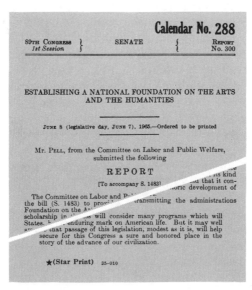

Calendar No. 288

| 89TH CONGRESS 1st Session | SENATE | REPORT No. 300 |

ESTABLISHING A NATIONAL FOUNDATION ON THE ARTS
AND THE HUMANITIES

JUNE 8 (legislative day, JUNE 7), 1965.—Ordered to be printed

Mr. PELL, from the Committee on Labor and Public Welfare,
submitted the following

REPORT

[To accompany S. 1483]

The Committee on Labor and P... ...its kind
the bill (S. 1483) to pro... ...nd that it con-
Foundation inoric development of
scholarship inwill consider many programs which will
States.enduring mark on American life. But it may well
... ...that passage of this legislation, modest as it is, will help
secure for this Congress a sure and honored place in the
story of the advance of our civilization.

★(Star Print) 35-019

Put Mr. Pell's name in a different type and you were in trouble. Omit it, as I did inadvertently, beginning too low with those large capital letters, REPORT, and you were in very deep trouble indeed. Off it went to the printer's when Steve wasn't looking. But he rescued me. Report No. 300, 89th Congress, 1st Session, bears a star, after which is written in parentheses, (Star Print). That means an error was caught in the nick of time, and Claiborne's name was properly inserted. To myself I sometimes say it just made it more of a collector's item.

Steve had rescued me before in the days of my Washington childhood. I had given him another document to be printed and widely circulated, and then discovered, with acute distress, a typo in material entrusted to me and authored by none other than Senator Javits. It was not a large typo. It might have gone for years undetected. But I knew it would be immediately apparent to the senior senator from New York. I rushed to find Steve.

He took me through long underground passageways into an area off limits to normal staff. "He is with me," Steve said to the first who inquired, and I was let pass.

Steve's white hair, the slightly florid countenance, the quick broad smile suggested someone you might encounter in a Dublin pub. Everyone knew him in his special domain, with the rows upon rows of linotype machines, crowded together under low ceilings, producing a decibel of sound deafening to the stranger.

"It ought to be about here," Steve said, surveying the scene. "I'll speak to the operator. You see if he has it."

The "off limits" rule applied everywhere, for these were the texts approved by a pyramid of Senate command. To alter them now was strictly forbidden, punishable, I guessed, by firing squad.

Steve was leaning over the linotype operator, who looked up, grinned, and held out his hand. In a matter of seconds they were off to one side having a cigarette, the operator's back to his machine.

It seemed like a total miracle, but there staring at me was the Javits paragraph: In a trice, with a dark soft pencil it was corrected. I stood back, watching as Steve and his friend returned. He moved over to me. I gave him a wink.

"Good boy," he said. "Quite a racket in here. Let's go home." In moments of tension I think of this story.

June had come, Washington's season of heat and thunderstorms. June 10th came, and seemingly all at once, the bill was scheduled for Senate debate. Great anxiety was beneath a strenuous effort at calm.

I tried to read the omens. In college days, walking from my room toward a dreaded final exam, I used to look fervently up through tall

trees at the heavens just visible through the leaves. I remember looking up through the trees as I neared the Capitol building early that morning.

Claiborne and I went together from his office. I had crammed my briefcase with thin cardboard files on every subject that conceivably might arise. I had not heard again from Dick Goodwin. I decided not to tell Claiborne of this admonition.

It crossed my mind that quiet word could be passed to a party or parties opposing the bill that it was flawed or could be flawed. No, I thought wishfully, it would not happen that way. We should concentrate on Senate passage; a veto would be possible only after the House acted. And I thought of reputations, and of Roger Stevens, and of Claiborne's instinct to eliminate the unnecessarily controversial, especially with this fragile and untried legislation. I remembered, too, a few Senate staff colleagues who had said, with such apparent sincerity, that they fully represented the views of their senators when, in fact, they "fully represented" themselves.

"Do you have the report?" Claiborne asked suddenly in the corridor. "It's right here," I said. We had reviewed it page by page.

I handed him the finished text, with the star in the corner.

He paused, opening the report, leafing quickly through it. "It's too long," he said. "It's thirty-one pages."

"It's not as long as the hearings," I suggested. "No one will read it," said Claiborne. "Well," I suggested, "that might be an advantage."

We went to the elevator. "Are the hearings all printed?" he asked. "All printed," I said, "all ready."

We were passing through the anteroom, with its polished floor and arched windows, tasseled curtains, carvings, wooden benches where lobbyists await a senator's appearance, where messages are dispatched by young dark-suited pages. I recognized no one in particular; the faithful would be in the gallery, I thought.

We passed the large desk with protecting glass surface where a guard sat to fend off the unauthorized.

"Mr. Biddle is with me," Claiborne said politely.

"Yes, Senator, thank you."

I gave the guard a smile, for by now I knew him well.

We moved past the machines casting out long sheets of news from the wire services. We walked by the commodious leather sofas where a couple of senators were sitting, leaning forward, engrossed in telephone conversations. No outsiders could accost us now.

We approached the door to the Senate chamber. I wondered what we would find, how many opposed. Claiborne pushed the tall opaque panel ajar. Holding my briefcase tightly, I followed him as he walked toward the majority leader in the front row, halfway around the curving

line of desks. I glanced toward the balcony. I recognized a few faces. Several rows were filled in the area designated for favored visitors.

Senator Mansfield was standing, speaking to Claiborne. "Claiborne," he said in his dry Montana accent, "you've got enough votes to pass this thing here and now. You've got practically a majority of the Senate signed up. Isn't that right?"

"We've got a lot of cosponsors," Claiborne said.

"A lot more than last time," I remember the majority leader saying. "All right, let's do it right now." I remember the sudden rush of pleasure beyond all expectation.

Mike Mansfield walked forward with Claiborne. Jack Javits was there, and Ernest Gruening. I stood behind, holding tight to the briefcase, listening to the magic words of Senate passage being spoken and feeling an enormous relief. The briefcase would not be needed.

Congratulations were being tendered. My work was being praised by Claiborne. Perhaps in my mind then, certainly later, I saw gazing down from the high reaches of the gallery, behind the spectators, Mac Lowry with his shock of white hair, his lips pursed, waving a finger in stern reprimand; and Dick Goodwin with his deep-set eyes contemplating future action; and the tall figure of Dillon Ripley, watching in a stance of disapproval, or disappointment; and Strom Thurmond waving the bill aloft and citing his fundamental difficulties.

They were not present, however. From the gallery's balustrade friends were waving at us.

This was the day of Senate passage—June 10, 1965.

And so is history made.

Here are some of its makers, the Senate sponsorship of S.1483, listed alphabetically in the report: Clinton Anderson, New Mexico; E.L. Bartlett, Alaska; Ross Bass, Tennessee; Birch Bayh, Indiana; Daniel Brewster, Maryland; Quentin Burdick, North Dakota; Robert Byrd, West Virginia; Clifford Case, New Jersey; Joseph Clark, Pennsylvania; John Sherman Cooper, Kentucky; Thomas Dodd, Connecticut; Paul Douglas, Illinois; Hiram Fong, Hawaii; Ernest Gruening, Alaska; Philip Hart, Michigan; Vance Hartke, Indiana; Daniel Inouye, Hawaii; Henry Jackson, Washington; Jacob Javits, New York; Edward Kennedy, Massachusetts; Robert Kennedy, New York; Thomas Kuchel, California; Edward Long, Missouri; Eugene McCarthy, Minnesota; Gale McGee, Wyoming; George McGovern, South Dakota; Thomas McIntyre, New Hampshire; Lee Metcalf, Montana; Jack Miller, Iowa; Walter Mondale, Minnesota (Hubert Humphrey was now Vice President); Joseph Montoya, New Mexico; Wayne Morse, Oregon; Frank Moss, Utah; George Murphy, California; Edmund Muskie, Maine; Maurine Neuberger, Oregon; Gaylord Nelson, Wisconsin; John Pastore, Rhode Island; Claiborne Pell, Rhode Island; Jen-

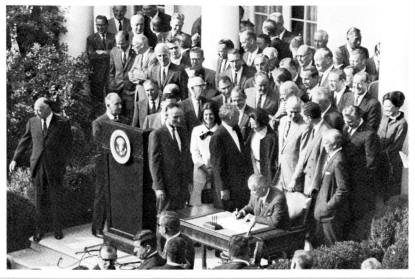

President Johnson signs the precedent-setting legislation in the Rose Garden! (A more intimate photo is also noted in the text)

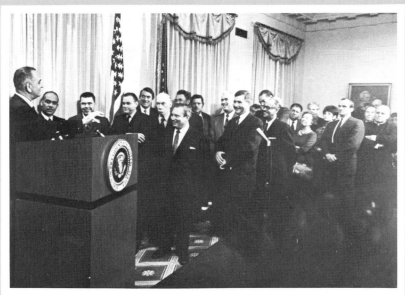

LBJ swears in the historic first National Council on The Arts. Mystery... Can you find Chairman Roger Stevens?

Plans for the American Film Institute,
with Liz Ashley, Greg Peck and
Roger Stevens... Youth and convictions!

A moment for special nostalgia.
with Claiborne and Hubert
Humphrey in days gone by...
about 25 years...

Claiborne and I study a legislative sticky wicket. That's Jean Frolicher behind me...

Senate + House confer on museum bill. Across from Claiborne + me, Marty LaVor, Al Quie, John Brademas, Jack Duncan. Lee Kimche is behind John.

The joint hearing tradition in
Congress! Claiborne, John
Brademas, Joe Duffey and I
discuss Arts and Humanities.

With Nancy Hanks, Frank Hodsoll,
Roger Stevens in a unique
photo of four chairmen...

Best wishes—
Jimmy Carter

President Carter listens to a nervous
candidate & an anecdote in the
Oval Office...

With Rosalynn Carter at a
White House arts reception—
and iced tea!

Two Mondales - two Biddles
at the Vice President's house...

Joan Mondale and I with the
President, after he raised the
arts budget!

*To Catherine and her . dearest friends and workers for good things – With appreciation and fond memories of so many delightful shared moments —
Sid Yates – 31.2/82*

Sidney Yates contemplates
The future...

Bipartisan spirit for The arts!
L.B. Joan Mondale, and Senators
Pell and Stafford, Democrat
and Republican...

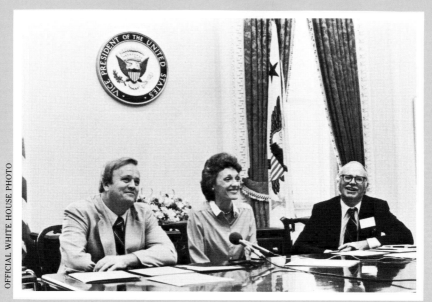

Max Cleland of the Veterans Admin.,
Joan & I at signing of a special
and new working agreement...
NEA + VA!

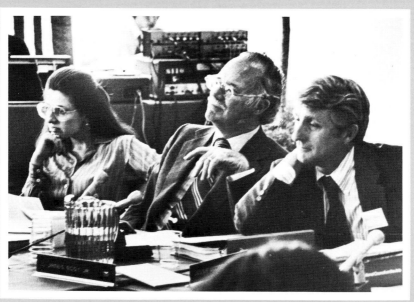

Endowment listeners... Deputies Mary
Anne Tighe, David Searles + Chairman.
A weighty moment at the Council table!

nings Randolph, West Virginia; Abraham Ribicoff, Connecticut; Joseph Tydings, Maryland; Harrison Williams, New Jersey; Ralph Yarborough, Texas.

California's Tom Kuchel, Republican minority leader, emphasized the bipartisanship of the enterprise, given such strong direction by Senator Javits. Others joined in: Frank Church, Idaho; William Fulbright, Arkansas; Barry Goldwater, Arizona (though it must be recalled that Senator Goldwater and Lyndon Johnson were not at the time on the best of terms); Hugh Scott, Pennsylvania; Stuart Symington, Missouri; John Tower, Texas. Senator Mansfield was in full support, but from a policy standpoint, because of his position, was not listed on Senate legislation.

If you look for the wagon train leaving for the wilderness and the unexplored on that June day, these were the individuals aboard. Just five from this list are still members of the U.S. Senate: Byrd, Burdick, Kennedy, Inouye, and Pell. In 1965 tied for seventy-third position in Senate seniority, Claiborne Pell now ranks sixth, heading for a probable fifth in rank during his present term. He might not quite sing out "wagons ho!" with the tones of Gary Cooper or Henry Fonda or John Wayne—but he led the pioneers.

Chapter 24

*I*SURRENDERED MY BRIEFCASE WITH ALL ITS ANNOTATED CONTENTS TO BOB McCord in the House, realizing that although the lights in the Senate might momentarily be going on all over the arts world, we were still in the trenches and a long way from any final victory, a long way from Tipperary.

There was always, it seemed, an extra distance to go. Bob suggested that the Perils of Pauline would be an apt comparison, but this Pauline never seemed to leave the railroad tracks. An event in mid-June is illustration.

On Monday morning, June 14, at ten o'clock—just four days after Senate passage—I was invited by the President and Mrs. Johnson to attend a White House Festival on the Arts.

It was the idea of Eric Goldman, given special White House assignment in 1965. I had met with Eric and his assistant Barbaralee Diamonstein. We had discussed my hopes and Claiborne's. We had looked toward the future. Eric, stocky, animated, with a quick wit and a fund of knowledge, was on leave from Princeton University, so there were those bonds in common as well. It seemed Eric knew from personal experience almost every noted personage in the arts; the few who might be missing

were known to Barbaralee. The idea, in essence, was to bring as many
as possible to the White House to emphasize the value of the arts in our
society, the Great Society in particular. To Eric the timing, with the Sen-
ate action, now seemed perfect—and so it was, if one considered the
arts alone. Eric had gone forward with special enthusiasm and a single-
mindedness of purpose, on the one hand admirable, but on the other,
as I tried to suggest, subject to review. He was not about to listen to
restraints, however; from his academic background, he saw no reason to.
And so, while the physical preparations were wonderfully contrived,
overlooked was the fact that some important invited artists were in
strong disagreement with Lyndon Johnson on the conflict in Vietnam.
One of them was the poet Robert Lowell, a dean among his peers.

The administration was not yet mired in the Vietnam War; this
was the late spring of Lyndon Johnson's first full year as elected Presi-
dent. But Robert Lowell was sufficiently convinced of wrongness—and
perhaps of how it could be expressed to best advantage in a personal
and publicized manner—that he sent a telegram to the President refusing
his invitation, and he made the refusal public. The Washington press,
always eager for news of this nature, sprang to attention.

Jack Valenti of the President's staff had asked me to come
promptly to the festival. I walked along the passage that leads from the
south entrance and is equipped with an expanse of windows close to the
Rose Garden. The walls had been transformed into an art gallery, with
abstract, colorist, and more traditional works on display. The modes of
expression were as varied as anyone could wish. The display had charm
and beauty and elegance. No one was there.

I entered a chamber beyond. Mrs. Johnson was sitting in the first
row, with perhaps sixty people ranging behind her. On a podium just
to the right of the First Lady, John Hersey was reading not *A Bell for
Adano,* but a particularly biting passage from his book *Hiroshima,* pub-
lished in 1946 and as strong an indictment of war and its perpetrators as
one might find.

Lady Bird Johnson's lips were tightly drawn, her eyes slightly nar-
rowed but composed. She sat very straight and waited until there was a
pause before rising and walking quietly and quickly and very erect from
the room.

After a short interval I followed. Jack Valenti—diminutive, with
those extraordinarily intense wide-set dark eyes—greeted me.

"Liv," he said. "We've got a problem." It did not seem to need
translation.

A buffet lunch had been scheduled, and there was to be a dinner
on the green expanse of the White House lawn. Round tables were in
place, with striped umbrellas above them for decoration, not utility, since

the day was bright with sunshine and relatively cool. I was assigned as a kind of outrider—a trusted member of the arts world with no White House ax to grind.

At lunch I noticed—for one could hardly miss him—a tall man in a white linen suit moving slowly through the crowds. It was Dwight Mac-Donald, literary leader, leader of liberal causes. He carried a sheaf of white paper and a pen, seeking signatures for all who would vigorously endorse poet Robert Lowell's position.

It seemed to me both the wrong time and the wrong place for this activity, no matter what one's personal beliefs happened to be. These were guests invited to the White House to celebrate the arts.

I moved in front of Dwight MacDonald and encountered Isaac Stern. "Please don't sign it," I said, explaining to Issac. "All right, I won't," Isaac said. "I'm here for the arts."

Members of the press were following the man in the white suit, but his travels were unproductive. I asked Mary McGrory, a slip of a lass then and full of beans, how many signatures were on the paper. "Two, I think," she said. "Two or three." But stirred by the trouble and its implications, she and her colleagues were bent on other interviews and other game. There would be little mention of the festival and lots about Vietnam.

That evening I sat at a table watching the candlelight flicker so pleasantly through the protective glass globes, above the grass and the red-and-white tablecloths. The mood, however, had turned somber. It was reported that the President would not appear at all, that he felt his wife had been subjected to insult. At length he did appear, moving genially for a brief time among the tables under Jack's guidance. Then he departed without making the speech originally planned. We were left on a night of gentle breeze with the flickering candles. None went out, as I recall, but the day seemed a bad omen for the arts—not to mention for Eric Goldman.

We entered the summer doldrums. The prevailing winds from the Senate, so marvelously buoyant and auspicious during those early June days, and the one-time enthusiasm of the White House, with that special phrase "a sure and honored place in the story of the advance of our civilization"—both seemed to die out. Even the attention of Tommy Corcoran lapsed into silence. On the ship of arts and humanities, the boards seemed only to complain and shrink.

With the theory that watched kettles never boil, I took a brief vacation in Maine, hoping that the act of unwatching might provoke motion. It did not. When I left, Bob McCord was talking sadly about problems in committee, focusing around Robert Griffin, the Michigan

congressman who had helped head the charge against the arts before. When I returned, the problems seemed to have increased rather than diminished—at best they were the same. I began to think in terms of the second session of the 89th Congress, when it would still be possible for the Congress as a whole to take constructive action. Would there be an inconclusive ending, just as before when the House had taken our Senate bill and so abbreviated it? Or were we becalmed in troubles beyond my detection? Were those dissatisfied with the Senate legislation quietly at work to scuttle it? Was there water seeping into the hold? My exploration could discover none--and by now I had reasonable sources of information to call upon. But the Washington mind grows innately suspicious; indeed, suspicion is integral to defense.

Then, as if there were just a rustle on the water or a small cloud just visible at the edge of the horizon, the slack ropes began slowly to move and the spars to shift, at first ever so little. Perhaps those small rowboats, used to extricate the bulk of a great tall ship from days of windless calm, could be recalled from their toils.

Attribute it to the travelings of Elvira Marquis, or to congressional return from the traditional summer recess, or to all those summaries of favorable arguments, and refutations for the unfavorable, prepared by this and other writers. Attribute it to strategy sessions we held with Frank Thompson and Bob McCord. Attribute it to a combination of all of these, but it was clear we were no longer stationary.

In fact, we were beginning to move from glassy seas toward the eye of the storm.

Late one afternoon, as September was beginning, I was called to Frank Thompson's office. The bill, despite objections from Bob Griffin and others, had received tentative committee approval.

The room was not quite as spacious as Claiborne's, but decorated with the same kind of memorabilia, the photographs, the signatures and messages, the reminders of the years spent in the political process. There were leather-covered chairs and a large desk. In front of it stood Frank in a striped summer suit, and a visitor in gray. I was introduced to McNeil Lowry, who regarded me with an expression suggesting some impatience.

"Livy," Frank said, "I'd like you to explain to Mac here the reason for the Senate bill relating to the National Council on the Arts. I believe you've seen his memorandum on the subject." This is a nice Washington phrasing for commencing a subject familiar to all, but not yet discussed in the company currently present, in this case by the three assembled together.

"I have," I answered, and gave the fullest explanation I could of

positions taken by Claiborne, by the Bureau of the Budget, by the Senate in passing the legislation. I pointed out that we felt the National Council on the Arts would in effect act as a board of directors, because of its prestige, because of Roger Stevens's respect for it, because the guidance of private citizen experts was so basic to the bill itself.

"How sure are you that this is the Budget Bureau's position? How sure are you that this is the President's position?" Mac Lowry asked, continuing to scrutinize me. "I'm very sure," I said. "I'm certain." And I explained that I had studied his memorandum with great care and did not believe it was necessary.

Mac was silent for a few moments. I could see, or rather sense, the close ties with Frank, the mutual regard. Frank remained the observer.

"I'd like to use your telephone, if I may," Mac said.

"Of course," said Frank. "Would you want to make a private call?"

"No," Mac said, looking at me. "This is fine. I'd like the White House," he was saying; and then, "Let me speak to Kermit Gordon." He gave his own name twice.

I had not met Kermit Gordon, director of the Bureau of the Budget, at the right hand of Lyndon Johnson. I could not conjure up a face or appearance. Frank said nothing.

Mac was waiting. "Ask him to call me, then," he was saying. "It's quite urgent. I'm in Frank Thompson's office, on the Hill. McNeil Lowry of the Ford Foundation."

He replaced the receiver. "They say he's in a meeting. I believe they'll get him for me," Mac told us. He spoke with that softly modulated tone of authority for which he was famous. I wondered if Frank at this eleventh hour was considering a drastic change in the bill to comply with his friend's philosophy, risking disapprovals that I felt would be voiced first by Bill Cannon in no uncertain terms. Would there be a House version and a Senate version, and then perhaps a conference between the two bodies on an issue that had seemed well beyond compromise?

The telephone rang. Wasn't there a slight smile on Mac's otherwise serious face?

"Yes," he said, "thank you. Hello, Kermit. How are you?"

He was discussing the arts and humanities legislation with Frank Thompson, Mac explained. Was Kermit Gordon familiar with it and with Frank's chairmanship role? "Good," Mac said. "Have you seen my memo to John Lindsay, then?" Apparently Kermit said no, or that he was not entirely familiar with its contents, and Mac was explaining it carefully, methodically, with elegant logic.

"I'm told there's objection to having a board of directors," he said, looking at Frank, seeming to smile just a trifle more.

"What's that, Kermit?" he asked. "I find that's somewhat hard to believe." He was listening intently, the other side of the conversation inaudible.

Mac slowly put down the receiver and looked steadily at me.

"Apparently you were right," he said quietly. Then he and Frank moved past me and into another room.

Mac Lowry seemed to have a choice. He could place the weight of his experience and of the Ford Foundation behind his convictions, or he could listen to other convictions and assess the weight of other principals on the scene. He is a man of integrity, deeply concerned with the future of the arts. On this late afternoon, turning into autumn, I think he saw he had no real choice after all.

One clear indication that events were moving toward a resolution came from the level of governmental importance of those interested in finding appropriate accommodations in the proposed foundation, either for themselves or those close to them. Roger Stevens sailed serenely along, momentarily free of ambush. Barnaby Keeney, I believe, knew of the Tommy Corcoran connection and may have felt momentarily secure—in particular because we were quietly asking Gus Arlt and others for reactions to a possible chairman's nomination for him, and we were finding agreeable replies.

Roger had one difficult problem, however. The National Council on the Arts was running out of money. Congress had supplied but $50,000 in appropriating funds for its beginnings. Roger had refused salary and traveled the country at his own expense. After it was belatedly discovered—to the consternation of many—that the world "annually" had been omitted in the funding process, a correcting amendment began working its way through congressional halls, but it had been sidetracked in favor of the larger bill. Its passage would set things straight, provided passage occurred. Meanwhile, the council's coffers, to pay a tiny staff of the dedicated and to hold meetings the law required, was virtually depleted. Roger, whose acumen in money matters was well known, was visiting all possible friendly offices, not for a renewal of $50,000, but for that relative security and permanence that a National Endowment for the Arts personified.

Enter now the Speaker of the House of Representatives, John Mc-Cormack of Massachusetts, a legendary figure, bespectacled, venerable, gaunt in appearance, craggy of feature. There were those who felt that the legends of John McCormack—after nineteen consecutive terms in the House and a political career starting during World War I—had all been written, and that he was in the twilight of his service. Be that as it may, he had a sudden great interest in having the director of the National Gal-

lery of Art serve as a member of the Federal Council on the Arts and
the Humanities, that previously described body of agency heads formed
to help coordinate the work of the two endowments and allay the con-
cerns of Senator Javits that there could be duplication of effort. I won-
dered why the Speaker would so concentrate on this relatively obscure
portion of the bill, until it was reported to me that the Mellon family—
the great philanthropists behind the National Gallery and other causes—
were concerned lest the interests they had fostered be neglected.

Somewhat of a tempest was created. It inundated the teapot.

John Walker, director of the National Gallery, was profoundly
knowledgeable of the visual arts and also of Mellon concerns, for Paul
Mellon served as president of the gallery. John's hair was wispy and
silvery; the large eyes under the tall forehead could be studious or hu-
morous. His reputation as erudite scholar was assured nationally and in-
ternationally. Obviously his expert advice and counsel would be of value.

This time there was a snag. Already in the legislation, designated
to membership on the Federal Council on the Arts and the Humanities,
was the secretary of the Smithsonian Institution, one Dillon Ripley. His
authority extended, in accord with the long-established table of govern-
mental organization, over the National Gallery of Art. In the hierarchy
involved, Dillon Ripley took precedence over John Walker; Dillon repre-
sented the Smithsonian Institution as a whole, and thus the National Gal-
lery, merely one of several bureaus under Smithsonian auspices.

We can recall Dillon's hesitance to adopt an Arts and Humanities
Foundation and help it toward independence. The National Gallery of
Art, as a bureau of the Smithsonian, had been helped a certain distance
toward independence, but no further. John Walker was not an equal to
Dillon Ripley in the chain of command, and therefore had no more rea-
son to belong to the Federal Council than the director of the Astrophysi-
cal Observatory, also a Smithsonian bureau. At least, so went the
argument.

It is surprising how much time all this took in the midst of perhaps
weightier matters. I wrote a long memorandum to Claiborne, marked
"confidential" and entitled "Three Possible Compromises on the Ripley-
Walker Dispute." One was to include John Walker as ex officio member
of the National Council on the Arts, a post given to Dillon as Smithsonian
secretary under the 1964 act. Dillon would move to the Federal Council,
as proper for an agency head, and John would serve where his knowl-
edge of the arts would be particularly valuable. A second solution was to
make it legally possible for Dillon to designate John to the council, fol-
lowing agreement among the parties. This would allow for face-saving
and generosity of spirit. But would the Speaker agree to either when he

was committed to putting John Walker squarely on the Federal Council, side by side with Dillon Ripley?

The third solution, which came to me at night, was to make it happen that Dillon Ripley be the first chairman of the Federal Council, elevating him above his colleague, John, and at the same time fulfilling the wishes of John McCormack and Paul Mellon. Claiborne liked number three, and that is the way it transpired. Dillon was given, quite properly, the recognition he merited for his Smithsonian role in both arts and humanities, and John was provided the involvement others of great power sought for him.

Carried into the midst of these endeavors, however, none of the protagonists—including the Speaker's mysterious and often enigmatic staff aide, Dr. Martin Sweig, who always in retrospect appears to me at the threshold of a Humphrey Bogart film—seemed to have absorbed the passage in the Senate report dealing with the purpose and function of the Federal Council. The promotion of cooperation, yes; but "the Federal Council thus constituted has no authority to direct or control the policies or programs of the two endowments."

Were they really searching so eagerly for such an assignment? Maybe Claiborne was right; the report was too long for reading. Suppose the plums on the tree, eyed from below with pleasure, turned a bit sour? That is a sequel for another time.

The episode, however, demonstrates a salient truth. Power in Washington for the arts and humanities at this time—as well as later—centered around a limited number of individuals. Very strong personalities were involved, never quite all at once in the events taking shape, and on occasion separately. They were always capable of determining action. They awakened, and sometimes they withdrew. But upset one through inadvertence or lack of attention, and the great vessel you thought securely in motion had just lost its keel.

Chapter 25

WE COME NOW TO A DARK AFTERNOON AND NIGHT OF TURBULENCE, perhaps the most fateful of all for the legislation.

During the dog days of summer, signs of serious discontent remained in the House for a time. But they were increasing, not waning as some had hoped. Undeniably, the bill was moving toward House debate, but simultaneously into growing acrimony.

Frank Thompson had dislodged the bill, as the Senate passed it, from the Committee on Education and Labor, chaired by Adam Clayton Powell. A quarter of the House report contained the views of those opposed, the so-called minority views that had been avoided in the Senate document.

The legislation was castigated as ill considered and overly premature. Studies by the National Council on the Arts were seen as essential to any further federal participation in cultural activities (shades of Philip Hanes!). The organizational structure of the proposed foundation was presented in bleaker terms as "an impenetrable thicket of duplication and overlapping."

"One naturally wonders," said the report, "why such a complicated organizational structure is necessary in the dispensing of Fed-

eral funds," which were termed "comparatively modest—for the present. . . . Could it be that this formidable bureaucratic framework is only the portent of the more lavish expenditure of Federal funds which will follow?"

"Frivolous" and "hasty" were adjectives used; government "control over the arts and humanities" was the bill's alleged design. The "creeping mediocrity" quote of "Russell Lynes, one of the editors of *Harper's* magazine," was used, and his invocation that the arts stay free of "our political processes."

Thornton Wilder was quoted, from an interview published in the *Washington Post* on May 6: "[Wilder] rejected as unnecessary a program of government subsidy for the creative artist. . . . 'There are no Miltons dying mute here today,' he said, adding that from every small American town 'anyone who can play the scales is rushed off to Vienna to study music' with funds 'raised by the local music appreciation club.' "

"I didn't see one in *Our Town*," might be a personal comment. In retrospect, the thought that young American musicians, or those musically inclined, had to be rushed off to Vienna seems a rather curious inclusion in this document, for the legislation was aimed specifically at providing greater opportunities for artists here at home—and indeed in Our Towns.

In this part of the House report there is another curious passage. It advocates matching grants for capital equipment and buildings as the only possible area for governmental aid. We had carefully avoided thoughts about this kind of help, for it was considered far too costly; one or two buildings could easily finish off all the authorized funds.

But the House was not interpreting these passages so closely. A trip to Vienna would appear exactly what an affluent arts community could afford. Why governmental help when the airline ticket was at hand? Capital grants would forestall the assistance to cultural programs that was at the very heart of the bill. The more impossible such grants might be, the better. The more vulnerable it could be made, the better.

Already flourishing arts and humanities communities were depicted. No attention was given to rising costs and to the fundamental inability of private philanthropy to meet these needs on its own. But that was not necessary. The appeal was to emotions more than to reason. The appeal was to traditional approaches, which are so rarely the seekers or sympathizers of the precedent-setting.

The report concluded by calling the legislation "a long step in the wrong direction." (It was obviously not considered a forward step of any sort for mankind.) Its rejection was urged.

* * *

The signers in the order appearing in the minority report were: William Ayres, Ohio; Robert Griffin, Michigan; Albert Quie, Minnesota; Charles Goodell, New York; David Martin, Nebraska; Glenn Andrews, Alabama; and Edward Gurney, Florida. William Ayres was the senior congressman of the group, having been elected to the House for eight consecutive terms. Ed Gurney and Bob Griffin were later to become U.S. senators; and Albert Quie, governor of Minnesota. I got to know the latter two in later times. Bob Griffin's views moderated toward the arts and humanities; Al Quie became a relative enthusiast and was to serve as ranking minority member of an authorizing subcommittee chaired by John Brademas. At the time, Al Quie was less opposed to the humanities cause than the arts and made this evident in a separate report statement.

Favorable, however, they were not. They had strong convictions and strong support. They believed they were right. They believed in their own cause. They were ready for battle and confident that past attitudes in the House would prevail once again.

To help them, there now came into view a personage of immense strength and conviction: Howard W. Smith of Virginia, member of the House for eighteen consecutive terms and chairman of the Committee on Rules. Howard W. Smith was outranked in seniority by just four others, including John McCormack. Many maintained, however, that Howard Smith was *the* most powerful representative in the House, and that the Rules Committee had more power than any other.

The Rules Committee was often described as a policeman, established to assure the orderly process and progress of legislation. It was there to prevent the 435 members from the possible chaos of individual actions taken without restraint. A House bill reported forward from a committee went next to the Committee on Rules. There it could receive the final green light necessary for floor debate, or it could receive a red light and be put on hold. (The Senate had no such procedure. It had a Committee on Rules, but for other matters of more limited range.)

On hold in the Rules Committee was where the arts and humanities resided in the autumn of 1965. Howard Smith was known by friends and foes alike as Judge Smith. He had been a judge in Alexandria for six years, after practicing law for eighteen, and then judge of the Sixteenth Judicial Circuit of Virginia for two more years before he turned to Congress. A man of polite demeanor and an iron will, he left no particle of doubt concerning his authority and the significance of his committee. He let it be known clearly, in plain unvarnished English, that he was opposed to the arts and humanities legislation. Period. It was on hold and the light was red; green was not a color it was about to turn.

"Can he really do this?" a distraught Elvira Marquis asked me one late summer day. "He can and has," I told her.

Roger Stevens requested and received an audience, but the legislative calendar remained unchanged.

There was recourse. In democratic institutions there always is. Legislation bottled up or imprisoned in the Rules Committee could be released by petition. This took the form of a House resolution, which a majority of the House needed to approve if the bill was then to be subject to full debate. If the resolution was considered and then passed, the bill would move from Rules Committee jurisdiction to the House floor. Such petitions were rare. Just one legislative day in the session was set aside for the purpose. Whoever endorsed the resolution risked the ire, and the memory, of Judge Smith. His memory of those who had opposed him was reported to be second to none.

There was an additional complication. Adam Clayton Powell, as committee chairman, had two bills held by the Rules Committee: arts and humanities (lampooners were now at work calling it arts and homilies) and a civil rights measure for equal employment opportunity. Judge Smith also firmly disagreed with the latter bill. The question was, which petition would chairman Powell put first? The experts were telling me that the civil rights proposals, if first, would automatically set the House so on edge that any discussion of cultural legislation would be engulfed in residues of ill feelings and frayed tempers, no matter what the merits of the case.

So was the stage set for the finale of the arts and humanities in this session of the 89th Congress. It was, indeed, the eye of the storm.

The House convened at 2 p.m. on September 14, 1965. I sat in one of the balconies with Elvira, Gus Arlt, and a few others who had followed the situation day by day and could not stay at home. There was little we could do, however, except watch. Occasionally, I went to discuss the developments with Frank Thompson. I had been told that chairman Powell would like to have some speech material. I had it ready, but it appeared it would not be used.

Judge Smith seemed to preside, not in the well of the House where most words are spoken, nor at the long Speaker's desk above, but in the rear of the chamber, where he could best observe and, when it seemed appropriate to him, buttonhole passersby. He was fighting for his long-held power, for the days of his glory, this gentleman from Virginia. To lose, especially to the arts and humanities bill—this flimsy, inconsequential bit of gossamer nonsense—I'm sure he found unthinkable. For with its loss to the floor, its escape from his special province, went a wide swath of his influence. One could guess the gist of his conversations: Look, Joe, you help me today and that bill you have for next year, don't worry about it. We'll get it through together.

A series of quorum calls began, dealing with procedural points the Judge had skillfully arranged. The basic issues were marvelously skirted in a sequence of parliamentary maneuverings that only the most experienced can execute with éclat, for they are up against similar experts who alone can fully comprehend the possibilities for the next move.

A quorum call takes place when it is suggested that a majority of members are not present to make a given decision. The Judge would make the suggestion; from the Speaker's desk would come a quorum call, and the Speaker would say, "The clerk will call the roll." And it came to pass that the evening of the first day was beginning, but it seemed like the sixth; and the Lord had created absolutely zilch.

According to my watch, in 1965 it took approximately thirty-five minutes for a majority of members to appear and be named and counted. The clerk must begin with A, Abbitt (Watkins, of Virginia) and end with Z, Zablocki (Clement, of Wisconsin). Clerks in the House (and to a lesser extent in the Senate, for there are so many fewer names) are accustomed to this procedure, and could probably do it—as has been sometimes averred—in their sleep. The voice is trained in modulation and inflection, so that each syllable is given precisely the value of the one before it, neither loud nor soft, just hanging in the air. Thirty-five minutes on the watch; and if in that time the troops were not assembled, we began again with A.

The quorum calls, the parliamentary avoidances of other issues went through the afternoon and into the evening. It is possible there may have been other such days in the House, but I recall nothing like it in my experience. It was reported that Adam Powell had agreed to put arts and humanities first on the agenda, but that now seemed almost academic. Precedent-setting legislation, a great distance from debate, was indirectly setting other precedents. The Judge was immutable and in command.

It may seem curious that members appeared so reluctant to assemble on the floor and get on with things. A certain furtive movement past Judge Smith could be observed, and a hasty departure: If you had a future bill subject to controversy or a project your constituents favored presently awaiting a rule, would you challenge the Judge on a matter to which you had already assigned a lesser priority? For those who objected moderately or with fervor to the proposed foundation, the Judge's tactics surely seemed heaven-sent. Their problems were being resolved without a single hammer needed to drive nails in the casket.

Clearly the concept of federal assistance to the nation's cultural future was not the issue. The future of one individual was the issue, and more. Time-honored rules of the House were also the issue. Suppose you were third in line, or fourth, and had witnessed the length of your own

seniority mantle growing. Suppose you were a Republican with similar seniority and saw the possibility of the House majority changing one day to your party's control. Suppose you were a chairman or an influential member of another committee long accustomed to established procedures and to the establishment. Would you want, this day, to challenge a venerable colleague, perhaps a good friend? Would you want to linger on the floor?

Congress provides a remedy for such soul-searching. Some might call it an expedient, but it is nonetheless valid to our system of democracy. Congress provides a parliamentary wand. Acolytes study its use. The master knows its every motion. In this case, the Judge knew that his spell must last through this day, just this day alone, and then the challenge would disappear. The battle would be won, and he would be the stronger for it. Congress knew this, too, and let the spell continue.

So the shadows lengthened and the evening advanced. To the prayerful and the listening, it may have seemed that the week was ending, all seven days; but whatever the time frame, it was apparent that creation had languished and that the Almighty was not in the office but on vacation.

Then, as there had been in the summer, an alteration occurred, subtle at the outset, hardly detectable, yet increasing in dimension.

Frank Thompson seemed more frequently present. At a distance Judge Smith seemed to observe him more closely. Frank was here speaking to a passerby, there touching the elbow of a colleague. Nods seemed to be replacing the smile, the slight shrug of a shoulder, the noncommittal look. And wasn't this a stranger at the edge of the House floor, and then another one? They were from the White House, I was informed; the President was interested.

During the following quorum call, the members seemed to stay by their desks longer, and during the next one, longer still. But it was nine o'clock, and ten o'clock. The legislative day, I thought, ends at midnight, and envisioned the resolution to release the bill from Rules presented at 11:59. The House might still bring the matter to a vote before adjourning.

Toward eleven o'clock I was asked to visit chairman Powell's office. I had met only his reputation—meteoric, one could say, widely known even at this time before the full emergence of his influence, and well before his demise. In the doorway of his office, I could hear the strength of the voice, to become a trademark, and in keeping with the large frame, the broad and handsome face with small mustache, the clasp of a handshake.

I gave him the speech material I had prepared, and he thanked me as he took the papers and held them. He looked as tall as a prophet,

and I was so taken by this image that for a moment I did not notice that he seemed to be supporting the edge of the doorway with his full weight. He held the speech in one hand, in the other a tall glass of what seemed to me milk.

"Mr. Chairman," I said, "we are all so hopeful that you can help us tonight."

"Of course," he said.

"Will it come up tonight?" I asked. "Is there time?"

He bestowed on me a large smile. "Keep the faith, baby!" he exclaimed in a loud voice, touched with fervor and humor.

He seemed to be looking not at me, however; there was something odd in his position. I felt a sudden start and glanced again at the glass in his hand. All at once he raised it and took a long swallow. The color was only in part the color of milk.

"How was he?" Elvira Marquis inquired when I returned to the gallery.

"Excellent," I said.

"Does he think there's a chance?" she asked. "So much depends on him."

"Yes," I responded. "It does."

There was a marked difference now on the House floor. Members came and stayed. More talked with Frank Thompson than with the Judge. Then, as the clock moved toward twelve, I made a discovery new to my understanding of Congress. The so-called legislative day would not necessarily end at midnight; it could extend until the House approved adjournment. Time seemed suddenly on our side. But midnight passed, and still Judge Smith remained steadfast at his work, prolonging, prolonging.

Among others present, weariness and frustration were noticeably growing. To observers in the gallery, it appeared that attrition could at last succeed for Judge Smith. How long would it be before the House approved a motion to adjourn as a welcomed expedient?

I will always remember that time, and the test of power, and the struggle of one leader to keep it unaltered. Horatio at the Bridge came to mind, but obliquely, for this was not a defender of a cause we believed in. He was fully within his prerogatives, however, and he was fighting for the life he believed in and had shaped. The last of the saber-toothed tigers, perhaps, admirable or grandiose—or neither of these? There were elements of both to recall.

They had decided to end it now, to bring it to conclusion. And so finally the spectacle narrowed, and the larger-than-life was on a smaller

scale. Finally it could be said to be just an old man who had lost a part of his battle, a part of his power.

Suddenly below us was Adam Clayton Powell. It was past one o'clock in the morning. He moved quickly into the well of the House and stood before one of the microphones. I looked in terrible suspense for a wavering in his stance or a slurring in his words.

There was none at all.

It would be nice to recount that my text was used and that the words I had so carefully prepared prevailed. It was not so. He spoke without notes—perhaps with a phrase or two I had offered, though I was never sure. He spoke from his heart with full grasp of the subject, the words rolling out across the floor as if from a pulpit. This was his style, and how in the best of his days he performed. The House listened; but it had already made up its mind, it seemed. House Resolution 478, providing for consideration of the National Foundation on the Arts and Humanities Act of 1965, was passed, and the House adjourned.

"Consideration" was the critical term. The bill was released, rescued, reprieved, given its chance. It would be debated on its merits, or demerits, on the floor of the House the following day. As so frequently happens, however, in this story of the hitherto untried, a moment of seeming triumph led back into a time of uncertainty and doubt. Perhaps we should have been used to it by now.

Chapter 26

THE FIELD GENERAL WHO LED THE ATTACK AGAINST THE LEGISLATION THAT next afternoon, September 15, 1965, was Congressman H.R. Gross from Iowa. H.R. Gross was synonymous with a set of values and particular strategies that had brought him both notoriety and fame. He was considered the Republican watchdog of the House: alert, always in wait for any sudden move to slip a bill through by unanimous consent when there was a lapse of attention.

"Is there objection?"

One voice is all it takes. It would belong to H.R. Gross.

"Objection is heard," would be intoned from the Speaker's desk, and that would be the end of that particular effort for speedy action. We had heard this voice before. Today he was after bigger fish to fry.

Born in 1899, H.R. Gross represented the center of his state. He was a Mason, an Elk, a member of the American Legion and of the Veterans of Foreign Wars. He was America's heartland and the bulwark of conservative attitudes. He was born in Waterloo, Iowa, and many attributed the turning of the tide on a whole variety of legislative proposals to strategies he had mastered. Often they focused on ridicule. In the House, his skills were well acknowledged.

He had been a newspaper reporter and editor for fourteen years following World War I, and then a radio news commentator for another thirteen (note a similarity to another public figure of great renown). Elected to the House in 1948, he had served ever since. And some, when they thought of his name and reputation, conjured up the image of an ogre presiding over the bones of victims. In appearance, however, he was deceptively mild mannered, almost bookish. It was the tart tongue, the shrewdness of knowledge and always the thoroughness of preparation that were his principal characteristics.

He was assisted on this September day by his colleague from Missouri, Durward Gorham Hall. Compared to the seniority achieved by H.R. Gross, Durward Hall, elected in 1960, was a relatively new arrival. He brought to the debate, however, a special element, utilized surprisingly and with telling effect—a profound knowledge of medicine, stemming from his college days and developing into a specialization in surgery. He had held high position in the Office of the Surgeon General, was a recipient of the Legion of Honor, a fellow of the American College of Surgeons, and congressional advisor to the World Health Assembly held in Geneva, Switzerland, in 1962. Until you heard him speak, his look was that of a studious country doctor called in for a friendly diagnostic bedside chat.

Frank Thompson was floor manager of the legislation. Adam Powell, as chairman of the House Education and Labor Committee, had held primary responsibility on the issue over the Rules and Judge Smith, but today the issue was the bill itself. That was Frank's to defend under traditions that bring a floor manager abruptly into the glare of attention.

From the gallery it seemed to me that Frank looked a bit weary. Almost resignedly he had seemed to accept the judgments that had ended discussions of Mac Lowry's efforts for drastic change in the bill. Frank seemed to me not as Gibraltar-like as he had appeared in the past—slender, wiry, perhaps a little gaunt—but he had been the diplomat who had won the concession from Adam Powell to place the arts and humanities bill first on the agenda during those hours and hours of quorum calls so recently ended.

Now a regularized procedure began. Here was the clerk of the House reading the bill line by line, as was the custom then.

He did not get far. I think none of us were prepared for what ensued.

The clerk had finished reading the opening paragraphs of the declaration of purpose. He was able to impart to them an excitement similar to the one aroused by a recitation of the 435 names of the members of the House of Representatives.

The procedure, however, has an important salutary effect. As the names begin to have a sameness about them after the first hundred or so, so does a verbatim reading of legislative language. A bill to provide technical supports for farm prices sounds not a great deal different from a bill calling for military intervention in Latin America. The plea for "world-wide respect and admiration for the Nation's high qualities as a leader in the realm of ideas and the spirit," sounded not unlike a declension of a pluperfect verb by an experienced grammarian.

Equally exciting was the definition paragraph for the humanities: "(a) The term 'humanities' includes, but is not limited to, the study of the following," the clerk intoned, and recited the subject areas in his marvelously emotionless voice. "(b) The term 'the arts' includes, but is not limited to, music (instrumental and vocal), dance—"

He got no further. As the bill was read it was subject to amendment offered from the floor. Here came the first amendment, presented by Mr. Gross, written by Mr. Hall.

"After the word 'dance' insert the following," said the clerk, reading with no change in style, his eyes downcast on the paper before him. Then there was a pause. The clerk glanced to one side, I remember, as if seeking advice; but of course there was none, for no one in his immediate vicinity was listening.

The task was resumed. "After the word 'dance' insert the following." It was a precisely anatomical description of a belly dancer, with this unforgettable phrasing: "including but not limited to the irregular jactitations and/or rhythmic contractions and coordinated relaxations of the serrati, obliques, and abdominis recti group of muscles—accompanied by rotary undulations, tilts, and turns timed with and attuned to the titillating and blended tones of synchronous woodwinds."

In the rendition, the clerk's voice seemed to falter in midstream and his face seemed to take on a rosy coloration. There were, after all, ladies present. I doubt if a more bizarre amendment, calculated to surprise, has ever been offered in the House. Jove's lightning bolt tossed from the Capitol roof could not have duplicated the effect.

After a moment of dead silence, the whole chamber erupted in laughter. I recall Jack Golodner, sitting nearby, looking stricken. "There he goes," he said quietly. "He's done it again."

Mr. Gross was now launched and in full stride. He would have worn his "tuxedo and his dancing shoes," he told the membership, had he realized the full extent of the federal giveaway.

Buoyed by the laughter—it seemed to come in waves—recognizing in its volume the weapon he had so often used before, knowing that the

threshold for ridiculing this fragile legislation right off the floor of the House was plainly in sight, Mr. Gross acknowledged with delight his collaborator and his wisdom in anatomy, and then lampooned the structure of the bill. A National Foundation on the Arts and Humanities, a National Endowment for the Arts, a National Council on the Arts. He gave to each an acronym—NFAH, NEA, NCA, NEH, NCH—and a "Federal Council on the Arts and Humanities," he said, FCAH. As he recited these combinations in a tone of obvious high humor, it sounded a little as if a contingent from Southeast Asia had arrived. I thought again of all the complexities in structure we had sought our best to avoid.

H.R. Gross was in full cry, the House following each word with an unrestrained hilarity. This was the vintage H.R. they had come to respect, either grudgingly or with a glad heart. He was indeed doing it again—and, to tell the truth, the whole thing was made to seem pretty ridiculous; it had even left old Judge Smith in eclipse.

Mr. Gross was finding the bill itself filled with the amusing and the presumptuous. A "professional practitioner" in the arts, he said—who else but a belly dancer? And a "professional practitioner in the humanities," he continued, and proclaimed his incomprehension of those words, knowing now it was time to conclude, knowing that the House at this point must act on his amendment, and that in its mood, it could take nothing seriously. The bill was ready for burial.

"I wouldn't know the difference between one of them and a bale of hay," he said, and the House laughed loudly.

Frank Thompson was standing. All at once he seemed tall, and he seemed quite calm. "The most surprising disclosure of the day," he told his colleagues, "is that the gentleman from a farm state doesn't know the difference between" (he paused for just a second) "a belly dancer and a bale of hay."

The reference point to the humanities had been missed on purpose. Indeed, so carried along by his rhetoric had H. R. Gross been, that the reference point was missed all around him.

And all at once it did not matter. The chamber was laughing with Frank Thompson. It was a wonderful joke. It was better than those preceding it.

For a moment H. R. Gross looked stunned.

"You're putting words into my mouth," he told Frank Thompson, but they weren't listening to him.

Suddenly, in the twinkling of an eye, he had lost.

I have always thought of Frank Thompson's thrust that afternoon as the greatest single example of presence of mind I witnessed in my

years with the Congress. It may have been instinctive. Certainly there was no time to plan, but that makes it all the more admirable. Like a second thunderbolt, it passed thorough the chamber and the room was different. The pyrotechnics were over. The amendment to enmesh the legislation in ridicule had failed.

Mr. Gross tried with a kind of growing desperation to rally his forces. He offered another amendment to include poker playing as an art, but he was missing his mark, his shots losing accuracy and strength and eventually he subsided.

There was much said about the arts and humanities on September 15. The old arguments were made on both sides, pro and con. The opposition in the House report was repeated. The refutations on which we had all worked so long, the support the cohorts for the arts had gathered, Elvira Marquis and her questings for the humanities—their presence was felt in the articulation of arguments. John Fogarty praised the Pell formula, the basis for it all. The heroes and the pioneers all spoke. The wisdom of the arts working in tandem with the humanities was demonstrated. And the sonorous, so often uplifting sounds from the days of hearings, the voices of artists and scholars, came back into focus.

But it was the mood in the House that had altered. To those in the gallery, a great incoming shell had just missed destroying its target and had exploded harmlessly. It was evident that the bill would pass.

The Senate acted on the legislation the very next evening. The bill approved by the House was essentially the one the Senate had approved in June, and it was returned with the Senate number S.1483. In a show of special courtesy and recognition, the House number was changed.

Feelings were far different from those a year earlier when the Senate—as a means of salvaging all that was possible at the time—accepted less than half a loaf. Now it was full measure.

Claiborne Pell spoke of the history of the legislation and of those who had "valiantly" supported its concepts and goals. He accorded me these words which, needless to say, I cherish: "I would like to pay particular tribute to Livingston L. Biddle," he said, "who has been my special assistant for two and a half years. Without his remarkable combination of knowledge in both the fields of arts and humanities, his own personal tactfulness and his tenacity, this bill would not be before us today. I have observed these qualities not only in his work on the Senate side, but also with our colleagues in the House and with the Executive Branch of our Government."

He spoke of John Fogarty and Bill Moorhead, and of the "indefati-

gable" efforts of Frank Thompson. On the night when Howard Smith had seemed for a time supreme, John Fogarty, while not always present and with much at stake, chose in the end the arts and humanities over those future favors the Judge could bestow. It was a courageous move, especially for one so senior himself; for the principle of senior prerogatives was so fundamentally involved.

Jack Javits spoke of his long involvement with the cause. They exchanged a number of compliments. Claiborne recognized him as the pioneer he was; he bestowed on Claiborne "enormous credit." Robert Kennedy joined his Republican colleague from New York. "It was the Senator from Rhode Island," he said, "who brought all those divergent points of view together so that we have before us this piece of legislation which can be the real stimulant . . . for our culture."

Then all of a sudden came Strom Thurmond: "Mr. President, I am opposed to the pending bill . . . because there is no constitutional authority for the Federal Government to enter this field. The breadth and scope of the authority of Congress is contained in Article I, Section 8 of the Constitution. Nowhere within the grants of power to Congress in this Section can there be found authority to sustain this proposal.

"This is sufficient reason to oppose . . . but if it were not, other reasons do exist. I have pointed out on numerous occasions my firmly held belief that Government subsidization of the arts will inevitably lead to the stifling of creativity and initiative. Government money will buy only mediocrity and true, creative talent will not be properly recognized because it will not have official Government approval.

"It would be a great mistake for the Nation for Congress to approve this proposal."

Once a voice we had needed to heed so closely, now it seemed only in the wilderness, a statement for the record, a statement to keep intact a point of view.

And then these "words of art" as they are termed—aptly in this case—were spoken and transcribed, as follows:

"*Mr. Pell:* Mr President, I move that the Senate concur on the House amendment.

"*The presiding officer:* The question is on agreeing to the motion of the Senator from Rhode Island.

"The motion was agreed to. [Those five words describe the voice vote involved.]

"*Mr. Javits:* Mr. President, I move to reconsider the vote by which the amendment of the House of Representatives was agreed to.

"Mr. Pell: I move to lay that motion on the table.

"The motion to lay on the table was agreed to," says the *Congressional Record* of September 16, 1965.

This bill could not be brought up again. In identical form, it had been passed by both houses of Congress.

The *Congressional Record* does not note time. By my watch, it was just past 8:30 p.m. on September 16, 1965.

It was over. We had reached Tipperary.

One final gremlin was suddenly espied. In the first Senate printing, there was a typo of a kind that once gave me shudders. The House had added one small amendment to clarify the problem—at one time so deeply divisive—of the professional and the amateur struggling toward excellence in the arts. As an area the new Arts Endowment could assist, the House had added "workshops," defined as "a production, the primary purpose of which is to encourage the artistic development or enjoyment of amateur, student, or other non-professional participants." The Senate, in approving the House-passed bill, had automatically approved this language, nicely rounding out for everyone the earlier agreements. But the typesetters wrote not workshop but "workship," and for a moment, as I read slowly and carefully through the text, it seemed to me that some strange bark might suddenly become perpetually afloat in our legislation. It was sunk by a corrective call to Steve Coffey.

The ceremony was in the Rose Garden. I have the photograph that shows Lyndon Johnson seated at a desk, reaching for a pen among an array on a stand placed in front of him. The bill awaited his signature.

Directly behind President Johnson in the photograph stands Claiborne Pell, arms partially folded, head slightly tilted to look over the President's shoulder. To Claiborne's left is Bill Moorhead. Both are slightly smiling, with eyes downcast and intent. To Claiborne's right is Frank Thompson, in a light suit contrasting with the others, turning for a word with John Fogarty, hands clasped, face solemn, wearing his characteristic small bow tie. To John's right, in the first row, is the Senate majority leader, Mike Mansfield, hands at his side, head turned toward the President, smiling quite broadly, for him. One can recognize among the others a young John Brademas, who would take Frank's place for the arts in the House; John Lindsay, taller than the others; and Marian Javits in a white fall coat, her dark hair cut just above its collar. Many attributed to her an important part of her senator husband's fondness for the arts. It seemed to me then, and years later as well, a mutual feeling holding them together despite times of vicissitude and final tragedy. And visi-

ble over John Fogarty's shoulders is Lady Bird Johnson. She is intent on the ceremony, and her contemplative smile is the broadest of all. Vice-President Hubert Humphrey spoke at festivities following the signing, with the passion and joy of which he was capable. Ernest Gruening was there, and Bob Lumiansky, who had testified at the hearings as an English professor and a member of the Commission on the Humanities. His career was still beginning. He would be appointed a member of the first National Council on the Humanities. A scholar with large, thoughtful eyes and a deep voice, he would later become president of both the American Council of Learned Societies and Phi Beta Kappa.

Members of the National Council on the Arts were there. That evening, Claiborne Pell held his annual party for Rhode Island students and Rhode Island friends in the garden of his Georgetown home, a hundred guests or more. I remember his asking me to find Gregory Peck and invite him to come. He did—and was for a time more the center of attention than anyone else.

As a memento of the signing, I keep a silver-topped pen, its dark blue base marked by the presidential seal and the President's name in his special script. S.1483 had its new number—P.L (for Public Law) 89 (for the 89th Congress)-209 (for its identifying place among other laws).

It was September 29, and the sunlight was bright and clear, as it can be in Washington's autumn when the wind comes from the north and west. Lyndon Johnson addressed the assembled guests. He spoke of the goals we all shared for the work of the two endowments. He spoke of the humanities and of the variety of the arts to be assisted.

And with sudden specificity, he said, "We will create an American Film Institute." I recall being with Roger Stevens, whose eyes widened. An American Film Institute? Where did that come from?

Well, it came from Roger's zealous and film-loving speechwriter and general aide, Frank Crowther, who had been asked to assist with the presidential text and who knew that Roger's primary affection was the theater. But I did not let on. (Frank is no longer with us; the source for the announcement was lost in time.) The ringing endorsement of the President of the United States remained, and it was prophetic.

For the endowment, as will be recounted, did indeed create an American Film Institute, with the help of Gregory Peck and George Stevens, the celebrated actor and the maker of fine films. The action provided its share of controversy, which overflowed into both the National Council and the halls of Congress, causing disputes and animosities that never quite subsided. But the Institute grew in size and strength, and Charlton Heston replaced Gregory Peck as its champion.

Most of all on that day, I suppose, I remember the Rose Garden

setting with the bright pillars of the White House in the background. I remember looking up above the trellises and the shapes of green shrubs at the line of the roof. It seemed to me that perched upon it, as in a symbolic painting from the past, could be Zeus and Hermes and Athena with accompanying retinue. For a moment, their heads seemed to hover, as if the sky were some great Renaissance ceiling.

Ah, these mortals! they would be saying—look what they have wrought!

Fancies, and reality, and an American Film Institute as a bolt from the blue, and so many familiar faces, mingling now in unfamiliar ways— the arts and humanities and government meeting and greeting each other for the first time like this.

There was a bit of sadness, too. I recall someone asking me, Dan Millsaps I think, "What are you going to do now—ride off into the sunset?"

Sadness was not to be.

A short time afterward, Roger Stevens and I were attending the same function at the National Gallery of Art. We were standing in the large interior court, near its central fountain. Roger took me toward one of the potted palms.

"You know more about this legislation than even I do," he told me with a smile. "How would you like to be my deputy?"

And suddenly here it was, partly the same, yet very different— another chapter, another part of my life in the arts.

Part Four
DEPUTY
CHAIRMAN

Chapter 27

I T WAS INDEED A FLEDGLING ENDOWMENT. OUR QUARTERS WERE IN A LOFT above Pennsylvania Avenue and 17th Street, one large room that had been used as a storage area for Kennedy Center belongings. Cartons of papers, boxes of all sizes were pushed into corners. My "desk" did not quite say "oranges" on the side, but it was a slatted crate, of medium size, from which some object had been unpacked. Balanced on it were my trusty portable typewriter and a telephone. I sat on a strong cardboard carton and sometimes a canvas-covered folding chair. It was obvious that the National Council on the Arts was nearing its penultimate pennies when the legislation was signed into law. We awaited our appropriation with undisguised joy.

Roger maintained a different sort of office, across the street in the Executive Office Building. The space went with the three hats he wore: chairman of the John F. Kennedy Center for the Performing Arts, as yet unbuilt; presidential advisor on the arts, the post that then went with the chairmanship of the National Council; and now chairman of the National Endowment for the Arts.

Working for Roger as deputy chairman was somewhat like being at the rim of an active volcano. There is a cartoon of the Lyndon John-

son days showing the White House in four frames: the first serene and composed, and the others in growing turmoil, roof about to explode, pillars twisted far out of shape, walls bulging, windows wildly askew. It was entitled "he's in." The same could be said of the Executive Office Building corridor where Roger's office was located when he was on the premises. He has been described as a dynamo and a super-activist, a traveler who considers it the height of plebianism to enter an aircraft more than thirty seconds before its scheduled departure. He had his theater interests still in New York, and his real estate interests only God knew precisely where, but his chief and consuming concern was to launch the new federal arts program successfully. Travel he did, with his message and mission. Abe Fortas once remarked that if there weren't a Roger Stevens "we'd have had to invent him."

One of my earliest solo assignments was to visit the Civil Service Commission to seek permission for appropriate staff. As a federal program we came by law under civil service, but the Civil Service Commission did not have anywhere on its roster experts in the arts. This I knew, and so I had provided in the law for exemption in the key posts we now planned to develop. Exemptions in general practice, however, were by no means usual.

A woman of obviously long experience greeted me. I told her I had an appointment with John Macy, chairman of the commission. It was my first experience with the real bureaucracy.

"While we're waiting," she said, "it would help me if you told me the nature of your business."

"Well, I'm helping to start a new program," I began.

"Yes?" her eyebrows were arched below the grey hair tightly combed back.

"The National Endowment for the Arts," I told her.

"To whom does it report?" she inquired, writing on a pad beside her.

"To the President," I said.

"No, no. I mean what department is it under? Programs come under departments, as you know."

"Not this one," I said. "It's a new agency. It's independent."

"Independent?" she asked, the eyebrows lifting further. "And what is it called again? The—" She looked down at the pad, and then at me.

"How long have you been in government?" she asked me.

"In the legislative branch for a number of years. In the executive branch for only a few days."

"I see," she said quite comfortably now, and with a brief smile. "You see, they're quite different. New programs are always under a

broader structure. We have health, for example, now under HEW. We have new programs under Commerce, for example EDA. It's done by law."

"I know," I said pleasantly to her. "I helped write this one."

She was frowning.

"Which one is that?"

"The one that created the National Endowment for the Arts. We report directly to the President. If you'll look in your organization charts, you'll see that—"

I paused. She was eyeing me now with considerable suspicion. How had an individual so misinformed managed this much ingress?

"And you are?"

"The deputy chairman," I said. "Just appointed."

"And you wish to see Mr. Macy about—?"

"About exemptions from civil service regulations. You see the law provides—"

"Exemptions?" she asked in a tone of some alarm. She arose from her desk. "Excuse me for a minute," she said.

She disappeared into a side office. I could hear urgency in her voice, as if perhaps suggesting that a guard be summoned. Then there was a sound of pages being turned and more pages, and the voices became quieter. The conversation ended.

Three minutes or so later, she reappeared. She was composed and perfectly businesslike.

"Mr. Macy will see you now," she said.

John W. Macy, chairman of the Civil Service Commission (later to be retitled the Office of Personnel Management), was key to the development of the brand-new program. Hawk-featured, sharp-eyed, he had nonetheless an air of geniality and relaxation. He and Roger had worked hard on the initial list of council members, whose quality set a tone of excellence and dedication that would be a model for the years to come. There was the factor of recognition, a touchstone for confidence among the American people. There was the emphasis on achievement. There was the representation of all the significant arts areas. And there was dedication and deep commitment to the arts.

John Macy listened patiently to my plea for employees suited to the special tasks they would perform in an agency without precedent. Our independence was acknowledged, and we were permitted to move forward.

In the earliest days, there were five of us: Roger, his deputy, Luna Diamond, Frank Crowther, and Charles Mark. Luna had worked for

many years on the Hill for Senator Clinton Anderson. She was the executive secretary personified. At first Roger seemed to mistake her ubiquitous nature and her simultaneous attention in divergent directions for a lack of efficiency, but he came to realize with the rest of us that Luna could, in fact, move expeditiously on several fronts. She was indefatigable, only on rarest occasions in tears because of one complex problem piled atop another and another. Roger learned with some surprise, I believe, that Luna was married to a highly skilled but quite modestly reticent Washington lawyer and owned with him a number of race horses and a mansion-sized house in Bethesda. She was the smiling "Jewish mother," in her own words, of the National Council on the Arts. They were devoted to her, and she to them. She had an air of naiveté, but give her five scattered places in the United States where Roger Stevens had to be the next day and a tome listing all the conceivable domestic flights, and Luna would have it resolved within the hour.

Frank Crowther served a different purpose. Roger was taken by his extensive knowledge of the arts and by his use of language. A voracious reader himself, Roger enjoyed Frank's ability to recall the often apt, the often obscure quotation. I can remember visiting bookstores with Roger. He would select five or six volumes quickly and deftly, smile at one and say, "Frank will like this, too." The books would be finished and digested, frequently in half a week, and new ones would be sought. Frank wrote the speeches and Roger gave them; and while they may not all live in history, audiences knew that the chairman was well conversant with more of the arts than theater; and Frank's own education grew apace.

When we moved to our first proper quarters at 18th and G Streets in a building that housed the Madison National Bank, Roger moved with us, while keeping his White House alliances, including access to its telephone system, undoubtedly the most remarkable in the world. On occasion, when Roger was absent, Frank would sit at Roger's large desk and prop his feet on it, a position Luna found devoid of contagious amusement. Frank would say, "Luna, get me Greg Peck on the line." It always seemed to me a miracle how swiftly such a call could be made.

"Hello, Greg?" Frank would say. "Guess who this is?—It's Frank.—What's that?—Frank Crowther.—What?—No—Crowther. Frank Crowther.—You know, with Roger Stevens.—No, it's not Roger, it's Frank.—No, Frank Crowther." He would hang up angrily. "Bad connection," he would tell Luna. "No, never mind, I'll try later on."

"Isn't he awful?" Luna would say softly to me, but with a wink and a broad Luna smile, for in a way we admired the brashness and knew that some day the name would be recognized and the call completed.

* * *

Charles Mark came from the arts vineyards, nurtured in part by the Hanes consort of Winston-Salem, North Carolina. Chuck had a broad background in local and state arts activities, and Roger had employed him to help organize and develop the endowment's mandated partnership with the states. He and Roger often traveled together, talking with state leaders and incipient state leaders, assessing abilities and personalities, and mapping the future. Chuck was a man of parts: humorist, storyteller, accent imitator, statement writer, with a fund of knowledge in the area selected for his particular competence.

He and I wrote the first appropriations submission for the National Endowment for the Humanities together, each sharing ideas and sections. I had worked already on the arts documents, but the appointments for the Humanities Council had not been completed as the appropriations deadlines approached. It took us two sleepless consecutive days and nights, but it was essential for the sake of the combined arts and humanities endeavor to get the words on paper.

In those beginning months, Henry Allen Moe, venerated and brilliant head of the Guggenheim Foundation and an arbiter and spokesman for much of the cultural world in New York, had been named by President Johnson as interim chairman of the Humanities Endowment. But Barnaby Keeney would serve as the first permanent chairman as soon as his 1966 academic year commitments at Brown University finished in June. Barnaby had been far from forgotten—Lyndon Johnson and Tommy Corcoran made certain of that—but as the first appropriations hearings approached, Roger Stevens and Henry Moe were in charge.

Henry was in his senior years, a bit stooped but so sprightly of mind that one entirely overlooked his age. Wearing bedroom slippers for comfort, he used to come padding softly into my office on G Street with a shy smile and a supply of fresh anecdotes. His scholarship was always present, but no more so than his wit. By all odds he was one of the most delightful and wise individuals ever to have crossed these pathways.

He had one failing: he knew almost nothing about the inhabitants of Capitol Hill. "Bill Hungate," he would say to me, "now there's a man I like very much. Someone who really can help. I had dinner with him last night. He's a fountain of information." William Hungate came from Missouri, had served in the Congress for two years, and was assigned to the Judiciary Committee. I did not have the heart to tell Henry that these credentials did not suggest to me the source of ultimate power for the humanities. It seemed better to try to help him prepare in other ways.

The initial experiences with the appropriations process of the Congress were not filled with sweetness and light, or even with a modest, minimal helping of pleasure. They were again times of learning for me,

for the principals of the endowment, and to some degree for the principals on the Hill. The congressional atmosphere, however, was one where suspicions prevailed, coupled with efforts to comprehend what manner of new creature was abroad in hallways long accustomed to the more mundane.

In fairness, one cannot blame the Congress for such attitudes, either at the staff level or in higher echelons. This was indeed a new undertaking. Its like had never been seen before in this setting. It was one thing to support it conceptually, but now it was aprowl for the taxpayers' money. And the guardians—in the garments with which they are wont to cloak themselves—were alerted.

A few were especially on the alert. In these latter days of 1965, Roger Stevens had come under attack. The leader was William Widnall, a Republican conservative from the same state of New Jersey that had produced the liberal Frank Thompson. Bill Widnall may have lacked deep experience with the arts, but he had long been an observer of political practices in a state where practices of a questionable nature are not unknown; and he found it passing strange that Roger, as endowment chairman, advisor on the arts to the President, and chairman of the John F. Kennedy Center for the Performing Arts, would retain private theatrical interests in New York as well as membership on the board of the Metropolitan Opera. The Met's national touring company was in financial trouble, and funding from the endowment was a strong possibility. Bill Widnall sensed all manner of conflict of interest, and he made his interpretation public.

It could be mentioned here that, while the mixture of half-truth with innuendo is on occasion a congressional ally, the tactic was in its infancy as far as the arts were concerned. But this particular infant grew and developed and is still very much with us. Periodically, various evils are conjured up, only to fade and then spring forth again. Usually, but not always, they are the result of misunderstanding. The not-for-profit arts, after all, are hardly a fertile field for the reaping of administrative fortune. The endowment gives money to the arts; the reverse does not happen.

In World War II, en route from Staten Island to Suez to serve as a volunteer ambulance driver with the American Field Service, I had found myself living in unbelievable squalor aboard ship next to another volunteer, one Newbold Noyes. "Newbie" Noyes and I had become fast friends, the sharers of moments beyond forgetting, as the ship moved with astounding good fortune through lurking German submarines, nightly detected, from the East Coast of the U.S. to Trinidad, across the South Atlantic to Capetown, past Madagascar to Aden and into the Red Sea.

Newbold had gone on to become editor of the *Washington Star,* a newspaper that in these mid 1960s had profound influence on Washington life.

At the outset Newbold had been personally skeptical of the idea of government helping the arts, and of my work and efforts. When I was with Claiborne he had invited me to present the case to his editorial writers, columnists, and leading reporters. The *Star* had shouted no loud hurrahs, but neither had it voiced objection. I had introduced Roger to Newbold and had discussed Roger's difficulties. Claiborne had come to Roger's defense in a statement I had drafted during my final Senate days. In part it said: "I am sure he will continue to act with the greatest sense of propriety and integrity, . . . just as I believe he has in the past."

On October 11, the *Star* published a compelling editorial. It spoke of the congressional attacks and of Roger Stevens as "singled out by the fault-finders as a man who may be charged with conflict of interest between federal employment and private investment. The possibility, it seems, is that he may somehow be able to exploit his new job to advance his personal, non-governmental theatrical enterprises.

"This is bunk," said the editorial. "Mr. Stevens has been rendering distinguished service to the United States for some years past, ever since coming to Washington at President Kennedy's invitation. During most of these years, indeed, he has served without compensation, cheerfully losing money in the process of getting a kick out of trying to do something worthwhile for America's cultural advancement. . . . The Widnall group, instead of criticizing him, should hail the fact that a man of his stature is available to serve the country's best interest."

I have saved the editorial. It has a signature word, as if directed to me. "Bunk," I knew, was a special favorite of Newbold Noyes, when his anger rose against what seemed the pretentious or the false.

Chapter 28

A S THESE CLOUDS PARTLY SHIFTED, OTHERS REPLACED THEM ON CAP-itol Hill. The new endowment moved toward its first appropri-ations hearings in the House of Representatives, where with time-hon-ored tradition appropriations begin.

The National Foundation on the Arts and the Humanities was as-signed to the House Subcommittee on the Interior Department and Re-lated Agencies, a decision that demonstrated a certain ambivalence toward the fledgling agency, but a certain logic as well. An educational setting would have been preferable, it seemed—and nearer to the pur-poses involved—but the subcommittee was the appropriations home of the Smithsonian Institution. So it started for the foundation, and so it re-mained.

In 1966, much as today, the Interior Department dealt with geog-raphy and geographic names, fish and wildlife, land management, mines, national parks, reclamation, territories beyond U.S. borders, energy sources, recreation, grazing lands, and redwood forests. Congressmen sought membership on the subcommittee because of constituent interests in these areas. They learned to master a complex array of details—how a dam is constructed, how much a spillway costs in Oregon or a break-

water to halt beach erosion in South Carolina. Members of the subcommittee presided over a budget running to the billions. And here, all at once, was a foreign substance, with a request so small there was undoubtedly something wrong with it. The arts were cast out like dragon's teeth, but unlike the fable, were far from rooted in the ground.

The chairman of the subcommittee was Winfield Denton, with silvery hair and a patriarchal appearance, though of more modest size. Born in 1896, he had served in both world wars, emerging from the second, which he joined as a major at age forty-six, as a lieutenant colonel. He had practiced law since 1922 and had served in his state legislature. He was a Mason and an Elk. He had been in the U.S. House of Representatives more than fifteen years, representing a rural district at the southern tip of Indiana—as far removed as geographically possible from the intellectual environs focused around Notre Dame in John Brademas's district.

George Evans was the chairman's clerk. Dark-haired with broad features, George knew the subjects under the subcommittee's jurisdiction with the usual encyclopedic detail common to this special breed. Give him a question on a mine authorized twenty years earlier, and the reference would be at his fingertips. Give him or his chairman a question about the arts, and we had a tabula rasa. But we also had a clerk who had to provide his principal with inquiries as sagaciously phrased as those he was accustomed to imparting. Cost had always been the main factor involved, precise estimates, precise replies. George and I—for Roger had delegated congressional preparation to me—discussed our upcoming submission.

"But how much does this American Film Institute cost?" George asked. "How many dollars? You say it will be worth millions. But to whom, how many, who are they, where are they?" I would answer that we were only submitting plans, ideas without an absolute precision of detail. "With no detail whatever, if you ask me," George would say. "You think the chairman will approve something like this?"

"I hope so, George."

George would roll his eyes in disbelief. It was obvious he had a real beaut on his hands.

I vividly recall Roger presenting the testimony I had prepared with help from Chuck Mark and Frank Crowther. With all due modesty, it seemed quite eloquent. It spoke of our mandate, of its unprecedented nature, of the members of the National Council on the Arts and their excellent reputations. It discussed plans to help individual artists and not-for-profit arts institutions. It emphasized the enormity of the needs we perceived and the challenge to stimulate nonfederal support, of state ac-

tivities already well begun, of the expectations the arts world had for an effective beginning. There were so many things we could do, and these were a few priorities.

Roger read the statement, a bit short of twenty pages, with feeling—or at least with the feeling he can impart to the written word. He is happier without a text (unlike Claiborne Pell who feels a text is more essential. How else can he properly ad lib?). Like Claiborne, Roger is not particularly skilled as an orator. So, while there was feeling, while the words were well enunciated and while it was in no way akin to a clerk reading 435 names on the House floor, Roger's delivery might have been improvable.

The setting was at close quarters. On one side of a long table, some five feet wide, in a relatively small hearing room, sat Winfield Denton with George Evans to his right. Roger and I sat across from them. Others would participate from time to time, but at the moment these were the main characters.

We had reached about the lower one-third of page three when I noticed that the old chairman's eyes seemed a bit top-heavy and his chin seemed similarly inclined downward. Soon there was a sound of measured breathing, quiet but unmistakable. George Evans looked straight ahead, at a point on the wall, it seemed, midway between Roger and me.

"Is that man asleep?" Roger whispered suddenly to me, glancing up from his text.

"No, he's just thinking," I answered. "Please keep on reading."

I believe I saw George nudge the chairman very gently in the ribs. He opened his eyes brightly and stared enigmatically at Roger Stevens.

So it went page by page.

"He is asleep, I tell you," Roger said at about page eleven.

"I don't think so," I said softly.

At about page thirteen, Roger whispered, "It's insulting; I've never had this happen before."

"It's our first time," I suggested under my breath. "Just do the formalities. Please. You'll see."

"And so, in conclusion," Roger was saying, and it seemed George inserted the gentle elbow once again.

Instantly the chairman's eyes were open. Very skillfully—and I say so admiringly, for I had used a similar tactic in the Senate—a little white card was slipped almost invisibly below the level of the table, within the chairman's scrutiny.

"That was a most illuminating statement, Mr. Stevens," Winfield Denton was saying. "Thank you very much." He glanced down and then at Roger again. "On page four, I noticed you referred to the arts in edu-

cation. I wonder if you could expand a little on that subject for the record."

Roger looked abruptly surprised. "He wasn't asleep, after all," he whispered. "You were right." Aloud he said, "Of course, Mr. Chairman. I'd be happy to expand on that subject. It's close to my own heart and to the thinking of the council."

But the eyelids sagged once more, and the chin, until the elbow gently and swiftly repeated its task. Another card seemed to glide into place.

"Very interesting, Mr. Stevens," said the chairman. "Now on page seven, I note these words. . . . Would you care to give us perhaps a broader view—briefly, of course, but take your time."

Roger's expression during the following twenty minutes or so changed slowly from the quizzical to the indignant. His blue eyes, when he is fully roused, can—like the renowned Phantom of cartoon heroics—cause milk to curdle.

He leaned toward me, as the chairman was now concluding, and inquired if I thought it would be appropriate if he stood up and punched the gentleman in the nose.

"You're joking, of course," I said.

"Maybe I'm not," Roger said, eyes flashing long spears.

"It's my job," I said, "working with Congress. You gave it to me— let me try."

Roger gave me a long look and departed.

I shook hands with George and thanked him as politely as possible. He smiled wryly and rolled his eyes toward the ceiling without comment. I followed Winfield Denton into the corridor outside the hearing room. He moved ahead of me slowly, at what might be called a meditative pace. Once in years gone by I had seen a film in which a princely ruler had learned after long practice how to go to sleep with his eyes open while attending theatrical performances in the royal box. It came to me that perhaps the congressman had seen it.

I touched the sleeve of his suit jacket. He paused and half-turned. He looked a bit rumpled, larger than when he was sitting at the table.

"Excuse me, Mr Chairman," I said, "but I just wanted a word with you."

He seemed unrecognizing.

"I was in the hearing," I said.

"What hearing was that?" he inquired mildly.

"The one on the arts," I told him.

His eyes snapped open wide, below the broad forehead and silver hair.

"Well, let me tell you one thing, young man," he responded in a voice abruptly strong. "That's the biggest boondoggle I've come across in a long time. If I have anything at all to do with it, it won't get a cent."

If Moses had suddenly appeared in a cloud of flame and smoke, taken all his tablets, smashed them on the floor, and loudly intoned, "All right—you can all go home!" I could not have felt more stricken. Not only did Winfield Denton have something to do with it; he was it. In his hands was success or failure. Let the chairman of an appropriations sub-committee strongly recommend zero, and zero it was likely to be for some time. Even a Frank Thompson could not intervene in the process now. He was chairman of the authorizing subcommittee; he was not on appropriations. Then as now, a friendly appropriations chairman can work wonders; an unfriendly one can pull the plug. I was aghast at the thought that, at the very threshold of life, we could be so expunged. And I was grateful that Roger was not present for the conversation.

"Zero?" I repeated.

He affirmed that assessment emphatically and added that our ability to write a proper proposal was worthy of approximately the same rating.

I said, "Mr. Chairman, I have spent most of my life in the arts. I worked very hard on the enabling legislation for this program. I feel dedicated to the arts. I think they're vitally important. Would it be possible for you to see me in your office for just a few minutes?"

"Definitely not now," he said.

"I didn't mean now. I mean someday soon, at your convenience."

He gazed at me solemnly. "It won't do you any good, young man," he said.

"Would you permit it, though?" I asked.

"Well—" he shrugged his wide shoulders. "I never turn down anyone who asks to see me. Remember, five minutes, only. No more. And not now. And it won't do you any good at all." I made an appointment as soon as I reached my telephone.

He had many problems in his district, he told me—improved roads, rural communication, milk for schoolchildren. What had the arts to do with any of it?

But he allowed me another visit after the first five minutes had ended, and a third visit, and a fourth. He was always the same—brusque, matter-of-fact, never impolite, never in any way yielding. Our conversations were short. I told him of my experiences in the arts; he told me about his district and its poverty. "I told you it wouldn't do you any good," he would repeat when we said goodbye.

But then one day when I entered his office, I remember him smil-

ing, for the first time, it seemed. He said, "Biddle, come on back here. I have something to tell you." It was the first time he had called me by name, and for the first time he took me into his private office.

"As you probably know," he began, "I'm running for reelection."

"It has not escaped my attention, Mr. Chairman," I said.

The past weekend, he continued, he'd been out in his district traveling the country roads in his old car. Suddenly, one of these narrow winding roads came to a fork. Off to the right was a narrower dirt track. At the beginning of its descent, scrawled in block lettering, was a small sign. It said, "Art Auction."

He was about to pass by, but stopped and backed up. "I thought to myself," he said, "I owe it to that fellow Biddle, who's been trying to brainwash me for weeks, to see just what's down there."

The car descended a steep hill. "And there at the bottom was an old barn," said the chairman, "a big one."

He went inside. "Facing me, on the opposite wall," he said, "was a picture. A painting of another old barn. And would you believe it? It looked exactly like the one on my grandmother's place when I was a boy growing up. Same kind of roof, same shape."

He approached the painting. There was a price tag just below.

"It said five dollars," he told me. "And I said, 'Who did this painting?' And this young man stood up. He had long hair and he had on blue jeans, and it looked like he hadn't washed for a while. But I had a five-dollar bill in my pocket, and I gave it to him, and he took the painting off the wall and gave it to me."

He paused, watching my face. "Now, here's the interesting thing, Biddle," he said. "There must have been two hundred people in that place. I hadn't noticed how many at all, and one by one they came up to me and they said, 'Congressman, we've known you for years and years, but we never thought we'd live to see the day when you bought a painting.'"

His smile broadened suddenly. "You're right, Biddle," he said. "You're absolutely right! There are *votes* in this!"

And a bit later: "Seriously," he said. "You worked for Pell all that time. What kind of stuff did you write for him? I'll bet the arts aren't any more popular in Rhode Island than they are where I live in Indiana. What kind of speech does he give?"

"It's a fairly simple one," I said. "It traces achievements, artistic ones, over the centuries. It has alliteration. Senator Pell likes that."

"Maybe you could do something like that for me," he said. "Let's hear how it goes. Try it out."

"It starts out like this, Mr. Chairman," I told him. "What do we

think of when we think of ancient Egypt? Do we remember the names of the long line of Pharaohs and Ptolemys, all their battles with each other—or do we remember the great architectural triumph of the Pyramids?" I gave the P's a little extra stress.

"Go on," said the chairman.

"What do we think of when we think of ancient Greece? Do we recall in detail all the wars between Athens and Sparta—or do we remember most of all the Acropolis and the Parthenon?"

"What was the first one again?" the chairman asked.

"The Acropolis. That's where the Parthenon is," I replied.

"Let's just go with the Parthenon," he said.

I decided to skip that special reference of Claiborne's, as a student of history, to times of the Renaissance—do we best recall the abiding work of Giotto or the conflicts between the Guelphs and Ghibbilines?—and move on to the Elizabethan era.

"Do we remember all the dukes and standard-bearers surrounding the Queen—or the poetry of John Donne and William Shakespeare?"

"I think we'll just go with Shakespeare," said the chairman after a moment's reflection.

What a wonderful image to recall after all these years: this venerable gentleman from rural Indiana striding forth to challenge doubting Thomases on the arts with a question on ancient Egypt, Greece, and the Bard of Avon. Perhaps best of all is the image of their astonished faces awaiting his replies.

The Arts Endowment grew from $2.5 million in funding for the first nine months of its existence to $4 million for its next full year, with an additional $2 million to commence the federal-state partnership and almost $2 million more to match those unrestricted gifts, that so-called "funny money." It was not a bonanza—it was pitifully small in relation to unmet needs—but neither was it zero.

Chapter 29

TARRYTOWN HOUSE—HIGH ABOVE THE BANKS OF NEW YORK'S HUDSON River and close to the former abode of America's nineteenth-century literary giant, Washington Irving—became the favorite meeting place of the National Council on the Arts.

It was organized as a "think tank," in contemporary parlance, for discussions and reflection by a limited number of visitors, accommodated in rooms of both size and charm. There were upstairs balconies and wide windows and a great quintuple-arched facade of porch below, with stone balustrades, an expanse of tile flooring, and steps leading down to lawns from which rose huge evergreens and beech and maple trees. There were fountains and Grecian columns and statues of cherubs, and of maidens both long-robed and unrobed. Built of the sturdiest stone, the house was topped by broad chimneys, gabled stone triangles, battlemented borderings to the roof. Fixtures in one bathroom were of gold. The house was originally a gift from a wife to a husband in the early years of the twentieth century.

There was a large swimming pool, sheltered by one side of the house, with a wooded bank at the end. One morning, just after sunrise, I was beside the pool for a plunge, alone except for an aged caretaker

who sifted leaves from the water with a long-handled heavy implement, equipped with stout prongs.

"You see that bank over there?" he asked me. I nodded.

"That's where I used to sit," he said in a mournful voice, "when she swam. In case she had a cramp or something."

"Who was that?" I asked, preparing to dive.

"Why herself—who else?" he replied. "Poor darling. Poor woman, indeed. Up and down, up and down. Back and forth, after he left, sometimes all night. If ever I should meet one of his family, I'd bust him with this." He lifted the rake ponderously. "I'd bust him for keeps."

It was the first time I'd heard, at first hand, the sad tale of this marital ending. Yet I knew of it from other interpretations, for the husband was my uncle Anthony Biddle's son Tony, and "herself" was his first wife, Mary Duke Biddle.

There were happier times. A story repeated in family circles as I grew up described my uncle's two children—born far ahead of me (my own father married relatively late in life)—and their weddings to members of the extraordinarily wealthy Duke family of North Carolina. Biddle sister and brother had married Duke brother and sister. Cordelia Biddle and Angier Duke were of an age; Tony and his Mary were not. It seemed, as the story was invariably unfolded, that young Tony was a student at St. Paul's boarding school in Concord, New Hampshire, when he and Mary first fancied each other. Young Tony was a superior athlete, and he went on to fame and high-ranking positions and even greater fortune in later days. But on this one day he was the star right fielder for the St. Paul's baseball nine. Each afternoon, out beyond the playing area, spectators had observed a parked Rolls Royce. On the day in question, Tony Biddle trotted once again to his right-field post, and trotted on and on until he reached the great automobile. So ended his days at St. Paul's, and so they began at Tarrytown.

I did not linger, however, on the early morning of my brief swim to recount this tale to the caretaker. It would have found no sympathetic ear.

Nevertheless, Tarrytown House had for me a feeling of personal nostalgia, a time when a house of this size was an accepted and unquestioned part of a protected background. If there had been madeleines and afternoon tea served on the terrace and porch, I could easily have continued readings of Marcel Proust, begun at college. I have been back to Tarrytown House since that period, and I still find it beckons me toward childhood and adolescence, as well as toward those special memories of a wholly new assemblage of the currently illustrious.

It was a remarkable experience to sit at the end of a long polished

table in these surroundings and watch this first National Council on the Arts deliberate. One became aware of gestures. Isaac Stern usually sat next to Agnes de Mille, with hair turning from blond toward white. Both wore heavy framed glasses. When both pairs were raised, as if instinctively, above eye level and placed atop heads of hair, one knew verbal sparks were about to fly.

"How can you possibly say a thing like that, Isaac?"

"Agnes, could you possibly be so misinformed?"

Elizabeth Ashley usually sat at the opposite end of the table from Roger and Chuck Mark and me. Elizabeth married the actor George Peppard and showed at moments the temperament that was later to grace and excite the stage writings of Tennessee Williams. Phil Hanes usually waited until the last moment before objecting in a quiet but high voice with deep southern lineages. He was seated at the start next to Agnes, who gave him both questioning (in the sense of who on earth is this?) and critical stares. "Bush" Brown, the architect and educator, and Rene d'Harnoncourt, champion of modern art, were usually voices of moderation and reason. Minoru Yamasaki, designer of much-praised buildings, had a pixiesh quality and always a bright intelligence. Lenny Bernstein was deferred to. Greg Peck spoke with such a marvelously resonant diction that the room fell silent when he cleared his throat to begin. Stanley Young, with a great round, mustachioed, Falstaffian countenance, was the council humorist. Paul Engle, the peerless teacher of creative writing in Iowa, spoke with poetic phrasing wrapped in witty allusion.

This council enjoyed Tarrytown because of the privacy it afforded them and the quick opportunities for camaraderie. The press was not present. At first there were no official written minutes. Roger simply had a tape recorder turned on, in a room acoustically so equipped for verbatim transcription. No one felt the walls were listening, however; the personal give-and-take were what mattered. Posterity would judge actions, not words.

But how uninitiated we were to the ways of government! Before half a year elapsed, here was an investigator at the door of my 1800 G Street Office. The Congress would like a full accounting of the National Council's meetings. How were its decisions reached? I explained that the council made recommendations, not decisions. The eyes grew shrewd as if sensing evasion. All right, where were the minutes?

I asked Roger his pleasure. "Just give them the tapes," he said in dismissal. I played one for him. It began, "If you really want to know what I think of—" (the congressman's name is omitted to protect the innocent).

"On second thought, don't give them the tapes," Roger said. "Just write some minutes, Liv."

It took many days with hours of attentive listening and editing, but this congressional investigation went away. From thence forward, minutes, not tapes, were carefully preserved.

Evenings at Tarrytown House were spent in what the management called the "pub-and-club" area, which passed in more generalized terms as the bar. The bar itself was discreetly short, decorated in one corner by a potted fern and a large, brass-ornamented, wood-encased pitcher, which could have been an antique flagon with contemporary adjustments. Polished brass was visible on trays and coffee urns behind the bar proper. There were whitened brick columns, strong and functional tables, chairs with wide-curving wooden arms and carved supports, light fixtures with tall hurricane globes. Sofas were of deep brown leather. Early American was the motif tastefully and comfortably followed. Just beyond was a billiard room, infrequently used, though the green felt surfaces were visible through an archway.

In these quarters the council continued the business of the day. Late-stayers were known to leave the premises after three in the morning, and Roger said more than once that he felt decisions were reached more after hours than during the long daily sessions. It was not that we were a hardy lot of imbibers, although the mid-1960s were before the days of Perrier and lime. To an objective observer the conversations would have sounded just as lucid after midnight as before. It seemed to me more and more that the interest was in a task that none of the participants had undertaken or shared before. There was an equality among these members. Some had experienced fame and attention more than others, but they were all undeniably representative of achievement. They all loved the arts. There was passion in that love, so their viewpoints were emphatically expressed. They were partisan to the art forms they best knew, and yet before long, here was Isaac Stern discussing needs for literature and Ralph Ellison discussing how to improve opportunities in chamber music.

When I think of the late-stayers, and the late-late-stayers, invariably I think of Ralph Ellison. Those who have read his *Invisible Man* know of the depth of his feelings and his masterful use of words. Roger and I and a few others would stay, often in the same corner of the bar, to be instructed, educated, entertained. The conversation was on weighty subjects—the emerging black voice in American society—but if there was a hint of friction present, it was not intended. We were friends in a temporarily isolated spot in the universe. This temporary quality made it all the more important that we come to full understanding.

Of us all, I think of Roger as the best listener. Perhaps he perceived his post in this manner. Some would maintain that he fancies

and practices the cryptic rather than the extended personal view of reminiscence. Others would suggest that words spoken in "Rogerese" mask an inability to pursue thoughts in a well-articulated fashion. Not so. For Roger, listening was not a restful expedient. His mind, as I have known it for many years, is ceaselessly occupied. At noon or 3:00 a.m., Roger's thoughts are his secret; the often sphinxlike expression rarely reveals more than a fraction of what is going on. But a sphinx is noted for being a marvelous listener, absorbing all it hears.

Roger was given a gavel to help him conduct council meetings. It was probably made of oak, for although it was of somewhat modest size, it made a loud crack when struck even lightly. I remember Roger holding the gavel against his cheek, undoubtedly helping the wood's patina, but unaware of it, sometimes leaning forward, sometimes back, his eyes always intent on the speaker. I do not recall the gavel being struck to maintain order, just at adjournment when a part of the day ended. If ever there was a fear that a "cultural czar" would outspeak and thus dominate members of a National Council, this chairman was refutation. And yet there was a presence. No one missed it. Only once do I remember that presence being taken completely by surprise.

We were having dinner at Tarrytown in a room that could be called baronial without overstatement. Many members of the council were still new to each other in terms of personalities and intimate likes and dislikes; close friendships were yet to be forged. It was like guests assembled at a British manse for a weekend. Conversation was polite and a bit spasmodic.

Tarrytown House was not exactly Twenty-One. We were on a government budget, and the cost of everything had been carefully negotiated. The management liked the clientele. We liked the management's price. What the food may have lacked in variety was overshadowed by the style of its presentation.

We were nearing the end of the meal when Roger announced that his good friend McNeil Lowry would be speaking to the council, sharing his expertise, providing some advice from the vantage point of the Ford Foundation's vice-president for humanities and the arts. Mac had arrived, forgiving of Biddle errors no matter how seemingly egregious at the time, forgiving of moments of critical disagreement in Frank Thompson's office, forgiving even of a Kermit Gordon and an intransigent Bureau of the Budget. Bygones were to be bygones tonight. The emphasis was on the future, not the past.

Most of the council members knew Mac Lowry. Some had shared in his largesse. His budget was $80 million per year, in large degree slated to help the Nation's major orchestras. We could hardly compete;

but we sat back to hear a scholarly voice, beginning in the familiar modulated tones.

I never knew what set it off exactly. I suspect it was something in the manner of speech, and unquestionably it had private relationships to the past. Mac was halfway through approximately paragraph five when the usually reticent and mild-mannered George Stevens—of film-making renown, sensitive in my earlier brief encounters with him—was on his feet at the opposite end of the long table.

What presumption, he appeared to inquire, had brought his man among us? What condescension was motivating these opening remarks? Was it possible there was some vast misunderstanding? Was it possible Mr. Lowry totally misunderstood the endowment's mandate and purpose? Was it possible for anyone to pontificate in a fashion so at odds with common sense?

And that was the time, and the only time in my memory, when Roger looked surprised at Tarrytown. He was not alone. There was complete silence at the table. Mac had halted in mid-sentence, his face almost the hue of his white shock of hair.

No one said, "Oh, come on now, George—for heaven's sake!" or made any like platitudinous, restraining comment. There was just absolute silence.

It was interrupted by the apparent sound of George's torso contacting the surface of the dining room table—where for a few seconds longer he remained, until Stanley Young and a couple of others wafted him, all at once, from the dining room.

Mac Lowry sat down next to Roger—and still there was silence. It was as if we were all in slow motion. No one spoke until the door suddenly opened.

Stanley Young pushed in front of him Agnes de Mille, wearing on her head a napkin folded in a white triangle. "Nurse de Mille," Stanley said, "reports no cause for alarm. The patient is resting comfortably."

The tension was broken. Stanley was laughing, and so were others, watching Agnes resume her seat. Normalcy returned, and a convivial mood. Mac completed his remarks. The next morning he and George shook hands. "He wasn't even in the bar," Roger said.

It was assumed that George had reason for his outburst and its delivery. He kept it to himself, and no one inquired. His international renown, his excellence in the arts were not a whit diminished. It was an episode, however, that I think brought that beginning council into greater harmony. No one thought the worse of George. He was part of a small family, developing close ties.

Chapter 30

THE ENDOWMENT'S STAFF GREW SLOWLY. DAVID STEWART, ARTS CONSULT-
ant for the American Council on Education, who had completed a
comprehensive national study of the teaching of film and filmmaking at
the college level, became the first director of the Education and Public
Media Programs. Ruth Mayleas came from the American National Thea-
ter and Academy to direct both the Theater and Dance Programs. Caro-
lyn Kizer, a well-known poet and editor of *Poetry Northwest* in Oregon,
was named to direct the Literature Program. Fannie Taylor moved from
the University of Wisconsin to direct projects in music. Paul Spreiregen
came from the directorship of urban programs at the American Institute
of Architects to serve as director for programs concerned with architec-
ture and design. June Arey came from North Carolina and administrative
experience with community arts programs to help the grants process in
its beginnings. And Henry Geldzahler, curator of American art and sculp-
ture at New York's Metropolitan Museum of Art, arrived to direct the
visual arts areas.

Program directors reported to the chairman and deputy and were
responsible for the faithful carrying out of recommendations made by
the National Council. As with the council itself, the staff was part of an

evolving close-knit family. Early directors, courtesy of John Macy, were exempt from the usual civil service selection process. They were recruited from among those suggested by council members, leading arts organizations, and individual artists. There was a growing excitement about working for the new National Endowment for the Arts. Applications for jobs were almost as numerous in the beginning as the flood of applications for endowment help. I usually conducted preliminary interviews, and then the apparently best qualified went to Roger.

I recall the day he interviewed Henry Geldzahler, who had been highly recommended by James Rorimer, director of the Metropolitan. Henry arrived at 1800 G Street wearing a white linen suit and a large-brimmed white hat. He was smoking, as was his habit, an expensive cigar of exceptional length. At that time I was showing a congressman our new offices, trying to demonstrate how effectively all the available space was utilized. We passed Roger's open door. An apparition in purest white on white was seated at Roger's desk, a trail of smoke drifting upward. Startled, the congressman gazed for a moment through the doorway before I moved him on. I expected the question, "Who is that?" but it was different. "Just *what* is that?" asked the congressman, in a tone mixing incredulity with a certain awe.

But in addition to his eccentricities Henry had the rare spark of genius, and I have concluded over the years that without eccentricity the arts would seem mundane. I am not referring necessarily to eccentricity connected with a lifestyle, but to originality, to daring to achieve the original.

Eccentricity so defined is the enemy of sameness and the friend of the questioning explorer. Eccentricity and individuality are in part allies.

At the endowment we were assembling talent and our own complement of personalities. David Stewart was mild and logical; Carolyn Kizer, outspoken and emotional: she would go to the barricades for a good writer. Fannie Taylor, bright and petite, knew the inner workings of the music world; Ruth Mayleas, tall and statuesque, was the same for theater. Paul Spreiregen seemed to have a grave demeanor, but an especially sophisticated wit lurked in those serious eyes. June Arey spoke with the slow accent of the South, but demonstrated a quick and professional efficiency. Starke Meyer, with an excellent background of government experience, assisted in transcribing our council meetings and in the visual arts. And there was swashbuckling, red-haired Diana Prior-Palmer, from an international arts background, whose accent reminded me of my days with the British army.

There were personality conflicts—big ones and small ones. An ex-

ample of the latter was a dispute between two efficient program aides who had adjacent desks. Over one was a reproduction of three ducks of varying sizes leaving a small pond below a mill with thatched roof and waterwheel. Above the other desk was a reproduction of a full-blown Modigliani nude. Neither could stand the sight of the other's decoration, and there was no room to move. Tears were shed and threats made and the reproductions began to take on symbols of inner character: know-nothing sentimentalist, lascivious panderer. I directed that both works be removed and was thereby accused, as I had anticipated, of gross and unfeeling censorship. The works were reinstalled, and all was well.

We were fortunate in those early days to receive a genuine print by Robert Motherwell. The famed artist was visiting our offices one after-noon and remarked to Roger and me that the walls of Roger's office seemed exceedingly bare.

"How can you call yourself an Arts Endowment?" Bob asked. "Where's the art?"

"Why don't you give us some?" Roger inquired.

Bob Motherwell paused, eyeing Roger archly. He was not the first, or the last, but he had been caught.

"Okay," he said after a moment or two, "it's a deal."

Not long afterward, a large, flat, rectangular package arrived, wrapped in brown paper. We removed the paper and the yards of tape, the heavy cardboard, the lighter pieces precisely cut and fitted—and there, elegantly framed, was a Robert Motherwell.

Roger was delighted. I carried it around while he selected the best location. "Not in my office," he said. "It won't be seen enough. We'll put it here, in the reception room. Everyone who comes in, for any reason whatever, will see it then, and it will say to them—the arts."

Roger chose the place carefully after he had sent me off for wire, a hammer, a hook, and a nail.

"Right there," he said as I held it aloft. "Perfect."

Bob came into our quarters again about two weeks later. Roger came from his office to greet him.

"Well, how do you like it?" he asked.

"It's very nice," said Bob, "only there's one slight improvement I'd suggest."

"What's that?" Roger asked, surprised.

Bob walked to the wall and turned the print very slowly upside down from the way it was hung.

Roger blinked without expression.

"Livy!" he said. "Didn't I tell you?"

* * *

Sureva Seligson came aboard to begin research endeavors, and in those first months she hired Ana Steele as a research assistant. Ana was slender and blue eyed, and it seemed that nothing was too much trouble for her. Of those early employees, pioneers themselves on another Conestoga wagon voyage heading west for far-off mountains, Ana alone remains today, as chief overseer of endowment planning. She is now married to John Clark, who arrived later and was titled secretary to the National Council. This was a more complex job than in Luna Diamond's early times, for there were now many committee meetings to arrange in addition to those of the council itself. But there is Ana, still willing to work the late hours, as she did for Roger, for Nancy Hanks, and for me.

From those early times mention should be made of Charlotte Woolard—blond with bright blue eyes, knowledgeable about government, having worked for Vice-President Humphrey. Charlotte was a whirlwind of activity, always cheerful and, in the fashion of those other first employees, willing to pitch in whenever needed and meet deadlines as they arose, quite frequently after regular hours. Charlotte was assigned to the chairman's office and took a desk near Luna Diamond. Charlotte is now an executive of the Kennedy Center, still with Roger Stevens, still keeping up with a demanding schedule. Luna has retired; but when we meet, nostalgic references are always exchanged.

There were also Rosa Keatts, working for Chuck Mark and the states with special dedication, and Anne Frailey, Virginia-accented feminine utility infielder, assigned a variety of chores all excellently accomplished; she was later to marry the distinguished Washington attorney, Marvin Braverman.

The phrase "esprit de corps" seems to apply best to a young organization. It does not really matter how divergent the personalities. Esprit de corps can help. I learned that during the war with the American Field Service and in my platoon of volunteer ambulance drivers. They were as divergent in viewpoint and background as one could imagine, but they worked together because they fully believed in the task at hand. So did this staff.

Charles Ruttenberg, the endowment's first general counsel, came from considerable experience in private law practice and with the National Science Foundation. Others have followed in his footsteps, but he set a special early example, combining imagination with acumen. We discussed the legislation at length, especially its openness toward new endeavors. "Thank God it was written primarily by a novelist and not by a lawyer," Chuck would say to me (I believe he was the first to make this

observation), and we would examine together the language of the Senate report as it related to congressional intent.

"The thing I like best about Chuck Ruttenberg," Roger Stevens confided, "is that he doesn't explain to you why something can't be done and quote to you from all those volumes he has in his office. He tells you how it *can* be done." It was true. The unprecedented in action became fitting companion for the unprecedented in legislated mission.

Charles and I worked on a number of "modifications," a Washington euphemism for bending the technicalities of a law without breaking it. As in physics, if the bending is done properly, with due regard for tensile strengths, sometimes a basic framework is not weakened but strengthened. So it was with the unrestricted gift section of our Public Law 89-209.

The federal appropriations authorized to match unrestricted gifts made to the endowment had been jokingly termed "funny money" at the Bureau of the Budget. The humor perceived a distinct possibility that no one in his right mind would make an unrestricted gift to the U.S. government and its new arts program, no matter how tax deductible it might be. Let the government decide on the expenditure of an individual's private philanthropy, carte blanche, no questions asked? In some circles the prospect indeed suggested comedy. The forecasts proved correct. In those beginning months, gifts of this nature were noticeably sparse.

But this posed a challenge. It was a time for imagination, not regrets. How could an unrestricted gift be transformed into a restricted one and be within the law? How could a legal process be devised to allow the prospective donor his choice? The donor would be a private citizen. Was not the National Council on the Arts composed of private citizens? Suppose the council advised its chairman on the priority of the gifts that might be received? The council's advisory position would take on a special importance in this case, for remember: The council could not mandate the use of funds and thus become the funding arm of government. But the council could suggest or recommend, and its recommendations could be made known. Should unrestricted gifts to the National Endowment for the Arts be made, our announcement declared, they would follow priorities recommended by the National Council on the Arts. The invisible became visible. Donors could choose among several alternatives; they could also make their own suggestions, which the council could consider and, if it so decided, also recommend.

Some told me it was a ruse; but after all, if you have prepared legislation you may also be privileged to help in its application. Charles Ruttenberg called it legal. Roger Stevens called it legal. And the Congress agreed. In fact, some chuckling was reported on the Hill toward a new

agency that had shown such early legalistic imagination. No laughter was reported from the Bureau of the Budget. Gifts began increasing. They were "unrestricted," of course, given to the National Endowment for the Arts, but they followed scrupulously the priorities announced by the council. The gift problem disappeared. It has never returned, for the Congress, in its wisdom, in due course amended the law to permit federal appropriations to match both restricted and *unrestricted* gifts made to the endowment.

As the staff grew in experience, there was a persistent lack: in the area of administration and the issuance of paychecks and the keeping of financial data in approved governmental form. At first the General Services Administration took care of such technical yet highly important matters as records on the expenditure of federal funds, grants, and salaries. The salaries seemed reasonably routine, and only once did an employee receive a check with three extra zeros inadvertently added to it. (Fortunately, he considered it a great curiosity rather than a possible bonanza, and the matter was speedily rectified.)

The GSA oversees sums of money so vast that the National Endowment for the Arts was hardly more than a momentary blip. Each week they issued us a taped accounting. To me, the problem was that the tape showed only one figure—dollars spent. There was no itemization. Taking my deputy's responsibilities earnestly, I kept from the outset my own log, on long lined sheets of yellow paper, recording every expenditure from pencils and erasers to the larger sums for support of arts organizations. If we were to spend nearly $3 million, including administrative costs, in a fiscal year, it seemed to me vital that I know, with precision and itemization, where the taxpayer's dollars were going.

I encountered a difficulty. My log did not agree with the tape. At first I assumed that the discrepancy was caused by a difference in timing. I consulted Robert Cox, whose experience included important positions with the Bureau of the Budget, the Department of Health, Education, and Welfare, and the Federal Communications Commission. He was now on our staff, making plans for the endowment to organize and run its own administrative services.

Bob appeared to me immensely well informed about the ways of the government's executive branch. One wall of his office was lined with manuals he had authored or coauthored. He seemed somewhat bemused by my yellow sheets. "Let the GSA do it," he counseled. "You're right, it's just the timing of things. My God, think of all the figures they keep. Think of all the computers."

I did. Computers were then on their way up in government. "Wait

'til we have our own," Bob said. "They could do all those sheets you have in seconds."

"I'd like to find the computer that does our work," I told him.

He raised dark, bushy eyebrows and gave me a half-smile. "That may not be easy, you know."

"I'd like for you to arrange it, if you can, Bob," I said.

I'm sure it was not his favorite assignment, but within a week he reported success. Somewhere in the labyrinths of GSA was a computer which, as a minuscule portion of its work, usually handled the endowment.

"And an operator?" I asked.

"And an operator," he replied.

I made an appointment to see her in the strange land where she worked. I explained my difficulties. She regarded the yellow sheets with barely concealed incredulity.

"What are these?" she asked.

I explained my own accounting system. "I wasn't ever too good at addition," I said, "but I've been over these figures so many times, I'm positive they're accurate."

"Manual work like that went out years ago," she said, handing me back the papers.

"I know," I said, "but it's my own way."

"Don't you have a machine?"

"We have an adding machine," I said. "But I really trust these. Would you do me a favor?" I asked. "Just do these top three pages. See if I'm wrong."

Her eyes told me that she was thinking perhaps if she humored this unusual deputy chairman from a Civil War period, he would go away. She took the three sheets quickly and set them forth with the most amazing dexterity of fingers I've ever witnessed. Perhaps seven seconds had elapsed.

She looked at her total, smiling. "Machines," she said, "do not lie."

So there it was—the modern Bob Cratchit, totting up figures in a dark Dickensian room, or Uriah Heep, that paragon of green-eyeshaded accountants, had been caught in error.

I was honestly shaken. I would not have believed it. I looked at her total, then mine, her figures, then mine. And a strange thing occurred. I noticed that my figure for stamps, $17.36, appeared on her printout as $13.76, and a dozen rows further my $205.79 was her $257.09.

I showed her these vagaries. She looked at them as if they related to some odd happening on another planet.

"But machines do not lie," she repeated with greater emphasis than before, and stood studying the figures over and over and over, so loath was she to believe that a machine capable of such wizardry could not correct the possibility of errant human fingers.

I am not suggesting here that we revert to the Bob Cratchits and the Uriah Heeps and the green eyeshades. Computers are here to stay, for better or worse, allegedly our most staunch technical allies. The endowment now has its own, in a separate large chamber. It was run by a small gentleman from East Asia, so alert, so full of sparkle that sometimes it seemed to me that he must enter the machine when no one else was around and quietly cajole its circuits and disks into perfect operation.

I must admit, however, that whenever a small digital mechanism comes from someone's pocket to multiply five numbers by five other ones or take a percentage, I feel a sudden twinge of anxiety for the old yellow sheets. Perhaps it's because I do my own writing on them, longhand, and always have.

Chapter 31

ONCENTRATING ITS LIMITED—SOME MIGHT SAY MEAGER—RESOURCES ON pilot projects, which could later be expanded into major programs, became a hallmark of the early work of the National Endowment for the Arts. Undertaken with spirit and conviction, so many of them became the sources for continuing efforts. The National Council on the Arts felt comfortable with this approach. It allowed full scope for imagination and for looking ahead toward a time when funding would grow. The "pilots" had to be soundly conceived because any failure at this stage would open the new endeavor to serious vulnerability. The overriding philosophy set forth in the basic legislation—the support of artistic excellence and making it more and more available to the people of our country—guided the first National Council, the first innovators with the tabula rasa before them. And yet sometimes overlooked are the details of the trail they blazed, the bark they uncovered for others to see, for their narrow trail in the course of a relatively short span in our history became an avenue with the early markings gone.

The Laboratory Theater Project for Education began. We shared in its design. Of all the pilots it was the most ambitious, for it was conceived as a partnership between a small endowment and a far more gen-

213

erously funded Arts and Humanities Branch of the U.S. Office of
Education, whose commissioner was the enlightened Francis Keppel. The
head of the Arts and Humanities Branch was Kathryn Bloom, slender,
with wide-set brown eyes, boundless energy, and a sharp mind. In those
days the accomplished female executive was not as prevalent as today;
equal rights had not yet illumined horizons. Kathryn Bloom epitomized
effectiveness; and Norman Eddy, her assistant, an educator's sense of
caring.

The concept for the project was new. We would take up to three
important cities, each of which had a potentially sophisticated audience
but no live theater of any great quality, and create in each city classic
theater of particular excellence. New Orleans and Providence were se-
lected to start the project, with Los Angeles as a third possibility.

What could the small endowment contribute to the Arts and Hu-
manities Branch? The answer related to legislative mandates—a stricter,
more circumscribed surround for the larger entity, a freer, more permis-
sive one for the smaller. As I had drafted it, as it had been enacted,
P.L.89-209 allowed for the endowment to work in ways the Arts and Hu-
manities Branch could not—in this instance, to fund the start-up costs
for an enterprise not heretofore attempted by government.

The endowment would provide funding for the professional direc-
tors, the professional actors, the costs of rehearsals, sets, designers, light-
ing experts, and so forth. After the curtain rose on opening night the
Office of Education would continue support. The endowment's share
would be approximately $165,000 per city. The total project would cost
in excess of one million dollars.

The emphasis was primarily on education. School pupils would be
bussed to the theater from all nearby areas. In Rhode Island, this would
mean virtually all the schools in the state would be involved. Louisiana
was less compact, but all parishes in a wide New Orleans area were to
participate. The students would be taught about the plays they would
see—primarily Shakespeare—in the classroom before and after experi-
encing the live matinee shows. In the evening, parents and an adult au-
dience could attend.

Said the Associated Press, "The biggest theatrical angel this season
isn't on Broadway—but in Washington. He is Uncle Sam, backing with
$1 million a multipurpose test of drama in education. . . . Taking part, in
a rare display of agency togetherness, are the National Endowment for
the Arts, the United States Office of Education and state and local school
boards. . . . It is the first time that two federal units have meshed efforts
and cash in the cause of culture."

In Providence, under the direction of Adrian Hall, the Trinity
Square Repertory Company was developed. Thousands of schoolchildren

saw the performances. Trinity Square is very much alive today, enriching the state with productions of high quality. Smaller groups have also formed, and the magic charm of theater has spread. Perhaps to Roger Stevens, the best compliment came from one young student who, when asked how the project appealed to him, replied, "I like it better than television." Obviously, in the development of theater in Rhode Island, parents had to come to see what so beguiled their children.

The first experience in New Orleans, under the artistic direction of Stuart Vaughan, was a bit different. During an early performance we received an emergency call from the theater. It seemed the actors could neither hear their lines nor project them, for the entire audience was munching on popcorn and crumpling the paper containers. Machinery and dispensers had just been placed in the lobby to make all this conveniently possible. It turned out that one of the city's cultural leaders, affiliated with the project, had a considerable interest in the manufacture of popcorn; this daily capacity matinee audience of possible consumers provided unexpected advantages. The actors shouted out their impeccable Shakespeare, but no one was attentive. One of the actors was reported to have shouted a few modern versions of Shakespearean words, but they disappeared into competing sounds.

It took a number of extremely tactful telephone calls to the culturally minded, including the entrepreneur, and to an infuriated director threatening dire repercussions (in the manner of wounded and dangerously infuriated theatrical directors) before matters were resolved. Popcorn consumption was limited to the lobby, thereby greatly reducing sales volume but not eliminating it. "But I warn you, Liv, if one kid starts chomping on that stuff in the seats, just *one*—." He didn't. She didn't. And the show went on, sparking before the end of a year new enthusiasm, new electricity for the arts in Louisiana. (It still seems strange to me that the city of Mardi Gras, of parades and spectacles, lacked important live theater in 1966, but so it was.)

We looked at three significant elements in this project: support for excellence in acting and directing; education for future followers of the arts, to bring their classroom subjects alive; and the development of a mature audience, ready to assist a local company when the time came. I remember being taken as a twelve-year-old to Stratford-on-Avon, to the then-new Shakespeare Theater, drinking a marvelously frosty stone bottle of ginger beer during intermission and watching the punters on the Avon pushing their long poles into calm reflective waters in the British twilight. In four nights I saw two tragedies, *Hamlet* and *Macbeth,* and two comedies, *Much Ado about Nothing* and *As You Like it.* I was introduced to the theater and the bard and to his extraordinary verse. Anew McMaster was then a young actor, playing the leads, on his way to a

renowned career. And though I have seen those comedies many times since, I have never laughed as hard as I did as a child of twelve. I was a Shakespeare fan forever.

The Laboratory Theater Project launched the endowment's support for resident professional theaters in other cities, where theater was just putting down or deepening its roots. Today's Theater Program assists with a budget of approximately $10 million annually. In these early days, only grants averaging less than $30,000 for the fourteen companies involved were possible. Yet they were building blocks for the future, the seed money nourishing not just the immediate soil, but the adjacent terrain, and on an ever-expanding basis. Resident professional companies grew in number and multiplied again and again.

This project also set our minds in motion about our congressional budget submission. As a person of impressive theatrical background, Roger knew that he would be vulnerable to attack should undue emphasis be placed on what would be considered his favorite art form. A variety of semantics was possible. For instance, if you said the Laboratory *Theater* Project for Education, that had a certain inescapable content. If, on the other hand, you said the *Laboratory* Theater Project for *Education,* that had another ring. In the early annual reports, education is given a full measure of attention, from the lab theater all the way to a film project with a university.

"Audience development" was another phrase that helped early presentations. Audience development and education are related and of mutual benefit, and this natural alliance aided our efforts to give the Congress a fully balanced overall program, with its emphasis evenly (and thus to the Congress, fairly) distributed.

Flexibility in budgeting was to be protected to the fullest extent possible. The council met four times a year and made its recommendations, which we all considered binding. Frequently the council would refine its recommendations. Once in a while, it would change its collective mind. At the same time, materials had to be supplied on a precise schedule to the congressional subcommittees.

What is this audience development stuff? George Evans on the House side would ask. The boss wants to know, Where is the money for theater? An asset for us at the beginning was the lack on Capitol Hill of any detailed knowledge of the subject matter. It was a little like the early times for atomic energy. The experts could assert that their complicated technical data was flawless without too much anxiety about contradiction, but members of the House and Senate soon became as expert as the experts. It took a while for this to happen in the arts. Sidney Yates, who chaired the House Interior Subcommittee during my chairmanship

of the endowment, changed the budget presentation system and put it under the categories of specific arts disciplines, once and for all.

Poetry in Schools was another project the council recommended in its first year of life. The concept, undertaken with the Academy of American Poets, was to bring leaders in the writing of poetry into classrooms to read, recite, speak, discuss, demonstrate how they composed, what motivated them, how they viewed the art they practiced. We wondered if the mix would work. Would it produce excitement? This was not a teaching project. The intent was to permit the poet and pupil to communicate without a formal curriculum and on special days, not regularly. It was to enrich learning, rather than to build on it, step by cumulative step. From the first try it was a success. The poets were of varying ages, selected for quality more than for engaging personality, but they became gregarious in their new surroundings. Most of all, in the sessions I had a chance to witness, a feeling of mutual caring was imparted, a feeling of union in a moment of time.

The project began in New York City and expanded first to schools in Pittsburgh and Detroit and then to Minneapolis, Chicago, and Los Angeles. Teachers were involved, to broaden their own horizons. Funding had to be modest, less than $150,000 over the first two years. But the experiment grew beyond its so called "pilot" start and became the basis for the endowment's Artists-in-Schools Program. The same principles were applied to other art forms—dance, music, theater, painting, sculpture. Not as teachers but as artists came the visitors. The budgets grew past one million dollars, and two, and state arts agencies followed in the tradition, with Hawaii, far from New York, becoming a later state model in the full-fledged program.

What makes a personal contact with the arts so special to young people? Is it perhaps just something new in the classroom to relieve the everyday routine? Does it represent simply a chance to escape, for a brief time, a disciplined attention? Certainly those elements are involved, yet there is something far deeper. I was to learn increasingly the answers as time went on.

In another first-year pioneering project, the endowment embarked on an American literary anthology, which was to contain the best poetry, fiction, essays, and criticism from American literary magazines. Of the $55,000 allotted, $45,000 was to go for awards to selected authors ($500 each to poets and $1,000 for longer pieces of fiction or nonfiction), and awards were to be presented to the magazine those work was chosen. A panel of experts was to assist; George Plimpton, then an erudite and noted editor of the *Paris Review,* was named editor of the anthology.

It was a bold venture, given much acclaim as it began. But it must be mentioned that a serious snag arose, not during Roger's time as chairman but after Nancy Hanks succeeded him. One entry, it was discovered, consisted of a one-line poem, to whit: "LIGHGHT." The author may not be clearly remembered, but the poem was. It caused a major stir on Capitol Hill, chiefly, I think, because initial press accounts added zeros to the $500 award. The figure was first reported as $50,000, and then reduced to $5,000 when the endowment remonstrated. As the reader may surmise, a headline stating: "Poet Receives Government Grant of $50,000 for One-Line Poem" is apt to attract notice, especially when the poem is quoted verbatim.

It is not defended here as great poetry. I have always believed it was describing light as a continuous process, beyond its usual designation; but on Capitol Hill they found it either another example of shameless waste (although the final truth of the correct amount lessened some criticism) or an example of a government agency, entrusted with the nation's cultural welfare, that couldn't even spell.

When the poem at last came up for review in the House Subcommittee on the Interior Department and Related Agencies, when tempers and feelings were running toward a boiling point, when the endowment, if it ever did, needed a friend, Clarence Long stepped into the breach. Clarence was always a champion of the oppressed. He was from Baltimore, and a member of the House for some twenty years. He had one of the keenest minds I have ever known, a craggy countenance and eyes that could be stern and full of authority or brightened by humor.

On this occasion, when the possibility of reduced appropriations for an agency at apparent fault was so clearly in the air, Clarence asked for the chairman's attention.

"Mr. Chairman," he said, "I don't pretend to know too much about poetry or poems—but this is the first one I've been able to memorize."

It broke the ice, and the attitudes, and it saved the day.

The endowment, in turn, saved the day on more than one occasion. Not often, but with compelling impact, the endowment has played a certain role: the rescue of the damsel, adrift on winter ice floes near Niagara Falls. In this case, it was the American Ballet Theatre (ABT), founded by Lucia Chase. (I can remember Lucia in the old, old days at Narragansett Pier, Rhode Island, when she shocked members in the dining room at the thoroughly conservative and summer-resorty Dunes Club, because how could a supposedly nice, well-brought-up girl be seen in the company of *dancers?* My own parents may well have shared this note of alarm.)

But now Lucia—having spent $10 million or even more of her own

resources on the ABT and having directed its growth to international consequences—had reached the end of the line. The ABT was about to disappear; if it had, there would have been no Mikhail Baryshnikov to give it his brilliance, no galaxies of later stars, no abiding worldwide acclaim. The dance would have suffered an irreparable loss. That possibility was perceived with utmost clarity by the National Council on the Arts.

Roger had to make no great plea. There was instant recognition of emergency. One of the council's and the endowment's first actions was a special emergency grant of $100,000 to Lucia's company, with a commitment of $250,000 to follow. That was 14 percent of the endowment's initial budget, and that showed the seriousness with which we viewed the emergency.

On December 20, 1965, Hubert Humphrey, now Vice-President, presented to ABT the very first check ($100,000) issued by the federal government in direct support of the arts. It was certainly a moment in history—and it kept history alive and renewing itself. The funds were matched. Other help stimulated by this special assistance arrived.

In the 1960s, however, important members of Congress regarded dance with the same attitudes as had Narragansett Dunes Club diners in an earlier part of the century. On one memorable occasion, a member of our House Appropriations Subcommittee, from a rural Virginia district, asked to go temporarily off the record in his questioning of Roger Stevens. "Mr. Stevens," he said when the court stenographer's fingers ceased to move over the keys of his transcribing machine, "isn't it true that most of the so-called male dancers in these companies you're talking about—isn't it true that most of them are—well—homosexuals?" There was a hint of laughter in the voice, to soften the element of probing derision. "Just for my own information, isn't that true?"

I recall Roger gazing with those blue eyes across the table.

"It may be true in a few instances," he said without raising his voice, "but I guarantee you this, Mr. Congressman: If any male dancer happened by right now, he'd be strong enough to pick you up by the waist and put you over his head and throw you straight out that window."

The line of questioning was not pursued.

And I also recall the story Edward Villella, the noted dancer who later was a member of the National Council, told about his youth. He had a burning ambition to become a great dancer, yet he found his goal subject to this same kind of misunderstanding. Eddie told us there was a small dance studio near his family's modest home in New York City. The studio was midway up a steep flight of steps that ascended from the street, and he used to climb them backwards, hopping up step by step, facing the pavement below, so that a passerby would assume he was

leaving, not heading for the doorway above—which he could open in a flash when no one was looking.

And I especially remember an urgent call from Roger during our first struggles with appropriations. George Mahon had just telephoned. He was the chairman of the House Committee on Appropriations, the full committee, a tall, often affable Texan from Lubbock. His wife, who was frequently in his office greeting visitors and screening others, never referred to Mr. Mahon, in my memory, by his first name. It was always a deferential, "The Chairman will see you" or "The Chairman thinks" or "I wouldn't know quite how to answer that, but the Chairman had to go to a meeting and won't be back." It was not just a family protocol, reminding me a bit of my great-aunt who always referred to her husband, even in the smallest of family gatherings, as "boss." Very few members of Congress called George Mahon "George."

"Mr. Chairman" was a particular requirement for a new and supplicant agency, and his pronouncement to Roger promised his support—provided that we gave no funding to dance.

"None?" I asked.

"None," said Roger. "No more. Think of something to do."

Here we were, having made a matching grant for ABT's rescue; but that had been blessed by the Vice-President and was past. Here we were, especially, with a further commitment to the company for $250,000 and a national tour. Here we were with plans to form a new service organization for dance companies, to enable them to share information, resources, fundraising techniques and ideas.

I went to see George Evans at our House Appropriations Subcommittee. With respect to ABT, I said, "We really feel it's preferable to include it under theater. The American Ballet *Theatre*. It's wonderful theater. It's unique." George gave me a long, long look, but did not comment. Maybe he thought we were complying with a full presentation of support for the theatrical world with which Roger was so linked. Perhaps he already knew about George Mahon and wanted his own chairman free of possible controversy. I did not inquire. We had some breathing room.

The help for the other dance companies, incidentally, was conveniently located under "technical assistance," a marvelously enigmatic and ubiquitous phrase in government, which here could apply to all the arts, not just one.

Chapter 32

THE MEDIA ARTS, FILM AND TELEVISION, WERE AMONG THE EARLIEST EN-dowment priorities. Strong foundations were put down for the future. The establishment of an American Film Institute, whether advertently or somewhat inadvertently announced by President Johnson, became a focus of early council meetings. Demonstrating our growing knowledge of accepted and traditional governmental procedure, we undertook a study to ascertain and emphasize need, to recommend budgetary scope, to decide on the best way to start. The Stanford Research Institute in California was chosen to conduct the study at a negotiated cost of $91,000. The study embraced both the United States and European countries. It determined that an institute was indeed vital to quality in the major art form of film and in keeping with significant contributions to such quality in countries abroad, where similar organizations already existed and where films of international artistic acclaim were a result.

Some suggested that Hollywood, if properly persuaded, could itself put greater emphasis on producing films of abiding value, without an institute backed by the endowment. But it was pointed out that the commercial box office hit and the not-so-commercial artistic achievement were two different creatures.

221

Here again were the roots of future discussions, future debate. Why should government funds be spent on developing art that the American public, the taxpayer, at any given time might find of no particular appeal or worthy of criticism or even abuse?

This is an argument that perennially follows the endowment, chasing after it, sometimes catching up. It will be addressed a number of times. It is clear, however, that the endowment was now setting both patterns for future programming and patterns for arguments that I predict will never cease. At their best, the arts are controversial. At their best, they stimulate controversy. That is what keeps us awake, alive. That is what quickens our faculties. The artist who plays it safe, who imitates, may find popularity for a short span of time, but not for a greater time to come.

Gregory Peck, the early champion for the AFI (initials soon commonplace in our discussion), argued eloquently, and Isaac Stern, Agnes de Mille, Paul Engle, and the others who had gained renown in other art forms listened with sympathetic attention.

Gregory spoke in his quiet, measured tones, looking so serious and concerned. He spoke of experience with Czechoslovakia and other countries where fine films gave a sense of artistic freedom and individuality, where the excellence and dedication served to elevate perceptions and tastes and attracted new audiences. Films were particularly American inventions. The history of America—its tastes, for better or worse, its fancies, dreams, heroes, heroines, magic moments, memorable times—was in large degree depicted on film. Over twenty thousand feature-length motion pictures had been produced in the first half of the twentieth century, and half had been irreparably lost because they were made with a nitrate process which, unknown to early filmmakers, makes film self-destruct unless given careful attention. Film preservation was thus a special need.

(It is worth noting that, since the creation of the AFI, a good part of the almost-lost nitrate film has been rescued, some 60 million feet, at a cost of over $16 million. In contrast to the $150,000 spent annually on spasmodic film preservation before 1967, the figure has grown to over $4 million a year today, with the endowment as catalyst supporting the cause on a matching basis.)

Especially needed as the endowment first moved forward was, in Gregory Peck's view, a special training unit for young filmmakers midway between graduation from college and a job in the industry. Prepare them technically, nourish their talents, and above all imbue them with the desire to explore, to experiment, to seek new ways of expression,

new ways of using the camera, and new ideas or new ways of expressing older ones—those were the concepts.

Shortly after 1966 began, the author Harper Lee was appointed to the National Council along with the painter Richard Diebenkorn. Harper sat next to Gregory at the council table. Her novel *To Kill a Mockingbird* had been turned into a fine motion picture, starring Gregory Peck. So Harper spoke out for the AFI from a literary understanding, her soft southern accent capable of loud remonstrance should someone disagree.

But after all, who could really disagree with Abraham Lincoln, a role with which the public still identifies Gregory Peck? (Or as someone else once said, who can disagree with Moses, a role Charlton Heston invested with his own personal talent, before he followed in Gregory's footsteps and became board chairman of the American Film Institute?)

It will be seen later how some were so bold as to challenge.

The AFI was to become the largest of the endowment's grantees. That can always cause, in that ominous Washington word, trouble.

The institute was financed under the provision of the law that made unrestricted gifts to the endowment matchable by government dollars. The council announced the institute's creation among its topmost priorities, and along came the Ford Foundation and friend Mac Lowry with a donation of $1.3 million.

It was not as easy as all that, however. Meetings were held and telephone calls expanded, and the Stanford research report studied and restudied. Lawyers appeared to ask again the question: How could an unrestricted gift be made for a specific purpose, when that purpose could not be identified with legal finality on paper, in advance?

To engender unrestricted gifts, Roger hired Fred Gash from New York City as consultant. Fred was high up in financial circles and with the Anti-Defamation League, and he knew scores of the affluent. He was short and agile with a quick smile. He was married to Emily Genauer, writer, pundit, syndicated columnist, intellectual, member of the newly formed National Council on the Humanities, now sister organization to the National Council on the Arts.

In these days Fred Gash and I were on the phone together at least three times a week, or he was in Washington meeting with Roger and me, sharing ideas. It took Fred a little while to comprehend the unrestricted-restricted nature of the work. Chuck Ruttenberg explained it. I explained it. Roger explained it—in precise-unprecise terms. Just get the money, Roger instructed Fred; don't worry about it. Fred did worry; but once he had well in mind that he was being given a new kind of chal-

lenge, he became a full-fledged disciple. He would find an oil man in Texas who liked opera or a merchandiser in Illinois who liked museums. I know it's "no-go" now, he would say; it's not on the council list, not yet. But keep it under your hat for the future; it could come in handy. Fred was tireless. To me, perhaps his most appealing attribute was his optimism. Oh, just one thing more, he'd say. Before I hang up, refresh my mind just once more on how this thing works legally when the gift is really on the line.

He may not have been solely responsible for the Ford Foundation gift for the formation of the AFI or for a like amount donated, in a rare gesture of rapport between the commercial and the noncommercial, by the Motion Picture Association of America. But he was responsible for a large gift from the Bristol-Meyers Company to initiate support for educational television. The $300,000 enabled the endowment to fund a series of arts programs with the Educational Broadcasting Corporation, which were made available, free of charge, to all educational television stations in the United States. That contribution gave us more freedom to fund the AFI.

It also led to further early support of educational television in Chicago, Indiana, and San Francisco, where station KQED embarked on an adventurous and experimental program in new television techniques applicable to the arts. I remember the assembled council being shown one such excerpt from experiments with the camera and dance. Dancers—though there was but one being photographed at various intervals—appeared to leap in intricate multiplications (too early for the word clone), to dance in unison and in contrapuntal rhythms. After watching in silence, the council declared the sequences "interesting," the word in arts criticism that generally signifies somewhat the opposite, and it was back to the drawing board. However, camera experts were learning that the performing arts came off best on television when they were not pictured head-on, not framed by a camera eye focused simply on stage center. New techniques were being developed—montages, close-ups—to give the flavor of a performance, much as the spectator's eye and imagination react to a live performance, catching the side nuances in momentary concentration, relating them to what has preceded a few moments before.

George Stevens, Jr., who had appeared as a witness before Congress in behalf of the arts, was chosen as the first director of the American Film Institute. With a characteristic twinkle in his eye, when asked why he had accepted this new post for such a fledgling organization, he said, "Because it isn't there."

Some might have suggested nepotism, but these Stevenses, senior and junior, father and son, were a rare and gifted team. George, Jr., was

exceptionally qualified. He constructed the organization with skill, care, and a particular dedication. The Stanford Research Institute study had recommended ideal endowment support at a level of close to $7 million. It has never reached such an amount, but George seemed to enjoy recollecting the figure on occasions when the growing size of the institute was criticized. Battles were to be fought in the council over the fact that the American Film Institute was the endowment's largest single grantee—two times more endowment funds were invested in AFI than in the Metropolitan Opera, five times more than in the largest symphony. Personalities were to clash. George Stevens and Michael Straight, deputy chairman to Nancy Hanks after Roger's time, at one point appeared to have problems even saying good morning to each other without a noticeable increase in decibel. Claiborne Pell was to intervene. John Brademas was to introduce special legislation which, if passed (it did not), would have established the AFI as an independent agency separately funded by Congress, and the sides on this issue were to grow as complex as the arts can ever become.

The AFI remains in place, however. George Stevens eventually moved into independent producing and directing, which he does with excellence and taste. Jean Firstenberg replaced him as AFI director. Jean has great depth of character and eminent wisdom. For a while the change from a dynamo in action to a more measured approach had a calming effect, and there was a bright time of honeymoon. But the old storms linger at the edge of the sea. The waters are never quite still.

When I was with Nancy Hanks, a newcomer to the council asked me, shaking her head and frowning, "What is this AFI? Everybody seems to whisper about it—or want to change the subject. Is it some kind of skeleton in the closet?"

Disputes, however, were outweighed by achievements. A Center for Advanced Film Studies was created in a great old mansion outside of Los Angeles, with studios and rolling lawns. A major film library for research and study was begun. Educational programs were initiated. A Directing Workshop for Women was established, and graduates and participants in the AFI Independent Filmmaker Program were winning Academy Awards. Ina Ginsburg headed new projects in Washington.

If it is as true as I believe it is that controversy is a basic characteristic of the arts, the American Film Institute is living proof, and the story will further unfold in this history.

But in the early days, there was euphoria. An important new organization in the arts had been founded. It was launched together with an accompanying program for television. Small budgets would grow (and they have).

* * *

The priorities of the National Council on the Arts were also grow-ing in appeal to the private community and to corporations. The *Chicago Tribune* said, "The remarkable fact is that the National Council on the Arts so far has been a muscular, fast-moving and unorthodox arm of the government which plants its punches where they are likely to count most and wastes neither energy nor money." Simultaneously, the business community, led by Chase Manhattan Bank president David Rockefeller, was beginning to organize a Business Committee for the Arts, with the goal of arts advocacy among corporate leaders. At the close of its first full year of life, the endowment's catalyst was manifest not only in real terms, but also symbolically and psychologically.

Chapter 33

RENÉ D'HARNONCOURT WAS A GIANT OF A MAN, BOTH IN PHYSICAL stature and in his knowledge of the visual arts, especially those of contemporary merit. He was the much-respected director of the Museum of Modern Art in New York City, still at the apex of its kind. He was tolerant and wise, with a Gallic twinkle in his eyes and a great wrinkled face capable of a great variety of expressions. He talked quietly and with such an accent that I once saw the transcriber we had hired for a council meeting watching René's face in deep concentration, his fingers hovering over the keys but never touching them. "I'm sorry," he told me later. "This is the first time it's ever happened. I couldn't understand a word he said."

Admittedly, it took an aural adjustment, but one knew that the words, often expressing complex ideas, were in English, not French; and after an initial experience or two, or three, they became clear. René had a deep rollicking laugh. Rabelais would have found him a most appealing character. At those first Tarrytown meetings, he usually sat toward the far end of the table, near the dark-haired actress Elizabeth Ashley, who gazed at him with her wide brown eyes in a mixture of awe and bemusement.

227

René was the originator of the endowment's noted Art in Public Places program, which was to grow greatly in scope over time, to expand into partnership with the General Services Administration for newly funded public buildings. It would also be the subject of a special brand of controversy, which will be recounted in another chapter.

On November 4, 1965, however, René wrote to Roger, "The proposal I would like to make today is, I believe, in tune with the President's program for the beautification of our country and will stress the council's concern about excellence in art. I would like to suggest that the council purchase or commission every year two or three works by eminent artists to be permanently placed in public premises."

It took the council a number of months to establish the proper procedures, but the concept was enthusiastically received at once. Matching grants of up to $30,000 each were announced, and cities were eligible to apply.

Philadelphia was one making application. The city requested funding to commission and erect a statue or large bust of the late John F. Kennedy—and the endowment was immediately in the midst of a major dilemma. Perhaps the request should have been anticipated, if not from Philadelphia, from some other source. René was taken aback. He had envisioned something far less personal, far more abstract, albeit in a time when abstract public art was untested.

Roger, pinpointing responsibility to the native heath of his deputy, asked me to draft a suitable official response. It said, after some thought, that although the memorializing of a President who had so supported the arts was a most laudable ideal, the endowment nevertheless believed that individuals should not be singled out as subjects for its new program. That meant no individuals—whether they be Presidents or Democrats for a presently Democratic city hall or Republicans for cities where Republicans were in charge.

The policy decision met with some archness from the then-Democratic city fathers of Philadelphia. If publicized, it would undoubtedly have met quite a different kind of reaction from the White House of the moment. But the decision was broad enough in essence to prevent either partisan or nonpartisan arguments, and the policy, thus initiated, remained for the future.

About this same time in Philadelphia, a few brave souls sponsored an outdoor exhibition of "modern" art in an urban, downtown setting. Three-dimensional mock-ups, painted black and made of plywood, emulated the work of contemporary sculptors such as David Smith. I visited the exhibition and was immediately informed by some influential spectators that it was a travesty eligible for immediate removal.

I suggested a different approach. "Look at City Hall," I

recommended, "with all its elaborate columns and Victorian-like embellishments. Look at the complex rooflines and arched doorways and decorations over each long window. Look at it from this vantage point, framed by the sides and buildings of this street. Put your hand up and over the David Smith in the foreground there, so that it's hidden. Without the sculpture, that's a view you've always seen. Now let your hand down and see the simple, plain, direct lines of the sculpture in contrast with your own familiar view. See the relationships, see the blending of different viewpoints and the black against the grey. Doesn't it all make each shape more interesting?"

My companion did as requested.

"Well?" I asked hopefully. "Doesn't the contemporary art add a new dimension to the old, and vice versa?"

My companion, from the city's power structure, shook his head. "Frankly," he said, "I never liked City Hall anyway."

Philadelphia came into play again, for it had been promised a real sculpture, not a mock-up. René had decided that the most eloquent beginning for this new, national endeavor—the one most likely, in his view, to excite the eye and the mind and quicken the heart—would be a tall, tower-shaped structure made of thin, polished segments of bright metal, variously attached, variously reflecting light. After roaming around the city for hours, he knew precisely where it should be: almost at the center of town. He envisioned the sculpture's lower extremities placed in a sunken walkway that he had explored, part of a mall below street level, with shops and a square open-air egress to sunlight above. The emergence of the sculpture to the level of the street and above would add to its interest and mystery. People would want to explore the base, and that would be added invitation to the shops.

Upon investigation, I discovered that the "land" in question, the sunken square area leading to open space, belonged to the Pennsylvania Railroad. In those days the Pennsylvania Railroad was a bastion of Philadelphia's tradition, and of its mentality. The railroad's roots were intertwined with its development. The so-called Main Line, the city's western suburbs of affluence and undeniable charm, was so named because the early railroaders built their stately mansions—and acquired land for sale to other arrivals—westward from Philadelphia, on a wide lateral line bisected by the principal tracks linking the City of Brotherly Love with Chicago. The president of the "Pennsy" was a revered citizen, accorded positions of high social prestige. Once, years before, I was joking with schoolmates on the Bryn Mawr Station platform about the perennial lateness of the rattling "Paoli Local," which served the Main Line. All at once a large gold watch with gold chain attached was thrust before me. "Young man," said a thunderous voice, "the train is fourteen seconds off

schedule, and here it comes now!" The speaker was the railroad's then-president, Martin Clement, church leader, civic leader, railroad tycoon.

The president of the Pennsy in the mid-1960s, before the cataclysmic financial demise of the railroad, was Stewart Saunders. He inhabited a Philadelphia office of truly immense size, lessening in comparison, but only slightly, the size of his desk. On this particular afternoon, he was visited by René d'Harnoncourt, member of the National Council on the Arts, Henry Geldzahler, director of the Visual Arts Program of the National Endowment for the Arts, and Livingston Biddle, the endowment's deputy chairman.

The difficulty was that someone on Mr. Saunders's staff had apparently neglected to fill him in on these designations. Instead, he greeted us with thoughts firmly in mind of a different relationship. Early on in my time with Claiborne Pell, I had worked on railroad problems and railroad legislation, while giving some of my morning hours and many early and late evenings to thoughts of the arts. I had become thoroughly familiar with American railroads, Japanese railroads, European speeds, and the Japanese "Bullet," which traveled at even higher velocity.

Claiborne, through legislation I had helped him initiate, became senatorial father of the Metroliner, which links Washington with Boston. While this is an interesting story in itself, it is only germane here because I had had dealings and a number of conversations with Stewart Saunders, as well as a pleasant but not extensive social association in the Philadelphia manner.

"How are the railroads, Liv?" he inquired as we crossed thick dark carpet toward his desk.

"Fine, I guess," I replied.

"And the good senator?"

"He's fine," I answered.

Stewart was not imposing in stature. He sat flanked by two staff men, standing tall and impassive, each at about arm's length from the president.

"And Rhode Island?" he asked, eyeing René seemingly for the first time, and then Henry Geldzahler, smoking his long cigar as always and wearing his customary white suit, sans broad-brim hat, but with whitish-blond hair cut long, in a fashion somewhat before its time.

"Rhode Island is fine," I replied.

I can now see easily how Stewart Saunders, as soon as René spoke a word or two in greeting, could have thought himself in the presence of an unintelligible French railroad expert and perhaps a Peruvian one or another foreign representative brought to this meeting by the emissary of the railroader's champion, Claiborne Pell.

"How are the railroads in France?" he inquired of René, who looked confused and made a monosyllabic but polite reply.

There was a pause, during which it struck me that things needed a quick clarification.

"You know I have a new job," I said.

"Oh?" He looked surprised. His face was round, his eyes very alert. His words were spoken rapidly, as if time was a constant factor and must not be lost. "Is that so?"

"I'm with the arts," I said.

"How's that?"

"With the National Endowment for the Arts," I said. "The deputy chairman. Mr. d'Harnoncourt represents our national council; Mr. Geldzahler, the Visual Arts Program."

"Make a note of that," Stewart said to the aide on his right. "How do the arts relate to Claiborne Pell?"

"Well," I said, "Claiborne is the sponsor for the arts legislation, but he's not in the immediate picture today, exactly."

"How do the arts relate to railroads?" Stewart Saunders asked.

"That's what we're here to explain," René said.

"What's that?" Stewart asked. He was looking at Henry and drew a cigar from a small tray in front of him. It was instantly lit by the aide to his left.

"We want to inquire about some land the railroad owns," I offered.

"What land is that?" Stewart asked, eyeing me now.

"It's in Midtown," I replied, "below street level. We understand it belongs to the railroad."

"You want to buy railroad land?" he asked.

"No, we want a right of way," René said.

Stewart gave René another puzzled glance, then looked back at me.

"We would like the railroad to allow us to put something on the land," I said.

"Like what?" he inquired.

"A piece of sculpture," I said.

"What was that again, Liv?" he asked.

"Sculpture," Henry Geldzahler said. "A sculpture done by an eminent modern artist."

"Who pays for it?"

"The National Endowment for the Arts pays half," I said, "and the City of Philadelphia pays the other."

"And the Pennsylvania Railroad?"

"Permits that part of its property to be used."

"In perpetuity?" Stewart asked.

"Yes," I said, "in perpetuity—if possible."

Stewart sat back in his chair, staring at the three of us as if we were visitors from Mars.

"Well, I guess we've got that much straight," he said. "Now what does this sculpture look like?" he inquired. "A statue? A statue of whom?"

"No, it is not a statue," René said with emphasis.

"Not a statue. I see," Stewart said. "Then what is it?"

"It is like a wonderful tree," René said, "rising up from the ground."

"A tree, did you say?" asked Stewart, at last, in some small measure, attuned to the accent.

"A magical tree," said René. "Fragile. Full of light. Moving."

"Moving?"

"Yes, shimmering. Moving. Catching the subtleties of sunlight and shadow."

Stewart seemed in thought for a moment. "How big is this tree?" he wanted to know.

"Perhaps very tall," René said.

"How tall is that?"

"Maybe a hundred and sixty, a hundred and seventy feet high."

Stewart leaned slightly forward in his chair. "Make a note of that," he said, without turning his eyes to his aide.

René sensed disapproval. "Of course, it could be smaller," he said. "perhaps sixty or seventy—even fifty feet."

"How wide is it?" Stewart asked after a short pause.

"Well, that depends," René said. "It would taper, of course, to a very thin top from a wider base."

"How wide would the base be?" Stewart asked.

"It could be quite wide," René answered. "Perhaps thirty feet across, fifteen in radius—or less—but the base itself, at the bottom, would probably be no more than a foot square."

"No more than a foot, to hold up a hundred and sixty?" Stewart asked.

"That's right," René said enthusiastically, his wrinkled face showing a smile. "It would not be heavy at all for its size. Full of air."

"Make a note," Stewart said, looking at me now with a quizzical expression. "How heavy?"

"Oh, that would be very difficult to say now," René said. "You see it would be made of steel. Steel alloy, polished."

"Steel?" asked Stewart.

"Little rods of thin steel, strung together. Perhaps an aluminum alloy. Little thin runners about as thick as a ruler, perhaps."

"I see," Stewart said. "Now, let's see, we have a statue—a sculpture—maybe over a hundred and sixty feet high, with a base of one foot or thirty feet."

"Up to thirty feet," René said.

"Up to thirty feet, with something about a foot square at the bottom. And it's made of steel parts tied together that can move."

"Just a little," René said.

"All right, just a little. I should think it would blow over."

"Oh, no," René said. "It would be very strongly anchored."

"In the Pennsylvania Railroad," Stewart Saunders said. "In perpetuity." He paused again. "Do you have a picture of it?"

"No," René said, "not yet. We wouldn't have a picture. We'd have a design."

"I see," Stewart repeated. "Well, do you have a design?"

"No, not yet," Henry Geldzahler said. "We'd need to consult with the artist. Mr. d'Harnoncourt could draw you a sketch."

"I already have," René said in a genial tone. "Here, on this paper."

He nudged it across the desk. Stewart looked down, and then toward me. "I must say it sounds a little vague," he stated.

"But you see the possibilities, I'm sure," René said. "A slender tower, a tree. Like symbols. Symbols of different moods. And mystery. Modern art always suggests a mystery that we can solve."

"Yes," Stewart said. He stood up, the aide on his left pulling back his chair. "It's been very interesting meeting with you gentlemen. It's been kind of an education. I will certainly think it over." He smiled just a bit and escorted us to the distant portal. René and Henry exited first.

Stewart touched my arm.

"Say hello to the senator for me," he said. "And tell him to stick to railroads."

"I'll never forget today," René said. "It was an experience I'll never forget. That wonderful office. It seemed the only thing lacking was the taxidermist, for all of us. Make a note of it," he said to Henry.

That may not appear the most auspicious of beginnings. But sculpture was created in Philadelphia, and in many other cities. A great outdoor Picasso shocked and then entranced Chicago; a Calder, installed in Grand Rapids, Michigan, was at first scorned and then became a prized possession—and helped make Michigan's Gerald Ford, while still a member of the U.S. House of Representatives, a convert to the arts.

For the endowment, among the press and in the world of the arts, a kind of honeymoon was in progress. There seemed to be such a sense of promise that the magic touch of beginner's luck continued.

Chapter 34

I N EARLY ENDOWMENT GRANTS TO THE FIFTEEN SIGNIFICANT RESIDENT PRO-
fessional theaters in the United States, the emphasis was on the train-
ing of professionals. The American Conservatory Theatre in California
was chosen for this purpose. Another grant supported works by predomi-
nantly black playwrights in schools and underprivileged areas of Los An-
geles. Joseph Papp's New York Shakespeare Festival received special
help to conduct throughout the city educational projects that had been
threatened with cancellation.

The training of artists, new opportunities for minority artists, and
Joe Papp's unique organization are all recurring themes of endowment
endeavors. But perhaps the most important theater decision—one that
was to have an impact on other art forms within the endowment's lexi-
con—involved the experimental, the off-Broadway, the off-off-Broadway.
These relatively small grants, I believe, set a pattern and example for
the future.

I recall words of caution being spoken, words of reserve and quiet
advice: Let's not stick our necks out, quite yet, not so far. Let's not ask
to be a target, quite yet. Let's not jeopardize good beginnings, other pro-
grams, by one mistake. Certainly, *we* understand this kind of theater, but

would the average congressman? Would he see support for a show critical of our national policy as an appropriate expenditure of tax dollars? Would the President? Remember the White House Festival on the Arts. Remember the reaction to criticism. And if the subject matter somehow isn't singled out, what about the language? What about nudity if it happens to be a part of a production? Remember Martha Graham in Europe, and congressional sensitivities then. That wasn't long ago. We have a clean slate. Why risk it quite yet?

But Roger Stevens was firm. Like Claiborne Pell, when his mind is made up, finally, he does not vacillate. He was convinced that the decision had a crucial bearing both on the endowment's beginnings and on its future. To be safe in the arts was to be static. To dare the new and experimental was in keeping with the goals we had wished to achieve—those new horizons we had hoped to reach, those new frontiers of expression that seemed so implicit in the enabling legislation. It is to Roger Stevens's lasting credit that he recognized so clearly the crucial nature of the decision about the experimental in art.

The council approved the grants at its meeting in mid-May 1967. The grants were begun. They were modest in scale because the budgets of the theaters and of the endowment itself were modest, but they were immense in implication. Included from New York City, pioneers again, were Albarwild Theatre Arts, Inc., its Playwrights' Unit, the American Place Theatre, Café La Mama, Chelsea Theatre Center, Judson Poet's Theatre, the New Theatre Workshop, and the Open Theatre. It was manifest that the new endowment was not playing safe, or static, with the arts.

The endowment became known for a bold and progressive outlook. Most foundations, most corporations, most individuals who serve on boards of directors of arts organizations tend to be conservative. Many arts administrators, looking at the box office and recognizing its financial impact, tend toward what has proved appealing in the past. Orchestras may slide into their repertory the work of a new composer, but so often it takes urging and unusual foresight. But here was the National Endowment for the Arts, which critics had prophesied would stifle creativity, with an approach 180 degrees different—and different, indeed, from the great majority of previous sources of funding and support. Over the years, the example has affected state programs and community arts enterprises. Government and imagination are not often said to be in step. In this case, with a new agency, they were.

And we dodged an early bullet. Produced off-Broadway was a revue entitled *Macbird.* In the production, Lyndon Johnson—thinly disguised—was presented in about as unfavorable a light as could be conceived, even on a bad day. *Macbird* received much media attention,

including, as I recollect, prominent coverage in *Time* magazine. The endowment, however, had not helped the theater involved. There was no mention of a National Endowment for the Arts.

The legislation clearly states: "In the administration of this Act, no department, agency, officer or employee of the United States shall exercise any direction, supervision or control over the policy determination, personnel or curriculum or the administration or operation of any school or non-federal agency, institution, organization or association."

That is fundamental to freedom of expression, and it means that government should not interfere with the work of a grantee once the grant is made. Faith is placed in the quality of the organization. No Big Brother intrudes.

The decision to be bold and venturesome has caused the endowment much travail. It would have caused the arts far, far more if the decision had been made otherwise.

I often think of this beginning as a high point of my two years with Roger Stevens. But I believe his favorite project was in another area, which involved his acumen in real estate, various diverse elements that had to be united, and his particular desire to assist the individual artist beyond the theater world. This project, too, was an experimental endeavor. Complexity engaged Roger. It challenged him. He believed nothing worthwhile was beyond resolution. It just needed to be "figured out"—and this project needed a maximum degree of figuring.

On Manhattan's lower West Side, he had located a huge, sprawling stone building that had housed the old Bell Telephone Company's laboratories, offices, and administrative personnel. It had courtyards and high ceilings and interiors of large dimensions, as well as more compact conventional space. What a magnificent place, Roger thought, to begin an artists' housing project, where musicians could compose on pianos, where painters and sculptors could work in areas giving full scope to their talents, where poets could live in quarters conducive to creativity, where dancers could have mirrored exercise rooms, where individuals in the arts could come together and interact and lend each other the helping forces of inspiration. It's never been done like this, Roger said, so we'll do it.

The project, first presented to the council in August 1966, required purchase and renovation of the building. Rents were to be minimal for the circumstances. Artists would pay less than for other quarters in the city, and they would receive more. The Artists' Housing Project was soon given full council blessing and endorsement.

The budget? Since our limited funds were largely committed, $100,000 was allocated. To purchase a gargantuan building in New York

City and renovate it with $100,000, that was the challenge. Figure it out, Roger said to Chuck Ruttenberg and me; and when we suggested we were slightly at a loss, Roger said, don't worry, we'll find a way.

He turned to his friend Jack Kaplan of the J. M. Kaplan Fund. A matching grant was made, and wheels began to turn. John Lindsay, the former congressman and now mayor of New York, became involved. Artists would bring new life to the neighborhood. They might sometimes have bohemian tendencies, but serious artists could enrich a community with their talents. Bistros and restaurants would grow; a bright new demeanor would replace drabness. Through the mayor, Roger, and friends at the departmental level in Lyndon Johnson's administration, a loan was secured, repayable from future rental income. The city provided leadership for funding, so that city and federal resources were supplied. Westbeth, as the building under renovation was called, began to take shape and form. Artists lined up for consideration by a special panel, which screened them carefully. There were many more applicants than there was available space, even though the plans called for up to 500 units, with studios of various shapes and sizes combined with living quarters.

I recall Roger asking me one day to visit the White House and explain the project to one of Lyndon Johnson's counselors. I asked for a briefing on the latest developments because Roger was keeping them somewhat to himself. He began an explanation and paused, looking out the window. "It's really so complicated I've sort of forgotten the thread there," he said. "On second thought, I'll come with you." Roger has a great knack for making the unexplainable perfectly explainable—chiefly, I think, because his listener often has the feeling that he, not Roger, has inadvertently missed something vital in the sequence being unfolded and does not want to show ignorance by asking for a detailed repetition. In any event, the repetition would have bothered Roger not a whit, for all was perfectly clear to him. It was working. What more was there to say?

Congress had a few more questions than the White House. In our budget we listed the project under "Programs and Planning in a Variety of Art Forms," to give it a nice, balanced flavor. But once again there were suspicions that somehow Roger Stevens, erstwhile reported purchaser of the Empire State Building, had finagled through the government a landlord's windfall and was about to bilk the needy from their daily bread. When the rental rates were mentioned, these apprehensions vanished into the air. When it was further mentioned that artists had yearly incomes low enough to be well within the guidelines for government help, applause began to replace doubts in the House.

Our earliest times with the Senate appropriations process involved chairman Carl Hayden, number one of all senators in seniority—born on October 2, 1877. Senator Hayden had initially evinced an interest in the

arts about parallel with the enthusiasm shown by Winfield Denton at the very start. But appropriations attitudes in the Senate had grown more compatible. Paul Eaton was the committee's clerk. His wife was a painter. One of her small canvases graced the wall of his office. Objection was not made to artists' housing.

A few looked through the law to see where there was any mention of real estate, but I was quick to point out the legislation's flexibility. Following the enumerations of prescribed endowment activity, there was the phrase "and other relevant projects." This was "other" and it was certainly "relevant." Besides, "purchase of facilities, purchase or rental of land" was findable, nicely tucked into the small print of section 3(d).

Again, this program was a sign of things to come. The endowment supported smaller spaces in New York, and suddenly it was discovered that artists not only brought their unique vitality to a community, but they also brought economic advantages. Small restaurants and bistros did spring into being. Garbage cans began to disappear from street corners. Windows were lighted at night, no longer boarded up. Doorways painted unusual colors gave notice of new residencies. *La Boheme's* Cafe Momus may have had less elaborate counterparts in the beginning, but the message was increasingly clear. Bring the arts into a community and expect transformation for the better.

On the grand scale, of course, we can think of New York City's Lincoln Center, which metamorphosed a slum area into avenues for limousines, and opera and grand symphonic music, and theater, and great interior murals by Marc Chagall, and a complex of buildings that would have seemed praiseworthy even to a high Renaissance Venetian doge. As one example of economic gain—outside of sizeable restaurants, apartment houses, business centers—there was the enormous increase in taxable real estate values to supplement city coffers.

We can also think of Winston-Salem, North Carolina, where an old textile mill in the center of town was changed into artists' studios. The saw-tooth windows, which had let in light for the machinery operators, faced north, ideal for the painter. The roofline told of artists at work. Nearby a large building was renovated for the performing arts and was, in years to come, dedicated to Roger Stevens.

At the invitation of National Council member and Winston-Salemite Phil Hanes, I gave an address there in February 1966, at the opening of a special community fundraising drive to support the arts. I know of no other American city of comparable size where the arts are given such care and attention. Planning support from the endowment helped trigger an awakened and enlightened citizenry toward increasing achievement: the development of an internationally recognized school for the arts, im-

portant accomplishments in orchestral work and dance, visual arts centers, museums, historic preservation. The financial and corporate communities joined. Winston-Salem has become a magnet attracting new residents. And it has sent its waves of enthusiasm out across the state. The state arts program has become a model.

Just after I became chairman of the endowment in November 1977, I revisited Winston-Salem. It was such a heartening experience to witness all the deepening roots of cultural growth. I remember saying in a speech at the North Carolina School for the Arts that, as a new arrival to the chairmanship, I was being asked constantly about the state of the arts in the United States. "I've just found it," I said.

Governor James Hunt, who was present, liked the comment so well that for a time special bumper stickers heralded North Carolina as "The State of the Arts."

Other pioneering programs in the endowment's early years were perhaps not as unconventional as off-Broadway theater or artists' housing, but boldly, if quietly, innovative. We began, for example, to explore how the arts could best benefit minorities and the disadvantaged, ethnic cultures, and residents of rural communities. It was the start of a continuing sequence of endowment work.

Alaska was preparing to celebrate its centennial. A small matching grant of $5,000 helped make professional theater available for the first time in Alaska history as part of the celebration. A grant was made to the Institute of American Indian Arts in New Mexico, the start of an emphasis on the arts of indigenous and historic value. A project with the University of Wisconsin explored how the arts can serve rural areas. As a result, the arts began to grow for the first time in the rural Midwest. Try it, you'll like it, the endowment seemed to suggest. People did. At the same time, music and theater training programs for underprivileged young people were supported in New York under the supervision of Dorothy Maynor, a gifted performing artist turned teacher and administrator. Similar projects were to follow elsewhere.

Support for museums began, the harbinger of a program that was to grow, in budgetary terms, to over four times that initial first-year appropriation of the entire National Endowment for the Arts. At the time a grand total of $150,000 was allocated for the Detroit Institute of Arts, the Institute of Contemporary Art in Boston, and the Amon Carter Museum of Western Art in Fort Worth. The intent was to encourage each museum to expand its services to its own community. "Outreach" thus came into the endowment's vocabulary—reaching a broader audience, with small traveling programs or exhibitions designed to encourage new interest and new participants who would, in turn, visit the museum proper. It

was another form of audience development, but it began with the work of the artist, with what will attract, appeal, enrich the mind.

Individual support for artists was begun. The American Academy of Arts and Letters served as an early panel to make selections and recommendations. Henry Geldzahler helped construct beginning panels for the Visual Arts Program. In an *Art News* editorial, the grants were termed "the best . . . that we have ever seen in this field. It reveals a sophisticated knowledge on the part of the regional advisory panels which made the recommendations and, even rarer, the facts have been tempered with tact, finesse, and a humane understanding of individual needs. . . . The whole enterprise is a major contribution to our culture," the editorial concluded. Other views were to rise to the surface, but in the highly subjective, often controversial area of grants to individuals—so vital to the legislative concepts and their development—the endowment was passing boldly and unscathed through what might, at some later times, seem a fiery furnace.

With a special grant, a photographic project was begun to study the life and environment of New York's Spanish Harlem. Photography was listed among the arts in the endowment's enabling legislation and, from this small beginning, was to grow in emphasis. Print workshops for artists were begun with support for Tatyana Grosman, who would become a world leader in this specialized field of the visual arts. I remember once asking Henry Geldzahler who Tatyana Grosman was. It was a little like asking Louis XVI who Marie Antoinette was.

In literature, support for independent presses was initiated. In later years, this project led to a major concentration on the often small, noncommercial organization that publishes the work of authors on their way up the ladder toward broader recognition. Many awards have come to writers the endowment has so helped in this way. And as the publishing world has become a province of mergers, as larger and larger houses dominate, as there is increasing emphasis on the best seller or the potential best seller, these small presses have assumed a growing significance. It would not be stretching the point to say that they are key to the preservation of American literacy. Often they are the source of a quality not found elsewhere, for as commercial television invades our lives, only the book with some massive common denominator (sometimes called sex and violence) can compete.

Attention was also given to international aspects of the arts: a Venice Biennale in 1966, fundless and adrift without endowment help; an international convocation of theater experts in Washington, discussing their needs and their ideas for improvements; the Spoleto Festival, just finding its own roots some sixty miles north of Rome.

The endowment's early mandate (later amended and liberalized) provided for support for the arts "in the United States." Harry McPherson, assistant secretary of state for educational and cultural affairs, had clearly testified to Congress that the new program should not intrude on established State Department practices abroad. At the time we were looking for all possible help, and not for disagreements, especially with a major federal department. The phrase I inserted into the early law, quoted above, had satisfied all concerned. Help could be provided for American representatives at a world theater conference in the United States and for American artists assembling an exhibition to be held in Venice, provided that the Italian end of things was not involved. But a festival in Spoleto?

"It's run by a wonderful man, Gian-Carlo Menotti," Roger said. "He's a genius and he's full of ideas, and very special in the arts. We've got to help him. We need a way."

The solution I developed for Roger worked. We would provide support for an American artist, Buckminster Fuller, to design a symbol for Spoleto, one that would be eminently visible, one that would last. It turned out to be one of Fuller's famous geodesic domes. It is still there. Visitors pass it as they move upward into this Italian hill town, with its ancient forum for moonlit dancers, its baroque theaters, its walled and church-spire-dominated square for orchestral music. Gian-Carlo, the composer of operas, credits that early endowment help with attracting enough other funding to enable him to expand, first in Spoleto, and, years later, to the Spoleto Festival in Charleston, South Carolina. The wheel spins its circle. Who can say we were not helping the arts in America with each beginning project?

It is clear how much the early National Council was concerned with decentralizing the arts, bringing them into new contexts, extending outward a new sense of invitation and welcome.

I remember being visited by the town manager of Seattle. He was in Washington, D.C., for a round of meetings with other agencies and departments, and he had heard of the newly created National Endowment for the Arts. Perhaps we could give him some advice. He understood, he said, that the arts could be important assets to communities. Would I explain to him the advantages involved? I ranged from the obvious cultural benefits to the more tangible, specifically the economic ones: The arts can attract business and business leaders because the environment they create makes a community an attractive place to live and work—an important factor to companies searching for a desirable location.

He listened carefully. I recall the tall stature of my visitor, the

dark blue suit (the uniform for government officialdom), the sensitive eyes and face. Can you prove this, he asked?

I told him I was sure of it.

He asked me to suggest an important cultural asset. Would it be an orchestra or the improvement of an orchestra? Would it be a museum or the enhancement of an existing one?

How about something new, I asked, less expensive than a full-scale orchestra or a museum addition? How about a dance company?

He pondered this. We believe dance will be the fastest-growing of all the arts, I said. It combines music with grace in motion, with drama, with settings that enchant the eye.

Did I have in mind such a company? Yes, I did, I told him. It was a fine, relatively new and growing company, artistically excellent. It would flourish in a new home. It would attract an audience, and it would bring luster to its new locale. The Robert Joffrey Ballet, I suggested. It would be a "first," an essentially eastern company, New York-based, finding a location for its talents in the West.

When he seemed not fully convinced, I suggested he see the company for himself. Not long afterward, we received an application for our matching support, involving Seattle and Robert Joffrey, and it was brought before the National Council on the Arts.

Under the guidance of Agnes de Mille, the council had already approved individual grants in choreography. The list of recipients was impressive. The amounts, averaging less than $9,000 each, could hardly be described by that same adjective, but they demonstrated that our initial difficulties with a not-so-enlightened Congress had been resolved for the moment. The recipients were: Alvin Ailey, Merce Cunningham, Martha Graham, José Limon, Alwin Nikolais, Anna Sokolow, Paul Taylor, and Antony Tudor. Quoted in the endowment's first annual report, as if to verify the credentials of these artists, were excerpts of critical acclaim from sources ranging from the *New York Times* to the *Christian Science Monitor*. And these choreographers led us forward and broadened the avenues of dance. A larger grant was committed to choreographer Jerome Robbins to establish an experimental program for actors, musicians, writers, and dancers, all working together in new partnerships. It was called an American Lyric Theatre Workshop. (Note the name, which still avoids direct mention of the profession of the principal talent involved.)

"Who is the choreographer for Robert Joffrey?" Agnes de Mille inquired, getting down to particulars, pushing her glasses upward in the familiar movement that indicated concern.

"Gerald Arpino," I answered, beside Roger Stevens at the council table.

"Who?" asked Agnes.

I repeated the name.

"Well, I'll just have to think about that," said Agnes. "Gerald Arpino," she said, and repeated it as a question.

"Gerald Arpino?"

No one else spoke.

"Why don't you check it out for us," Roger said, sensing the possibility of objection and, as was customary to the close ties he was building with the council, wishing to avoid it.

Agnes seemed to give her glasses another little hike. "All right, I will," she said very firmly. And that was the end of the discussion.

Not long thereafter, however, we heard from Agnes de Mille. Gerald Arpino was just fine; dance authorities Agnes trusted had confidence in his talent and his future. The grant was approved in February 1966.

It was far from immense, but in keeping with the resources of the time: $25,000 matched by the Washington State Arts Commission to help establish for Bob Joffrey's company a summer residency for a northwest audience in Seattle and neighboring Tacoma. It made history as the first time a New York-based company had shifted a good part of its activity westward. The audience grew. The reception was enthusiastic, as was the critical acclaim. The promised cultural asset achieved its goal.

Coupled with endowment support for a national tour by Martha Graham's company and by the resurrected American Ballet Theatre, audiences for dance began to multiply, and new companies came into being in communities touched by the tours. In 1966, the audience for dance was approximately one million, the vast majority concentrated in New York City. That audience continued strong, but as time progressed another fifteen million in audience was added outside New York. The shifting of Bob Joffrey's company to the West Coast seemed in keeping with ideas whose time had arrived. And Congress forgot its reservations about dancers.

The same concepts were applied to opera. The endowment supported the Metropolitan Opera's national touring company in its efforts to give special low-priced performances for students and labor groups. Julius Rudel, the famed impresario, was assisted in the training of young conductors and singers. And the endowment initiated the development of regional opera in the southeastern United States. From a perspective of twenty years, it is interesting to note how many of the seeds planted led to growth. From beginnings in Miami, opera has expanded to such southern states as Alabama, Arkansas, Georgia, Mississippi, and South Carolina—as well as, of course, across the United States from coast to coast.

Chapter 35

*I*F SO MUCH OF THESE EARLY EFFORTS FORESHADOWED A JOURNEY TOWARD the distant mountains, with others joining the first pioneers, some expectations had the elements of a mirage.

Among the earliest projects the National Council discussed was the creation of a National Design Institute. The architect members of the council—Albert Bush-Brown, Minoru Yamasaki, and William Pereira—spent a number of hours at Tarrytown considering how to present the concept to the council as a whole. I served as a draftsman for a pronouncement.

In part, it said, "The Institute is envisioned as an independent facility which will serve citizens, cities, and states in their search for higher quality in the physical environment. It is anticipated that the Institute will involve leading architects, planners, and designers, as well as mayors, planning commissioners, governors, industrialists, educators, public officials, and private citizens, in programs to enhance all pertinent aspects of the arts of architecture, planning, landscape architecture, and design as they relate to the environment."

Each of these words and phrases was thoroughly discussed and understood among the three. I recall a kind of missionary zeal in this

small caucus at the prospect of a revolutionary step toward the improvement of public taste and awareness.

The "manifesto," such as it was, found enthusiastic response at the council table, where fellow artists were not unaccustomed to abstract thoughts and the expression of an ideal uncluttered by detail. Minoru Yamaskai, slight in stature with darkly sensitive eyes, had designed a number of buildings of great beauty and elegance, including the Woodrow Wilson School for International Studies at Princeton University, with its reflecting pool and tall, graceful, repeated archways. Bill Pereira, urbane, sharp-featured, with a quick laugh, was best known for his work in California and along the West Coast. "Bush" Brown headed the Rhode Island School of Design. With them their artist colleagues could dream a little of achievements to come.

When asked for some specifics, Minoru said, "This will cover everything from skyscraper to park bench, to a light fixture in a public building, to a doorknob." There were nods of approval as each member envisioned a functional object and how it could be changed with imagination.

But when we presented the idea to the Congress as part of our proposed budget, reactions were a bit different. Roger, when questioned at the hearing, read through the Tarrytown verbiage.

Had he said mayors, governors, industrialists, and educators? Roger was asked.

Yes indeed, Congressman.

And they'd all work together, they'd all agree?

The discussion would lead to a new kind of consensus, Roger suggested.

And what would they be discussing?

Well, it could be skyscrapers, or public parks, or light fixtures, or even doorknobs, things like that, Roger said.

Doorknobs?

From the large down to the small.

Are you suggesting redesigning doorknobs, Mr. Stevens?

Well, said Roger, that was just an illustration.

Door handles or doorknobs? How on earth would you get a bunch of mayors and governors to redesign a round doorknob?

From this kind of questioning, it began to be clear that a National Institute of Design—unlike an American Film Institute—needed perhaps a bit more thought given to its explanation.

I remember Roger saying to me, "Let me see that paper again;" and then, "The deputy chairman will provide further information to the committee."

* * *

Robert Nathan Associates in Washington was selected to conduct a needs examination of the proposal. Says the endowment's second annual report, "Recognizing the enormous complexity of the field of environmental design as a whole, and recognizing, too, the great number of existing programs, both governmental and private, it was felt necessary to do a careful study to avoid duplication and assure program effectiveness." These careful governmental words, together with the word "study," satisfied the Congress; but neither Robert Nathan or Associates quite got a handle on the concept, either. It was a little like discussions I once heard when the National Council on the Humanities sought to define "the humanities" in philosophic terms. Paragraphs were spoken, pages were written, but neither precision of focus nor specificity was the guiding attribute.

It is notable that in the early annual reports one descriptive term is omitted. Roger had been asked in Congress how the National Council envisioned the composition of a team to recommend solutions to architectural and design concerns—the remodeling of a city's waterfront, for example.

Well, there would be an engineer, Roger said (nods of agreement), an architect (nods), a city planner (nods), a public official (nods again), a design expert (yes, nods), and a poet, said Roger.

A what?

The word poet does not appear, in this context, in the annual report. A design institute, combining the talents and visions of the arts with practicality, was deferred.

But the Architecture and Design Program began with grants to individuals, permitting selected students to broaden their knowledge, and to organizations, for demonstration projects that could serve as national models for better overall design in various locales. And the ideas, though ephemeral at the start, entered into the endowment's future, and through that future into larger entities of government. Cities did change their skylines and waterfronts through endowment planning grants. Buildings believed obsolete, scheduled for demolition, were suddenly perceived to have historic value and historic beauty—and beauty in their own right. Old city sections were rejuvenated. Victorian architecture was given a renaissance, in San Francisco and in Albany, New York. The special color and style of Art Nouveau were preserved in Florida. The fascinatingly elaborate interiors of old movie houses—with vast spaces, embossed ceilings, murals rivaling the Arabian Nights—were rescued from the wrecking machine's stone ball and became new performing arts centers.

Other agencies and departments often help supply funding for such projects once underway, but only the endowment has authority—

in that flexible legislation—for planning, for the architect's model, the drawings, the illustrations which when completed and displayed give a local citizenry the tangible, the specific for action. The relatively small endowment planning grant multiplies, often at a geometric rate, with private and nonendowment funding added. A dollar ratio of up to a hundred to one is not unusual.

It took a while, but the right combinations were found—perhaps not exemplified by a doorknob, or by a poet's words, but by an old stained glass window reflecting sunlight over a handsome Victorian staircase, or by something as mundane as a government pamphlet given, with endowment urging, an uplift in typeface and a more readable graphic design.

The endowment's second annual report offers an apology. It explains that an approved project to create a "master chamber orchestra," under the direction of Alexander Schneider, just did not work out, and that "a different and more successful solution to the problem is presently being sought."

The problem, brought to the council's attention by Isaac Stern, centered around the lack of accomplished instrumentalists. Especially, said Isaac, did this apply to string musicians, the players of violins, violas, cellos. The solution: an orchestra directed by the beloved "Sacha" Schneider—a dean among musicians, respected, indeed venerated—would travel the country, and local musicians would join it and play with the experts. There would be special training for young musicians, and over time, as the ripples spread out from the source, the needs would be corrected.

Unfortunately, there were disagreements over just who would play in the master orchestra. Symphonic organizations expressed concern, lest their first-or second-string musicians be beguiled away to perform with Sacha nationally. The best established musicians might embark on an exciting new enterprise, but what about the best established organizations left behind? What about salaries? Sacha seemed intent on real inducements.

Wouldn't they undercut established procedures and contracts, even though few musicians at the time had year-long guarantees of work?

It might be observed that the arts, if left to their own devices, are apt to choose in favor of what has worked in the past, rather than the innovative that could come to solid ground in the future. This, of course, is natural. But since we tend to assume the opposite—that the arts are full of high imaginings—the discovery of conservative attitudes comes with a certain bump until it is understood. Leadership, a catalyst, can

change all that; but not right then, in terms of a master chamber orchestra.

But Isaac was right. There was a dearth of talented string players. Remembering those admonitions, the endowment began addressing them in different ways. Organizations like the one Rudolf Serkin, the pianist of international repute, began developing and directing in Marlboro, Vermont, received endowment assistance. Chamber music played by the especially talented young wafted gently across the wooded hillsides. Musicians came to work with each other and with "Rudy," who played with them, who helped them grow. And they, in turn, formed small groups and traveled and grew in renown. Chamber music was given special attention during my tenure, particularly owing to a personal visit to Marlboro. The chamber group and the chamber orchestra have become more and more familiar to a larger audience, who have come to enjoy works by composers rarely heard twenty years ago. It is a specialized audience, but as its numbers grow, so does the listening ear become attentive to the magic of an individual violin or a cello. And so is the world of music enriched—again, the results of early ideas. The early mirage proved an oasis, after all.

From the very start, I always felt a particular delight in being in the company of great artists. It took me a time to graduate from feeling starstruck to realizing that, as an official of the endowment and as a writer of novels, my views were to their liking.

I remember my earliest encounter with Isaac Stern at Tarrytown. Isaac sometimes tells an old story on himself that features two women talking. One says joyfully, "I heard Isaac Stern last night." The other says, "What did he say?" I had heard Isaac play; delight is always there. I had not heard him talk to me.

I said, after a few beginnings, "That's a beautiful tie you're wearing." It was red and black, actually thin diagonal ribbons of red, contrasting with thin ribbons of black, skillfully sewn. There was a little shop in an arcade off Piccadilly Street in London that made ties of this nature. I had once purchased one, but I had not seen its like since then, though I had often looked. Isaac said he liked it, too. The next day at my place at the council table was a thin white box. Inside was an identical tie; I remembered that, as I spoke to him, he was en route to a concert in New York. He had stopped to purchase the tie.

So Isaac helped create the chamber music movement in the United States, and he found a lifetime devotee in Livingston Biddle. He spoke elegantly in my behalf and in behalf of excellence in the arts at the ceremony when I was sworn into office as chairman.

* * *

Isaac's enthusiasm and his articulate style could carry all along. To hear him speak was to hear oratory almost at the same level of persuasiveness as his violin mastery. As illustration, there is the famous violin varnish story. It was famous to us all at the time, though its notoriety did not extend much beyond the immediate endowment family. It might have. It might have revolutionized the violin world. Who knows? It might still.

The beginning was at an early council meeting held in Washington rather than Tarrytown; it was winter and icy roads along the Hudson River did not beckon. The room was spacious, relatively low-ceilinged, businesslike, acoustically well equipped. The council sat at a long table. The audience included our Washington staff and a few invited guests. One was Theodore Hazlitt, director of the Mellon Charitable Trust in Pittsburgh, well known in private philanthropic circles. Tall, white-haired, with a ready smile, he wanted to learn more about this new Washington-based agency. He was not disappointed.

Isaac arrived, and he had exciting news for us. We were at once attentive. What, in particular, made the violin an instrument of great mellowness yet special sensitivity, he inquired? He answered the question. It was made of wood, worked and reworked according to age-old traditions and craftsmanship. Why were Philadelphia's Academy of Music and New York's Carnegie Hall such perfect places for the subleties of great music? Because wood dominated their interiors—old wood seasoned by the years, wood on the face of the boxes themselves mellowed by time. Why were they having problems with newer centers of music? They had forgotten about the special resonance of wood, with its properties that could absorb the harsh and return the essence in just the right degree. Plastic materials and other substitutes could not compare with the virtues of old-fashioned wood. (I recalled once witnessing the experiment of a pin being dropped on stage in the Philadelphia Academy of Music and hearing that minuscule sound, neither muted nor reverberant, in a remote corner of the auditorium.)

But what made the wood in a seventeenth-century violin fashioned in Italy so special? Isaac went on. What distinguished the Stradivarius violin so that it was unique, sought after, played and played again with uninterrupted tonal quality during succeeding centuries? You could emulate the lamination; you could duplicate the shape, the conformation of the instrument, down to the minutest detail. Why was it special? Why did violinists search for these violins, now relatively few in number, made at a particular time in a particular small European region?

Was there a coincidence? Was special genius involved? Not so much that, Isaac told his fascinated audience. It was—and he paused,

viewing us as Edison, or Galileo, or Archimedes might have viewed his listeners—the oil that was rubbed into the wood, the oil that gave the wood its patina. The wood of all fine violins, modern or not, was carefully oiled and varnished, Isaac explained; but in northern Italy, at the magic time, the olive oil for the varnish was kept in wooden vats, their interiors soaked through the years, resulting in a rich coloration. But—and here was the nub—in this Italian environment, special to violin-making, it was not just any olive oil, and not from adjacent groves. Olive oil from Greece was imported and mingled and suffused into the vats, oil from the groves of trees in one particular Greek region. In fact, it might even be narrowed down to one olive grove.

How did he know all this? Isaac was asked. A researcher from the laboratories of Eastman Kodak had explained it. Greek olive oil, from seventeenth-century Greece: that was the "open sesame." Analysis of the varnish on an instrument over two and a half centuries old had revealed a unique substance in the varnish, and historic records showed that the oil had been imported. And best of all, Isaac said, the special olive groves in Greece were still producing, for the olive trees, gnarled and green and silvery, outlast the years and centuries, and the fruit is renewed.

Suppose we were to send a researcher to Greece, a special expert to investigate, the council wondered. Suppose an oil could be found and a varnish concocted, exactly like that Antonio Stradivari (or Antonius Stradivarius) had used. Might not a modern instrument be transformed? Suppose a formula was discovered and a magic touch imparted. Certainly modern research could furnish the tools.

Roger was clearly aware of the intensity of the discussion. We had already allocated most of our resources. Might we spare $5,000 to begin the project with an individual grant, enough to send a proper investigator to explore and analyze the Greek groves?

I could see Theodore Hazlitt approaching. He caught my eye and beckoned. "We will match whatever you decide," he whispered. I relayed the generosity in a whisper to Roger, and a total of $7,000, half of it matched, was approved.

I think we all heard that morning the beckonings of Greece and of a mystery on the threshold of remarkable solution. We were entranced as if by the pipes of Pan or by Euterpe, muse of music. We learned of Fernando Sacconi, world-famous authority on the making of a violin and of the Eastman-Kodak chemistry which could hold the key to the needed research.

So where is the new/old Strandivarius? Where is the formula with magic properties? Where are the vats of olive oil, mingled perhaps with Italian residues (for these great standing containers, like stately giant urns, are not discarded)? Are they not now imported to the U.S.?

It was not to be. The expert researcher did not live to make his voyage. In mind's eye I still picture him climbing a rocky hillside toward the grove of special olives, the Aegean shimmering with blue below him.

The moment faded, however. Some day it may be revived. Orpheus with his lyre, said to have the capability of charming even rocks and trees, may yet serve as a guide.

The prospect was carried on the books for some time.

What is this violin varnish grant, Mr. Stevens?

Oh yes, that one. Yes—it's been delayed.

Chapter 36

PRESS RELATIONS WERE OF CONCERN TO ROGER AND TO US ALL. FROM OUR early sequestered settings the press had been kept fully informed. *Life* magazine had covered an initial council meeting at Tarrytown, but had taken pictures chiefly of celebrities in discussion. Program matters were relatively sparse and received less attention. But now it was the summer of 1966, and the endowment's first major press conference was scheduled.

Roger had chosen the upstairs at Sardi's for the event and had reserved it with his own private resources. It was to be simple, yet prestigious, with the council in attendance, the luminaries, guests, leaders in the arts, leaders in philanthropy, leaders in education—not in great numbers, but enough. We had invited about twenty-five of the top press representatives in news and in the arts. Roger was fond of Sardi's. It always reminded him of the successes he had known in the theater—the excitement, waiting past midnight for first reviews; stars on tenderhooks at a cast table, watching the door.

We were packing up our belongings on the broad expanse of the Tarrytown terrace, under the pillars, in the shade. It was a beautiful warm afternoon. Lunch had been completed.

Roger hailed Polly Pollock, our director for public information, who had joined the endowment not long before. She had worked for the *Philadelphia Evening Bulletin* when I had been a reporter. She had been a feature writer. She had edited the women's page and the arts news, and she knew a large number of press people in Washington, along the eastern seaboard, and points west. She was down-to-earth. She was also a bit nervous, as this was her first important council meeting, and she wanted no mistakes whatsoever.

She had stayed up well past midnight each day writing a series of short releases on each of the council actions. The pages were assembled in order of funding levels, but Polly had given them no priority; she had discussed that with me, but would leave the final determinations to Roger. Depending on the order he selected for announcement, she would write the lead, and the package would be complete. Upon arrival in New York arrangements had been made for a stencil machine and typist (that was the state of duplication in 1966). The entire release would be finished by no later than 10 p.m., all needed copies made, and we would all get a good night's rest.

Roger was saying goodbye and see-you-tomorrow to his council. The distinguished departed with compliments. Luncheon plates were disappearing, and gone.

The pioneering and the precedent-setting were involved, waiting to be announced. Questions of council philosophy and policy had been discussed. A beginning panel system was set in motion, with the council reviewing lists of possible panel members from the illustrious and highly knowledgeable in the various arts fields.

A matter of lasting consequence to the endowment's future work had been debated and resolved. It arose when Isaac Stern mentioned the excellence of Carnegie Hall in New York. But you're its leader, someone said. You shouldn't speak of Carnegie Hall. Isn't that conflict of interest?

He was not speaking about some possible future grant, Isaac explained; he was merely giving an illustration. But it brought into abrupt focus the role of the National Council on the Arts and its membership. What would be considered, under another set of circumstances, special pleading? Should council members refrain from any mention of institutions with which they were affiliated? What precisely was conflict of interest, and, perhaps more important, what gave the appearance of such conflict? Should panelists in theater, for example, be without an affiliation to theater organizations? Ideally, in the best of situations, should theater grants (using the same example) be reviewed by individuals who

had no relationship whatsoever to any applicant? Ideally, should a similar kind of format apply to some future membership of the council itself?

This is an issue so fundamental to the endowment and its guiding council that sometimes it is overlooked. Here it came into sharp light for the first time: If you assembled a group of disinterested engineers, for instance, to determine support for the arts, obviously you would have no conflict of interest. You also would have a measure for judging work in engineering, but not excellence in the arts.

I pointed out that the basic premise of the legislation establishing the National Council, and later the endowment, was that council members be experts in the arts. They were to be selected for their knowledge and experience and for representing those qualities in the most distinguished fashion. Obviously, they could not achieve their reputations without being leaders in their respective fields. Obviously, they did not work in a vacuum. Their careers were inevitably intermixed with organizations. For an Isaac Stern there would be no important musical group in the country with which he was not, to a degree, familiar. So it would be for the other art forms. Often the expertise would cross discrete boundaries, for the expert's range of knowledge is constantly broadened through experience. The same philosophy was meant to guide the selection of panels of private citizen experts in the arts. Each of these words was important individually, and when joined together they were basic to the law.

So much for philosophy. How about the matters of behavior? Chuck Ruttenberg drafted a document on proprieties, which has been refined and amended over time but is as clear in its essence now as then. Yes, an Isaac Stern could evaluate excellence in terms of his own experience (how else could he describe it?); but if any council member was part of an organization requesting support, that member could neither speak nor write in its behalf. This meant that council members would occasionally leave the meeting room, and minutes would show, for the record, an abstention from voting and participating.

The same regulations applied to the panel members who were chosen for their expertise and knowledge. During my tenure, I made a particular point of observing and monitoring panels at work. Periodically, they came under attack. Yet I have seen a panel of over twenty, a majority of whom had direct affiliation with organizations seeking endowment help, punctiliously conforming to well-established procedures. And in my long experience, there has been a certain bending over backward to be fair.

Why is this? Why isn't there more of an atmosphere of I'll-vote-for-you-if-you'll-vote-for-me? The answer can be given on two levels:

pride and reputation. There is personal pride in the arts organization involved and pride in serving on the panel itself, for such service is considered an accolade to one's own excellence. The reputation relates to one's peers, and how they judge each panelist in action.

There will always be skepticism on this subject—as there should be. Criticism simply means that the watchers are sleepless. It is well to remember, however, that the process, so initiated by the first council, implicit in the law, fundamental to the overall program, has stood its testing in time.

Philosophy, policy matters, and projects with those limited funds, all ready for press announcement, awaited this day for literary birth. Individual grants to composers, creative writers, choreographers; the American Film Institute's beginning; the Laboratory Theater Project; the American Ballet Theatre's national tour; new help for a variety of creative individuals through the Artists' Housing Project; and assistance to a Playwright's Experimental Theatre to enable the production in small local theaters of plays that would have the potential of later reaching a far wider audience: each had its complexities, each its rationale. I had reviewed Polly's preparation and found it good.

"Well," Roger said, waving to the last council departee, "let's see those papers, Polly."

She drew them from her large purse and smoothed them out on a table. Roger seated himself, put on his glasses, and at that point a zephyr, then a funnel of wind, stirred from some unexplained source, arrived. The papers whirled upward, over the balustrade close by. Caught in sunlight, they climbed for a brief time, then cascaded into a field below us, where they tumbled across the grass, descending a slope, receding into the distance.

About sixty pieces of paper were involved. I ran hastily after them, Polly somewhere behind. The breeze continued. A narrow stream lay at the foot of the slope. Some papers managed to reach the current. Others were stuck in reeds and brush. It was suddenly impossible to retrieve more than a handful intact, and the pagination was beyond belief.

Roger surveyed the scene calmly. "We'll just use the carbons," he said. But it appeared they had been packed in a box and were speeding off to New York, or perhaps Washington. We never quite found them.

Roger gave Polly a long, long look and said to me, "Never mind, we'll write the press release in the car." Polly was a silent partner. Roger sat in the front, I behind him with a pad. I still have those notes. By the time we had reached New York, we had completed a tentative first para-

graph, which ended, after a series of phrases and commas, "the National Council on the Arts, Roger L. Stevens, chairman, announced today." One paragraph, tentative or not, a press release does not make.

I assembled the troops and we worked into the small hours, from notes, from memories, from other bits of paper we had kept. The press arrived at Sardi's on schedule. The press releases did not. They came by taxi from the printers, as some reporters were leaving.

It is true the press received and wrote about a somewhat different story, and facts and ideas, than originally intended, but they did their interviews faithfully with the members of the council and staff leaders present.

There is a happy ending. The coverage was favorable. The endowment was thus launched into an assortment of printed praise. But in my mind I still see white pages fluttering in blue sky over Tarrytown House.

We had very little bad press in those early days. As time went on, as the endowment grew, as applications mounted at far greater rates than available funds, and the numbers of programs and subdivisions of programs inevitably grew, the press could pick and choose. They could describe a dissatisfied applicant; they could criticize the thrust of a program; they could wonder about more help for talented minority artists. Under the Freedom of Information Act, they could examine panel records and draw conclusions, either accurate or erroneous until explained and corrected. Was the endowment "populist" or "elitist?" If the former, wasn't quality in the arts threatened with dire consequences; if the latter, weren't the grassroots growth of the arts and the wellsprings of American culture placed at a disadvantage? Shouldn't the states have more autonomy? Shouldn't state leaders be more involved with the National Council? Weren't some programs getting more attention than others? How about photography as a major art form? How about the folk arts? How about jazz, which could be called America's classical music? As time went on, there was much to write about—and question, sometimes harshly, and with a vehemence customary to the arts.

But in the early days, the best in the press, the established and respected experts, had a different focus. There was hope in the air. The cultural life of the country was about to awaken. There was a vision, but it was a shared vision. The press could translate it. It required an act of faith, and perhaps a willing suspension of disbelief at times, but there was also a special opportunity to help shape the future. We welcomed advice and discussion, and we were speaking of goals that members of the press could help formulate and make more tangible.

Notable among such writers were Brendan Gill of *The New*

Yorker, Clive Barnes of the *New York Times,* and Frank Getlein of the *Washington Star.* Frank was a particularly regular visitor. He never sacrificed objectivity, but he gave us more than we gave him. He gave us a sympathetic ear and a vast understanding of the subject, and he made the voice of the arts both compelling and articulate. The press helped us put our best foot forward. In Washington that was in itself a refreshing precedent.

Chapter 37

THE FIRST NATIONAL COUNCIL ON THE ARTS WELCOMED MANY DISTINguished visitors to its discussions. Some addressed the council sessions, others were observers of the proceedings. On one memorable afternoon Yehudi Menuhin spoke with such passion and conviction, explaining how he was developing a program to help young musicians in England, that he lost total track of time. For a while the council, held by his eloquence, did so too—but not much beyond an hour and a half. On this occasion, we could say we had "heard" both Yehudi and Isaac, though not on violins.

George Kennan, diplomat, educator, then director of the National Institute of Arts and Letters, came and launched the initial cooperation between institute and endowment. The endowment's prestige was thus enhanced, the fledgling given an upward hand by the veteran. Later, with the leading philanthropic, scholarly, and artistic groups, it was the endowment that was sought out for company.

Frank Keppel as U.S. commissioner of education came to endorse the concept of the Laboratory Theater. Dillon Ripley was a guest along with others in the hierarchy of the Smithsonian Institution, including David Scott, director of the National Collection of Fine Arts, and Theodore

Taylor, assistant to Dillon, and present at most meetings. Mark Schubart came as director of education programs at New York's Lincoln Center. Karel Yasko came to represent the General Services Administration and took to heart the council's stress on improved design in diverse fields of government. Karel was a pioneer himself in this area, with an enthusiasm encouraged by his council friends. Lucas Foss, the eminent composer and conductor, was a guest. Almost always present was a leading representative of the National Council of Fine Arts Deans.

No early visitor was more distinguished than Henry Allen Moe, the first and custodian chairman of the National Endowment for the Humanities until the arrival of Barnaby Keeney in the summer of 1966. Some compared Henry to an owl with a small mustache. I do not believe they meant to be derogatory, but to suggest wisdom with a human appendage of modest proportions. Henry was rarely ruffled, not even when he was told by an angered House Appropriations leader that he had no business presenting a budget for approval and at the same time maintaining it first required approval by a National Council on the Humanities not yet appointed. Henry said he found no real anomaly in the situation. Respectfully, he said, he could not guarantee unilaterally that his proposals would be carried out verbatim, or in less definite terms, until his council reviewed them, and that would depend on Lyndon Johnson's speed in appointing the council membership. So the House simply gave Henry a cipher at first—though there were compliments on his initial budget submission, which Chuck Mark and I, in a great effort toward arts and humanities brotherhood, had helped prepare. Henry presented it as possible, but without its full portfolio.

Henry's council came into being before the Senate considered its first-year Humanities Endowment appropriation, and a modified Moe-Mark-Biddle plan was approved. But the humanities admittedly were off to a rockier appropriations start than the arts, where a council had been in place for many months.

As the courtly, soft-spoken, eminently principled Henry Moe stepped aside, Barnaby Keeney sought to regain full momentum for the humanities. The arts, he saw, were beginning to capture public attention. They were no longer quite the political misfits they once had been. They were no longer quite the frivolous partner in distress, which the fearless knights in humanities attire had saved during the hectic times of legislative battle. Roger Stevens was imparting to the arts a certain cachet, perhaps not overly noticeable beyond the reaches of the Potomac River, but definitely to be remarked within Washington, D.C.

At this time—before his own large Georgetown house with extensive boxwood-adorned and terraced garden was acquired—Roger rented a similarly spacious mansion, also with Georgetown address, from the

David K.E. Bruces. (David Bruce served as an ambassador, notably to the Court of St. James. Evangeline Bruce was noted for her impeccable taste.) The house had a ballroom at ground level, and therein assembled, not for dancing but for convivial discussion at cocktail-buffet dinner hours, an assortment of the capital city's VIPs, particularly those who might influence the course of cultural progress.

Guests were chosen not only from among the converted, to spread the good news about the arts, but also from among the unconverted, the skeptics who might listen to the news and gain new insights. Conservatives and liberals mingled. Roger and his wife Christine—tall, stately in appearance, modest in speech and demeanor—were excellent hosts. Christine's affections lay with the arts, but also with the strays of the world; at that time it was animals subjected to medical experimentation and to unnecessary cruelties. In those early days the strays of the world could have been said to include elements of the arts. They found a special home at the Stevens's.

In Washington one entertains, with a careful regimen of protocol, the powerful and they in turn begin to respond. The host and hostess must be recognized in their own rights; the locale must provide opportunities for a sufficient number of chance encounters with lawmakers, press personalities, and others involved in the notoriety of the moment. Given the proper mix, the event fulfills enough personal needs on all sides, so that it can be repeated with at first a growing and then an eventually assured sense of success.

All this Barnaby Keeney perceived at a glance, being a sophisticated scholar and wise in the ways of the world. He sought to develop a counterpart to the Stevens's; but his house was smaller, more professional, and it was not in Georgetown. And the humanists gathered had seemingly less to offer than their arts confreres. They were given to long conversation or detailed rebuttal, which a congressman at the end of the day might find engaging, but only for a while—say, three to four minutes. Arts people laugh a lot at cocktail parties. They are given to gestures and quick hyperboles. You do not have to listen intently to enjoy their company. At Barnaby's, with wife Mary Keeney, albeit a dutiful and practical provider, the decibel of conversation was different than that at the Stevens's. It lacked the possibility of unexpected explosive attraction.

This, too, Barnaby perceived, and took action on another level. It was decided to enliven the humanities, to give them a germane quality, laced with wit and humor, so that they could compete with the press coverage the arts were receiving. The Humanities Endowment announced that in addition to its more traditional early projects it would study the cartoon and its development and impact on American life. The focus would be on the work of Thomas Nast, whose inventions had

sparked discussion and given a vivid new look to the pages of the American newspaper in the late nineteenth century. The Tammany tiger, aprowl in city scandal, the Republican elephant and Democratic donkey, Boss Tweed and his notorious Tweed Ring—all would be featured as progenitors of today's political cartoons. There is no doubt that Thomas Nast and the heirs of his tradition have uniquely stirred public attention and in the process enhanced American journalism. In a sense the project combined both the arts and the humanities, but the latter endowment would undertake it.

For a time, the humanities believed they had a winner. The press, somnolent over other announcements, awakened. Barnaby Keeney and the National Endowment for the Humanities were in the limelight, and the arts were not in sight. Unfortunately, an overzealous public relations type felt the project needed a title that would give it more pronounced popular notice and relate it to the immediacy of the moment. For who, beyond the relatively erudite, would at once identify Thomas Nast or a Tammany tiger?

The project thus was billed as "The History of the Comic Strip." The press pounced on the title with the relish of an unguarded tackle discovering a loose football in the Super Bowl. So, unfortunately, did the Congress. Members of the House of Representatives found vast amusement in the title. No doubt feeling nostalgia for the fabled H.R. Gross and his followers, members rose to their feet in competitive renderings. Little Orphan Annie seemed a particular favorite, with the heroine, Daddy Warbucks, and Sandy given appropriate voices or sounds. Fiorello La Guardia in his heyday, reading the comics to his listeners over the radio amid newspaper strikes in New York City, provided less dramatic flair than these members of the House. It was appropriations season. Now, at last, would distinguished representatives from every state of the Union come to grips with the boondoggle inherent in this new program? Hadn't sufficient warning been given?

In the quiet moments of recollection, one can smile with a kind of rueful pleasure at the Grand Ole Opry the House was capable of producing for the beginnings of the Arts and Humanities Endowments, imitating the querulous voice of a little girl and the bark of her inseparable canine companion. But it was serious business at the time. It can be estimated that excursions into fields of the recognizably popular cost the Humanities Endowment close to $1 million in appropriations. The arts, boldly tracing the course of cultural achievement from ancient Egypt and ancient Greece to the present, remained unscathed.

Parity in funding between the two endowments, as contemplated in the legislation I had prepared, thus did not occur at first. Supposedly

studious and prestigious Big Brother got less than allegedly unpredictable and coquettish Little Sister. It was not permanent. Parity was to be restored and to remain a tradition for many years—but not with Little Orphan Annie on the House floor.

It must be admitted that Roger Stevens did not find the outcome described above wholly displeasing. The same cannot be said for Barnaby Keeney.

Chapter 38

*I*N THE LATE SPRING OF 1967, ROGER STEVENS AND I DISCUSSED HOW BEST to provide the Congress with pertinent information on the magnitude of the endowment's tasks. Hearings to reauthorize the entire arts and humanities program were being scheduled for July and August. They would be the first reauthorization hearings for the two agencies. It seemed a most opportune moment to tell the Congress that the Arts Endowment, started with an appropriation of but $2.5 million, had many miles to go and all manner of bright promise to fulfill before it could ever contemplate a rest. But how to present this information?

Administrations do not look kindly on agencies, especially upstart ones, that advocate exceeding their budgeted limitations. Each year, the Bureau of the Budget (now OMB) prescribes detailed figures for each part of the executive branch. The agency head testifies to Congress on his or her prescribed amount; he or she may not go beyond it. The traditional obligation is to defend the sum as necessary to the program's health, essential to meet needs, and hence the right choice.

President Johnson's administration looked with favor toward the arts and with admiration toward Roger, but not with any hint of unlimited generosity. The administration's request to Congress, as it is called,

was within the $10 million per year limit. Congressional reauthorization could hardly be expected to exceed such a request initially. After all, Democrats formed the majority in both the Senate and House, and the President normally worked closely with both legislative bodies. In these days, the Senate was a bit more liberal toward the arts than the House, and authorizations were greater than appropriated funds, but the prospects for a dramatic shift into high gear were negligible, and there were penalties to be accrued from overstepping established procedures and protocols.

On the other hand, if Congress believed $10 million annually was both a current and a foreseeable maximum (certainly it was four times greater than the start, and we had been explaining to all who would listen what had been achieved with very limited sums), how could far, far larger numbers be recommended, verified, and vigorously defended?

Was it impossible?

Roger and I discussed the real and identifiable needs in the arts. Estimates, although admittedly not fully precise, ranged upward to $200 million per year.

"We don't want to frighten them all to death," Roger said.

"How about $150 million?" I suggested. Roger meditated, scanning the papers on his desk.

"Not quite one-fifty," he said. "Let's try to make it somewhere just below. Maybe $147.4 million, with the decimal point. Document it. Stay with the facts. And figure out how we can do it without jeopardizing anything, or anyone."

There was a way, I discovered. My research told me that, if the Congress asked an agency head for information via a direct congressional inquiry, such tidings must be forthcoming. I knew that both Claiborne Pell and Frank Thompson were interested in discovering the real needs involved—not the pretended needs, not the vaguely estimated or the hearsay, but the factual and the valid.

Accordingly, and with the help of old friends, a letter came in spontaneous fashion to Roger Stevens from Claiborne Pell, requesting "that when you appear before the Senate Subcommittee on August 15 to testify . . . you furnish the Subcommittee with detailed information about the future needs of the Arts Endowment. . . . The Subcommittee," said the letter, "would be interested in learning from you, in as specific terms as possible, the amounts which you believe the Endowment could prudently spend in the near future to carry out its Congressional mandate. . . . I know," the letter concluded, "that this evaluation from you about the needs in the Arts will be very helpful to the Subcommittee."

A similar direct congressional inquiry came from Frank Thomp-

son. We were thus given the privilege, and the opportunity, of making our case free of the normal restrictions of the Budget Bureau. Whether in private they lauded our method of approach is not known. They could not object.

(My knowledge of this process was to stand me in good stead as time went by, particularly when as endowment chairman I was called upon to defend to the Congress a budget proposed by the Reagan administration that cut exactly in half the budget proposed by outgoing President Carter.)

Many long nights during the summer of 1967 were spent documenting the arts needs of the nation so that they would comply with Roger's dictum: equate with the critical financial state of the arts and offer both a realistic assessment of goals and realistic ways of reaching them, or at least reaching toward them.

Chuck Mark and I sat in adjoining rooms with the midnight oil burning regularly after staff members had departed. We were surrounded by material garnered from a variety of sources. There were studies now from the Rockefeller Brothers Fund, from the Ford Foundation, and from two Princeton professors, William Bowen and William Baumol, who had written about the difficulties facing the performing arts nationwide. (Bowen would later become president of Princeton.) We had developing data from arts organizations and state arts councils. We learned, for example, from the National Association of Music Schools that there were 35,981 music majors in 238 member institutions in the United States. Comprehensive figures were in relatively short supply then so we delighted in this kind of detail; it showed we were doing our homework and gave authenticity to the product. The transcript of the 1967 congressional hearings summarizes our work, in the smallest of type, on some forty pages. We ourselves used almost 800 pages of text, edited down to just under 200, with footnotes, charts, and graphs in addition.

The grand total was approximately $148.3 million. There was intentionally no final tally sheet; the statements and data in the various arts fields were allowed minor flexibilities. The words could be well spent, judiciously spent, prudently spent, and priority were given particular emphasis. Nowhere was it suggested that this, or any part of it, might be in accord with Bureau of the Budget planning. It was the Arts Endowment's response to Congress.

Admittedly there are a few flights of fancy, a hint of pie in the sky here and there. I was writing about wider horizons on dark nights, and as Charles Mark sometimes said, we were hungry. Most of the material, however, is straightforward, expository in style, and has a full statistical basis.

Some passages have an element of prophecy. Major help for the nation's symphony orchestras, a stress on touring in the performing arts, accelerated support for individual artists, increased emphasis on new works by American composers and playwrights, all have transpired. But other ideas took different courses. The media program described then was more ambitious than later was the case. The concept of using endowment support to give a television dimension to arts projects—concerts, theater productions, operas—was never fully implemented. The seed was planted, however, and it grew into such TV successes as "Live from Lincoln Center" and "Live from the Met," seen and enjoyed by millions of viewers. Similarly, education in the arts was given greater stress than it later received. The emphasis envisioned for orchestras and chamber music groups in smaller communities was some ten years ahead of its time and has not yet been completely realized, but an eventual $10 million program to help the Nation's museums was right on target, with a future closer by.

The ideas for some projects remained valid, though the methods for providing assistance were later changed. For instance, how could we best help the Nation's sculptors, who often worked with heavy metals and on pieces of a very large scale? The artist's studio, even in an idealized Westbeth, does not quite fit that type of work. We theorized that we could establish regional foundries for artists working on monumental sculpture. The equipment, the lifts, the light, the high ceilings could accommodate a number of sculptors. The concept was translated into support for less commodious space, into more numerous quarters adaptable for individual use, into places where various kinds of visual artists could create new work and display it—and into more individual grants to the artists themselves.

We discussed the concept of a national magazine for criticism, with a start-up cost of $150,000 in endowment funds. Twenty years later it was still under discussion. Roger was convinced then, and remains convinced now, that better criticism would improve the quality of the arts. Too often in relatively small towns and cities, the arts critic's job falls to the neophyte journalist, to the inexperienced, to the sportswriter given a couple of free tickets to a touring orchestral group and asked as a consequence to write its review. But should the government support criticism?

To me the advantages outweigh the disadvantages. A first-rate magazine, in part—only in part—assisted by the National Endowment for the Arts, with excellently trained and literate critics sent to cover the many splendors of the arts wherever in the country they exist, would seem to me an immensely valuable publication. Its readership would grow, and as a country we would be more aware of manifold and devel-

oping blessings, beyond the centers where the relatively few experienced critics ply their trade.

But the issue is unresolved. On the obverse of the coin are lingering doubts. If government, indirectly through the writing it supports, makes judgments about what is good, what is not good, and what is mediocre, does that not imply an inappropriate influence on taste, quite different from partial help to an arts organization or an individual requesting that help and recommended by a private citizen panel of experts? So the controversy continues. Help to provide training for critics and for meetings where critics can exchange their views and ideas, their own goals and dreams, has to date involved endowment aid, but not a formal publication.

The concept for a National Design Institute, together with the scope of projects it could undertake, was set forth for the record in the most specific form to date, and it elicited congressional comment, this time favorable, particularly from Claiborne Pell. His chief of staff for cultural concerns during the time I was deputy chairman of the endowment was Stephen J. Wexler. Steve was acknowledged to be one of the Senate's finest workers. Thorough, diligent, competitive, and sometimes combative, he represented his principal with a rare ability. He was not prepossessing in stature, but his face, especially the large eyes, was so constantly alert and attentive that one forgot about the stature and instead was conscious of a quick and questing mind. Steve was sometimes considered abrasive by those whose answers failed to fully satisfy him; he was not, for example, a favorite of Nancy Hanks. He and I were fast friends. I believe he respected my knowledge of the arts, and I respected his skill at his appointed tasks. During the summer of 1967, we were in somewhat opposite courts, Steve preparing the hearings for his chairman, I preparing answers for mine. In Washington, there are special boundary lines drawn between a professional relationship and friendship. Though they are invisible, we both knew them well, and did not trespass.

Claiborne Pell had been to the Island of Delos in the Aegean Sea with Constantine Doxiades, whose reputation as philosopher-architect-humanist was growing. There were some who considered him more showman than profound thinker. Claiborne was not among them. As he described his voyage aboard the Doxiades yacht, every day was enhanced by new intellectual exploration with a small number of guests who had been invited because of their achievements in statesmanship and in the areas of knowledge Doxiades himself had sought to assimilate and express. The blue waters, the white buildings, the tranquility, the sense of antiquity and of the contemporary—all added different dimensions to the trip. Claiborne returned with the word "ekistics," which

could be described, though somewhat imperfectly, as the science of human settlements.

The very same ideas the architect members of the National Council on the Arts had been seeking to articulate, and which the House of Representatives had found too vague for practical deciphering, now found an enthusiastic spokesman in Claiborne Pell. In fact, he proposed to Roger Stevens that our basic law be amended to include "ekistics" right up front, in the opening language. The suggestion at our first reauthorization hearings caught Roger and some others by surprise, especially since Roger had encountered his own problems in enunciating just what a design institute would do.

"Planning for human beings in urban settlements cannot be considered only on the basis of quick transportation or quick garbage disposal or efficient architecture," said Claiborne. "It has to concern itself with the whole human being, with his sense of integrity, privacy of purpose, and sense of beauty, and also a sense of happiness which is part of it all." The architect council members had never put it any better.

The "actual Design Institute" would really serve two functions, Claiborne continued: "that of a bank," where knowledge and information would be stored and available, and "a more active role," providing specific project support. Again, no one had been more cogently accurate.

Claiborne asked Roger for reaction to his proposed amendment, which would add to the declaration of purpose, following "democracy demands wisdom and vision in its citizens," the phrase "according to the principles of ekistics."

Roger demurred after a moment or two, or three. He praised carefully the concepts motivating the amendment and suggested that perhaps substitute phrasing might be possible. The existing law, he implied, might also be fundamentally broad enough to encompass the senator's ideas.

Claiborne in turn pointed out that, while ekistics might be a relative newcomer to the language, it could well be recorded in the next edition of the *Encyclopedia Brittannica*. Moreover, inclusion in the Arts and Humanities Act would no doubt guarantee its inclusion in Webster's dictionary. From the witness table with Roger, I looked at Steve Wexler. His face showed no expression. At a poker table, he could have been holding a pair of deuces or a straight flush. Was the senator serious? Was it a flight of fancy? Was it all tinged with humor? It was certainly true that, if such a Pell amendment were adopted, the House of Representatives would have another chance for revelry.

Knowing Claiborne Pell for as long as I have, I knew the senator was serious. He had made a discovery; he liked it. It had a bizarre sound. He didn't object. He wanted to make a point. He believed it was in keep-

ing with the endowment's presentation, with the National Council, and it was as natural to him as his espousal of the arts themselves. But there is also a quixotic side to Claiborne, and so there was the hint of humor, undetectable by the inexperienced observer. If you looked at Claiborne Pell that day and wondered what kind of crazy idea he would come up with next, you would have made a wrong assumption.

It was a moment in time for the arts and humanities—in that large paneled Senate hearing room, always filled with weighty tradition and so often with the matter-of-fact. Would the arts and humanities (for the phrasing would apply equally) be provided with a word that no one, including the senator from Rhode Island, could precisely define?

In his mild, thoughtful, serious voice, Claiborne posed a question to Jack Javits. "What do you think, Jack?" The senior senator from New York pondered. "Claiborne," he said at last, "I don't think we're quite ready for it . . . yet."

New phraseology was drafted, however, and enacted into law.

After each definition section, setting forth the areas of activity for each endowment, these words were added: "and the study and application of the arts [humanities] to the human environment."

And so in the end Claiborne Pell had his way.

Chapter 39

THE 1967 HEARINGS PRODUCED A DISCUSSION OF A DIFFERENT KIND, STEM-ming from the American Artists Professional League. This time the league was represented not by Wheeler Williams (who had suggested that he and Claiborne Pell shared an Indian princess as an ancestor), but by Michael Werboff, who offered a revelation almost as startling.

He had been born in Russia in the days of the czars. His progress as a painter had involved long and arduous academic training. He specialized in portraiture. Now, in later life, he could display sequences of reproductions of his careful work—the famous, the socially prominent, those with historic credentials. He spoke in a deep voice, accented by his background. Like Wheeler Williams before him, he was laudatory about little in contemporary art. The avant-garde he could dismiss, generally speaking, as "avant-garbage."

Claiborne had known him for years and tended to agree with some of his opinions, when temperately expressed, for Claiborne was, in many respects, a traditionalist in the arts himself. He believed that the American public preferred the representational to the abstract, which may well have been the case. Claiborne, however, recognized that his own taste was subjective and should not be an undue restraint or influ-

ence on any endowment program. Michael Werboff was not exactly of the same opinion.

In contrast, Henry Geldzahler, shaping the endowment's Visual Arts Program, believed passionately in both the value and the importance of the fully contemporary. He could speak long and eloquently, and with the knowledge of an art historian and a museum curator, about modern artists and their quests for new discoveries. To Henry—and to the National Council on the Arts as a whole—art was at its engaging best when it sought and found a new and illuminating frontier.

The American Artists Professional League stopped quite a bit short of endorsing the more recent discoveries Henry espoused. Claiborne later said that he thought "Michel" would liven up the proceedings. That he did.

He began temperately enough by commending Claiborne for asking the endowment to furnish slides of the work of a hundred grantees so that he could assess the numbers of representational artists as opposed to those of the nonrepresentational. We had estimated that 75 percent were in the latter range. Claiborne found no objection. Michael Werboff dissented.

At Claiborne's recommendation, the league had been invited to express its views at a council meeting at Tarrytown. Roger had solicited suggestions for members of the visual arts panel, but "so far nothing has happened," Michael complained.

"Surely not enough time has passed," Claiborne said. "If you will rest a bit," he added, "somebody representing your same general view, if not one of those you specifically nominated, eventually will serve on a panel."

"I am sure that some of these advisors were museum directors," Michael Werboff told the subcommittee. "In the last Corcoran Biennial, the prizes were awarded by three museum directors. Here is their choice for first prize . . . and a gold medal. . . . This is a canvas painted pink with no design on it." He held up a reproduction. "On the left side there is one little dab of pink paint and on the bottom there is a green stripe not quite to the end. That is all."

"How do you know it is the bottom?" Claiborne asked.

"Pardon me?" asked Michael, surprised.

"How do you know it is the bottom?" Claiborne repeated. "The green stripe, couldn't it be on the top?"

But Michael Werboff was not about to be distracted. From a larger portfolio he extracted additional illustrations. "I was lucky enough to get a magazine that has color reproductions of a monkey's paintings," he said.

The announcement instantly brought every eye in the room to the witness table. "And here I have the monkey paintings and next to it some of man's performances which were practically with the same kind of technique."

Under the wide chandelier, amid the rows of seats, along the great curved platform where the senators sat, there was not a single inattentive spectator in the chamber, including Henry Geldzahler, Roger Stevens, and Senator Ralph Yarborough.

"Here is 'the artist' at work," Michael continued. "Now here is one of the monkey's paintings, and here is de Kooning using the same colors and almost the same technique." Could the senators tell the difference between two more illustrations? Man or monkey? There was a quiet in the room. Man or monkey, which was which? No reply was offered.

"Now, Mr. de Kooning was a man who was given the highest order that we can bestow on a civilian, the Medal of Freedom," Michael Werboff continued. He brought out an illustration of one of Willem de Kooning's paintings of women, done in the swirls and colors the artist had used in a noted series. "Monstrous caricatures," he said. From then on the testimony became less temperate, with a final non-bouquet thrown in the direction of Henry Geldzahler as "artistically speaking the worst enemy of American traditional artists."

The silence in the room seemed to deepen. Roger and Henry looked as if the roof might just have lost all its supports. Claiborne remained quite calm. He began leading Michael Werboff into less troublesome waters. But the image of the monkey and the artist lingered throughout the hearing.

When it ended that day, Richard Yarborough, an important aide to his father, approached me. We had known each other during my Senate years with Claiborne and the subcommittee.

"I'm sorry to say this to you," Dick began, "because I know you're on the other side in your job now—but my father wants to talk to this Mr. Werboff. He wants an introduction. He thinks maybe we should get some new language written into the law." One glance told me this was a matter of seriousness to the ranking Democrat on the subcommittee.

"Against abstract art, that kind of thing?" I asked.

Along those lines, Dick agreed, his face stern.

"All right," I said. "You know representational art is a favorite of Claiborne Pell's. It's also something many Russians find particularly appealing," I said. "The pictorial. The illustrative. In Russia, the abstract in art is somewhat frowned upon, as you know."

Was I saying Mr. Werboff was Russian, I was asked?

"Oh yes, certainly," I told Dick. "That's his background."

Dick looked at me. "You don't mean he's a *Communist,* do you?"

"Oh no," I answered. "I didn't say that at all—only about the interpretations of art, how it's perceived, at different times."

Dick walked away. Not long afterward father and son left the hearing room.

So full freedom of expression and the integrity of the endowment's panel system, given a sudden unexpected test, were both maintained, even though on that morning not everyone may have been aware of the roles they played. Claiborne Pell the questioner, Michael Werboff the challenger, another as defender—although on that day Michael, or "Michel," might have considered himself the defender against the erroneous and the false.

I have known him now through all the years. He is an artist with one of his paintings—one of a great, great many—in the famous Prado Museum in Madrid. You may have to look a bit to find it, but it is there. He has not exactly mellowed with time. He can still deliver denunciation, with a following "but I have no personal animosity" for whatever individual is involved. Diatribe may not be as successful on Capitol Hill as a more modulated attack. But then the artist, full of convictions, is not often given to modulation. The convictions remain, and they will always remain, on both sides, or on many sides, when the arts raise a controversy.

The hearings followed in the tradition established in 1965. On certain days, they were held jointly, with Senate and House subcommittees sitting together. The traditional was slowly beginning to replace the precedent-setting, and the voices speaking out in support of a developing agency had, in many cases, spoken before. So was the legislation of 1965 surviving its time of congressional testing. So was the agency being affirmed in its purpose.

Now to the $148.3 million we proposed to meet current needs in the arts. There was a colloquy between Roger Stevens and James Scheuer, Bronx Democrat, third in rank on Frank Thompson's House subcommittee. Roger was explaining that the initial mention that "our Council could spend very effectively $150 million a year" produced "a sort of gasp" on the part of those present. It seemed Washington understatement at its very best. Then, as we all waited for an outpouring of remonstrance, Jim Scheuer volunteered that as far as he was concerned there was "no gasp at all."

I remember that incident clearly and rediscovered it in the pages and pages of text that the Congress preserves in its archives. It was almost casually spoken. Yet it marked a highly significant "first:" a recog-

nition that the endowment might be hampered for a while by restricted funding, but that avenues ahead broadened. Jim Scheuer was highly regarded then and now. List him among the pioneers; for when he made that remark, others did not remonstrate. They gave him careful attention.

In the fall of 1967 a gentleman "of the cloth" visited my office. He was tall; I was later to discover he had been a skilled basketball player, but in the days when six-feet-three or-four was an impressive height. He had an open face, no sign of guile, close-cropped hair, a deep voice with a hint of Irish forebears, and an engaging smile. He was Arthur Clark, a Jesuit from Fordham University.

I had met at Georgetown University a somewhat younger Jesuit, full of energy and conviction, who was convinced that the arts must become more important in education. They were cornerstones of the literate mind, of enlightened expression. The Rev. Terence Netter was a teacher of philosophy with the kind of broad educational background the Jesuits have a special way of instilling in those with intellectual talent. He was a painter, a painter-explorer, with a feeling for color and abstract shapes.

Terry Netter had consulted with me on arts projects at Georgetown. We agreed fully on the values inherent in the arts. Through him I knew that Fordham was planning a new liberal arts college, not at its headquarters in the Bronx, but at Lincoln Center. The college was to stand opposite the Juilliard School of Music, which was scheduled to move from upper Manhattan to the city's developing cultural center.

I had been asked if I would help advise on plans for Fordham at Lincoln Center, on a curriculum, on possible educational ideas. Arthur Clark had invited me to lunch, and we sat down together in a restaurant not far from my office.

Father Clark talked in general terms. He would be the dean of the new college, now well under construction. There would be some dozen floors and a wide façade overlooking the Metropolitan Opera House and the neighboring square with the fountain in the middle. The idea was to attract a new kind of student to Fordham. There would be particular emphasis on the arts, which the Bronx campus lacked in terms of courses and concentrations. How would I advise? What kind of faculty would seem desirable?

We chatted amiably. Father Clark was a congenial man who enjoyed a long cigar after lunch. But I began to have an uneasy feeling that there was more to the conversation than appeared on the surface. I had expected to be asked for names of appropriate educators for this

new undertaking, and I had a few I felt would be good recommendations. But the conversation kept sliding away from other names, and suddenly I knew why.

"Would you be interested?" Father Clark asked.

"Of course," I said. "It's a fascinating idea, and an ideal place. Anyone would be interested."

He meant personally, Father Clark said in a mild tone, almost off-hand, and I realized the purpose of the lunch.

At the same instant I realized he might well think of me as belonging to the Catholic faith. Terry Netter and I had not discussed religion in detail, though I had professed high regard for Jesuit teaching. Fordham was certainly a Catholic University with Jesuit leadership.

"Father," I said slowly, "lest there be any misunderstanding, please, I want you to know I am not a Catholic."

I anticipated surprise. Instead, Father Clark put his large hand on my arm and said, "My son, if you were a Catholic, I wouldn't be interviewing you."

I think I decided then and there that, if the talk proceeded along the lines indicated, I could not resist. There was further inducement. Arthur Clark said with a smile, "You're deputy chairman now, isn't that right?" "It is," I answered. "How would you like to be chairman," he asked, "chairman for the arts?"

It seemed to me a fulfillment. I would be in charge of designing an entire curriculum and hiring the faculty to teach it. I would not be limited by existing Fordham scales of pay. A three-year contract was offered, a full professorship, at rates above the government's salary. New York City was undeniably the center of the Nation's arts, and Lincoln Center was the center of that center. I would have the opportunity to work with Mark Schubart, who headed the Lincoln Center educational program and whom I had come to know, and with Peter Menin, head of the Juilliard School. It would be possible, I thought, to devise an exchange program, with academic subjects taught at Fordham for Juilliard students and music training at Juilliard for especially talented new Fordhamites. This proved to be the case.

But best of all, perhaps, was approval of a concept I presented to Arthur Clark and through him to Leo McLaughlin, president of the university. At the new college we would concentrate on the arts, humanities, and social sciences, with each area given a third of the emphasis. There would be interlocking courses that would stress the relationships among the three fields. There would be three divisional chairmen. As the first to be selected I would help choose the other two. It all seemed irresistible.

Roger Stevens gave me his blessing, and there was a farewell ceremony at the fall meeting of the National Council on the Arts. I remember trying to think of what I would say on departure. I had been with the council and the endowment almost exactly two years. It was a memorable time in so many ways, and in itself a fulfillment, as I looked back to that younger writer who had come to Washington as a neophyte to work for Claiborne Pell.

To Roger I sought to express my "immense regard" for him and for his leadership and my lasting thanks for the "exceptional experience" he had given me and for "the many months we have spent together." To the council I remember reversing the thoughts expressed in the traditional phrase *"Ave atque vale,"* hail and farewell, and making it farewell—and hail. Hail to these remarkable individuals, to their accomplishments as artists, as arts leaders, and as council members. Midway through my brief remarks, standing by Roger, facing the council, I had the sudden feeling that I should not be saying goodbye at all, that this was indeed home—but there was to be a new home, and it beckoned.

Fordham greeted its new faculty member at a reception. I was meeting future colleagues, shaking hands. I noticed that the names were all prefaced by the word "professor," spoken with emphasis and a certain formality. It was a new environment for me, quite different from welcoming the great scholars of the country to a Senate hearing or listening, as arts representative, to the deliberations of the National Council on the Humanities. I was to become familiar with the intricacies of the new environment, as with other intricacies in the past—and with the speed accorded fresh information, or rumor, in academic circles.

The faces were all smiling, the tone of voice pleasant and cordial. Then one of the speakers said, "Professor Biddle, we were trying to think a little before you came. We couldn't quite recall the title of your doctoral dissertation." Ah! I thought all at once, a full professor, even in the arts, is supposed to have more than a bachelor of arts degree. I sensed I was surrounded by Ph.D.s. There must be suspicion here, perhaps a salary in question, perhaps a readiness to pounce.

No one ceased to smile, and all seemed quiet; a Washington experience came to the rescue. "Oh?" I said, smiling. "My dissertation" (omitting the word doctoral) "was on government and the arts."

"It was?" the questioner asked. He paused. "But I couldn't find it published."

"That's strange," I said, "because it was published in two volumes, which I partly edited myself. Then there's the shorter version, which in fact appeared as a Senate document, No. 300, 89th Congress, First Session."

I was not asked the same question again.

There was another special reminder of Washington. As 1969 advanced, the White House of President Richard Nixon considered the endowment's chairmanship. Roger's four-year term would expire in the fall. The legislation I had drafted provided eligibility for reappointment.

Would the President nominate Roger for another four years?

In a phone call to New York Claiborne Pell told me that, while many favored such action—including himself and Roger's former deputy, the chances were now nil. Roger had been adjudged to be "just too visible a Democrat," Claiborne said. The fact that he had been Adlai Stevenson's finance chairman made the visibility clearer. Most Democrats and some Republicans supported Roger, but to the White House it was time for a change.

Leonard Garment had just visited his office, Claiborne said, with this news and alternative choices. Leonard was a most influential counselor even then. We can compare him to Abe Fortas in Lyndon Johnson's time. Both were staunch advocates for the arts. In the new administration Leonard Garment was their champion.

Claiborne was the senator key to Leonard's task: the required Senate confirmation of a nominee. As chairman of the subcommittee most involved, original sponsor of the arts and humanities legislation, his approval, in this case, would be tantamount to Senate approval. His disapproval would signify delay, dispute, and difficulty, which the White House wished hard to avoid. Satisfied that he had done all he could for Roger's cause, Claiborne listened to the alternatives. He reported them to me and asked for advice.

There were a half dozen names at the top of the list. The President's leading candidate, Leonard said, was Morton May, an important St. Louis business leader with strong interests in the arts. He had a possible liability, however. He had given notice that he would devote three full days of each working week to the endowment, but that he would need the remaining two for his wide-ranging business concerns.

"Is that enough time?" Claiborne asked.

I told him it did not seem so. "The program needs constant attention. Roger gave it seven days a week."

"All right," Claiborne said. "That's in line with my own feelings. There's a drawback then."

He mentioned other possibilities: John Hightower, leader of New York state's exemplary arts efforts; John McFadyen, a highly regarded architect and also a leader in New York state arts activities. Both, I knew, would have the support of Jack Javits, now long-time ranking Republican

senator on the subcommittee, as would of course the President's first choice.

I suggested to Claiborne that, while the names were well known to me, while I admired their accomplishments, somehow they did not quite measure up to Roger's credentials. "Is there anyone else?" I asked.

"Yes," Claiborne answered, "several others. Nancy Hanks is one of them." Claiborne waited a moment. "What's your reaction? Can you refresh my own memory?"

I gave Claiborne a summary of Nancy's community successes in the arts, her association with the Rockefellers. "She's the one, you know, who brought John Rockefeller to testify at the hearing when he called the arts so central to life. She's able and conscientious and talented."

"I remember," Claiborne said. He paused for a bit. "A woman in the job—that seems like a good idea to me at this point. I'll tell Leonard." After another moment he said, "I think it will also appeal to Jack."

I never told Nancy about this telephone call. As time went on, I believed it would be self-serving. This book seems an appropriate place for its recording. It bears on future chapters.

The three years at Fordham could be a book in themselves. There were marvelous times for a full professor in the arts. There were wonderful students—from many backgrounds, from the sheltered suburbs to the inner city, in almost infinite variety; yet they had in common talent or the unmistakable potential of talent. Harry Levy, a great and respected scholar from City College, was chosen to head the Humanities Division; and to head the Division of Social Sciences, Margaret Mead, world-famous anthropologist.

While the building at Lincoln Center was being finished during the winter and spring of 1968, four of us would meet regularly for lunch at a small local restaurant called the Ginger Man. We would look out on Lincoln Center's square and plan the courses to be given, the faculty to be hired, the brochure to describe this brand-new, and to a degree experimental, educational program. I was to write the brochure's draft for the others' approval.

Arthur Clark, the Jesuit, presided. Harry Levy, the Jewish scholar, was witty and wise, small and wiry in stature, white-haired, enormously articulate. Margaret Mead, a law unto herself, brought along always her famous shepherd's crook, though as sprightly as she was she scarcely needed it for support. And there was Protestant Biddle. It was an ecumenical group, in accord with the university's changing image, particularly as it pertained to Lincoln Center.

At these long lunches, with our heads in the clouds, it did not oc-

cur to me that my future life would not be here in New York, in education. So much had been spoken and written and discussed by the National Council on the Arts about the importance of teaching young people about the special values of the arts. Here was the opportunity.

No one at the table then could remotely foresee that in two years' time all would change. Fordham would lose a visionary president. Another would arrive with different thoughts and a plan to meet an acute financial crisis. The arts would suffer. In a way not unknown in academe, they would be the first to go. Harry Levy would move on, and Margaret Mead, and at the end of his contract, this writer—after for a while seeking to play his own version of Horatio at the Bridge and preserve part of those early ideas.

So ended a chapter, illuminating in part, enhancing of experience in part, frustrating in part. I was to learn that what had appeared a life's fulfillment was only a preliminary.

Part Five

THE LEGISLATION
EXTENDED

Chapter 40

AS A TRANSITION TO A RETURN TO WASHINGTON, LET US DROP THE curtain on the three years at Fordham University at Lincoln Center. It was nice to be called professor, especially by students one had come to admire, and there is no doubt that dimensions of understanding and its application to the academic process were a valuable addition to my life and to experiences that lay ahead. The same can be said of almost two added years in the old Philadelphia setting, where I planned once again to pursue writing. Thoughts of the long-postponed Washington novel vied for attention with the Fordham time as a unique experiment in education worth transcribing. Then along came the Pennsylvania Ballet Company, praised and supported by a daughter who loves the arts as I do. The company, which had great artistic potential, was as close to financial insolvency as any arts organization I have ever encountered. This I realized too late, after agreeing to serve as chairman—a task, it was said invitingly, that would require at most two days a month!

We will also draw a curtain on this time, though the two days a month became approximately twelve hours a day until, with the clock flashing signals of disaster, in truth seconds short of midnight, I was able to secure a to-me miraculous $3 million five-year Ford Foundation grant

and repay all manner of loans—personal, family, and bank. It was a time of trauma and a time of learning, at very close proximity, about crises in the arts.

But intermingled tragically with these days was an illness to the wife I had first met in Italy during World War II when she was with the American Red Cross abroad. Frances died of cancer in May of 1972. Claiborne Pell came from Washington to the funeral. I think it distressed him to see his old friend so taken with grief after so many days in the hospital and hopes that were at moments bright, but gradually faded away.

This was a very dark time for me and our two children—a daughter married, a son just reaching the end of his four years at Princeton University. We had always been so close as a family. It was hard to realize there was now such a change.

You need to get back into life, Claiborne counseled. "You need to be active and occupied; that's the best help." It was good advice.

He invited me to Rhode Island, where I became not only occupied but also immersed in a political campaign in which Claiborne Pell was himself immersed. It was his most difficult campaign against a most formidable foe—John Chafee, highly regarded former Rhode Island governor, then secretary of the navy—in a home area where the navy supplied the majority of jobs. I wrote speeches and made some, studied and researched many issues, and got little sleep. Just as work with the Pennsylvania Ballet showed me at first hand the arts in extremis, so did these Rhode Island months show me just how, at rooftop level, the storms of politics in a democracy can blow and be overcome. In the early fall of 1972, local polls reflected Claiborne's chances as almost beyond hope, but he won his third Senate term. Rhode Island had its way, and I returned with a good friend to Washington.

Richard Nixon was inaugurated for a second term on a bitterly cold, sharply clear January day in 1973, as I began my own second "incarnation" on Capitol Hill. "He is not my favorite President," said Claiborne. The months ahead were to end in chaos and unprecedented action, as a President of the United States resigned on the threshold of impeachment. Watergate was the quicksand in which this administration became mired. One could say that Vietnam contributed primarily to the withdrawal of Lyndon Johnson and the hostage crisis in Iran to the defeat of Jimmy Carter, but Watergate was a domestic tragedy, and a catastrophe for the party in power. The consequences impinged on us all, but they were nowhere a factor in January 1973 as I thought of time to come.

It is easy in Washington to become too specialized. Beginning as neophyte and generalist, I, too, felt the need to concentrate in a particu-

lar area. For that is how a career grows, as the neophyte is trained and becomes more expert with time. But the arts and humanities cover such broad areas, dealing with cultural change and progress, understanding and expression. A specialist in these fields need not fear limitations. As I reconstruct these years of the 1960s and 1970s I find the memories deeply involved with events that shaped our history, events that only added to the need and rationale for a new emphasis on cultural matters, on matters of such importance to the strength of the human spirit.

The Arts and Humanities Foundation came into being in a period of ferment, when the past was severely questioned and new horizons were welcomed. The civil rights movement, with all its contrasts of dusty violence and lofty aspirations for brotherhood and sisterhood among human beings, the revulsion against war and against the concept of Americans sent abroad to kill, the focus on broadly conceived social programs to bring more fairness and equality to our country, the effort to improve education and make its best qualities available to all, the endeavors to lessen poverty—all these elements rotated around each other as if drawn and connected by a similar gravity. The wisdom that can come from the humanities and the enlightenment that can come from the arts were part and parcel of the same universe, not operating in a vacuum but implicitly and fundamentally connected.

Could they not serve to better illumine the days of the present and the days of the future? Through them could not the United States speak out with a clearer voice, more admired, given greater attention? Could not such a voice be heard above the rattlings of weaponry, with the specter of stockpiles of armaments, machinery, and countermachinery rising so high as to shade off the sun?

Not then—and not yet, you say; we must first be strong and then fully commit resources to cultural progress. But there is an anomaly here. The arts and humanities have intelligently wonderful answers to ferment and turmoil, danger and confusion. Can we not have a new Age of Reason, a new Age of Enlightenment, an Age of Harmony? Is not man's creative and cultural genius timeless and without temporary engines of the apocalypse? We sense today affirmative replies, but they are more muted than resounding. We do sense affirmation that cultural values can grow in a material environment. We have seen that happen; we have witnessed over a short span of years the benefits of unmistakable results.

Now in his third term in the U.S. Senate, Claiborne Pell was prepared to put the shaping of such concepts and convictions and aspirations to a test. We were once again in our old alliance of friendship and work.

He had made a campaign pledge at the recommendation of his friend. As chairman of the Subcommittee on Arts and Humanities, he

would seek a $400 million authorization for the two endowments, $200 million for each. Many considered it extreme and wholly unrealistic. Unquestionably, the endowments were growing. From those sparse beginning days, from an authorized $5 million per year and an appropriated $2.5 million, the annual sums had steadily mounted. By fiscal year 1973, eight years into the Arts Endowment's life, the annual authorization had grown to $40 million and the appropriation to $38 million. Increments of $20 million a year had been approved, and had been considered generous.

But here was our bill, S.795, introduced in the beginning of 1973, calling for $80 million for the Arts Endowment the following year, $140 million the year following, and $200 million for 1976. Preposterous, said the opponents. Obviously Roger Stevens was not among them.

For the sake of history, remember the $150 million (plus or minus), often obscured, recommended by Roger and his deputy six years earlier in the summer of 1967. An outrageous sum to critics, it was very much in keeping with Claiborne Pell's current proposals. After all, the recommendation had been documented with care. Recalling it brought sharply into focus the real needs in the arts. It was in no way difficult for me to justify the sums now proposed. Even at the zenith figure, the endowment's potential was well short of full realization.

Senator William Proxmire was in strong disagreement. As a Democrat from Wisconsin, he represented what is so often referred to as Middle America, a land of farms and frequently conservative points of view, a land where the arts were not as yet in a time of blooming. Bill Proxmire, with the clear eyes and sharp features associated with wide spaces, was Claiborne Pell's senior by three years. (In current terms, he ranks third in the Senate in seniority, as contrasted with Claiborne's sixth position.)

Senator Proxmire was rapidly gaining his reputation as a principal defender against waste in government. He is the author of a volume entitled *The Fleecing of America,* which chronicles his considerable efforts; and he created the Golden Fleece Award, which he bestows periodically on agencies considered guilty of or responsible for outstanding wasteful actions. The award, with its fulsome publicity, is beyond doubt the least desirable accolade an agency or an individual can receive, particularly because of the senator's service on the Senate Committee on Appropriations, from which offenders can be penalized.

In 1973, William Proxmire was a formidable opponent in the Senate—indeed, the most formidable the endowment had faced in its Senate history. The stage was set in mid-April for a full-scale debate, and though Claiborne had gained in rank and prestige, particularly in view of his come-from-behind defeat of John Chafee, many felt he was now confronting an insuperable foe.

Senator Proxmire circulated a summary of his views and objections to all members of the Senate in advance.

"Funds for the Foundation [on the Arts and the Humanities] under S.795 explode," he wrote. "In the past," he continued, "the annual increase in spending has been $20 million a year. Under this bill, it jumps by increments of $80 million in the first year and $120 million in each of the following two years." He proposed to cut a total of $360 million from the legislation Claiborne had presented. The battle lines were drawn.

I do not believe I have ever worked harder on a preparation. The first time out, of course, had required the most thorough research, but the earlier arguments had often been philosophical ones. We were in the realm of ideas more than of substance, of projects that might take form but were still untried. Now the arguments were of a different kind. Pilot projects had proved effective. They could readily be expanded. If you were to place just one accomplished artist in each of the Nation's 90,000 schools, for example, you would have a budget equal to the maximum total in the current bill. Or, if you were to use the $80 million to award matching grants to the country's growing number of major symphony orchestras, you would still fall short of the support originally provided by the Ford Foundation, which had turned its attention to less concentrated cultural fields.

A great new life was taking shape in all the arts. The arts were growing in hope. There were more and more dance companies and resident professional theater companies. Museums were beginning to attract unprecedented audiences and were facing the need for vastly increased budgets to serve their visitors properly. While the sums involved seemed relatively large, they were in reality not so at all. Only when viewed in the Proxmire context of annualized percentages and year-by-year comparisons did they seem excessive, and the steps upward a cause for stumble or fall.

Claiborne was the bill's floor manager. Once again I had my well-filled briefcase, together with two accordion-type files. In each compartment was a short fact sheet, legible in double-spaced capitals. An index was at hand, but it was also committed to memory. This time—unlike the day when S.1483 cleared the Senate in 1965 by voice vote—all this information was needed.

The "hot seat" was brought onto the Senate floor for me. The debates lasted over a period of two days, with some respite for other business. Most of the time, Senators Pell and Proxmire held forth.

In retrospect, this was for me a time of drama of the highest nature, in this high-ceilinged room with its dark-polished individual desks, with the little snuff boxes still present, with the gleaming but discrete

name plates affixed to each desk top in meticulous order for rank and party. The eagle is embossed on the ceiling glass; the galleries circle the chamber; the president pro tem's desk stands above the Senate "well," flanked on one side by those who note each passing word and action and are at once available should a senator find a parliamentary difficulty or challenge beyond his coping. So much of history is made here. Returning, I recall these two days, and the others—but especially these two.

At the time, however, I was most aware of tension in a cramped space. It seemed to me that the future of the program was very much at stake. It could proceed in accordance with the Senate's established practice, on the basis of annual increments kept within the confines of precise percentages comparing past with present and future, or it could be given an opening through which to soar. It had been an unprecedented endeavor to start with. It should move forward in like manner.

Senator Mike Mansfield was still majority leader, in his tall and angular and soft-spoken way directing traffic for other legislation. There was a new assistant majority leader in Robert Byrd, even then with silvery hair, the same senator who had spoken eloquently about the arts in initial hearings.

But mostly, it was Pell and Proxmire who stood in debate, Bill Proxmire higher up in the rows of desks, Claiborne at the vacated majority leader's desk at floor level. They spoke a long time, back and forth, with Claiborne turned toward the Proxmire elevation.

Claiborne would thank the distinguished senator from Wisconsin for his interesting and illuminating question, and as he spoke his hand would drop past my shoulder, and I would place in it the reply that would seem most appropriate. Or Claiborne would begin the response from his own knowledge and supplement with, "I believe we have some statistics that will make this all more clear." And on some occasions the hand remained empty as I frantically sought to produce the necessaries. Claiborne would look down and ad-lib, and so it went, with the senator from Wisconsin also having in his immediate proximity an aide-de-bataille and keeper of the files.

At the end of the first day, forensic judges could well have given the lead to the senator from Wisconsin. His voice was caustic at times, sarcastic at others; he spoke with greater range and tone. But Claiborne, never a master of forensic techniques, gave the facts and the figures, the statistics and the details of a program on its way to success.

Senator Proxmire repeated his theory of an agency not expanding but exploding. Priorities were out of line, he maintained: the $400 million proposed for the Arts and Humanities Endowments for 1976 was almost as much as the $425 million cut from the present year's budget of

the Office of Economic Opportunity and five times the amount spent for the Peace Corps.

He prophesied that the sums Claiborne recommended would "promote stale, sterile, establishment art. There is no way to promote excellence in the arts by shoveling out the money," he said, adding that "government will soon become the principal patron of the arts in the United States" if the Pell bill were adopted. "There is no way to prevent official censorship if government pays the freight." It was like Strom Thurmond, with added weapons.

He was right, of course: If government became the principal patron, art in the United States would indeed suffer. But the philosophy of the original legislation, Claiborne pointed out, was entirely opposite. New funding was critical to expanded growth of the arts; new funding would strengthen the catalyst and make possible multiplied support from nonfederal and nongovernmental sources. That was the realism involved, and the proof was already demonstrated and demonstrable.

As the confrontation increased in tempo, the strength of the Appropriations Committee emerged. Senator John McClellan, its chairman, previously absent from the debates, suddenly appeared—a venerable senator, always respected, sometimes feared, but noted for fairness and also for getting his own way. He was tall only in his bearing. His voice, touched by the deep South, was somewhat rasping, but it carried a great authority. He laid it out on the line in unequivocal terms: This proposed funding of Claiborne Pell's was beyond the limits of reasonable discussion; it should not survive. The appearance and statement made an undeniable impact on the debate, as does any strong statement made in Congress by a leader in Appropriations. It showed that William Proxmire was calling up his heaviest artillery at a strategic time, but possibly it also showed that he believed help was needed. Claiborne let the chairman have his say, for he had already placed into the Record and summarized a lengthy and comprehensive overview of how the new funding could be used most judiciously, with projections based on experience already gained.

Then came an especially welcome surprise. I had long worked with Terry Emerson, at first when he so well represented the legal counsel's office in the Senate and later as he moved into the office of Senator Barry Goldwater. We had become good friends. The arts were a part of Terry's thinking and his life, and he spoke of them with full understanding. I had not realized until April 11, 1973, the second day of the great debate, how integral was such an understanding to the beliefs of Barry Goldwater.

"Today I rise in unqualified support of a renewal of the charter for the National Endowment for the Arts," he said. And while John Mc-

Clellan's words had their particular impact on the Senate, Barry Goldwater's had a significance all their own.

"I am satisfied that the federal unit is *not* dominating the state or local governments—it is not issuing a maze of confusing and restrictive regulations that encumber local initiative to meet local needs—it is *not* channelling its support only into particular kinds of projects which meet the preconceived, peculiar tastes of a federal bureaucracy. What it is doing—and doing well—is to uplift the development of locally conceived programs and to help these programs stand on their own locally guided feet."

"Mr. President," said the senator, "the proof of what I am saying appears in the record of events happening in my own State of Arizona." He went on to detail a statewide network of newly developing arts festivals and spoke of 596 different arts events in Arizona during the previous year. "The total attendance at these events numbered over 616,000 persons," he said, and added that the $182,000 in federal funds expended was "far surpassed by $803,000 of local funds contributed toward the projects."

"In summary, Mr. President," Senator Goldwater concluded, "I can say with all conviction that the National Endowment for the Arts, assisted by the state arts commissions and councils, has awakened a healthy interest in the arts and encouraged the growth of an enormous diversity of cultural events throughout the United States."

I was quietly assimilating these phrases when John Tower, the Republican senator from Texas, joined in with his endorsement.

To have two Republican senators, usually considered conservative and thrift-conscious leaders, speak so warmly and compellingly about the values of the arts brought joy to our part of the Senate floor.

And when the final vote came, there was another surprise. By a margin of 61 to 30, by better than two to one, Claiborne's bill prevailed.

Considering the forces arrayed against him, including leaders in his own Democratic party, it seemed remarkable. Usually Appropriations members triumph over members of the authorization process. Usually senior members can exert a dominating influence. To me this day proved a turning point, both in the senatorial career of Claiborne Pell and in the way in which the arts were regarded on Capitol Hill.

Senator Javits was valiant once again. The concept of bipartisanship was strengthened. Powerful voices expected a victory. It escaped them. Fundamentally, it was a vote for the arts and humanities, regardless of political affiliation—and it was also a vote of special confidence in Claiborne Pell's assessment of value and priority. I think we won because we were better prepared. We had answers the other side did not. Claiborne sounded more informed, more temperate, and therefore more

wise. Combined with his recent victory at the polls in Rhode Island, this day's vote was the beginning of a new sense of respect. The seemingly eccentric senator of just a few years past could be welcomed into the club, that loosely knit and not-quite-defined relatively small group of senators who had the regard of their colleagues, who were not demagogues on issues, who were more thoughtful and patient toward a diversity of viewpoint.

Changes in senatorial appraisals come slowly, but one began to hear the word "integrity" rather than "eccentric" and "unrealistic." I mark this moment as the clearly defined time when Claiborne emerged as the Senate's principal authority on the arts. Author of the original bill, he had gained the authority. His advice was to be sought more and more often. He was considered fair, and that is perhaps the Senate's highest accolade for a lasting reputation.

As for the arts, they were to grow in funding, not as greatly as we proposed and the Senate on these April days approved, but steadily and with a feeling of momentum. John Brademas in the House of Representatives was unable to match the Pell figures. This we had anticipated in a body that was still reluctant to see the arts advance and where the voices of old critics were still very much to be heard. But the Senate figures were the magnet for a growing sense of progress.

The Arts Endowment under the chairmanship of Nancy Hanks was winning plaudits as an exemplary agency. Nancy had given me on request reams of material for the April confrontation. It was not difficult to highlight, because so much of it was familiar to me. I indeed had the advantage of a unique perspective. Senator Proxmire's staff, keenly intelligent as they were, simply did not have the same profoundly helpful experience. Their attack was not deep enough, and it ran aground.

As a significant footnote to this history, let it also be noted that in April of 1973, the arts overshadowed the humanities in the discussions. Barry Goldwater talked of the arts. Senator Proxmire spoke most frequently about the arts. My preparation covered both fields as carefully as possible, but the arts were the prime target for debate and also the prime example of achievement.

Barnaby Keeney and Roger Stevens had both departed, their terms expired. Leadership in the Humanities Endowment was passing from Wally Edgerton—Barnaby's deputy who had replaced him as acting chairman—to Ronald Berman, a scholar from California well regarded by the Nixon administration. But the old sonorous ring of "the humanities," the impetus that phrase imparted to the original legislation, that protective paternal arm around the frivolous shoulder of the arts, that symbol of wisdom as contrasted with the more fragile and unpredictable—all these once-dominant images had somewhat faded.

Those April days signaled a kind of transfer in importance from humanities to arts. The latter, rather than the former, was now to reach out a helping hand and to draw the other upward. Claiborne Pell, John Brademas, the leaders now in Senate and House, were committed to parity in funding for the two endowments. But while the concept had once favored a quickening of help for the arts, now the reverse was true. So it would remain, until in the 1980s the twain drew apart, and Eurydice could not reach out quite far enough to pull abreast her Orpheus.

We should not forget to emphasize again here the role of Roger Stevens and those earlier high numbers for the arts Charles Mark and I prepared for his presentation in 1967. I doubt we could have proceeded with the same hopes and confidence without the work of that earlier summer. Particularly in terms of legislative history and evolution, the first step well taken makes the second easier.

Others may claim the unique and the foremost, and have made claims, staking out their campsites en route to present peaks. Roger presided over a budget that grew from $2.5 million to approximately $12 million. Nancy Hanks in her eight years as chairman presided over budgets that grew to slightly more than $100 million a year. Livingston Biddle in his four-year tenure presided over budgets that grew to approximately $165 million. Those are the facts. They are subject to individual interpretation.

You can say with validity that the increase in Nancy's time saw the largest percentage increase of all. You can say that in Biddle's time, more funds were appropriated than in the previous years combined. We all enjoy raising the flag.

Time has a way of washing over events and dimming memories. So please remember in the sequence of history that Roger Stevens first enunciated in public forum, in the Congress, the manifold needs of the arts in the U.S.; and Claiborne Pell first expanded on those figures, and, in a vote surprising for its margin and in the only two-day debate of its kind in the history of the Senate, gained their Senate approval.

It was, in terms of the proposed funds, the high-water mark of the Arts Endowment. Almost a decade and a half later, the proposed $200 million has never been reached in an appropriation. We have witnessed a variety of reluctance in the Congress as a whole, and in subsequent administrations. And we have seen in recent times battles to reduce an outsized deficit and fiscal developments that invariably enmesh the arts like the serpent and Laocoon. We have seen faltering of spirit and commitment, and new leaders emerging, and very special new heroes.

Some day, I am convinced, we will see that April figure achieved, for it opened a window in the sky.

Chapter 41

THERE WAS ANOTHER IMPORTANT ARTS AND HUMANITIES EVENT IN 1973, AN early summer event extending for almost a full working week.

Claiborne Pell had a particular regard for museums—as repositories of the cultural treasures of civilizations past and present, as educational institutions to instruct and give heightened understanding, as special exhibitors of mankind's creative talent and history.

One can trace Claiborne's appreciation of the arts and museums first to college days and then to early experiences that introduced him to the voters of Rhode Island. With an old family stationwagon, he transported examples of works of art from one rural community to another as a kind of improvised traveling show. He was taken with the interest of the viewers, and they were obviously taken with him in a number of ways. As an upstart candidate who was not even endorsed by his party, he went on to win his Senate seat, defeating two former governors vying for the position.

My own regard for museums goes back to childhood explorations inside a great Grecian temple-like structure, the Philadelphia Museum of Art. From the front steps one overlooks a large equestrian statue of George Washington, with the distant tower of a Victorian city hall behind

him at the opposite end of the Parkway. It is a place that cameras like to catch. Inside are rooms and rooms of paintings and furniture and artifacts, some of a family-donated origin. I enjoyed wandering alone and absorbing all the eye could encompass, which as a child and from a relatively low level seemed of a huge and almost mysterious import.

Museums are part of the language of the basic Arts and Humanities Act. In 1973, both endowments were conducting programs to assist museums, building on the projects started by Roger Stevens and Barnaby Keeney. Claiborne wanted a more wide-ranging coverage. Early on I had devised for him a legislative initiative called the National Museum Act. Its title suggested more than it actually contained, for it pertained to the then so-called National Museum, one of several buildings in the Smithsonian Institution complex. As chairman of the Senate's Subcommittee on the Smithsonian, Claiborne presented the legislation to the parent Rules Committee, and it was swiftly approved by the committee, by the Senate, and by the Congress in 1965, the year in which events of a far broader cultural scope took place. Help in this act went modestly toward the training of museum professionals, with the National Museum as focus.

My other early venture into special museum legislation also involved the Rules Committee and the Smithsonian. Claiborne told me that his good friend Charles Webb, a flyer and businessman, had spoken glowingly of a collection of antique aircraft stored in an open field near Suitland, Maryland. Jim Bradley, assistant secretary under Dillon Ripley at the Smithsonian, spoke with a similar enthusiasm about the collection. For almost twenty years, he informed me, he had been seeking legislation to house the collection in permanent quarters. I visited the open field with Charlie Webb.

There on the green grass on a fall day, with weeds poking up here and there, was a wondrous assortment of flying machines, some from World War II, some Japanese, some German, some American, some from earlier times.

They were encased in close-wrapped plastic, so the outlines alone were visible. Nearby was a rusty hanger in which two Smithsonian artisans were sewing, with a special old-fashioned stitch, canvas to the wing struts of a plane. It was the plane in which Admiral Byrd had flown to the South Pole, I was told—one historic airplane reconstructed with painstaking care, a vast neglected gathering of aeronautical lore in a field. And there was a new space program just beginning, from which a new generation of historic craft would emerge.

Claiborne was not excited at first. Charles Lindbergh's plane hung in the Smithsonian. It didn't seem to attract exceptional attention. There were other more important ideas. But I dreamed of those old planes in

the open field; and Jim Bradley, sensing a friend who had not yet been exposed to procrastination and failure, persisted.

Claiborne was now prodded not only by me but also by Dillon Ripley. He agreed to hold a hearing and examine proposals. I remember the Japanese architects from Hellmuth, Obata and Kassabaum presenting their firm's plans as the lowest bidders. It would take approximately $40 million, at maximum, to construct the building they envisioned, with connecting modules and ingenious walkways so that visitors could see the aircraft from different levels. There would be old generations and the new—challenging the Russian Sputnik and placing John Glenn in orbit round the earth.

I remember the Rules Committee meeting when the new Smithsonian project was discussed. Claiborne, now satisfied that the ideas were sound and the legislation I had prepared worth presenting, spoke in its behalf. There was silence. Forty million dollars was silently considered. Everett Jordan, the wise and kindly senator from North Carolina who had listened closely to Philip Hanes's objections to the arts legislation, was as always in the chair. My friend Gordon Harrison, the chief clerk, sat poker-faced behind the chairman. Then all at once Carl Curtis, a usually conservative Republican senator from Nebraska, spoke. "Clai," he said, "if this seems good to you, it's okay with me. I think we need it."

In these annals the unexpected is an often-recurrent theme. It is the only predictable thing I know in politics. It served again. No one voiced objection. With a strongly favorable report composed by Gordon Harrison and me, the legislation was passed by the Senate and later by the House. It became law, and in due course construction began for a new National Air and Space Museum on Washington's Mall.

(I recalled the committee's action with Carl Curtis one evening, years later. "Why, that's great!" he said. "Did I really do that?" proving that we may not always recollect with lasting clarity all the good things we do.)

Since it opened in 1976, finally but within budgeted figures, the museum has become the Capital's largest attraction for visitors, with an attendance close to 80,000 a week in the high season. It celebrates our explorations, our courage, and our genius in a manner linked to cultural progress. Creative expression in the arts and in science are akin. Albert Einstein gave his formula to the ages, but for personal inspiration and joy he turned to his violin. So did Sherlock Holmes.

The Smithsonian was delighted with our success after so many years of trying. Claiborne Pell, however, was not quite sure at first that he had helped create a lasting benefit. One day, as I was taking him home to Georgetown, he asked me to turn away from his usual route

along Constitution Avenue so that we could pass by the new museum that was at last nearing completion. We faced the two eastern modules.

"It's not so bad," he said, "not too bad a size."

We turned into Independence Avenue, and there, marching in extended monumental cadence, were the other six connected buildings.

"Good Lord," he said half in jest, "it's Biddle's Folly!"

Claiborne believes with an unswerving conviction that the Mall in Washington, stretching from the Lincoln Memorial in the west to the Capitol in the east, should be preserved for open space, for walking or jogging, for leisurely pursuits in the open air. It should not be unduly cluttered by manmade objects, no matter how prepossessing. The scope of the Air and Space Museum almost caused him to regret his endorsement. Almost, but not quite.

Each year thereafter, Dillon Ripley visited Claiborne. They would have lunch in the Senate Dining Room and adjourn to the broad terrace below the Capitol overlooking the Mall. On occasion, I would be present. Dillon would mention, as if the idea had just occurred, his hopes for a new museum. Claiborne would mention "Biddle's Folly," which, as I recall, Dillon never found exactly provocative of laughter. It was mentioned in a slightly needling, slightly teasing manner, albeit friendly and intended as a reminder.

A year would pass, and a similar conversation would ensue.

And that is good reason why the latest Smithsonian museum complex is approximately 96 percent underground. Once called the Nation's "attic," does this mean that a new metaphor of "cellar" might be applied? Not in this book! Does one spend time looking out the window in the Guggenheim in New York, or the Louvre in Paris, or the Tate in London, or the Prado in Madrid? Are not the interior views most enticing, most enriching, the ones that captivate mind and heart? The new Smithsonian space, from the lowest level upward, or simply from one area to another, seems to soar, to uplift the spirit.

To me it is a singular achievement in the remarkable career of Dillon Ripley. It has been called his "last hurrah." The emphasis should be on the cheer, from those who can discover a panoply of special collections and from those who can still enjoy the vistas of Washington's great Mall in the open air.

In the early summer of 1973, museum leaders had their first real opportunity to express their needs and aspirations to the Congress. They came from all parts of the Nation, and some from Canada. The arts and humanities had received unprecedented focus in earlier times. Now the focus turned to the museum world exclusively, and it was as if a great release valve had been opened.

Joseph Patterson had been director of the American Association of Museums. He was succeeded by Kyran McGrath. "Pat" Patterson was the museum scholar and Kyran was the association's activator and organizer. He had worked on Capitol Hill. He had acumen and an engaging wit. As time went on, he built new alliances among art museums and museums of historic context—arts and humanities.

The leaders of the AAM, the trustees and officers, included representatives from large museums and from smaller ones, from Maine to California, the Great Lakes to the Gulf of Mexico, all seeking attention.

At first, one might have mistaken some of them for "ladies in tennis shoes" (not the most complimentary congressional designation) from Boston. But this would have been a superficial judgment. They quickly became knowledgeable about the political process. There was still a certain reticence toward the word "politician," and a sense of uneasiness that on Capitol Hill lurked dangerous threats to a museum's independence. But these were largely dispelled when Claiborne spoke to them. He became, in effect, Saint Museum.

The work of Elvira Marquis and early advocates for the arts was recalled. Museums were now learning to "inform" the Congress (they preferred the word to "lobby"). Yet they were gathering for cultural endeavors a new force, at first relatively limited in focus, dominated by a natural self-interest, but growing in influence. To a future and broadened arts advocacy, museums were to bring their own new and beneficial dimension. They were to join evolving partnerships with other arts areas and help strengthen them, though not always with harmonious accord.

A leader of particular note in these days was Esther Anderson, who indeed came from Boston and the Museum of Fine Arts. Esther was also an organizer, with an unfailingly pleasant demeanor and an unflagging efficiency. She was in her own special way a pioneer, and she kept the trustees unified in approach and purpose, at least for a while. She shared a quality with others of that moment: indefatigability. They came to Washington. They spent long hours in meetings and discussions and in making plans with me. They testified or were responsible for the testimony that would be meaningful. They reported to an ever-widening constituency, who in turn stirred the interest of others.

The hearings were the most comprehensive of their kind in congressional annals—almost 800 pages of text, in that fine print, in a green bound volume. A review today demonstrates the analysis and description of every conceivable museum problem, needs for additional space, better climate control, improved collections and collection care, staff training, audience development, educational needs, better resources to pay for the heat and light. Museums in other countries are often the beneficiaries

of a total government support, and so we have the French chateaux, the Tate Museum, Leningrad's Hermitage.

But at home we would apply principles already at work—matching grants and a partnership with the private sector.

It did not matter to these early museum leaders that no immediate legislative results ensued. After all, the Arts and Humanities Endowments had been months and months in developing after the essential ground-work was in place. A separate program for museums? Claiborne Pell in the Senate and John Brademas in the House both favored it. It would come.

It is time to pause for a personal moment. On November 3, 1973, I was married to Catharina Baart, an artist, born in Holland. We met by chance at a Washington party, introduced by my old colleague Stewart McClure and his friend Betty Williams, with whom Catharina had taught art in the D.C. public school system. We found, in talk of the arts and our experiences, that magic spark of rapport, which is like no other in life and which at once seems to suggest a far, far longer acquaintance than merely a few short minutes of conversation. Our first date the pre-vious May had been to a performance of *Romeo and Juliet* presented by the Stuttgart Ballet. It was danced by Marcia Heydee and Richard Cragin. They will always be a special couple to us.

We were married in old St. John's Church on Lafayette Square opposite the White House; Dr. John Harper, a friend of many years, was the minister. Catharina had only a sister living in the United States. Clai-borne Pell gave her away and the reception was given by Claiborne and his wife Nuala in their Georgetown house, with its large garden behind and with its statues and paintings and portraits which both Nuala and Claiborne cherish.

Catharina has given me, through her own painting and deep knowledge, a far more profound understanding of the visual arts than I had ever gained. We share in love for each other a love for all the arts: music, theater, dance. Perhaps I have helped her understand the writer, and the effort needed to place the words in the right places, and the con-stant struggle to do so, and improve. But it is not really necessary to attempt explanation, for she faces identical problems with a bare canvas. The discipline of work, and of endeavor, is the same for both of us. Surely those bonds help deepen the love we feel.

Chapter 42

I N THE SUMMER OF 1974, NANCY HANKS ASKED ME TO JOIN THE NATIONAL Endowment for the Arts and to establish the first Office of Congressional Liaison. Claiborne approved the transition, believing at this juncture that I could serve the arts best at the agency.

Though the endowment had grown so markedly from the Roger Stevens days, it was in a sense like coming home. So many of those I'd known well in the past were still involved. Problems were there, as always, but they were different from before. They were the result of growth, and sometimes, as in a broadening and more swiftly flowing river, they were beneath the surface.

I had been acquainted with Nancy Hanks for more than ten years. Now I had the opportunity to know her well. Nancy's personality was given to contrasts. The large brown eyes, soft brown hair, lips more full than spare, the even roundness of face suggested that "beauty" and "striking" were words with which Nancy must have been familiar growing up. Early pictures especially showed these qualities. Her smile was engaging. The soft voice had its own resonance. She dressed with taste, but not in the latest couturier styles. Elegance was not as much present as efficiency. The brown eyes looked at the tasks she had to accomplish.

They looked directly and inquisitively, often probingly, as if to seek the heart of the matter, to eliminate inconsequence. She was self-disciplined, so much so that one took this characteristic for granted. She could laugh at times. But forget her work, her duties, for a day or an evening? That was not as easy. She could be charming; and she could be hard as nails if she felt such a posture was required for success. She was determined. She was dedicated. She was pragmatic. The ideals were there, those she felt were within her best reach. If there were others, they did not beguile her.

While my work was primarily concerned with Congress, it was not always so. Each year Nancy, as chairman, was bidden to appear before budget authorities to justify the agency's request for funding for the next fiscal year. The request was thoroughly discussed and questioned, and often reduced, before it became a part of the so-called "President's budget," that huge volume transmitted to Capitol Hill.

In Roger's time we had "defended" the figures the Johnson administration had allotted for the arts and then responded to that "direct congressional inquiry" and proceeded to justify, many times over, the prescribed sums. Procedures for the endowment were now more orthodox—and, I will say, more adversarial.

Budget authorities knew that Nancy Hanks had friends in high places. The endowment's budget examiner knew, for example, that he could hardly compete with the Rockefeller family, which had nurtured Nancy's early career, or with Leonard Garment, that exceedingly wise and arts-minded counselor who guided President Nixon on the arts and other matters where his wisdom was desired. But Nancy's position seemed only to intensify the budget examiner's enthusiasm for thoroughness in review, for a study in detail of budgetary minutiae. In Roger's time, an examination of this nature once led to such an explosion of disbelief that it was discontinued. But these examiners now were not sidetracked by explosions of disbelief, and it was clear to me from their expressions, as I sat facing them at close range, that they had the support of their field commanders all the way along the budgetary front.

At first Nancy had shaken her head, no, to my suggestion that I accompany her and her staff experts to this meeting. "Livy, it's all technical stuff," she said. "It's all these figures and tables. It's not congressional relations."

"I'll sit in the back of the room," I said.

"There are never enough chairs," she said to me; and then, "Oh, all right. Maybe you *should* see it; maybe you'll find it interesting. But don't speak up—it's just too complicated."

The examiner was discussing in somber tones funding for the Nation's Bicentennial. He reminded Nancy of the budgetary generosity that

permitted the endowment to support the development of Bicentennial activities. That was one-time generosity, he emphasized. It did not extend into the budget now under review. One time meant one time. Nancy's budget would be automatically *reduced* by the amount it had been raised for special preparatory work, as she would well understand.

She looked suddenly confused, an expression I came to recognize as exceedingly rare. She glanced at the others with her for rebuttal. No one spoke. I raised my hand. Nancy saw it, but did not respond. She continued to look about for a reply. So I said in a firm voice, "I just want to point out, that is not in line with congressional intent."

"What isn't?" asked the examiner sharply, his eyes shifting suddenly toward me.

"Your statement about funding for the Bicentennial."

Nancy looked at me as if to remonstrate, as if the interruption was awkward and ill-timed.

"The Congress determined just the opposite of one-time funding for the endowment for this purpose," I said. "It stated clearly that these funds were to be the springboard for the expansion of efforts, and that they should in the future increase in amounts at least as great as the present levels of growth. The Bicentennial is to signal a beginning, not an end."

The examiner seemed to glare in my direction. "How do you know that?" he asked.

It is one time in my life that I had a really wonderful answer to such a question. "Because I wrote it," I said.

Nancy looked pleased.

Not so readily resolved was one of Nancy's most persistent and vexing problems, the American Film Institute. Now going on eight years old, the AFI was attracting growing attention. Its director George Stevens, Jr., like his famous filmmaker father before him, was a person of strong character and dynamic ability. His ambition was to make the AFI the source of true excellence in motion pictures, free from compromises with the purely commercial, free from the mediocrity and tastelessness that the purely commercial is sometimes likely to develop. The AFI was to train young artists, to support the work of the most talented, to preserve mountains of historic early films in danger of permanent deterioration. It was to act as a symbol, a reminder of past achievements, a special harbinger of new ones. It was to fulfill the goals envisioned by Gregory Peck and George's father—and it was to reach the annual $7 million funding level first recommended in 1966 by the Stanford Research Institute, whose endowment-funded study had led to its creation.

But idealistic aspirations are one thing, funding another. Sides were drawn. Nancy had sought to maintain objectivity, but the National Council on the Arts was divided, and Michael Straight, Nancy's deputy chairman, tended to side quite definitely with a more modest growth rate than George Stevens, Jr., championed.

George felt strongly that the AFI, established by the endowment, was the endowment's particular responsibility. It was not a grantee per se, like symphony orchestras or dance companies or museums, for example. It was the child of its father, and it was growing up and reaching realization of what had been planned for it to accomplish. Its abilities should not be judged by the panel of experts formed to review applications in the field of media. Its qualities, instead, should be reviewed by the National Council on the Arts itself, directly, George believed. After all, the President of the United States had declared, at the signing of the Arts and Humanities Act on September 29, 1965, "We will *create* an American Film Institute." He had not said, We will create a symphony orchestra. No one remembered the quotation better than George Stevens.

The viewpoint made sense to many. It made sense, for instance, to Claiborne Pell. It made sense to John Brademas. Both liked and had high regard for George. It did not make such sense, however, to Michael Straight.

Michael was more idealist than pragmatist. He was erudite, a writer with a gift and flair for langauge, an individual, his own person, tall, handsome in features, sartorially impeccable whether on the tennis court or in a business suit. He had a deep pleasant voice, an easy laugh, and a temper that had a tendency to smoulder. He belonged to the Whitney family, whose patronage of the arts and philanthropy could be said to vie in spirit with that of the Rockefeller family. It was just that one had more resources than the other. Michael's own resources, however, were considerable—in things material, but more especially in convictions.

(I am, of course, well aware of the other elements in Michael's life, of the pathways he traveled before I knew him well, of the criticism such journeys evoked, of the mark they left. But these are not germane to this book; they are Michael's own business, to discuss or not to discuss. I prefer to leave them that way, for these elements had no impact on the arts, nor on the job he carried out as deputy chairman, nor, as far as I can see, on any kind of lasting detrimental international involvement, as some have at times hinted. I knew Michael on the tennis courts as a lefthanded player with a fearsome serve and backhand, and for a number of years as Nancy's deputy, dedicated, as was she, to the work.)

Thus, two individuals of purpose, Michael and George, met—one could say increasingly head-on. Polite exchanges sometimes evinced acrimony. They began to attract their own groups of aficionados, people of

consequence who accelerated, and enlivened, the element of dispute. They were mentioned at dinner conversations in Washington, in itself a signal of rarefied notice—I can't believe that Michael can't see the light. I can't believe that George is so stubborn. All of this did have an impact on the arts, and on the Arts Endowment, and on Capitol Hill.

In my waning days with Claiborne, before I joined Nancy, I briefed him in depth and he determined to act. "I think it's time to knock heads together," he said. And so the principals, including Nancy, Michael, and George, were invited to his special office—one he had now acquired below the Senate floor, a sanctum sanctorum given to few senators. John Brademas was also invited and came with his Arts and Humanities chief of staff, Jack Duncan, with whom I was already in close rapport. Jack stands out as among the very best and most talented workers for the arts in Congress I ever encountered.

Claiborne's concept of knocking heads together, it must be recorded, did not exactly coincide with a literal or figurative facsimile. The meeting, with Nancy, Michael, and George sitting at first silent and somewhat on the edge of their chairs, anticipating I am not sure precisely what, consisted first of a polite but firm lecture by Claiborne on the value of working in unison for a common cause and good and on the danger of permitting strong personalities to interfere. Diplomacy, Claiborne urged, was desirable. Otherwise, disagreements could affect the confidence in which the endowment was held, and the reputation of the American Film Institute. And while there were no protocols issued, no final communique, the parties agreed to carry out Claiborne's counsel in spirit.

My work with Nancy was in part to ensure that the spirit be upheld. Nancy, it could be said, tended to side with Michael. On the other hand, I always felt that George, minus the element of abrasion, could be both practical and reasonable. By some the dispute was equated to a subsiding storm; but people of volatile natures were involved, people of visibility and influence, in the Senate and House and in the private world among the luminaries of film and business. The endowment's hull in the mid-1970s was far from invulnerable.

John Brademas took a more active course. John was uncertain as to how long cooperation would last. To avoid possible future damage, and believing he had Claiborne's at least tacit approval, he introduced legislation to end the dispute, to finish its festering, to separate the combatants and send them forever into neutral corners. A bill was prepared establishing the institute as an independent, quasigovernmental, quasiprivate organization. It would receive funding from Congress. It would be

fully eligible for tax-exempt donations. It would have its own trustees and be released from any hampering National Endowment for the Arts affiliation. To the legislation's protagonists, this was a logical conclusion for an organization created by government and now spun off into its own orbit, to fend for itself, to justify its own congressional requests, to raise its own funding.

Harry McPherson, who was assistant secretary of state for educational and cultural affairs in the early 1960s, who had worked hard for the Lyndon Johnson White House, and who had graduated into private law practice, was legally advising the AFI. George and Harry, and leaders in film, expressed confidence that they would succeed better than in the past.

The concept began a different controversy—idealistic and practical at the same time, extending to the roots of government support for the arts. It might be expected that Michael Straight would feel relieved, and the National Council, and Nancy Hanks. Not really so, however. A serious question arose for the Arts Endowment chairman: Should the arts be fragmented? Should there be one program for film and the media at the endowment and another with a partly government-supported American Film Institute? Should the endowment abandon its support of film and leave it to the AFI? No, said Michael Straight; and no, said Nancy Hanks—privately, for there was another question. What about John Brademas and all good relations for the future, relations that went far beyond the single major art form of film?

I was now Nancy's congressional liaison. I saw clearly a *modus vivendi*. We would simply work with the new AFI as John Brademas proposed. All things considered, it seemed to me not only possible, but desirable. I recommended to Nancy not to oppose, not to express full agreement if that was her wish, and to work with the will of the Congress. Her testimony on the issue, before the House subcommittee John Brademas chaired, was accepted in good faith by the chairman.

But on the Senate side, Claiborne seemed to have philosophical concerns, and his support became qualified. He would agree with the bill if the House as a whole adopted it. John pushed his bill forward to the floor. There were damaging complications. Representatives of college and university film programs and developing small experimental film organizations in various parts of the country, disenchanted by the AFI's treatment of their requests for help, complained to their congressmen. On the eve of the legislation's consideration, their voices were suddenly heard everywhere. It was suggested that Nancy Hanks had quietly and privately engineered the protest. I have never believed this was true, and I think I was in the best position to know. But I am not as sure about

all members of a staff, intimately involved with the controversy, with partisan views of their own. John's bill did not pass. It was the only such defeat he ever sustained in behalf of the arts.

While I was with Nancy, reason rather than a lack of it seemed thereafter to prevail between the endowment and the AFI. Michael was not satisfied, nor did he agree with the positions I took. He withdrew somewhat from this arena, partly on Nancy's recommendation. There was a friction, of which I was only dimly conscious. But he is a man with an integrity of conviction, Michael Straight, and so is George Stevens.

And so the AFI remained with the endowment. Diplomacy, Claiborne had counseled. But diplomacy does not reside in just one particular area of the endowment's tasks.

Is there a lesson to be learned here? Certainly the arguments in this case were pervasive. Could they be called model arguments, subject to model solutions? No, they are not special; and they only get out of hand when the chemistry among individuals goes awry. That is hardly unusual, but Biddle's law of the pervasiveness of what is never fully predictable applies.

Chapter 43

T HE NATION'S LEGITIMATE MUSEUMS CONSERVATIVELY NUMBER OVER 5,000—
not counting the myriad roadside enterprises that harbor and display
merchandise, often under a "museum" banner, everything from rare
rocks to rare shells, rare snakes, and other fauna. Of these 5,000 approx-
imately one-third are art museums, of a great variety and diverse size,
from the largest, such as the Metropolitan Museum in New York, to the
two-room collections in small towns. All are growing in size, in impor-
tance, in attendance. Less numerous in the mid 1970s, they nevertheless
represented an immense potential. They also represented immense
needs, if they were to fulfill their potentials—their cultural mission, as
museum leaders defined it.

George C. Seybolt became leader of the Trustees Committee of
the American Association of Museums. A trustee of the Museum of Fine
Arts, Boston, George was a successful businessman, with fortunes stem-
ming from the Underwood Company, with its "Red Devil" logo and its
large assortment of popular edibles. He was also a collector with a pen-
chant for and a particular knowledge of Americana. A broad-shouldered,
genial man with wit and with the toughness that comes from intense
competition and business victories, George was an old friend of Claiborne

Pell. Their association did not go back to school days, but to London in World War II, where both were stationed for a time during the Nazi blitz and where they established those special bonds that shared wartime experiences create.

Nancy Hanks was acquainted with George's leadership in the museum world, and he was appointed to the National Council on the Arts due in large measure to her recommendation to the powers within the Nixon administration. It was Nancy's thought that from a council vantage point George would support an endowment museum role that would fend off possible efforts to establish a separate museum program elsewhere.

Nancy had decided that the American Film Institute episode should not be repeated, with museums or any other segment of the arts community. A separate bureau for orchestras or for theaters? Never!

But once again, the principals involved were all-important, and they were not readily predictable in new crosscurrents of concept and philosophy. John Brademas was convinced that a pluralistic approach to the arts and government funding was best for all concerned. In the case of museums they could be assisted by state and municipal governments and by the Arts Endowment or the Humanities Endowment depending on the kinds of collections they exhibited. On occasion both endowments could be involved—an art exhibition given by the humanities a special historic interpretation, for example. But John wanted coverage for science museums, accorded relatively little attention at this point, and he wanted modest support for museum operating costs. Nancy felt the latter was unwarranted, a Pandora's box of complications, for the concept could easily spread like a virus among applicants from other art forms. Project support, said Nancy, was discrete; it provided the needed stimuli for accelerated private giving. The system was working, and it was complex enough. To general operating support Nancy said a determined no. She spoke to John, who smiled noncommittally and said he would continue to think it over.

It can well be maintained that the 1973 museum hearings Claiborne Pell conducted had created a momentum that did not abate. Thus, John Brademas joined with Claiborne, and Claiborne joined with John, and in 1975 a Museum Services Act took shape. It proposed that a new museum program be created within the Department of Health, Education, and Welfare. An Institute of Museum Services would be established to assist museums in their educational purposes, "in conjunction with formal systems of elementary, secondary and post-secondary education," including "programs of non-formal education with all age groups." And operating costs would be provided. In mid-1975 hearings began again in earnest, and the legislation took on an aura of congressional viability—

though it seemed to me that "inevitability" was a more precise word if the momentum continued.

I wrote Nancy a long confidential memorandum in which I suggested that the endowment begin to explore operating costs for museums with pilot projects in three areas—a large city, one of medium size, one much smaller—in different parts of the country. The pros and cons of operational help would be tested, as would new educational ideas and projects. The effort would last two years. Congress would be regularly informed. If at the period's end the advantages of operating support outweighed the disadvantages, the endowment would request added funds for a new mission. It seemed a way to forestall a confrontation. My loyalties were now necessarily with Nancy. But most of all it seemed logical. I thought it would satisfy Claiborne and John, and George Seybolt, and a National Council on the Arts, restless at another apparent threat to fragment the endowment's work.

Nancy read the memorandum overnight, and the next morning she asked me to join her in her office. You've overlooked, she suggested, that Claiborne Pell resisted setting up an independent AFI. I disagreed. His reaction wasn't wholly negative; it was more wait-and-see. He and John Brademas had never experienced a difference they hadn't resolved, I pointed out. Nothing on the Hill is stark black or stark white; there are always shadings. And museums cover such a wide spectrum. They aren't limited to one particular field. Films are included in many museum programs; museums are sometimes centers for music or for the performing arts. It's not the same as with the AFI. The philosophy is different, and the support is deep. There's a definite feeling the endowment isn't doing enough, and can't do enough in a balanced program.

Nancy listened but shook her head. She had enough reinforcement in the administration to voice official disapproval, to announce the administration's unequivocal opposition, if it should come to that.

"Nancy," I remember saying to her, "if Claiborne Pell and John Brademas mutually decided to establish an Institute for the Improvement of Tiddlywinks, they would manage it, sooner or later. You're just underestimating their strength."

She laughed at the notion and put it aside. "Don't worry about it," she told me. "I can't tell you everything—but it's not going to happen."

But it did.

It happened a year later, and in another chapter.

Mitigating against growing confrontations, however, was another legislative proposal on which there was unanimous agreement by all hands concerned.

Particular tribute here should be accorded Stephen Wexler, Clai-

borne's staff leader for education, the arts, and the humanities after my move to work for Nancy. Steve had a genius for legislation. Our long friendship continued. He and his Scottish-ancestored, red-haired, attractive, and studious wife lived on the banks of an inlet from the Chesapeake Bay near Annapolis. They were immensely proud of their infant son, Adam. Catharina and I would visit them for picnics, swimming, sailing. Steve loved relaxing on the water in his small boat, but his mind was never fully at rest. He enjoyed, as did I, discussing legislation of the past, how it might be improved, and Claiborne's regard for museums.

After the 1973 hearing, Steve Wexler and Kyran McGrath helped develop the museum bill. I would relate Nancy's reservations, but there was another broad area we discussed that did not show the potential for conflicting views. From my experience, I knew about the rising cost of mounting important exhibitions from other parts of the world. The insurance costs were perhaps the most serious single factor. A quarter of a million dollars in insurance premiums was by no means unusual, and it was often estimated much higher. Thus the exhibit from abroad would remain unrealized.

But our research told us other countries, where the arts had deeper traditional sources of governmental subsidy, simply gave such exhibits a governmental guarantee. If a work of art were damaged, lost or stolen during the exhibit, the country housing it would compensate the lender, with the funds supplied not through a conventional insurance policy, but by the government involved. It was working in Great Britain, in France, even as far away as Australia. Not only was it working, it had become established practice. The key finding we made was that losses were so rare they were virtually nonexistent because such great care was taken of the objects on display. No government likes to lose its funds unnecessarily. Therefore, the security involved, the packing and unpacking, the crates, the transportation, all were subject to especially thorough and demanding criteria.

Why not inaugurate the same procedures in the United States? In 1974, two large and fascinating exhibits were proposed, one from the People's Republic of China, the other from the Soviet Union. The rarest kinds of artifacts were to be displayed at the National Gallery of Art in Washington: jade, ancient porcelains, and priceless statuary from China, a mighty collection of ancient Scythian gold from Russia. For almost all Americans the experience would be unique.

Claiborne Pell took leadership in the Senate, John Brademas in the House. Steve Wexler, Jack Duncan, and I worked on details, and the Congress approved on a one-time trial basis the indemnification guarantees for both exhibits. They went without a hitch. There was no damage,

no loss; nothing was stolen. (This did not surprise me after seeing the special guards provided, especially by China. It was sometimes difficult to tell which was an austerely dressed high-ranking Chinese official standing in front of an exhibit case and which was an austerely dressed guardian.)

On June 4, 1975, Claiborne's Senate subcommittee and John's House counterpart held a special joint hearing to explore how to establish indemnification as a regular procedure.

Claiborne pointed to the international values of the concept. John Brademas explained that insurance costs for the Chinese archeological treasures were estimated at up to $400,000 for its visit to the Nelson-Atkins Museum in Kansas City following the Washington opening.

Douglas Dillon, former secretary of the treasury, president of the board of trustees of the Metropolitan Museum of Art, spoke of the national interest in assisting "cultural exchanges between nations" to increase "understanding and goodwill." Leonid Brezhnev, in a letter transmitted by the Soviet ambassador to the United States, Anatoly Dobrynin, applauded the "mutual understanding between our two nations" engendered by the Soviet exhibit and those who had made it possible.

Said Douglas Dillon: "We have obtained detailed figures showing the [experience of the] British. . . . For the past six years, works of art valued at approximately $275 million were indemnified." The loss ratio? One one-hundredth of one percent, in one claim of $33,500, which the British government paid. The legislation was progressing.

It was decided that private insurance could cover the first $25,000 at risk in individual exhibitions, with the rest to be government-indemnified. Ronald Berman, chairman of the Humanities Endowment, testified in support of the intent of the legislation, as did Nancy Hanks, more vigorously, in a statement I had helped prepare for her. It was not an easy statement, as might be anticipated, for the Nixon administration, through the Office of Management and Budget, objected; the legislation needed "further study;" its desirability was in question.

Robert Wade, the endowment's astute general counsel, helped in the legislation's refinement. So did Peter Solmssen, who added the State Department's wisdom to the enterprise. So did Daniel Herrick, vice president of New York's Metropolitan, who brought a wealth of knowledge and support to the cause. Sherman Lee from the Cleveland Museum of Art, then a member of the National Humanities Council and one of the country's most illustrious art historians and museum directors, praised the legislation. Senator Walter Mondale gave his endorsement, as did Larry Pressler, a relatively new, arts-conscious representative from South Dakota who was to become an arts-conscious senator in 1979. Alan

Cranston, senator from California, voiced approval. As always, Senator Javits was present to give his endorsement and his help.

Dillon Ripley and Carter Brown, now director of the National Gallery of Art, gave supportive testimony. So, especially, did George Seybolt. He spoke of the earlier Arts and Humanities Act and continued: "Now we consider ways of aiding and enhancing—on a global scale—this pioneering and historic cultural program."

It is interesting to note that at this hearing the insurance industry voiced no strong objection to the proposals. In fact, a statement from Washington's Huntington T. Block, an international fine arts insurance expert, said in part: "In the short run it is accurate to say that my office would lose business, . . . but in the long run what's good for museums must be good also for those of us who serve them. Large exhibitions breed smaller exhibitions; and as I understand this legislation, it only concerns itself with international exhibitions of particular significance. . . . You may register me as a supporter of the bill now before you."

Museums across the Nation warmly welcomed the new ideas. It was a "quiet" bill, in congressional parlance. It moved without dispatch, but with steady progress.

Later, when I was working again for Claiborne, I remember seeking to explain the lack of risk to a very literal-minded Senate budget official.

"Suppose a whole exhibition was lost in a plane crash. What then?"

"It would have to be several simultaneous crashes," I said. "The exhibition wouldn't all come in one conveyor."

"But what is the *total* risk involved?" I was asked.

"Negligible," I replied, now in charge of the bill for Claiborne.

It did not satisfy. The total was set at $250 million, more than the whole arts and humanities program. But this was still a "quiet" bill. Its statistics were absorbed by a few specialists and in general were unchallenged.

It was not until the legislation reached the Senate floor for a quiet voice vote and passage that insurance companies began to awaken to the potential of lost premiums. At the eleventh hour, calls began to light congressional switchboards. But they came too late. Congress passed the bill. A somewhat confused White House threatened a veto, but there was such a groundswell of support that no veto materialized.

It is difficult to overestimate the benefits derived from this brief legislation, less than four pages long. Conceptually, they were easy to

explain. Technically, they were far less so. In writing the final Senate report, I made sure to emphasize the concepts over the technicalities. History has done the same. Every great international exhibition, from the superbly beautiful contents of King Tut's tomb to those of the "treasure houses" of Great Britain, has been made possible in the United States in large degree because of the Arts and Artifacts Indemnity Act. Literally millions of museum visitors have been enlightened, in cities from New York to San Francisco, Chicago to New Orleans. Huntington Block was correct. Major international exhibits, bringing these once-in-a-lifetime displays for the first time to American eyes, have spawned smaller and more localized exhibits, because they have brought a new audience into the museum world, an audience that returns, and contributes. As international ambassadors, as teachers of history from the days of Alexander the Great down through the ages, the exhibits have been a special source for stimulating understanding and goodwill in a troubled time. Cultural avenues among disagreeing nations are seldom given proper attention, in my view. Yet so often they furnish the roadways along which others more political, more concerned with business and trade may more freely travel.

On the purely technical side? More than a decade has gone by since the legislation was enacted. The total value of the exhibitions has represented hundreds of million of dollars. Once there was minor damage. It came from a small nail, inadvertently left in an elaborate packing case, that penetrated the border of a painting with a small prick. An expert immediately rectified the damage. Is this a matter of good fortune, of a continuing lucky star? I do not believe so. If you could watch, as I have, the infinite care accorded to objects, from the smallest alabaster vial to a framed masterpiece so large it can hardly fit into the yawning doorway of the largest cargo plane, you would conclude that the lenders need not be concerned. This in itself is another byproduct, for in a decade we have learned not only how to make the major international exhibit more secure, but how to move the smaller one more safely and expeditiously from museum to museum here at home.

A final comment on Arts and Artifacts and its lasting impact.

Both Nancy Hanks and Ronald Berman had been obliged by protocol to include the Nixon administration's objection to the proposed legislation. Nancy had asked me to make her testimony as affirmative as possible without disagreeing in entire substance with the administration. She spoke far more of the values of international cultural exchange than about the administration's disapproval. She risked reprimand, but she firmly believed in the concepts and had wanted me to work fully with the congressional drafters.

Said John Brademas, with his full command of congressional par-
lance and of this situation, after praising the testimony of Douglas Dillon:
"I make this observation only by way of commending in advance
another witness, Nancy Hanks, for her eloquent statement in support of
the principle embodied [here], while at the same time noting that Miss
Hanks, who will have the opportunity to defend herself shortly . . . is
also constrained to point out that the Office of Management and Budget
is opposed to the legislation." John turned toward Claiborne sitting next
to him. "I have almost come to the conclusion, Mr. Chairman, that even
when you can achieve a positive purpose without costing much, or in-
deed perhaps anything, the Office of Management and Budget instinc-
tively says no."

Careful readers may have already discovered some subjects for
review. First, this colloquy took place after the American Film Institute
episode; it suggested continuing goodwill—or its restoration—between
John and Nancy, at least on a public plane. Second, here was legislation
the administration objected to being passed by Congress and signed into
law by the President. Third, did Nancy not realize that there were paral-
lels to be drawn and lessons to be learned from this legislation and its
implications for the broader museum proposals Claiborne Pell and John
Brademas endorsed? Could Nancy still believe that objections voiced by
the forces of the Nixon administration could ultimately block a separate
museum program? The answer is yes, she did.

Chapter 44

MY WORK WITH NANCY HANKS TOOK ON A GREATER VARIETY. SOME-
times toward the close of a business day she would walk down
the corridor from her large corner office, now at Columbia Plaza over-
looking the Kennedy Center, to my smaller quarters and say in that fa-
miliar understated Washington language, "Livy, if you haven't anything
particular to do after six, I'd like to see you."

Sometimes we would talk for an hour or so. In the next office was
Florence Lowe, Nancy's director of public information, who accompanied
her everywhere and made as sure as possible that the press was friendly.
I have rarely encountered a person as devoted as was Florence to her
task. She was a veteran of press relations; we also had Philadelphia
backgrounds to share. Florence had exceptional singleness of purpose,
and she was dedicated to Nancy's success; in presenting her to the world,
Florence helped ensure it.

But these talks were usually without Florence, or Michael Straight.
Nancy's mind was constantly active, and usually she had some specific
topic for discussion. Most frequently it related to the Hill, to its personali-
ties, to changing leaderships as they occurred. But often, too, Nancy
wanted a philosophical reaction, and on occasion a reaction toward

members of her staff. With minimal exception, they were also dedicated to Nancy's leadership and to the endowment's success because of it.

She was a perfectionist, Nancy Hanks. Her family at home was an aging mother, sprightly in demeanor, quiet in her ways, nonintrusive. In her relatively small Georgetown house, with red brick façade and outside stairway with wrought-iron banister, Nancy worked until late hours every night. What was left unresolved in daylight would go home in a voluminous, somewhat battered, dark blue leather briefcase. I would see it always standing near the door.

While Claiborne Pell pretty much trusted me entirely with writing his speeches, making legislative preparations, and the like, Nancy found it hard to delegate any such freedom. I remember my surprise when my draft of our yearly congressional appropriations testimony was sent back approved, but full of editorial markings. A period would be changed to a semicolon. Reverse orders were common—begin with this phrase, let the rest follow. It was clear she had read every word and thought about it. This was *her* written testimony, not her oral summation. I felt obliged to point out that she had spent a great deal of time on something that, at best, would be read in some detail by a congressional staffer hurrying through a volume of testimony from others, often on subjects unrelated to the arts. Nancy fingered the marked pages and said in her quiet, authoritative manner, with the slight trace of a southern accent, "But Livy, that's the way I want it."

I never questioned the process afterward. It was her way of doing things, with preciseness and supervision. Nancy, I knew, would never say, "But I never said that" or "No, that isn't what I meant at all." She was the same with everyone—the program directors, the administrators, the budgeters. That was a chief reason for the voluminous briefcase. She was an early riser; her day at the office began early. She was well organized, and she knew exactly how she wanted her day to go, whom to see, which problem to deal with at which time. Her brown eyes could be soft and attentive, and they could be the reverse when she felt wrong existed. Some felt she was devious, the southern inflection a camouflage over true intentions. My own impression was quite different. I think Nancy simply placed on the endowment the face she wanted, the one she found most desirable, necessary, essential; and she tried with all her efforts to make it stick. Her discontents were to be masked in public. Her countenance was to be of compelling presence. She was proud of her work and confident in the future. The Congress treated her with courtesy and with respect, and in some cases, as with Senator Alan Bible, chairman of the Appropriations subcommittee concerned with the arts, with an almost paternal affection. Nancy would respond with a smile and a twinkle and a "why Senator, that's so nice to hear. . . " In the House,

Julia Butler Hansen was Alan Bible's counterpart and gave Nancy the successful-executive-woman-to-successful-executive-woman kind of close rapport. When Sidney Yates replaced Julia Hansen a closeness of understanding continued, for even in his beginning as chairman Sid Yates found the arts to have value and priority.

There were some wonderfully memorable moments.

Erica Jong's novel *Fear of Flying* caused a literary stir of some magnitude. It caused an even greater stir in the House of Representatives when it was discovered she had written on the flyleaf that without the help of the National Endowment for the Arts the book would not have been possible. Representative William Bauman took exception. Others suggested that the federal government, through taxpayer money, was now supporting the scurrilous and the pornographic, and further, that since ladies were present, a reading of the text would be inappropriate. Should members so desire, a copy of the book was available at a nearby desk. The desk was surrounded by the curious, as was my telephone beleaguered by callers.

If someone asked merely, "What is this *Fear of Flying* thing that's causing commotion?" I would answer quickly, "Oh, that. Don't worry about it. It's just the new biography of the astronaut." Strangely, this satisfied quite a number of initial callers. If the question were phrased a bit differently—What is this pornography you people are foisting off on the American taxpayer?—I had to be more circumspect.

Nancy took the matter seriously, as she should have. And of course, so did I. Once again—as had happened before and has happened since and will no doubt happen again—the endowment's congressional mandate to provide grants to individuals (as well as to organizations) was scrutinized and questioned and debated.

Roger Stevens's reaction to criticism was to attack the critic, unless, of course, a member of Congress was involved. Roger had a low tolerance of criticism. Nancy's tolerance was no higher, but she was not given to a quick reach for the jugular vein. Her responses were more measured. Once again, in this case, the storm passed by.

Nancy's problems were basically related to the endowment's growth from adolescence toward maturity. Growing up brought its share of pain. The AFI episode left scars. The threat of an unwanted schism with museums could not be put aside. Museum leaders, once so entirely friendly to the endowment, now perceived divided loyalties—and visions of increased future support. Some suggested that all the endowment needed to do was to double at once its allocation of funds for museums and the loyalties would return to one hundred percent. But Nancy would

have none of that kind of materialism. Don't fragment the arts, she insisted, and everyone listened—except museums and to some extent orchestras, who felt that if their museum brethren succeeded they might try a similarly pluralistic route for additional resources.

Perhaps the problem of greatest concern, however, involved relationships with the states, with state arts agencies, their directors, the chairmen and members of their councils. They had organized themselves, with the endowment's blessing and help, into the National Assembly of State Arts Agencies, or NASAA. The ending double "A" was a bit difficult to pronounce, but the mission of NASAA was clear: greater participation in the workings of the endowment.

Again, growth was a factor. The state agencies, which had turned to the endowment for moral and philosophical aid in their early struggle for recognition and hard-won modest appropriations, were growing in effectiveness, reputation, acceptance, and self-confidence,. They wanted more sunlight. Create another being, some might say, and you can wind up with Frankenstein. Conservatives at the endowment cautioned against too much independence. In my view a balance was the most essential ingredient. Is not the talented offspring to be rewarded?

Congress had determined that 20 percent of the funds appropriated for the Arts Endowment should go toward the assistance and development of state programs. Here was, in fact, a pluralistic and mutually helpful endeavor. A performing arts group in a state, for example, could receive state matching funds and apply separately to the endowment for matching federal sums and national recognition. There was absolutely no question that the state agencies and their councils were greatly enhancing knowledge and understanding of the arts. Governors, state legislatures, and hardheaded municipal officials were becoming aware that the arts could provide tangible, readily understood benefits. And there was a growing vocal constituency, which visited state capitals at first with a certain reticence, but with increasing expertise. State appropriations began to multiply. It was a sign of good government to support the arts, modestly of course, but without that earlier doubt and misgiving. In short, the arts were beginning to enter the mainstream of American political life, where they had never had opportunity to venture. Once-icy waters were warming. This progress was gradual. We were still among tributaries of the river, but there was no question about a sense of direction.

And so the states said to Nancy Hanks: Give us your National Council to debate, give us a chance to serve on your panels, let us develop national policy with you. We know at first hand the organizations and the individuals you serve. We don't ask for more than 20 percent of the funds, but we ask to be welcomed as equal in knowledge and ability.

Some members of the National Council said, Who are these up-starts at the gates? They may know something about quality, but how can they, as Idahoans or South Dakotans, for instance, know how to compare a museum in Boise with New York's Metropolitan or a musical group in Sioux Falls with the Chicago Symphony? Leave to these young warriors the territories to be managed at home base; but leave to some-one else the ultimate adjudications of excellence. Both sides used the basic law as vindication for the concepts they professed, but nowhere in it was there enough specificity.

It neither said that state leaders should be sought as national advi-sors, nor did it exclude them.

Nancy Hanks was caught in the middle on this issue. To side fully with vocal members of her council, who represented an aura of majority, would be to risk popular outcry and lead to questions about the structure guiding endowment decisions. The majority of Congress was well satis-fied with that structure, with the council and panels of experts in the arts. A majority of Congress did not wish to interfere with the experts in the arts. But suppose the definition were questioned?

It was a situation that Nancy did not resolve. State leaders were invited to report more frequently to the council. On occasion, their words were taken as perhaps a sharper critique than intended. It was a little like the American Film Institute. Strong personalities can intrude on logic.

There were strong personalities—in Jim Edgy who became head of NASAA or Steve Sell who directed the Minnesota Council on the Arts. They faced Nancy Hanks and Michael Straight, and a kind of undeclared conflict ensued. It could seem to verge toward armistice, but it did not deviate from positions of disagreement. Nancy was a believer in osmosis: disagreeing elements will eventually merge, given a compatible environ-ment. Perhaps there was not enough fundamental respect involved. Ev-eryone tried to express respect, but no one quite believed it. In such conditions, a situation gradually worsens. Here it was not like the Ameri-can Film Institute, whose progress had reached at least a temporary level of evenhanded review.

I learned many lessons from Nancy Hanks. I admired most of all her unfailing, unwavering adherence to the goals she believed in. She may well have thought her beliefs multifaceted, but they were quite ba-sic. She believed in a National Endowment for the Arts. The states were necessary and needed participants, but she was opposed to any weaken-ing of the endowment. She gave it her full and energetic attention. Though I worked with her so closely day by day, I was not aware that her health showed signs of failing. She kept this to herself and in a strict confidence with Florence Lowe. Her energy seemed to me unchanging.

In a time of remarkable growth for the endowment, Nancy was a valiant leader. She won friends in the Congress. She won the support of the Nixon and Ford administrations. She had particularly powerful friends in Leonard Garment and Nelson Rockefeller, but they would not have been as forthcoming if they had not liked and admired the arts chairman.

Nancy appreciated humor. She would react to memoranda—which she could study at night—with little tragicomic masks in the margins, upturned mouths and laughing eyes for applause, downturned mouths and sorrowful eyes for questioning or disapproval. Anger was rarely seen; only once do I remember her in a towering rage, and this toward Ronald Berman, the Humanities Endowment chairman.

In 1974 the Office of Management and Budget began a procedure to change the starting date of the government's fiscal year from July 1 to October 1, to better coincide with nongovernmental practice. A transition period was provided for the changeover, to occur a year hence. Special appropriations would be made for July, August, and September. Then the new fiscal year would begin. Nancy realized that a once-in-a-lifetime bonanza for the endowment was possible. Most of the large arts organizations received their grants at the start of a fiscal year, in July or August under the old rubric. They would be funded in the transition period, Nancy decided—and then again toward the close of the first new fiscal year. Thus they would receive two grants, not one, in just more than a calendar year. It was a brilliant budgetary ploy, and it succeeded. The OMB recommended to Congress a major transition period sum for the Arts Endowment. I had worked hard to ensure that Congress would react favorably. After all, we were following a pattern, in accord with what regularly occurred in July and August.

In contrast, sizable Humanities Endowment grants usually fell toward the end of the fiscal year, in May and June. Hence the Humanities Endowment requested and received approval for a more modest transition period sum. All at once, Ron Berman awakened to Nancy's approved request. At the eleventh hour, midnight oil was burned. Ron requested that the total of the two amounts, arts and humanities, be divided in half, with the Arts Endowment receiving considerably less for the transition, the Humanities Endowment considerably more. It was in keeping, he said, with the principle of parity in funding between the two endowments. The Arts Endowment, he seemed to have implied, would be pleased to concur.

Now it was Nancy's turn to awaken, when informed that the Berman request might well be honored. "Why, that—" Nancy exclaimed in indignation, but left the remainder simmeringly unfinished. "That's

hardly fair, is it?" she asked and remarked further on the proprietary ownership of a good idea suddenly gone astray. I was instructed to call Ronald Berman and express our "deep concern." Nancy made a few other calls. All this was after dark on the night when the final OMB figures were being locked into print. Nancy did not lose this one. From the tenor of her conversations, I did not think she would.

It was the endowment's tenth anniversary—September 1975. Lady Bird Johnson had decided that the creation of the National Foundation on the Arts and the Humanities represented a most special achievement of her late husband's administration and that its anniversary should be celebrated in appropriate Texas style, by a symposium at the Lyndon Johnson Library in Austin and by related events. Luminaries in the arts and humanities were invited, together with the legislative pioneers: Claiborne Pell, Jack Javits, Hubert Humphrey, Frank Thompson, John Brademas, the two chairmen, Roger Stevens and Nancy Hanks. I was invited because of my work in the development and evolution of the program. I remember four of us sitting at a table in the hotel lounge in Austin awaiting transport to the day's festivities—Claiborne, Senators Humphrey and Javits, and me. Hubert Humphrey was remembering the day of the legislation's final passage. It hardly seemed ten years; it seemed more like yesterday. Jack Javits agreed. Much more like yesterday; he'd been thinking the same thing on the plane to Texas. Hubert Humphrey was smitten by nostalgia. Ten years, yesterday. He pictured himself and the senior senator from New York standing arm in arm in the well of the Senate; and with the blessings of majority leader Mike Mansfield, they had jointly battled through to the bill's approval, in all its precedent-setting and historic import.

Yes, said Jack Javits, that's how it was, that's where they were—there by the desk of the president pro tem, two old friends from opposite political parties linked in a common history-making purpose.

Which of them had made the conclusive historic motion? They could not precisely recollect. Hubert Humphrey recalled that Jack Javits had deferred to the Democrat because the Senate was so organized, out of courtesy, said Hubert. Yes, that's right, Jack Javits agreed. Like yesterday—and ten years had passed.

Suddenly they both turned.

"Gee, Clai. You were there, too, weren't you?"

And just then the spell was broken by the arrival of a Johnson aide.

"Gentlemen," he said, "the bus is ready."

We all rose and followed him. Claiborne nudged my elbow. "Is that the way it really happened?" he asked quietly.

"No," I said. "You were the floor manager. It was yours, of course."

"Why didn't you tell them?" he asked.

"I didn't have time," I somewhat evaded, for there were two other good reasons: How, under such circumstances, do you challenge a senior senator and a former Vice-President? And do you really want to intrude on such memories?

Let's recall, however:

"*Mr. Pell:* Mr. President, I move that the Senate concur on the House amendment.

"*The Presiding Officer:* The question is on agreeing to the motion of the Senator from Rhode Island.

"The motion was agreed to."

So does the Senate record the event of September 16, 1965.

Senator Javits made the secondary motion, the so-called motion to reconsider. Claiborne made the concluding motion to table any future reconsideration. But a floor manager is a floor manager is a floor manager. And besides, Hubert Humphrey could not have been present to vote on September 16, 1965. He was Lyndon Johnson's Vice-President.

So they were thinking of other battles for the arts and the humanities, other times when they had joined forces, figuratively arm in arm. Their contributions are imbedded in the legislation. Their spirits are there and always will be. Memories need not always be factual.

The following evening, late at night, Claiborne called. Catharina and I were sleeping. His voice seemed distant, full of distress and grief. Steve Wexler had been killed.

Steve often drove a motorcycle. It seemed to fit his love of adventure. This time he had been on a routine mission from his house near Annapolis to the grocery store. A speeding, police-pursued car, coming from the opposite direction, had veered sharply—so went the report. The motorcycle has been struck with great force. Steve had been killed instantly.

I spoke the next morning to Nancy about the tragedy. I spoke to Claiborne. I offered to work for him once again, if he felt it would help. Yes, he said. Please, please do.

Chapter 45

A NEW RULE IN THE SENATE PRECLUDED A MEMBER FROM SERVING as chairman of more than one subcommittee on any given committee. Claiborne Pell, on the Committee on Human Resources (the old Committee on Labor and Public Welfare) was chairman of both the Subcommittee on Arts and Humanities and the Subcommittee on Education. Many years before, the venerable committee chairman Lister Hill had wondered if the recently arrived senator from Rhode Island had the temerity to consider replacing Wayne Morse, the Oregonian who made Education his own special province. Now more than a dozen years had gone by. Wayne Morse was no longer in the Senate. Nor was Lister Hill. Claiborne, rising annually in seniority, inherited the Morse subcommittee. It was a particular signal of prestige, with a budget in the billions of dollars. Which should he keep, he had asked me: Arts and Humanities, whose beginnings he had indeed founded, whose program he had so uniquely nourished, or Education, with broader-funded national implications?

I suggested the solution that remains today. Why not have one subcommittee, for Education, Arts, and Humanities? The then committee

chairman, Harrison Williams from New Jersey, agreed. A choice was not required.

My new position with Claiborne involved general direction of this expanded subcommittee. Now my three years at Fordham University were of particular advantage. I concentrated, however, on the arts and humanities, and Jean Frolicher, who had worked with Steve Wexler, concentrated on education. There were times when the two concentrations merged. Jean had outstanding ability. The labyrinths of education legislation were no mystery to her. It was said that under Wayne Morse and his chief aide, Charles Lee, laws on education had become so complexly intertwined that only they could understand and unravel them. Jean proved this to be a Senate myth, as did Gregory Fusco, now with the portfolio of Senator Javits in all three fields. In his special ability Greg was in the tradition of Javits's chief staffers, a tradition of excellence that went back to Al Lesser, Steve Kurzman, and Roy Millenson. He also knew intimately all the maps of the region, how to assert a Javits prerogative, when to accede to a chairman's wish, when to initiate, when to consider possible compromise. There were no surprises in the legislation we dealt with. Much of it we could recite verbatim, knowing the origins of the phrasings and the innuendos.

I decided to focus on how the Arts and Humanities Act could be enhanced, especially in view of the growth of the program, its experiences with the private sector of philanthropy, and a possible slowing of appropriations after the Bicentennial period of increase. It seemed to me that private philanthropy, corporate and individual, was ready to respond to the needs of the arts with new enthusiasm. The arts were becoming a byword in areas where they had either never existed in any strength or been misunderstood. How to excite further support, and in a way that the Congress would find appealing? Could the matching ratio prescribed by law, one federal dollar to match a nonfederal dollar, be subject to some change?

The months with Nancy had clearly demonstrated that this basic legal match was being exceeded. Conservative estimates showed one federal dollar invested in the arts generated at least three times that amount, and more, over time. How about making such a matching ratio a legal requirement, under prescribed conditions? What should these conditions be? Perhaps they best suited the larger organizations, the metropolitan symphonies, the major performing arts entities, the big museums, which had the appropriate fundraising capability. Such a program, if added separately to regular appropriations, could ideally mean relatively more funding for the smaller groups.

Still on the books was the old section 10(a)(2) of the original legis-

lation, the section used for initial unrestricted gifts made to the endowment and then the more forthcoming restricted ones. That section, with its own special ratio of match, could be utilized. But how would it look simply to set forth in legislation an amendment of section 10(a)(2)? Only the most expert translator of legislative language, and very possibly only a handful of members of Congress, would have the foggiest notion of what was up. In some cases such a procedure is not without advantage. But not now. Section 10(a)(2) was simply not sexy enough. The citation, I decided, would have no popular appeal at all.

What were we proposing? What was the concept? Was it not a challenge? All at once, that word seemed right—a special challenge grant program, independent of other programs, with major support from the endowment, matched three to one from nonfederal sources. A challenge to corporate givers. A challenge to individuals. Would it work? Why not give it a try?

Somehow, that word "challenge" was key. It described not only a proposed new area for endowment work, but also the endowment's basic philosophy—a challenge, a catalyst, a stimulus. "Challenge" it was.

It worked. Claiborne was enthusiastic, and John Brademas. The Congress was enthusiastic. Nancy Hanks was particularly enthusiastic. Ron Berman, at the Humanities Endowment, felt it could succeed. I was more certain of the arts.

Gerald Ford was now President of the United States. Richard Nixon had resigned. It was a time that tore at the fabric of our government and at the roots of presidential integrity. The dogs of confusion and ruptured confidence had gone baying through the streets, and the White House had changed from promise to personal tragedy. Some wounds were healing, however, and the arts were an area virtually unaffected. Nancy Hanks, Leonard Garment, and Nelson Rockefeller took protective stances. Gerald Ford announced his conversion from skeptic to arts defender, chiefly because of a Calder mobile in Grand Rapids, Michigan, the center of his one-time congressional base. From a severely questioned metal shape incomprehensible to early viewers, it came to be fancied and beloved by the city's inhabitants. It became their logo, and Gerald Ford's opinions on the arts shifted in similar fashion. Betty Ford, his wife, was once a dancer. Together they listened attentively to Nancy Hanks.

Thus the new ideas to stimulate philanthropy had appeal to a President establishing his own credentials for leadership in many sectors, and to his Office of Management and Budget. In October 1976 President Ford signed the new Challenge Grant Program into law. The initial recommendation of $12 million for the Arts Endowment challenge grants

became $9 million when Congress appropriated the funds, but the amount was for only part of a fiscal year; the next time around, the amount was doubled. Nancy used the total, $9 million and $18 million, to launch the new endeavor.

In its third year, under my stewardship, the challenge grant appropriation rose to an annual $30 million. It was popular from the outset. The grants Nancy announced were in the "blockbuster" category, at a level of $1 million each. They translated at once into over $100 million for the arts ($27 million, plus three times that amount, the necessary match). There were instant success stories, as the funds actually raised exceeded the matching requirements.

To Claiborne Pell and to me, the experiment succeeded beyond our visions. The experiment worked despite the rise and fall of presidents. It continues working.

Simultaneously, the museum legislation moved to center stage, with momentum from those recordsetting hearings of 1973 increasing, with museum leaders listening more to Claiborne Pell and John Brademas than to Nancy Hanks. It seemed my forecast to her was correct. This was a wave that no Canute, male or female, and no OMB, no matter how astute, could withstand.

George Seybolt was in the vanguard and was accorded Claiborne's enthusiastic support. Lee Kimche, who had organized science museums throughout the country and who spoke eloquently about the need for general operating support for all museums, was also in the vanguard and given strong support and encouragement by John Brademas. Lee was a woman of great perspicacity, with unflinching resolve, a worker of unflagging energy. It was evident to me that Claiborne and John, John and Claiborne, were going to emerge from this long, hard struggle victorious—soon, not at some future time.

I found the cause of great merit. Museums needed pluralistic funding. The endowments could not accommodate all their needs. They were the most numerous not-for-profit cultural organizations in the Nation. Their potential to educate and enlighten, to entertain as well as to instruct, was immense. With the Arts and Artifacts Indemnity Program the potential was enhanced. With the Challenge Grant Program needed expansion could occur. Once receptacles for safe storage and little more, museums had become dynamic. Old giants had awakened. Claiborne believed in a modest start for the new endeavor, but one growing to at least $50 million annually within a reasonably short time. So I took out the 1973 hearings, which I had helped organize with such care, reread their close to a thousand pages, and buckled on the necessaries of battle.

I spoke again to Nancy. She clearly saw the signs. Birnam Wood

was advancing and hardly disguised. She did not retreat, in private conversations. I had not anticipated she would. It was not a moment for "what ifs" or "what if you hads." I have a letter from Nancy, written as I was leaving her service. It spoke of the adversarial role I might take on returning to the Senate. I wrote to her that I would never consider myself an adversary after all the work we had done. She was thinking, no doubt, of museums, and so was I. The battle, however, was not against Nancy Hanks. It was in favor of museums.

In that respect, Nancy was not in opposition, but she had a very different interpretation of the methods to be used.

A large question remained. Where should a new Institute of Museum Services best be placed? Claiborne and I were not fully convinced that the Department of Health, Education, and Welfare—as the early version of the legislation had suggested—would be the most beneficial lodging. Nor was John Brademas fully convinced. Should the institute be placed within the National Endowment for the Arts, following the precedent of the American Film Institute? (Nancy would not support that alternative for reasons already made clear, but there was the advantage of keeping cultural endeavors as contained as possible.) Should it be within the Smithsonian, where a modest program of museum training under the National Museum Act of 1965 was already underway? Smithsonian authorities indicated to me, enough, already; a broad new nationally oriented museum program would tend to detract from the Smithsonian's reputation of objectivity toward the museum world. The grantmaking institute could become the tail that wagged the dog, I was told.

Should the institute be independent? Claiborne and John discussed the pros and cons. A relationship to both endowments could be legislated. Council guidance could be shared, so as to utilize the best of existing advice and encourage cooperation. Museum leaders predictably liked the independent approach. But the old concerns of the 1960s about vulnerability for a controversial fledgling came again to the surface—especially, in this case, for a fledgling that could well receive immediate objection from the Office of Management and Budget.

Finally, there was a technical possibility. A new institute could be placed within the Federal Council on the Arts and the Humanities, the bridge established in 1965 between the two endowments. The Federal Council had served as a convenient home for the indemnity program and had already found full congressional acceptance. Claiborne and I were inclined toward such a solution, but the principal goal was early enactment of the program itself in accord with mounting expressions of museum difficulties and needs.

Enter Albert Quie, the congressman from Minnesota. Al Quie had

once opposed the arts and humanities legislation in concept. Now he had become ranking Republican leader on the Brademas subcommittee, an ally rather than a foe, and was on his way to becoming governor of his home state. He informed John Brademas that he would support the institute if it were placed within HEW. Otherwise, he would not.

To Claiborne, to me, and to Senator Javits, the continuing staunch ranking Republican arts leader on the Senate side, the matter was not worth a disruption in prolonged arguments. If it was to be HEW, why risk a damaging House division? And so agreement was reached. The institute was created, and there was no objection from OMB. President Ford signed the legislation into law.

It might be asked why Albert Quie acted as he did, for his action secured the approval of a Republican House membership and a Republican administration. "Controversial" was removed as an adjective for the bill. Was it the persuasiveness of John Brademas? Certainly—but perhaps not entirely.

Information suggested that Nancy herself was a motivator. If so, why? The same sources suggested that President Ford's Department of Health, Education, and Welfare might be slow in developing the newly arrived institute; indeed, it might emulate molasses in its speed. The new home might also prove architecturally unsound. It might, for instance, lack plumbing and a front door. It might also lack budgetary requests. Within its myriad and complex pages of figures, HEW might just possibly misplace the necessary annual funding line or give it a token and no more. Might the new home possibly become devoid of house, and just a plot of ground with a stone inscribed in small letters "Requiescat in Pace"?

Those possibilities were never tested. A great sea change overtook America's government. By a most narrow margin Jimmy Carter became President of the United States. Joseph Califano became secretary of HEW. Joe was a friend of Claiborne's, a friend of John's. He was a friend of museums, their values, and their educational potential. He became a friend of George Seybolt and of Lee Kimche. These two, recommended by Claiborne Pell and John Brademas, were nominated by President Carter and confirmed by the Senate as chairman of the National Museum Services Board and director of the Institute of Museum Services, respectively. The director carried out the wishes of the board. The director also managed the program. There was competition between George and Lee, to put it mildly. Claiborne once called it in jest a "mariage de convenance." But basic friendships were not threatened. A strong program emerged. Museums benefited from the competitiveness. George's board possessed an exemplary membership, from all sections of the

country, from museums large and small, of all kinds. Lee made sure that the science museums shared in the grants process, but so did art museums and history museums, and in some cases zoos and botanical gardens. I think the endowments, too, benefited from the competition, as in a city where one newspaper is suddenly facing a competitor and the news is sharper, the reporters more alert. Arts Endowment projects were reviewed for improvement. The scope of museum help was reviewed for expansion.

Nancy's term continued for almost a year under the Carter administration. She did not lose her own convictions; but in the end, I think, she recognized the value of pluralism.

Chapter 46

WE CAME NOW TO AN EVEN MORE COMPLICATED SITUATION—ONE WITH far-reaching and in some respects continuing repercussions. It began with an appraisal by Claiborne Pell. It led to the demise of a chairman. It led also to emphasis on a verbiage regarding the arts and humanities that is overly simplistic and therefore apt to be misleading, one that still lingers in public print.

In his travels around the country, in the course of speeches he gave, Claiborne would ask two short questions: Who leads the arts in this state? Who leads the humanities? He found answers to the first question readily forthcoming. The second question evoked answers that resembled the response of someone who is not a sports fan when asked what Stan Musial's batting average was in 1941. Why the lack of knowledge, Claiborne wondered?

There was a simple reason. By 1976 the arts were becoming rooted all across the Nation. They were no longer treated as frivolous, as unwanted and clouded by suspicion. They had become respectable, even in political circles. They were bearing potential cornucopias of untried and unexpected joy. They were enlivening the human spirit. Artists were gaining recognition, not yet in keeping with European traditions, but for

bringing new dimensions to life and its fulfillment. Dance, as an example, once considered effete and provocative of sly congressional humor, was indeed the fastest-growing major art form in the country. Grace, beauty, illumination—these were qualities the newly discovered arts were imparting.

So their leaders were known and appreciated; and when they talked at their state capitals and in their communities, they found attentive ears. The arts had come to stay, and they were being welcomed.

What about the humanities and their mission? The National Endowment for the Humanities had created state programs, but they stemmed from a Washington base. State council members were appointed by the endowment, not by the governors of each state, as was the case with the arts. This procedure was deliberate, said endowment chairman Ronald Berman, because the humanities were different from the arts. It was suggested that gubernatorial appointments could seriously jeopardize their integrity. To raise the possibility was to indicate a lack of understanding of the humanities themselves.

Ron Berman had been a friend of Steve Wexler's. On occasion we had all shared lunch, or I would visit his office to talk with him and his excellent congressional liaison, Joseph Hagan. The episode with Nancy Hanks and the transition period budget was in the past. But not so the humanities and a broader involvement in the states.

Something seemed amiss in the reasoning he espoused, something I have alluded to already. It seemed to denigrate the political process as we have developed it in the United States. Would Thomas Jefferson, a great Founding Father humanist, wish such separation and detachment? Weren't the Jeffersonian concepts integral to the political process, to all aspects of government? Should the humanities be set somehow apart, isolated from government, or should they be within the framework, within the fabric? Was a state governor automatically so benighted that he or she could not appreciate the values of the humanities? Was a Washington decision inevitably superior? If political leaders were so intrinsically fallible, why would Ron Berman welcome appointment though the political process, by the President, and seek renewal in office through the same procedure? It seemed very much to me as if the final conclusions to be drawn, by the line of reasoning advanced, were that politicians at a Washington level were tolerable, but at a state level they were too close to being venal ignoramuses for the humanities to risk any full partnership with them. It disturbed me to find no reasonable effort at rebuttal. We were talking about the very fundamentals of a program created through the political process, about the closest kind of initial partnership between government and the wisdom of illustrious scholars.

It made me think that centralization of control was an underlying

issue. Had Ron Berman decided he wanted none of Nancy's controversy with the states? And yet the controversy came from growing state sophistication in the arts, from increasingly qualified leaders able to speak with increasing authority on the subject of excellence. Was not an example of American democracy at laudable work? Why should the humanities shun it?

While I was serving with Nancy, Claiborne Pell had introduced legislation drafted by Steve Wexler that would enable the creation of state programs for the humanities akin to those pioneered and developed by the arts. The concept was to bring the values of the humanities into more general focus. In the early 1960s we had noted that mighty civilizations had given as much importance to the philosopher as to the artist. In ancient Greece, an Aristotle was equated with a Eurypides, or an Herodotus, the father of history, with the epic poet Homer. Why were today's leaders in the humanities given relatively little attention, and today's leaders in the arts so much more? Claiborne clearly remembered how the humanities had furthered the cause of the arts in the early legislative days. Now the humanities needed a different kind of helping hand. They needed release from their own ivory tower. They needed a stronger, more persuasive, more clearly comprehended voice in the cultural growth of the Nation. The voice was losing its timbre and resolution because there were not enough listeners. Scholars were talking too much to scholars, just as a few years earlier artists had been talking to artists, and relatively few others were listening. If we were one day to have a great new Augustan Age, as some described it, surely the cultural assets of America did not reside with the arts alone. The humanities were essential.

But the hand Claiborne offered was instantly rejected by his scholarly constituents and by writers in newspapers who began likening Claiborne Pell to a sort of modern-day Attila bent on destroying, by lack of knowledge, the humanities' integrity and sacred honor. Overlooked in these writings was Claiborne's deep involvement with the founding of the National Endowment for the Humanities, with ideals and goals so clearly enunciated. A dozen years had elapsed. Memories appeared shorter.

When I returned to the Senate from the Arts Endowment, I found much confusion on this issue, scathing newspaper articles and a great unwillingness on the part of the humanities to consider any manner of compromise. It appeared to be Ron Berman's conviction, and his resolve, that Claiborne Pell was unequivocally wrong and must be proven so. He disclaimed any linkage to the press campaign, but it appeared well organized and covered newspapers in Rhode Island.

It was a debilitating exercise for all concerned. Claiborne Pell is

the opposite of a vindictive person. Many alternative approaches were proposed: gradually phasing in state humanities programs, testing them for efficacy, giving them a voluntary aspect, providing incentives for state involvement. Couldn't the Humanities Endowment call a conference of state leaders to determine how best to set the new programs in motion, as Roger Stevens had done in the early days of the Arts Endowment?

These proposals were presented as suggestions, subject to modification or improvement. The purpose was plain: how to emphasize the importance of the humanities and bring them more into national focus. Like the change in national attitudes toward the arts, the change in understanding of the humanities would not be sudden. But scholars, teachers, philosophers, historians, and leaders in the social sciences needed to begin articulating the message more clearly. Those in the political process, at all levels of government, could be the new listeners, and ultimately the beneficiaries.

We emphasized that, since its start in 1966, the federal-state arts program at the endowment was generating $60 million annually in state support, from a beginning sum of less than $3 million; that more than 1,000 community arts councils had been developed nationwide; that county arts councils were coming into being. There was no parallel to these developments for the humanities. True, there were some fifty potential sources of criticism among the state arts programs, but this was a balancing force preventing a federal domination. It made for discussions and examinations and new ideas needed for artistic growth, and we were convinced the same process would invigorate the humanities. Nancy Hanks might be having problems with state leaders; but certainly she, and Roger before her, could underscore the basic value of the federal-state partnership the Arts Endowment had brought to pass. It was the yeast for growth.

The Humanities Endowment remained immobile in objection. With the advantage of time, I find no logical explanation. It seemed that the Holy Grail must be defended against the Infidel. Exaggerations and over-simplifications grew. For the first time two words, allegedly opposite, appeared in assessments of the situation: elitism and populism. They had come to stay. They still appear in print today. They were convenient at the time, like tags that identify the owners of luggage. Ron Berman was an elitist; Claiborne Pell, a populist. Elitism was equated with an espousal of quality and excellence; populism, with efforts to undermine excellence thorough infusions of mediocrity. In this context, elitism did not and still does not carry a connotation of exclusivity, of aloofness; nor did populism in this context carry thoughts of bringing benefits to widening num-

bers of citizens. The words were used to show either praise or
derogation.

Another word was inserted into the argument: politicization. Clai-
borne Pell was "politicizing" the humanities. Shame and abomination.
But what else could one expect from Attila the Hun?

There was irony in all of this. An irresponsible neanderthal loose
in the United States Senate? A homo sapiens of unexcelled intellect on
the rampart of the humanities? That was not exactly the way the Senate
as a whole viewed its veteran champion of cultural causes, nor was it
exactly the way the scholarly leaders remaining from the 1960s viewed
the humanities chairman. But it was essentially the way these two were
depicted in the press. Perhaps it was this interpretation of events that
encouraged Ron Berman to persevere on the journey of his own reap-
pointment. He became convinced, it seemed, that ninety-nine senators
would react with favor toward him, while one would not.

Now, in the summer of 1976, he had almost reached the end of
his four-year term. President Ford had nominated him for reappointment.
A new term required Senate confirmation. In my conversations with him,
he appeared to feel certain of it. He rejected as "wholly unacceptable"
our final effort to bridge the legislative chasm. It would have allowed the
states to determine their own best future, either under the existing Ber-
man programs or under the Pell proposals.

To me this was a dismal period in the relations of the National
Endowment for the Humanities with the Congress. The endowment had
been built on mutual faith and mutual respect. While the initial cast of
characters was highly individualized and capable of highly individualized
expression, there was a basic unity of purpose, so disagreements could
be overcome. This, indeed, befits the humanities—the readiness for dia-
logue on difficult matters. Now there was no such dialogue. A once
bright flame was sputtering out.

It became exceedingly difficult for me to find a passage to old
friends in the humanities cause. Yes, they recognized merit in Claiborne
Pell's proposals; but they also recognized that grants, essential to their
well-being, came from another source. It was as if blinds were drawn
across windows. One worked among unaccustomed shadows. A few old
friends, like Matthew Hodgson, who was then head of the University of
North Carolina Press at Chapel Hill, stood forth and were eager for full
discussion; but many were silent. It was all very understandable, Clai-
borne told me, with his usual equanimity. He would read the critical arti-
cles, and Ron Berman's continuing disclaimers, with a faint smile and

hand them back. It was like the attacks other opponents had mounted. They bounced off the shield. I understand, he would say; I can't say I blame any of them. There was sadness in the statement.

It was a dismal time.

And as we prepared for a two-day Senate hearing on Ronald Berman's qualifications for reappointment—with Claiborne presiding—there was an unfortunate letter. It bore Ron Berman's signature. I learned of it through a telephone call from Bill Cannon, once head of the arts and humanities at the old Bureau of the Budget, once deputy chairman of the Arts Endowment following L. Biddle, and now assistant to the president of the University of Chicago.

What has happened to our great old defender Claiborne Pell? Bill inquired.

Happened in what way? I asked.

He seems much changed, Bill said. Is it true? He was confused, he told me. So was his president. He was calling for information.

Listen to this, he said to me, and read me the letter.

It referred to the "Pell Affair" and enclosed an "accurate" summary of it. Implicit, said the letter, was the attempted politicization of the agency. Claiborne Pell objected to the "professional" use of endowment funds, preferring that NEH support go to "state bureaucracies, and then be disseminated to grocers and lumberjacks to enable them to practice (with a question mark) the humanities." It also enclosed a newspaper article which, it said, had "nailed down the issue."

After giving Bill my explanation, I asked him to read the letter again and to send me a copy so I could respond properly. The copy did not arrive. I spoke to Bill a few days later. He apologized, but said he had received other instructions.

I felt there was a special import to all of this, particularly when I learned that letters of similar content had gone to other figures in academe. No one was willing to share a copy.

Claiborne, however, took the matter more philosophically. Anyone was entitled to write a letter, he said. Even if Ronald Berman had personally signed it, he was so privileged. But it could have been signed by someone else. Didn't I have the right, under certain circumstances, to sign "Claiborne Pell?" And as for the repeated disclaimers and expressions of personal regard, and a professed wish to deal not with personalities but only with "issues"—well, it was all within an understandable and developing framework. So the letter, unlike one of a scarlet hue, was not a centerpiece in the unfolding of events.

The hearing was held. Many questions were asked. Claiborne had requested a thorough review of the endowment's administration by the General Accounting Office, a routine procedure. In the view of the Hu-

manities Endowment, the GAO had issued a clean bill of health, but to those more critical, practices of a questionable nature were revealed. No untoward skeletons were unearthed, however, no incurable maladies.

Ron Berman, I think, felt he had acquitted himself well, and that the Senate's traditional process would be followed, with a consideration by the Committee on Human Resources followed by action on the Senate floor. Some of Ron Berman's persuasion suggested another scenario. It was late in the legislative year. A presidential election was looming— Gerald Ford against Jimmy Carter. If no action was taken on the Berman nomination, it would lapse when Congress adjourned for the year. The nomination would have to be resubmitted when Congress reconvened in January 1977. But suppose the governor of Georgia won? Would he, under the circumstances, nominate Ronald Berman for Senate confirmation? Obviously, a resubmission would depend on a Ford victory; what if the Senate, in committee and with Claiborne Pell's influence, simply delayed and went home to the elections, leaving the nomination of Ronald Berman as unfinished business?

Claiborne was not one to pursue such tactics. It would be yes or no in committee. If yes, it would go, of course, to the Senate floor.

We did discuss the eventuality of a Gerry Ford victory and a resubmission of the nomination. Should it fail and then be revived, that was certainly possible. "I wouldn't make the same effort to object a second time," Claiborne told me. "I think I've had my say."

And he had. The nomination was considered in the full committee. It did not pass. Ron Berman was not confirmed for a second term. Jimmy Carter was elected and began the process of finding a new chairman for the National Endowment for the Humanities. This dismal time for the endowment in its relations with the Congress came to an end.

Some would call it a happy ending, others an unhappy one. For the first time, a candidate nominated by the President for the chairmanship of an endowment had failed to win Senate approval.

I believe there are lessons to be learned. The qualifications of the individuals involved were given a new emphasis. This emphasis would continue, as would lasting qualities of faith and trust and trusted leadership, which were also involved.

Chapter 47

JIMMY CARTER'S PRESIDENCY BROUGHT A NEW STYLE OF GOVERNMENT TO Washington. A clear indication came from his famous walk with his wife Rosalyn down Pennsylvania Avenue during the inauguration day parade. From the limousine's plate-glass shelter they descended, smiling and confident, waving at the crowds, strolling along the principal thoroughfare of what was that day their city. The sunshine under a warm winter sky seemed to signal that the heavens were responsive.

For the arts, it was a time of rising hopes. Vice-President Walter Mondale had been a member of Claiborne Pell's subcommittee. Joan, his wife, was known for her love of the arts and for the hours she worked at her potter's wheel, casting out new shapes and designs from clay. She knew the satisfaction of the creative process. She could identify with and communicate with artists. She was sensitive and understanding. Under the high Victorian ceilings of the Vice-President's house on Massachusetts Avenue, there would be an emphasis on the arts. It would not have the surrounds of affluence that belonged to Nelson Rockefeller. The more homelike tones there would belong intrinsically to the new family in residence and to the new administration. Jimmy Carter and Walter Mondale

seemed to share closer personal ties than their predecessors. The signs were auspicious.

Down the line a bit from the White House a transition team, the first of its kind, began work right after the election. The arts area was under the auspices of Louise Wiener, an able arts administrator who had worked in Georgia. Louise called Jack Duncan from the House and me from the Senate into a series of meetings and briefings and discussions. She was quick and intelligent, and she believed that a Carter imprimatur was desirable as a first arts priority. She was skeptical of Nancy Hanks, seeming to think Nancy might have absorbed too much Republican philosophy. There was a sense of mission among the Carter arrivals, a feeling that the old was suspect. It took Louise a little while to recognize that the arts depended on bipartisan support and that sometimes a Jack Javits was sorely needed. But Louise's efforts brightened the transition. Those who felt she was personally ambitious for high office in her assigned area felt threatened. Nancy would always ask about her activities, as if an unfriendly wave was about to wash over the doorsill.

Nancy, however, had waterproof compartments well prepared should the need arise. Claiborne Pell praised her achievements. In this transition time, I believe Nancy felt reasonably secure. Roger Stevens was even more secure at the Kennedy Center. He had become as permanent there as seemingly had Clement Conger, the impeccably knowledgeable curator of the White House. (Later, as curator of the State Department, he oversaw the renovation of the elegant Diplomatic Reception Rooms, adding American period furnishings of finest craftsmanship.) Administrations could come and go, but Roger Stevens and Clem Conger appeared beyond the winds of change.

The recently created Institute of Museum Services, led by George Seybolt and Lee Kimche, found the terrain hospitable and the natives friendly at the Department of HEW under Joe Califano, its secretary. Nancy Hanks, no longer able to influence the institute's destiny, accepted it as if she had all along. It put down its own roots, helped in the Senate by Claiborne, and in the House by John Brademas and by Sidney Yates, who was growing in reputation and influence and was in charge of Interior Department and cultural appropriations. Lee and George, George and Lee, with the new board of important museum leaders, worked together in a time of prosperity. Even that word "board" was no longer contested.

Few mentioned that Nancy Hanks's term as Arts Endowment chairman would expire in November of 1977. That was months away.

The Humanities Endowment put the new administration to its ini-

tial cultural test. Who would lead the humanities? Ron Berman, recognizing that lightning would not strike again, one way or the other, stepped aside. His deputy Robert Kingston became acting chairman. Bob, whom I had known for years, came from a British background. A man of erudition, skilled in administration, genuinely liked, he performed his tasks well, but he was identified with times past.

The representatives of the humanities, released from Ron Berman's difficult last days, suddenly were full of ideas.

The problem was, there was no cohesion, and there were many who quested. To Claiborne and me, Robert Lumiansky seemed particularly well qualified. He had been an early witness before Congress on the importance of a national humanities program. I had known him since his earlier days as a professor of literature of the University of Pennsylvania. Bob Lumiansky's academic honors and accomplishments were legion. In 1977, he served as head of both the American Council of Learned Societies and of Phi Beta Kappa, thus representing two of three major constituencies favorable to the endowment's beginning (the other was the American Council of Graduate Schools). Bob was a World War II hero decorated by both the Bronze Star and the Croix de Guerre, not a usual combination by any means. He was talented, articulate, with a fine sense of humor—and an obvious flair for finding successful passage amid the labyrinths of the academic world.

To John Brademas, the individual in shiniest armor was James Billington, head of the Smithsonian Institution's Woodrow Wilson International Center for Scholars. Jim was himself a renowned scholar who had specialized in Soviet-American relations and was recognized as a foremost authority in his field. An able administrator, well versed in Washington complexities, he also seemed eminently qualified. When Bob Lumiansky signaled that he wished to pursue his relatively new high responsibilities in the scholarly world, Claiborne and John joined in support of Jim Billington (who is today librarian of Congress).

To the Carter administration, however, the immediate leading candidate was Alfred Stern, a scholar from Wayne State University who had worked valiantly in the campaign and was now a White House counselor under the aegis of Stuart Eizenstat, credited along with Hamilton Jordan and Jody Powell as the master technicians of victory. Al Stern was full of ideas; sometimes it seemed to me his quick intelligence outsped his listeners. Sent on a mission of introduction to the Hill, he did not win endorsement from John Brademas, who remained loyal to his own candidate.

A confrontation of sorts ensued. Al Stern was withdrawn from the lists, but so was Jim Billington, and we all returned to a field temporarily

without candidates for the chairmanship Ron Berman had vacated. It was not an empty field for long.

It seemed to me at the time, and still seems so, that I was part of a drama developing on some fabled Shakespearean terrain, where the view for both onlooker and participant was extended. One watched the separate tents pitched, the identifying banners held aloft, the surroundings of worthy and separate support. Each day a battlement would be assaulted, with cries and flashing blades and scaling ladders. Then one figure would appear atop the highest tower and raise his sword aloft for all to see. He would instantly be pierced by the bowmen of his colleagues, en masse below, and all would return to tents and rest before reassembling and having another go at it—minus one, of course.

The principal combatants included Sir Warren of Bemis, a leading educator and humanist from Ohio, introduced to Claiborne Pell by Senator John Glenn; Sir Kolbert of Albuquerque, city council president in that New Mexico city and a scholar of considerable note with a doctorate in French literature; Sir Charles of Blitzer, assistant secretary for history and art at the Smithsonian, long identified with the endowment's development and scholarship; Sir Otis of Singleterry, president of the University of Kentucky; and Sir John of Maguire, president of the State University of New York at Old Westbury, Long Island.

Claiborne would ask me to meet with the candidates before they met with him and discuss their visions and hopes. I preserve memos about these encounters, as I sought to present their credentials in the best possible manner. Some were scholarly and reflective, others political activists; Dr. Kolbert, for example, engaged me with his combination of learned background, humor, and astute knowledge of governmental processes. I felt always in the presence of gifted and diverse abilities, well suited to the endowment's demands.

The White House established a five-person screening committee, consisting of Elizabeth Sifton, editor of Viking Press and daughter of the late theologian Reinhold Neibuhr; Roger Kennedy, acting vice president for the arts at the Ford Foundation; William Goetzmann, professor at the University of Texas; June Bingham, author and wife of Congressman Jonathan Bingham from New York; and Hugh Sloster, president of Atlanta's Morehouse College.

Barry Jagoda at the White House would receive the committee's recommendations and relay them to me. Within a short period, I got to know Barry well, his intensely bright eyes, his quick manner of speech, his dedication to the new administration—and his frustrations as the selection process kept unraveling. The press took notice. Phillip Kadis, in my view one of the top cultural writers Washington has produced, used

slightly less reverent imagery. Quoting "a White House aide" in an article for the *Star,* he wrote:

"It was like a Marx Brothers movie. The candidates were going through that revolving door so fast, you needed freeze-frame photography to distinguish them."

It seemed sad to me, however, that the humanities were bent on such internecine war. (I was to discover it later with the arts, on a more personal basis.) Feelings ran high. Personalities emerged with opinions of inflexible sinew. I recall one woman accosting me in regard to one of the knights errant with such a verbal barrage that it seemed I was in the company of a suddenly speech-gifted and knitting-devoid Madame La-Farge in the shadows of a French guillotine. Her opponent took an arrow in the chest the following day, or perhaps even that same evening.

At the White House, a staffer told the press that the President was "spending more time on this than he is on the SALT talks." It was clear that disarmament was not apparent on this domestic front. As might be expected, there were also a number of mixed and missed signals. One candidate, in fact, publicly announced his endorsement by the President and shortly thereafter his own withdrawal from the competition, before either event had received White House notice.

It was not surprising, then, that when the name Sir Joseph of Duffey emerged, he stepped onto a plain relatively unpeopled by the quick. A small group was sent forward to reconnoiter. Jack Duncan and I were consulted, then John Brademas and Claiborne Pell. No objections were discovered, and the President moved forward. A proper sword and shield were bestowed. Joe walked into the sunlight.

Friends of John Maguire let it be known that in their judgment Joe Duffey was masquerading in courtly attire, when actually he was not a knight at all but a wolf in sheep's clothing. Hadn't Joseph promised his support—and his full and liege-lord support, too—to John? Were we about to witness a drama of clandestine meetings and broken vows, of vaulting ambition thwarted at the very last trump? Fortunately, we were not.

Joseph, it turned out, had supported John. The hand of final decision had simply been placed on the shoulder of one, not the other. But there was no great culminating triumphal march. There were not enough left stirring.

It reminded me a little of the time when Harry Truman had appeared suddenly on, it seemed, an empty stage. Who was Harry Truman? What were his likes and dislikes? How would, or could, he govern?

Who was Joe Duffey? Those who had known him, even for a brief time, as I had, found the answer reassuring. The son of a West Virginia

coal miner, he had pursued his education with a singleness of purpose. He had earned his doctorate in theology and had taught for close to ten years at the Hartford Seminary and at Yale University, in sociology. He had been ordained as a minister. He had served as the chief administrative officer for the American Association of University Professors. He had been active in governmental life, a strong advocate of the antiwar movement of the previous decade, a worker for goals expressed by Eugene McCarthy and George McGovern. He had once run unsuccessfully for political office in Connecticut. An interviewer in the *Washington Post* described him as "reflective, intelligent, adventurous and considerate." I concurred. Bob Lumiansky, representing a majority of scholarly thought and opinion, voiced no dissent, finding favor in the blendings of the academic with the governmental.

Joe Duffey was of medium height, sandy haired. His bearing suggested the athlete; his face, the attributes of humor and tested knowledge. He had his detractors. Some called him crassly political; others found his academic background insufficient to the needs of the scholar. He then held a leading position within the State Department's Bureau of Educational and Cultural Affairs, where critics felt he demonstrated a lack of administrative skill.

But the critics had lost their energy. Joe's Senate confirmation was not contested. Friendship between the National Endowment for the Humanities and the Congress was restored.

In the course of these proceedings, from start to finish, I became aware of how widespread in academic circles was the misinterpretation of Claiborne Pell's views about the Humanities Endowment and its improvement. As the year advanced, the basic legislation was amended so that the Pell concepts would be in part included—in part because we had already decided on the modifications Ronald Berman had rejected out of hand.

The law now added a new dimension to state programs in the humanities. Claiborne Pell and John Brademas had worked on this together. Jack Duncan, Greg Fusco for Senator Javits, Marty LaVor for Congressman Quie, and I had worked long hours on preparations and drafts. The majorities and minorities in House and Senate had reached subcommittee agreements.

The law provided incentives to effect the greater state involvement we sought. It presented options so that no inappropriate change would occur. An educational process was implicit, so that the states and Washington could be more closely allied. Most important, perhaps, the endowment chairman was in essence directed to encourage state participation and to work closely with state governments in developing pro-

grams that would have wider application than in the past. In this respect, a Washington domination came to an end.

"I want to see the values of the humanities reaching out and having a real impact on the lives of Americans," Claiborne said in a statement prepared for the *Chronicle of Higher Education.* "The State programs, involving one fifth of the funding (as with the arts), are important to this concept. We must also consider the national program and its outreach to the Nation. The humanities must appeal to those without an advanced, formal education. They must appeal to young people. Quality must be constantly stressed, but it must be made available to the many and in the broadest possible way to our society."

Few could quarrel. Most found it surprising, in their interviews and discussions, that Claiborne seemed to be so reasonable and logical. Where was the extremism of the newspaper articles? Where was the Philistine? It was like finding an old, intelligent, and compassionate friend once more. The old friend had not changed, after all.

On Tuesday, March 31, 1977, the *Washington Post* carried a brief Associated Press news story that began, "President Carter said Wednesday he wants to eliminate an 'elitist attitude' from the National Endowment for the Humanities and expand its programs for those to whom they are now unavailable." There it was again. Elitism, with an opposite, populism. A President had used the word. It would be a long time fading.

The simplistic. The misunderstood. Joe Duffey took up the challenge of making the humanities less simplistic and more understood.

As the *Post* wrote on August 7, "From the controversy this has kicked up in the papers, you would think that this is the government post that will bring peace to the Middle East and rain to California and religion to the Kremlin." It was not so, of course, but the humanities had shown in no uncertain terms that they could capture attention.

"With this chairmanship decided," the *Post* concluded, "the White House should be able to turn its attention to the National Endowment for the Arts."

Chapter 48

*I*N THE EARLY MONTHS OF THE CARTER ADMINISTRATION EFFORTS FOCUSED
on more generous appropriations requests for the arts and the build-
ing of solid rapport with a new OMB leadership. Then the emphasis
shifted to the future and to finding a way for the arts, and the humani-
ties, to have a broader impact on government as a whole.

Thoughts on the function of the Federal Council on the Arts and
the Humanities were revived. The Federal Council had been included in
the initial legislation primarily as a means of satisfying Senator Javits
that there would be no duplication of effort as the two endowments,
fledgling and untried, began their tasks. The Federal Council, consisting
of the heads of agencies and departments that had an interest in cultural
matters, would meet and review endowment activities to ensure that
they would be discrete unto themselves when appropriate and coopera-
tive when that was perceived best.

Lyndon Johnson had appointed Dillon Ripley as the first chairman
of the Federal Council. There was a memorable moment when Dillon, in
the presence of the first chairmen of the two endowments, seemed to
believe that his position overtopped the other two. I can well recall

Roger Stevens's loud summons—"Liv!"—on the occasion. As the drafter of the legislation, Roger said, would I please explain to the secretary of the Smithsonian Institution the precise nature of his appointed tasks? I explained they were essentially that of liaison, not supervisory over endowment officials or their undertakings. Dillon did not call the Federal Council into conclave again for some time. It became for awhile a reason for afternoon teas and philosophic commentaries. Some described it as moribund.

There were in this group, however, individuals who could truly lead in cultural matters—including the Smithsonian's secretary, the librarian of Congress, the secretary of education, the director of the National Science Foundation, the director of the National Gallery of Art, a designee of the secretary of state, representatives from both the Senate and House, and, of course, both endowment chairmen and the leadership of the Institute of Museum Services. The President was given authority to add to or change membership on the council from time to time and to appoint a chairman from among the members.

The Federal Council had been given a specific job in implementing the Arts and Artifacts Indemnity Program, and a small and specialized staff was assigned for this purpose. But I saw the council itself as worthy of revival and of a broader mission. I had sent a memorandum to Claiborne Pell on the subject and had thought that Joe Duffey, should his candidacy for Humanities Endowment chairman fail, would be well suited as chairman of a revived Federal Council. But destiny was elsewhere.

At this point, as the heat of another summer gripped Washington, Joan Mondale sought advice from Claiborne Pell. How would he envision that she best realize her interest in advancing the arts? He and I reviewed together the opportunities a Federal Council would afford, and I prepared a proposal for Claiborne suggesting that the President could appoint Joan to the council and then as its chairman. I outlined this idea for Joan and her arts chief of staff Bess Abell at a lunch Claiborne gave for the four of us in the Senate Dining Room. Joan saw the possibilities for her special contribution. We discussed the idea favorably, but the White House lawyers felt such action might cause criticism, so Joan Mondale became honorary chairman of the Federal Council on the Arts and the Humanities. Joe Duffey was named official chairman, supplementing his principal duties; but it was Joan in particular who gave the council a new life and a brightness of vision. There was a White House ceremony. The President expressed his hopes for the arts and Joan's mission. I had a feeling of "bon voyage" for the Federal Council, as when a ship long in drydock is readied not for coastal waters, but for the high seas.

* * *

I have been asked when it first occurred to me that I might—just possibly, someday—become chairman of the National Endowment for the Arts. Certainly never when I was drafting for Claiborne the Arts and Humanities Act and writing under the heading of National Endowment for the Arts, "the Endowment shall be headed by a chairman." Nor did it occur to me when I was working for Roger Stevens, or for Nancy Hanks, or for Claiborne once more after Steve Wexler's death. I thought of my work as enhancing the endowment through the legislative process, through firmer, more enthusiastic relations with the Congress. I had gained in experience; opportunities had been given to me. The improvement of the endowment, the overcoming of complex difficulty, the gradual but steady growth of support, a patient but optimistic attention to detail—all these brought deep satisfaction. I am an optimist at heart. It gave me a special joy to find that one individual given an opportunity in government can have a tangible impact on events, and that the optimistic goal, when nourished with care day by day, week by week, year by year, can come closer to fulfillment. That was enough. I had no other thoughts for a long while.

As the summer of 1977 advanced, however, a different ray of light was perceptible on a distant horizon. It suggested a faint possibility. It also suggested that it might be imaginary and disappear as the cloud covers changed. My wife Catharina, the source of encouragement all through my work, was sure it was not hallucination, but I was less sanguine. If the humanities chairmanship was an example, it was a long, long way to go. Oddly enough, however, the quest for a humanities leader provided me with new friends. I was aware of quiet but persisting support. Claiborne gave me his, but he told me he thought the possibility was remote, just as I viewed it at the start.

During the summer I was visited by a number of arts leaders from the state and community movements. They wanted my views, and I gave them without hesitation. I was asked if I wanted the job. I saw no sense in being coy or evasive. Of course, I said—it's a great opportunity, the best I know of; but I continued to think the opportunity remote. Too many others, including Nancy Hanks, thought it a great opportunity, also.

Early in the year, Claiborne had told Nancy that he was philosophically opposed to a chairman of either endowment receiving a third four-year term. (The enabling legislation provides that a chairman is eligible for reappointment and does not preclude a third term.) Claiborne believed that approval for a second term was acceptable, as long as the work had been performed excellently to date. He had considered

Nancy's work of that high caliber when President Nixon had nominated her for reappointment, and for approval by the Senate, in 1973. He had not found Ronald Berman's work of the same caliber. But a third term, Claiborne believed, could involve too much influence by one individual on the development of the arts. No matter how wise, no matter how well intentioned, an individual could begin to assert his or her own thoughts or biases on the delicate balance between the guidance of private citizens and the dominance of one in ultimate federal authority. The council, the panels, the process itself could be threatened, unwittingly perhaps. The old saying that power corrupts, but absolute power . . . is absolutely delightful could easily begin to apply, even though the chief protagonist vehemently or scoffingly denies such interpretation. And so, in the course of private conversation at a dinner party (following a Washington tradition that invariably includes business with pleasure) Claiborne told Nancy that he would not favor a third term, for anyone, in the arts or the humanities.

Nancy seemed surprised. She told me of the episode, smiling and shaking her head. "And I gave him a good meal, too," she said jokingly, and seemed to discount the moment or just to put it aside. "Claiborne is such a dear person," she said. He had given her only high praise, and on this occasion he repeated it—with the caveat. He would change his mind, she seemed to say, if such a time came. Obviously, she did not think of me then as a competitor.

During this 1977 summer Claiborne was invited to give the principal and concluding address to the annual meeting of the Association of American University Presses in Asheville, North Carolina. It was an organization whose work Claiborne had long supported. Part of his interest stemmed from his appointment to the National Historical Publications and Records Commission, at the recommendation of Justice William Brennan. I did the staff work for the speech. I had learned in detail of the difficulties many university presses faced in publishing scholarly writings, which had intrinsic literary and scholarly merit but virtually no commercial appeal. These presses were university funded; but budgets, as everywhere in the arts and humanities, were limited. The result was that frequently a book of value to erudition and knowledge was shelved in favor of one perhaps of less intrinsic merit that would in its sale and distribution come closer to making ends meet financially. Claiborne and I, assisted by the able and intelligent commission director, Berkeley Tompkins, had designed a process to determine the break-even point for a publication and allow for help from the commission or from the Humanities Endowment, provided that either body, through its own panel review system, found the project sufficiently worthwhile. We had been making headway with these concepts, often finding that relatively small

grants—less than $10,000, less than $5,000 in some cases—would make the difference between publication and rejection. It paralleled, in some respects, the Arts Endowment's grants to small independent presses publishing the work of emerging American authors for the first time. (Was this an elitist concept, or populist? Or was it—perish the thought in terms of simplicity—a good combination?)

At the last moment, Senate business prevented Claiborne from attending the meeting in Asheville. He sent me to represent him. I found many friends and a spirit of warm regard for Claiborne Pell. A number of these leaders understood his stance against Ronald Berman. It was an opportunity for me to explain it to others. I had composed quite a scholarly address for Claiborne to give (and he had approved it with particular care), but on the final evening of the conference, as I stood on the rostrum to present Claiborne's words, I felt the audience beginning to drift. The final session had contained several scholarly jokes toward the participants. Rising laughter had been heard at an otherwise serious conclave.

Glancing at the program, I saw following "Concluding Address by Senator Claiborne Pell" and adjournment, the word "Entertainment." This presented a note of challenge. Somewhere within my person, the element of ham is not unknown. It may have surfaced for the first time when I composed a musical comedy parody score for actress-daughter Cordelia and was suddenly and miraculously given the opportunity to sing my own lyrics when the far more professional lead was stricken on opening night by summer flu. On that occasion, I overcame acute stage fright when the evening curtain rose to reveal an almost empty house— my son, a young woman with him, a cat that had wandered in from outside, two small children, and two large family retainers. The latter reported to their employers, however, that there was an odd occurrence going on inside the old abandoned movie house, and the next night it was SRO. Ever since, from time to time, my daughter's instructions echoing from another past—"Daddy, you go out there a nobody, and you come back a star"—take hold once again.

This occasion seemed suitable. I felt I should not abbreviate Claiborne's speech, for he had given it so much thought himself. As I noticed eyes and profiles turning surreptitiously toward the exit signs, I made a few jottings. All at once, as the address ended, I announced there would be a brief transition to the next item on the agenda—"Entertainment."

"So I will sing for you," I said.

The eyes and profiles moved away from the exit signs. I had full audience attention once more, though the expressions suggested not so much anticipation as astonishment.

I do not have a trained voice. My father did, but not his son. But I can carry a tune. I had thought of a special duet by two great artists and comedians from long ago—Ethel Merman and Bert Lahr, together in *DuBarry and a Lady*. It is called "Friendship." It seemed appropriate.

"If you're ever in a jam
Here I am
If you're ever in a mess
S.O.S
If you're ever down a well
And need someone swell
Ring the bell—
For Pell!
For it's friendship, friendship. . . ."

There was, to my joy, a standing ovation. The meeting concluded.

At the ensuing festivities, we were entertained by great professional exponents of the dance, the Grandfather Mountain Cloggers. Undeniably they enhanced what I had tried to begin. The episode is recorded here because it caused a near personal disaster, as surprising to me as were my announced efforts at song to the scholarly audience.

Publishers Weekly covered the conference and included a photo of me at the microphone with the legend, "Friendship," but with the lyrics askew: "If you ever need a grant, call on Pell. If you ever need a subsidy, ring my bell."

Subsidy? A forbidden word in the Biddle lexicon. Support, yes. Subvention, in the Javits phrase, possibly. But in a song—or elsewhere—subsidy, never. Besides, the lines did not scan with the tune, and as any songwriter knows, the words and music should agree. Still, the matter did not seem cause for indignation. The audience had applauded the meaning intended.

Not so the *Wall Street Journal*. This paper decided in an editorial that what had been represented at Asheville was pork-barrel politics at its most insidious. Claiborne Pell was cast in the role of claiming the arts and humanities "as a personal fiefdom." His assistant presumably was feudal agent, doing just what was not crystal clear, but it was obviously nefarious. A rereading of the comments failed to disclose just how a traditional pork barrel could be venally filled with the activities of worthy but needy scholars; but skullduggery was afoot, and a senator's staff member had brought it blatantly to public attention.

At this moment, Paul Richard, the *Washington Post*'s resident authority on cultural matters, asked me for an interview. There he was, with photographer, at my desk in the office of the Senate subcommittee,

Arts and Business Council meeting-
Phillipe de Montebello, of The Met,
Celeste Holm, John Connor, Agnes
De Mille, Billy Taylor...

Congratulating Jacob Lawrence on his
swearing in as a Council member.
New member Theo Bikel approves.

We celebrate start of endowment's
new opera/Musical Theater
program with sponsor, Hal Prince...

Why are we smiling? It's a story of
artistic magic at the Corcoran.
From left; Michael Bolvinick, director,
LB, Pat Hayes and David Kreeger.

Papa Haydn (Slava Rostropovich) conducts The Toy
Symphony. From l., Lenny Bernstein, "Zbig" Brzezinski,
Sen. Charles Percy, Jean Pierre Rampal,
Isaac Stern and.. Kazoo player.
 "Your unforgettable performance made me
 cry," wrote Slava!

Catharina bestows esteem on Isaac
Stern. Armand Hammer approves. Bill
McSweeny is profiled...

The unparalleled Luciano and
two devoted aficianados...

Catharina chaired a gala for
our greatly admired "Misha"
and limitless fans at the Kennedy
Center—

I seak to convince Mrs. Lopez.
Portillo on the best start for
a special arts program with Mexico...

At The Great Wall of China with
John Reinhardt, Marta Istomin and
officials on our great cultural
Mission...

An award from the American
Association of University Presses,
delivered by Matt Hodgson. The
invaluable Pat Sanders is at left.

Hands across the Nile! Jehan Sadat,
John Jova as endowment's
"Egypt Today" opens...

Charlton Heston and I agree on the
value of the arts. I agree on
friendship with Moses!

President Reagan and Daniel
Terra, given the new title of
Ambassador. at large for Cultural Affairs.

From commencement speaker a
~~last~~ *last* Hurrah! to the graduating
class at Providence College.

PHOTO BY MARY ELLEN MARK

The Team of Biddle & Biddle...

not asking about the *Wall Street Journal* as I had expected, but with the information that I was now considered the frontrunner for the Arts Endowment's chairmanship. He asked for my reaction and thoughts.

The *Post* published a long interview. It covered my life and my government work and my feelings about the endowment. It concluded: "He has only friendly things to say about Nancy Hanks and her stewardship. . . . 'The arts,' he says, 'are far better organized than when she took the job. . . . The advocacy organizations, the opera people, and the people who support museums or the theater, and the state and community people have to work with one another if the federal budget for the arts is to significantly increase. Special interest groups defeat one another's efforts. They should form in a united front. The issue isn't mass versus class. You have to maintain quality. I do not know who will get the chairmanship, but I do know that making quality available to the maximum number of citizens is the essence of the job.' "

Was it a trial balloon?

Paul quoted Barry Jagoda at the White House: President Carter, said Barry, has not yet begun "to focus on the issue." That was true, and I should know, for I had begun discussions with Peter Kyros, son of a congressman from Maine and a chief assistant to Vice-President Mondale, on the process to be used in choosing the chairman for the arts.

In Lyndon Johnson's day, an article, long or short, suggesting that someone was in line for an important position was the finish of that particular road. The sign said dead end. In this case, Peter telephoned. The article, he said, had done me no harm.

Shortly thereafter an editorial appeared in the *New Republic.* "The *Washington Post,*" it said, "reports that the next chairman of the National Endowment for the Arts is likely to be Livingston L. Biddle, Jr." It repeated the *Wall Street Journal* allegations, and it concluded with a fairly definitive statement: "Carter could not make a worse appointment if he tried." The editorial bore the engaging title, "Biddle to Pell to Hell."

The *Journal* and the *New Republic* had supported Ron Berman. But this enmity was of unusual intensity. Joe Duffey had suffered barbs of ill feeling, but they had not quite found the level of the River Styx. Again, in earlier times, such an editorial could have transported the individual involved not just to the banks of the river, but well across it.

I remember when I first reported the song episode to Claiborne, and the first repercussion. He did not like the references to himself in the press and wanted it all fully explained. He listened for a time, then put his hand on my shoulder.

"Livy," he said, "I want you to do me a favor."

"Of course," I said. "What is it?"

"Don't sing again," he said.

Chapter 49

I T CERTAINLY DID NOT SEEM SO TO ME AT THE TIME—IT SEEMED PRECISELY the reverse—but it is possible that Asheville, North Carolina, was a plus rather than a minus. Prominent educators wrote in my behalf, including in particular Chester Kerr, director of the Yale University Press. The *Journal* did not quite retract or withdraw its criticism, but the tone of an amendation it published was different, and it ended by saying that no matter what the interpretation of the song, "Mr. Biddle has reportedly been tapped as the next head of the National Endowment for the Arts."

This was still news to me, though there was a growing feeling that the remote was becoming the possible. It gave me a feeling of anxiety more than repose, for it meant that what might be achievable needed achieving by one's own best energies. I used to awaken with the sense that I was on the bridge of a ship and had just heard an explosion below decks. Would examination show repairs to be made or an uncontrollable cascade of water?

Other possible candidates received attention:

· Wes Uhlman, mayor of Seattle, an experienced, indeed formidable campaigner who had led his city's espousal for the arts;

- Michael Straight, Nancy's excellent deputy, unlike Nancy a Democrat
 with a background in part related to liberal causes, an individual with
 an undeniably profound understanding of the values of the arts, with
 governmental service dating back to the Kennedy administration.
 (There was no reference at this time to Michael's strange experiences,
 later self-revealed, in the shadowy world that borders on international
 espionage);
- Peggy Cooper of Washington, D.C., described by Paul Richard as
 "bright, female, black and young," reportedly with support from An-
 drew Young, whom the President admired and had appointed to repre-
 sent the United States at the United Nations. Peggy was the founder of
 the much-praised Workshops for Careers in the Arts and was involved
 with the development of the District to Columbia's Duke Ellington High
 School for the Arts;
- Vernon Alden, chairman of the Massachusetts Council on the Arts, in-
 telligent, a business leader, highly esteemed, well connected politically
 and educationally, the initiator of state programs that were bellwethers
 in the country;
- McNeil Lowry, former vice-president for the arts and humanities at the
 Ford Foundation, one of the great authorities and a senior statesman
 in the cultural field, supported by both Frank Thompson—the old lion
 of early congressional debates—and Roger Stevens, who told me he
 thought Mac Lowry was best of all;
- Roger Kennedy, who succeeded Mac Lowry at the Ford Foundation,
 eminently well qualified, a person whose talents I have especially ad-
 mired;
- individuals of stature and national reputation in museums and the per-
 forming arts, many of whom had worked closely with the endowment
 during the past eight years with Nancy, some of whom who I knew
 had considered the chairmanship and were ready to strive for it should
 there be a Nancy Hanks departure; and
- Nancy Hanks herself.

Nancy's term was due to expire in October. As we entered the fall
season, as the weather turned brisk, so did the pace of activity and spec-
ulation. A search committee was at work, more circumspectly perhaps
than in the case of the earlier humanities struggle. Helped by Joan Mon-
dale, the committee was sifting through a wide assortment of names, in-
cluding the relatively new president of the Rhode Island School of
Design, Lee Hall, a woman of both determination and charm, an artist
and administrator, well regarded by Claiborne but not accorded his back-
ing as was I.

In the midst of these activities, none of them conclusive by any

means, Nancy visited the President. There were many rumors about this meeting, before and after. It was also rumored that Joan Mondale, after discussion with Nancy, had indicated her support—or was "leaning," in Washington vernacular, toward the idea of Nancy's continuance.

After the meeting at the White House—at the time neither confirmed or denied—it was reported that the President had lauded the work accomplished with great skill and had been receptive to the incumbent remaining in office. The phrase "invited to stay" was suggested, but "receptive to the possibility," I think, is more correct. To a number of people, however, by not saying no, the President had said yes.

Nancy Hanks was a realist. It seems unlikely that she heard a "yes," but I believe she was convinced that she had done the best job humanly possible and that no one else could offer the same degree of experience and knowledge. Those closest to her at the endowment had developed a special loyalty, as for a victorious and understanding general in battle. There was loyalty, too, in many quarters of the arts world, witness to a time of prospering. A "Mother Courage" has appeal. The long evenings of solitary work, the special dedication, the career directed step by step toward goals now being achieved, all enhanced reality and its image. But it is also possible in Washington, where power is such a strong characteristic, to be enticed by notions of infallibility or irreplaceability. Nancy could be enticed with good reason. That was perhaps part of it, but not, I think, the determining factor. Nancy loved her job. She may have *grown* to love it, but love was certainly there; and it is not the most practical or realistic of allies.

Meanwhile, back in the Senate, a Biddle candidacy was receiving growing attention. The trial balloon of the first interview, if such it was, had floated out over the seas and disappeared without puncture. And the ship was cruising once more, without the wake of a torpedo glimpsed from the bridge.

It was pointed out that unlike Roger Stevens, unlike Nancy Hanks, I had a basic personal experience as a writer, as an artist, as someone personally familiar with all the pains and the difficulties, as well as the sometime joy, of creative expression. My work for Fordham University as an innovator in the educational sphere, as a developer of the values of the arts in education, was unlike those before me in the job. My work in drafting the legislation, refining it, preparing its changes and improvements, designing related cultural legislation also gave me an experience unlike others. I had a particular grounding in the philosophies and beliefs basic to support for the arts in the United States and abroad, as well as a sense of this special opportunity to affirm and strengthen my own convictions in a very fundamental way. I was schooled in administration and in the supervision of personnel. (In fact, my final year at Fordham University was in large measure

devoted to administrative and budgetary tasks at the Lincoln Center College campus, when funding for the arts grew short and the university wished to get maximum mileage from its high-salaried employee.) I was under no illusions, however.

Others could put forward combinations of experience that had particular attraction.

In September, the National Assembly of State Arts Agencies held its annual conference at Snowbird, high in the mountains beyond Salt Lake City. I was invited and brought Catharina with me. I remember a sunset time when we took the ski lift to its highest destination, just for a look at the steep slopes not yet in winter mantle. Light snow fell; the air was misty, more penetrating than sharply cold. Anne Murphy, who had been my assistant in congressional liaison at the endowment and whom Nancy had appointed as my replacement on my recommendation, had told Catharina confidentially that all manner of rumors persisted, that she could not guess the chairmanship outcome, but that one thing seemed certain. "It's not to be your husband," said Anne, I believe, with the thought that high expectations, if unrealized, could lead to much keener disappointment. George Seybolt had imparted to Catharina a similar confidence. We sought from the mountain peak to peer into the mists. Inscrutable they were.

Nancy Hanks was not present at Snowbird. It was rumored that she had decided to step aside, and her absence now seemed to give the rumor credence. Vern Alden came from Massachusetts, with his excellent council director, Anne Hawley, whom I was beginning to know as one of the very brightest voices in all of the state arts movement. Anne, of course, was thinking of Vernon Alden. He and I met together before the opening dinner, at his suggestion. We exchanged friendly pledges: If either of us were nominated, the other would give full support. We remembered the humanities when potential nominees were in daily duel. But the emphasis was on *if*. If, as far as I was concerned, also applied to Nancy Hanks. The certainty of the unpredictable was embedded in my experience.

Michael Straight sought to defend Nancy's policies toward the states. The task was growing harder. Jim Edgy from Ohio and Steve Sell from Minnesota spoke out again for more state participation. I found their arguments persuasive, as I had in the past. Michael seemed less than fully comfortable in his own arguments. It was obvious that times were changing. Resolutions to familiar problems seemed avoided. It was as if the attenders were playing a waiting game. Toward the end of the meeting, news came from Washington. It seemed the White House list had been considerably narrowed. There was a Biddle on it. There did not appear to be a Michael Straight.

* * *

Peter Kyros spoke with me upon my return to Washington. I was to
be interviewed by the President. I remember once being interviewed at the
White House, after Roger Stevens had asked for me as his deputy chairman.
It was not a presidential interview; it was conducted by Marvin Watson,
Lyndon Johnson's trusted counselor. I tried to imagine then what I would be
asked and recall sifting through my mind all the art history I could muster,
all the names of contemporary artists and arts leaders, all the various back-
ground material I had ever assembled. As I sat waiting for my interview,
across from me on the wall were small paintings of the American West by
James Cabell, American Indians done with such attention to detail and au-
thenticity, color and composition. I was studying them, wondering if they
might enter the conversation, when a door opened. Marvin Watson smiled
and extended his hand.

"I hear you're going to be working for Roger," he said, surveying
me. "Well, that's fine. Welcome aboard."

And that was it.

That would not be it this time.

"Have you any idea what the President will ask me?" I inquired of
Peter.

"He may ask you about Nancy Hanks," Peter said.

"She is still a possibility?" I asked.

"The President thinks highly of her," Peter answered.

Peter was exceptionally well trained as a lawyer. I recognized that
was as far as it would, and should, go. I did not ask about others receiving
interviews. It was suddenly not relevant. This, after all the years, was my
own chance. I was on my own, and that was as it should be.

I put on my best suit and a blue striped tie, which Catharina had
given me and which I wore for good luck, and went to the White House. I
entered under the portico nearest the Executive Office Building. It was early
in the afternoon of a mild, sunny, autumnal day.

Inside the doorway, I gave my name to the attendant at the desk on
the right, seated myself on a deep, leather-covered couch, and tried to com-
pose myself and my thoughts. A vote crucial to the President's effort to es-
tablish a coherent energy policy was scheduled to occur that day in the
Senate, and I noticed several senators passing by on their way to the Oval
Office or returning from it. I kept looking down at a newspaper on my lap. I
did not want attention or further speculation from any wandering represen-
tatives of the press. The time passed slowly. The hour set for my interview
came and went. The flurry of visitors continued in the corridors. Then it
was quiet again, and the room almost empty.

I was ushered into the busy chamber next to the Oval Office. I was
greeted warmly and the door beyond was indicated. I stepped through it. It

closed. I had expected a staff member to follow, with pad and pencil. I thought of Senate interviews, with staff almost always present. I was surprised to find myself quite alone.

I heard the President's voice outside the closed door opposite me. Then it opened and he stepped alone across the threshold, and the door closed.

We shook hands. He gestured toward a striped sofa for me, and took the upholstered wing chair nearby. Equidistant was an antique butler's tray table with a bowl of flowers. I recall the bronze bust, which appeared to be Lyndon Johnson, below a bookcase recessed in the wall. Next to me was the antique base of a Chinese lamp, but I noticed its presence only afterward in a photograph, ingeniously taken, for there was no photographer in sight. My entire thoughts were focused on the President.

He sat relaxed, I toward the edge of the sofa. He asked me not about current press articles, but about my past, about the novels I had written. I was astonished that he knew about them in some detail, that he knew about the Fordham experience and about the early work I had done in the Senate. Hands lightly clasped and resting on one knee crossed atop the other, he spoke with no notes, no props of any kind. On this exceptionally busy day, he had my biography in his head. I still marvel at this. When I had heard his voice at the doorway, though the words were not fully audible, an upcoming interview had not been mentioned; but at some brief time in advance, it seemed, a paper, a summary, places, a background had been committed to memory. I have mastered no such skill. He had done it easily, fluently, without pause or need to be prompted.

"You have written four novels," he said. "You were successfully writing. But you came to Washington to work in the Senate. Why?"

I suddenly decided to respond with a brief anecdote. I told the President of my seven-year-old daughter's first experience at public speaking in school. Each pupil was assigned to describe to classmates where his or her father worked. Since it was Philadelphia, the traditional pursuits were featured—the law, banking, medicine. Competition among the young speakers became instantly apparent. A spacious legal office lined with books floor to ceiling, with an expanse of window overlooking approaches to the city, was outdone by a banker's quarters beneath a great rotunda with massive Greek columns, and then by a doctor's suite, with nurses in attendance and a view of Independence Square in historic panorama. At last it came to Cordelia, intensely loyal, intensely competitive. She embarked boldly on her account. "My father," she began, and paused. "My father works—," she tried again, her small face filled, according to the teacher's account, with competitive energy. She paused a second time, then boldly concluded, "in the attic!"

"So I really came to Washington to get out of the attic, Mr. President," I said. He burst into laughter, and then the phone rang.

He went quickly to his desk and picked up the receiver.

"It was the Vice-President," he said on returning. "It's a tie vote in the Senate. He's there to break the tie for us." I offered congratulations, for I well knew this was a victory the President much wanted and needed.

"What about Nancy Hanks?" he asked. "What's your opinion of her?"

I said I thought Nancy had done excellent work at the endowment.

"If you were in her place," he said, "would you do the same things or something different?"

"I would try to continue the best of her programs," I answered. "But I would have, as any chairman, my own individual style and ideas."

He surveyed me for a moment and did not press further. He asked me instead about what endowment programs I thought best, about their philosophy and history.

These were questions I could answer easily. I responded, mindful of the time, of the President's day, and of the events in the Senate.

As I was leaving, he said, "Which of your novels do you like best? Which should I read?"

"The Village Beyond," I replied.

He gave me a smile. "All right," he said. "I'll try."

I reviewed the interview in my thoughts, sometimes with a positive feeling that I had done as well as ever I could, sometimes with negative feelings that I had responded too cautiously (or too boldly), too flippantly (or too seriously), too briefly (or too verbosely). I am blessed with a good memory. The conversation came back to me verbatim, and I wondered about the next interviewee, and if he or she, for both genders were involved, had similar reflections.

I was sitting at my desk in the Senate when I heard the telephone ringing across the glass partition at the desk of Ann Price, our valiant committee assistant who had worked for Claiborne almost as long as I. It was about ten in the morning. A Senate hearing was just getting under way in the large chamber down the hall, but it was not on the arts and humanities.

I heard Ann's voice. "Who?" A pause. "Oh . . . Yes, he is. Just a minute, please."

She put her head around the partition.

"It's Mrs. Mondale," she said in a whisper.

I raised the receiver. "The President has just notified me," Mrs. Mondale said. "It's you."

Wonderful news indeed, from a wonderful lady.

Chapter 50

THE ANNOUNCEMENT WAS MADE. THE PRESIDENT INTENDED TO NOMINATE me as chairman of the Arts Endowment. The word "intended" was necessary, for now I needed to undergo a full clearance by the FBI, a routine and time-consuming process for all presidential nominees.

Time was not in abundance. Nancy's term had expired. She had withdrawn. Michael Straight was acting chairman. Congress was casting its eyes and its thoughts homeward. I would need the clearance and official nomination and a committee hearing before the Senate acted. It seemed likely that the nomination would not receive such attention. It would not lapse, for Congress was completing only half of its biennium and if all the preparations were finished the matter could be considered after the next session convened in January. That would enable Michael to serve as acting chairman for a minimum of four months, possibly more.

Michael disclaimed any such ideas, but on October 10 a lengthy interview with him appeared in the *Los Angeles Times*. Conducted by Barbara Isenberg, extremely astute and knowledgeable about all the complexities of the arts, it was described by her as a "long and painful monologue on what he feels is wrong and due to get worse in federal

arts policy." He had a few nice things to say about his old colleague at the endowment, and eloquent praise for Nancy Hanks, but in the main the monologue was critical—critical of me, of Claiborne Pell, of Joan Mondale, of President Carter, of White House attitudes toward the arts. The words political and politicization were back in usage and given special emphasis. Michael painted a somber, gloomy picture of the future; the good old days were drawing to a close.

Those who praise Nancy Hanks often speak of her political sagacity, her ability to work wonders with Congress and the White House, her understanding and her skillful mastery of the political process. These are indeed virtues; Nancy was a great practitioner of the art of government and well knew its importance to the endowment. I have often heard Michael stress these qualities, and I would be the first to say that he possessed them also. His relations with Congress had so often been exemplary. It seemed odd for him to speak now so negatively of the political process.

What motivated his special and requested interview? Was it pique, as some suggested? Was it frustration, as others suggested, that here at last he was in charge of the endowment, away from past influences, free to run his own course, and given no opportunity to pursue it for an extended time? Did he wish, as still others imagined, that through criticism he could forestall the choice of Nancy Hanks's successor and himself fill the void with growing permanence?

None of the above, I think, though each may have been in small part involved. From time to time, as I have known him, Michael is given to ruminations of a somber kind. He can appear like a figure in a Dostoevsky novel, self-questioning, tormented by searchings that are in essence admirable but like will-o'-the-wisps not conclusive. His intellect is enormous. He has championed many causes worth defending. He is a writer of great ability, a sometime musician, and an art collector. His laughter is unrestrained, when he laughs. But he is a restless soul, like a Hamlet without a Horatio. Despite the critique and those dire predictions, I remain Michael's friend. I do not believe that feeling is greatly returned; neither do I think Michael has quite found his home.

The FBI clearance was issued in the rapidly waning days of the 95th Congress's first session, and the White House officially sent the nomination to the Senate. Claiborne thought it inappropriate for him to conduct a hearing. Senator Harrison Williams, chairman of the full committee, was not in town. Time was expiring. It was suggested I see Jennings Randolph from West Virginia, a supporter of the arts and senior on the committee. I had worked with his excellent staff, with Patria Forsythe on the committee, but I did not know the senator well. His wife, how-

ever, I knew was ill; he went home to West Virginia as often as he could to be with her.

I made an appointment and went to his office. He greeted me sympathetically, but said he had planned to leave Washington that evening. The weekend was approaching; the Congress, adjourning. It seemed a hearing might take place, at the earliest, the following February. Politely he accompanied me to the door of his private office and opened it. On the threshold was, unexpectedly, Tommy Corcoran.

He looked at me with an expression of surprise, and at Senator Randolph. Ever since the Roosevelt years, they had known each other and worked harmoniously. They had a rare friendship, akin to the variety that comrades in battle win on the fields of combat, a kind of wartime closeness that time only makes more secure. Jennings Randolph seemed as pleased to see Tommy Corcoran on his doorstep as Tommy seemed surprised to see me.

"What are you doing here?" Tommy asked.

"You know this man?" Jennings inquired.

"Do I know him!" said Tommy with a smile. "Of course, I know him. He's helped me often. Remember Barnaby Keeney?" he asked.

He put one arm around my shoulder and the other around the senator's shoulder, and we went back into the office. A hearing was arranged.

I had determined to address the subject of populism and elitism directly and made the issue, that erroneous and overly simplistic issue, the theme of my opening statement to the Senate. The endowment's purpose, I said, was to support the arts and artists of high quality and make that quality, those talents, available to the greatest possible number of our citizens for their understanding, appreciation, joy, enrichment. That was historically and philosophically the concept. It could be summarized in a brief phrase: access to the best. Access was the populist side of the coin, elitism the other—but elitism in its best sense, not as exclusivity, but as the selection of excellence. It was the same coin. It was not two philosophies at odds with each other. That was a distortion of the historic mission. The mission had been clear from the word go; if confirmed, I would seek with all my strength to enhance that course.

I was questioned with thoughtfulness and care. As I moved forward to the witness table, I had noticed Michael Straight sitting near the aisle. I wondered if he would volunteer as a witness; he was not on the prepared roster for the day.

I remember John Chafee noting that I was 58 years old. Should you serve two terms as your predecessor did, he said, wouldn't you already be over the retirement age?

I recall Jennings Randolph, born in 1902 and 75 years old at the time, turning in his chair. He had not quite understood the senator's question, he said.

Senator Chafee looked quickly toward an epitome of Senate seniority and did not pursue his question.

I must add my personal feelings on this occasion. It was an extraordinary moment for me. I had arranged this table so often. I had prepared with such care, and sometimes trepidation and misgivings of inexperience long ago, the great upraised semicircle, with its polished wood coping, at which the senators were seated. All the details of the room were familiar to me. Catharina was near the front row of chairs. Those who knew and had known me were there—Claiborne Pell, other friends. So much of my life was present in this room.

At the conclusion, Catharina and I went to the upraised platform to thank Jennings Randolph for his courtesy in presiding. I looked for Michael Straight, but did not see him. He had not come forward to object, nor had anyone else.

There was another problem, however. We had reached the day before the scheduled adjournment. The committee would not meet again this session. A nomination from a committee to the Senate usually needs at least twenty-four hours "to lie at the desk;" that is, to be available for scrutiny, should senators wish to examine credentials, question them, object to them. My name was with the committee, not at the desk.

The only procedure remaining was a committee poll. In such circumstances, unanimous approval is required. If the poll is to succeed, each senator must express approval by personal signature. No matter how trusted, a staff person cannot be surrogate. As the poll neared completion, as Senator Javits signed, and conservative Republicans and the Democratic side, suddenly Senator Kennedy's signature was missing. He had gone, on his way to Massachusetts, I was told. His staff had tried to catch him, but unfortunately he had taken a different elevator. The poll was incomplete. Time had run out. Its result could not possibly arrive at the Senate floor that evening. The nomination, almost unanimously approved, would have to await convening of the second session of the 95th Congress at the end of the next January.

I was at my desk considering this when the phone rang. Senator Edward Kennedy had been reached at the airport.

He had signed favorably. The nomination was being delivered to the Senate as a whole.

It was Friday, November 4, the final day of the session. My nomination could not be considered before its twenty-four-hour period of rest

ended. I figured that would be after seven o'clock. Would the Senate still be at work? The answer seemed yes. A volume of unfinished business remained, as is always the case. I had observed these final days, the routine and always the unexpected—patience running short, a maneuver to bypass regular procedures thwarted, another causing delays, plane reservations made and cancelled, tempers mounting, a majority leader finding it increasingly difficult to maintain order. If it was to be approved at this point, my nomination must be "without objection"—that is, by unanimous consent. One objection would terminate consideration. It rested at the desk, awaiting comment.

In the late afternoon I had finished my tasks for Claiborne. We had talked once about a vacation, but the days had diminished. Perhaps this was the last.

As evening came, I visited Claiborne in his special private quarters under the Senate chamber. Entering, I visualized this room again filled by others from the past—seekers of the humanities chairmanship; Nancy Hanks, George Stevens, John Brademas discussing the future of the AFI; cultural leaders, museum officials; George Seybolt, bristling with newly discovered information.

"You look nervous," Claiborne said. "Go home and relax."

He stood up from his desk. "I have a commitment from Bob Byrd" (now majority leader), he said. "We'll get to your nomination before we close down."

"Is it a firm commitment, Claiborne?" I asked.

Claiborne seemed momentarily annoyed. "Livy," he said, "I've been a senator for many years. I think I know if a commitment is firm or not." Then he said, "It's a very long day, as you know. It'll probably be after ten o'clock before we're through. Maybe later. A lot of confusion, as always happens, as you know. But don't worry about it. Go home. Relax. Take Catharina out to dinner."

I followed his advice. There was nothing I could do in the Senate. It was not right to linger. I was in limbo. Tonight would decide where I would be tomorrow.

We went to the movies, at the AFI's small theater at the Kennedy Center, I remember well—but I do not recollect the film. My thoughts were elsewhere. I gave Catharina no summation of technical problems, of things that might go askew at the last minute, or second, despite Claiborne's finest efforts. In my heart, I trusted them; in my mind I saw the long string of complications and complexities.

It was a double feature. The second picture was in progress. I left Catharina in her seat, took a nearby escalator, and found a phone booth. The hallway outside was empty. I closed the glass door and dialed the number of the Senate Democratic cloakroom. A friend answered.

"Have they gotten to the Biddle nomination yet?" I asked.

"Strange you should call," I was told. "Wait a second."

Suddenly and unmistakably, over the receiver came my name, and the nomination, and a voice like that of Howard Baker, Republican senator from Tennessee.

"Reserving the right to object."

My heart sank.

Another voice: "The senator from Tennessee reserves the right to object." Then Senator Baker again. "And I shall not object," and further words about procedural matters.

Then Claiborne Pell, "Mr. President, I emphasize the delight I feel with this nomination."

And Senator Williams's voice to concur with Claiborne.

And then, "Without objection the nomination is considered and confirmed." And Robert Byrd's voice was recognizable. "Mr. President. I move to reconsider."

Finally a voice I did not identify, but which was Robert Stafford's, now a key member of the Senate Subcommittee on Education, Arts, and Humanities: "I move to lay that motion on the table."

The time-honored words. A few minutes later the session ended.

"Did you hear that? I put the phone out in the doorway."

"Yes, I heard," I answered.

We had reached Tipperary once again.

The old ship, battered a bit but well afloat, had reached its harbor. All things considered, Joe Duffey had it easy.

Part Six
CHAIRMAN FOR THE ARTS

Chapter 51

MY TERM BEGAN NOVEMBER 7, 1977. I WAS SWORN INTO OFFICE BY
John Brademas at a ceremony in the Old Executive Office
Building next to the White House. Isaac Stern; Father Gilbert Hartke
from the initial National Council on the Arts; Billy Taylor, the preeminent
jazz authority and musician who had been appointed to the council; and
Vi Curtis Hinton, head of the District of Columbia's Commission on the
Arts and Humanities, all spoke. They addressed past traditions and an
evolving and bright future. The abiding values of the arts were empha-
sized, and quality. Isaac especially spoke of quality and excellence, which
he so well personified in his career. Father Hartke spoke of the impor-
tance of the council and the guidance of private citizen experts. Vi and
Billy spoke of the individual artist and of bringing the arts out across the
country, so that increasingly they would be given opportunity to grow.
The remarks were extemporaneous, but they stressed goals I had long
cherished and now, in this special new position, would seek to fulfill.

Joan Mondale was with us on the dais, and the members of our
immediate family were present. Catharina held the traditional Bible when
the solemn words were pronounced. She would be with me during these
next four years both at home and whenever we traveled—a particular

inspiration to me, of course, but also a knowledgeable, witty, and wise friend to all the arts on our many voyages. She listened intently and patiently to all my speeches made from so many rostrums and under so many different circumstances, and gave them a private review afterward—usually favorable, but not always. She was a bright ambassador for the arts wherever we went, sometimes paving the way for my own contributions.

She made friends for the endowment—particularly, I think, because her love for the arts was always so manifest, her sensitivity to her fellow artists so clearly personal. My observations were often of the diplomatic sort, and always made in public, while Catharina's were essentially private, the response of one artist to another. Unfailingly I understood the effort involved in creative achievement, in doing one's best. When offering my views or impressions, the dedication of the artist was central to my thoughts, the struggle for expression, the understanding that goals might not always be, at that particular moment, fully met. Praise, therefore, was not a problem for me; nor did I have trouble making it seem genuine. Artists are sensitive to such words as "interesting," which reflect an attempt to mask one's views. Catharina shared this respect for the creative process, but she was usually more direct. She was, after all, not expressing a public reaction, but a private one. In this respect, also, we were a team. Sometimes the private reaction was sought more than the public one. Once in a while, the two were intermingled, with occasionally surprising results. But one thing was clear: We shared a deep affection for all aspects of the arts, and we learned from each other.

I sought that memorable day to express the feeling that so many parts of my life seemed to have come together, at one place, at one time, uniquely for me. It is a rare moment for any individual—that sense of one day out of others, one day lifted up and placed just so, one moment in time.

With these thoughts, I had remembered a poem studied in college by the French romantic writer Alphonse de Lamartine:

> *"Ainsi toujours poussé*
> *vers de nouveaux rivages,*
> *Dans la nuit eternelle*
> *emporté sans retour,*
> *Ne pourrons-nous jamais*
> *sur l'ocean des ages*
> *Jetter l'ancre un seul jour?"*
> *"Thus always driven*
> *toward new and distant shores,*
> *into eternal night*

borne away without return,
can we never
on the ocean of time
put down the anchor for one single day?"

For a moment, on the ocean of time, the anchor had come to rest, the chain was taut, time was motionless, I don't believe quite in that same way for me since or before.

A critic said, Why did he have to choose a *French* poet? Why not an American one? I could have answered that nostalgia, reflected from the past to the present, comes from many tributaries, and that a young college student, beguiled by the dark forests and watery sunlit glades of romantic literature, had found in that poem harmonies of language and a question then unanswered and unanswerable. I recalled quoting the lines once to a French lieutenant on a battlefield in World War II. "Ah yes, Lamartine!" he said enthusiastically. "Un Romantique veritable!"—many tributaries for a thought.

That afternoon and evening was a time of joy. There was a celebration at the Corcoran Gallery. Claiborne Pell was there, his charming wife Nuala, David Kreeger, head of the Corcoran and cultural leader of Washington, with his wife Carmen (an apt name for the arts)—the major dignitaries, and a great assemblage of well-wishers.

I remember Sidney Yates, chairman of the Arts Endowment's appropriations subcommittee in the House, remarking on the crowds. "Are these all grantees?" he asked with a broad smile.

"Not now—but maybe some day," I told him.

A huge cake was brought in, as if at a birthday party.

I was proudly introducing daughter Cordelia, on her way to an acting and writing career in New York, and son Livy, on his way to a career in architecture and development, and the grandchildren, Cordy and Richard, ages 10 and 8. A choir from Howard University, gowned in black and purple, sang from the steps leading grandly upward from the Corcoran's main galleries.

On Monday, November 7, my first day on the job, a sheet had been torn from a large calendar and attached to my office door. Under the date the legend in red crayon said, "The endowment Livs it up!" There were memories inside the door, Nancy's long table in the center of the room, with a smaller work area through another doorway. I decided to use the big table for my desk, on which I could spread the day's or week's business, tidy up for meetings, and pull forward sufficient chairs. After the Senate's abbreviated space, this was a great luxury, as was the expanse of windows on two sides. To the right they overlooked the Kennedy Center and the Potomac River, the bridges, scullers on

spring afternoons, flame-red sunsets in the fall. If one approached and leaned toward the glass, there was Georgetown. And straight ahead were the Lincoln and Jefferson Memorials, and planes gliding in constant procession toward the airport or leaving it. The Capitol, a distant white dome, was visible if again one neared the glass and peered east. Those two large rectangles of glass provided, beyond a doubt, one of the finest views of Washington, for they were ten stories high. My spirits were like the view.

It was not always so in those ensuing four years. There were times of deep travail. Twice the endowment came under severe attack, once from Congress, once by a new administration, prepared at the outset, it seemed, to eliminate a National Endowment for the Arts or to reduce it to impotency. And there were other attacks, less severe but nonetheless persistent and disturbing. As funding grew—from $100 million annually to almost $165 million in these four years—so did problems among those with particular interests who considered their own of overriding importance. Internecine struggles hovered at the edges of daily pursuits, and sometimes took the center position. Renewed and given new voices were the old arguments of quality (and the few) versus mediocrity (and the many), the arguments of politicization (and the venal), the arguments of the "haves" and the "have nots," and of the deserving but left out. Most of these difficulties and their results flowed out of the past, gathering force. On occasion, they resulted from actions I took myself and, I believe, would take again.

The greater part of these four years, however, was full of positive activity, giving a feeling of optimism, joy, and at times exuberance. The arts were indeed putting down their roots; and although it was sometimes said I was growing weeds, that always seemed to me strange imagery, stemming from strange gardeners whose tastes might not even have found satisfaction in the most esoteric greenhouses of Louis XVI. Wherever the arts are rooted, this country's garden is the beneficiary. The problem is not in finding an exotic fertilizer for a limited space or vista, but in developing a basically hospitable soil. And the neighbor's garden is viewed, and if it is perceived superior, efforts are made to emulate or surpass it. So grows, for example, a ballet company in a Cleveland, Ohio, and its dancers next year are better than they were a year earlier. Quality in the arts does not lie hidden when one is motivated by discovery; and strange as it may seem to a handful of the Nation's allegedly most illustrious critics, quality is increasingly recognizable and desired by the newly observant, not just in the large metropolis.

Some of my own efforts were concerned with discovery, some with preserving and maintaining and developing the best of the present day—the best orchestras and museums, the most distinguished. My

themes involved quality and access to it—and a balanced program with a focus always on the individual artists, without whom obviously there is no audience, no center for performance or exhibition, no life. The balance was always in dispute; but there would, I felt, be enough resources in my term to encourage the newly deserving as well as the mature.

That meant some of the previous "have nots" would find help. It meant that the arts would reach into areas that had not previously made their acquaintance. It meant new ways of funding, in accord with the resources each applicant had at hand. Some of the better-funded would have to dig a bit deeper for the federal support they sought. The endowment as catalyst would be given new roles, when circumstances justified them. Controversial, yes; but the way was long and the wind needed warming, and a balmier climate. In keeping with all tradition, it was not a time to rest.

These days were long, with early risings and late conclusions. It surprised some that Catharina, and I took only one week of vacation in four years. But there is an altogether different side to this. Isn't a vacation supposed to renew, to refresh, to recharge the batteries, to revitalize? For us the arts do this. So it was a joy, not a chore, to spend the evenings after the hours in the office seeing a new play, hearing new music, watching a talented dancer perform—or watching an incipient talent one feels will grow in skill and then to excellence. A busman's holiday? Ah, but consider the bus! And the drivers! A Leonard Bernstein, a Mstislav Rostropovich, a Mikhail Baryshnikov, a Henry Fonda, a Beverly Sills.

For me the job was the best I could imagine. But one must love the arts, and understand them, try to better understand, try to learn, find joy in learning—not lie bemused by the sun on a beach in Hawaii, if you happen to be there, but seek out the gallery where the artists congregate, the village center where they work, and see, like the most complex and disciplined ballet, not a commercial type of hula, but how the dance was performed, with all its rituals, a hundred years ago.

These were years spent in close association with Joan Mondale—unexcelled as advocate for the arts, an indefatigable traveler and speaker in their behalf. The Vice-President's house, on those broad grounds near the Naval Observatory, near the embassies on Massachusetts Avenue, became a focus for the visual arts, for regional exhibits from North, South, East, and West. Like Catharina a student of art history, Joan imparted her own love of painting and sculpture and the potter's wheel to great numbers of visitors, officials or friends, assembled for large meetings or just coming to call. I remember one early summer function, with a tent to accommodate the crowd after they had wandered through the

high-ceilinged rooms with their tall windows in the Victorian style. A flutist was at work near the doorway as guests strolled past. The music was haunting, but entirely atonal.

"Is he tuning up or playing?" the Vice-President asked me quietly.

"He's playing, Mr. Vice-President," I replied.

"I was afraid you'd tell me that," Walter Mondale said, with a private smile.

I was devoted to both of them, as was Catharina. I recall my first visit to this gray house with its feeling of space and light. I was let into the front hallway, with a white-banistered staircase slanting diagonally upward from the corner near the open doorway to the dining room. I was to have breakfast with Joan and Bess Abell and go over plans and ideas. Bess was marvelously skilled, highly efficient, with long experience in government at its highest levels. She had worked with Liz Carpenter in the White House for Lyndon Johnson, and for Mrs. Johnson as a special advisor and counselor. Bess was nicknamed "the iron butterfly." If that can be translated as a firm and staunch gentleness of manner, then it seems apt to me. Unfailingly, Bess accomplished her varied and demanding assignments, but I never heard complaints about the iron intruding. The same qualities were in Joan Mondale: a basic firmness that allowed for some bending, but only to a point, a firmness that did not yield on principles, and a dominant graciousness reflected in a warm and open smile. Joan and Bess Abell were a team.

I was alone in the hallway. I glanced at my watch. I was precisely on time, as I had planned to be.

There was a tread on the stairs, early morning brightness entering through one of the tall windows and reflected against the white banisters.

The Vice-President descended. He waved a greeting.

"Joan will be down in a second, Livy," he said, and crossed cheerfully toward me. We shook hands, and he was gone through the front door.

New then to my new job, it suddenly struck me that I was also in a fairly high estate. I suppose the domestic nature of the scene was largely responsible, but I also remember the opportunity to feel at home.

I remember another episode, of a different yet related kind. It was during a time of budget preparation, a winter day. President Carter was seeking to reduce domestic spending. Agencies, departments, members of the executive branch were to hold the line, with almost no exceptions. (Those policies, those particular edicts have sometimes been overlooked. Fiscal responsibility is the sole province of neither political party nor administration; it is simply given different interpretations.)

I was seeking a small increase in funding, an almost invisible dot

on a figurative radar screen monitoring the vast federal expenditures of recent years. Yet it seemed to me of the greatest importance. We were asking to be among those few exceptions because, relatively small though the sum was, it could signal a special commitment. It could send a message of special good cheer to the arts. It could recognize the singular importance of the endowment's catalyst, for the additional $5 million in federal funding would translate into four times that amount when the private sector matching support was added. The small increase would keep momentum alive, even in a time of restraint.

Joan Mondale and I had discussed all this carefully. Now she called me. The Vice-President would be seeing the President that same evening, on a variety of subjects. The arts would be on the agenda—not first, but there. "Fritz would like you to prepare the arguments," Joan told me. "Three reasons. Three paragraphs. On one page." I was to call him when it was ready and read the paragraphs aloud, so he could make his notes.

I closed the door and cancelled other activities. Somerset Maugham, whose advice I had studiously read in years gone by, said a writer should never be distracted by a view. He had bricked up the window beside his desk on the French Riviera. My old Bryn Mawr "attic" had contained only the smallest of apertures, for air on summer days before air conditioning. Now I closed the curtains, brought out a few files, put them on the long table with a pad of yellow paper, and went to work.

In two hours, I was satisfied I had put the case as best I could in the space required. I placed a call to the Vice-President. He was soon on the wire. I read him the first paragraph.

"It's perfect," he said. "Wait a second. Let me get pencil and paper. I want to take it down just as is."

We went through the document.

"It's fine," he said, "exactly what I wanted." I wished him good luck, and opened the door and the curtains.

Joan called me the next morning. "You'll be happy to know the President has approved the increase."

It was almost like that earlier call she had made. I asked if I might call the Vice-President to express my thanks.

"Of course," she said.

I placed another call to the White House. In less than an hour, it was returned.

"Mr. Vice-President," I said joyfully, "you've given the arts a marvelous present for the New Year."

"I'm very glad," he responded. "I'm very glad to help."

"If you don't mind," I said, "could you tell me, so I'll know for the

future, which of the reasons you used—which seemed best to the President?"

"Oh, I didn't use any of them, Liv," he said with a chuckle. "I just told the President my wife would divorce me if he didn't agree."

Chapter 52

I N THE CHAIRMAN'S JOB, THERE IS NO SUBSTITUTE FOR THE PERSONAL EN-
counter. The first two trips for Catharina and me as chairman were to
Cleveland and Detroit. (We always paid personally for Catharina's travel,
though she worked as hard as I did to make our trips successful.) They
illustrate the benefits of travel, which are considerable for the health of
the arts and for any chairman's ability to work with a firsthand knowl-
edge.

I had not realized just how a chairman of the National Endowment
for the Arts is regarded away from Washington. At extremes, he is Santa
Claus, whatever the season, or Scrooge hoarding his resources in misun-
derstandings. He is also the Oracle at Delphi, asked for help and advice.
And somehow—despite all the literature on the endowment's application
process, the panel system, the guidance of the experts on the National
Council—he is the one deemed best to approach for a change of heart or
mind.

One of my principal contributions, I think, was to set forth the
chairman's role. Only in the rarest of instances should he intrude on the
process of expert private citizen review and guidance. His job is to
strengthen the process and ensure that it functions objectively and effec-

tively, honestly and with full integrity. His job is to listen and observe and gather a multiplicity of knowledge that he can share and use to inspire others.

Above all, I believe, his job is to express a commitment. Commitment must come both from the mind—philosophically—and from the heart. If it comes from one and not the other, that will be perceived. In expressing his own commitment, the chairman expresses commitment from the President, the Vice-President, and the White House. Any faltering is noticed, but not always in a vocal way. (The arts are not known to parade in protest along Pennsylvania Avenue, though in recent times they have marched to state capitols with their pleas for help.) Any encouraging and substantial word is also noticed and passes through the arts grapevine with astonishing rapidity.

Leadership is deeply involved, of course, in the chairman's job. There are countless decisions to make, large and small, and there are initiatives to be devised and put forward. But leadership in commitment is key, and to me the best way of describing what the work can accomplish. Commitment can be passed from one to another. When that happens, a chairman should rejoice; and when he finds it already in place, he is nourished and rejoices, too.

Nina Gibans, Jim Edgy, and Ric Wanetik were among our hosts in Cleveland. Nina was the executive director and mastermind of the Cleveland Area Arts Council, embracing the performing and visual arts, museums, and a uniquely broad range of cultural activities, with growing municipal and business support. It was an example to emulate. Nina, sympathetic and wise, provided energy for its growing success. She was already a friend when we went to Cleveland. I had known her in meetings with state and community arts representatives. I could see now how much she was achieving. Jim Edgy's experience with the Ohio Arts Council was also well known to me, as was his excellent direction of the National Assembly of State Arts Agencies. He was youthful, vigorous, respected, and he later became a deputy chairman of the endowment. Ric Wanetik was one of those rare and gifted workers in the arts who can do almost anything requested, and do it extremely well—public relations, administration, management, research, all with a flair that enhanced his developing career.

Our first day in Cleveland may have been a bit more crowded than other days on other trips, but it was typical to our experiences—to see as much as possible, to meet and speak with all concerned. We began at eight o'clock with a television taping and interview, followed by a ten o'clock meeting with music authority Kenneth Haas and a speech to the Cleveland Youth Orchestra. By eleven, we were at the Cleveland Mu-

seum of Art in the company of Sherman Lee, among the country's most illustrious museum leaders. By noon, we were at the august City Club with a formal address to give there, carried live on TV (not a usual event for a new chairman). Then came a question-and-answer period for an audience of arts and business representatives, then a walk though the Cleveland Arcade, bright with the lively arts, and a press conference at the Cleveland Area Arts Council's offices. A meeting at the Cleveland Foundation library came next; Homer Wadsworth, foundation president and a special stimulator of private philanthropy for the arts, helped preside. By four o'clock, we were in the offices of the *Cleveland Plain Dealer,* explaining my concepts of the program for the future to an editorial board not always enthusiastic about federal arts assistance. We had an early dinner, with another, briefer address at the great old Union Club, hosted by arts and business leaders. It was followed by a performance of the Cleveland Ballet, newly rejuvenated by a native son, Ian Horvath, and by Dennis Nahat, late of the American Ballet Theatre. Finally, there was a reception, and toasts, and a postmidnight ASTB ("and so to bed," as I used to write in a little diary, parentally provided, on a trip to Paris when I was a child and retired a lot earlier, and alone).

Cleveland was a typical experience, but it was also, of course, unique in some respects. The arts in Cleveland, Ohio, are not the arts in Jackson, Mississippi, or San Francisco, or Seattle. They all reflect a basic vitality, and a talented artist has much in common with a talented colleague. But each individual, each city, each town is special, with particular needs and aspirations. By working to stimulate the growth of the arts across the country, we are never aiming for sameness. Sameness is as unlikely in the arts as would be two identical fingerprints. Those differences are part of the magic. To understand them is part of the reason for a chairman's voyage.

It was interesting for me to hear Nina Gibans discuss the emergence of the so-called CETA Program for the Arts. I had helped to include the arts in the recently adopted Comprehensive Employment Training Act. In Cleveland the new legislation was providing training for young artists and involving more than 1,000 Clevelanders in community arts work. The endowment was being called on to assist with artistic advice, but the funds came from elsewhere in government, from areas concerned primarily with economic development and unemployment.

We had explained to Congress that artists could be unemployed as often as those with other skills; a person without a job was a person without a job. The CETA program was a good example of governmental assistance benefiting arts pursuits in areas the endowment should encourage, but not with its own resources. The concept and example

reinforced ideas I was already developing for a wider cultural emphasis in other government-aided programs.

In Cleveland, we also visited the Music School Settlement, the largest community music school in the country, involving almost 5,000 students weekly. We saw the beginnings of murals painted on the walls of public housing and noted the pride in these beginnings. We attended a benefit for the Cleveland Institute of Art, at a different pole from the CETA program. Yet perhaps someday a disadvantaged youngster, given a start, might progress to degree studies at such a selective institution. One government program alone could not help solve the need for enlightened education in the arts. It would take a combination.

We went to Karamu House, a special center for the arts, organized on a multiracial basis, yet often focusing on the black experience. Started as a neighborhood settlement house during World War I, it had expanded to include dance, music, poetry, and theater, in training, in performances, in exhibitions. It was an example of how well the arts can transcend racial boundaries. I was pleased to announce the endowment was giving it strong support.

We met with the leaders of the five largest arts institutions, including the orchestra, then under the direction of Lorin Maazel, and the art museum. The rumor worrying them was that the new chairman was turning his attention from the majors to the minors. I explained that each side needed help, but that the major institutions should be given full opportunity for growth and greater service. After all, they were the country's, or a city's, examples of excellence and of long hard work. The federal dollar was not in unlimited supply, but neither was the highest quality in the arts.

We had a working dinner with the Ohio Citizens Committee for the Arts, the fundraisers, our partners in support—the senior partners, I said, for private support should always be dominant. We met with union leaders and state senators and representatives. Because of the work Jim Edgy and Nina Gibans had done, these individuals were now supporting the arts. They were making some allowances for those groups the endowment's legislation emphasized, the groups struggling to meet the union wage scale. We discussed the idea of temporary permissiveness to a few organizations most in need, of contracts individually arranged, and there was general agreement.

As I always did in our travels, I summarized the most recent assistance from the endowment. In the first round of grants for fiscal 1978, just approved by the National Council on the Arts, the total for Cleveland was $286,000. It was hardly a staggering sum, but from the reaction you might have thought millions were at stake. Actually, the element of far

larger sums was present, because the endowment had an unfailing multiplier effect on other funding.

While Cleveland demonstrated a panorama of the arts, Detroit focused attention on one area, jazz, which Billy Taylor was to describe to me, and to the National Council, as America's classical music. Jazz had been an uncertain lodger at the endowment. It had been placed under the rubric of the folk arts, under those art forms considered indigenous to the American heritage. To some this suggested a parallel with the fiddle-playing of the Appalachian wilderness, limited to a relatively few highly skilled, venerable and venerated practitioners, or with the pottery of the gifted American Indian or with Cajun singers in the back country of Louisiana. It suggested an art form fading from the American scene, rather than one with a sense of new life. It suggested the edges of the river rather than a main stream. Should not an American audience, accustomed to Bach, Brahms, and Beethoven, open its ears more to Brubeck or Benny Powell or Vishnu Wood or Monk Montgomery? Was not Billy Taylor's music akin in complexity to Bach? Was jazz not, after all, music—an especially American kind of music, not a folk art?

On December 12, 1977, the Marquette Room of the Detroit Renaissance Center was crowded, as a huge nightclub might be on its busiest, most populous night of the year. The saxophone, the clarinet, the trumpet, the bass, the drums, all were audible, dominated only by the sounds of a multitude of voices. Smoke circulated in the atmosphere. A dais and a microphone had been arranged. The mood was animated, welcoming, yet speculative. Who was this new chairman? What were his views? Did he believe in jazz? as an art form? in need of help? What in his Philadelphia background might indicate such leanings? Was he foreigner or friend?

John Conyers, congressman from Detroit and himself a jazz musician, gave me a fine introduction. I spoke about the variety of the arts and jazz as American music, and I was applauded. I was learning, finding a way, and I came to believe deeply in what I was seeking to express that evening—to the dedicated, the talented, and those practiced in the techniques of survival, those who had known exclusion. With Billy Taylor's help, I was to start a special program for jazz and give it a home of its own.

I will add this. A white person in our society remains suspect to the black. As a people we have not reached a point close to where the color of skin is negated. We may be closer than we were over a decade ago, certainly two decades ago, and there are bonds of understanding that in the past never existed. But suspicion lurks on both sides of an

equation, except among unusual individuals who can see through the morass of the superficial, remove the lead weights of what is preconceived and so generally accepted, and reach through to a sense of oneness or wholeness.

It seems to me, from so many observations, that the arts provide that slender avenue. If you play, with exceptional grace, the clarinet or piano or trumpet or tympani, the color of skin of your colleague, performing with an equal ability, matters not. It may matter before or afterward in private times, but not in that special moment of self-expression and fulfillment in company with another. So that special moment becomes the bond, and the other private times can become superficial, less full of meaning.

I have given much thought to this particular aspect of the arts, for it applies not just to domestic patterns of prejudice, black versus white, white versus black, color versus color. It has an international application. The black artist, the black jazz musician has found an acclaim in Europe and the Soviet Union exceeding his homeland's. He or she becomes one with the audience, and they with him or her. Artistry speaks far better than the spoken word, addressing not the superficial, but speaking universally to the human being.

In our travels, I have pondered the many benefits of the arts. This story to me is revealing. I was in Houston to address a national conference of music educators. I had visited the city's large arts organizations, but I particularly wanted to see a smaller one, which was receiving endowment support of less than $10,000 for the year.

It was in an economically deprived Hispanic neighborhood. Driving there was like crossing through the desert of poverty in other cities where a population struggles against difficult odds. All at once I confronted a large brick building, an abandoned movie theater. It was being renovated slowly, and by hand, by people in the neighborhood. Nearby the small houses had a different look. Small rectangles of grass in front of them had been cut; windows were glazed, not patched with paper. Doorways were freshly painted. I went inside the brick building. A performance area was nearly complete, a stage in place. Classes were in progress in theater and dance. The teachers were of Hispanic background, and of high professional caliber, carefully selected. The endowment's funding had been matched by small donations from this community and by larger ones from elsewhere in the city.

It was like an oasis in the desert. I spoke with the director, small, wiry, energetic: "We started here first as a health clinic," he told me. "We thought health, the problems of drugs, were the most necessary to deal with and correct. But then," he said, "we came to realize that just

to be physically well is not enough. We realized we needed something special for the human spirit. And so we turned to the arts."

Not far away was a public school. Between theater and school, the wall facing the street had been decorated with murals. Inside the small school building the same vivid colors, traditional to Hispanic culture, had been repeated in crayons by the very young, in paints by those a bit older. "We didn't have this work before," the principal told me. "It's because of what's going on with the parents over there." She paused, indicating the direction of the theater building. "It's strange," she said. "The truancy rate here used to be almost 85 percent. Now it's less than 15 percent—and, believe it or not, these children are learning to read and write and do arithmetic for the first time because they can express themselves and enjoy it, like this. Believe it or not, it's an education for me to see it happening."

It was not an isolated episode. I was to see variations on this theme many times, in many places. But "something special for the human spirit"—that was a particular phrase.

Chapter 53

I T SEEMED TO ME THE ENDOWMENT HAD REACHED A STAGE OF DEVELOP-
ment that called for structural changes. In the old days with Roger
Stevens, a chairman and deputy chairman were sufficient. In Nancy's
time, the volume of work had increased, the number of programs, the
funding. Had she continued in office, I believe she would have recog-
nized that alternations were necessary. I decided on three principal areas
for particular supervision and placed a deputy chairman in charge of
each: administration, including budget and planning; programs; and part-
nership with states and other subdivisions organized at community and
local levels. Such a structure required individuals who could work well
together, for there was some inevitable overlapping of responsibilities;
the programs in the major arts disciplines needed to work with state and
local leaderships, for example, and budgets were a common denominator
needing the collaboration of all. Yet each deputy's responsibilities were
essentially discrete.

For the first area, I chose David Searles. David had worked for
Nancy Hanks and gave a continuity and long experience to the whole.
He came from Bangor, Maine, and spoke with an unmistakable Down
East accent. He had the integrity I find synonymous with New England

at its best. He had the respect of the endowment staff in all areas of its work, and equally the respect of the National Council. He was smart and sharp and dedicated. I could ask no more.

Mary Ann Tighe became the deputy for programs. There are few people I have encountered over the years to whom I would unhesitatingly ascribe the adjective "brilliant;" here was one. She had the fire of youth, and she was full of ideas. She became a diplomat among the programs, and was able, in open conference, no holds barred, to adjust yearly funding allotments for music, theater, museums, and the rest, so that most of the time full accord was reached without resorting to an appeal to me. That was no small feat, for the program directors were older and illustrious in their fields, backed by panels of distinguished experts. Each was anxious to increase the scope of work, to add new concepts, when the total funds available were always much less than needed, when the ideal was always beyond reach. Mary Ann worked with authority, efficiency, and fairness. She had no favorites, which was undoubtedly one reason for her success. Others were a sense of humor and an articulate voice. She had written about the arts in published literary style. She had worked for Joan Mondale and had first come to my attention in that capacity. When I called Joan to suggest that Mary Ann come to the endowment, there was somewhat of a pause in the conversation, but I think we both knew this was a new opportunity.

Jim Edgy brought his own great knowledge of the state arts programs and all related ramifications to the third area. State leaders had earlier selected him to head their national organization, the National Assembly of State Arts Agencies. It was heartening to feel that he could translate this regard into a new extension of his career.

Now came the program directors, all of whom I knew well, all of whom had worked for Nancy Hanks. Most were in the Schedule A category of federal employment—that is, more subject to change than the regular civil servant. (Since my first meeting with John Macy many years earlier, the endowment had been able to appoint staff to its key programmatic positions without full dependence on Civil Service listings.) With the program directors, I made another decision, immediately unpopular, immediately controversial: I decided on a policy of rotation, generally limiting the time in the position to five consecutive years.

The program director has, I believe, the most sensitive position at the endowment. He or she works with the panels of experts appointed by the chairman to review all grant applications. There are bound to be relationships between panel members and program directors. That is human nature—and the nature of professional collegiality. I have attended many panel meetings, and I have seen the care taken to preserve both trust and objectivity. To be scrupulously fair is a cherished goal. All real-

ize that these qualities are fundamental to the panel system and that the panel system is basic to the original legislation, and basic to the endowment's success. The process needs a continuing affirmation, a refreshing from time to time. Otherwise the pattern of grants can become static, not because there has been a conscious effort to perpetuate a status quo, but simply because the same minds deal continually with the same problems. I had noted a tendency in this direction, by no means obvious, by no means intentional. If the process was to refresh its own integrity, it needed new voices, without losing continuity of purpose.

So I determined that the panels should be rotated regularly, with one-third changing each two years, and that program directors should not be permanent. The National Council changed every six years, by a third of its membership. The chairman served for four years and could be reappointed, but I absolutely agreed with Claiborne Pell: two terms for a chairman, arts or humanities, was also an appropriate limit.

I remember well the morning I announced my philosophical convictions to the program directors assembled around the long table. There was a hush in the room, and all regarded for a time the view through the windows. I explained that my own thoughts were still evolving, that I would like counsel on how a specific plan could be developed, that I had only praise for all present and for the conduct of their work. I remember John Spencer, who had headed the Museum Program for a long time, saying that while the concepts applied to him, he could not but agree with them. And that was a sad part of it all: John—whose work at the endowment was uniformly outstanding and who epitomized fairness and a knowledge respected nationally, and, indeed, in international circles—was gone in a few months, but to an excellent new educational post in North Carolina, where he added to a distinguished career.

This was a result I hoped would occur. It seemed right that work at the endowment should be a springboard to contributions elsewhere, perhaps even in an art form related but not identical to the experience already gained. It seemed possible and desirable that such new horizons might eventually lead back again to the endowment, as a later step in an expanded career. A network of valuable experience could grow. The private world of the arts could find exceptional administrators. The public agency could find sources of new strength. And it has happened this way, in a number of cases.

But there was a different side entirely to this discussion and its results. Some in the arts reported that I was trying to get rid of "dead wood" or eliminate those with whom I disagreed or that this was all a disguised plan to bring into the endowment political cronies who would recognize quality about as easily as they would the work of an early Picasso.

My explanations that the process of change would be flexible, that five years was simply a benchmark, not an absolute, were overlooked. The policy was described in some quarters as arbitrary, and hence motivated—no doubt—by unstated reasons. Also overlooked was my provision that I would work in each case to ensure as unhurtful a transition as possible and that I would help each individual as best I could toward a new assignment. It was easiest for the press simply to use the five-year period involved and then find out those who had been employed longer.

The problem focused around theater, where a director had worked with great skill since the early days of Roger Stevens, for over ten years. There could be no doubt that "rotation" applied here. The Theatre Communications Group (TCG), which represents theater in the United States, invited me to address their annual spring conference, held that year in Princeton, New Jersey. The audience ranks easily among the three most hostile I confronted while in office. Old stories and past anecdotes were of little use. When the director's name was mentioned, the audience rose as one and applauded, and then sat in stony silence, watching the rostrum.

It was an uncomfortable time. I found it distressing to see in front of me so many I had come to know over the years, fellow toilers in the cause for the arts, so misinterpreting and so suddenly mistrustful. I shortened my talk about plans for the field of drama (there was enough in the auditorium) and began a general discussion, open to all present. Now the word arbitrary was repeated with force, and there were questions on how anyone could think of consigning away a decade of invaluable experience and trusted service. The views were not sentimental. They were stated in anger.

Oddly enough, for this was hardly the intention, they convinced me that the policy I had announced was proper. If one program, combining the arts and government, so depended on one individual, or was *perceived* to depend on one person, it was time for a change.

I sought hard to find the best. Tom Freudenheim came from leading the Baltimore Museum of Art to head the Museum Program. Michael Pittas came from Harvard and a career of accomplishment in urban design to direct the endowment's Architecture and Design Program. Ezra Laderman, composer and music authority of international reputation, came to run the endowment's wide-ranging assistance to music; and Arthur Ballet, a theater personage recognized throughout the country for his skills, came to head this area. A few program directors stayed on in new positions.

Brian O'Doherty—under Nancy, the director of the Visual Arts Program—now applied an equal talent as director of the Media Program.

In fact, Brian seemed to find his new position more challenging. Brian was well assisted by Catherine Wyler, daughter of award-winning father William and herself experienced in the field of independent filmmaking, which the endowment wished to support.

Suddenly, there was no more criticism. The chairman was not Dr. Jekyll after all. I had learned an endowment lesson: If you believe you are in the right, persevere—and if you believe you are in the right in the arts, there will always be some who think you are dead wrong.

I should have known, of course, especially in view of earlier remarks I made in Washington, to the National Press Club. In speaking of my elevation, I used an episode taken from another time in history. Marshal Lyautey, favored among Napoleon's famous leaders, was being complimented for the magnificence of his newly acquired chateau. How did it come to you? he was asked. "From the Emperor," he responded. "He told me I had survived so many cannonadings, it was mine. And, my friend, if you like, I will arm all those men you see through the gate there, and here in the courtyard, and they will all shoot at you. And, if you reach the front door safely, then the chateau is yours!"

There was growing competition now for the leading endowment jobs. To those I interviewed and in some instances invited for interviews, I explained how I believed an endowment program director could benefit the arts. If museums were involved, it was the entire spectrum of such institutions. A program director could develop new ideas, refine and reshape past projects, see with special eyes what was most needed and what was not. A new program director was only bound by the past if the past had proved of value.

So it was, as one example, that a new emphasis on exhibitions was initiated, with museums determining what best suited their needs, their audience, and its growth. The small museum designed its own project, often on a specialized subject known to have particular community appeal. And the larger museums opted most frequently for the more definitive display, for the historic, the world-renowned artist or group of artists. Because of the indemnification legislation, insurance costs were minimized. If there was a show where history was as involved as artistry, we worked in tandem with the Humanities Endowment, reaffirming alliances that from the start had been considered so essential.

A once-in-a-lifetime exhibit of Picasso's work was made possible. Major exhibits traveled from city to city: an elaborate and beautiful recreation of Pompeii, with its mosaics and sculpture and glimpses of its villas; and treasures of gold from Peru, jewels and jewelry, garments of beaten gold. A figurative "quinquireme of Nineveh," which John Masefield once described, brought its cargoes of the remarkable to many new harbors.

* * *

These exhibitions were nicknamed "blockbusters." Their benefits were both direct and indirect. They attracted immense crowds. Extravagantly pictured and described, they generated their own public relations. They also brought attention that could be translated into added members and new friends for a museum. They invited further explorations into the museum itself or into related literature.

It was a particular delight for Catharina and me to explore, to go beyond the immediate focus of interest when we visited a museum. Invariably we would find the director or a curator waiting for us outside or in an entrance hallway. I became used to the expression of greeting so tempered with an early reserve: Here is that bureaucrat from Washington; we'd better be nice and gloss over an undoubted lack of knowledge, because he can help us (*something* will strike his fancy, somewhere). And Catharina would say, looking a distance past the welcomer: "I can't believe I'm looking at a Daubigny. One of his best, I'd say."

Startled, the official would turn. "Why yes," he'd say, "it *is* a Daubigny."

"I don't think he ever got quite that color green again," Catharina would remark, in genuine excitement. "Do you?"

The market value of the National Endowment for the Arts would leap upward. From then on two experts in the visual arts would be in communion. And it always happened thus, though it was not always Charles Daubigny. Nor was it ever at first sighting an obvious choice, one a chairman might perchance identify. I always marveled at the selection, and the reaction to it, and the sudden lift of spirit it provided.

So in our work with museums we thought of the intangibles—the invitation of education, the additions to the quest for knowledge, knowledge through vision, knowledge by osmosis. And pleasure. And new perspectives. And we thought of the tangibles that would leave a museum with new advantages after the particular exhibit concluded.

The arts, the artist, and the audience: those allied elements were common to all programs. Ezra Laderman talked of the need to support chamber music, and we went to Marlboro, Vermont, to find a special source. High in the hills above Brattleboro, in timbered buildings with the fragrance of sun-heated wood, young musicians played their hearts out, seeking to improve their already substantial talents. We talked to Rudolf Serkin, once a member of the National Council on the Arts and an old friend. Some twenty-five years earlier, I had shared in the first glimmerings of Marlboro with Henry Persons and his wife Dorothy, who owned a rambling Victorian house on the outskirts of town. There one evening in the Christmas holidays, a small Peter Serkin, prowling away

from the adults, had found an organ in a loft above the living room and had played a Bach fugue. We discovered that night that the Serkin son and Biddle daughter were twins, born on the same day in the same year. Peter, suddenly in the company of the grownups, ceased playing. Rudy raised the hinged seat of the bench on which he had perched and drew out another composition.

"Play this," he suggested.

The small boy looked at it in the half light.

"But it's for piano," he said.

Rudy waved his arm. "Transpose it," he said, "in your head."

Son looked at father. "Let's see you do it, dad," he countered. It was the same rejoinder son Livy would have made had *his* father criticized the lack of a spiral on a pass with a football.

But there was a difference now at Marlboro. I could help a Rudy and a Peter Serkin, and the concert artists, and those seeking to climb that precarious ladder of the arts. After all the years in between a then and a now, I had been given that good fortune.

Chapter 54

W HEN ONE SEEKS TO IMPROVE, AND THROUGH IMPROVEMENT TO change, one has unlocked the door to controversy. But the static and the status quo present greater hazards to the arts, and I was determined to make the endowment more fully responsive in every way. The policy of changing program directors and panel members seemed in accord with that goal. There were a dozen program directors and more than 500 panelists. Some of the latter were concerned with policy changes within the programmatic areas, and the majority dealt with review of applications, now numbering close to 25,000 a year and increasing.

Similarly, I was determined to explore, to a greater degree than in the past, new opportunities for artists who were now called "minorities." The word had come from the civil rights movement and the mid-1960s, when the Nation's consciousness and its conscience turned toward recognition of the underprivileged and the disenfranchised. Martin Luther King, on that sweltering and uplifting summer day beside the Lincoln Memorial, with the crowds stretching to the limits of vision, had told us of his dream and had called on us to join in its fulfillment. The reactionary forces, the assassin-minded—and the militant on another side—had

made realization of the dream more difficult. But the arts had humane dimensions. The question was how best to recognize talent. The proper answers lay, certainly in part, in responsive and enlightened attitudes.

I am not sure the word "minorities" serves us well. A "minority artist" seems to suggest an artist not fully accomplished. But other terms and words are more limiting and sometimes more demeaning, and they provide targets for prejudice. Minority was a more generic word that had an understood meaning. But was not Monet a minority artist when, with just a handful of others, he altered forever the painter's depiction of sunlight? All pioneering artists have been initially in a minority. Was not Claiborne Pell a minority senator in espousing a National Endowment for the Arts?

That may be begging the point, but I quarrel with generic terms, which by euphemism can gloss over deeper-rooted and sometimes festering problems. I studied the statistics and the records and determined that to be more responsive, more fair, and more open, we should create a new process to aid in wider understanding of the arts, both philosophically and tangibly.

I began an Office of Minority Concerns. The words, though imperfect, were as good and as understandable to all as I could devise. The office was placed in the hands of a director and a principal assistant— Gordon Braithwaite, with a history of endowment service and with wide and respected associations in the black community, and Joe Rodriguez, an artist himself, articulate and intelligent. Walter Anderson, among the senior officials at the endowment and for many years under Nancy Hanks its Music Program director, I named as my special assistant to help me focus on these concerns and to act as liaison with all involved. If the new office was to succeed, it needed the support of all programs. Walter had won the regard of his peers, which would help make that goal possible.

The deputies were, of course, deeply involved in minority concerns and in the need to address them. In choosing new panel members, the endowment staff made a special effort to recommend and involve those best qualified to express points of view particular to artists in a minority situation—the black or Hispanic artist, the American Indian, the Asian-American. The black artist and the Hispanic artist, however, were the most numerous and seemed to need the most attention.

Here was a developing role for the National Endowment for the Arts. An artist creates his or her work from a particular cultural background. A Billy Taylor may understand all the intricacies of Johann Sebastian Bach, but Billy's music and his talent are individual, in keeping with the talents of all fine artists. A black artist may be fully cognizant of a white tradition in painting, but he or she expresses a cultural back-

ground in part quite different from the white. That expression is individual, and perhaps not comprehensible at once to the white viewer—or no more so than were Claude Monet's water lilies to a late nineteenth-century French audience. Rejection, even derision, is easy when there is a lack of understanding. The same holds true, of course, for the Hispanic artist, who paints or performs or writes from a cultural background foreign to others. In the arts, it is a danger simply to hold up the mirror of one's own knowledge and find praise only for what conforms to it. For a government program in a democracy to limit or prescribe or judge by limited standards and opinions is a special danger.

I started an Hispanic Task Force. Preliminary steps had been taken by Michael Straight, who left the endowment just before the day I arrived. At the first meeting of the National Council over which I presided as chairman, a small group of Hispanic leaders made a presentation of their needs. The council listened with interest and sympathy, and the task force was begun, the first group of its kind in the endowment's history.

Jacinto Quirarte, dean of fine arts at the University of Texas at San Antonio, served as chairman. Tall, handsome, soft-spoken, with dark hair flecked with silver, he resembled in some respects a Spanish grandee, commanding in presence on the balcony of his hacienda. He spoke in scholarly and modulated tones, his large and sad grey eyes the dominant features of his face. Diego Navarrette, executive dean at West Pima College in Arizona and former chairman of the Expansion Arts panel, spoke with a poetic fervor, eyes full of intensity and a passionate purpose. There was the fiery Marta Moreno Vega, who headed the Association of Hispanic Arts, headquartered in New York, and the equally fiery Miriam Colon Edgar, director of the Puerto Rican Traveling Theater Company. There was Antonino Hernandez-Lizaso, a government coordinator for the arts in Miami and a composer-conductor. Antonino was perhaps the most outspoken, though there was competition. And there was Luis Jimenez from New Mexico, a sculptor of national reputation with his large and colorful work, cowboys and rearing bucking steeds full of energy. There were poets, painters, dancers, composers, photographers on the task force. On the council itself during my term were Martina Arroyo of the Metropolitan Opera Company and Margo Albert, who had played opposite Ronald Coleman in *Lost Horizon* and was the wife of film star Eddie Albert. (The "Margo" came from her early film days, when to use an Hispanic name could have precluded steady employment.) Margo was the moving force of the Galeria de la Raza in Los Angeles, which had an exceptional program for the arts in education and presented the Hispanic arts to a broad and unrestricted audience. And there was Bernie Lopez, director of the state arts council in New Mexico, skilled in gov-

ernmental advocacy, slender and mustachioed, with a keen wit and long administrative experience. In many ways these men and women were survivors in a society that was often inattentive. To provide equal support was not of first importance, however. To provide equal opportunity was.

The task force met and conducted its research in different areas. Deputy chairman David Searles often met with them. Spanish with a Maine accent was overlooked, for David's dedication was quickly perceived. The panel structure became more responsive; applications once given perfunctory notice were now better understood. Patterns began to change. Weeds? By no means. But a garden given a greater variety of bloom? That was the purpose.

The early meetings were frequently contentious. Unlike Washingtonese, the Spanish language is not famous for understatement. Survivors given the chance for more are apt to lose patience. David's diplomacy was not always a source of rescue. Chicanos, from years of experience, mistrusted New Yorkers and Puerto Ricans, and vice versa, and trisected. Yet these were artists, and they had the arts in common. The art of surviving requires shrewdness and wisdom, and it was perceived that more could be gained in unity than in fragmentation. This was my own theme, and it found an audience.

Gordon Braithwaite was black, Walter Anderson was black, Joe Rodriguez was Hispanic, but they were capable of looking beyond partisanship. There were confrontations and accusations, and there were passionate differences of opinion. There were voices of reason, and there were practical reasons for a developing harmony. An increase of understanding, an increase of opportunities, the establishment of a network of guidance and counsel—it began to happen. A sense of optimism emerged. We all meant what we said we meant. Trust emerged, too.

That first year support for minority arts projects (those that could be clearly defined) rose from $8 million to $11 million, or close to 40 percent. In terms of the overall budget, the change was relatively minor, but it showed direction. Percentages also shifted upward in employment of general staff, in applications approved for minority groups, in regular programs and challenge grants.

Congresswoman Shirley Chisholm invited me to appear before the Congressional Black Caucus. "We want to hear your story," she said pleasantly. "It's going to be quite informal." We had a good record to discuss.

The hearing room was arranged with a series of semicircular seats, rising in tiers. On each rested a number of microphones for the individual speakers, seeming to number close to seventy-five. At the low-

est level, Shirley Chisholm was seated at a small table. She invited me to join her and gave me a friendly introduction.

I began by explaining that my efforts were not to alter the endowment's basic work or to compromise excellence, but to develop a fundamental fairness and the opportunity for all artists to be reviewed fairly. I would not have placed an emphasis on minority concerns, I said, had I not believed that corrections and improvements were in order. I went over some results.

The others began to speak. I was immediately aware of the tenor of the remarks. The first speaker greeted me politely and said he looked forward to improvements; the second concentrated more on the improvements desirable; the third, more on the undesirability of the past; the fourth, on present actions; the fifth, on the need for more strenuous work; the sixth, on the undesirability of the present, and so on. By the time the final speaker's turn arrived, from the highest tier, I was at a loss to guess how the previous speaker could be topped, but not for long.

Mr. Biddle, you are an evil and dangerous man, and we will be doing our best to get rid of you.

Informality, it seemed to me, was not fully descriptive.

In summing up, Ms. Chisholm remarked that this was telling it, brothers and sisters, like it is.

I saw David Searles, in a gathering of endowment workers in front of us, rising from his chair. A.B. Spellman, black poet and scholar who would head the Expansion Arts Program in days to come, looked uncomfortable. Others looked distressed. I wondered if I should attack and decided I was well outnumbered. I thanked the speakers for their candid views and said I hoped to be around for a while. I could not recall feeling more disheartened.

Then we joined each other for conversation. I remembered vividly the Theatre Communications Group meeting in Princeton. I sought out an old friend from the past. "How could you possibly say to me what you did?" I asked.

"Man, that's real Mau Mau," he said with a broad and a suddenly very beguiling smile. "You better get used to it."

We did a lot more research, with Phil Kadis, whom I had asked to join the endowment's planning staff, assembling the findings. We discovered that, while Shirley Chisholm was correct that out of 325 staff positions, only five minority employees were at the higher-echelon GS-15 level; we in fact employed only twenty-four such GS-15s. Minority employees were thus 21 percent of that responsible work force. Similarly, it was true that of 309 challenge grantees, only fifteen had been minority organizations, but the majority of such applicants had been successful,

whereas for all applicants, the percentage of successes was less. Shirley Chisholm said that eight black dance companies were "denied" recent support for touring. In fact *seven* had been unsuccessful in their applications, but an equal number had been provided support—a ratio respectable for the endowment as a whole.

Statistics can be turned in various ways. These and others were reported to Congress. Shirley remained an implacable advocate, but the episode of the many tiers was not repeated.

In San Francisco we visited the Mexican Museum, directed by Peter Rodriguez (not related to the endowment's Joe), and observed in a relatively small space—well-lighted, with an impeccable attention to display—the artifacts, the tradition, the cultural expression of Mexican-American artists. We saw the pottery of Candelario Medrano with its surrealistic overtones; the examples of ancient clay statuary; the meticulously representational figures, clothed in jewel-decorated fabrics, reverent in theme and from earlier times. We saw the altar pieces of the Day of the Dead, with their intricately arranged compositions, small carved skeletons, devils, crosses, simulated fruits and vegetables, and candles in elaborate holders. In other contexts these *ofrendas* could be called whimsical, macabre, even grotesque, but in family homes or at gravesites they are symbols of belief, respect, the inevitability of death, the continuance of life. On El Dia de los Muertos, death seems transcendent, yet given a festival aura.

I paused to think of my own beliefs. I wanted to learn more. I was aware of the remarkable diversity of mankind within the common denominator of the arts.

At the new Afro-American Historical Museum in Philadelphia, we attended a preview of a black opera, an earnest attempt by talented young artists to create a new art form, based on traditional drama, choreography, and music, but combining a European heritage with African harmonies and rhythm. The music had an excitement, a special flavor. It offered a glimpse of one culture striving to affirm its individuality among the currents of other cultures. This was an evening when the genuine was clear.

The genuine was always present at the Elma Lewis School for the Arts in Boston. Elma had extraordinary tenacity. Diminutive in stature, her skin of mahogany hue, she persevered, teaching, directing, cajoling, scolding, sympathizing. Like others, she had been haunted by adversity over the years. She had struggled with staff, with unmet expectations, with financial crises. A grantee since the Roger Stevens regime, she continued to receive support under my tenure. I admired how Elma kept going. She never lost her spirit; it is the secret of her success. I spoke at

the celebration of her freshly renovated quarters, and a large chorus of her best young vocalists sang out a message for Christmas and the New Year.

An almost identical valor characterized Miriam Colon, president of the Puerto Rican Traveling Theater in New York. Toward the end of my tenure in 1981, the theater held formal inauguration ceremonies for its new home "in the Broadway area," as Miram wrote, "304 West 47th Street." The address was significant. It meant a location among famous colleagues in New York City. It meant an end to efforts in the temporary, the never satisfactory, the less accessible, the always slightly suspect. The event meant prestige and recognition. Discouragements, severe financial travail—Miriam had known them in all their flappings of raven wings over the doorways.

So on a March night, there was celebration. I addressed the gathering, seeking as I had in Boston to praise their achievements and exceptional energies. Mayor Koch was there, along with many government dignitaries from the Senate and House and from Puerto Rico. The lights were bright and festive. It occurred to me that for once this small dark-haired lady—with the big flashing eyes, the indomitable chin, the now-joyful voice—could enjoy an evening without care.

Mayor Marion Barry of the District of Columbia, with his tall and elegant wife, Effi, gave special support to the arts, following the tradition of their predecessors, Walter and Benetta Washington.

The District of Columbia Commission on the Arts and Humanities was strengthened in budget and by the leadership of Peggy Cooper. Peggy was sometimes friend, sometimes antagonist, determined that minorities in the arts would receive their deserved share of support—deserved as Peggy interpreted the word, liberally, but with an absolute firmness of conviction. Others might voice a militantly firm viewpoint for effect, but Peggy expressed her attitudes and beliefs with logic, with preciseness of information, and with a gifted command of language. We were never in total agreement, but that was the nature of the relationship, and proper to it. She was among the very best of the arts advocates I encountered. I will not say I always looked forward to our conversations, but I respected them.

I was a keynote speaker at a special awards dinner of the National Association of Negro Musicians, headed by its president, Brazeal Dennard. I remember with much pleasure Ken Billups, highly regarded as a music panelist at the endowment, providing me with a generous introduction at a gathering where Catharina and I were in almost total minor-

ity and when the endowment's aid to black artists was under particular scrutiny and debate.

We worked with the gifted Arthur Mitchell, founder of the Dance Theater of Harlem, helped by the endowment in its very beginning as a training school for young dancers, and later as it grew in artistic and performing skills to its worldwide reputation. This is a good example of the National Endowment for the Arts fostering the start and continuance of particular success.

And in the District of Columbia, we worked to establish a new center for the arts, with minorities well represented, in the Lansburgh's department store building on Seventh Street. Vacated in large part, it was balanced between demolition or revival. It was close enough to Pennsylvania Avenue to attract attention from development authorities interested in enhancing the famous route to the Capitol. The immediate surroundings were shabby. Why not an art center to attract a new clientele to the neighborhood?

I gave a number of presentations to business and civic leaders. A plan was approved. The endowment provided a challenge grant for work to begin. The ratio of three nonfederal dollars to capture one endowment dollar was met. The center grew. So did other places for the arts, galleries, studios, new or improved restaurants—a look different from the past and, I think, much better.

In all my discussions on minority issues, I heard one particular concern reiterated. The applicants had but one program that gave them shelter and, they felt, full understanding. It was called Expansion Arts, created by Nancy Hanks and director Vantile Whitfield to address the arts as they developed and to answer minority needs. Expansion Arts, however, was criticized as a dead-end street. Once afforded help from the program, a grantee was stuck, unable to move into one of the arts discipline programs—music or dance or theater. A grant from Expansion Arts was helpful for a beginning, but it was not the springboard it should have been. The grants were generally small, and the opportunity for growth was relatively lacking.

But there was also an advantage: the lack of competition with larger, more established institutions in which panelists might well have greater confidence. Was a grantee not better off with a small amount of support from Expansion Arts than with no support at all from another program?

Was there another solution? I felt it lay in the proven concept of challenge, in that area of endowment work where the organization was challenged to go beyond an equal, one-to-one match and meet a more demanding ratio. The regular challenge grant required a ratio of three or

four to one. A sliding scale would present relatively less hardship in the beginning and more responsibilities as time continued. Legally, I decided, it would be possible to construct such a flexible program, and with it a new type of assistance.

They were called "advancement grants," and they were instantly sought. Applicants were scrutinized most rigorously by fiscal experts, and of course, for artistic quality. But these were, in most cases, grantees we knew, grantees whose artistic value was not in question. The competition was intense, the most intense of any I knew as chairman. Here, however, was the opportunity to escape from a pattern, to progress, and, most important, to prove full financial ability.

Almost 300 organizations applied for the first round of grants in 1980. Eight were selected, but the number of the successful soon grew. Represented were the fields of literature, dance, folk arts, jazz, theater, and museums. At the New York celebration announcing the program's beginning, U.S. Representatives Ted Weiss and William Green, a Democrat and a Republican, kept manifest the endowment's bipartisan spirit. Council member Toni Morrison, in the literary tradition of earlier member Ralph Ellison, was a welcoming participant in the ceremonies. These first advancement grant recipients paved the way for others. Indicative of the level of competence was the Negro Ensemble Company, with Douglas Turner Ward as its director; "A Soldier's Play" (later *A Soldier's Story* on the screen) came from this company. The arts, and the public, gave it highest accolades.

Elizabeth Weil was also present at the ceremonies. She directed the Challenge Grant Program, and now guided this, a variation on a similar theme. Of all those who worked so hard at the endowment during my time as chairman, none was more outstanding than Liz Weil. Intelligence and conscientiousness were hers in abundance. I am sure there were times when the rigors of "Advancement" pressed hard upon her, but she had special faith in the benefits to be gained. That faith, with her own skill, gave us heartening results.

And then there came a morning when I was visited by a group of minority leaders, in the arts and in civil rights. This was a regular occurrence, though the group changed from time to time. Confrontation had become more modulated, but it continued. This morning, it continued, I thought, unreasonably. So I said with a smile, "You know, there's an old musical comedy I saw years ago. It was called 'Annie Get Your Gun,' and there was an Ethel Merman song in it that went like this—'He's gone about as far as he can go. . . .' Well," I said, "I've gone that distance, because I believed it was right—but it's as far as I'm going. No further. No more. That's it."

No one laughed that I can recall. No one smiled. It was a rather

solemn moment, despite an intention to keep it light. No one remonstrated, no one praised. No one suggested one more for the road. That was it.

I had worked with so many leaders in the minority areas of the country. I had learned about distrust and disavowal, and about affection. I do not think we ever compromised with quality or with intolerance. I had consulted with artists and administrators, with those in government, with educators, with principals in the civil rights movement such as the greatly wise Dorothy Height and Coretta King. I believed that the endowment was now responsive, as I meant it to be—and fair.

Chapter 55

ARLY IN 1978, DURING MY FIRST HEARING ON BUDGETARY NEEDS BEFORE the House Appropriations Subcommittee on Interior and Related Agencies (of which the Arts Endowment was one), chairman Sidney Yates took me aside. "Liv," he said, "the endowment has grown steadily over the years. I believe in its concepts. I don't feel I have a full understanding of all its activities. I want to understand them all. I want a full familiarity of how they developed and why. If something is wrong, if there's a need to correct, better to know about it now, when you're entering the job, rather than later when it's all your responsibility." He was asking the parent Committee on Appropriations to conduct a full-scale study and investigation. The Humanities Endowment would undergo a similar investigation. Both were in their thirteenth year of operation. Congress had been presented annually with volumes of testimony from the two endowments and from outside witnesses questioned on the efficacy of the programs, but Congress never had made this kind of comprehensive probing on its own.

We had nothing to hide. We believed what we were doing was entirely justified and of increasing value to the arts, to individual artists,

to partnerships with the private world and other governmental groups, to the stimulation of greatly increased philanthropy and awareness of the contributions the arts could make in communities large and small. We believed our record was sound. We were diligently seeking to improve upon it.

In July the investigation began. I welcomed it. How the endowment's activities had grown was a complex story involving the diverse nature of the arts, and needs to be met with increasing but still limited funding. "Music, instrumental and vocal," as in the enabling legislation, now involved many areas: orchestras; the librettist and the composer; the important area of American jazz; opera; the solo artist; the potentials of chamber music and choral music. There were a growing number of variations on a central theme, each individual, each requiring differing kinds of applications for support and differing methods of review. So it was among the dozen major program fields. To celebrate and assist the diversity of the arts, a diversity of response was essential. Those basics must be part of the story.

So all the books were opened for study, all the files and related documents, the sensitive and the routine. I instructed the endowment staff to be forthright in all interviews and discussions. Panel and council meetings were open to the investigating team, two individuals seemingly well trained in reviewing practices and well schooled in congressional concerns. I met and talked with them upon their arrival.

Eight months after it began, the investigation concluded with the issuance of an eighty-one page report. I was given an advance copy, in keeping with a normal procedure of courtesy for an agency head.

On the first page, in paragraph two, I found a compliment. The investigative staff wrote that the endowment had been "cooperative and candid during the survey, extending invitations to attend executive sessions and meetings normally closed. . . . The Investigative Staff notes the change in leadership and direction during the past year," the report continued, "and recognizes some endowment activities and policies were begun under a previous leadership." So far it was factual and true.

In paragraph four, I read: "The Investigative Staff found the NEA deficient in its management policy and practices to the extent that the NEA, in the opinion of the Investigative Staff, fails to meet its legislative mandate."

I remember sitting alone at my office table and looking for a long time at these lines. "Fails to meet its legislative mandate." That seemed to me about as severe a complaint as could be made. Could better meet? Does not fully meet? There was no mitigation, however. The words had a bleak and conclusive tone. They seemed to suggest not a survey but harsh criticism. I read further. My impression was reinforced.

How could this be? Granted, the investigators may not previously have been acquainted with all the intricacies of the arts. Granted, they came not from Sidney Yates's subcommittee, but from the full House Committee on Appropriations. Were they not, however, individuals of intelligence? Had they not spent eight months in careful research?

But wait—what was this? I read again, on page one. "The NEA," it said, "is charged, with the advice of the National Council on the Arts, to develop and promote a national policy for the arts."

There was a fundamental omission. The endowment was never authorized by Congress to develop national policy for the arts or to promote it. To develop a broadly conceived national policy *of support for* the arts—those were the words I had once drafted. A national policy would have been shunned at the very outset as authoritarian, as reminiscent of dictatorship and of arbitrary governmental rule and control. So the words "of support for" were there, to indicate partnership and basic guidance, not by government but by private citizen experts. To misunderstand the difference involved was to misunderstand the law itself and its mandate. No wonder, then, that failure was perceived. Had we succeeded, the endowment would have been altogether different than Congress had intended. There would indeed be in place what Congress had most feared: a cultural czar.

But if my assessment was valid, was not this investigative report flawed at the outset? Did it not build on flawed assumptions? I called in my most experienced staff members and asked them to review the report in confidence. Page by page I did the same that day, reading quickly, making notes.

I was asked if I knew the investigative staff had received experience at the FBI. Whether this was true did not seem germane. The report was written and in the possession of Congress; it must be addressed on that basis.

That evening, I recall meeting Sidney Yates at an arts function. I did not yet know him well, but I knew that he was particularly interested in the arts and in their progress. He told me that he understood the investigative report had been completed but that he had not yet seen it. Had I had a chance to read it through?

"Not entirely," I answered. "But to some extent."

"What was your reaction?" he asked in a friendly tone.

"I was outraged," I told him.

He looked surprised. "Outraged?" he asked after a short pause.

"Outraged!"

It was not an adjective to be used lightly in a conversation with such a leader in Congress, and by a new chairman still finding his way in a new post.

Sidney gazed at me quietly. I had not been known for intemperate remarks.

"All right," he said with a slight and partly aloof smile. "Tell me about it, in writing."

We did. I reviewed the document with minute care, almost word by word, as did others—Ana Steele, the endowment's senior in terms of continuing service, among them. Our reply was approximately the same in length and detail as the report. Its tone was considered. Should it be couched in polite phraseology? Should it be deferential to the traditional wisdom of Congress? Or should it indeed reflect outrage? With some modification, I opted for this course, doing much of the final writing and editing. The endowment's reputation was at stake; and since the report recommended a moratorium on any further increases in funding until corrections were made, so was its life.

So we began by stating our initial belief that "an outside, objective, and fresh review of the Endowment would be useful in supplementing the Endowment's own internal review, which has already resulted in major policy changes." We disclaimed, of course, perfection or infallibility, but wrote, "We are deeply distressed by the report presented to us and contend unequivocally that it represents a most serious disservice by consistently misrepresenting our mandate and operations. Although hundreds of hours were spent by the Investigative Staff in their interviews and research, as well as by the Endowment Staff, panelists and others cooperating in their every request, we find the report so flawed both conceptually and technically as to be almost without merit."

These were strong words. So were "misleading innuendo" and criticism of the method of analysis used, and "large, damaging, and unfounded conclusions" drawn from the "insubstantial and unsubstantiated."

"We find the report misinterprets our legislative mandate," we wrote for Sidney Yates, "[it] draws sweeping conclusions based on supposed facts that are breathtakingly inaccurate, gives almost no recognition to administrative reforms undertaken within a very tight budget during the very time of the investigation, and finally, is haphazard and often reliant on gossip and hearsay in its methods of reporting."

From a perspective of time, from emotions remembered, reviewed, and considered in greater tranquility, the basic flaw in the report lay in its lack of the authentic. It could not be corroborated by a knowledgeable and experienced review of the record. Therefore, it was objectively refutable. We set about refuting it line by line. The question was: Would we be believed?

It is not unusual in government, or elsewhere, for the criticized to become the critic. Is that not a part of the whole democratic process? Freedom of expression is often freedom to find fault on either side of an issue. Of course the endowment would react, would defend itself against alleged mistakes, errors, and failure. Was it this, however? Sidney Yates could provide the answer, formally and in accordance with all the protocols and traditions of the legislative branch and its oversight of the executive branch.

Sidney Yates was in a difficult position. As subcommittee chairman, he had requested the investigation; it had been conducted by investigators the committee trusted. They were not malicious individuals, despite some feelings of my own staff. They were doing their job in the way they understood it, just as we were doing ours. On a few points, we could agree. For example, the endowment was authorized to contract for services, as well as to furnish grant support. There were not, relatively speaking, a great number of contracts. They involved research projects and special studies, assessments of need in a particular arts area, assessments of how best to stimulate corporate giving. Our approach to contracts could be improved; but just as in the case of the panel system, the corrections were in progress, independent of any congressional review. It was especially distressing to find the superficial so often taken for fact, and then the seeming fact used in a broader sense to produce a generalized finding.

In these days I became better acquainted with Sidney Yates, his special regard for the arts, his knowledge, and, above all, his sense of fairness. Nothing was taken for granted on either side of the issue. We were given ample opportunity to present our case, not just on paper, but in great detail at a special hearing Sidney Yates conducted. During the two days of testimony our refutations were examined, as were the investigators' response and our response to that. At the conclusion, it was determined that the negative emphasis of the report was unfair. Sid Yates was quoted as saying that while "useful material" had been assembled, it gave a "misimpression, . . . which is why I brought the reports before the hearings and gave the endowment the opportunity for review and rebuttal." In the end the investigators' report was set aside. We could continue with an emphasis on the positive.

It was an arduous time, a time of testing and soul-searching, as my colleagues and I scrutinized and analyzed each step the endowment had taken for well over a decade. We did not ask what we had done wrong, but how we could do better? For the National Endowment for the Arts, it was a time of examination and questioning. It was also, in a certain sense, a time of affirmation. Nothing so focuses one's attention, goes the comment, as the prospect of hanging. In this respect, our attention was focused in spades.

* * *

Ruth Dean wrote extensively about these moments. As a staff writer for the *Washington Star,* she covered the arts, and did so with an exceptional knowledge and caring. Ruth was never satisfied with the half-truth. Sensitive to the smallest effort at evasion, she simply rephrased her questions and skillfully put them another way. Her articles had a thoroughness rarely found in any press writings on any subject. I used to worry about her calls and welcome them at the same time.

She wrote of the "drama" of the hearings described here, "including a surprise appearance by Rep. Shirley Chisholm on behalf of the Black Caucus to protest endowment practices—later refuted." She spoke of the "disappointment" of Sidney Yates with the investigative report. In a long article Malcolm Carter, Associated Press reporter based in New York City, quoted chairman Yates again: "I do not think the report has really achieved the purpose, at least that I hoped for. . . . What struck me about the committee's report was the total lack of commendation." Carter reviewed the subjects of criticism—a "closed circle" of application review, a lack of adequate review time—and took me to task for using language that was too "intemperate." A sense of outrage, however, does suggest certain phrasing, and had I not been given invitation?

Malcolm Carter made this point, interesting in an historic sense: "Both the report and the reply proved that the National Endowment for the Arts had reached maturity at 14 years of age. For all those years, its benefactors on Capitol Hill and its supporters elsewhere had felt that to criticize the endowment was to arm those in power who considered the arts too frivolous to warrant federal expenditures. That the endowment could suffer an assault like this meant that it had passed beyond childhood and into adolescence. That it could *withstand* such an assault, fighting with gloves off, meant that it had now grown up."

Ruth Dean described Sid Yates as an unassuming, friendly, relaxed man, "a mixture of soft charm and sharp perception." I also thought of him on occasion as the tiger ready to pounce.

In an early appropriations hearing Mr. Yates held the printed volume of our testimony and, placing the binder under his nose, said to me, "It doesn't smell too well. Don't you agree, Mr. Chairman?"

I was uncertain how to reply. Was it a jest? Was it an innuendo? Or was it simply a factual statement about the plastic? The moment slipped by, for after a short pause he turned to matters of funding.

As I came to know Sid Yates, I realized he had expected a rejoinder—something humorous, or semi-barbed, or something unexpected. In later days, I came to anticipate the unexpected. It was a part of his questioning. Often it provoked laughter, sometimes from his colleagues on the subcommittee, more often from those in the rows of chairs ob-

serving the hearing in a room always crowded with people interested in the arts.

He had grown up in Chicago, with a family who loved music—a sister who played the piano, a brother-in-law in the business of selling phonographs and records. He enjoyed listening to operas and symphonies. He and his wife, Addie—charming, witty, dynamic, talented in music, a courageous participant in life—became art collectors. They were in part the rediscovers of the impressionist Gustave Caillebotte, whose work they possess, work that languished for a time in the shadow of more noted masters.

Born in 1909, Sid Yates had received two degrees from the University of Chicago, bachelor of arts in philosophy in 1931, doctor of jurisprudence in 1933. He had served in the Navy in World War II, entered state politics in 1935, the year of his marriage, and was elected to Congress in 1945. In consecutive service, he missed one Congress, the 88th, when he ran against the well-known Everett Dirksen for the Senate and was narrowly defeated. It was when President John Kennedy chose to favor seeking a supportive Republican voice rather than the voice of a gifted member of his own party. Sidney Yates was appointed to a United Nations ambassadorship, but returned to the House in 1964, where he has been for the ensuing years—in all, eighteen terms now, thirty-six years. He ranks fifth in total terms of service in the House of Representatives.

In the arts area, he was assisted during my time as endowment chairman by Fred Mohrman and Michael Dorf. Fred worked as subcommittee staff principal, quietly seated near his chairman, looking out over the tops of his glasses or down at the wealth of material kept in readiness, annotated, marked. I never saw Fred's preparations miss a beat. "I remember that conversation we had a couple of years ago on . . ." Sidney would begin, and mention a distant subject, statistic or whatever. Instantly, the reference would be at his elbow. I admired Fred greatly, remembering my own past efforts in the Senate. We had a background in common.

Mike Dorf was assigned to the Yates office as special counsel. He was a writer, a lawyer, a sometime composer of musical scores. He loved the arts, and he gave them dedicated attention and particular understanding. His responsibilities kept growing with time. He, too, had my particular admiration.

It was a remarkably fine office, but no mention of it can be made without recognition of the exceptional ability of Sidney's administrative assistant, Mary Bain. The wife of a pianist and a devotee of the arts, Herbert Bain, Mary had been through all the political skirmishes, battles, and wars with Sidney Yates. She had been a high-ranking official in state

government when she joined his staff. She directed it with a talent I found unique. Mary could be the defender of the portal or the welcoming hostess with equal aplomb. She had such spirit and such a quick wit and intelligence that it at once inspired a lasting respect and a lasting loyalty. It also inspired affection from all concerned with the arts. There was no question, ever, about Mary's loyalty. It was with Sid.

In the Senate, Ted Stevens was for a time the parallel appropriations subcommittee chairman. Then when he moved upward in Senate authority, it was James McClure from Idaho. Both senators knew the endowment well and understood the benefits of federal support for the arts. Both were advocates. Ted Stevens discounted the criticism contained in the House report and did not pursue it. Louise McClure was especially interested in the visual arts and in Idaho artists. Ted Stevens's wife, Cathy, has in more recent times joined the board of the Washington Opera. A graduate of Harvard Law School, a pilot with the 14th Air Force in China during World War II, a former public official in Washington and majority leader in his state's legislature, Ted Stevens came to the U.S. Senate in 1948 and has steadily risen in senatorial authority. He is scholarly in appearance and dogged in persistence, deceptively gentle, eminently firm, and fair. His interest in the arts spurred cultural development in Alaska—a leading example of how one member of Congress, concerned about the arts, can greatly encourage cultural benefits at home. I agreed with him on the need for greater state involvement. It was a common bond, and a position of advocacy he repeated each year.

So there were sympathetic attitudes in Congress. The Senate's recommended funding figures were usually below the figures approved by the House. There would be a conference between House and Senate, with the leaders, Sidney Yates and Ted Stevens or Jim McClure. Usually, with his own special powers of persuasion and experience, Sid Yates would prevail.

He did so, I think, because his particular knowledge of the subject was so generally respected. It was said that Senate conferees, knowing of Sidney's support, placed the arts a bit lower than the House to gain concessions in conference. Then they could bargain for their own favorites in a total appropriations bill of several billion dollars, covering the broad reaches of the whole Department of the Interior. Most of that is exaggeration. In a House-Senate conference of this magnitude, many issues are of high consequence. To the arts, the sums involved have profound meaning; out of billions, a tiny percentage can mean progress or a retreat, a growing catalyst or a regression, optimism or pessimism. The difference, though relatively small, is hard won. There are never easy solutions in a conference with such a multiplicity of priorities and with

such an inflexible ceiling for the final total. A special kind of leadership is necessary, a firmness toward one's own sense of importance. Sidney Yates has provided that special leadership year after year. Among supporters of the arts in Congress, he stands out.

After the Investigative Report had been aired, he said, "I really wanted to find out how the Endowment worked, what they did and how they did it, what their problems were, what their faults were and what their good points were." He undertook his own personal review. He would visit the endowment, always unannounced, and talk with program directors and other staff members. I realized then that a tiger was not prowling the corridors, but an individual in great authority, ready to listen and absorb, to criticize with the idea of improving. At first, program directors were wary, but those feelings eased, for he could speak with them with an equality of knowledge. He could discuss music or literature or museums or painting, whatever subjects were on his program that day. I remember once being in his presence at a small exhibition of Mexican art. He could identify the artists better than anyone in the room.

When I was chairman we had the formal relationship necessary to our work. An agency head is usually circumspect in his statements and rejoinders when it comes to testimony before a subcommittee at appropriations time. I think of the other subcommittee members. On the majority Democratic side were: Clarence Long from Maryland and Norman Dicks from Washington, who were believers in the arts from the outset; Jamie Whitten from Mississippi, the House's most senior member and Appropriations Committee chairman, who sat with us from time to time and tempered support with some doubts; John Murtha from Pennsylvania, whose expressed doubts and serious reservations changed as the arts moved out from the major cities and across the country in accord with the beliefs he and I shared; Robert Duncan from Oregon, a skeptic on most issues, with an outspoken wit exemplified in colloquies with his chairman. On the Republican side, I think of Joseph McDade, also from Pennsylvania and among the founding fathers of the Arts Endowment; Ralph Regula from Ohio, given often to early reservations; and Clair Burgener from California, a keen observer and essentially a friend. I think, too, of an early subcommittee Democrat, Gunn McKay from Utah, white-haired and articulate but not always about the values of the arts.

They all listened to Sid Yates, but never in full agreement. It was a contentious subcommittee, and each member had quite definite priorities. Circumspection and thoroughness seemed to me, in the beginning, a valid approach.

But following the investigative report, the mood changed somewhat. Chairman Yates would listen to my comments and remarks and then call to the witness table the program directors. They would look at

me for guidance, and I would give them a nod for candor. They were often queried at length on needs, on problems or on goals as they saw them. I was not always certain we advanced our best foot forward, but the discussions were lively and touched with humor, and it was said that more time was spent on the arts than on other issues. Sidney Yates once paid me the ultimate compliment by remarking on the exceptional nature of the staff I had brought together. He always recognized candor, and it became our principal source of help.

Since leaving the endowment, I have come to know Sidney Yates as a good and close personal friend. It is a source of particular joy. Once, when I was chairman, there was a gala evening at the Arena Stage in Washington. Addie Yates, Sidney's talented wife, had put together songs with original lyrics and a program celebrating facets of national life—and, on occasion, giving them the flavor of parody. Addie had asked Nuala Pell who might help with the singing renditions and Nuala (not Claiborne!) had suggested that I had a reasonable voice. I knew Addie but slightly then. She came to the endowment with a pianist, to inquire in what key I sang. She found it disturbing that I had no ready answer, but I was entrusted with a song. I realized that the lyrics were by chairman Yates himself, to a melody from "Fiddler on the Roof." The words were perfectly fitted to the music and had a complex rhyme scheme. I recall rehearsing in solitude in the Arena basement before the performance. Suddenly in the dim light a figure loomed, approaching me. It was Mr. Yates. "Sing it well, Liv," he said in a commandingly cheery tone. I haven't the foggiest notion in which key the ballad was rendered, but, believe me, I made no mistake in the lyrics.

It seemed to me all the VIPs in Washington were there that evening. I masqueraded as a candidate seeking election and in plaintive quest for a fundraiser, rather than the matchmaker in "Fiddler on the Roof." I made up a large cardboard button, gleaming and many-hued, with the legend, "Live a Little with Biddle." Come to think of it, I might still use it some day.

These moments come back to me with nostalgia, with feelings of loss and gain. They come out of the shadows, the half-lights, the lights that signal events. They come from memories over a long period of time. Words and memories and songs, special individuals whose friendship one cherishes in life, individuals particularly identified with the arts. I think of Marvin Sadik and later Alan Fern of the National Portrait Gallery; George White, architect of the Capitol; and O.B. Hardison, the particularly gifted scholar who directed with innovative skill the Folger Shakespeare Library and Theatre. So many shared their experience with me and helped to instruct me.

Catharina and I have many photographs framed and placed in

daily view to remind us of the opportunities we have so enjoyed. And we have snapshots to revive special memories. One small sequence displays a birthday party for Sidney Yates in his offices after my work as chairman ended. I gave him a greeting, without accompaniment, in whatever key. But if there had been a musical score, it might have said "molto con expressione." I had my own lyrics this time, sung to a Cole Porter melody—"You're the Top!"

Chapter 56

THE NATIONAL COUNCIL ON THE ARTS WAS CONCEIVED AS THE ESSENTIAL means of ensuring the guidance of private citizen experts. In the early days, its advice and wisdom set into motion new beginnings for the arts. The members talked beyond the limits of regular meetings and late into the night about hopes and visions and the possibility of fulfillment. And funding grew, and programs grew more numerous and more complex as new avenues of support were opened.

Twelve years after enactment of the basic law, the council found itself concerned less with vision than with an increasingly detailed review. From less than a hundred, applications were growing to well beyond 25,000 annually. Before their meetings, council members received larger and larger volumes containing detailed evaluations by panelists in each field, each subdivision. Under the law, the chairman cannot take action without a council recommendation. The review process was intrinsic to the endowment's integrity and to its success, to the trust of the arts community, itself growing rapidly. As that growth occurred, as knowledge spread, as the arts grew in diversity, so did they grow in an expressed diversity of viewpoint, and in contention, often with each other for a better place in a brighter day.

It seemed to me that we needed some unifying forces, not to try to lessen the diversity that made the arts special, but to provide coherence, so that support could proceed without unnecessary argument. I felt the council could be such a force, and I found its members had a great desire to become more involved.

One of their concerns was that routine was detracting from imagination, that necessary but time-consuming activities were intruding on the three-day meetings, held five times a year. Program guidelines were presented in minutely detailed printed form, and there were pages and pages of recorded panel work. I tried an experiment. I asked the council members to review the panel recommendations in private, so that when they came to the meetings their questions, not each approval, could be discussed. Would the members be conscientious enough to make a time-saving effort work? Not only was there an encouraging yes, but there was now time to review the controversial and highlight it. The sense that the council's work was too much of a rubber stamp faded.

Most of all, however, the council wanted a greater share in the endowment's preparations for the growing scope of its activities. How could one be ready to discuss a budgetary change knowledgeably without a familiarity with the motivating factors? How could one react to a proposed programmatic change without sharing in the steps leading to it? How could one advance a new idea or policy intelligently without a thorough knowledge of the background?

J.C. Dickinson (always with those initials, sometimes to supplement, "Josh") was a particular leader in this respect. Director of the Florida State Museum, he was eminently qualified as a museum authority and an educational authority. He worked on the council in close rapport with Willard "Sandy" Boyd, then president of the University of Iowa and later president of the Field Museum of Natural History in Chicago.

Josh Dickinson headed the Policy and Planning Committee I organized with members Theodore Bikel, once president of Actors' Equity and union leader; Maureen Dees, from the community theater world in Georgia; Martin Friedman, director of the Walker Art Center in Minneapolis; and Bernard Lopez, the state arts council director in New Mexico. Deputy chairman David Searles gave them the staffing they required, including the former journalist Phil Kadis, Larry Baden, Eva Jacob, and Larry Kubota, all of whom were experienced in applying to planning the essentials of research, which emanated from a small group headed by Harold Horowitz.

Policies are never easily generalized, and are less so in the arts. The case of OOBA—an early point of tension for the new committee—comes to mind. OOBA was not played on a tuba in the Caribbean,

though I never could quite suppress a smile at the acronym. This OOBA was a most serious association concerned with the welfare of the off-off Broadway theater, championed early on by Roger Stevens and the source of creative work and creative talent in New York City. The association found the usual union wage scale too difficult for its members to meet and sought to make its opinions widely known. The endowment had from the beginning allocated a small percentage of its annual budget to the so-called service organizations, which help strengthen arts groups and thus help strengthen opportunities for individual artists. OOBA was within this category of endowment help.

But was not OOBA engaged in lobbying against proper compensation for actors, indeed against those pay scales espoused by the endowment's congressional mandate, reached after the bitter debates on this subject in the early 1960s? So suggested Theo Bikel, while Martin Friedman suggested that Theo might best withdraw from the discussion because of possible conflict of interest.

What did the actors think? They wanted financially secure small theaters to employ them; they also wanted their just desserts in wages. They were divided on the issue. The theaters felt they needed OOBA's help as their representative, as a coordinator for private fundraising; thus, in essence, they were "management" and opposed to a union they considered, in some respects, unfeeling. Had these small theaters been less vital to the field of theater as a whole, the matter would have been of a limited impact. But tensions were high, and increasing.

And tensions were high at the endowment when the relatively new committee of the council sought a resolution. Theo Bikel spoke out in resonant voice for justice as he saw it; Martin gave strong objection. Our general counsel Robert Wade, now in the position of the early Solomonic Charles Ruttenberg, was called in to rule on conflict of interest as it applied to OOBA vis à vis the law, and Theo Bikel vis à vis OOBA. Suddenly the committee was locked in acrimony, and into a tie vote.

I decided to break the tie, which was my prerogative, without a formal request or a formal legal determination. I ruled that Theo was within the boundaries of propriety as long as he argued for the principle involved with reference to a particular grantee, and that OOBA could continue to receive help as long as such help was used for its normal work, not to argue against the union. I asked the association for a special financial report with activities clearly detailed. I visited Don Grody, then director of Actors' Equity, and the wage scales were arranged to follow the sliding scales Equity on occasion permitted.

A relatively small issue, a small moment in history—but a lot was at stake, including perceptions of fairness, personal to me, and in broader context.

* * *

Josh Dickinson brought the council into the policy and planning area with great dedication of his own time and energy. While the ramifications of the House investigative report were still being felt, Sidney Yates asked that we produce a five-year plan to help guide the endowment's future and Congress's appraisal of priorities. Josh and his committee led the development of the plan.

The concept itself met with resistance among the program directors. How could you plan when funding depended each year on the ups or the downs of a given Congress? Suppose you set forth a program goal that a limit on funding would not allow. Was it not preferable to avoid volunteering prospects for a rosier future than might materialize? Might not a five-year plan force the endowment into procedures that could quickly change or become outmoded, especially given the changing nature of support for the arts? If we committed ourselves to a particular path, might it not take a later turning and leave us headed in the wrong direction?

Josh Dickinson guided the committee skillfully away from error. The plan developed. The full shape of things was not precisely forecast, but there was enough to stimulate interest, enough to stimulate vision, and enough to satisfy congressional concern.

The plan reaffirmed goals of the past and gave them an articulate new framework. It restated priorities and gave them stronger rationales. There were policy changes, shifts in emphasis, new directions. Once enunciated, the goals were incentives to the program areas for solutions in which all could join in good spirit.

"Unquestionably," it was stated, the endowment would give increased support to individual artists. Institutional support would focus on the creative project more than the "ongoing" project. Artistic quality, not budget size, would be stressed as a criterion for the size of the grant; the larger organization could thus receive more or less than before, and the smaller one could find new opportunity.

Challenge grant recipients would be permitted to reapply, after successful completion of their first endeavors and a period of review and self-analysis. These grantees began to build on broader foundations.

There would be enhanced opportunities for touring by performing arts organizations, in accord with efforts to make the best in the arts more available across the country. The media arts would be stressed as those particularly able to reach widened audiences with quality productions. Education in the arts would receive new focus in work with the Office of Education. Emerging institutions would be encouraged by regional, state and local organizations working with the endowment. More attention would be given to small presses providing quality in literature,

and to broadened exhibition spaces for artists working in small groups with other artists. Regional media centers would provide space, equipment, and guidance for artists in film and photography, radio and television. Advocacy for the merits and advantages of the arts would be strengthened. The Design Arts Program (given a generic name and including architecture) would shift from programmatic support toward the broader ranges of advocacy, demonstrating what could be accomplished with good design and its application. It was not the old National Design Institute idea revived, but the current program would broaden in scope.

The plan was adopted by the council as a whole, transmitted to the Congress, and given general approval. It established, I believe, a feeling of sharing, of participation, of renewed validity for the council in its own self-assessment. The council meetings at which the plan was discussed were exceptionally well attended. Members spoke out with a vigor I found reminiscent of the enthusiasm of earliest council days. The council, in my view, took on a cohesive strength in keeping with its mission.

Two new committees were formed. An Education Committee was established under Sandy Boyd's direction to strengthen the endowment's educational role within an evolving departmental structure in the Carter administration. And a new committee consisting of council members and state arts leaders would address what I felt was still a growing tension between the council and the states over the sharing and delineation of their responsibilities. No one could better chair the latter committee than Lida Rogers, newly appointed by President Carter and director of the state program in Mississippi, an individual of firmness, of diplomatic skills, of respected experience. She had a joint loyalty to the endowment and to the state movement. She did not perceive loyalty in terms of a division, but in terms of the development of the arts. She and I were in accord on this—though there were many, dating back to the tenure of Nancy Hanks, who took sides, advertently or inadvertently, logically or emotionally, understanding all the history involved or yielding sometimes to hearsay and half-truths.

State and local leaders became increasingly involved in the work of the council and the endowment. The National Assembly of Community Arts Agencies was organized under the direction of Lee Howard, a forthright and impressive advocate. When the endowment came into being, community councils were exceedingly sparse. Now they were growing from the hundreds toward the thousands. Following the examples of the state and national programs, they were relying on qualified private citizen advice, serving as coordinators, as advocates, as the guides for added support. Sometimes the community and local arts agencies were government-based; often they were privately initiated.

They demonstrated the rising tide of civic participation in the values of the arts.

Some felt that there was a natural hierarchy, going from national to local, with the National Council at the apex, the ultimate protector of quality. Over the years, state leaders had been welcomed more as guests than as partners. This attitude might have applied and been justified as the state programs developed in funding and sophistication, but now their combined budgets almost equaled the endowment's budget. The funds they received from state governments were won through strenuous efforts and reflected the message all of us wished to transmit: the arts were important, and they had a vital role in the Nation's well-being.

It was suggested that the states support the relatively smaller community organizations and the council concern itself with the larger, nationally prominent organizations. That might seem, on the surface, a logical distribution of responsibility, but on inspection it was an arbitrary one. The states were deeply concerned with both the large and the small.

An Ohio Arts Council supported such a nationally prominent institution as its Cleveland Museum of Art; a Pennsylvania state program assisted the nationally renowned Philadelphia Orchestra. The states were proud of the scope of their programs, and of their ability to discriminate and discover, nourish and support quality.

I was convinced our enterprise was too broad-based for arbitrary distinctions. I preferred the pluralistic approach, with each area of assistance, local to national, having discrete responsibilities natural to its own evolution and purpose, but always with opportunities for multiple support. Pluralism and the democratic process go well together. The original legislation envisioned a pluralistic system, with state arts agencies given the same standards of excellence to uphold as the national endowment and council. The integrity of the council would not be eroded by principles of pluralism. Its integrity rested not on artificial barriers devised to prevent intrusion, but on the open doors that permitted a free and shared interchange of ideas. If controversy was a corollary, it was also the life blood of the arts themselves.

Chapter 57

W HILE I WAS CHAIRMAN, I HAD THE OPPORTUNITY TO WORK IN CLOSE
association with the great artists of our country and with the
civic leaders appointed to the National Council because of their special
dedication. It was the belief of Joan Mondale and me that the artists
should predominate. These convictions were reflected in the nominations
transmitted to the Senate by President Carter and approved. (As it was
for ambassadors and leading government officials, Senate confirmation
was now required for council members.)

New to the council during my tenure were James Rosenquist, the
painter whose work has had such an important impact on the visual arts;
Robert Shaw, a leader in both orchestral and choral music; Kurt Adler,
the dean of operatic music; Robert Joffrey, preeminent in ballet; Erich
Leinsdorf, the conductor of unique ability; Toni Morrison, the writer and
winner of literary awards; Margo Albert, described in an earlier chapter;
I.M. Pei, the architect of so much that is significant to the cultural life of
America; and the exceptionally talented Jacob Lawrence.

The council's rotation process—with a third of its members chang-
ing every two years—makes possible overlapping terms of services. Dur-
ing my chairmanship, I headed a council that also included Martina

Arroyo, Theo Bikel, and Billy Taylor, all mentioned earlier; Harold Prince, the genius behind much of the best in theater and musical theater; Franklin Schaffner, with award-winning film credentials; Van Cliburn, the uniquely gifted pianist; Jerome Robbins, choreographer whom the initial National Council under Roger Stevens and deputy Biddle had already singled out for distinction; and Gunther Schuller, the composer, artistic director, and president of the New England Conservatory of Music. During my beginning months, before the 1978 changes were made and they departed, I worked with Harry Weese, architect of Washington's Arena Stage, first theater-in-the-round, among many other leading structures; Judith Jamison, prima ballerina; Eudora Welty, writer of masterpieces; and Jamie Wyeth, the wonderfully gifted painter, following in the family tradition of his father and grandfather.

These individuals were not just nationally known, their repute was international. They graced the deliberations by their presence, just as Isaac Stern, Agnes de Mille, and Leonard Bernstein had blessed earlier council work by their presence and perceptions and insights.

They were sometimes observers. They were often outspoken. They had a firmness of viewpoint. They spoke from years of experience. They believed passionately in the work of the endowment. They wanted to see it continue to improve as a great catalyst for the development of the arts. In essence, the integrity of the council, its impact, its regard, depends on the distinction and expression of its artist members. To weaken that perception would be a most serious loss. It must be a perception that comes from the White House, as it did during the Carter years. It must be clearly recognized and respected in the making of appointments. It is crucial to the commitment an administration provides.

They were sometimes objectors, these famous artists. I remember the objection expressed by Erich Leinsdorf even before his council membership, when he was given the sheafs of papers to be completed for security purposes and for his own government clearance to serve. This was not national defense, he maintained. It was a matter of principle, he told me over the phone, before we became friends. What earthly sense was there to this cumbersome procedure for an artist? It was a good question. Yet at the same time, it could be asked, why should an artist be exempt from the detailed procedures, albeit newly established, calling for the examination by both White House and U.S. Senate of all presidential nominees for high position and Senate consideration? I consulted with Lloyd Cutler, the President's counsel, and Michael Cardozo, the next in command. I consulted with the Senate. No exemption was possible. The papers were duly filled out in full, but I hand-carried them to their destinations, and a privacy of thorough review was arranged. It satisfied Erich, and pleased him, I think, that what appeared to him as needless

bureaucracy had been given consideration and, in some measure, over-
come. It pleased me to have Erich Leinsdorf on the council, and it
pleased the world of music to see him there.

Not all, of course, were artists. Not all should be. The council must
be balanced by other voices, other experiences of an intrinsic value to
the arts. So there were Lida Rogers and Bernie Lopez, representing
state leaderships. George Seybolt, before he became chairman of the Na-
tional Museum Services Board, represented both an important business-
man's love of the arts and a long and authoritative experience with their
development in Boston. Henry Cauthen was a businessman and an edu-
cator, as president of the South Carolina Educational Television Network.
James Robertson from San Francisco was an investment counselor, but
with a dominant love for the arts and a deep knowledge of their needs.
Leonard Farber was one of the country's leading developers, but one
who had pioneered in placing the arts and space for the arts prominently
in his building complexes. Appointed during the term of Nancy Hanks
and serving throughout my four years were William Eells and Geraldine
Stutz. Bill Eells was a high-ranking public utilities official in his business
life, but he had a close and longstanding relationship with exemplary
arts programs in Ohio. Geraldine headed Henri Bendel, the famed center
of high fashion in New York, but she contributed her executive talents
generously to the cultural organizations in her city; and she represented
as well the field of costume and fashion design, listed for support in the
endowment's enabling legislation at the behest of Senator Javits. Geral-
dine, however, by no means limited her participation in council discus-
sions to this aspect of her career. She was consistently among the most
articulate of members, speaking out with conviction and experience on a
wide range of issues.

And in the business-arts area, there was the case of James Barnett,
nominated in 1980 for one year only (along with Sandra Hale, a Minne-
sota state and community arts expert). Both filled the sixth year of unex-
pired terms of other members who had departed. (It is a tribute to the
prestige of the council, I think, that even such abbreviated terms were so
desirable.) Jim Barnett was a knowledgeable Atlantan with years of ser-
vice to the arts, as faithful board member of major organizations, as pa-
tron and contributor. He was quite within the tradition of a council that
respected business acumen expanded toward cultural pursuits. Jim's ac-
tual business, however, was somewhat unusual. He had been a promoter
of professional wrestling. As his resources had grown he had focused
them and his interests on the arts—the symphony, the theater, museums.
He had a quick and lively mind, and he found it not remotely amusing
when Howard Metzenbaum, the liberal and often outspoken Democratic

senator from Ohio, took exception to his credentials and suggested further senatorial review. What a ruckus ensued!

Howard was an arts leader in the Senate, in the process of helping form, with Claiborne Pell, a Concerned Senators for the Arts group, to parallel in some respects the developing Congressional Arts Caucus in the House. How could an organizer of professional wrestling know about the intricacies and sensitivities of the arts? Senator Metzenbaum seemed to inquire. Jim Barnett without my knowledge responded. In effect he inquired, via the press, how would an individual who had derived personal resources from business undertakings concerned sometimes with parking lots gain the background needed for a stint in the U.S. Senate? Wasn't the business itself somewhat incidental to the end results? Jim seemed to say—but that part of the equation did not appear emphasized. The parking lots were.

Put temporarily on hold for additional study, Jim's nomination appeared to slip several rungs on the congressional ladder for approval. In fact, it seemed at the moment off the ladder altogether. These were the days of "Boom Boom" Mancini in pugilistic circles. We now heard rumors of a "Boom Boom" Barnett, and Jim asked for advice.

A letter to the senator would be a start, I recommended. Shortly thereafter, Jim read me a draft beginning: "Dear Senator: If I have inconvenienced you, I'm sorry, but . . ." Hold it, Jim, I suggested, and we went back to the drawing board.

In due course, Senator Metzenbaum and his excellent staff—headed in this case by Peter Harris, with whom I had often worked in my years on the Hill—were mollified and forgave. And Jim, recognizing that a senator can be quite different from a business acquaintance, forgave, seeing the suspected slight as fulfillment of official responsibility. We could return to the business of the endowment.

I always found Jim Barnett among our most engaging council members. Like Jim Robertson, he was unfailingly generous with his time and personal provender. There were times when we brought together dignitaries from the arts and many related fields and gave them sustenance, but there was no "entertainment" item for these special occasions in the endowment's budget. The federal government in those days frowned on funding for such events, needed as they might be to promote new relationships in conviviality as well as in serious roundtable discussion. We depended on private resources, on the two Jims and on a few others who were willing and able to help. Jim Barnett and Jim Robertson were thus possessed of angel's wings. Yes, I remember *that*, well.

And I remember the arguments they advanced, for the large arts institutions, for the small and in distress, and for a full and comprehen-

sive diversity of program. And I well recall Rosalind Wyman, with the broadest kind of cultural background, concentrated in the media arts in California, film and television. She would bring to the table her voluminous council book, so marked and annotated that you knew she had read and reviewed it for many hours. Prepared for discussion and argument, pro and con, and turning her large dark eyes toward her neighbors, she would say, "I hope you've all done your homework because I sure have done mine."

I remember Arthur Jacobs—a preservationist from Florida who had almost singlehandedly rescued a whole town of historic significance, with its marvelously fanciful architecture—giving his own statements a positive thrust, head bent forward, slender torso tense, challenging disagreement, making a point of order, suggesting a parliamentary discrepancy.

I remember Norman Champ, in the business and arts tradition focused this time on St. Louis. Norm Champ hardly ever agreed with anyone on any subject. Like Phil Hanes long before him, Norm Champ was the council's stormy petrel, its conscience on occasions, its defense against ever taking a subject, no matter how seemingly minor, for granted.

Then would speak in more measured tones a Sandy Boyd; or in more rolling tones, in agreement or disagreement, even in indignation, a Theo Bikel; and especially when it came to matters of education and the arts and how the two could be better allied, a Tom Bergin, dean of continuing education at Notre Dame University.

When it came to problems of artists struggling in the Nation's underprivileged sections, urban or rural, Jessie Woods spoke. She was the founding spirit and head of the Urban Gateways Program in Chicago, an innovator at providing special opportunities for talent. Generally, she spoke in a quiet voice tinged with recollections that combined sadness with hope and optimism. When the quiet voice was raised, however, and the wide-set eyes looked up sharply, I knew an objection would be heard, and a valid one.

And if I needed a sagacious opinion on education or on minority needs, Dolores Wharton could supply one. She had been with the council under Nancy Hanks. Her attendance at meetings was almost unfailing, her memory keen. Her husband, Clifton, headed the State University of New York at Albany. But Dolores had a mind of her own; as the saying goes, when she spoke, people listened.

In my four years in office, I served with over forty different council members. Twice, in 1978 and 1980, President Carter nominated new

members and the Senate concurred. That process is as it should be, I believe. A President may change two-thirds of the National Council on the Arts in one term. Joan Mondale and I went over the names involved again and again. I remember the telephone calls made to the possible candidates. Would they accept a nomination if it were offered? And did they know the functions of the council, as legally prescribed, as developed over time? Did they know the time it would involve—up to fifteen days of meetings in a year, plus volunteer committee work? I cannot remember a negative response, only enthusiasm.

It never occurred to us in making these overtures to inquire about political persuasions or affiliations. I would not know the answers today, either with regard to the council or to the far greater numbers of experts who served on the endowment's review panels and program policy panels. Government support of the arts should be kept bipartisan or nonpartisan politically. Artists make their own decisions; but to choose among the arts for political reasons is to do a great disservice to the program, as it was conceived, as its traditions demonstrate. This is not a remark made casually or to be neglected as time passes. It is a cardinal necessity.

There was always the question of schedule, particularly for the artist members. They were performing, they were on location, their work was being exhibited abroad and they were there. Council meetings were scheduled a year in advance; some artists had commitments involving longer sequences of time. And yet they attended. Theo Bikel would catch the notorious "Red Eye" night plane from the West Coast and arrive sleepless, as Gregory Peck had done in earlier days. And if there was an unbridgeable difficulty, the artist would make known his or her recommendations through the council office, managed always with care and patience and detail, first by Luna Diamond and later by John Clark. The presence of the artist on the council could therefore be felt in absentia.

I recall trying to express this concept at a farewell party for departing council members in 1980. They included Jerome Robbins, Gunther Schuller, and Van Cliburn. Van had missed several meetings, but had taken pains to present his own specific views. I was making a toast, which I hoped would be graceful. I intended to say our affection and gratitude was with Van all the time, even when he was not in our midst. Instead it came out like this: "We love you, Van, even when you're not with us—which is all the time." Unaware of the unintended, I was continuing when the audience of past and present members, government and arts dignitaries, broke into volumes of laughter, with Van's as sudden and spontaneous as the rest. An attempted correction merely prolonged the laughter. Yes, I remember *that*, very well.

Memory also brings back the appearance of Hal Prince one morning at the council table after an all-night flight from Paris, where he was busily engaged in a French production of his work. On the agenda that day was the question of establishing a new endowment program for opera/musical theater, a program combining two art forms, giving new vitality to each, and using terms that could be interchangeable but in the past had been exclusive and even antipathetic. Opera to many meant the great classics, principally of European origin. Opera conjured up the mighty Metropolitan and its retinues of stars and divas dating back to earlier epochs and continuing undiminished. Musical theater connoted for many the musical comedy, an American contribution to the arts, greatly popular, greatly entertaining—the Great White Way, lights aglow and in dazzling circulation on a marquee, the extravaganza, millions of dollars. There was the endowment's not-for-profit area on the one hand, the profitable beyond endowment needs on the other.

But such perceptions of difference were growing erroneous. The large musical was an increasing financial risk. Costs of performance continued to rise. Talented actors looked elsewhere. Broadway was turning to smaller shows, frequently nonmusical plays with small casts, and sometimes with a cast of one. Investors chiefly financed the certain success, or at the least the more certain, the revival of past successes, not the new, the fresh or the experimental. Hal Prince's work reflected those latter attributes. With him, I felt we should open up opportunities for both musical theater and opera to develop in the not-for-profit arts. We would preserve the name of opera (it could scarcely be removed), but we would add new dimensions to dramas sung and given musical emphasis. We would help encourage talents to return and invigorate what fundamentally was a single, though complex, major area of artistic expression.

It was a controversial idea, and there was resistance based on long traditions. How would the council react? Anxiety seemed to accompany Hal Prince into the room. He is a slim, wiry man, with a small white beard and eyes of great intensity. His voice was often raised at council meetings, for his feelings were as intense as his eyes. Sometimes they seemed to avoid contact with another viewpoint. Now an endorsement by the members present was needed.

We sat at a U-shaped table, which accommodated the council itself. My seat was in the center of the U, and beyond it were the rows of chairs, in front and at an angle to the right, for the endowment's staff, press representatives, guests, and observers. The large space most frequently used was reserved on other occasions as a ballroom at the Four Seasons Hotel in Georgetown. It was usually crowded, but deferentially quiet during our deliberations. The council was so focused on its work

that the necessity of conducting business in public seemed but a minor interference.

How different, this, from old days at Tarrytown House and a council meeting in virtual solitude. The principles of freedom of information and access to information had altered the rules. During each meeting, we would close the doors to the outside world when grant recommendations were being reviewed, in the belief that such discussions might reflect unfavorably on applicants; remarks could be taken from context and thus be damaging. But the majority of our sessions were open to all.

Into this environment stepped Hal Prince, wearing a light gray suit, looking dapper as always, but fatigued and unsmiling, cheeks slightly flushed, eyes now searching for anticipated opposition. I quickly stepped to his side before he took his place at the table.

"How is it going?" he whispered. "Who is against the proposal?"

"I think you'll find general agreement," I said softly.

"Really?" His voice was unbelieving and he took his seat.

We had done the homework, Mary Ann Tighe, Ezra Laderman, and me. It had taken a number of months of patient work. The council was receptive. In a few minutes, the new program was approved.

"Is that all?" Hal seemed to ask, looking around, searching other faces. "No more?"

He stood up. "I'm leaving," he announced with a smile. "I didn't think I'd make it—but there's a plane back to Paris in half an hour."

Some have suggested that a National Council on the Arts is unneeded, that the panels of private citizen experts in the arts are unneeded, that the endowment's administrative costs, running slightly in excess of 7 percent of the total budget, could be pared by a percentage point, or maybe two, if this element of guidance was removed. Leaders of privately run philanthropic institutions, including no less an authority than the Ford Foundation's former vice-president McNeil Lowry, have suggested that a highly competent staff, experienced and well chosen, could accomplish the endowment's work more efficiently than the present process permits.

But there is a great difference between the private institution and the public one. I remember in Rochester, New York, talking to our host Alan Cameros, well known as a business and arts leader who provides generous philanthropy to the arts. He told me that one individual, not himself, essentially decided how his support should be apportioned—and the choices were always respected. That would last about two seconds in a public program.

What is the function of the National Council of Arts? Newcomers,

burdened with ten pounds of notebooks, long meetings, and perhaps seemingly inconclusive debate, may at first wonder. And critics may say, sure, there's a group of famous artists, but what do they *really* do?

They do a great deal. They are the invaluable guides to policies and innovations. They speak initially from their own experience, but after two years or so, they become immensely knowledgeable about the variety of the arts. I saw this happen on the first council under Roger, and on the final one I chaired. They are too many individuals ever to be homogenized, so the opinions remain sharply defined. Without exception, the emphasis is on quality. They themselves have achieved excellence, so they are its protagonists and its protectors. No meeting took place in my times with Roger or Nancy, or in my own day, without a repetition of that basic theme and the application of that theme to the intelligent review of myriad requests for assistance.

But what do they *really* do? They are the essential element in government support for the arts in the United States. A staff, no matter how experienced and wise, could not succeed by itself in terms of our democratic processes any more than could a President without a Congress. You may criticize it as cumbersome, prone to delays, indecisive, and procrastinating, but it is the guardian against dictatorship and autocracy. Power corrupts, but absolute power . . . is absolutely delightful. I recall saying that once to the council in a moment of whimsy, but it is true. A National Council on the Arts is the ultimate guardian against a cultural czar, a final individual arbiter of taste and dispenser of patronage. The fundamental involvement of the private citizen expert ensures for the program its trust and integrity. So it was conceived. So it must remain.

And so it provides continuity to the whole of the endeavor. Chairmen change. Staff changes, leaderships change, political parties and administrations change; but structures stay intact. Council rotation is integral to its vitality; but while two-thirds of the council membership changes in each span of four years, the remaining one-third have long and experienced service.

Continuity, integrity, unique support for the arts in America's democracy. Now let's ask again: What does the National Council *really* do?

Chapter 58

A PRINCIPAL THEME OF MY WORK AT THE ENDOWMENT WAS UNITY. The danger of a "politicization" of the arts seemed as remote to me as would the abandonment of excellence or dedication. But fragmentation of the arts, the emergence of special interest groups vying for attention, was a serious problem, partly inevitable but partly also given a vocal exaggeration. It was natural for each group to believe it made a superior contribution to the national welfare. Partisanship was to be expected, and indeed applauded, for it indicated a strength of conviction. A sense of perspective was needed, however, and could be supplied through the endowment's own structure. Allotments among the various programs from each year's appropriated funds were vigorously contested, argued, and reargued; but once decided, partisanship ended, and the ranks were joined to defend that unified approach.

I urged the various groups representing the constituencies of the arts to adopt the same approach: the American Symphony Orchestra League, Theatre Communications Group, the American Association of Dance Companies (later Dance/USA), the American Association of Museums, Opera America, the state organizations and the emerging local arts associations, and Actors' Equity. Whenever I spoke to these organiza-

423

tions, I presented a similar message. Join together, I told them, speak for your own cause, but in a context that recognizes and celebrates the value of all the arts. Internecine struggles among arts groups are healthy, up to a point; taken to extremes, they are self defeating. Unity of purpose must be our goal. Then the water will rise and the ship float on a broader sea. Congress is used to special interest groups, but if conflicting particular requests become numerous, Congress—by no means fully cognizant of the arts—will lose its wish to help. Lobby the endowment if you will; but when you appeal to the Congress or to the administration, put aside your differences as much as you can.

I was put to an early test. I had committed myself at the outset to provide the Nation's symphony orchestras with a larger annual allotment than ever before. I had studied the matter carefully, I believed, and the council had agreed that change was in order. An increase of more than 10 percent was involved, for a total of $8.6 million. I was pleased with the decision, as I was by the invitation of the American Symphony Orchestra League to address their annual convention in Chicago. I would explain the new level of funding.

Walter Anderson had been director of the endowment's Music Program during Nancy's years, giving valiant service. The policy of rotation of directors was still in development. Walter came to see me as soon as I arrived in Chicago. He had attended the opening of the convention. They're up in arms, he told me; it isn't enough, they say.

"I don't think we can go farther," I said. "This seemed fair to both of us."

"I know," he agreed, and shook his head sadly. "It's not going to be easy for you. Too bad," he said. "Too bad," and paused before adding an experienced Washington understatement. "They all seem pretty upset," he said.

Number three on my all-time list of least favorite reactions was about to occur. In the great ballroom where the delegates were assembling, friends from the past went by without lingering for a greeting. I felt a sense of isolation and remonstrance, and an unsettling surround of anger. It was not a happy feeling for someone new to his position, seeking to bring the arts together in purpose, facing his largest audience to date—well over a thousand of the most eminent symphony administrators, directors, and leading musicians. I could see "Auld Lang Syne" was not to be featured.

They sat at round tables as far as the eye could reach. I was at the traditional rectangular head table, sitting beside the director of the Chicago Symphony.

Did I know Sidney Yates? he inquired in a mild voice, giving me particular scrutiny.

"Of course," I said.

"He's an old friend," said the director. "He is a great believer in symphonies."

"So am I," I suggested. It was let go unanswered.

"Ten million, that's what we should have here and now," a companion said across the table. "Anything less is absurd!"

When I rose to speak at the lectern at the center of the head table, I looked out over the audience. It was as if Grant Wood had painted every face with the unbudging resolutness of "American Gothic." Pitchforks appeared to rise from the tablecloths. Post-lunch coffee cups were still. Silence filled the room. I said I had come in the hopes of bringing good news, and I outlined my proposals.

Given opportunity for expression, the audience appeared to erupt. Banners advertising "Ten Million Now!" all of a sudden were unfurled. Placards that listed the various states of the union were held aloft, and they were waved up and down and sideways in the time-honored manner of nonsymphonic conventions. It seemed certain that "politicization" of the arts was the intended message.

I can still feel the impact of this crowd of angry people. They appeared convinced that my efforts were a compromise in keeping with my political background, a cop-out, the epitome of failed commitment. But taken by what might have seemed my failure to respond, or rebut, or argue, or disclaim, they made an egregious error. They sang to me.

A group of at least thirty, with excellent voices, trained and talented, came forward from the round tables. They sang a fugue, a mournful dirge, musically precise, a lament for a failing chairman, for a lost friend, a brooding, somber critique of his actions. Anger was deep in that room.

Waves of applause were heard, as the audience gave the chorus an ovation. My hosts at the head table suggested that there was an exit not far away, off to one side, should I wish to use it. Distantly I thought of H.R. Gross and Frank Thompson.

"May I respond?" I asked.

They looked at me in great surprise.

"Certainly," they said.

I want to the rostrum and expressed gratitude for the excellence of the music, and there was silence again, a questioning silence, I felt. Perhaps I was about to relent or surrender; perhaps I would reveal a caustic nature and thus be an easier target.

"I would like to respond to you all," I said seriously, "and it just so happens that I have brought with me the world-famous, internationally acclaimed Biddle *a cappella* choir and chorus."

Now there really was a questioning silence, as I turned to right and left, gesturing toward invisible arrivals.

"If the basses would stand over there, please," I suggested. "And the tenors there, and the five baritones next to them . . . and on this side, please, the sopranos and altos. This is a group," I told the audience, "which has never—in its long and historic existence—been known to sing on key."

I sounded an imaginary pitchpipe and began:

If you're ever in a jam,
Here I am
If you're ever in a mess
S.O.S.
If you ever lose your
teeth when you're out to dine . . .
Borrow mine!
For it's friendship,
friendship
Just a perfect
blend-ship
When other friendships
have been forgot . . .
Ours will still be . . . hot!

It was like magic. The audience, laughing, stood up to applaud. They relented, not I. And I can recall Irma Lazarus, an elegant leader of the arts in Ohio, finding me and shaking hands, and telling me that the tide had turned. I will always especially remember Irma at that moment.

We did not get beyond $8.6 million that time, but we got closer to $10 million the following year, and two years later the American Symphony Orchestra League held a dinner for Catharina and me in New York. "Auld Lang Syne" was on the agenda.

(Historians may recall Claiborne Pell's counsel with regard to "Music, vocal." But are there not exceptions permitted for hard and fast rules? Is there not always a moment for a song? And as a rare footnote: though readers may recall the melody, and those other circumstances—on this occasion, no one wrote a single unpleasant word.)

Chapter 59

*T*HE PRINCIPLES AND GOALS OF UNITY, COOPERATION, AND COORDINATION, I believed, were essential to the arts as they grew as a national force, as they rode forth with new messages of their centrality of life. But those principles and goals and messages imparted ought also to apply within government. With the endowment as focus, other agencies could develop important and related work, far beyond the endowment's scope of funding for any foreseeable future.

The Federal Council on the Arts and the Humanities, devised to coordinate the activities of the two endowments with those of other federal programs, had been relatively dormant. Now revived, with Joan Mondale as its honorary chairperson, the Federal Council was potentially a key unifying force. Joan and I determined to work together in a major endeavor to elevate the importance of the arts among the Federal Council's membership, among agency and department heads whose programs could benefit by an often-new cultural emphasis. She was superb at this task. She had been given the nickname "Joan of Arts," perhaps at first without full appreciation, but now the sense of mission was clear, as was her remarkable ability as advocate and diplomat.

We made plans carefully together. The early ones brought results

with the Department of Transportation. In the House of Representatives
Frank Thompson wanted to see old railroad stations, no longer in full
use, given new vitality as small cultural centers. These efforts were ex-
panded to include works of art, murals, and sculpture in other train sta-
tions and in airports. The Atlanta airport was first to see the new
brightness of the arts. Brock Adams, secretary of transportation (later a
U.S. senator), confessed privately to me that at first he had underesti-
mated the extent of Joan's persistence; she would not take even a tenta-
tive "no" for an answer.

She worked quietly, at the Vice-President's house or at a modest
office in the Executive Office Building, with Bess Abell, Judy Whittlesey,
and Shirley Koteen. The small staff was used to detail and welcomed in-
novation. Joan would call and discuss a lunch at the Vice-President's and
ask me for a well-annotated agenda for the occasion.

We would assemble with the honored guest of the moment, high-
ranking in the administration, always affable, guarded toward any per-
sonal overtures, knowing the general outline of matters to be reviewed,
and at home in such casual and friendly atmosphere. The meal was al-
ways unpretentious, but elegantly presented in the high-ceilinged dining
room with the bay windows looking out over the lawn. Leading exam-
ples of contemporary art were always visible in a corner, on the side-
board or just outside the doorway.

The meal would be nearly concluded when Joan would say, "Liv,
tell us how you feel about all this." I would give the views I had already
shared with Joan, which she had approved. She would nod and smile
graciously, and then, looking at the honored guest, would say in a quiet
and pleasant voice, "Well! I guess we're all agreed then, aren't we?"

More than one such guest, en route to the cars parked outside on
the wide circle in front of the house, touched my arm and said, looking
toward the tall windows, that he had just been sandbagged by an expert.

We had started a process new to the endowment. I assigned Paul
Asciolla to be our intergovernmental representative and to help imple-
ment agreements made among agencies and departments. Paul had
grown up on the battlefields of Rhode Island's intense political struggles
and was also well acquainted with the sometimes equally intense strug-
gles within the Catholic Church. Paul could sense objection before it
came.

One must realize that the National Endowment for the Arts was
an agency of minor size in a government in which size was often synon-
ymous with power and influence. Agreements made from on high
required staff agreements if they were to work. The power of staff at
levels below the immediately visible can be the difference between the

health of a project or its demise. To cultivate one's garden well in Washington, one must find friends among all who till the soil. Those aspects of the scene are indelibly a part of my own experience. It was unusual for the small to influence the large; the matter of turf was deeply involved. What was this upstart agency doing in waters beyond its depth? What legislative act authorized this kind of intrusion? I was not unfamiliar with such questions; in other contexts at other times, I might have asked them myself. So we searched for friends, just as I had once searched for friends on Capitol Hill, and found them at first few and far between.

At the Department of Housing and Urban Development, Geno Baroni came to our aid and to our cause, and helped develop a program we called Livable Cities. Small arts centers would be made integral to urban planning in the ghetto areas of blight and poverty. Sometimes just a storefront with space beyond for exhibition or a gathering was used. Those beginnings can be the acorns of change. We saw it happen. We knew it would work. It was Monsignor Geno Baroni, and he knew it would work, too. He and Paul Asciolla had worked together in the past.

To assist in the process of intergovernmental collaboration, we devised the memorandum of understanding. With preparations completed, I would meet with the head of the cooperating group and we would sign a document outlining our intentions and plans. It was thus that I met in solemn conclave with secretary of the interior Cecil Andrus. Sitting together at a desk, facing members of the press with photographers, we signed the agreement. No such document had been signed before. We pledged to work together toward "integrating the arts, cultural enrichment activities and historic preservation in our Nation's recreation system, parks, and other programs of the Interior Department."

Secretary Andrus looked forward to "this sharing of the expertise of the Arts Endowment," and I spoke of "the beginning of a promising partnership and of the value of interagency cooperation." It was an opportunity to emphasize my belief that "the arts and their values need to be recognized all through government. The endowment," I said, "is concerned with our cultural resources in the broad diversity of the arts; the Interior Department, with our natural resources. We need to recognize the common identity of the two." I suggested that the country's national parks could increasingly focus attention on the arts, in performances, in exhibitions where there were centers for display, in outdoor concerts following the example of Wolf Trap Farm Park in Virginia, part of the national park network, where the arts find a special outdoor summer home.

In accordance with this agreement, memoranda of understanding were signed with the Heritage Conservation and Recreation Service of

the Interior Department, to include the arts in urban programs, and with the National Park Service.

The formal introduction of this document, signed in July 1980, is worth recording:

> *Recognizing that the arts and related cultural programs are capable of improving the quality of life of our Nation and that the Director of the National Park Service (NPS) is charged with the responsibility of administering the National Park System which contains outstanding areas reflecting the natural and historic heritage of this Nation; and recognizing that the National Endowment for the Arts (NEA) has as one of its goals the preservation of the best of this Nation's artistic and cultural heritage, the Arts Endowment and the National Park Service acknowledge that it is appropriate for the two federal agencies to work closely together in areas of mutual concern.*

Another memorandum of understanding was arranged to give form and substance to the government's pluralistic support for museums. It emphasized that the federal government should provide its support in a manner that encourages, but does not dominate, nonfederal support, and that intellectual freedom and creativity are best protected within a network of coordinated federal programs. Under the agreement, made in May 1979, the National Science Foundation would increase its support for museum projects "primarily scientific or technical in nature." Projects were defined as one-time expenditures for "discrete programs;" that is, those involving one particular aspect of a museum's work. The Institute for Museum Services, with George Seybolt and Lee Kimche in charge, would concentrate on "matching grants for general operating support." Assistance for the training of museum professionals would be shared by the IMS and the Smithsonian Institution under the National Museum Act, as would "services to the field," shorthand for help to groups of museums in seminars, conferences, research, and publications. The Arts Endowment would support primarily projects in the arts, as appropriate to its practices, while the Humanities Endowment would focus its assistance on interpreting and illuminating "the social, historical and cultural contexts" of exhibits and presentations.

Most important, a working group within the Federal Council was established to implement these procedures, to draft the guidelines for funding and the divisions of responsibility. Joint funding of projects among the agreeing agencies was permissible, but only when they were "intentional and well-considered." Sidney Yates had expressed particular concern that, with five federal groups all authorized to aid in museum activities, unintentional duplication could result, with applicants applying

undetected to a number of sources for a similar project. The memorandum set into motion a clearinghouse for applications that could cross boundary lines.

Preparing this memorandum was both a difficult and a highly important task. On its success rested the fate of the multiple approaches to museum assistance in which we believed. Agencies could no longer be everything to all their diverse constituencies. That limitation rankled at first with some leaders, experienced in Washington's turf conflicts. It seemed to me sometimes that we were preparing the peace treaty for the end of the Hundred Years War, but full cooperation was overriding. The wisdom and diplomacy of Paul Perrot, assistant secretary of the Smithsonian, was of invaluable assistance in this regard. As in the past, he demonstrated the patience, the careful attention to detail and the caring that made his contributions so valuable and so persuasive.

The agreement was an example of how the cultural elements in the country can accomplish more in unison than apart. Congress applauded the effort. The constituents at last saw its merits. Self-interest can see the advantages of the common good. It is a lesson that democracy can teach.

So new bridges were begun and extended. Sometimes they crossed into territory that produced abrupt challenge.

Since its inception, the endowment had envisioned an America where the art of sculpture would enhance areas where the public congregated. Ancient Egyptians, ancient Greeks and Romans, the Renaissance, civilizations old and new had known the beauties of sculpture out-of-doors. Since our earliest endowment efforts, when René d'Harnoncourt, Henry Geldzahler, and I met with Stewart Saunders in solemn, even though temporarily misinterpreted discussion about public art in Philadelphia, Art in Public Places was an endowment hallmark.

More recently, the endowment had been joined in its scope by the General Services Administration under the leadership of Jay Solomon, an individual of both sophistication and sophisticated understanding of the arts, with an artist wife who exhibited her photography nationally and with an enthusiasm for both contemporary and historic sculpture. Jay looked with pleasure on expanding Art in Public Places. His support added new dimensions to the program, for GSA's budget was vastly larger than the endowment's. Endowment panelists were utilized, and major new funding was provided by GSA. The program increased. Growing numbers of projects were being received for review, from cities and from smaller communities.

One came from the town of Huron, South Dakota, population circa 1,300. A new post office was erected there. The ground in front seemed

especially suitable for a modest piece of outdoor sculpture. We have seen how appreciation of the arts was gained, even by a future President of the United States, from a single sculptural work of art in his native Grand Rapids, Michigan. In Huron, South Dakota, attitudes involved a local citizenry and, it appeared, in particular a town professional in the plumbing industry.

My knowledge that the situation was, in the Washington phrase, "a little off track" (meaning that derailment was manifestly in view) came from a call from Representative James Abdnor, a South Dakota Republican with long service and pertinent congressional seniority. Mr. Abdnor informed me with some emphasis that an alleged work of art had been placed in his district, and that I would do well to have it removed forthwith. I was indirectly reminded of his ranking position on the Appropriations subcommittee that concerned itself regularly with the General Services Administration, and told that a petition had been signed by almost every adult Huronite, all of voting age, demanding the sculpture's removal. It was suggested that it would fit, for transportation off the premises, on a flatbed truck.

So informed, I was quick to investigate. It seemed that the endowment, in accordance with now-established practice, had been responsible for the panel choosing the artist, who in turn had submitted a scale model of his work for review. The panel numbered three, one from the environs of Huron and two from afield, as it had been felt that full expertise in the arts could benefit from a bit of friendly bolstering from beyond the immediate community. It came to pass that the model was reviewed in the midst of a great winter snow. The two outsiders had arrived on the scene. The other panelist was snowed in. All, I was informed, had communicated with each other and unanimously approved the model.

I was shown photographs of the work and the model. It appeared straightforward, within the traditions of simplicity for such work, hardly evocative of controversy. Four slanted burnished metal plates were linked by a dark rounded wooden form and set against the earth. It was entitled "Hoe Down," in accordance with the rural and farming environment; and one could imagine the blades of this basic implement, multiplied and enlarged, on the point of turning the soil. It did not have the graceful abstract recline of a Henry Moore figure or the metallic sharpness of line in a David Smith. But the piece had, I thought, a strength and integrity. The more one looked at it, the more one saw, even in the photographs, the casting of different shadows, the reflection of differing intensities of light. I suggested these possibilities, and noted that a Picasso in Chicago, a Calder in Michigan, and even a Michelangelo monumental statue in Florence, Italy, had received an initial and substantial lack of

laudatory notice, only to find the same degree of approval later. I was informed that the flatbed truck was receiving messages of bon voyage for its trek to Huron.

I hit upon a different solution. Why not let the artist explain his intentions at first hand? He was noted for his friendliness and articulate views. Perhaps the citizens would find, face to face with him, insights and engaging discussion. Visits by artists were infrequent at best in Huron. Let's give it a try, I thought, and give the local citizenry a chance to overcome the feeling that the federal government was interfering with taste and freedom by creating an incomprehensible monstrosity—as the primary critic and apparent spokesman had indicated. It was he who plied proudly the plumber's important trade.

The artist arrived, ready as all artists are for controversy, not so much concerned with persuasion as with honest opinion. A great many townspeople, it was reported with care, went with him to the sculpture, and viturally everyone was impressed. The magic communion between artist and audience was taking effect. Criticism was disappearing. When the artist emphasized that honor had been bestowed upon him by the excellent placement of his work, feelings of pride went through the audience. Then, in so many words, he added: It's exactly the way I envisioned it. The sunlight is a perfect accent on the four diagonal forms joined strongly together. It's just right. It suggests perfectly the three large capital letters I conceived—H-H-H, Hubert Horatio Humphrey, born right herc in Huron, South Dakota.

In a town with then a preponderance of Republican philosophy, and with Congressman James Abdnor, the remarks were given special attention. Not only was the federal government apparently impinging on freedom and taste; it was now imposing a heretofore unrecognized political bias.

Joan Mondale and Jay Solomon strongly urged me to hold fast. The tradition and very possibly the future of Art in Public Places was at stake. Feelings, if intense before, were set on edge as if a large dentist's drill had been given full current.

I suggested a moratorium: we couldn't reach a decision in the midst of these emotions. And, once again, in my experience—as with that Appropriations chairman in the endowment's first congressional funding encounter—there was reasonable response. No limit was prescribed, but yes, a few days would be possible—and then the truck.

I called Senator George McGovern, a great supporter of the arts. This was his state. He listened patiently and then informed me, in terms I could understand, that he was running for reelection. How could I ask him, seriously, to enter such a controversy?

I could see the approach of the truck clearly in my mind. "Hoe

Down" would be hoisted aboard. There would be cheers. A work of art would be removed. The episode would be repeated; a precedent would be set. That fundamental characteristic of the arts, the ability to stimulate controversy and through controversy an awakening to other points of view and vision would be given unceremonious exit. Much was at issue here—the integrity of a program, of its process, but in a larger sense the integrity of the arts. And yet we are a democracy, dependent on the views of the majority.

A week went by, and two weeks. Our bags were packed for a last-minute journey to Huron. Another set of circumstances was in progress, however, an inevitable consequence, but one I had overlooked.

Naturally, the situation had not escaped press attention in South Dakota. All at once visitors arrived to view the alleged monstrosity. The curious came, and in a growing number. All at once what had seemed worthy of swift demise was a tourist attraction. Another fundamental of the arts was having its way—the economic benefit that comes from the tourist.

It was reported to me that certain business interests, including those dealing with the basics of pipes and related fixtures, expanded profitably into the supply of edibles for the hungry. Something similar must have occurred because criticism subsided. The moratorium was indefinitely prolonged.

And from somewhere high above, I like to think that Hubert Horatio Humphrey looked down and smiled.

Chapter 60

THE CATALYST ROLE OF THE ENDOWMENT WAS FOCUSING NEW ATTENTION on the arts and increasing the awareness of their benefits in many parts of government.

Joan Mondale and I worked with the National Council on the Aging to strengthen programs for older people that stressed the arts as special enrichers of experience and banishers of solitude. We concentrated also on efforts for the handicapped. Larry Molloy was a pioneer of this work. So was Phyllis Wyeth, wife of James the artist and onetime National Council on the Arts member. Phyllis had been seriously injured years before in an accident. It is difficult for her to walk, but walk she does, and travel, and bring her gregarious nature and her compelling words to the cause of arts for the handicapped.

At the endowment I created an Office of Special Constituencies with Paula Terry as its staff, following work begun by Leilani Duke (who is now with the Getty Trust in California, directing a broader scope of arts activities). Paula worked with government programs dealing with the aging, the handicapped, those institutionalized in hospitals. There are immense therapeutic blessings derived from the arts. Paula helped make this manifest. She was compassionate and innovative. Her salary was

minuscule in terms of our total budget, but her work had a far-reaching effect.

Itzhak Perlman, among the world's most renowned violinists, is handicapped almost in the same way as Phyllis Wyeth. Itzhak came to call upon the council and spoke of the serious troubles he had trying to climb stairs to a stage or to a backstage dressing room. One council member privately took to a wheelchair himself to see exactly how it was from the handicapped person's point of view. And so programs were put in motion to make arts facilities more accessible to artist and audience. It was a time of awakening to a need, and it should be noted that the endowment was greatly involved in the process and that its chairman sought to reinforce the importance of it whenever hearings on these subjects were held on Capitol Hill.

During my tenure we established a Task Force on Education, headed by Sandy Boyd of the National Council. It emphasized the professional training of artists as an endowment goal, and it reaffirmed the value of the Artists-in-School Program, begun so long before by the first council with a few poets in a New York school, and now expanded to programs in virtually every state. Endowment funds were often privately matched and matched again by state and local support. The artists were not in schools to compete with or replace teachers. Rather, they were special resources, according to a school's plans and wishes, for deeper understanding of the arts in demonstration, in exposition.

The task force also pointed to the need for wider attention to the arts in all levels of American education, from primary grades to the relatively new field of continuing education, so well represented on the council by Tom Bergin from Notre Dame. David Rockefeller, Jr., son within that family enclave noted for both special philanthropy and governmental service, had become chairman of a twenty-five-member panel of leading artists and educators under the aegis of the American Council on the Arts in Education. Soft-spoken, serious, with a deep love for the arts, David had brought into being a report entitled *Coming to Our Senses,* which placed the arts as priorities in the American educational system. I still find it excellent reading, as timely today as it was when it was published a decade ago. There were congressional hearings on *Coming to Our Senses.* As a friend on the Hill suggested to me, "We have a new sequence: reading, writing, arithmetic, and the arts—or would you want the arts first?" He knew my answer without asking.

New significance for the arts in education is one thing to discuss, analyze or make the subject of conferences, but it is quite another to shape into reality. *Coming to Our Senses* contained over a hundred different proposals, all valid, all germane; but no one could quite agree

which was number one, or even which were the top three or four. A new advocacy, a new sense of urgency seemed necessary. Sandy Boyd and I, together with Joan Mondale, decided that we would once again use the endowment's catalytic ability, but in a way not explored before. We would recommend that the endowment and the Office of Education join in funding a new position that would equally serve both funders. We would find an individual suited to both sides, with credentials in education and a similarly strong background in the arts—a "doer," an activist, capable, in Claiborne Pell's phrase, of "knocking heads together," and also of creating agreement.

Ernest Boyer headed the Office of Education. In the tradition of my earlier friend, Francis Keppel, Ernie Boyer was keenly imaginative, with that combination of humor and wisdom I have mentioned before as unusual in government. He and I and Sandy Boyd interviewed and screened a good many applicants who had been intrigued by the job announcement and by what it could accomplish. Some who had outstanding records and were highly qualified were reluctant to forecast success and envisioned with some misgiving a moving of mountains and the changing of long-established traditions. He or she would need to deal with individualized state departments of education, with thinking that was comfortable with the status quo, and with a federal government staff in educational fields that was, like others, suspicious of intrusion and change.

We chose Vince Lindstrom for the new post. Vince had a record of accomplishment in the arts and education in North Dakota—not South. Admittedly, his experience was somewhat localized, but he had achieved wonders in generating the kind of cooperative spirit we sought. He brought a freshness and enthusiasm to his interview that others lacked. He was a unanimous choice. He resembled a young Viking, blue-eyed, red-bearded. He would embark on these new waters in 1979 without the impediment of misgiving.

We may have expected too much. Vince was perhaps too imbued with zeal. Doors opened and brightness entered his expeditions, but thickets and briars of sheltered pathways caught at the elbow and clothing. A sense of frustration replaced efforts at patience, and Vince moved on, elsewhere in his own life and career.

We adopted a more moderate approach. We worked together without an intermediary. Projects were planned to serve as later models. Staffs became friendly and respecting of responsibilities. Ernie Boyer was a man of rare enlightenment. When President Carter named Shirley Hufstedler as the first secretary of education toward the end of his term, she and I proceeded to explore, to develop and build for the future. I also worked with Mary Berry, assistant secretary of education. Her keen mind was receptive. We created only the foundations, however. The edifice

that houses the arts prominently within the halls of education is far from completion. The claims of the so-called "basics," the three Rs, the priorities of science and technology in an increasingly technical and computerized world, are strong. Vikings on exploratory voyages do not always return with treasure, but they pioneer. Something new on the map is marked out.

Some day, I am convinced, others in high educational posts, federal, state and local, will recognize the essential nature of the arts. If they have a central importance to life, certainly they have such an importance to education and to the preparation for life. Our creative spirit, as well as our more practical abilities, needs nourishment. Place any young person into the magic arena of the arts, and there is a change. The arts enrich. They also invite the learning process itself.

I have seen the results among students at the college level and among disadvantaged children. My wife Catharina, long a teacher of art the District of Columbia's public school system, has witnessed and has been responsible for the kindling of the same spark. Someday it will grow. Enrichment of the human spirit is not just an esoteric idea. Not at all.

Other joint undertakings, also precedent-setting, were conducive to more rapid results.

In September of 1979 I signed a memorandum of understanding with Max Cleland, head of the Veterans Administration, to increase opportunities for artists and bring the arts to veterans' hospitals. Joan Mondale presided at the ceremonies. I had known Max Cleland during my time in the Senate, where he also had worked. He lost his limbs in the Vietnam War and moved about in a wheelchair, his strong torso always upright, his broad face usually showing a broad smile. No one was more respected in government, and I always felt fortunate to have such a friend.

We agreed to initiate two related programs: first, to place artists-in-residence in veterans' hospitals, beginning in Virginia; and second, to include the visual arts—paintings, murals, sculpture—in these hospitals. Funding would be supplied by the VA; artists would be chosen, as the VA requested, through the endowment's panel system. The results were immediate and heartwarming. To me, they represented a very special joining together of opportunity and need.

A few months earlier another ceremony had taken place, at the Vice-President's house, linking the Arts Endowment with the Small Business Administration. One may ask what two such different agencies had

in common. Artists themselves had supplied the answer: They wanted a better understanding of business and financial techniques, marketing, advertising, and taxes. They wanted to know more about materials, especially those that pose potential hazards. They wanted to learn how to prepare portfolios and work for sale, how to set up shops individually or in consort with others. In short, artists had told us they needed to know the intricacies of small business, fitted to their efforts and careers.

We spoke from the stairs leading diagonally upward from the front hall—Joan in introduction of Vernon Weaver, head of the Small Business Administration, and I as endowment chairman.

We spoke of partnership and again of commitment. A series of conferences would be arranged beginning in Los Angeles, Chicago, and New York. The nationwide network of SBA offices and experience would be used. The endowment would develop the agenda and select leading artists as speakers. But technical assistance would come chiefly from the business community, with the SBA defraying the costs. A training manual underwritten by the SBA would be included. The conferences would reflect the theme of 1979 at the endowment—help to the individual artist.

To many of us, the response was amazing. Best SBA estimates told us to expect up to 200 at each of the three conferences. Instead, in Los Angeles, the audience of artists was so large that one group had to watch the proceedings on quickly arranged closed-circuit television. More than 4,000 artists attended the first programs. In all, more than fifty gatherings took place, in most parts of the country.

My special assistant, Lee Caplin, coordinated this whole project, which so exceeded our expectations—perhaps not to Lee, who clearly saw the benefits from the start. His skill and enthusiasm were particularly valuable. The returns, this time quite tangible, far outstripped the minimal endowment cost. *The Business of Art* was published in 1982 by Prentice-Hall and sold widely, with proceeds donated to the Arts Endowment. In my introduction I pointed out that as "one of the many ironies of history, many artists, while revered and respected for the work they produce, are unable to support themselves wholly from their creations." The book included articles by authorities in both the arts and business, and it covered such subjects as financial planning, taxes applicable to an artist's work, copyright procedures, selling under contract, dealerships from East to West Coasts, toxic materials, museum purchases, and corporate collections and sponsorship. The intangibles of the arts were given a highly tangible boost.

Chapter 61

FROM ANOTHER BUSINESS PERSPECTIVE, I WORKED THROUGHOUT MY term to strengthen cooperation between the corporate world and the Arts Endowment. Business leaders tend to mistrust government—more so, I think, when there is a Democratic administration. Their skepticism is not always expressed in words, but one can sense a questioning attitude.

In the endowment's beginnings, Roger Stevens had helped assemble a group of business leaders and artists in New York City. Over an excellent lunch, camaraderie was developed, but then came speeches and brief remarks from the participants. A corporate head had suggested that artists knew very little about American business efficiency and know-how and could profit from knowing more. Isaac Stern, somewhat nettled, had suggested that business knew very little about the arts. Separations of viewpoint were not exactly bridged that day, though Roger, representing both his own business experience and the arts, strove for a happy conclusion. Some, however, expressed privately to me views that suggested a peace table was not exactly in the next room.

Nancy Hanks, with a Republican administration in power, also strove as chairman for the ties that would link the business community

to the arts. Corporate cultural philanthropy was increasing. The catalyst of the endowment's matching funds was vigorously at work. Business representatives such as George Seybolt, Bill Eells, and Jim Robertson served on the council. Nancy brought on board Carl Stover, a former political science professor at Stanford, with diplomatic experience and excellent Rockefeller and Bicentennial credentials. A Cultural Resources Project was begun, focused on developing new friendships between the endowment and corporate philanthropy. Carl was ably assisted by John Skuce and a board of directors, chaired by Pennsylvania's former Governor Raymond Shafer, for whom I had much personal regard. The concept was that, with endowment start-up assistance, the project could in time be self-sustaining, its own catalyst to supplement the endowment's efforts.

My study of business and corporate relationships, however, convinced me that perceptions were crucial to success. If it was perceived, and it was in some quarters, that the endowment was seeking to lead or direct business contributions to the arts, there would be inevitable negative reactions, from mild criticism to outright animus. A complete mutuality of effort was crucial. To advance Cultural Resources, Nancy Hanks conceived a pooling of support from corporations to match the funds she deemed necessary for the beginnings of the Challenge Grant Program. Corporations would contribute to the endowment (tax free, by law), and the monies would be distributed in accordance with the endowment's respected panel system. The private citizen principles would thus be safeguarded; the corporate world would be assured of an excellent investment. Contributions to the pool would be duly noted and celebrated, with corporate support at a broader level than otherwise possible.

But where was the individualized gift in such a process, the traditional identity of Corporation X with Arts Organization Y? Where was selectivity in grantmaking? Where, in fact, was corporate freedom to make a particular choice? Was this right to be altered under, of all things, a Republican administration?

While I was still with Claiborne Pell, Nancy asked me to help mollify business concerns at a meeting in Robert Sarnoff's elegant apartment, high above New York City's avenues. I was to represent nonpartisanship in the developing argument, as well as a perspective on the legislation's beginnings. Carl Stover was there representing Nancy, and my Senate colleague Greg Fusco came from Senator Javits's office. It was a well-attended session, but it was not particularly congenial. I could see that the idea of corporations pooling their giving to the arts had touched a raw nerve.

In a similar vein, not long after my own term began, challenge grants in the San Francisco area were criticized by businesses there as

too concentrated and overly generous, as forcing corporate giving to fo-
cus on a few arts organizations selected by the government. That was
the feeling, even though each applicant had been asked to assess in ad-
vance its potential to obtain matching funds in the community, even
though these findings were carefully reviewed.

There was no doubt that the endowment's relationship to business
was a touchy situation. I adopted an approach I could believe in, an ap-
proach that is at the core of my convictions: that government must be a
junior partner in its help to the arts. It must never seek to dominate or
domineer. Government can provide guidance when sought, and it must
listen with the greatest attention to outside opinions. I had many per-
sonal meetings with business leaders. These brought more and more re-
wards to the endowment, but it took many months and lots of effort.

I worked with the pioneers of corporate support for the arts:
George Weissman and Frank Saunders at Philip Morris; *Denver Post* pub-
lisher Donald Seawell, who created a great new performing arts center
in that city; Winton Blount, once U.S. postmaster general and an emi-
nent arts philanthropist from Alabama; Armand Hammer and William
McSweeny of Occidental Petroleum; Helen Brown, director of the CBS
Foundation; Elliott Cattarulla and Leonard Fleischer at Exxon; Bob
Kingsley, also of Exxon and chairman of the Arts and Business Council;
Krome George and Charles Griswold at Alcoa; Jack Kiermaier at CBS;
Robert Leys and Archie Boe at Allstate Insurance; William Ruder of
Ruder and Finn; Rawleigh Warner at Mobil; Sibyl Simon, director of the
Arts and Business Council in New York; Gordon Getty and the Getty
Trust; Norton Simon and his special philanthropy; Kenneth Dayton, once
a National Council member, and Richard Conte, once an endowment offi-
cial, at Dayton Hudson; Donald Kendall of Pepsi Cola; Robert Schneider
of Xerox; William Shane of Atlantic Richfield (at one time we had been
copy boys together on the Philadelphia *Evening Bulletin)*; John DeButts
of AT&T; William Orme of General Electric; Humphrey Sullivan of Lever
Brothers; Clark MacGregor of United Technologies, former member of
Congress; and from Business Committee for the Arts, its president when
my term began, Goldwyn McClellan, his successor, Edward Strauss, and
BCA's vice-president, Michael d'Amelio.

We met regularly in small groups, sometimes in Washington, more
often at corporate offices or at the headquarters of Business Committee
for the Arts in New York. Conversations were candid, lively, used to ex-
change ideas and information rather than to create policy. I found these
open discussions, and the increasing sense of friendliness, immensely im-
portant to the endowment's work.

Corporate support doubled, and doubled again, and doubled after
that, reaching a total of close to $450 million a year in my time, far ex-

ceeding the endowment's annual appropriation. A junior partner, that seemed to appeal. And yet the endowment by itself far exceeded the potential of any one corporation. Now that elements of suspicion were removed, we could talk freely about our own plans and discover how they could mesh with others.

I hope the day will come when business leaders frequently visit the endowment with specific goals in mind: What can I do for community orchestras or for *my* community orchestra? How can we best help opera in this particular city? How can we reach greater audiences for the arts here at our home base?

There are at least two cardinal principles, I believe: First, the corporate gift, whatever the size, should remain individualized, and the corporation should be appropriately acknowledged for its special initiative; and second, corporate giving, as a general rule, should not be expected to go beyond investor sensitivity. It is unrealistic to believe the large corporation will fund the experimental in art. That simply is not a fair responsibility. But the enlightened corporation can help lead *toward* new artistic expressions. It already has.

I remember with delight, for example, two efforts supported by corporations that over the years have proven themselves to be enlightened sponsors of the arts. Philip Morris, in company with the endowment, initiated an exhibit of contemporary American art. At the opening at the National Collection of Fine Arts both Frank Saunders and I spoke. The work was partly figurative, partly abstract, by artists from the West—artists, said Philip Morris, of a special time and place, yet universal. It was an excellent and varied exhibit, full of vitality and color. Philip Morris used vignettes of the exhibit in its advertisements. "It takes art to make a company great," read the message. Bravo! is my view of that message.

On another occasion, we helped inaugurate a special project to aid major American symphony orchestras to tour in the United States, to visit areas where such performances had been available only on records. Hearing a great orchestra for the first time—or witnessing for the first time any superior live performance—brings an excitement that so often beckons the imagination for more, that awakens a wish for excellence. The project was sponsored by AT&T and it was the first of its kind— exemplary also, and a joy.

There were moments when signals between the endowment and corporate leadership seemed slightly mixed. The Skowhegan School in Maine, renowned for the excellence of its students and teachers, had been approved for a challenge grant; and Steven Martindale, active in cultural matters in Washington and beyond, asked if I would personally present the grant at the school's annual fundraising and awards dinner in

New York. I was glad to accept. I spoke about the excellence of the school and its importance to the visual arts, and I delivered a facsimile check. Among those honored was Donald Kendall of Pepsi Cola, for his leadership and for the support his company was providing to the arts. In his remarks, he suggested that, while he was not quite recommending the return of the endowment's check, business leaders were quite able to support the arts, thank you, on their own. Privately, however, during the course of the evening, he took me aside. He had recently been named to head the board of directors of the American Ballet Theater. Endowment help, he said, was greatly needed. Was it on the way? It was, as it had been in the past.

Allstate chairman Archie Boe was also president of the Lyric Opera of Chicago. At one point in my term as endowment chairman, the opera was on the brink of financial crisis. Its board was recognizing both the necessity for administrative improvements and the cost of implementing them. I was able to help with a so-called Chairman's Grant, which the enabling legislation allows in cases of emergency or particular need. The action requires a panel clearance, and it must later be reported to the council. Sums were limited to a maximum of $15,000 and must, of course, be matched. In this case, however, help was on the way at once, and as so often happens with endowment support, help was multiplied, from business and other sources. The Lyric survived and employed an outstanding opera management professional, Ardis Krainik, to rejuvenate the company.

In essence, business and the endowment moved forward together. That relationship, a vital element in cultural progress, must be founded on trust, respect, and a commitment to shared responsibilities. Leadership? That is often a part of the sharing, as is inspiration, and who inspires whom to act. Business responds to the catalyst. The problems with challenge grants in San Francisco subsided when businesses discovered that they themselves could do more than before.

Claiborne Pell's dictum on success again comes to mind: Always let the other fellow have *your* way. In a true partnership, it works on both sides.

Chapter 62

*A*N AREA OF PARTICULAR CONCERN TO ME WAS THE INTERNATIONAL one, for the arts can serve as unique ambassadors in a world where turmoil and conflict, contest and competition, suspicion and seeming inflexibility are so often the norm. We have often disagreed strenuously with the Soviet Union—sometimes when there is a relaxing of tensions, sometimes with all the machinery at our disposal menacingly or strategically poised—and they take issue with us in a similar fashion. But we can enjoy and appreciate the greatness of their ballet, and they can applaud ours, and neither needs to argue about who invented dance, because neither of us did. Dance is as old as civilization. Like the other arts, it communicates in a way that neither language, nor weaponry, nor the politics of governance can.

Midway into my term, a delegation of Soviet cultural leaders arrived in Washington. They wished to learn about a National Endowment for the Arts. The Department of State wanted our complete cooperation. It's very serious and highly important, I was told in a phone conversation; the President wants them to feel at home. There were some fifteen of them—the Cultural Minister, leaders of the arts in the state capitals, their aides, and an expert interpreter. As they were in the elevator

climbing to our floor, I suddenly remembered a sentence in Russian, self-taught years before, when just after World War II I had thought about a career in diplomacy and few were studying the language. It was the first sentence on the Berlitz records I purchased: it said, "In this picture is the family," and identified the members, down to the smallest, holding a doll.

It came back to me, intact. In my wallet, I always carry a picture of my family. I brought it out quickly and gave it a glance. Sure enough, there was even a small granddaughter holding a doll.

The elevator doors opened. A great crowd seemed to emerge, with the minister a step ahead. In my greeting, I extended the photograph. In this picture is represented my family, the mother, father, grandmother, grandfather—and the granddaughter with the doll. It was an instantaneous success. Smiles broke forth everywhere. The heavy garments of winter, the fur hats were being removed. The picture was being passed from hand to hand. I was later informed I had pronounced the somewhat difficult word doll in Russian so well that—consternation of consternations—the interpreter was let go.

I was tongue-tied! We were sitting at the long table in my office. The entire delegation was smiling, all speaking at once. I could not remember yes or no, or how are you, or goodbye, or a single simple phrase I had once studied. My brain was stuck.

I could tell that the guests, apparently noticing the possibility of some problem, had decided they had overwhelmed me with too many voices. After all, here was a chairman of a National Endowment for the Arts who spoke fluently in their language. Give him a chance. So they began addressing me one by one and got the same response or rather a total lack of it. A look of puzzlement rapidly replaced good humor. A few more tries were spoken much more slowly. The interpreter was seen to reappear, summoned to the doorway.

Now, it is not the easiest thing, I discovered, to explain a rather complex attempt at American levity to a delegation of this sort, seriously intent on examining the National Endowment for the Arts of another country. The interpreter was listening carefully to me. You study Russian, why just one sentence? It was at this point that I learned about the doll—why a doll? All the others were most attentive. Finally the interpreter spoke at some length.

There was silence.

Then a man more heavy-set than all the rest said slowly in a heavily accented tone, but in English, "You make . . . joke . . . of *us?*"

I had the premonition that I would soon be hearing President Carter's voice on the telephone—Biddle was slated for his own Siberia.

"No, no, not a joke," I said, "an effort to . . . make you all feel at home."

"At home?" the voice seemed thick with a questioning sarcasm.

"It's the only sentence in Russian I know," I said, "the only one I can remember from long ago. I thought we should introduce ourselves. Families . . . the arts are like a family."

"Families?"

They had been in the office more than twenty minutes. They were scheduled for thirty-five. We had not even touched on an endowment for the arts.

But suddenly, again from toward the end of the table, a wallet was produced. A picture was extended.

"My family."

I reached for it, as if it had been sent from heaven.

"But there is no doll," I said, using the Russian word.

"No doll?"

There was a sudden loud burst of laughter. "No doll. No doll!"

"The arts are interpreting to each other," I suggested to the translator, who put the thought into Russian. A great thaw seemed to set in.

The minister was complaining about the time. I was giving the interpreter brochures on endowment programs, all the relevant material rushed to my office.

The minister stood up and spoke to the interpreter, who spoke to me.

"You can have dinner tonight?" he asked.

"Of course," I answered, "with the greatest pleasure."

"All of us," said the interpreter, "and you."

It was a merry meal. I even thought of a few old phrases I had forgotten, and have forgotten again. The minister told me, nudging a colleague, that the different areas of Russia wanted as much voice in the arts as state leaders I knew. Some of the same problems, he said; the arts are complicated. They were also the interpreters that rescued me that day.

One of my first endowment assignments, as chairman-designate, even before Senate confirmation, was to accompany Rosalynn Carter to the Mexican-U.S. border in the furtherance of cultural exchange and goodwill. Joe Duffey, already chairman of the National Endowment for the Humanities, was in the official party. So was John Jova, former ambassador to Mexico, quiet and genial, impeccable in Spanish, beloved in Mexico, with a vast fund of knowledge. We sat together during the travel time. I learned much from John then, and later; he headed Meridian House in Washington with a purpose and a reputation for increasing international cultural understanding, which he himself so enhanced.

It was my first time with Mrs. Carter. I had known Mrs. Johnson

well, Mrs. Nixon and Mrs. Ford through introductions and passing brief conversations at large functions. But here was an opportunity to be with a new First Lady, with few others involved, on a journey that was important to her. She made one feel her keen interest not so much by what she said, but by how she reacted to other views, listening carefully, with a quiet grace I found key to her character. I think it was basic to her role as First Lady as she saw it. In the wide-set eyes I could see an inner strength and fiber, and always a desire to learn. It made me feel that the President was fortunate. Eyes are, to me, always most revealing. These were sometimes opaque, masking a thought or emotion; but they were exceptionally deep, without a trace of the superficial.

We traveled by presidential plane to south Texas, then by car to the border. Mrs. Lopez-Portillo, wife of the Mexican president, met us there. She was statuesque, eloquent in speech with the large dark eyes of her cultural background. The two First Ladies exchanged remarks and spoke a bit about history and more about a better future. I was taken by the accoutrements Mrs. Lopez-Portillo wore, at her ears, around her neck. They were large and seemed alive with tiny lights. It was suggested that they were very delicately and unobtrusively electrified, and that the high-ranking Mexican army and security officer, at his First Lady's side, was equipped with a battery in case there was a failure of current. I suppose such information is what makes work with the CIA interesting.

Whatever flamboyance there was, however, it was superceded by expressions of friendship and good humor. The two First Ladies seemed happy with each other's company. I discussed with cultural officials some modest endowment arts projects in south Texas, where there was a Mexican cultural background, and we visited a Mexican arts center not far from the border to view paintings and ceramics. Toward the end of the day, Mrs. Carter was off in another direction. John Jova and I were billeted, after meetings, in a Texas hotel before returning to Washington the next morning. I called Catharina. It was November 3, 1977, our fourth wedding anniversary; she was with me on all of our voyages thereafter!

During that early part of November 1978, Joe Duffey and I determined to follow up on the Mexican experience. We would join forces, arts and humanities, humanities and arts, just as those now seemingly ancient pronouncements in the original legislation recommended. The arts and humanities are closely allied partners, said the Senate report in 1965. They were now joined in new concepts: we would celebrate the cultural life of other countries and so enhance our own. A liberalizing of the basic legislation now permitted modest funding in international areas.

Artists and scholars from here and abroad would share in these enriching endeavors. The ambassadorial attributes of the arts would be given opportunities; scholarly knowledge would be increased and interpreted. And just to help ensure that all would be understood, we published a brochure in Spanish, "La Dotacion Nacional para las Artes," the National Endowment for the Arts.

The program focused on the present—the word "today" was in the title, but todays were related to past histories, and to tomorrows.

Meridian House was chosen for the opening of Mexico Today. With its elegant interior, lofty ceilings, great glass-paneled doorways opening to a wide terrace shaded by linden trees and with a panoramic view of Washington, it is a traditional focus for international events. John Jova made this one special with a luncheon honoring Octavio Paz, poet, diplomat, and educator. I could happily point out to the audience assembled that his translator was an eminent American poet, Muriel Rukeyser, who coincidentally served as a panelist for the endowment's Literature Program.

Rufino Tamayo, painter of those dark-hued delicate abstractions that so individualize his work, was honored in Washington at an exhibit at the Phillips Collection and in New York at the Guggenheim Museum. An extensive exhibit of pre-Columbian art and artifacts took place at the National Gallery of Art. Seminars and exhibitions followed across the United States.

Mrs. Lopez-Portillo, conservatively attired this time, came to Washington and was honored by a VIP lunch at the State Department. We began planning for an important exhibit of American art in Mexico City. To facilitate matters, I brought together at the endowment Peter Marzio, director of Washington's Corcoran Gallery of Art; Stephen Weil of the Hirshhorn; Carter Brown of the National Gallery; Laughlin Phillips of the Phillips Collection; and Joshua Taylor of the National Collection of Fine Arts. It was a special group of leaders, each with important contributions to make. High-level discussions could not have found higher levels. I was able to explain with confidence the security and protective measures the exhibition would receive in Mexico and how significant and how much desired it was. Joshua Taylor, who had greater experience with Mexico than the rest of us, agreed to a special organizing role. John Reinhardt, director of the International Communication Agency (ICA) joined with me in emphasizing the goals of understanding the President sought to develop. Harold Schneidman, John's deputy, and Joe Duffey were also partners in this meeting. It stands out to me as representing the strong cooperation possible between government and the private world of the arts when there is mutual trust and regard. Obsta-

cles, and there are always obstacles to such an international undertaking, can be overcome but the experts have to know that their expertise is given precedence.

Mexico Today (1978) was one of five such programs we undertook. Others were with Japan (1979), Belgium (1980), Egypt (1981), and subsequently the Scandanavian countries (for which I was careful to provide advance funding toward the end of my tenure, just in case the relatively small sum involved should slip from the budget amid the threats of drastic and crippling reduction).

Japan Today brought together American and Japanese artists in keeping with these first steps toward international cultural exchange. It gave the United States a view of Japanese theater, music, painting, and the decorative arts, past and present. It expanded ideas for our own artists. Art develops in accordance with changing traditions and the creation of the new, which in turn attracts a following and is in turn changed. The wider the source material, the greater the opportunities for talent to grow. Thus the sparse but intricately balanced design in a Japanese line drawing of a past century is reflected in the work of a later artist who individualizes yet assimilates its value. Japan Today led to enhancements of the Japan-American Friendship Commission in support for American artists traveling and working in Japan. And it led to a memorable journey for Catharina and me in 1981, when the Japanese government invited us to see for ourselves, to learn from the ancient arts and the new.

Japan Today had both Japanese and American private sponsorship. Over $2 million was raised, with the endowment's seed money comprising less than 10 percent. Some 180 cultural institutions were involved and 530 separate cultural events occurred in ten cities—Washington, New York, Chicago, Denver, Boston, Los Angeles, Miami, Albuquerque, St. Louis, and Aspen, Colorado, where an International Design Conference chose Japan as its theme. Arts and humanities, humanities and arts—the statistics reflect the scope of these programs. We were able to report them personally on our trip to Japan.

The Belgium Today program was just as extensive. It included an eight-week celebration of Belgium's contributions to cultural progress—exhibitions from the twentieth century to the fifteenth, from the work of Leon Spilliaert at the Phillips Collection in Washington to the religious masterpiece, the *Triptych of the Legend of the True Cross,* at the Morgan Library in New York. As with the other programs, Kathleen Bannon of the Arts Endowment and James Craft of the Humanities Endowment provided outstanding staff help. I remember especially the work of Patricia McFate, then deputy chairman of the Humanities Endowment; Lucie de

Myttenaere of the Belgian Embassy; Jane Livingston at the Corcoran; Charles Ryskamp at the Morgan; and Emile Boulepaep, president of the Belgian American Educational Foundation, who made the seeds of our federal support grow.

Our program celebrated the 150th year of independence of Belgium, a culture joining Flemish and French backgrounds, a complex nation with language differences, a monarchy, and democratic principles. King Baudouin and Queen Fabiola gave their support and their presence. They came to the White House—he tall and slender, with the thin expressive face of a sensitive, perhaps somewhat introspective poet, and she with the look of deep intelligence and with the hint of quiet amusement often at her lips. It seemed to me that Belgium Today, celebrating cultural achievement, was as welcome to them as it was to us.

Later, at the Belgian Embassy, the king honored me with the Order of Leopold II. It was a banner day for the Biddles, and I will always cherish this decoration—blue ribbon, golden cross, circular wreath, blue enameled medallion with lion in the center. Ambassador Raoul Schoumaker presided over the ceremony; he and his wife, Cecile, had aided the Belgium Today program from its inception, enthusiastically and with unstinting energy.

Jehan Sadat, wife of Egypt's president, came for the opening of Egypt Today in Washington early in 1981. Preparations had been underway for many months. We had been invited to Egypt after I became chairman, on a brief trip organized by Esther Coopersmith with the U.S. delegation to the United Nations, to help Mrs. Sadat open the ancient Temples of Philae. The temples had been rescued from the waters above the Aswan Dam, moved stone by ancient stone from far below the surface of what is now an inland sea, and placed on an island, built to a precise likeness of their former home. Gloriously preserved, they are exemplary of the concepts of preservation the world over.

Jehan Sadat gave great dignity and charm to the Egypt Today ceremonies. She has those classic features, that proud tilt of head, that quiet smile, that poetic gift of language—and of the English language—which I knew came from admiration and study of Shelley and the romantic poets, familiar from my own college work. We had talked in Egypt with Anwar Sadat, who conveyed his regard for President Carter and his profound concern for the hostages then held in Iran. Catharina and I felt a special closeness to these two leaders.

That opening night, after listening to Mrs. Sadat and thinking of our journey to Egypt, I put aside my prepared remarks and tried to express our feelings: "Madame Sadat, as you spoke to us, I remembered the trip my wife and I took to Egypt, and the day we saw Abu Simbel

and its towering monument—also, like Philae, rescued from the Nile waters. Deep in its interior, at the end of narrowing, long corridors of stone, is a statue of one of Egypt's great early rulers. We know the sun rises at a slightly, very slightly, different position on the horizon each day. So did the ancient Egyptians. And this immense monument with all its magnificent facade and interior rooms is arranged so that once a year, a single shaft of the rising sun penetrates the long stone passageways, penetrates the shadows, and falls for just a moment on the statue's face, on his birthday. It's a symbolic moment, then and now. Today, we celebrate a brilliant ray of light, of illumination, shining on us, as if through the corridors of history—through the shadows—reflecting brilliance. The special brilliance of the arts. Madame Sadat, you reflect that brightness, that luster, the illumination the arts and humanities provide."

I am very glad I saved the little white cards on which I scribbled that evening, for so much has changed.

Ambassador Ghorbal of Egypt; Joe Duffey; Dillon Ripley; John Jova; Mohammed Hakki and his wife, from the Egyptian Embassy who had so helped us on our Egyptian voyage; John Reinhardt; Janet Solinger, who headed the Smithsonian Resident Associates, the private citizen sponsoring group for the "Today" occasions—all were present that evening with a host of other dignitaries and guests. I introduced Dr. Mahmoud al Hefney, a pioneer of music education in Egypt with a quintet of musicians bearing his name. The *oud* and the *quannan,* instruments from a 5,000-year-old past, were heard for the first time in the crowded auditorium of the National Academy of Sciences, where these opening ceremonies took place.

Included in Egypt Today were art exhibitions, lectures and seminars of scholars, film festivals, concerts, and dance performances. (Not the belly dance, I might add, in case Mr. H.R. Gross of Iowa is somewhere listening.) Tapestries, sculpture, paintings were featured; poetry, the modern Egyptian novel and short story. From the humanities side came a focus on history, archeology, and discussions of a society in transition and crucial to peace in the Middle East and the world. Egypt Today moved from Washington beginnings to a far wider audience—first in New York and then via Texas to California. So the Nile met the Potomac and the Pacific as well.

The two endowments supplied the modest seed money for "Today" programs and made certain they were well launched, but principal support came from corporations with business interests in the countries involved. It was a chance for businesses to demonstrate belief in cultural

activities and to enhance goodwill for their own enterprises, and they
responded; self-interest and philanthropy can be helpful companions. In
keeping with such initiatives, Lee Abbott, vice-president of Nabisco,
called me one day, not to ask for financial aid for his company's project,
but to ask for an endowment blessing. He planned to bring Canadian
artists and paintings to Nabisco headquarters in New Jersey, where long
stretches of wall space had been readied for exhibition purposes. Catharina and I and Canadian ambassador Peter Towe and his wife helped open
the exhibit. It was a first for Nabisco, and it was so well received that
they began to plan for a similar effort with Mexico, where Nabisco also
had a branch of its business. And in Washington Marc Zuver with
endowment support began his excellent emphasis on Mexican and Hispanic culture at Fondo del Sol's gallery.

Thus we began, with four very different cultural pasts and presents: a neighbor, with a background in part shared, in part contrasted; a
nation once a bitter enemy, turned to friend; a small nation with a long
record of independence, yet struggling for a secure identity; a country in
the midst of current and past animosities. Art and history—all grist for
our own understanding, our own identity. Learning is a humbling experience; it is also essential. It unlocks and opens the future.

The Scandinavian countries were next. We had worked hard with
the embassies involved, in particular with the ambassador of Sweden,
Wilhelm Wachtmeister. His artist wife Ula and Catharina had often exchanged thoughts and ideas on painting. We shaped the plans, and in my
final weeks in office set aside funding to assure their safety and good
use.

It is sad for me to think that there would be Scandinavia Today,
and then no more. A great void remains to be filled. Too often the
United States seeks to use its cultural programs as tools of influence with
other countries, rather than as efforts to both learn and teach. Old
friends have as much to give us as we give to them. International exchange should not be limited or one-sided. Let this government be a catalyst, let it demonstrate concern and intelligence, and the sky is the limit.
Certainly, funds are short, but the record clearly shows how, from small
beginnings, achievements can ensue. First, however, there must be the
commitment. That is the chicken and the egg, in one.

I was privileged to represent President Carter and speak for him
at events of international scope which his schedule kept him from
attending. On April 6, 1980, the Corcoran Gallery held a special ceremony for an exhibition of the contemporary art of Senegal and in honor
of Senegal's president, Sedar Senghor. Mayor Marion Barry also spoke as

one who had helped to initiate the exhibit, as did James Cheek, president of Howard University, which had commemorated President Senghor's achievements.

He was a remarkable man, imposing in stature, a poet, a philosopher. He combined within his own person, as I told him in my remarks, the arts, the humanities, and government. He seemed to enjoy the compliment. There were poetry readings from Senegal and the United States and a display of tapestries in which the president took great pride; they were woven with skill and with striking colors, examples of what President Senghor had planned for a beginning and developing industry. It is always a treat to find a government leader who is himself immersed in the arts.

On another occasion President Carter asked me to be his spokesman at the first international ballet competition held in the United States. It was in accordance with a plan that alternated competitions between the U.S. and Varna, Bulgaria, where prestigious competitions had traditionally been held. Jackson, Mississippi, was chosen as the American partner. "Why Jackson, of all places?" a northeastern skeptic asked with arched brow and tone of voice. "Why not New York, the center of dance?"

The answer was that Jackson was a state capital, with elegant houses and wide verandas, southern hospitality, and a lively new interest in the arts. Early in my term, I had helped the city dedicate a new cultural center. The competition was a resounding success, attracting dance experts from all around the globe and an ebullience of talented young dancers. President Carter, through his arts chairman, presented the awards; but major credit for the renaissance of Mississippi and the arts goes to Lida Rogers, director of the state arts program. She has a special knack for changing goals into reality.

In the fall of 1978, John Reinhardt headed an American delegation to Paris for the 20th Anniversary General Conference of UNESCO. Joe Duffey and I were included. It is not the purpose here to argue about U.S. participation in UNESCO and its later ending. Much can be said pro and con. In my endowment time, however, this was a unique forum for worldwide cultural discussions of all shadings, from agreement with American democratic views to the opposite.

I had immense regard for John Reinhardt, in this and other contexts. John was at once firm in his convictions and considerate in hearing another side. He was forthright, not given to diplomatic evasions. His face was strong, his eyes direct. As a black leader he communicated particularly well with African-born Amadou Mahtar M'Bow, UNESCO's direc-

tor-general, a person whose quick smile and bearing gave, in my view, both a dignity and a sense of friendliness to the organization.

We traveled with Peter Kyros from the Vice-President's office and were met by Ralph Rinzler of the Smithsonian, who had arrived a day or so in advance to prepare for the meetings. Joe Duffey was already there with his expert in international matters, James McCargar, formerly with the Department of State. We worked with Ambassador Esteban Torres, the U.S. permanent representative to UNESCO, and Gabriel Guerra-Mondragon, executive secretary of the U.S. National Commission for UNESCO. Each morning we took an early subway from our small hotel on the Left Bank to the headquarters, which bustled with activity, the corridors filled with a great assortment of languages and accents and often a diversity of native attire—the caftan, the burnoose, a flowing robe with gold border.

We talked of the individual rights of the artist, of freedom of expression, and of the role of the artist in society. In these days, there was much willingness to exchange opinions. The Soviet side argued that the state owed the artist protection for a free expression of thought, but that such expression was linked to the state's point of view. Too limited, we said, too constrained. But there was give-and-take and an interest in seeking understanding. I could see shortcomings in UNESCO, but to me they seemed far from unsurmountable. We met with experts in film, literature, and the performing arts. We lunched with delegates from Egypt and India.

We were in Paris only a few days, laying the foundations for discussions and official position papers to follow. Two days before our departure, at our regular start-of-the-day delegation meeting, it was suggested that the endowment should provide an evening of the arts for the delegation leaders from the more than one hundred countries represented. The Humanities Endowment had presented an earlier program and film on the American short story, which I felt could nicely cover the arts as well, for the small budget we shared had been exhausted. But I was not exactly given the opportunity to withdraw. Could I not cable or send for more?

No way, to use the current phrase. No way to spend the American taxpayers' money entertaining over a hundred ambassadorially ranked diplomats from around the world, and their staff experts.

So improvise, it was suggested.

I was pondering the development, glancing toward Catharina, who had discovered something highly interesting to observe, far away, it seemed, through a neighboring window. I thought of the number of francs in my wallet and of the remaining twenty-dollar traveler's check.

The prestige of the Arts Endowment is involved, and United States prestige, someone offered. And people were leaving to pursue their own assignments for the morning and afternoon.

Then, all at once behind me, there was a sound, like a slight soft rustling. Those who have lived a life in the arts know the sound, and on very rare occasions can hear it. It comes from angel wings.

"Do you need some money?" whispered a voice. It was Denise Hale, Mrs. Prentis Hale, from San Francisco, one of our delegation. "I don't have money enough right now," she said. "But don't worry, I'll have it by evening."

We made our plans. I learned that the noted musical *Bubbling Brown Sugar* was playing in Paris. I knew the manager. We talked. Fine, he said, the cast would like to do a special show for you.

"For free?" I asked.

"No," he said, "on one condition."

I held the telephone closer.

"That you give them all a party to introduce them to all the ambassadors."

"Done," I told him after a moment's thought. "Agreed."

The next morning, at my place at the delegation's table, was an envelope. It contained francs, not dollars, and lots of them, just enough for the party we would give with Denise Hale.

Catharina and I had watched other UNESCO evening presentations. They were formally announced from a long stage, with the auditorium darkened, with spotlights on two microphones at opposite sides of the platform. The host for the evening spoke into one microphone in his native tongue. An interpreter spoke at the other microphone and translated into French, the traditional language of diplomacy.

We decided that Catharina, who speaks flawless French, would be my interpreter. Schooled in French during her youth in Holland, she had studied painting and exhibited in Paris in bygone years, and knew Matisse and Dufy and Picasso. Yes, she would translate perfectly.

Perhaps she translated too well.

The lights went down in the great auditorium. The two microphones were bathed in cones of light. We advanced from separate wings. We could not quite see each other, so bright was the light, but we could hear each word magnified.

"As chairman of the National Endowment for the Arts, I am delighted to be with you this evening," I began, and waited.

I could hear the phrase repeated in melodious French. "As chairman of the National Endowment for the Arts . . ."

It was just as we had rehearsed over a quick meal by the Seine, but suddenly there was a roar of laughter.

I looked toward Catharina. What had happened? Certainly the language was French, flawlessly spoken.

"I am happy to bring to you tonight a wonderful American musical . . ."

Again, a perfect translation—and laughter growing, not subsiding.

The audience was thinking, what is this? Two American chairmen up there, not one. We had missed the protocols of UNESCO translation. Ours was not translation. Ours was words with echo.

A few minutes later we were rejoining Ambassador Torres. He held up his arms in praise. "I don't know how you did it," he said. "But you've sure got 'em in the aisles!"

The performance was superb, the show even better, I think, than when we had seen it in Washington. Jazz, dancing, Americana. Ambassadors applauded in midstream, at the end of a riff, when a solo part ended, before another began, just as if an American audience had taught them. And now the cast and the dignitaries mingled in a room with chandeliers, and the performers were introduced and embraced.

It is remembered as a time of special unity in the arts. The high spirits continued until the final glass of champagne and a special toast to the arts around the world, to a National Endowment for the Arts in the United States—and to Mrs. Prentis Hale.

Chapter 63

IN MY WORK WITH THE ARTS ENDOWMENT, AS IN LIFE ITSELF, CERTAIN MO-
ments stand out. Some have been mentioned. There are others.

During my first year as chairman, Catharina and I were invited to
the annual Academy Awards ceremonies in California. We are both to a
degree "starstruck," particular fans of the leading talents that have made
America preeminent in the art of film. Whenever we have a free eve-
ning, a great rarity then and somewhat less so now, it often finds us in
our favorite fifth-row-from-the-back seats at the American Film Institute's
comfortable small theater at Washington's Kennedy Center fascinated
by a masterwork resurrected from the past, a film frequently preserved
for posterity, and for us, by the AFI's efforts.

Catharina had never been to Hollywood—or to the Grand Canyon
or, indeed, to many parts of the United States—when we were married
in 1973. Now came the opportunity to stay with friends near Beverly
Hills, for me to visit for the first time the AFI's center for developing
artists on the outskirts of Los Angeles, and to see the Academy Awards—
in person, live, with the stars.

On the appointed evening, a car edged up the driveway at our
friends' house. Beverly and Harold Berkowitz were our hosts, she an ac-

tress, he a lawyer. They seemed to find nothing remarkable about the car, but to me, it was the largest I had viewed, ever. The stretch limousine was not yet prevalent in a Washington with a White House given to more modest transportation. The rear area seemed capable of accommodating both Ginger Rogers and Fred Astaire in action. I told Harold I was mightily impressed. He gave me a look that suggested I had enjoyed a sheltered upbringing, and we departed. We were all in our best clothes, and I felt somewhat conspicuous sitting in such splendor, until I realized that we were joining a sea of similar vehicles beginning to maneuver like great ocean liners toward the Dorothy Chandler Pavilion, its façade already aglow and the sky around it crossed by those moving shafts of light, which I had seen only on television, beamed upward toward the heavens.

The cars moved with such care, majestically, nearly but never touching an inch of chromium or gleaming polished metal. They formed slowly into single file. Ahead, in the distance, was the point of debarkation with a carpeted path on which stood the sentinels of the press, holding cameras and microphones. Flashes from the picture-taking seemed uninterrupted. Between us and the carpet were stands for spectators, rising against the illumined high walls and crowded to overflowing. Police stood at close intervals at the base of the stands to guard what seemed a long ribbon stretched taut from end to end.

But every few moments, someone leaped from the lowest row and plunged into the midst of the traffic, and found identification. "Diane Keaton! Diane Keaton!" we heard. "Right here!" and saw the finger pointing with an excited gesture, and heard the crowd cheer.

Barbara Streisand! Bill Cosby! Names were shouted, cheering grew louder. Barbara Stanwyck, from past days of glory, appeared to receive a standing ovation.

All at once, a young lady's face was peering into the back of our car. She focused on me, next to the window. Her eyes were shielded with cupped hands. They were intense and questioning. I was transfixed, hypnotized, unable to blink. We regarded each other for a number of extra-long seconds, separated only by the narrow pane of glass.

Abruptly the face was gone. But its owner stood triumphantly beside our ocean liner, now momentarily halted, now edging forward. One hand was upraised toward the crowd. The other pointed toward the window.

A strident voice was raised for all to hear.

"*Nobody!*" it shouted.

We flew to Moultrie, Georgia, in a beautiful small pristine jet plane from Armand Hammer's Occidental Petroleum. Our hosts for the jour-

ney were William and Dorothy McSweeny of Occidental. Bill was Armand's key representative in Washington and key to the corporation's success, a man with a Boston-bred political humor, a man of letters, Irish grace, love of the arts; Dorothy, tall and slender, served as a trustee of Washington cultural institutions. We traveled with Thomas Beard of President Carter's staff; he hailed from Moultrie and played an important role in the 1980 occasion, as unique as any I have ever experienced.

A major part of Armand's superlative collection of Impressionist paintings, known and admired the world over, was going to this Georgia town to be displayed in a public school, in a rural community far from any metropolitan center and far from the august corridors of a large museum. Armand Hammer, with Bill McSweeny and Tom Beard, had developed the idea. Catharina and I were helping in its celebration, in a somewhat symbolic way as head of our government's program for the arts and as a spokesman for bringing their attributes to wider audiences. In this case, it would be art of an exceptional excellence viewed for the first time.

We stayed with Matt and Jacqueline Friedlander, on a shaded street in an atmosphere of southern hospitality, and found them as enthused as we. Jackie was a member of the Georgia Council for the Arts and Humanities and knew well the excellence of the works involved.

We had a ceremony in the school. Armand Hammer arrived with his wife, Frances. I spoke of Armand's philanthropy, as remarkable in the United States as his collection, as his desire to share its joys in this special manner. I spoke of his work to increase international understanding and prospects for peace, and he took this as a cue to emphasize recent cultural agreements he had reached with the Soviet Union. Armand has a bearing of strength; Frances is a slender and gracious partner. I know they found the event moving and worthwhile. It was a warm day. The audience, seated and standing in rows at the back of the auditorium and along the aisles, gave him rapt attention; but everyone wanted to see the exhibit.

The paintings were adequately but simply lit, with some space between each. It was the light in the works themselves, however, that most illumined them. Matisse, Van Gogh, Monet, Cezanne, and a wonderful Mary Cassatt—there were almost twenty masterpieces on display. Some in the audience had come in from the fields to see them, in work clothes, in overalls. They stood in groups, moving very slowly, observing, totally intent.

"I never thought I'd ever see anything like this," they said, in variations, in repetitions. Armand Hammer with Frances stood off in one corner of the room, chatting with town officials.

I was a silent observer. This room seemed to me a particular affir-

mation. No one, I thought, could more greatly enjoy these works of art than those present. Others might be able to discourse more on the artists and their styles, but no one could find a greater sense of joy and wonder. Magic was communicated, and also love. Perhaps it can be better described. I do not know how.

I was suddenly aware of a discordant note. At the end of the room on a slightly raised platform stood two of the largest state troopers one could imagine. Expressionless, they stared forward, over the crowd, toward the doorways opposite.

I approached them and offered a good evening to one, as they seemed so out of character with the surroundings. Immediately the eyes moved toward me in suspicion. I thought of a movie—a confederate attracts police attention while another skillfully perpetrates a theft. Here was the "confederate" saying hello. I noticed the revolver on the belt and the hand loosely resting on its holster. I introduced myself quickly. Suspicion seemed to ease, though I doubt that the National Endowment for the Arts was a regular topic of discussion between the two. From the government, I explained, which was better. From the President.

"What do you think about the exhibition?" I inquired.

There was a ready answer.

The taller trooper leaned down and spoke in a deeply southern confidential tone: "Brother, let me tell you something," he whispered, shifting his eyes once more toward the spectators. "They've got a fortune here. A real fortune!" He paused. "In frames!"

"In what?" I asked, feeling I might have heard amiss.

"In frames!" he repeated. "Did you ever see carving like that, or gold? That's real gold leaf. You better believe. Look at all of it!"

"What about inside the frames?" I inquired.

"Inside is nothing," he told me. "Inside is crazy. Did you ever see a tree looked like that? That's yaller there. See what I mean? See there? Those leaves should be green. And see there? There's a red one!"

"But these were artists," I said, "who painted light as they saw it. The effect of light on objects. For the first time in history they went outdoors and looked at nature in sunlight, and painted it."

There was no response. This was probably the confederate, after all.

"Try something," I suggested. "Look out the window there, at that tree in the yard. Look at the leaves. Are they really green?"

The large brimmed hat shifted.

"Of course, they're green. Anybody knows—" There was a pause again. "Wait a second now. Wait one second. Yaller. I can see yaller. No kidding! Just as plain—"

"And in the shadow?"

"In the shadder? Wait one second now. Just look at that—there's purple!"

"No red?"

"No red. But purple—" The voice was suddenly upraised. "Hey, Bucky—come over here—take a look!"

In *Topkapi*, I thought, the paintings would all have vanished from the room.

Sometimes Catharina—as a private citizen with her own rights— helped smaller arts organizations when we felt my involvement could be construed as conflict of interest. Once during an intermission, she spoke on behalf of a small Washington ballet group striving upward in quality. And a reporter, whom she mistook for a guest, asked why, when she was a painter by profession, she would give such attention to dance. Said Catharina, "It's very easy to explain: Painting, to which I'm devoted and on which I spend most of my own time in the arts, is like a husband— but dance is like a lover." The next day, well-wishers telephoned constantly to ask, "Who is your lover?" The newspaper had personalized the story: "Painting is like my husband—but dance is like my lover." Yes, I recall it clearly. Said Catharina magnanimously to the curious, in this case the two could be combined.

We were in Boston to help open an exhibition of the great eighteenth-century French painter of still lifes, Jean Baptiste Chardin. The endowment had provided support for the show; the indemnification program had aided its coming to American shores.

Pleasure always accompanied a visit to the Boston Museum of Fine Arts. Our friend George Seybolt and his wife, Didi, had contributed to its prestige and reputation. I. M. Pei designed for it a new wing, initiated by an endowment challenge grant, which both officials and observers considered the single most important stimulant for success, the one from which other philanthropy had stemmed. It is a cherished experience to walk into a great museum and wander through its new addition, gazing upward at the vaulted ceiling and the light it brings, seeing walls hung with works of art and sculpture in place, and feeling that you, as an individual, have had a hand in all of this. I. M. Pei could experience greater joy, perhaps, or the donors who gave more than the endowment gave, but that does not detract at all from the walk, or from the upward gaze of the eyes.

I had studied Chardin in college, in passing, through a survey of art history. I recalled the still lifes. I was told that Catharina and I would be interviewed on arrival at the museum, at the entrance to the exhibit. I would be asked about the funding, about general support for the mu-

seum, about the growing assistance to the arts in Massachusetts, where Anne Hawley directed the state arts council and Vernon Alden was its chairman. I had memorized the details, as was my custom, on the plane. Oh yes, I was also told, be ready to summarize the history and purpose of the endowment in about a minute (I could do this in a minute, or an hour, or longer, depending on the time permitted).

The plane was late. We were late. We dressed hurriedly in our best attire and arrived just as the large TV camera on wheels and its crew advanced toward us. The little red light signifying the tape turning was already switched on.

"I'm here with the Biddles in front of the new exhibition of Chardin at the Boston Museum of Fine Arts." We were identified, and the announcer turned to me. "Mr. Biddle," he said, "will you describe for our viewers that painting on the wall behind you?"

I had the terrible feeling that I would turn and find death staring at me. Instead, there was a very large painting, not a Chardin I recalled. It was certainly not the one on the cover of the catalogue. The chances were, I assumed, over 90 percent in favor of Chardin. But we had not entered the exhibit. Suppose the arts chairman made an error, for all New England to see.

"Well sir," I said, surveying the canvas. "It certainly is . . . a large painting, isn't it?"

It was then that Catharina, by now attuned to the nicetics of Washington phrasing, cleared her throat. "If I might just say a word," she began.

"Please go ahead," I told her.

"This is one of Chardin's earlier works," she said. "As my husband points out, it's large—." She paused. "But that's because the young Chardin was seeking to impress the famous French Academy, trying to enter it. His other canvases are smaller and usually they depict just inanimate subjects. Here, however, he uses both the inanimate and the animate. I think the viewer can see the nose of a small dog poking in, right there in the lower right corner, and above it in the corner again, you can see the beak of a parrot pointing downward. And where these two diagonals meet, where they focus our eyes, is the center of the canvas itself and this wonderful bowl of fruit. It's an example of how well, perhaps better than almost anyone, Chardin painted the beautiful surfaces that characterize his mastery of the still life."

The interviewer gazed for a second or so at Catharina, then motioned to the camera and crew, and we all moved through an entryway and into the exhibition itself.

"Mr. Biddle," said the interviewer with a brief smile toward me, "will you kindly read to us the title of this first painting?"

I obeyed. It was of an inanimate rabbit and a plate, as I recall.

"And now, Mrs. Biddle," the voice continued invitingly, "perhaps you'll tell us about this painting and the next two, as they relate to the exhibition as a whole."

It can be readily seen that there are immense advantages to being married to an artist, and to an expert art historian, with a good memory.

I remember flying in a little jitney plane, caught in winter winds en route to South Bend, Indiana, with John Brademas and James Jeffords, enlightened and arts-supportive congressman from Vermont. The plane was bouncing all over the sky. John was reading a book; Jim Jeffords, a magazine. We were to help open an exhibition of Robert Indiana's artistry and hold a discussion and meeting at Notre Dame. I thought, look at these two gentlemen on this winter night in this small fragile craft. Isn't this courageous bipartisanship for the arts! John the Democrat and subcommittee chairman, Jim the Republican arts leader. God bless them, here in this little jitney plane. Isn't it like the arts—fragile, tenuous, buffeted by winds, yet proudly well aloft in a stormy sky?

Chapter 64

OTHER MOMENTS ARE INDELIBLY RECORDED IN THE MEMORIES OF THESE years, especially from our travels. In the fall of 1980, just before the presidential elections, we were part of the first official U.S. cultural mission to the People's Republic of China. John Reinhardt, as director of the International Communication Agency, headed the group, which included Tom Litzenberg of the Humanities Endowment, Julian Euell of the Smithsonian, and John Wilmerding of the National Gallery of Art. We traveled in roomy black sedans made in Russia, with a Chinese official and a driver in the front seat. Our car was number two in the procession, with a protocol politely but firmly maintained, as we discovered when once entering the third vehicle by mistake. We always stayed in luxurious quarters, guest houses in gardens, and in what had once been the Austrian Embassy in Beijing, where our great tiled bathroom was as large as a squash court.

Our hosts were enormously hospitable. We met leaders from heads of state to city mayors to our cultural counterparts. We traveled to the Great Wall and to Xian, where those extraordinary archeological treasures, the life-size terra cotta figures simulating an army guarding the ancient ruler's tomb, are laboriously being excavated bit by tiny bit.

I watched as a finger suddenly emerged, sifted out of the dusty soil. "They are all here," said our guide. "All the statues. Thousands of them. They can't escape. In another hundred years or so, we will have them all."

We talked about literature and dance, museums, drama, music, and film. We watched on location a new film in production, with a delicately lovely young star, her salary approximately $17 per month. (Hollywood, did you hear?)

We were given vivid, firsthand accounts of the Gang of Four, of the oppression of artists, their hardships and physical suffering during the Cultural Revolution, all changing under the new regime. Everywhere we talked of cultural exchange—small groups, large groups, individuals to teach and perform, to demonstrate great talent, like Isaac Stern. We saw the stirrings of new dramatic forms, the traditional folk dances of the past, the exuberant vitality of Chinese opera, a small boy no more than five years old playing Mozart on his violin with such precise and serious concentration and feeling. And while others rested, Catharina and I saw *The Merchant of Venice* played in Chinese as farce to uproarious laughter from an audience who had waited for seats in long, long lines, only in part accommodated even by the large theater. We saw *Le Bourgeois Gentilhomme,* also in Chinese; the Comedie Francaise could have learned lessons from its sophisticated interpretation. We went to the teeming metropolis of Shanghai and to the water gardens of Hangzhou. One day on the road we drove by a communal farm amid rectangular fields, with a low building almost windowless near the road, the laborers outside, stationary, watching our convoy pass.

"They don't look very happy," Catharina remarked to our officials in the front seat.

"I see that they are all smiling," he said. "Do you see those little pigs, there behind the fence? Well, they belong to one of the farmers. And for the first time this year, he can take them into town and sell them, and keep some of the sale for himself."

"Ah!" said Catharina pleasantly. "I understand. You are becoming capitalists."

There was sudden silence in the car. Our host glanced toward the driver, his head motionless, his focus toward the road.

"Please, Mrs. Biddle," said our official guide quietly. "We don't like to use that word."

And there was the night of the banquet, one of several held especially for our delegation. The mission was considered so important that we had disembarked in Tokyo for the appropriate diplomatic briefings. We were instructed that at each of the banquets there would be toasts,

first by a host official, to be followed at once by our individual responses. So it would go until all our group was honored. We were to pay closest attention when our own turns came, so we could most appropriately reply. Don't make a mistake, we were warned; the President considers this visit essential to future understanding.

Before dinner there was always a convivial atmosphere. I would explain the endowment's job, its functions, the presidential appointment, the term of office. But I found that this knowledge was to a degree familiar.

Now it was my turn to listen. "Mr. Biddle," began the toast at our table, "you are like a swan come among us. . . ." There were words in Chinese, then again in English. Again the image of the swan occurred, and once more, as the toast continued.

What was it, I asked myself? Special reference was intended. How to answer? Was it a special time for the swan? Swan Lake? No, that was hardly it. I caught Catharina's eye. She looked perplexed. Then about a third of the way around the circular table from my place, I saw an interpreter leaning toward me. The toast was concluding, I could tell. The interpreter leaned further, his expression concerned, yet with just the trace of a smile.

He was whispering, "Minister has birds mixed up, I think. I think he means lame duck."

Ah, the inscrutable East! How right they were, to deduce my days as chairman were finite.

But in response I overlooked possible abbreviation. "Mr. Minister, your words give us all wings, to soar." And, come to think of it, the duck has quite an honored place in Chinese ornithology, better even than the swan.

E Wahine, E Kanaka, E Oluha, Kay Aloha, O Hawaii-Nei.

I said these words at the Merry Monarch Festival of ancient dance traditions on the island of Hilo. In translation: This my girl, I her man, both of us together, bring our love and our special best wishes to you, Hawaii.

We were overjoyed by the welcome given us everywhere—from Governor George Ariyoshi and his First Lady; from Congressman Daniel Akaka and his wife; from Beatris Ranis and Alfred Preis, the state's arts chairperson and its director, whom I'd known in Roger Stevens's time; from Margaret Cameron, the philanthropist in cultural progress; from symphony and museum leaders; and from artists in so many communities, so many small centers where talents were growing. We brought with us Kamaki Kanahele from the endowment's education program. Kamaki can trace his lineage to Hawaii's kings. His mother, Agnes Kahanihoo-

kaha Cope, is well known throughout the state and was often our companion (I remember her contagious smile, boundless energy, hibiscus flower in her hair). It was the first time an endowment chairman had visited Hawaii.

On all occasions when I was asked to speak, I would ask Kamaki to precede me, to provide a chant, in accordance with his training as a young man in the traditions of the islands. He is well over six feet in height. He has a deep, melodious voice. Always there were poetic images—we bring you greetings like rain falling on forest leaves, like orchids blooming—in a language full of poetic sounds. How could I fail in my own remarks? The days would begin with a printed notation: Awaken to a Hawaiian sunrise. Where else would an official agenda so commence?

At the dance festival we were able to announce a small endowment grant, less than $10,000—the sort of grant I was accustomed to hearing was not enough (sometimes less politely stated). Here it might have been a million dollars from the reaction of the audience at this huge festival, with the massed groups of dancers, each led by a patriarch in long and voluminous robes, very tall, carrying a long staff of authority.

Kamaki taught me words in Hawaiian, and Eni Hunken, running for public office on American Samoa, taught me words in Samoan. Palauni Tuiasosopo ("Brownie" to large numbers of his friends) was our Samoan host. I came to announce an endowment grant for the arts program he headed as chairman. (Samoa is treated as a state in the enabling legislation, with matching funds available.) Again, we were first-time endowment visitors. Again, the effort was toward enhancing a cultural heritage in music and dance and choral singing. We visited a school where the art of making tapa cloth from the bark of the white mulberry was preserved following the old traditions. And we had the unique experience of joining a council of island chieftains, which lasted from morning until mid-afternoon.

We sat crossed-legged, Catharina beside me in an open-air, wood-floored building with high roof of thatched palms. Each chieftain, including the honored guests, sat facing the others. Nectars from palm leaves and coconuts were ceremoniously prepared. There was a "talking chief," long schooled in rhetoric, bare-chested, with black robe tied at the waist, who spoke in part for the others, offering greetings and toasts and leading the discussions on Samoa, on its arts, on its aspirations.

I had no "talking chief," but I had rehearsed carefully our own greetings in Samoan. The Chiefs nodded, and smiled, and nodded again. This man was trying. The breeze from Pago Pago blew gently in under the thatched palms.

* * *

In contrast, there was rain when we visited the Hopi and Navajo Indians on their reservations in Arizona. Our special host was Dino DeConcini, chairman of the state arts council and the brother of Dennis DeConcini, U.S. senator. Both were leaders in the arts well beyond state borders. I know of no two brothers in our national life more involved with the importance of cultural progress.

We arrived at the Grand Canyon, at the old El Tovar Hotel, for an evening meeting with about one hundred directors and officers of Arizona arts institutions. It was somewhat of a sentimental journey for me. I remembered the hotel from about fifty years earlier, when I came with my parents to view the Great American West. We arrived by train on the little railroad spur that wound its way up to the canyon's edge. El Tovar seemed to have changed little, with its large rustic wood-beamed foyer. But the Grand Canyon was invisible, to Catharina's shocked disappointment. A thick fog obscured it, and even the railing of the small balcony outside our bedroom.

Our schedule was inflexible and busy. We departed early the next morning. Catharina was silent in the car. Then she said, I'm doing metaphysical work; maybe we can have one more look. At the last turn before the road moved on, we drove to the canyon's rim, with the wintry fog everywhere, touching the nearest trees and shrub growth, hiding them. We left the car and walked to the lookout point.

For years, Catharina had thought of the Grand Canyon. Was it escaping in the mists? It was not. As we looked together, as a startled Dino DeConcini looked, out of the depths came the fog, billowing up as if chased by a giant wind. Suddenly the whole panorama was sunlit.

I was not overly surprised, knowing well my wife's metaphysical earnestness and her abilities. "There it is!" she exclaimed. "At last!" Indeed it was, in all its majesty.

But rain was a constant companion by evening, when we reached the principal Hopi mesa. I believe so much in helping to preserve our cultural heritages—plural, for they are many. We were announcing small grants from the endowment, and we were invited to attend, as a most special privilege, a religious ceremony celebrating nourishment of the crops and the annual visit of the deities—the kachinas—from neighboring mountains. In ceremonial attire as diverse and individual as falling flakes of snow—from the "mud men" caked in pink-colored earth to all the fancies of beads and plumage—the kachinas appeared suddenly on the mesa, in clusters, in groups, in solo dances. They dispensed small gifts. To wide-eyed children, almost apprehensive in expression, these were real mountain spirits, no question about it. To everyone there was a

sense of awe as the spiritual meanings were imparted, as dancers whirled and turned, as the drums sounded and grew louder, as the processions climbed the mesa's slopes.

We had met earlier with Hopi artists Fred and Michael Kaboti, with Abbott Sekaquaptewa, solemn chairman of the Hopi Tribal Council. Similarly, we were to meet with Peter MacDonald, chairman of the Navajo tribe at the town of Window Rock, where the winds of time have caused the lofty aperture in the stone. Later we were to address Governor Bruce Babbitt's banquet in honor of the arts and his first special arts awards—a singular event, emulated in time by other governors. We were to review plans for the arts in Arizona with Louise Tester, director of the state program and one of the most experienced and wise of all.

But especially I remember the mysterious hours on that rain-swept Arizona mesa. Toward midnight, we were invited into the ceremonial room itself, square with white-washed walls, entered by a ladder from the roof. We were told it would be difficult to leave once we were inside.

The dancers changed from time to time, one group replacing another. Their leader would call from the rooftop, and the religious leader would call from below, the voices high-pitched, half chants, half melodies, eerie with the sound of the falling rain. The dancers would suddenly descend the ladder, stand for a moment, and then begin a slow circling of the room, with each group staying for perhaps half an hour.

They moved with grace yet deliberation. Gourds were shaken. There was a steady drumbeat that varied from group to group. As soon as the dancers saw Catharina and me—non-Hopis in this sacred chamber—expressions were hostile, questioning, masked. They danced by us, turning their eyes toward us, turning them away. They wore bright feathers, beads, necklaces of fruits and vegetables, the crops they wished to harvest in abundance. The hostile eyes turned, and turned away. Perhaps two hours went by.

Then suddenly a huge dancer slowed his step in front of Catharina and paused.

From the cord around his neck, he detached an orange and slowly held it out.

She took it from him and bowed her head. He moved on.

The solemnity of the night, its slow measured pace, never altered. But the eyes changed.

Chapter 65

I
F THERE IS A GENUINENESS TO THE ARTS, IF THERE IS A MOMENT WHEN
the unique transcends the commonplace, an audience is held. To say
that the arts entertain is missing half the point. The arts extend our abil-
ity to appreciate. At their best, they hold us enthralled.

Catherine Filene Shouse is identified by Wolf Trap Farm Park as is
Washington by its monuments. She is the principal philanthropic donor
of this wooded and meadowed area within a short journey of the Capitol.
It is a national park visited by thousands each year, and Kay Shouse has
long presided over its programs. There is nothing more pleasant than a
summer picnic on the grounds and afterward, under the stars, a perfor-
mance of opera or symphonic music or a concert in a contemporary
vein. Under the stars is not always the case, however. I remember the
opera Medea played during a great thunderstorm, when the sky was
streaked by lightning and the claps of thunder almost obliterated the mu-
sic. Medea, about to murder her children in ancient Greek frenzy, was
nearly struck by a real lightning bolt from on high and screamed so loud
that the reviewers spoke of exceptional dramatic fervor from the diva.

But the scene I remember best was toward dusk on a summer

night, when over the tops of the trees behind the auditorium and the sloping lawn outside where so many sit appeared the first telltale signs of impending storm. The clouds moved inexorably. A ballet was in progress on the stage. No one moved from the bank.

The clouds drew closer. There was shelter at the top of the hill, near the entrances. No one moved from the bank.

The first dark rumbling sounds from above were heard. No one moved.

The rain started, and now there was some movement, just enough to extract rain gear from canvas bags carried in preparation. Rubber blankets were neatly and quietly spread.

And the rain fell in torrents; the wind blew sheets of water. No one moved. The storm passed on. The ballet progressed. A few lingering drops of rain fell from the nearby trees.

Among the joys of these years were the opportunities to praise the abilities of artists and arts leaders, on behalf of the endowment and the Nation in a larger sense, but also more personally, on behalf of Catharina and myself. There were sculptress Louise Nevelson; Patrick Hayes, the impresario who initially brought quality in the arts to Washington; Martin Feinstein, impresario in his own right in opera and symphony; Abram Lerner, impresario in the visual arts for Joseph Hirshhorn, who gave us all the Hirshhorn Museum and Sculpture Garden.

There were other special public moments when I could congratulate Fredric Mann, founder of summer concerts in the glades of Philadelphia's Fairmount Park; Carl Weinhardt, for his re-creation of Vizcaya, the Renaissance palace and garden near Miami; Luciano Pavarotti, for his pioneering work with young singers; Richard Coe, among the all-time greatest of theater critics; Roger Stevens and George; Zelda and Tom Fichandler at Arena Stage's thirtieth anniversary; Henry Fonda and Beverly Sills. A public official becomes accustomed to public utterance. It was not so with me in these cases. My mind always went to their rare achievements. They can be described in many ways in terms of unusual talent, but best of all they can be described as governed by the commitment of the heart.

There were, of course, great numbers of speeches. I learned early on not to read my remarks. In one or two of those first speeches I managed to induce sleep. Short of an explosion in the front row, I know of nothing more disconcerting to the person on the rostrum than to watch the nearest eyes glazing over. Roger Stevens agrees with me. So I spoke with small white cards on which phrases and ideas were written and visi-

ble at a glance. Given some latitude and variety, one's convictions can
be expressed. Statistics, whenever used, needed no detailed reminders,
for they were in my memory after the years of work.

On occasion one feels a special affinity develop with an audience.
It is quite magical, or was for me, to sense that people were really attentive, that we were brought together not just in the expected manner but
in a closeness we could share. Catharina was my best critic. She was
never without encouragement; but once in a while the accolade was
there, and I could learn from her why it was.

I remember speaking to the wives of members of Congress at a
large and knowledgeable gathering arranged by Susie Dicks, wife of Norman Dicks from Washington state, and Sala Burton, wife of Philip Burton
from California. I often combined history with purpose, anecdote, and
stories of the most recent endowment developments, but this time I was
given the sort of response that lasts a long time with a speaker. There
was another time, quite different, yet similar in the essence of reaction,
when I spoke to a group of religious leaders about spiritual values of the
arts—not about the arts in religion, but about the inspiration, the uplift of
spirit that comes both from the arts and from a deep religious experience.

I think of Anderson Clark in this regard. Anderson then headed
with Richard Clark (no relation) a group known as Affiliate Artists, which
had an exceptional program bringing artist-in-residence concepts to communities, often off the beaten track. In a small town, for instance, a talented artist would meet with businessmen and local officials—with those
not necessarily culturally inclined as well as with those more receptive
from the start. It was a program with an increasing audience and a
growing record of success for the artist. Anderson was also a Presbyterian minister, gregarious, humorous, with an open and engaging personality that endeared him to the many friends he made. He brought me
among his colleagues and religious leaders, and I found my own convictions reflected by theirs. It was not about dogma or specific belief that I
spoke to them or they spoke to me. It was about a parallel sense of spiritual value. That time, those moments I best recall, made a bridge
between church and government, church and state, religion and art. I
trust that some day that time may seem more like a harbinger than a
memory, for there is much to explore and to share.

I spoke at commencement exercises and was accorded a number
of honorary degrees, listed later for the record of endowment years. In
my speeches, I tried to steer away from the practicalities of preparing for
life and emphasize the merits of the individual and the qualities I find

most appealing and necessary: imagination, an awakened awareness, an open mind to new understanding and vision. The blessings of individuality in a society too often concerned with sameness, perceptiveness, and the uplifting of the human spirit—all these are virtues.

At Catholic University, where I was awarded my only honorary doctor of laws degree, I recall giving the commencement address under a light, misty rain at open-air ceremonies. Students, friends, faculty, families stretched out below and into the distance. I was completely immersed in what I was trying to express when I saw Cardinal Cooke, sitting on the dais next to me, bend his head a trifle.

I leaned a trifle toward him.

"I think somebody up there likes you," he said in a quiet voice.

I noticed, suddenly, that the rain had stopped.

I had been in office for less than a year when I was asked by almost the entire congressional delegation from Texas to speak at the dedication of a new arts center in the rural community of Round Top. I needed to be back in Washington that evening. The day was so hectic with split-second connections that Catharina remained in Washington to be surrogate in case of delays. I was working on a speech on the plane from Washington via Norfolk to Dallas, to connect to Austin, to connect with a car journey, when all at once I noticed sunlight bright on the cards resting in front of me, and few minutes later sunlight again. We were circling. The captain announced that there was ground fog in Norfolk; we wouldn't be much delayed. But we circled and circled again. I looked at my watch. The whole day seemed suddenly lost.

On one of the cards, I explained my problem and my duties, and those who had requested them, and pushed the little buzzer over the seat. When the stewardess appeared I gave her the card and asked her quietly to bring it to the cockpit. She reacted as if I had handed her Cleopatra's asp.

"Don't," she said, "don't . . . ," and started to back away. Other passengers began to stare.

"Please," I said, half-rising, "just read the note."

She retreated several steps, glanced down, paused, then hurried forward. I had the feeling everyone in the plane was staring in my direction. I sat down.

A few minutes later, the captain appeared at my seat.

"What is this national endowment?" he inquired.

I told him. He smiled.

"I'll say one thing for it," he said. "It knows how to attract attention."

He was wonderfully helpful. He phoned ahead. The governor of Texas, no less, sent transport. The day was saved in all respects.

That was in 1978—some years ago. I do not believe I would try a similar note again.

Governmental leaders are well remembered. We met with Sir Roy Shaw, chairman of the Arts Council of Great Britain. I could tell him that his council in earlier years had served as an important model for my early legislative efforts, and he could tell me that the British shared almost identical problems faced by their "American cousins."

Among the most memorable leaders was Luis Ferre, former governor of Puerto Rico (his brother was mayor of Miami). A man of impeccable taste and scholarly knowledge, he took us across the island from San Juan to Ponce. Together we explored the large museum he had built with his own resources and saw his fine collection of works from many countries and schools of art.

The then-governor, Carlo Romero-Barcelo, and his wife, Kate, met with us. In their particular support of the arts they reminded us of another gubernatorial husband-wife team, Michael and Kitty Dukakis, in Massachusetts. Puerto Rico was then at the top of the funders for the arts on a per capita basis among all states and territories—not surprising in the presence of strong commitments and a venerable scholar like Ricardo Alegria, a founder of the commonwealth arts program. He greeted us in overalls in the dusty yet gracefully arched interior of a building whose restoration he was supervising in Viejo San Juan, the center of island history.

I remember a special lunch hosted by Carlos Sann, chairman of Puerto Rico's "Instituto," its renowned Institute of Culture. Troubador-poets moved among the tables, improvising narrative ballads—"There was an endowment man from Washington." We met with Hector Compos-Parsi, a Puerto Rican member of the endowment's Hispanic Task Force, at a gathering he hosted. I remember the white-pillared balcony where we talked, dense, dark foliage beside it, the loud song of insects in the thick shadows, and the sound of music inside.

The arts were alive on the Caribbean islands. On St. Croix, on St. Thomas, new centers, indoors and out, were taking shape. The Virgin Islands Council on the Arts reflected the energy of Rita Forbes, its artist-director. I can see her in bright, flowered attire and dark hair, calling down a welcome from her hillside verandah.

We traveled in every state from Maine to California, east and west, north and south. I remembered how important Roger Stevens

found his visits to the states. This was true for me as well. The chairman, if he or she is to be a successful guide and advocate, must see at first hand and assimilate. Knowledge is imparted from the desk. It is gained elsewhere.

We were in Maine one snowy December night. Our hosts were Shepherd Lee and his wife, a potter, an artist like Joan Mondale in ceramics. Shepherd met us and we were driving over icy roads to our first meeting. It was night. Stars were out. Shepherd was a political and business leader. He owned a substantial automobile dealership, and we passed its headquarters. Suddenly, in the lights, over the many rows of parked vehicles awaiting sale, there was a message in the cold New England air. It said, "Happy Birthday, Catharina."

It made up for being far from home.

September 25, 1980 was the fifteenth anniversary of the National Endowment for the Arts. There was a feeling of joy all through our offices. The endowment's record was being praised. Criticism had temporarily, at least, subsided. When you looked back a decade and a half, you were deeply aware of the long road traveled. When you looked ahead, you saw brighter visions. You saw the mountains in the distance. Funding was growing, governmental and private. The roots of the arts were deeper in the soil.

The White House had agreed on special ceremonies. The President was vigorously in the midst of a difficult campaign. Forecasts varied. There was optimism and some sense of impending pessimism. The hostages were still in Iran. The nation's economy struggled against a huge increase in the world price of oil. It could hardly be blamed on a U.S. President, but our nation can be sometimes less than discriminating in blame. Unemployment was also a factor, though it would get worse a year hence. So were thoughts of continued prosperity. In a year a recession would arrive under a different aegis, but a Carter prosperity was still an issue. Optimism and pessimism, a President and First Lady aware of both sides, the hope and the danger.

The arts, however, were joyous, and the White House was joyous that day. If ever that sense of commitment was imparted by our government, it was imparted then, in the midst of problems and difficulties put aside for the moment.

I had asked David Kreeger to help me with a special symbolic gesture. He had taken the request to heart. David and Carmen Kreeger represent the arts in so many special ways. David's life story links both great ability and American opportunity with a father who escaped to the United States from impoverishment and persecution in Russia. David's house contains an art collection that would make many museums envi-

ous. His philanthropy is constant; once in his own time of financial crisis, he sold some of his paintings to keep his philanthropic pledges, even though they might readily have been excused. He is a man of his word, and he has given leadership for many years to the Corcoran Gallery, Arena Stage, the National Symphony, the Washington Opera. He is also the possessor of violins in the traditions of their most historic makers; and what's more, he can play them. Gifted with humor, he is the only such art lover I know who can play with flair a movement from Mozart— with the music upside down.

David agreed to play the violin. Our friend Mstislav Rostropovich, world-famous cellist who had started as maestro of the National Symphony as I started as arts chairman, would carry the melody on the piano. And I would play, also. Rosalynn Carter, with grace and a smile that suggested just a shade of uncertainty, introduced us to a great crowd in the East Room.

We played "Happy birthday to you" (loud clash of huge cymbals), "happy birthday to you" (even louder clash).

The cymbals were my responsibility. David had suggested them and had given me instruction. They had been spirited into the room and hidden behind the piano.

Awards and citations, along with celebration, fortunately go with this territory—keys to cities, inscribed medallions, framed parchments, many illustrious signatures. Here they are cherished and stand in places of honor. Perhaps children will review them some day, and grandchildren, and beyond. But that may not happen in a world of change. I worry not, nor does Catharina, for these are the keepsakes of a special time in our lives. They are personal. They bring back the memories to us, and only vicariously to others. They are the "lares and penates" of our abode, the reminders of good fortune.

Perhaps my most favorite, if I were to choose, is one from the Philadelphia Arts Alliance, presented on March 29, 1980. We were in Philadelphia the night before staying with friends, to visit my mother who was in failing health. She called when we arrived to say how pleased she was and how she looked forward to the morrow. Early the next day and quite suddenly, unexpectedly she died. We were very close. She had given me much of my love for the arts when I was a child, when she read to my brother and me from the books she loved or played the piano—Chopin or a composition my father had written to accompany poetry he had composed. He had died two decades before. I thought of the old Bryn Mawr house and how we used to frolic around it in a time of brightness, and for me an uncomplicated time, long ago.

The arts alliance called to ask if we wanted to postpone the eve-

ning and set a later date. We said no. So many preparations had been made. Beyond that, however, it was right to continue and in keeping.
Just the full sense of loss was postponed for a while.

My parents loved Philadelphia. I do not believe my father ever was quite reconciled to the novels his son wrote about his native city, though he professed appreciation at times, brought his friends to auto-graphings, and was pleased with reviews. Still, I think he would have preferred the Chicago locale he had suggested. Father did not criticize his hometown. He found it exemplary. So, often, did I.

That night I well remember Anthony Ridgway, the son of one of my father's greatest friends, introducing me. I sought to describe the arts in Philadelphia and elsewhere extending toward the future from the past:

"A prophet is not without honor, save in his own country, and in his own house" (Matthew XIII:57). Perhaps that night in Philadelphia there was some measure of exception.

Chapter 66

T RAVEL, ALTHOUGH USEFUL AND SIGNIFICANT, WAS NOT OUR USUAL FARE. we spent an average of a little more than three days a month on journeys to view the arts at first hand, to study and discuss needs and how they could be met, and most important, to affirm our government's commitment to partnership in cultural progress. More than eighty percent of the time was spent in the Washington office. My concepts of the position were not changed in essence, but they were strengthened by time and the guiding principles remained.

Quality in the arts must be paramount to the chairman's work, and it must be safeguarded through the eyes, ears, and intelligence of experts. No one is infallible, but panels of knowledgeable private citizen experts, refreshed periodically by new points of view yet representing a continuity of trusted opinion, are the best guarantees of quality in the application process. More than 500 panelists annually, from all the major disciplines, were involved during my tenure. They were paid on a per diem basis for the limited periods each worked, an invaluable investment. Quality and excellence, the words must be applied with skill and with intimate knowledge of each art form involved. They must be sought with diligence and sensitivity, and never taken for granted.

I believe I strengthened this private citizen review process, although a chairman's legal prerogative offers greater latitude. Twice I did intercede in the basic process, not to overturn a decision but to request further review: once for the American Shakespeare Theatre in Connecticut and once for the Houston Ballet Company. Respected opinions suggested the initial assessments were wrong, or at least one-sided. Panelists realized they had based their views more on the applicants' past work than on their current performances. These were happy endings; but the point is that the integrity of the system was not hurt. My own concern, I think, was vindicated. Both companies continued to achievement. In other cases where there was controversy, initial views were corroborated or they were modified by the council, as is proper—not by the chairman.

And once, I asked that a project the endowment had supported be stopped. Involved was a small grant to a television group in New York that had subgranted funds to a young filmmaker intent on depicting the horrors of violence on the screen. He arranged his camera in front of a small dog, and then he shot it and filmed the animal's death. I asked that the film be withdrawn, and it was. It was my one loss—some thought serious—to freedom of expression. But I did not regret it, then or later. It proves, I suppose, that the arts are forever controversial, and that any exceptions to a rule are part of that controversy, but in the end not damaging.

Attention to the importance of the individual artist is another guiding principle, equal to quality and excellence in the arts. Here two factors made increased help possible. One was a growth in overall funds, from a beginning total in 1977 of approximately $100 million annually to close to $165 million four years later. But there was another factor, rooted in my earliest work in the Senate and shared with Claiborne Pell. Others would have relegated federal support to arts institutions and organizations, but we believed otherwise. So, from 1977 to 1981, the endowment gave increased attention to the artists themselves, in painting, writing, photography, choreography, solo performance, indeed in all program areas. It is sometimes overlooked, that individual role. We speak of a symphony and a hundred musicians, each helped indirectly by a grant to the organization, or of the administrators who can make the difference between efficiency and financial crisis, or of state, community, and local arts agencies, of museums and art centers, and of centers of education. We too easily forget the one who creates the excellence we wish to nourish. The individual artist must always be front and center in the endowment's thoughts and plans.

The guiding principle of access to excellence in the arts relates to the future audience as well as to the present one. The individual artist's

work is vastly diminished—some would say negated—if there is no audience. But an audience, whether listening, reading or seeing, is not there only to applaud. It must be considered as the receptacle of insights that stimulate both it and the arts. The eyes, ears, mind, and sight of the audience need challenging more than entertaining; for so is imagination, pleasure, sorrow or joy transferred; and so from within the audience an artist for tomorrow, or the parent of an artist, can emerge. This, as was written those years ago in the Senate, is the climate in which the arts flourish.

I have forgotten exactly why I saved in a file folder handwritten notes addressed to Hilton Kramer, eminent *New York Times* critic and on occasion critic of L. Biddle. He was wont to complain that too much attention was being given to nurturing the arts too widely. My notes contain thoughts worth repeating: "I fully agree with Mr. Kramer regarding the values of the arts he so well describes. . . . Consistently, as chairman, I have emphasized how the arts enrich us as individuals, how they provide us with insights and wisdom, how they enlighten us, and illuminate our lives. But the arts belong now to the whole fabric of our society. They are in the mainstream of our democracy. They belong there. Their benefits are discussed at all levels of government, federal, state, and local. For the first time in the United States, the arts are becoming recognized as having a deep impact on our national life. . . . The arts are not in the ivory tower. They are not cloistered away for limited appreciation. Their values should be available to all."

That means: the arts in rural areas, as my admired friend John Murtha, from a rural Pennsylvania congressional district, advised; the arts in the major cities, a Chicago of Sidney Yates, a New York of Jack Javits; a symphony orchestra in Alaska, the vision of a Senator Ted Stevens; the arts as an important asset to be developed in all possible aspects of governmental activity, as we envisioned in these years; the arts for a growing audience, whenever the magic can touch them.

At a press conference in New York on October 20, 1981, less than a month before Francis Hodsoll became chairman of the endowment, I described the planning of our Media Program and the culmination of many months of work. Through television, film, and still on occasion through radio, quality in the arts can reach an audience in ways never before possible. We had proven results: Television does not detract from a live audience. It does just the reverse, because the audience, perhaps aware for the first time of the excellence of what they are seeing, wants next to experience the real thing. So on this October day, I announced "the largest collection of cultural programs for public television and radio ever funded by the National Endowment for the Arts." Brian O'Doherty,

the Media Program director, had helped mightily in these endeavors, and was with me, along with his wit and gift of language and Irish erudition.

Sixty-three endowment grants totaling just over $7 million were announced. The cost of all the projects was over $31 million, showing again the persuasiveness of the catalyst in action. Endowment-pioneered projects—*Dance in America, Live from the Met, Non-Fiction Television, Live from Lincoln Center*—were involved. They have been viewed by many millions. The great variety of the arts were involved, both celebrated and emerging artists, both grants as large as $800,000 to present a new series on Opera-Musical Theater, in accordance with the beliefs of Hal Prince, and a $10,000 grant to the Guggenheim Museum to chronicle the work of one of America's giants of photography, Alfred Stieglitz. It is good to know that this aspect of the endowment's endeavors continues to grow in purpose—with particular encouragement, I am pleased to note, from Sidney Yates. Emphasis should also be placed on the cooperative work initiated between the endowment and National Public Radio, headed by Frank Mankiewicz, and with Washington's educational television station, WETA, headed by Ward Chamberlin. Ward is a longtime friend whose enterprise and courage I first knew on Italian battlefields below Monte Cassino, when we served together in World War II as volunteer ambulance drivers.

It is an interesting and historic corollary, which deserves a special emphasis, that projects with endowment participation were those that attracted particular outside funding. The tradition continues with the NPR leadership of Dean Boal and Lucien Wulsin, another good and talented friend from past years.

The endowment must be guided by consistency to encourage long-range planning, but also by enough flexibility to meet the challenge of a sudden inescapable emergency. The arts are never far from the dangers of financial distress. So often they are at the edge of the precipice. This goes with their work, with their optimism. Some of the most important help the endowment provides is in this margin between danger and firm ground. That is where the initial support, matched and matched again, is of such value. Sometimes, however, the abyss is perilously close, and rescue, not the deferral of danger, is needed.

During my chairmanship perhaps the best example of rescue was Robert Joffrey's dance company. This was a group of exceptional artists, of national and international renown, confronting not a postponement of their combined efforts, but the end of them. In my time, there was often the cry of "wolf." Danger would be prowling nearby, but not yet at the door. Bob Joffrey came to see me. I called in the experts I most

trusted. Bob brought his own advisers. All financial records were re-
viewed. The abyss was there, beyond question. When the mountaineer
is dangling in mid-air, you don't blame the rock he may have tripped on
or the ledge he thought secure. You reach out a hand.

Here was an artistically excellent company with immense poten-
tial, financially undone. Compounding the crisis, former and anticipated
Joffrey supporters had backed away. No one wants to support apparent
failure.

We devised an immediate plan for help. We went to New York,
the Joffrey's headquarters, to announce it. I had consulted on an emer-
gency basis with the Dance Program panel and with the council; ap-
proval was unanimous. The sum of $100,000 would be granted at once;
up to $150,000 more would be available. The Joffrey Ballet was com-
mitted to matching those funds at a ratio of three to one within a nine-
month period. Some said it was a gamble. Suppose the matching fell
short? To me, it was a matter of careful assessment, and it was a matter
of trust.

We were not mistaken. The requirements were fulfilled. The per-
ceptions of financial disaster were entirely changed. Philanthropy re-
turned, and the rest of the story is well known—a progression of success
for the company. When I see it perform, when Catharina and I talk with
Bob Joffrey and his colleague, Gerald Arpino, I sometimes think back to
that visit by the town manager of Seattle, when a young company was
about to receive the chance to spread its wings.

Then there is the principle of unity—unity of purpose for the arts.
There must be a voice, not from dissident groups vying for position, not
from internecine wars large and small, but a resonant and clarion voice
in praise of all the arts, of their central value, a voice for our private-
sector and government leaders to hear, and to hear more and more, as
increasing numbers join in. That may once have been a pipe dream. Not
now.

When I was being considered as a candidate for chairman, an old
friend experienced in cultural pursuits asked me how I could possibly
want such a job, and gave me a metaphor: Three arts directors are sit-
ting at a table, enjoying their monthly lunch together. The first speaks of
looming financial collapse—if he gets through another two months, he
will be fortunate. The second describes a six-month span before impend-
ing crisis. The third tells his friends that for the first time in the history
of his organization, he foresees solvency at year's end, a balanced
budget. Just then a corporate leader passes the table. "It's the end of the
year and tax time," he says. "I have $5,000 left over and a check for

the neediest among you. Just fill in the name and it's yours." Before he has finished, speaker number three has picked up the check and vanished. It is the principle of unity that can change the story.

But there are many signs of change.

My special goal was to help encourage a stronger federal-state partnership, and then to expand the network among states, communities, and the endowment. I worked with state legislators in their early efforts to build a national organization emphasizing the arts, as I did with municipalities and the U.S. Conference of Mayors. Governors, too, established a committee to focus on assisting the growth of arts. The private sector began to join in these efforts, from Kansas to New York City. I took the opportunity to encourage a united approach by addressing a meeting of Kansas state officials and business leaders and, later, a large meeting bringing together business, government, and the arts organized by Mayor Edward Koch and his commissioner on cultural affairs, Henry Geldzahler.

These partnerships need broadened horizons. A guiding principle during my term—emphasizing the advantages of supporting the arts nationally and internationally among the widest possible spectrum of government—is essentially on hold at present. The endowment's resources, as skilled advisor and program guide and developer, are yet to be realized. Such wonderful opportunities exist. They cry out for leadership.

The quality of unity, however, giving greater purpose and momentum to our cultural life, grew ever stronger in the private world. From its early days I have worked with ACA (now the American Council for the Arts). George Irwin and then pollster Louis Harris were its early leaders. Now it is Eugene Dorsey, and Milton Rhodes, himself an initiator of exceptional programs for the arts in North Carolina, and Jack Duncan, my colleague on Capitol Hill in the Claiborne Pell-John Brademas days. They give leadership to ACA as it becomes a major unifying force. Once, long ago, described as an organization in quest of a mission, I believe it has found that mission. Milton brings years of valuable private experience to this work; Jack, his wisdom from both Congress and the arts. They are a special combination.

Through my meetings with the important representatives of the various and diverse art forms, the American Arts Alliance was begun during my term. Its unifying work is now broad-based, and in part directed toward Capitol Hill, to the Congressional Arts Caucus in the House, begun by Fred Richmond, then chaired by Tom Downey followed by Bob Carr, and to Concerned Senators for the Arts, jointly chaired at its inception by Claiborne Pell and Howard Metzenbaum. Both groups demonstrate growing arts support. Anne Murphy directs AAA with skill and with experience gained in political battles and at the endowment.

She was my assistant when I started the Office of Congressional Liaison for Nancy Hanks. Later she headed the office when I returned to the Senate.

It is no longer unusual to find in Congress a general laudatory attitude toward the arts and new voices to articulate it. In the Senate, beyond those mentioned, I think of Daniel Inouye, Bennett Johnston, Patrick Leahy, Dale Bumpers, Mark Hatfield, Lowell Weicker, and Thad Cochran on appropriations; Robert Stafford, Paul Simon, Brock Adams, Chris Dodd, and Spark Matsunaga on the authorizing side. The latter five also served as arts supporters in the House, Paul Simon as chairman of the old Thompson-Brademas subcommittee following William Ford. Steadfast to the arts since 1972 has been Lindy Boggs. And in the Congress as a whole surely a dean of arts supporters is Claude Pepper, who has served first in the Senate and then in the House since 1936.

Richard Stone is a good example of leadership for the arts moving from a home base to Washington. He was secretary of state in Florida and developed a strong arts program before election to the U.S. Senate in 1974. Florida's governor Bob Graham, with whom I worked, gave the program its deeper roots and was elected a U.S. senator in 1986.

I think also of the wives of members of Congress, who have contributed their own abilities to their husbands' careers and to the cause of the arts: Evie Thompson and Lucy Moorhead were greatly supportive in the beginning. Addie Yates was a pioneer. Mary Ellen Brademas encouraged John in his arts leadership. Emily Scheuer, an artist herself, gave special help to Jim. Jeanette Williams was deeply interested in the arts and helped them grow in New Jersey, just as Marcelle Leahy does in Vermont, along with Helen Stafford. In the same way Tess McDade helped her husband Joe. And bridging all the years and efforts toward success is Nuala Pell, who from the start greatly helped to inspire Claiborne's work and his convictions.

I think, too, of staff members who worked with me over time: Bill Cochrane of the Senate Rules Committee, who added much to my Washington education; Marjorie Whittaker, assistant chief clerk to Stewart McClure; Don Elisburg and Stephen Paradise, who followed him; and these expert professionals in the authorizing process—Nik Edes, Lisa Walker, Nadine Arrington, Polly Gault, and Sven Groennings. On appropriations Dwight Dyer and Caroline Fuller stand out in memory. And on Claiborne Pell's subcommittee staff is Alexander Crary, giving to the arts and humanities particularly experienced attention.

Others have been named; they all comprise an expanding group where once there were so few. The barriers of indifference are slowly being moved away. In time, they will disappear. My mother had a venerable German music teacher; and when she was hastening to finish a les-

son one afternoon, old Miss Biedermann held up a stern and unyielding hand. "Eugenia," she said in a tone that brooked no trace of disagreement, "Wagner vas *never* in a hurry!"

The guiding principle of balance is essential, and it relates to all the others. Balance is necessary among all the many art forms represented, with each regularly studied according to its needs and placed within the mosaic of an annual budget. The design may change from year to year, but like a work of art, it must be a balanced and unified design. I brought changes in minority attention, new programs for jazz and musical theater, panel responsiveness, council participation, funding levels, and evolving partnerships; but I did not alter a total balance. Large institutions received slightly more than half of our appropriations; the smaller ones, slightly less than half. This was a pattern from the past, and it has stood the test of time. Major institutions are, of course, less numerous than the others, but they must be given their own opportunities to develop, to employ more artists, to broaden in scope their exhibits and their presentations. Their collective and individual imagination must be fully kindled.

Balance is not just the arrangement of numbers suitable to a given moment. Balance relates to the traditional and to the contemporary, to the mainstream and to the avant garde. Perhaps in an ideal world it would be possible to determine more precise responsibilities for supporting the arts. It would be possible to decide that corporate support would go primarily to the traditional, the less controversial, for this is where such support often feels most at home. The same would apply to much private individual philanthropy, to boards of directors who generally— not always, but generally—have conservative inclinations, and to foundations subject to a conservative scrutiny. All this would suggest that government support be concerned chiefly with the most controversial, with emerging groups, with areas of the arts that generally have the least appeal to private philanthropy. Ideally, it might well be a valid division of duties—but the word "generally" is the problem. And who is to say Congress would approve?

The balanced program is the best system—pluralism in support of the arts, as it was conceived, as it evolved. There must be a constant exchange of information among the networks of support. The federal program in balance can serve as a model from which others can learn.

One final caution here: Patience must be a part of the balance described, as much as vigorous action. We can call the development of the arts in twenty years miraculous, and it is. But it never bursts forth in a town or city or state—or within ourselves—all at once. It does take time.

Balance has many virtues. Support of differing kinds, support with special purposes are parts of the process. The endowment's Challenge Grant Program is sometimes considered its crowning achievement, for the statistics are most appealing: one federal dollar stimulating five or six times that amount, sometimes ten times or more. There have been renovations of museums, great new exhibition spaces, seeds that grow into tall sunflowers, magic beanstalks rising toward the skies. Members of Congress, conserving appropriations, like to point in this direction. Indeed, the word "challenge" has become synonymous with the endowment's work and mission. But sometimes the challenge of matching one for one, as prescribed in the basic law, is as demanding as meeting the higher ratios later added for special circumstances. Fundamentally, the Challenge Grant Program is particularly directed toward an organization of size and reputation. An endowment fund is begun. A museum installs climate control so that a valuable collection no longer deteriorates. A five-year process of careful planning is drawn as the blueprint for achievable growth.

There is another type of grant, unique among federal agencies, that provides even higher ratios of support above the initial federal support. The Design Arts Program supplies it. It provides for the planning crucial to changing the face of a city. The endowment's share is always relatively small, on average less than $35,000, often less than $25,000. Groups of preservationists working with architects and city planners become involved. Scale models are made and put on display. The plan evolves. It gathers popular momentum. It is submitted to other federal agencies for major governmental help, in the millions of dollars. The point is that the plan has a reputable base. The best minds have been focused on it. A panel at the endowment has reviewed the participants, their credentials and intentions. The millions generated sometimes mask the endowment's role, yet without it there would be no result at all. Pittsburgh, Savannah, Milwaukee, Jersey City, Boston, Galveston, Troy are a few cities that have felt the impact of this program. You will not find the name of the National Endowment for the Arts emblazoned on the billboards, but in a visit to such cities, it is worth remembering just how the change began. There is balance between preserved traditions of fine American architecture and contemporary excellence. They are not exclusive. They enhance one another in the same way that the woven colors of an ancient Navajo tapestry enhance the plain white stretch of wall and rectangles of glass in an elegant modern apartment.

Some have been noted before, but they deserve particular mention in this chapter. They are the program directors who so greatly helped me maintain the balance, the flexibility, the responsiveness, and

the originality we all sought: Rhoda Grauer in dance; Bess Hawes in the folk arts, after Alan Jabbour who went on to direct a new program for the folk arts at the Library of Congress along with Ray Dockstader, once of Senator Mansfield's staff; Esther Novak in a new "Interarts" area we began, involving projects in a variety of art forms and, for the first time, those who presented them; Ezra Laderman in music; Tom Freudenheim in museums; Joe Prince in education and artists-in-schools; Arthur Ballet in theater; Ed Corn in opera and musical theater; Leonard Randolph, David Wilk, and Mary McCarthy in literature; Aida Chapman in jazz; Jim Melchert in the visual arts; A.B. Spellman in expansion arts; Brian O'Doherty in the media arts. And once more the deputies and other officials: Mary Ann Tighe for all programs; David Searles for policy and planning; Jim Edgy at first and then Henry Putsch in the Office of Partnership; Don Moore, who toward the end of my tenure took David's place, moving there from chief staff officer for the Federal Council on the Arts and the Humanities; Paul Berman and Charles Mixon in administration; Kathleen Bannon in international matters; Gordan Braithwaite in minority concerns; Larry Chernikoff in congressional liaison; Larry Baden in budget; Florence Lowe in public information; Anthony Tighe (no relation to Mary Ann) in grants; Harold Horowitz in research; Liz Weil in challenge; and two with longest service, Ana Steele and Aida Schoenfield. And there were Walter Anderson and Lee Caplin, and Larry Reger in administration, who went on to head the American Association of Museums, and the absolutely invaluable Pat Sanders, who gave the chairman's office an unfailing efficiency and good cheer. How the list extends in one's mind. I am not surprised that Sidney Yates could give it such accolade.

I remember the passionate opinions expressed, the convictions, the controversies we had, the agreements. We were closely knit, I think, because the fundamental goal was shared. That bears repetition. Large government agencies tend to become collections of empires, each one protected by a wall discouraging entrance. But this one was small. There was a volunteer spirit that was akin to my ambulance work during World War II. People went the extra mile, not because it was expected, or demanded, or even requested, but because they wanted to.

The experience of panelists has been emphasized as vital to the endowment's success in all fields of the arts. Illustrative of this talented guidance in both the shaping of policy concepts and in the long days of review were Michael Bessie, the noted publisher and editor, and William Meredith, who was to be poet-in-residence at the Library of Congress (as close as we then came to a poet laureate). Both worked in the endowment's literary areas.

There were also these panelists and panel chairmen: Peter Zeisler

and Adrian Hall, experts in theater; Bruce Marks, choreographer and director-manager, in dance; Carlisle Floyd, composer of operas; Stephen Sondheim, composer and lyricist; Natalie Hinderas, concert pianist and professor of music; Larry Ridley, bassist and music educator, in jazz; Shirley Franklin, outstanding community arts leader, in expansion arts; Archie Green, national authority of folk arts; Marta Istomin, gifted artistic director of Washington's Kennedy Center; Harvey Lichtenstein, director of the Brooklyn Academy, adviser on Interarts and a variety of art forms; Albert "Nick" Webster, managing director of the New York Philharmonic, who devoted so much of his time to the leadership of the music panel.

One could fill many pages with such names. The panel members were such special sources of wisdom. They brought their experience as artists, as respected administrators, often as state leaders, to meetings lasting into the night hours and continuing the next day, and the day after that. They met regularly; there was hardly a day without a panel meeting.

Panel members, with the directors of each program, helped present recommendations to the council. I liked the idea of a particularly distinguished panelist moving to serve on the council or from the council to a panel position, as did filmmaker Robert Wise. On occasion a panel member "graduated" to become program director, as with Ed Corn, who gave his long experience to the emerging Opera/Musical Theater Program. I favored the idea of bolstering the entire process with an orderly system of change—and an evolution in keeping with the arts themselves.

The regional representatives should also be mentioned here. They roved afield, interpreting the endowment's guidelines for assistance, helping prospective applicants, and bringing perspectives from outside to us in Washington. In my own travels I thought of the "reps" as fellow ambassadors. They gave me the latest, immediate news.

Their faces, their accomplishments return vividly after these years: Rudy Nashan in New England; John Wessel, who covered New York and affiliated Hispanic arts in Puerto Rico and the Caribbean; Ed Garcia in the Middle Atlantic states; Gerald Ness in the "mid-South;" Bob Hollister in the Gulf states; Frances Poteet in the Southern Plains states; Bert Masor in the Great Lakes region; Romalyn Tilghman in the "North Plains;" Louis Leroy in the Southwest; Terry Melton in the Northwest; Virginia Torres in southern California and Nevada; Dale Kobler in northern California and the Pacific, Hawaii, Guam, and Samoa.

They were a special breed, these regional reps. They learned to listen and absorb, and to live out of suitcases for weeks at a time, as they traversed their territories, giving important added dimensions to the information we needed. I found their work invaluable.

The council, the panels, the state, local, and community partner-
ships, individual philanthropy, business leadership, the program directors
and supporting staff, the regional representatives, the chairman and the
deputies—these are part of the whole. Fit them all together, give them
luster, and the arts can develop in greatest harmony.

Chapter 67

*T*HEN ONE DAY IN 1981 CAME FOR ME THE FINAL STORM. MENACING IN A SOM-
ber sky, it threatened to destroy all the years of work. To a degree it
was unexpected.

President Carter's fiscal year 1982 budget, passed on for approval
or disapproval by a new administration, called for a total of $175 million
for the Arts Endowment, an increase of nearly $15 million, which, in dif-
ficult times, we had battled very hard to secure. It seemed unlikely to
me that the administration taking office in January would fully endorse
an outgoing President's recommendations in this regard; and yet, in the
past, changes in White House leadership had affirmed endowment sup-
port. Through the years of Presidents Johnson, Nixon, Ford, and Carter,
two Democrats, two Republicans, endowment funding had steadily in-
creased, recommended to the Congress by each administration. Besides,
was not Ronald Reagan from the arts community, the first President to
be an artist in his own right? Was not Nancy Reagan from a background
in the arts?

In designing the Arts and Humanities Act, Claiborne Pell and I
had wished to distance the endowment chairmanship from political con-
siderations and from a presidential election year. My four-year term, pre-

scribed by statute (and thus not subject to "the pleasure" of a President
in the phrase applied to cabinet appointments and ambassadors) had ten
months yet to run. I was a lame duck, in all probability, but not a dead
one.

Robert Carter was emissary to the endowment from the new ad-
ministration. He was soft spoken, benign in countenance, but astute at
the same time, and I found him sympathetic in our private discussions.
But it was he who first corroborated to me the rumor that President
Reagan's Office of Management and Budget, under former Congressman
David Stockman, was considering a 50 percent cut for the endowment.

"Fifty percent?" I remember asking.

"It may not happen," said Bob, "but it's being considered."

It happened.

In the first budget papers transmitted to us, it was curiously "justi-
fied." That is the word so ubiquitously used in Washington to provide the
rationale for actions taken.

We read in disbelief: "The Administration will propose reductions
in the budget authority for the Arts and Humanities of about 50 per-
cent. . . . Reductions of this magnitude are premised on the concept
that Federal policy for arts and humanities support must be completely
revamped. For too long, the Endowments have spread Federal financing
into an ever-wider range of artistic and literary endeavor, promoting the
notion that the Federal Government should be the financial patron of
first resort for both individuals and institutions engaged in artistic and
literary pursuits. This policy has resulted in a reduction in the historic
role of private individual and corporate support in these key areas. These
reductions in Federal support are a first step toward reversing this
trend. . . . The proposed reduction will be achieved by amending the
1982 budget by $85 million for the Arts Endowment. . . . Additional re-
ductions in budget authority will be made in 1983, 1984, 1985 and 1986."

I read in disbelief, not so much because of the size of the reduc-
tions, for by now rumors were circulating fast and furiously, but because
of the explanations. I remember meeting Nancy Hanks at an annual press
function just after the budget had been published. "They've given the
wrong reasons," she said, and shook her head in dismay.

These reasons came from sources involved in many varied recom-
mendations for the new administration, from so-called "conservative"
thinkers who felt queasy in general about the role of the federal govern-
ment—sources like the American Enterprise Institute and the Heritage
Foundation. The arguments of large government versus small, or small*er*,
are not new. They persist. There is much to be said in favor of limiting
the size of government, of better defining responsibilities so that the pri-
vate sector has the maximum opportunity to contribute to the nation's

well-being. But these arguments, applied to the size of the National Endowment for the Arts and its concepts, its philosophies, and its record, were ludicrous.

Even a cursory examination of statistics, of the original legislation, of any challenge grant, of any of the endowment's many partnerships or of the strength and effectiveness of its catalyst purpose would disclose the absurdity of these statements. Far from reducing the historic role of the individual and the corporation in behalf of the arts, the endowment had been the catalyst for an increase in support *fifteen* times greater than before there was a National Endowment for the Arts. In the decade before an endowment, private support for the arts had been flat, static, relatively small. Now it was reaching beyond $3 billion a year. And in contrast to earlier limited activity on the East and West Coasts and in a few major cities, the arts were a vital and growing presence all across the country. That was the history. Endowment support was conceived as the stimulus for private, state, and local giving. It had succeeded remarkably, and it was but a small percentage of all the totals involved. Was that a "financial patron of the first resort?" One might ask in just what resort these notions had been concocted.

I fear they stemmed from ignorance, from a failure to examine any appropriate documentation, and from a failure to discriminate. The endowment was pushed into an immense total package marked "too much government is bad." That it did not fit seemed of no great consequence because perhaps other smallish entities might not fit either and that would disturb the basic reasoning.

There was deep indignation. One remembered, inevitably, the sense of outrage expressed when the work and mission of the endowment had been interpreted in obvious error. But we were not engaged now with a sympathetic and excellently informed congressional chairman. We were dealing with an issue. We had to combat it.

I consulted with Bob Carter. He was rumored to be possibly my successor as endowment chairman. His background included knowledge of the arts and political acumen as head of the Republican Party in the District of Columbia, a position about as difficult as being head of the refrigerator sales division in Antarctica. He had gained distinction, and people liked his low-key attitude.

The final budgetary language was modified and shortened. It said: "Reductions of this magnitude are premised on the concept that Federal policy for the Arts and Humanities support must be revamped" (not "completely" revamped, just revamped). "In recent years, the Endowments have spread Federal financial support into an ever-wider range of artistic and cultural endeavor" (not "literary," but cultural endeavor. Apparently someone had explained that "literary endeavor" did not pre-

cisely describe the work of the Humanities Endowment). "This action will place more emphasis on the role of private philanthropy and State and local support for arts and cultural activities."

The derogatory "for too long" had been replaced by the milder opening "in recent years." Gone was the nonsense about a "financial patron of first resort" and its implications. The finished product did not exactly ring with continuity of thought; one might argue that bringing the arts and humanities out across the country was not a disadvantage and that there was a certain nonsequitur in the following sentence to the preceding thought. Abbreviation, however, had been rather cunningly devised, if such was the intention. The blatantly incorrect had been excised. The statement now had a nice, opaque governmentese, inscrutable to a degree, and a sense of the inviolate.

The 50 percent cut had in no way been altered.

Bob Carter disappeared. One day he was there; the next he was not. He was reportedly on leave, traveling. We were not to see him again. Close ties with the administration receded, though I do remember calling the White House one evening to let them know that Arthur Mitchell was about to perform at the Kennedy Center.

"Arthur who?" asked the voice politely.

"Arthur Mitchell."

"Yes?"

"Director of the Dance Theater of Harlem."

"Did you say Harlem?"

"One of the country's very best companies," I said. "Supported by the National Endowment for the Arts since its beginnings, years ago, as a ballet school."

There was a pause. The new administration, it will be recalled, had not found endearing response from minorities.

"The President would enjoy it," I said. "And Mrs. Reagan—the Dance Theater of Harlem."

I admit to surprise. When Catharina and I went toward the front-row seats to which we have subscribed for years, evidence of the Secret Service was plain. When the curtain parted, not only were the President and First Lady in the center box, but the Vice-President and Mrs. Bush.

The curtain parted because Arthur had been busy preparing a little ceremony in tribute to one of his company. The two now emerged to the apron of the stage. Arthur looked out across the audience and upward. Astonishment overtook him. He seemed briefly to squint—then he raised his hand in greeting.

"Mr. President," he said in a loud voice, "and Mrs. Reagan. Mr.

Vice-President," he continued in the same tone, pausing for a second. "And Mrs. Muskie."

There was a moment of dead silence, then laughter all across the audience, good-natured and in volume. Arthur broke up in laughter at his astounding mistake. "Maybe I should read the paper more," I heard him say. I don't recall George Bush favoring the moment with much of a smile.

I recall another encounter I found greatly illuminating in these early weeks of 1981. I sought hard to find a staff authority at OMB who was involved with "reductions of this magnitude," who had perhaps developed and processed them for the wielder of the knife itself. Feeling close to the source, I extended an invitation to lunch. In my old Senate training, when you found the staff person chiefly involved, you found the access you sought. My companion was dressed as I had dressed in early Senate days: dark suit, white shirt, dark necktie. The face was keenly intelligent, youthful, assured, eyes alert and focused on me.

Why cut the arts so deeply? I asked. What was the real rationale?

It was very simple, I was told. The endowment was supporting art that the people did not want or understand, art of no real value.

How so? I inquired. Could I have an example?

Well, he said, he didn't really know too much about the arts, but he did know what an audience liked.

And that was to be assisted? I inquired.

Of course, he said. That had consequence.

A symphony, perhaps, I suggested.

A symphony—yes, he agreed. But not just any symphony. A classic one.

What was his own favorite? I asked. He was silent for several seconds. Beethoven, I suggested. Maybe Beethoven's Fifth Symphony.

He brightened instantly. Exactly, he said. That's it precisely.

I asked what made it a classic. It has stood the test of time, he answered at once.

I asked if in his view it had stood the test of the early nineteenth-century audiences of Beethoven's day. When there was no quick reply, but rather the look of one entering somewhat unfamiliar waters, I reminded him that Beethoven's work was considered to possess pioneering elements, an avant garde quality for its time. Critics found some of his harmonies bizarre. Many great artists, I suggested, are discovered and uplifted in lasting reputation not in their lifetimes but by future generations. The arts constantly evolve.

I sensed these were new thoughts for him, but of a passing inter-

est, not important enough to change a fixed attitude. We parted without any rancor. It occurred to me, however, that I had found a clear representation of the enemy and that the enemy was less than flexible. The 50 percent cut would remain; and as the head of the agency, part of the executive branch of government, it would be my responsibility, however unpleasant, to present these recommended reductions in our annual budget submission to Congress.

The alternative was to resign as a matter of principle. There were painful thoughts about this that I shared with Catharina. But then who—appointed in my place by the President—would continue to seek a remedy?

The National Council on the Arts met and tried to see President Reagan, but without avail. I sought the help of Republican congressional leaders. Joe McDade, that early and doughty pioneer leader of support for the arts, told me of a heated discussion he had held with David Stockman. Tom Evans from Delaware, married to a gifted artist, among the President's close circle of advisers in Congress and a believer in the arts, tried valiantly to shift the attitudes, but they were now firmly in place. To modify reductions for the arts would be to open a Pandora's box of complaints from other quarters and to place the total budget in dispute and jeopardy. I was advised to await developments on Capitol Hill and to stand firm. I was also told by friends in Congress that the administration planned to eliminate the endowment altogether over a three-year period, to reduce it first to impotence and then cause it to disappear.

One might wonder what the leaders in the arts outside Washington, in the private sector, in states and local government were doing at this time. I think they were stunned and confused. Many hoped that it was a bad dream that would dissipate. Many found it so strange that the constructive partnerships the endowment had created were now given as reason for its drastic curtailment that they found the situation unreal and hence difficult to assess. Many refused to believe that larger issues could submerge the arts. Many refused to believe that a President, popular in so many ways, would in this case fail in vision. Surely a President noted for fairness would relent. These excessive, extraordinary reductions would be given more modest proportions in keeping with what other areas of government were recommended to receive. There was a kind of ostrich-and-sand syndrome present, natural in a time of confusion.

The trouble is that no newly elected President has control over all aspects of his government—only those, if he is fortunate, of his immediate concern. There was no one within OMB to speak vigorously for the

arts. At the Arts Endowment, the chairman was a suspect Democrat from a previous administration defeated at the polls. Through some piece of misguided legislation from a remote past, he was still in office.

I received a call from the Office of Personnel Management. I had on my roster certain employees, I was reminded, who were exempt from standard civil service requirements and thus not entirely protected by civil service laws. That was true, wasn't it?

"Yes," I said. "They are chiefly in the program areas. We've always had such an arrangement." I knew what was coming.

"I want their resignations within a week," came the instruction.

"Very well," I said. "I will get them." I quickly replaced the receiver.

I called in all my most senior officials and gave them the news, and I had our legal office prepare appropriate documents proffering the resignations. The papers were dated that day, but to take effect at the expiration of my term, by law to last until November.

In a few days, I was called again.

"Where are those resignations?" I was asked.

"I have them all," I answered. "Just as you asked."

"But where are they? Why aren't they on my desk?"

"You didn't ask for that, sir," I responded. "You asked for the resignations. I have them all. They're in the bottom drawer of a bureau at home for perfect safekeeping. They take effect when my term expires in November."

There was a long pause.

"Are you playing games with me, Biddle?" was the question.

"No indeed, sir." I replied. "I followed the instructions you gave me to the letter."

"Listen," I was told. "We could get rid of you tomorrow if we wanted to."

"You know I have a statutory term of four years."

"That doesn't matter," I was told.

"All right," I said. "If the President wants me to resign, I'll consider it—but it has to be from him and over his signature."

I wasn't called again on this subject. But not too long afterward there awaited me on my office table early one morning a mysterious plain manila envelope. I opened it.

It was a copy of a document purportedly from the legal office in the White House. To whom it was transmitted was deleted, but it addressed the subject of Livingston Biddle and was in answer to the question of how to get rid of the subject individual. I was totally absorbed.

Apparently, during the Hoover administration, the head of a small

agency who had a statutory term from Congress had refused to resign on request of the President. The matter had gone all the way to the Supreme Court, which reportedly had ruled that the resignation must occur, for ultimately the President has authority over all employed in the executive branch; his authority therefore in this case was supreme. However, having recounted this case history, the document concluded that litigation of this sort, if repeated, would far exceed in time subject individual's statutory term—and besides, he was considered popular enough to suggest a less drastic solution.

I never asked how the envelope reached my desk. It was somewhat strange to think that there was a friendly mole somewhere at work in high places. No one claimed credit.

Upon us now were the months of doubt and agony, the spring of our deepest discontent. These words may sound extreme; yet a review of the papers preserved from this time reminds me of the excruciating task of preparing, as we were obligated to do, a detailed budget submission for Congress showing the severity of the reductions and, at the same time, in good conscience presenting them as the recommendation of an administration to which, as employees, as officials, we owed allegiance. How do you defend something with which you totally disagree? How do you protect the jobs and livelihood of a dedicated staff? How do you try your best to save your own life's work?

I found one answer in my testimony to the Congress. Sidney Yates began his annual hearing by saying he understood that the presentation of this budget was an inescapable obligation. Many hours had been spent in its preparation. Each deputy, program director, office head had considered over and over again the impact of the 50 percent reduction. Sometimes in the course of our discussions we would think in terms of the elimination of a program and a transfer of rescued funds to another cause so that *its* limitations might be slightly improved.

But which program, which art form should so be treated? At this level of reduction, would such an expedient really help? In the end, it seemed fairer to cut each program in half. Each in itself was at a different level, with orchestras and museums the largest entities. To subtract disproportionately, to move relatively small sums from place to place, seemed pointless. But these many, many hours revealed starkly to me that an endowment cut in half would be decimated. The council, in its own agonizing work, agreed. We could perhaps sustain reductions of between 10 and 15 percent. They would still be larger than those recommended elsewhere, but OMB talked about lower priorities for the arts than elsewhere. That was a fact of life. But to destroy half the agency appeared intolerable and mindless.

From our statistical analysis of records culled from over the years, moreover, we knew an $85 million cut in the endowment's program would be multiplied; I estimated the factor at three. The catalyst would be removed. The funds it traditionally had stimulated, year by year, would be diminished. Any alternatives, no matter how presented in rhetoric, would be years away. Most important of all, the sense of commitment at the highest level of government, which had so nourished the record of growth in the arts, would be gone.

So it was that Sidney Yates, after expressing his understanding, said that reductions of this magnitude would appear not to meet the real needs in the arts. I was silent for a moment, for I felt my comments would be monitored, and I awaited a question—similar in nature to the one Claiborne Pell and Frank Thompson of the Senate and House once put to Roger Stevens: What were the real needs in the arts?

Sidney Yates asked me the question. It was, as it had been years before, a direct congressional inquiry. I was free, indeed I was obligated, to answer. We had a long discussion on the needs involved. The program directors were similarly questioned. We were instructed to prepare careful alternative budgets showing the impact of reductions of 5, 10, 15, and 20 percent. We complied, using a detailed procedure of proportionate cuts for each program. Each would receive, at each level of reduction, a similar percentage of the total funds available. Each program director agonized with remaining distributions in program subdivisions. At an overall 20 percent reduction, the severity of deprivation in terms of planning, in terms of long-developed support, was starkly clear.

We had no idea how it all would end. There occurred two related events: The administration proposed a "recission" of over $30 million in the funds already appropriated to the endowment for that current fiscal year, and the President appointed a special task force to investigate both the Arts and the Humanities Endowments and to make recommendations about their respective futures—if any, seemed implied.

In ancient Greek mythology, giants of unusual size piled Mount Pelion and Mount Ossa atop each other so they could reach the heavens and overthrow the gods. It is related that they were repelled by the sun god Apollo. The new question seemed to be, Where on earth was an Apollo?

Chapter 68

THE RECISSION WAS PERHAPS THE MOST DISRUPTIVE ANNOUNCEMENT OF all. Half the fiscal year had gone by. The endowment dispenses its support in keeping with long-established procedures. Some institutional grants—to opera companies and museums, for example—are made early in the fiscal year, but in the Media Arts Program, half of the funding is granted in a fiscal year's concluding months. The endowment receives its appropriations from Congress in prescribed allotments, by no means all at once. Thus the recission would penalize those awaiting funds already promised but not yet disbursed. Half the Media Arts Program was in jeopardy and 70 percent of the Visual Arts Program. Almost all of the Dance Program's support for touring companies—where a $3 million endowment investment would generate $12 million in earned income for the eighty-nine organizations involved—would be lost. This aspect of the program had been years in evolving. It was basic to the health of the dance companies and basic also to the concept of making excellence in the arts available to the widest possible audience. Newspaper articles appeared and voices were raised in protest; but the arts community was generally in a state of numb disbelief. Recission, by executive order from

on high, was a new word, a Washington word unencountered in previous experience.

The Presidential Task Force on the Arts and Humanities, it was suggested, was being created with the express purpose of dismantling the agency. It would proceed with a Washington-type examination whose consequences had been predetermined. They were in accord with those revealing budgetary phrasings that spoke of a governmental usurpation of private initiatives and a sequence of further sharp strokes of the saber after the first onslaught. The White House, it seemed, was listening to a parade of drummers other than the arts.

My first encounter with the evolving task force was not reassuring. I was visited, under an aegis of White House authority, by Barnabas McHenry and his assistant Kate Moore. Barnabas had served as general counsel to the *Reader's Digest* for almost twenty years. His arts credentials included trusteeships of the Metropolitan Museum of Art and the Metropolitan Opera, and he was noted for leadership in New York City's cultural affairs. He was helping to organize the task force and would become its vice-chairman, given broad responsibilities. I had met him earlier, with Roger Stevens, he reminded me. He was a highly sophisticated conversationalist. Kate Moore, with a learned and studious intensity of expression, sat at the table taking notes.

The first question he asked was what had the endowment done wrong in the past and under my tenure. What did I most regret, what would I change were I to start all over again?

It occurred to me that Robert E. Lee (who happens to be maternally a distant ancestor) could have shared my thoughts had he been challenged in a similar way at Appomattox. Perhaps he would have withdrawn his sword. I was not about to deliver mine.

I had thought many times about questions like that, I answered. "And?"

And, basically, I said, I wouldn't change a thing.

Barney McHenry looked dissatisfied. It won't help, he told me, to say there are no errors. We need some place to start. You must realize I'm here to help. I don't want to see the endowment destroyed; I don't want to see it disappear, though there are some, he indicated, who wanted just that.

I told him I was sadly aware such was the case.

So we have to have a starting place, he continued. What's wrong? What can we change for the better? What can we recommend? Nothing's perfect, he was suggesting. Give me some ammunition, confide in me, I'm a friend.

I told him I fully agreed. Nothing is perfect; we tried hard and

constantly to improve. I described measures I had taken in this regard and their evolution from the time of Roger Stevens and Nancy Hanks.

He listened, neither agreeing nor disagreeing. Some money must be wasted somewhere, he seemed to be saying. Let's pinpoint where it is and begin.

But I was not about to invent criticism. We talked for a while longer. I wondered about motivations but could not decipher them. His tall, slender, urbane figure and demeanor had for me the same inscrutability as Kate Moore's slender fingers writing the notes. He said he was not actually involved with the cuts or the recission; his work was with the task force. It would meet a number of times and hire its own professional staff. The endowment, I said, would cooperate in every possible way.

I had the feeling the endowment was in a period wholly new to its experience. It had been examined and scrutinized before but never like this. There seemed to be a sense of inevitability, like a bank of fog moving in with the wind behind it. It was hard to see toward any horizon.

The task force consisted of twenty-nine members. Its mission included examination of both endowments. It was headed by three chairmen: Charlton Heston, famous in film, a friend of the President and First Lady, for the arts; Hanna Gray, president of the University of Chicago, for the humanities; and Daniel Terra, newly appointed ambassador-at-large for cultural affairs, for the government.

David Morse, who had worked for Senator Javits, was named as staff director, and Ann Leven, vice-president and senior corporate planning officer for the Chase Manhattan Bank, as staff chief for the arts. (For a recent twelve years she had also served as treasurer of the Metropolitan Museum of Art.) David I had known well and greatly respected; Ann possessed unusual intelligence. Both were meticulously professional, and in this time our relationships were at arm's length to ensure objectivity. The imperatives remained: restrictions were necessary, problems must be found. A vastly reduced budget seemed the corollary, though in our discussions we talked about general concepts rather than adversarial roles.

Other than the three chairmen and Barnabas McHenry, members of the task force ranged from friends of government support for the arts to those who objected. Both Roger Stevens and Nancy Hanks were members. They spoke of past traditions, of their own memories. I was asked to address the task force at a luncheon meeting at Decatur House on a steaming Washington summer day, with a white tent above the outside terrace seeming to reflect the heat rather than diminish it. The audience

was not the most attentive I have encountered, though Daniel Terra, somewhat to my surprise, gave me a most cordial welcome. I had the address typed and circulated, for I wished to present a comprehensive statement for the record, and this was my best opportunity. It summarized all the history and the work, gave all relevant statistics and all my convictions.

I attended a number of task force meetings, where it seemed evident that vocal objections to concepts of federal assistance were dominant. The rumors persisted that the full severity of reduction, the full magnitude announced in the administration's budget would be validated.

Yet a chemistry was at work which was at first difficult to assess. It came in part from the complexity of the issues, once initial reaction was faced with detail. For example, suppose there were a greatly curtailed endowment supporting the arts of recognized appeal: a limited number of major museums and exhibits, the orchestras, the large theater, opera, and dance groups with classic repertoire. And no chamber music? Well, perhaps just a Marlboro endeavor with a Rudolf Serkin. And no more? How do you limit? Let staff figure that out; we're talking here about ideas.

To a listener, the discussions often seemed to go afield. Many members were trying to assimilate vast amounts of information—digests of programs requested from the endowments, written comments submitted by the National Council on the Arts, statements from the National Assembly of State Art Agencies, the American Association of Museums, the Theater Communications Group, the American Symphony Orchestra League, exploring in depth the needs involved and the benefits of past assistance and accompanied by reams of statistical information.

I was reminded at times of the earliest meetings of the National Council, when explorations were beginning and questions of preliminaries were excusable. Here, however, were new discoverers grappling, figuratively speaking, with a wheel. But it was already rounded, given shape, and in motion with numbers of similarly fashioned objects, large and small and interconnected. In such cases, it is usually easier for a newcomer to stop the machinery and turn off the switch rather than extract a particular part.

I had breakfast one morning with Charlton Heston in Washington. I was especially eager to see him, for he had been an early member of the council, had been serving as chairman of the American Film Institute, and surely knew the philosophy of federal support from an historical standpoint. His handsome features were attentively composed, half-profiled, eyes watching me under craggy brows. I thought of him again as Ben Hur driving his chariot to victory, as Moses with the tablets of law held up for all to see. I thought of his close friendship with the President,

and of the rules that seemed to separate his mission from mine. He made no commitments. I expected none. The recission, however, did seem unfair, he said.

But a different chemistry was at work at this time. I was not aware of it then. In Greek mythology the gods of Olympus repelled those invaders, though they were of giant frame. Occasionally, the dwellers of Olympus assumed a mortal disguise and traveled on the earth at first undetected. So it was as these contemporary confrontations proceeded.

My own attention shifted to the Congress and to Sidney Yates and his colleagues concerned with appropriations. Gradually, as the weeks of summer advanced, a sense of hope began to return. The complexities of the arts, it seemed, were beginning to enmesh the task force and slow its direction. More emphasis was being given to tax incentives for philanthropic giving and to the work of the Federal Council on the Arts and the Humanities. The rumors, so unanimously attuned to the demolition of the endowment, were now suggesting a gradual turning away from drastic structural change. My innate skepticism, ingrained after all these years, was not satisfied, but it was nice to recognize once more an emerging optimism. The battles with our budget and the 50 percent reduction were far from over, but all at once the recission from current appropriations disappeared. The deadline passed, and the recission lapsed for want of affirmative congressional action.

Chapter 69

*I*N OCTOBER 1981, THE TASK FORCE ISSUED ITS REPORT TO THE PRESIDENT. After the myriad documents prepared, copied, mailed, and transmitted, after myriad interviews, the meetings on both East and West Coasts, the wide divergences in ideology represented—from the citadels of business to the paths of the arts and the "less traveled by," in that Robert Frost phrase—there emerged a relatively brief document: less than forty pages of text, including biographies of the members and assorted photographs. It was bound in dark gray paper embossed with discreet silver lettering on the front cover. It said:

> Basically, the National Endowments are sound and should remain as originally conceived. The Task Force does not recommend fundamental change in the roles of the Chairman or of the National Councils, but rather reaffirms and encourages their partnership in the formulation of policy as well as in grant-making. Furthermore, we endorse the professional panel review system, which puts judgments in the hands of those outside the Federal government, as a means of ensuring competence and integrity in grant decisions.

> *It has been enlightening to the Task Force to study the
> interweaving of public and private support. We have learned
> that public support generates private giving, helps set stan-
> dards, and spurs innovation by the recipient. Public support
> has been important for the major cultural institutions but,
> equally important, it has tended to encourage smaller groups,
> to help creative movements survive.*
> *The Task Force reaffirms the principle of diverse
> sources of public funding for the arts and humanities activities
> as expressed in the Endowment's enabling legislation.*

There was a section recommending private citizen involvement
with the Federal Council, and there were constructive views on tax pol-
icy, guided by Washington cultural leader Leonard Silverstein, who had
been assigned to develop these recommendations from a background of
government service and high reputation in the law.

Barnabas McHenry is shown in one photograph with a somewhat
quizzical yet attentive expression, wearing his characteristic broad-
striped shirt and polka-dot tie, head turned toward a speaker off-camera
at his left. It is hard to ascertain his thoughts. In another photo, a child
stands with head tilted upward gazing at a large abstract painting. Con-
centric circles, suggestive of a giant target, are depicted.

To me the task force had hit the bull's-eye.

Frank Hodsoll came from the White House office of James Baker,
one day to become secretary of the treasury. Frank was, in an Irish
phrase, "a great figure of a man," large in the dimensions a linebacker
could envy, quick in intelligence, long in experience with political life,
shorter in the arts. But no voice was raised to suggest possible burdens
of a political background this time around. I was not, of course, privy to
his selection, but it was clear he was the President's choice. It was also
clear that my time was soon to expire.

We discussed the endowment at length in his White House office.
I imparted as much as I could. Frank had learned about the endowment
through association with the task force. He could not say so directly, but
I believe he was pleased by the steps being taken by Sidney Yates and
the Congress. I gave him some "words of art" about the wisdom of Con-
gress and suggested how they might be applied to difficult budgetary
reductions should they persist. I do not believe they were ever quite used
as proffered, but Frank's situation was much different from mine, in
terms of party affiliation and its implications.

When Frank's nomination was transmitted to the Senate—at about
the same time as mine had been in an earlier Congress, near the end of
the session—a few old friends called to wonder if perhaps the papers

might be placed toward the lower middle of the stack of credentials of others awaiting Senate action. Such placement could permit me more months in office, into February or March of the following year. I remembered all the complications surrounding my own confirmation and my great wish to get started. Frank's papers were placed in the proper spot for earliest action, and old friends were thanked for their thoughts. I spoke with Claiborne about Frank's situation, and the niceties of Senate procedure moved forward apace.

It would be a new endowment. It would be an old endowment. There would be continuity. There would be legacies from the past. In the phrase of that Office of Management and Budget official, spoken in a different yet related context, it had "stood the test of time."

Also in October 1981, there was a conference in Pittsburgh to emphasize the contributions of the arts to urban environments. It was a culmination of many activities I had undertaken—a conference on the principles of excellence in design I had initiated with Joan Mondale in Washington, continuing work on the establishment of a National Building Museum in Washington where examples of the best in American architecture would be presented for study and emulation, and the advances made by the endowment's Design Arts Program. Under the direction of Michael Pittas, assisted by Charles Zucker, it had increasingly served as an advocate and catalyst for ideas and projects to improve the American landscape in the buildings we build, in the creative uses we find for them.

The Pittsburgh conference focused on the competitive advantage enjoyed by cities that give attention to the arts, to centers for creative activity, to the esplanades that open up new cultural vistas. Some such cities have been mentioned in these pages. Baltimore's new Inner Harbor complex, a tribute to Mayor Donald Schaefer, also comes to mind, as does Los Angeles's music-filled plazas at a time of annual festival and celebration, so identified with Mayor Tom Bradley.

A special endowment involvement and partnership were featured in Pittsburgh, where a revitalizing endeavor called Renaissance II was in progress. Approximately 500 participants attended the conference, sponsored by almost all arts-connected organizations, from Opera America and the American Symphony Orchestra League to Partners for Livable Places to labor and education groups to the American Council for the Arts to American societies concerned with landscape architecture and interior design to city managers and legal and legislative professionals. It was called The Arts Edge, celebrating the economic benefits of the arts and their ability to lift our spirits. I thought again of those early council discussions with Albert Bush-Brown, Minoru Yamasaki, and Bill

Pereira, and of how far we had come, and of the journey ahead. Renaissance (Roman numeral I) got rid of the smoke in Pittsburgh a decade earlier. Renaissance II showed how alive is a city where the arts are alive.

And finally, in culmination, came the news that seemed at its basis life or death. Would the endowment be cut by 50 percent? The answer was no. Would it be cut by 25 percent? No, again. Would it be cut by 15 percent? No. By 10 percent, then—surely by that amount. Again, the answer was no.

When Congress worked its will, the reduction was just over 6 percent. Programs once believed lost could remain virtually intact. In Congress, the sense of fairness had prevailed. But much more important, in this new time of stringency and changing priorities, the arts had been reaffirmed. In my memory, no federal program of any kind had so risen above its first recommended sum.

The call came from Sidney Yates's office, when he was still engaged with all the final details of his appropriations bill. Agreement had been reached on funding for the arts; a few other matters were still in dispute, but the arts were safe.

To me it was like a miracle, and he—as I have told him a number of times now—the miracle worker.

It was—after these months and these years—a legacy I could leave to my successor.

Detroit was the final stop away from home, October 31, 1981—a visit to the Detroit Institute of Arts, where the endowment was helping support a major exhibition.

I look at the old folder and notes from the trip—for this exhibit, $75,000 in endowment funds; for the institute, a total of fifty-seven grants and $1,726,290 over a ten-year span; a challenge grant of $750,000 already matched by $8,546,932 raised by the museum. Grants for the state of Michigan during the fiscal year 1980, ninety-five totaling $1,151,346. Grants for Michigan for the fiscal year 1981 just concluded, a 12 percent increase.

Catharina and I enter the lofty interior of the institute and meet with Fred Cummings, the director, whom we both highly regard. We talk of the arts and their future. Before we leave, Catharina has renewed acquaintances with numbers of other friends—those on the walls, in the frames, lit skillfully, preserved in galleries that have the climate control the endowment helped provide. The masters of past and present, in the

long continuum and evolution of the arts—to me these are more recent friends, but I know them better than before.

Coincidentally, Detroit was almost the first city we visited when these experiences began four years earlier. We had been there to help inaugurate the start of an endowment emphasis on jazz, from whose roots stem so much of American music. So at the institute, memories returned—Billy Taylor, the musician; John Conyers, the congressman most involved. The arts communicated back and forth in time and place and with each other, as they do, as they always have.

The centerpiece exhibit now was entitled "The Golden Age of Naples." Paintings, sculpture, furnishings of unusual delicacy and historic style were included in the galleries—"Naples in the 18th century," said the catalogue, "when that city was one of the major commercial and artistic centers of Europe."

The arts and commerce two centuries ago. The arts and the modern corporation. The arts and private philanthropy. The arts and governmental commitment. Themes that can work together. Tapestries yet to be made.

A Golden Age for the arts in the United States? It is a distance removed, but we are closer to it than we were. Believe me, it will come.

Chapter 70

I T WILL COME BECAUSE PEOPLE CARE, AND CARE ENOUGH TO MAKE IT
happen, people in the arts, in private philanthropy, in government at
local, state, and federal levels, people who can translate the increasing
regard for the arts into growing support.

Our cultural needs and goals are addressed publicly on a wider
range of issues than before. Congress considers artists' rights, the safe-
guarding of copyrights and royalties, inequities in the tax structure that
affect artists. Robert Rauschenberg, energized by such an intelligent ad-
vocate of artists' rights as Rubin Gorewitz, testifies on the anomaly that
an artist can deduct only the cost of the canvas and materials when do-
nating work to a museum while a collector can deduct its fair market
value. Such discrepancies are receiving public sympathy as the arts and
their complexities are better understood.

And, in a framework of expanding attention, consider these words
from Nancy Reagan, quoted in the Arts Endowment's magazine, *Arts Re-
view:*

> *I think one of the most important roles the Endowment
> has played lies in its search for artistic excellence and its re-*

ward for that excellence. . . . It has given artists—in all disciplines working in every part of the country—the financial encouragement to experiment and refine their art. . . . The Endowment, through its Challenge Grant Program, has been responsible for more than $1 billion in new money being contributed to the arts by the private sector, by corporations, foundations, and individuals.

Mrs. Reagan emphasizes the importance of support for minority organizations in the arts and of the partnership role the endowment plays with state, regional, and local governments and with the private sector. She continues:

The Endowment was established at a crucial stage in the growth of the arts. . . . Largely because of the Endowment, today artists do not have to move to big cities in order to create their art. The arts have become so widely recognized and respected as a profession that today artistic life and creativity can occur virtually anywhere in this nation. In 1965, it was difficult if not impossible for an unknown artist to show his or her work. Today, there are hundreds of alternatives to museums and galleries where artists' work can be seen. . . . Dance and opera and theater and writers and painters and sculptors became . . . a part of the landscape all across America—in many places where they had not previously existed. The Endowment's accomplishments are evident.

Consider those recent words in relation to the 1981 budget recommendation and its rationale, which portrayed the endowment as irresponsibly profligate, the arts as of questionable merit, and federal assistance as motivating the curtailment of private giving to the arts. One is tempted to remark that a long way has been traveled.

Endowment chairman Frank Hodsoll is halfway into his second term. I have heard difficult-to-convince members of the National Council praise his hard work, his increase in understanding of the complicated endeavor involved. It is as if the arts themselves had provided their own educational blessings and helped create respected leadership. The full dimensions of the arts may not have been visible in the beginning; they are much more so, I believe, today.

We must recognize, however, wider changes in attitudes, even a changing of heart. I was puzzled by this during the spring, summer, and fall of the task force in 1981. In recounting a tale from Greek mythology I suggested how the dwellers of Olympus were said to travel the earth on occasion in mortal disguise. Not too long ago it seemed to me I had found such a voyager.

He was deeply involved with the task force as cochairman, representing government. One might liken him to a Phoebus Apollo in energy and vigor. He is Daniel J. Terra, ambassador-at-large for cultural affairs, a new position created by President Reagan for one of his most accomplished supporters, but above all for one whose persuasiveness is linked to an exceptional personal commitment to the arts. Daniel Terra, I am convinced, more than anyone else altered the attitudes and hence the findings of the task force from negative to positive and thus set in motion a change of heart.

Dan Terra is the founder of an important museum, an expert in American art, an erudite collector. He is in the tradition of other close presidential advisors who knew and loved the arts—an Abe Fortas for a Lyndon Johnson, a Leonard Garment for a Richard Nixon. He has one particular attribute that surpasses those of the others: He is an eminent business leader. In an administration that gives attention to increased private philanthropy, increased corporate giving to the arts, Dan Terra's is the most experienced voice for encouragement in cultural fields.

His mother was a dancer from the Italian arts center of Florence. The family moved to Philadelphia before Dan's birth. His first wife, Adeline—they were married in 1937—died during 1982. She was an art major in college, a student of English literature and history. Early Terra philanthropy focused on the arts and a museum setting at Penn State. His is an American success story. He studied chemical engineering at college and law at Columbia University, at the University of Pennsylvania, and at Northwestern. He discovered a process that would to revolutionize magazine publications by shortening printing time from thirty days to just one. With borrowings of $2,500 he founded Lawter International, Inc. Initially a small research company in Chicago, it became a major source of his fortune. He expanded his activities into real estate and development, with an eye to excellence in architecture.

Dan Terra became a collector of art, learning, researching, visiting the galleries and museums, and gradually focusing his attention on American painting. His acquisitions grew from a small landscape purchased for $50 to increasingly major works. He can recount the history and background of each one, from the time he acquired the historic and monumental *Gallery of the Louvre* by Samuel F. B. Morse to his successful competition with Armand Hammer in securing a masterpiece by Mary Cassatt. His collection has more than 800 works of American art.

Now a Chicagoan, he founded a museum in suburban Evanston. It led to a far more significant enterprise, the creation of the Terra Museum of American Art in the heart of the city. The museum's location was carefully chosen to be at the center of business on North Michigan Ave-

nue. Dan Terra feels it serves as a symbol of the winning partnership between business and the arts.

I have known him for seven years—during the tragic period when Adeline passed on, and during the happiness he found with Judith Banks, whom he married in 1986 and who is now bringing her enthusiasm and knowledge to his work. Together they are a team.

The only Republican national finance chairman who has come from the arts, Dan Terra believes in their bipartisanship. We share that strong belief. A Senator Pell would not have succeeded without a Senator Javits. A Presidential Task Force might well have reached a then-currently espoused partisan view of the arts had it not been for Dan Terra. His knowledge was respected; hence it persuaded. Had he expressed from the administration a pressing need to curtail, to revamp, to alter and minimize, certainly the task force report and its results would have been far different. He was convinced of the benefits of the endowment's work. He had made his own assessments. He is totally loyal to his chief and at the same time loyal to the fundamental values that have nourished the arts. It never seemed to him, in our many conversations, a dichotomy.

His duties are varied, from the ceremonial to the substantive and subjective. For an ambassador-at-large there are many functions to attend and initiate. The high-ceilinged eighth-floor rooms at the Department of State, elegantly furnished with the antiques of American craftsmanship under the aegis of Clement Conger, are especially fitted to the ceremonial. Dan and Judy Terra are special hosts there. Both understand the need to nourish the arts at home and to expand their international presence beyond ceremonial celebration.

Dan considers the Terra Museum in Chicago, where his mother's memory is honored, an achievement presently exceeding others in his career. His involvement has been criticized as too personal, sometimes intrusive on a professional staff. But isn't this like saying that the individual responsible for creation in the arts should find a surrogate?

The museum bears a personal name. So do many others. They reflect an individual point of view. In this case, for Dan Terra is seventy-five years old, reflected are years of learning about the arts and making decisions after consultations and discussions, but with a final personal commitment. The artist, when pleased, must have two convictions: that the work, right now, at the given moment, is the very best the artist can accomplish, and that some day, perhaps as early as tomorrow, it can be improved. When the latter conviction is missing, the quest ends egocentrically short of its mark. With Dan the quest, he points out, is far from completion.

He has given new impetus to an Art-in-Embassies Program, begun over two decades ago, which exhibits American works of art on foreign soil. Following Dan's recommendation, Lee Kimche was named to head this program. She reports 129 embassies involved, in contrast to only five when the program started. With Dan's help and with special help from Leonore Annenberg, former chief of protocol, and Wendy Luers, new private funding is being generated on a bi-partisan basis. Dan intends to focus increasing personal attention on the benefits of this program in the future. And visiting his office since 1981 have been hundreds of representatives from abroad. He explains to them how our national endowment works as a catalyst in its own American way. He believes seeds have already been planted for new partnerships with the countries involved. The example of the American experience is given new attention. It is especially interesting to me that this nation, marked in 1965 as the only country in the civilized world that gave no governmental support to the arts, has now developed a program others would like to emulate.

The attribute I find especially appealing in Dan Terra is the joy he gets from his work. He likes to bring people together, business leaders and cultural leaders. The two are becoming more interchangeable.

His major new endeavor, however, goes beyond the Department of State, the present administration, and the turmoil of these times, to the quiet village of Giverny in France, to the home of Claude Monet. He envisions a museum of American art in this special setting, celebrating American artists who painted there and others who preceded them and followed after, introducing them to the many visitors who come to Giverny, almost with a sense of pilgrimage, from all over the world. He sees the museum stimulating new bonds between France and America, following past traditions toward a brighter future. Thus the concept is in keeping with fundamental goals, those that educate, those that inspire, and those that can demonstrate both the particularized and the universal values of the arts.

Chapter 71

BRINGING THE CREATIVE TALENTS OF AMERICAN ARTISTS TO FULL REC-
ognition on foreign shores can have immense consequences for
the legacies we leave. Twenty-five years ago, a relatively short time in
history, the flow was most often in the opposite direction. America was
perceived as materialist, as interested in practicalities, a nation focused
on business know-how with little time for cultural pursuits. So know-how
in the arts came to us from others—in dance, in music, in writing, in
great museums, in theater. The young government official who singled
out Beethoven's Fifth Symphony for lasting value would hardly have sug-
gested an Aaron Copland or a Charles Ives. Traditions abroad were un-
deniably deeper and longer lasting, and we found comfortable identity
with them. The flow of cultural achievements washed in on us, and those
who rode in with the waves found us in part welcoming and in part edu-
cable.

See, however, what has happened in the quarter-century since the
United States government found the arts worthy of commitment. See
how the catalyst has worked. See how the arts have multiplied. Witness
a Luciano Pavarotti starting a special training program for opera not in
Italy—his home and the native heath of the art form—but in Philadelphia.

See also how a Museum of African Art, pioneered by a Warren Robbins years ago with great diligence but relatively little early support, now finds an elegant new home in the Smithsonian Institution. The centers of international recognition of the arts are shifting. Their satellites grow.

We must not exaggerate, however, the dynamics of change. They are occurring perhaps more rapidly than we first foresaw, but they are a far distance from maturity. It can be said that the arts, in a time of competition with the most stringent of priorities, are treading water. Their gains during two and a half decades often seem difficult to sustain. One feels the arts suffering. But they are not sinking, and they have developed a quality of resiliency. Like a long-distance runner they are gaining in experience.

And the waves are moving outward. American art has been enthusiastically received in the Soviet Union, Japan, India, Africa. It is finding new friends in Europe, new discoverers, new believers. As we have placed our own significance on artistic achievement, so have we made our own discoveries past and present. To the French citizens of Giverny it may not have been readily apparent that near the renowned gardens of Monet, American impressionists lived and painted and gave the world their individualized interpretations of light and color and form. We learn of their work. We learn of our past. So do the citizens of Giverny. So do visitors from around the world who come first to see the Monet gardens.

The lilies bloom on their round green floating leaves and close at night. The willow branches stretch down over a profusion of flowers. There is the arch of the famous Japanese bridge entwined by a wisteria vine carefully pruned. Visitors pass in both directions crossing the bridge, and I am reminded of the bridge the arts make—with many crossings possible and a sense of unfolding delight.

The arts are our unfailing ambassadors. They are the best we can provide. They are the most enlightened. They enter portals otherwise closed. A wise nineteenth-century British statesman and prime minister once suggested that we have no perpetual friends, no perpetual enemies, only those that a given national interest at a given time prescribes. But the arts are perpetual allies. They can be personal and beyond time.

My own favorite example is Sir Oliver and Lady Wright of the United Kingdom. It is favorite because they were both not only consummate ambassadorial diplomats but also talented and personal participants in the arts. In a most special and endearing way they enriched and enlivened the cultural life of our nation's capital and what it can mean.

Should there be a minister of culture in the United States? The question has been debated. The title coincides with those in most other countries and elevates in importance the person holding it: *the* authority,

the individual who can speak for a nation's cultural growth. But the endowments for the arts and the humanities are not ministries, or one ministry. They are different because they are catalysts for growth, not its arbiters. That is *their* history and tradition; that is what has been tested and not found wanting.

A minister of culture would be inappropriate in my view, but an ambassador-at-large for cultural affairs with cabinet rank is an idea worth considering—one who would work with the endowments closely and thoughtfully, and with all related programs in a pluralistic system, one who could bring matters of cultural import into the cabinet room and so make their importance and their universal goals increasingly relevant. The arts and humanities belong in that setting.

Daniel Terra finds effectiveness in his work because it is unstructured. But I think of transition and moving toward a time when government as a whole finds in the arts and cultural values not a stranger, not a sometimes welcome guest, but a warm and particularly honored friend.

There is so much yet to do. How will it be ten years from now? or twenty? Will there be other great defenders, other great champions, other true Horatios at the Bridge? Who will the new heroes be in the Nation, in Congress, in administrations yet to come?

I have known the best of the past heroes and the best of those present. I sometimes like to envision a great old turreted and many-windowed structure in which they are assembled. They are all there. In the evenings they gather around an enormous fireplace with blazing logs and a carved stone mantel, for the air is crisp outside. The doors open occasionally to admit new arrivals.

From the upper terrace, but not quite level with it, is a view of the mountain peaks.

Index

ABOUT THE AMERICAN COUNCIL FOR THE ARTS

The American Council for the Arts (ACA) is one of the nation's primary sources of legislative news affecting all of the arts and serves as a leading advisor to arts administrators, educators, elected officials, arts patrons and the general public. To accomplish its goal of strong advocacy of the arts, ACA promotes public debate in various national, state and local forums; communicates as a publisher of books, journals, Vantage Point magazine and ACA UpDate; provides information services through its extensive arts education, policy and management library; and has as its key policy issues arts education, the needs of individual artists, private-sector initiatives, and international cultural relations.

BOARD OF DIRECTORS

MAJOR CONTRIBUTORS

GOLDEN BENEFACTORS ($75,000 and up)
American Telephone & Telegraph Company
Gannett Foundation
Southwestern Bell

BENEFACTORS ($50,000-$74,999)
Aetna Life & Casualty Company
National Endowment for the Arts
Southwestern Bell

SUSTAINERS ($25,000-$49,999)
Robert H. Ahmanson
American Re-Insurance Co.
Mr. and Mrs. Jack S. Blanton, Sr.
The Coca-Cola Company
Eleanor Naylor Dana Trust
Philip Morris Companies, Inc.
The Reed Foundation
Sears, Roebuck, & Co.
Elton B. Stephens
Mr. and Mrs. Richard L. Swig

SPONSORS ($15,000-$24,999)
Geraldine R. Dodge Foundation
Exxon Corporation
General Motors Corporation
IBM Corporation
Ruth Lilly
Merrill Lynch, Pierce, Fenner, & Smith Incorporated
Metropolitan Life Foundation
Rockefeller Foundation
The San Francisco Foundation
Mr. John Straus

PATRONS ($10,000-$14,999)
American International Corporation
American International Group, Inc.
Ashland Oil, Inc.
Mr. and Mrs. Frederick Dupree, Jr.
Equitable Life Assurance Society
Toni K. Goodale
Susan R. Kelly
Mutual Benefit Life
N.W. Ayer, Inc.
Peat, Marwick, Mitchell
Mrs. Charles Peebler
Murray Charles Pfister
Mrs. Paul Schorr, III
Mrs. Alfred R. Shands

DONORS ($5,000-$9,999)
The Allstate Foundation
American Stock Exchange, Inc.
Ameritech
Atlantic Richfield Company
Batus, Inc.
Bell Atlantic
Boeing Company
Bozell, Jacobs, Kenyon & Eckhardt
CIGNA Corporation
Dayton Hudson Foundation
Joseph Drown Foundation
Federated Investors, Inc.
The First Boston Corporation
Ford Motor Company Fund
Gannett Outdoor
David H. Harris
Louis Harris & Associates
The Hartford Courant
The Irvine Company
Howard S. Kelberg
GFI/Knoll International Foundation
The Joe and Emily Lowe Foundation, Inc.
Lewis Manilow
MBIA, Inc.
Mobil Foundation, Inc.
Morgan Guaranty Trust Company
Morrison-Knudsen Corporation
New York Times Company Foundation
Prudential Insurance Company of America
RJR Nabisco, Inc.

Mr. David Rockefeller, Jr.
Henry C. Rogers
Mr. and Mrs. LeRoy Rubin
Shell Companies Foundation
David E. Skinner
Allen M. Turner
Warner Lambert Company
Whirlpool Foundation
Xerox Corporation

CONTRIBUTORS ($2,000-$4,999)
Alcoa Foundation
Allied Corporation
American Electric Power Company, Inc.
American Express Foundation
Mr. and Mrs. Curtis L. Blake
Gerald D. Blatherwick
Edward Block
Borg-Warner Co.
Donald L. Bren
Bristol-Myers Fund
C.W. Shaver
Chevron USA, Inc.
Mrs. Howard Stephen Cowan
Mrs. George Dunklin
Eastman Kodak Company
Emerson Electric Co.
Ethyl Corporation
Thomas M. Giardini
Donald R. Greene
Mrs. John Hall
Eldridge C. Hanes
Alexander Julian
Henry Kates
John Kilpatrick
Mrs. Robert Lorton
Marsh & McLennan Companies
The Monsanto Fund
Robert M. Montgomery, Jr.
Velma V. Morrison
New York Life Foundation
Overbrook Foundation
Phillips Petroleum Foundation
Procter & Gamble Fund
Raytheon Company
Mr. & Mrs. Richard S. Reynolds, III

Rubbermaid, Inc.
Sara Lee Corporation
Frank Saunders
Joseph E. Seagram & Sons
Sears, Roebuck, & Co.
Union Pacific Foundation
Mrs. Gerald H. Westby
Westinghouse Electric Fund
Betty Bentsen Winn
Mrs. R. Dan Winn

FRIENDS ($1,000-$1,999)
Morris J. Alhadeff
AmSouth Bank N.A.
Mr. Wallace Barnes
Bell South
Mr. Stephen Belth
Binney & Smith
T. Winfield Blackwell
Houston Blount
William A. Brady, M.D.
Mrs. Martin Brown
Alan Cameros
Mrs. George P. Caulkins
Mrs. Jay Cherniack
Chesebrough-Pond's Inc.
Chrysler Corporation Fund
Citizens and Southern Corporation
David L. Coffin
Thomas B. Coleman
Donald G. Conrad
Cooper Industries
Mrs. Crittenden Currie
Eugene C. Dorsey
Mrs. Frederick Dupree
Mrs. Hubert Everist
Dr. and Mrs. John M. Gibbons
Lee Gillespie
Eldridge C. Hanes
R. Philip Hanes, Jr.
Mrs. Lyndon B. Johnson
Mrs. Albert Kerry
Mrs. Roy A. Kite
Mrs. James Knapp
Henry Kohn
Kraft, Inc.

Mr. Robert Krissel
Mrs. C.L. Landen, Jr.
Thomas B. Lemann
Robert Leys
Florri D. McMillan
Mrs. Michael A. Miles
George Mitchell
Sondra G. Myers
Mr. and Mrs. William G. Pannill
Pantone, Inc.
Diane Parker
General Dillman Rash
W. Ann Reynolds
Mrs. Kay Riordan-Steuerwald
Judith & Ronald S. Rosen
Mrs. William A. Schreyer
Security Pacific
Dr. James H. Semans
Marie Walsh Sharpe Art Foundation
Mr. and Mrs. Stephen D. Susman
Tandy Corporation
Textron Charitable Trust
Mrs. John E. Velde, Jr.
Esther Wachtell
Frederick Weisman
Mrs. William F. Whitfield
Lawrence A. Wien
Mrs. Thomas Williams, Jr.
Elaine Percy Wilson
F.W. Woolworth Co.
Mr. and Mrs. William T. Young

THE NATIONAL PATRONS OF THE AMERICAN COUNCIL FOR THE ARTS

Robert H. Ahmanson
Beverly Hills, CA

Morris J. Alhadeff
Renton, WA

Anne Bartley
Washington, DC

T. Winfield Blackwell
Winston-Salem, NC

William A. Brady, M.D.
Winston-Salem, NC

Mr. Donald Bren
Newport Beach, CA

Mrs. Martin Brown
Nashville, TN

Alan Cameros
Rochester, NY

Mrs. George P. Caulkins
Denver, CO

Mrs. Jay Cherniack
Omaha, NE

Thomas B. Coleman
New Orleans, LA

Stepania Conrad
West Hartford, CT

Mrs. Howard Stephen Cowan
Boothbay Harbor, ME

Mrs. Crittenden Currie
Memphis, TN

Mrs. George H. Dunklin
Pine Bluff, AR

Mrs. Hubert Everist
Sioux City, IA

Lee Gillespie
Cambridge, MA

Mrs. John Hall
Ashland, KY

R. Philip Hanes, Jr.
Winston-Salem, NC

Mrs. Skitch Henderson
New Milford, CT

Mrs. Lyndon B. Johnson
Austin, TX

Alexander Julian
New York, NY

Henry Kates
Providence, RI

Mrs. Albert Kerry
Seattle, WA

Mrs. Roy A. Kite
Paradise Valley, AZ

Mrs. James Knapp
Balboa, CA

Henry Kohn
New York, NY

Mr. Robert Krissel
Long Island City, NY

Mrs. C.L. Landen, Jr.
Omaha, NE

Gale Layman
Newport Beach, CA

Thomas B. Lemann
New Orleans, LA

Ruth Lilly
Indianapolis, IN

Ellen Liman
New York, NY

Mrs. Robert Lorton
Tulsa, OK

Florri D. McMillan
Chicago, IL

Mrs. Michael A. Miles
Lake Foret, IL

Robert M. Montgomery, Jr.
West Palm Beach, FL

Diane Parker
Baltimore, MD

General Dillman Rash
Louisville, KY

Richard S. Reynolds, III
Richmond, VA

Mrs. Kay Riordan-Steuerwald
Keystone, SD

Ronald Rosen
Encino, CA

Mrs. LeRoy Rubin
Stamford, CT

Mrs. William A. Schreyer
Princeton, NJ

Dr. James H. Semans
Durham, NC

Mrs. John E. Velde, Jr.
Omaha, NE

Mr. Frederick Weisman
Los Angeles, CA

Mrs. William F. Whitfield
Albuquerque, NM

Lawrence A. Wien
New York, NY

Mrs. Thomas Williams, Jr.
Thomasville, GA

Elaine Percy Wilson
Rochester, NY

Betty Bentsen Winn
McAllen, TX